Architecture of the future

richard rogers

A CIP catalogue record for this book is available from the Library of Congress, Washington D.C., USA.

Bibliographic information published by Die Deutsche Bibliothek

Die Deutsche Bibliothek lists this publication in the Deutsche Nationalbibliografie; detailed bibliographic data is available in the internet at http://dnb.ddb.de.

© 2006 Birkhäuser – Publishers for Architecture,
P.O. Box 133,
CH-4010 Basel, Switzerland

Part of Springer Science+Business Media

Text © 2006 Kenneth Powell
The moral right of the author has been asserted

Additional quotation text © 2006 Architectural directors
Richard Rogers Partnership
The moral right of the author has been asserted

All plans and drawings © 2006 Richard Rogers Partnership
The moral right of the author has been asserted

This book is also available in a Spanish language edition (ISBN-13: 978-3-7643-7351-1).

Printed on acid-free paper produced from chlorine-free pulp. TCF ∞

Printed in Italy

ISBN-13: 978-3-7643-7049-7
ISBN-10: 3-7643-7049-1

9 8 7 6 5 4 3 2 1

http://www.birkhauser.ch

Architecture of the future

richard rogers

Kenneth Powell

Edited by Robert Torday

Birkhäuser – Publishers for Architecture

Basel • Boston • Berlin

Acknowledgements

Thanks are due to the Directors at RRP for their collaboration throughout the long gestation of this book.

Philip Dennis at RRP has made a heroic contribution to the overall layout of the book. His calm and skilful liaison between project directors and the external graphic designers has been invaluable.

The initial concept design for this book was created by Stephen Coates. Pete Taylor and Paul Wood of Ocean Blue have seen the project through with amazing speed and efficiency.

Virginia McLeod has undertaken many daunting editorial tasks with great dedication and necessary wit.

Thanks also to the author, Kenneth Powell, for his assistance in bringing this project to fruition and to Tina Wilson for her help on many issues.

RT

Contents

Public Buildings 3

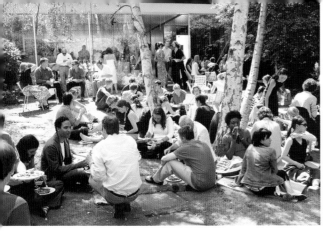

Foreword

Left to Right, Top Row: Staff summer party at the Rogers House, Wimbledon; Mike Davies; Mark Darbon; Ivan Harbour. Centre Row: Ian Birtles and Andrew Morris; John Young and Richard Rogers; Graham Stirk. Bottom Row: Richard Paul and Laurie Abbott; Lennart Grut; Amarjit Kalsi; A design meeting at Thames Wharf Studios.

The last decade has been a period of remarkable growth and development for the Partnership, in terms of research, ideas and the breadth of new talent coming to the fore. This foreword to a new book on the work of the practice provides an excellent opportunity to pay tribute to a remarkable team. Our ongoing success is due in large part to younger directors such as Graham Stirk, Ivan Harbour, Andrew Morris, Amarjit Kalsi, Richard Paul and Mark Darbon, who have all assumed prominent roles within the practice.

As this 'new generation' takes greater design responsibility, the dynamic of the practice is inevitably changing. Graham Stirk's award-winning office schemes such as Wood Street, Lloyd's Register and, most recently, the great Leadenhall Building, Ivan Harbour's designs for the Bordeaux and Antwerp Law Courts and Barajas Airport, and Richard Paul's high-rise schemes at Canary Wharf, can all be seen as significant markers in the ongoing evolution of the practice.

These recent and ongoing projects embody the dominant themes which have driven our work for decades – the search for uplifting architecture which in turn creates the context for civilised urban life. The proper use of technology – as a means, not as an end – is the key to the future. Faced with the consequences of the abuse of technology, however, the practice supports architecture which respects the natural world and the place of man within it. A passion for cities informs the work of the practice – cities should be, above all else, meeting places for people, places to live and to enjoy a full life. I have always argued in favour of densely inhabited cities where high buildings have a role to play – not the insensate slabs of the recent past but low energy, possibly mixed-use buildings, appropriately sited within the context of revitalised public space, and with the grace of form to enhance an established skyline.

We are essentially optimistic in outlook and build optimistic buildings. This is an enormously exciting time for the practice and for the team that will take our work forwards into the 21st century.

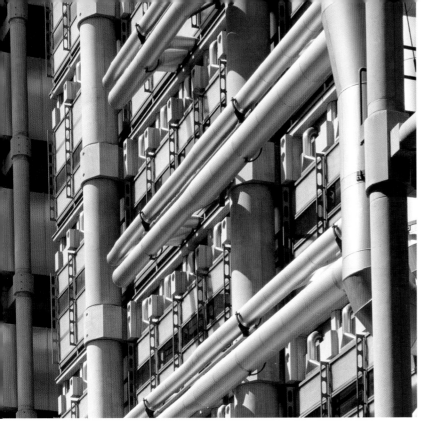

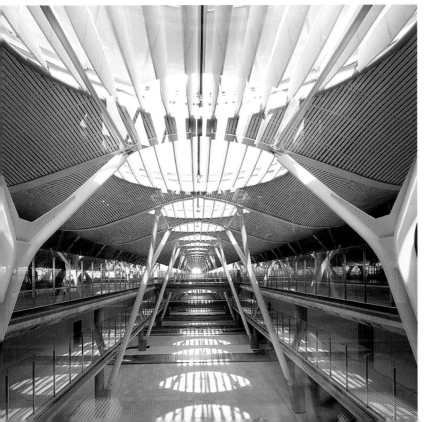
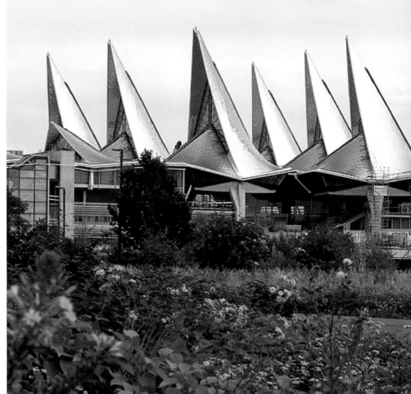

Introduction

Kenneth Powell

For more than quarter of a century, Richard Rogers has been one of the undisputed leaders of British architecture and a major figure on the international architectural scene. He remains an inspirational figure, not only for those who work with him – his architecture is about teamwork – but for the architectural profession more widely and for many who believe that a better environment is the way to a healthier society.

Rogers achieved world renown with the Centre Pompidou in Paris, generally recognised as one of the key European buildings of the post-war years, created another masterpiece at the heart of London in the shape of Lloyd's and has since built throughout Europe and beyond. Current projects include international airport terminals for Madrid and London, the National Assembly for Wales in Cardiff, new law courts in Antwerp, a library for Birmingham and a City Academy for Hackney, one of London's most deprived inner-city areas. His practice is democratic in spirit, relentlessly inventive and innovative, with the enthusiasm of youth leavening the lessons of maturity. Appointed to the

House of Lords in 1996 as a Labour life peer, taking the title Lord Rogers of Riverside, Richard Rogers has never abandoned the radical convictions that drove him, for example, as a young man, to campaign for the abolition of nuclear weapons. He believes that architecture is a social art and that architects, though they cannot transform society through their professional labours alone, have a responsibility to work for a better world for all.

For all his fame and the honours he has accumulated, Richard Rogers in his early 70s retains his vision of the central role architecture can play within the evolution of a saner society and a more humane world order. Perhaps uniquely amongst the architects of his generation, he has inherited the moral and social conscience that was at the heart of the Modern Movement and is a campaigner and polemicist, prominent in Britain as a defender of the Modernist tradition in architecture in the face of the traditionalist backlash which took place in the 1980s.

Long recognised as a major European player in terms

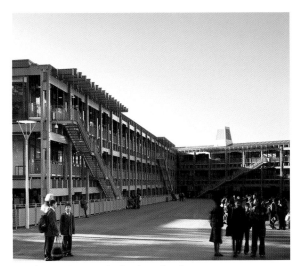
Mossbourne Community Academy, London.

than the exception. Generally regarded as the most comprehensive set of guidelines for the delivery of sustainable compact cities, many of the report's recommendations were subsequently incorporated within the government's Urban White Paper, unveiled in November 2000.

A life-long champion of urban living, Rogers remains a passionate Londoner who believes that London is the world's greatest city, with the potential to become an even better place if only those in power will give it the means to do so. 'Urban morphology', says Rogers, 'depends for its vitality on successful public spaces: a well-designed city is a fundamental catalyst for a civil society; and civility implies living in harmony with the past, the present, and the future.' The universality of Rogers' vision of architecture has inspired the practice's work: diverse, potent, expressive, sometimes startling, but, above all, designed with the needs of people in mind. It is the work of a great humanist – in the true, Renaissance sense of the word.

Humanism has always been at the centre of Richard Rogers' philosophy of architecture. If there is one architect in history whom he admires above all others (and claims, contentiously, as a pioneer of Modernism) it is the Florentine Renaissance master Filippo Brunelleschi. Rogers' first years were spent

of urban design, Rogers continues to champion what he regards as the enormous potential of urban living. Cosmopolitan by nature, his influence as both architect and urban strategist is evident throughout Europe – he is Chief Adviser on Architecture and Urbanism to the Mayor of London and a member of the Mayor's Advisory Cabinet, while also advising the Mayor of Barcelona as a member of the Urban Strategies Council.

Although an architect practising on a global stage, Rogers is, more than ever before, a political activist involved in local and central government. In 1997, soon after the election of Tony Blair's Labour government in Britain, Rogers was appointed to chair the government's Urban Task Force (UTF) with a brief to 'establish a new vision for urban regeneration founded on the principles of design excellence, social well-being and environmental responsibility within a viable economic and legislative framework'. The Task Force produced a report championing the cause of brownfield redevelopment entitled 'Towards an Urban Renaissance' – a seminal document on the extent of England's inner-city decline, containing more than a hundred radical proposals to reverse this trend. The UTF vision is of compact, polycentric, live/work, socially mixed, well-connected, well-designed and environmentally responsible cities – a 'blue-print' that should become part of our everyday urban language, the norm rather

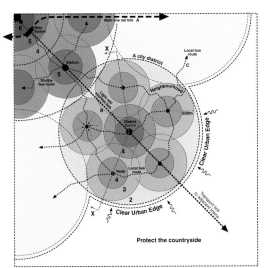
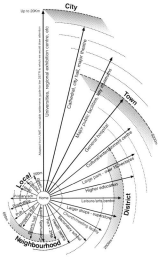

Diagrams showing the benefits of compact neighbourhoods and the equitable provision of social amenities (UTF Report 1999).

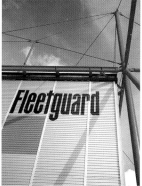

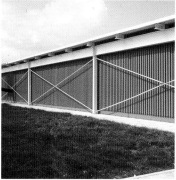

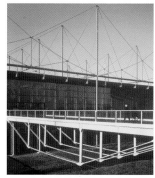
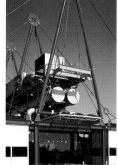
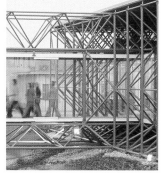

in an apartment within sight of Brunelleschi's great dome, the supreme monument of the city of Florence. Rogers is proud of his Italian origins. He was born on 23 July 1933, in Florence, the son of Anglo-Italian parents who emigrated to England on the eve of the Second World War. After military service, he resolved to study architecture – inspired to no small degree, it seems, by the example of his older cousin, the architect Ernesto Rogers (1909–69), whose Milan-based BBPR practice had been one of the foundations of Modernism in Italy. Rogers entered the Architectural Association School in London in 1954. Between 1961 and 1962 he studied at Yale University, where his teachers included Paul Rudolph, Serge Chermayeff and the young James Stirling. It was at Yale that Rogers met Norman Foster, two years his junior and a graduate of Manchester University. When the two men returned from the USA in 1963, they founded, with Wendy Cheeseman (later Wendy Foster) and Rogers' first wife Su Rogers, their own practice – Team 4.

Team 4's first major work was the house at Creek Vean, Cornwall, built for the parents of Rogers' first wife, Su, and reflecting the strong influence on both Rogers and Foster of American domestic architecture and especially of Frank Lloyd Wright. The natural and 'organic' character of this house foreshadows themes to which Rogers and Foster were to return some years later; it received the first award ever given to a house by the

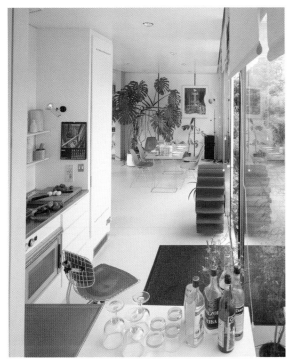

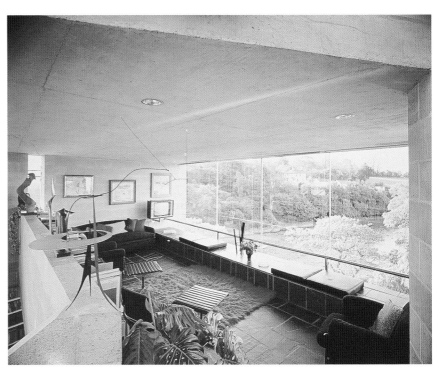

The Studio at the Rogers House, Wimbledon, London, UK.

Creek Vean, Feock, Cornwall, UK.

RIBA and is now clearly established as a key work in the careers of both architects. Better known at the time, however, was Reliance Controls, a factory, completed in 1966, notable for the flexibility and essentially democratic nature of its plan and the tough elegance of its structure and materials. The building was acclaimed, but the acclaim produced no new commissions. Towards the end of 1967, Team 4 was dissolved for sheer lack of work. Perhaps it is a memory of the difficulties that he faced in his early years of practice that has made Rogers such a staunch supporter of young architects and new movements in architecture.

After the dissolution of Team 4, Rogers spent three years in partnership with his then wife, Su. John Young later joined this team and together they worked on projects which, though small in scale, were to prove highly significant in the context of the practice's later work. Fortuitously, it seems in retrospect, he was able to experiment and to define more closely his key objectives as an architect. While Creek Vean had been a carefully crafted, one-off work of architecture, the house Rogers designed for his own parents was more influenced by the Case Study houses of Rudolf Schindler, Rafael Soriano and Craig Ellwood, and by Charles and Ray Eames' house at Pacific Palisades, California, constructed as a kit of prefabricated parts.

The Rogers House, completed in 1969, incorporated the potential for a high degree of change. It was seen as a possible prototype for the mass-produced, energy-efficient houses which Rogers, influenced by Buckminster Fuller, saw (and still sees) as a solution to world housing shortages. The 'Zip-Up' house project was even more radical: an energy-efficient modular structure which could be extended, altered or even dismantled and moved to another site by its occupants. Rogers' use of materials was entirely in tune with the Fuller approach, which placed flexibility before monumentality. He has consistently resisted every influence that threatens to 'freeze' his architecture or confine it within fixed programmes. The experimentalism in his work has persisted into a new century.

The Centre Pompidou

The Centre Georges Pompidou retains the image of experimentalism even today. The project was the product of a remarkable partnership between Rogers and Renzo Piano, ably supported by trusted colleagues such as John Young, Marco Goldschmied, Mike Davies and Laurie Abbott. The building is notable not only for the shock tactics of its design but also for its successful regeneration of one of the more deprived areas of central Paris, and marked the beginning of Rogers' career as one of the most influential urban architects of the post-war era. Piano and he saw the building as a 'live centre of information and entertainment' – a flexible container and a dynamic communications machine, highly serviced and made from prefabricated parts, attracting as wide a public as possible by cutting across traditional institutional limits. The Pompidou was to be, they explained, 'a truly dynamic meeting place where activities would overlap in flexible, well-serviced spaces, a people's centre, a university of the street reflecting the constantly changing needs of its users – a place for all people of all ages, all creeds, for young and old – a cross between an information-orientated, computerised New York's Times Square and the British Museum.' The Centre Pompidou – or 'Beaubourg' as it became generally known – has become one of the most popular of modern buildings and is one of the greatest tourist attractions in France. The great public square and the opportunity for continued public circulation up the facade of the building created what has been hailed as 'the world's first vertical piazza' – with streets in the air, terraces, elevators and escalators. There is a tension in the building, nonetheless, between its role as a 'people's place' (a phrase which Rogers still uses), attractive and remarkable for its own inherent qualities, and its ostensible function as a container for cultural activities, including a library and an art gallery, which cannot be entirely free-form and ad hoc but have fixed and predictable requirements. Critical discussion of the building has continued since the day it opened and has centred on the relationship between its architecture – flexible, indeterminate, machine-inspired – and the activities which go on within it.

Many critics of Beaubourg have refused to recognise the degree to which Rogers and Piano succeeded in revolutionising the presentation of art and culture without trivialising either. The concept of a flexible form designed in such a way that the parts as well as the plan itself could be adapted to the building's changing needs, where the building was more like a robot than a Miesian frozen temple – emulating modern music or jazz where the beat was clear but allowed for improvisation. But the real point of the Pompidou Centre lies in the fact that it is an entirely new building type – legibility of the constituent parts was a key driver, as was flexibility, achieved by placing all services and movement on the outside. Rogers had certainly been influenced by Cedric Price and the Archigram group – young architects and students including Peter Cook, Ron Herron and Mike Webb – which aimed to break down the conventional boundaries of architecture through the use of technology. He warmed to Archigram's ideals and to projects like the Fun Palace of 1965, conceived by Cedric Price in collaboration with the radical theatre director Joan Littlewood. (Price was an associate, but never a member, of the Archigram group.) However, when Archigram was in its crucial early years, Rogers had left the AA and was in the USA, where his thinking developed independently. Beaubourg was consciously seen as a place for enjoyment and pleasure:

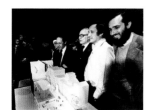

Press conference for IRCAM, Paris, with Pierre Boulez, Robert Bordaz, Richard Rogers and Renzo Piano.

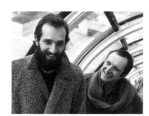

Renzo Piano and Richard Rogers, Centre Pompidou, Paris.

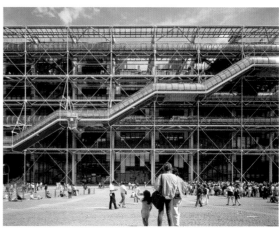

Escalators snaking up the main facade of the Centre Pompidou.

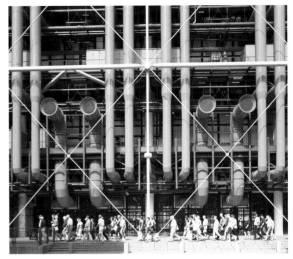

Above, Right and Below Far Right: External services for the Centre Pompidou, Paris, are celebrated with colour-coding. Below Right: Detail of the building's expressed external structure.

there was an element in it of the peculiarly Sixties mix of hedonism and social radicalism. In Piano's words 'Richard brought to technological invention, especially the High Tech movement, a social dimension. In a sense Pompidou – with its dynamic facade offering images and information – was a direct response to the 1968 revolution both in the USA and Europe.' Some earlier 'schools' of modern design influenced Rogers towards an architecture of movement and three-dimensional drama – Beaubourg is really a vast, serviced shed, rooted in the flexible, social architecture he so admired in the pioneering work of 'Bucky' Fuller.

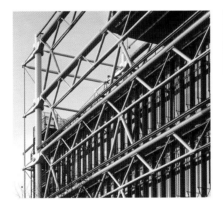

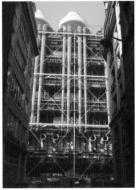

Rogers has never, in fact, been able to conceive of an architecture which is designed, Archigram-wise, just for pleasure or 'fun' any more than he can countenance buildings designed purely for profit. His reforming instincts had been strengthened when, as a student, he discovered the work of the Italian Futurists and that of Antonio Sant'Elia in particular. The latter's vision of the modern city, expounded in the years before the First World War, was a vision of mechanical movement and mass production. Sant'Elia spoke of architecture 'exhausted by tradition' and incapable of meeting modern needs. By the time that Rogers was a student, Modernism was triumphant but even in the early 1970s there were rumblings of public dissatisfaction with its achievements. These were soon to become vociferous and to usher in the fashions for

Post Modernism, 'community architecture', urban conservation and other protest movements. Rogers saw that modern architecture, which had become dominant in Britain after 1945 on the basis of its social gospel, was running out of steam. It had some moral purpose left – despite the best efforts of the commercial modernists and their clients in the property industry – but had ceased to be a popular art as conceived by the Russian Constructivists and their 'Realist Manifesto' – Lissitsky, Tatlin, Rodchenko, Antoine Pevsner and Naum Gabo (with whom Rogers had stayed during his Yale stint) – who saw buildings as 'social condensors' in a revolutionary society and whose influence filtered through to the architectural scene during the inter-war years. They could certainly be detected in a building

which had fascinated Rogers since the day he first saw it: the Maison de Verre in Paris. Constructed in 1928–32, the house – built within the framework of an old Left Bank 'hôtel' – was designed by Pierre Chareau in collaboration with the Dutchman Bernard Bijvoet. The Maison de Verre is unforgettable for its diffused light – which the practice sought to re-create at Lloyd's – and for its ruthlessly thorough-going use of straightforward engineering materials and components in a domestic context. Paris also provided a model – albeit on a far smaller scale than Beaubourg – of a flexible building designed for popular entertainment and cultural activities. The Maison du Peuple in Clichy, completed in 1939, was designed by the architects Beaudouin & Lods but had been conceived and engineered by the 'constructor' Jean Prouvé. Prouvé was a pioneer in the use of pre-fabricated, mass-produced components – which he had used successfully in his housing schemes for those left homeless after the Second World War. He was a member, fortuitously enough, of the jury for the Pompidou Centre competition, where he proved sympathetic to the Piano & Rogers entry. Long before there was Prouvé, however, there was Paxton. Rogers

had been taught at the AA that Paxton's Crystal Palace was the supreme example of the 'real', progressive architecture of the 19th century. Not only the astylar purity but equally the popular success of the Crystal Palace impressed him, as did the enormous visual impact of the great Victorian railway stations.

The Pompidou Centre came to be seen as one of the great monuments of High Tech – a label that Rogers resisted from the start. Undeniably, the building made a great display of its technical services, but Rogers has never sought to celebrate technology for its own sake but rather to see it as the servant of mankind. However, in contrast to much of the work of his former partner Norman Foster – where refinement and purity have been the aim – his buildings continue to have a vigour of form and expression which begs comparison with the work of the Victorian engineers. Rogers' awareness of history is strong: the inspiration is there. In the wake of Pompidou, however, the elegant PA Technology Laboratory in Cambridge, England, one of the few other projects undertaken by Piano & Rogers during the construction of Beaubourg, has an almost self-effacing elegance and contains few hints of what was to come at Lloyd's.

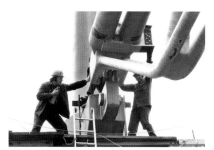
Centre Pompidou during construction.

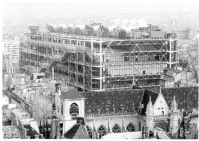
The Centre Pompidou – an iconic addition to the Paris skyline.

Library, Centre Pompidou.

The piazza has become a dynamic meeting point for Parisians and visitors.

Lloyd's of London

Lloyd's cemented RRP's position as one of the leading architectural practices. At first sight, there seems to be a gulf between the radical architecture of the building and the character of this old City of London institution (with its roots in the coffee houses of the 18th century). Yet Lloyd's is, in essence, a market place, where risks are taken, and the new building expresses that character more appropriately than the pompous corporate Classicism of its 1920s predecessor. The practice won the Lloyd's competition with a strategy for accommodation, the result of a wide-ranging analysis and a series of mathematical models, not an architectural design. It took eight years, from the commission to the opening, to build Lloyd's. During that time, the scheme evolved markedly. Early models show a structure which rises to slender towers, a Futurist vision.

The approach to servicing at Lloyd's was that of Beaubourg – to place it on the perimeter. In the event, this proved to be immensely beneficial, since Lloyd's use of electronic information technology increased greatly as the building went up and the servicing – especially the air-conditioning – had to be much augmented. The result was the growth of the towers into the top-heavy, 'Gothic' structures seen today. The popular interpretation of Lloyd's as a cathedral of technology is, however, misguided. Though a high degree of artificial servicing was needed, the building was highly progressive in terms of energy efficiency. Employing the atrium as a heat stack, the exposed concrete structure as a heat sink, and the void between the internal and external glazing as an air plenum for return air anticipates the energy strategy of schemes of the 1990s (such as the Nottingham government offices). Insulation, heat return systems and the provision of opening windows and facilities for all who work in the building to control their own micro-environment were pioneering measures.

The basic plan of Lloyd's owed a great deal to the example of Louis I. Kahn, whose Richards Laboratories at the University of Pennsylvania (1957–1960) had inaugurated his development of the architecture of 'served' and 'servant' spaces. The service towers of the Richards building had an antecedent in Frank Lloyd Wright's 1900s Larkin Building. The form of the Larkin, an open atrium surrounded by galleries, was, in essence, that of Lloyd's. The character of the interior, lit by diffused light, recalled that of Wright's Johnson Wax offices and, of course, that of the Maison de Verre too.

Lloyd's is a commercial building, designed for capitalist transactions. If anything, the inward-looking character of the interior, a fortress of insurance, confirms its essentially 'private' nature. Yet RRP always saw Lloyd's as an enhancement of the public realm. They wanted a ground floor largely accessible to the

John Young and Richard Rogers with a model of Lloyd's.

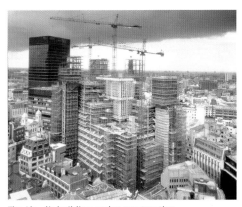
The Lloyd's building under construction.

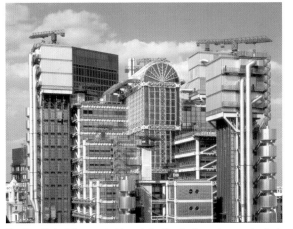
The Lloyd's building – a bold contribution to the urban context of the City of London.

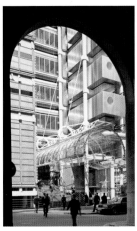
The main entrance on Lime Street.

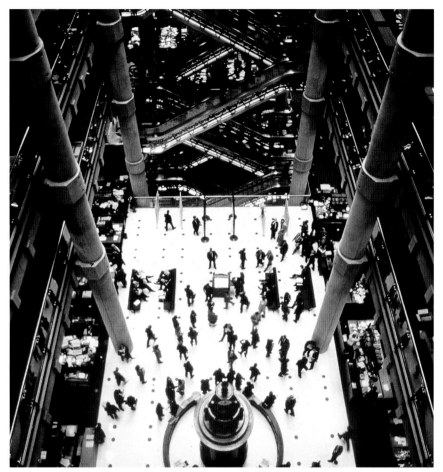

View down into 'The Room'.

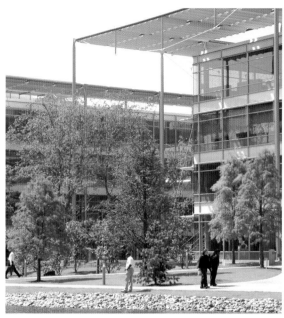

Chiswick Park, London, has set new standards for business parks, offering flexible office accommodation within an imaginatively landscaped setting.

public, allowing movement across the site and a link into the existing pedestrian network of the 19th-century Leadenhall Market. The practice's ambitions in this direction were to be largely thwarted by security issues – the public 'lobby' familiar in the USA has never been the norm in Britain. Lloyd's does, however, enrich London as a place for people. In contrast to the earlier modern office buildings of the City, like the nearby 1960s Commercial Union tower, it is at home in the irregular (and basically medieval) street pattern. The scale of its detailing is right for its surroundings. On the skyline, Lloyd's is a spectacular modern monument, but on the street, it appears as the most striking work of sculpture added to London in the last hundred years, a work of art on a grand scale.

Programmatic indeterminacy

Lloyd's represented a highpoint in the development of the practice's expressive architecture of mechanical form and appeared to confirm Rogers' identity as a High Tech architect. In fact, the building was completed at about the same time as Foster's Hongkong Shanghai Bank – which came as close as Foster ever did to the expressive manner of Rogers. In both cases, however, building form was a response to client brief and the work of the two offices thereafter moved in distinctly different directions, undermining the idea of a High Tech school of design.

The brief at Lloyd's was to create a building that would, by means of its flexibility and scope for expansion (and, for that matter, contraction), serve the needs of the clients for at least half a century. Lloyd's

has been characterised (by the critic Martin Pawley) as a compromise between the exploding requirements of the new information technology of the 1980s and traditional notions of the role of architecture. It is, Pawley has forcefully argued, too 'permanent' a building: a series of serviced sheds would have met the brief more economically. Yet this analysis is at odds not only with the realities of building in a major European city but with Rogers' philosophy of architecture: he seeks an architectural order which is 'more open and dynamic, yet harmonious – buildings must be flexible, capable of 'revision'. This programmatic indeterminacy

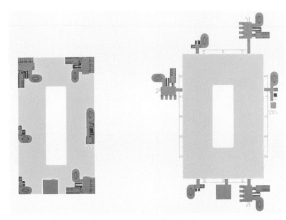

Unlike traditional office layouts, at Lloyd's the service cores are located externally, maximising available space and providing large, uninterrupted, flexible floorplans.

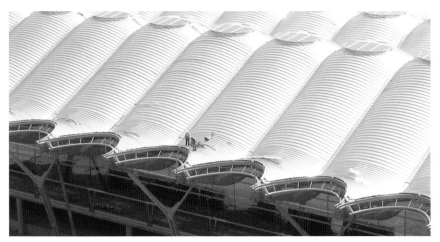

Barajas Airport, Madrid, exemplifies the practice's 'loose fit' approach; here the modular, highly innovative design allows for future flexibility.

is an expression of the building resolved by the correct architectural balance between permanence and change, improvisation with a coherent totality'. Rogers insists that 'some more permanent order is needed both to meet urban contextual priorities and to give visual coherence to the building itself'. It is the contrast between the elements of 'experience' and 'contingency', Rogers argues, between the 'complete' and the 'open', which is at the heart of the 'richly layered and articulated' architecture he seeks and was an element missing in the 'bland, oversimplified' buildings of the International Style at its worst.

It is misguided to judge the practice's work, apart from some of the earlier experimental projects, in terms of the realisation of some Fullerian / Archigram-style vision of an impermanent, ever-changing approach to 'shelter'. Rogers the humanist could never accept an architecture determined by pure function. Architecture glorifies shelter, he says – and it communicates via 'a clear hierarchy of identifiable, legible spaces and volumes'. A well-serviced shed might, temporarily at least, meet the needs of users. But it would be deficient as a contribution to the public realm. Rogers might see the adage that 'architecture starts where function stops' as inherently Post Modern, yet his outlook is 'traditional' to the extent that he sees architecture's public role as paramount. Rogers is not prepared to see 'civility' turned into an argument for reaction. He takes issue with a view of tradition which sees it as consisting in a reproduction of the urban forms and architectural styles of past ages. Current historicists, he says, 'suffer from selective amnesia' when they fail to accept that much of the best architecture of the past was notable for being innovative, revolutionary and in stark contrast to its 'context'. Rogers' concern to promote a progressive 'civil' architecture also makes him a vocal critic of the failures of modern architecture. He believes that it has gone wrong in so far as it has lost sight of the best principles of the Modern Movement. He argues that it has failed because of the lack of inspired patronage and the lack of civic leadership – 'our architecture … has been sacrificed to the private interests of the market and the short-sighted economies of public officials'.

Coin Street, London, UK.

'London as it could be', Royal Academy, London, UK.

London/urbanism

Even as Lloyd's was being built, RRP was at work on the plans for Coin Street, on the South Bank of the River Thames. The Coin Street project developed the themes of Lloyd's – not only in architectural terms (it would have given London's riverside a dramatic new emphasis) but also in the way it attempted to reconcile private and public interests. RRP started with a potential commission to build just offices. This, Rogers felt, was entirely unacceptable and detrimental to London. Under his influence, the scheme evolved to include housing, shopping and a lot of public space. The great arcade at the centre of the project was a brilliant stroke: a convincing revival of a 19th-century urban form which perhaps owed something to James Stirling's 1970 scheme for Derby town centre. The proposed new Thames pedestrian bridge was a similarly Victorian gesture. The scheme offered some hope for reviving the life of the South Bank – which suffered from being cut off from the West End. It represented a remarkable movement on the part of private developers – whose image in London was then largely negative – towards meeting the needs of local communities. By the early 1980s, however, 'community architecture' was being widely advanced in Britain as a panacea for urban problems. Rogers distrusted the anti-modern, anti-architecture emotions which some adherents of

the movement espoused, but he felt strongly that local people should be involved in development and that it should attempt to address their needs. The architectural form of Coin Street strongly recalled Lloyd's, but the spirit of the scheme had more in common with Beaubourg. Its abandonment after a series of planning inquiries paved the way for some of the disastrous planning policies of the 1980s in Britain. (In its first incarnation, for instance, the Canary Wharf project was purely an 'office city' which lacked a social dimension.) After the failure of the Coin Street project, the site remained largely vacant for years and only recently has good quality social housing been constructed there.

Another key example of RRP's quest to create significant public space within the capital was the competition entry for the extension to the National Gallery. Short-listed in 1982, the RRP scheme was a daring development of the ideas inherent in the Pompidou Centre, but cast in the architectural language of Lloyd's. The brief for the project was extremely unsatisfactory – a typically Thatcherite 'vision' which casually delivered a prime public site long designated as an extension of one of Britain's leading cultural institutions into the hands of a developer. The deal quite

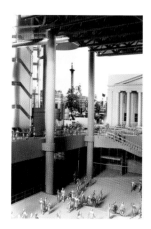

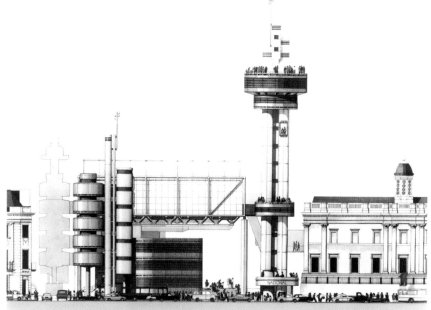

Above and Top Right: National Gallery Extension, London, UK.

simply sacrificed public good for commercial gain – in return for the opportunity to build an office building the developer would provide a single-storey gallery for the government. Even though the brief proved unworkable, Rogers and his team addressed it with brio, even proposing a tall tower to complement the spire of St Martin-in-the-Fields. More significant perhaps was the scheme's strategy for public space. Though Rogers wanted to pedestrianise the Square, he knew the conservative climate would never stand for it. Instead, the practice devised a subterranean galleria linking the Gallery to the centre of Trafalgar Square, thereby creating a new pedestrian route from Trafalgar Square right through to Leicester Square, the heart of London's West End. Although the scheme came nowhere near to being built, it established Rogers as a major force in the replanning of late 20th-century London. It also prompted a series of lively exchanges in *The Times* with the Prince of Wales, who had very publicly voiced his disapproval of many of the competition entries. Rogers resented what he felt amounted to unconstitutional influence over public planning issues, confirming his view that the capital was being strangled by the innate conservatism of the establishment.

Rogers' opportunity for a riposte came in 1986 when he was invited to exhibit, alongside Norman Foster and James Stirling (identified by the media – not inaccurately – as 'the big three'), at the Royal Academy. Rogers' contribution – 'London as it could be' – presented a spirited and humanist vision for the heart of London, a city for people. The scheme pedestrianised and linked the three major squares – Trafalgar Square, Leicester Square and Piccadilly Circus – and continued the walk down Northumberland Avenue to the Thames. The Embankment between Waterloo Bridge and Blackfriars was developed as a great south-facing park, while along its entire length the Embankment Road was sunk below ground. Perhaps most memorable was a new suspension bridge linking Waterloo Bridge and the South Bank via an island in the Thames including a 'Museum for Today'. Charing Cross station was to be converted into private development to pay for the scheme. A suspended monorail connected the enlarged terminus of Waterloo with Trafalgar Square. Visually the most dramatic statement was the bridge which straddled a 40-foot-long water tank in the middle of the Royal Academy – James Stirling supplied the goldfish! Rogers knew that the Thatcher government would not even consider public investment on this scale – the planning objectives he proposed would have required an all-London planning authority akin to that which the government had only lately wound up.

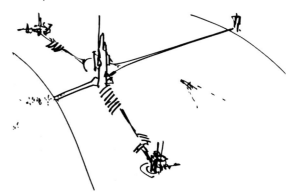

Sketch of the proposed bridge across the River Thames.

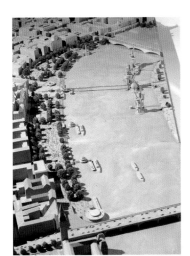
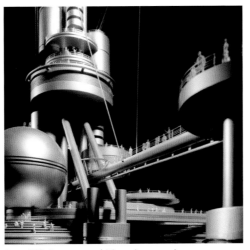

The key to RRP's contribution to 'London as it could be' was an ambitious river crossing.

Social and ecological harmony

Rogers' concern over the state of London has grown during the years following the Coin Street debacle. In 1989, ten years after the accession to power of Margaret Thatcher, he declared that his ultimate ideal was 'a humanist city where there is a perfect balance between individual needs and public concerns; where a child can roam happily and at peace. If such a society existed, then the architect who builds and designs today's vulgar places for the prevailing society would design beautiful places; parks, squares, tree-lined avenues'. Rogers saw no prospect of a humanist city emerging from the market-oriented conservatism of the 1980s. This drove him further into the field of party politics and culminated in his campaigning for the Labour opposition in the general election of 1992. 'A New London', written by Labour politician Mark Fisher, contained an introduction by Rogers, a 'call to action' in which he restated many of the principles contained in the 'London as it could be' project.

By the election year of 1992, Rogers' vision had expanded beyond the river and strictly architectural formulae. He saw London as, potentially, 'a metropolis

of social and ecological harmony'. Rogers' socialism, if such it is, has all the purity and idealism of the William Morris tradition, but – unlike Morris – he has seen capitalist society enrich the workers and enlarge the boundaries of their lives. Developers in Britain have assumed the role of the state as patrons and promoters, with some positive results – the developer Stuart Lipton, for example, one of RRP's clients at Coin Street, has consistently promoted the cause of high-quality commercial building that enhances the public realm. RRP's masterplan for the Royal Docks in London, where Lipton was again the client, managed to be both visionary and highly commercial.

In the case of Paternoster Square in the City, RRP proposed a meeting place for people which offered dramatic links to the underground system, a reflection of his concern for the role of public transport in the capital. RRP's scheme also tackled the need to develop a truly compact piece of morphology where space was contained by buildings rather than buildings dictating the structure of the space. Rogers was appalled that Prince Charles proved sufficiently influential to over-rule the original decision which would have made them winners of the competition. His robust article in *The Times*, 'Pulling down the Prince', stated his

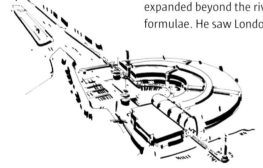

Proposals for retail and leisure amenities alongside a marina at the Royal Docks, London.

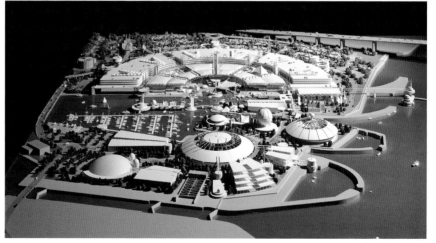

The decommissioning of the Royal Docks created the opportunity to reinvent a large swathe of Thames river frontage and disused dockyards. In the event, only the strategic intent of the masterplan has been realised.

RRP's proposals for Paternoster Square included a new tube station; a lofty glazed atrium offered views of St Paul's.

concern of Rogers' urbanism: 'hope for the future is rooted in memory of the past', he says.

Rogers' growing position as a public and media figure was confirmed by an invitation from the BBC in 1995 to deliver the prestigious Reith Lectures (Rogers was the first architect to be invited – the lectures were typically the domain of philosophers, writers, historians and scientists). This offered him the opportunity to expand on his vision for urban regeneration and a revised text of the lectures was published in 1997 as 'Cities for a small planet'. 'Cities that are beautiful, safe and equitable are within our grasp', Rogers insisted, bringing together examples of good and bad urban practice from around the world and reminding his readers of the startling statistic that the population of the world's cities had increased tenfold between 1950 and 1990. The Reith Lectures, Rogers believes, 'started the ball rolling' for a new campaign of urban renaissance in Britain and certainly filtered down into the rhetoric of politics.

views forcefully but did not prevent the subsequent 'deadeningly static' approach to the replanning of the area. The masterplan for the Potsdamer Platz in Berlin equally arose from a commission by private owners. The practice saw the project as a chance to put a contemporary heart in Berlin and to develop Rogers' concepts of sustainable development. But once more politics raised its head and what Rogers sees as a 'misplaced nostalgia' for the car-dominated bustle of pre-war Potsdamer Platz won the day, rejecting RRP's vision for a high degree of green space serviced by well integrated public transport. The practice's proposal was a blueprint for 'a city centre that, while respecting the historical patterns of the past, looked to the future'. Reconciling past, present and future has been a central

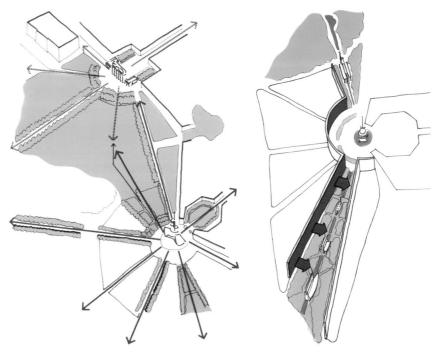

Potsdamer Platz: The analysis addressed the way the development would radiate out from the centre, and the provision of a green corridor.

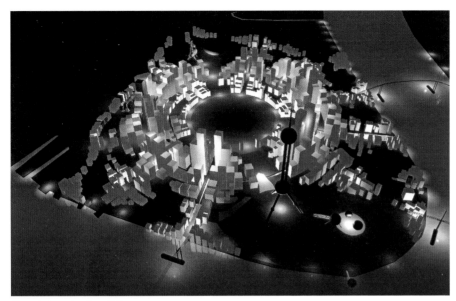

Shanghai masterplan, China.

The radiating geometry of the proposed Shanghai masterplan.

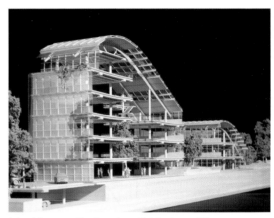

Inland Revenue Headquarters, Nottingham, UK.

Technology/ecology

Rogers' talk of 'ecological harmony' is far more than mere rhetoric. 'Green' issues have increasingly been addressed in his architecture but he has applied an ecological analysis equally to wider planning matters. The Potsdamer Platz scheme used the green wedge of parkland across the site and its sweep of canal to recycle energy and water from the buildings. Parkland invades the mixed-use quarter that RRP proposed for the Chinese metropolis of Shanghai. (What was actually built, a mass of office towers surrounded by intertwined motorways on the crudest North American model, could not have been more at odds with the idea of a sustainable city.) The Shanghai Pudong project for half a million people was a highly developed masterplanning project, embracing the concept of sustainable, compact, mixed-use, well-connected and designed cities.

The Bussy St Georges masterplan, developed by Graham Stirk and his team in 1987–88 for a new town in the Paris region, focused on green space and water set against dense masses of building. Rogers does not see green space as necessarily anti-urban. The greatest era of town planning in London, he recalls, was the Georgian age, when thickly planted squares were juxtaposed against regular terraces of housing, producing areas that are both densely inhabited and environmentally benign. The practice's Nottingham government offices project (1992) set a great arc of buildings against a sweep of green. It exemplified how the effect of energy consciousness can influence the built form. Wind, sun, water and airflow could dramatically change the process of design, hitherto dominated either by the clear identity of a building's intended use, i.e. house or law court, or by the platonic structural form of adaptable architecture such as Beaubourg or the Rogers House. The Nottingham scheme was the only competition entry to attempt a radical approach, particularly in terms of its low-energy servicing agenda. In fact it proved too radical for the civil servants and remained unbuilt, but its lessons informed many of RRP's projects during the 1990s and on into the new century.

Research and experiment

More than most architectural offices of the present day, the practice is a think-tank and an experimental laboratory. Research is an essential adjunct to practice, Rogers believes. Work on the Zip-Up and Autonomous House projects in the late 1960s and early 1980s generated some radical ideas on energy production and conservation. Given that buildings accounted for 50 percent of British energy consumption, the cost of running a building amounted, over a typical building's lifespan, to a sum far in excess of the capital cost of the project. Well before the so-called 'energy-crisis' of the 1970s, Rogers was working on projects for self-sufficient buildings, where windmills and solar cells generated power and water, and waste was recycled or reused. The first Elias house project provided for a house which could be 'opened up' by day, using moveable shutters, and closed at night. Designed for a site on Long Island, New York, the house could be pulled back from the sea edge on wheels when storms threatened. It was a short move from this to the Futurum Diner, a project clearly inspired by Buckminster Fuller's 1940s Wichita House. Rogers has always much respected Fuller's pioneering achievements, but they have undoubtedly had a rather less obvious impact on his work than on that of Norman Foster. Ultimately the message of Fuller was that architecture should fade away as the design of buildings became as logical – and ephemeral – as that of other mass-produced goods. Fuller wanted buildings which, to use an axiom of the Australian architect Glenn Murcutt, 'touch the ground lightly' and were demountable and portable. His philosophy was, in essence, anti-urban – an extension of the American dream of the great outdoors and a vision which Rogers could never share.

Futurum Diner Project.

Change and flexibility

The use of appropriate technology has long been a central principle in the work of the practice, but not to the extent of entirely supplanting more traditional notions of architectural order. The practice's architecture evolved – between Reliance Controls and Lloyd's at least – against a background of exploding technology, with designs conceived as constantly changing entities. A recent example of this philosophy is, of course, the Millennium Dome at Greenwich – providing a universal cover allowed an early start on site, moving forward with the infrastructure whilst the nature of the content was still very much in flux. The Dome proved superb at responding to the changing content proposals. As project director Mike Davies describes, 'the building was about openness and transparency and freedom to move around – a sort of loose-fit, non-constraining, friendly overcoat.' This tallies exactly with Rogers' aspiration: 'controlled transformation' is impossible in 'an architecture of total, finite perfection'. Services would wear out or become obsolete many times during the life of a building. The architecture should provide for ease of replacement, with the services clearly separated from the structural elements. At the Cambridge PATS building, services were suspended from the main floor slab. At the PA Technology Laboratory, Princeton, they were positioned along the central 'spine' of the building. At the INMOS factory in South Wales, the latter arrangement prevailed. The resulting buildings

Zip-Up House Project.

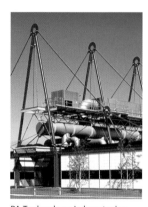
PA Technology Laboratories, Princeton, New Jersey, USA.

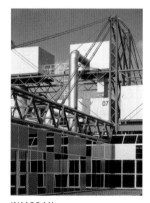
INMOS Microprocessor Factory, Newport, UK.

were, in each instance, architecturally dramatic, individual and highly memorable. At Lloyd's, of course, the drama became intense – and was intensified even during the process of construction (for reasons already outlined). There is plenty of functional logic in the way Lloyd's looks – not least in terms of its servicing and energy-saving provisions – but the pleasure taken in the expression of this logic is frankly architectural. The building as mere container does not attract Rogers, who readily admits that his architecture is more expressive – 'exuberant, I suppose' he concedes – than that of his friend and former partner, Norman Foster.

The practice's approach to the servicing of buildings has obvious benefits in terms of internal space, which is freed from obstructions and highly efficient in space and energy-saving terms. Not that the resulting interiors eschew drama. The great central 'street' at the INMOS factory, the lofty interior of Fleetguard in Brittany and, most obviously, the magnificent central atrium of Lloyd's all reflect a desire to integrate interior and exterior. The unbuilt Coin Street and Paternoster Square projects provided for great enclosed public spaces which would have been staggering in scale. The practice has consistently sought to open up buildings to the public realm, carving atria, gallerias and internal streets out of what might be perceived as 'private' domains.

Richard Rogers has never foreseen architecture 'fading away' in favour of a deterministic, if benign, building technology. Indeed, he is one of the most vociferous campaigners anywhere for the cause of architecture as an art. Rogers' role as a spokesman for the cause of architecture has come about, to some degree, against his own inclinations: he has stepped in where others declined to speak out. This made him a natural choice, for example, as the first chairman of London's Architecture Foundation (1991–2001), as well as Chairman of the Board at the Tate Gallery (1981–89) and Deputy Chairman of the Arts Council (1994–97). Rogers' personality is complex. He is not a natural public speaker – his extrovert nature emerges far more effectively in a small gathering – but he has dutifully taken up the role of a public spokesman for architecture.

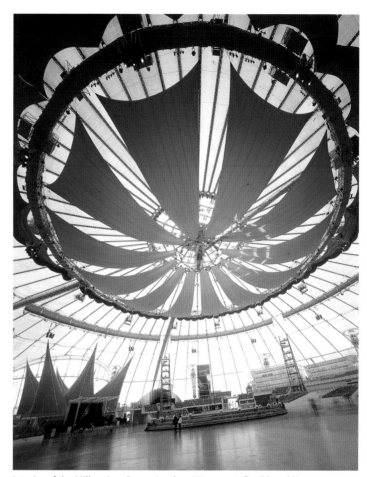

Interior of the Millennium Dome, London, UK – a vast, flexible public space.

Millennium Dome on opening night, New Year's Eve, 1999.

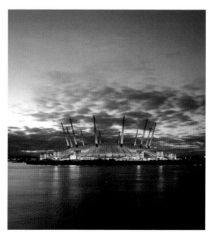

The Dome viewed from the north bank of the River Thames.

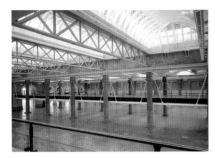

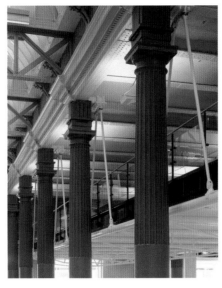

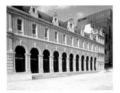

Interior (above), exterior (below) and detail view (right) of the Billingsgate Fish Market, London, UK.

Conservation/history

Rogers' commitment to the city is reflected in his firm defence of historic buildings and places. It is no accident that his own offices are housed in an old building, a 19th-century warehouse in west London. Though profoundly opposed to historicism as an influence on contemporary architecture, Rogers believes in the re-use of historic buildings when appropriate – at Thames Wharf, the conversion is remarkably straightforward and respectful, with the qualities of the brick-vaulted interiors highlighted and the only notable innovation being the introduction of bold colours for metal elements and a dramatic glazed pavilion at roof level. The practice worked with Lifschutz Davidson, one of a number of smaller studios which have benefited from Rogers' patronage and encouragement (others include Future Systems, Alan Stanton, David Chipperfield and Troughton McAslan). The housing development at Thames Wharf was designed to complement the existing buildings with its mix of brickwork and steel and glass. The juxtaposition of old and new has created a dynamic stretch of river frontage, where there was once only a very drab and polluted industrial site.

At Billingsgate Market in the City of London the practice became involved in the conservationist campaign to rescue the 19th-century building from demolition. When the pressure group SAVE sought help on Billingsgate, the practice responded positively and endorsed a plan to refurbish the market hall and build profitable offices on the adjacent lorry park. This demonstration that conservation was financially and practically viable helped to head off the threat of demolition. In due course, after the building had changed hands, RRP was appointed to convert it into a modern dealing room. Billingsgate has been widely recognised as a classic example of re-use. Within an immaculately restored exterior is a splendid internal space where new work is clearly delineated from old in a manner which is entirely in accordance with the philosophy of the preservation movement. Rogers ensured that the painstaking conversion reflected the purity of the concept: 'our brief was to deliver a contemporary transformation of the old fish market – this required bold but sensitive intervention on our part.'

Rogers lives in a typical early 19th-century terraced house off the King's Road in Chelsea. Again, the exterior gives no hint of what is within. In this instance the existing arrangement of small rooms was at odds with the needs of the architect and his family. He clearly looked to the Maison de Verre, that icon of his youth, for inspiration, creating a lofty and brilliantly lit internal living space. The conversion was not uncontroversial, but its respect for 'civility' softened adverse criticism. The practice's success in dealing with retained historic buildings has added credibility to its growing involvement in the field of urban planning. New architecture has nothing to fear from historic surroundings, Rogers

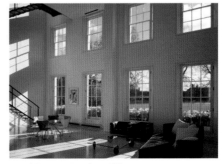

Royal Avenue, London, UK.

believes. Yet there are occasions when the past must be reproduced. At Billingsgate, it would have been perverse and wrong not to replace elements of the exterior which had been lost over the years, and indeed where necessary his team commissioned exact replicas made of the best materials.

Rogers is convinced that modern architecture, 'if done correctly', can meet society's changing needs and still offer a convincing dialogue with a wider historical urban context. 'Being able to read a consistent architectural development – from medieval to Renaissance to Neo-Classical – is part of the magic and vitality of an enriching urban experience. Diocletian's palace at Split, the cathedral at Syracuse in Sicily, the Teatro di Marcello in Rome and the Orangerie in the Jardin des Tuileries in Paris are all perfect examples of architecture in evolution – buildings that have adapted seamlessly to change.' Rogers is usually wary of 'tiptoe-ing around history' so when he proposed to rebuild in facsimile a section of the lost Inigo Jones piazza at Covent Garden as part of his scheme for the redevelopment of the Royal Opera House, surprise was expressed in some quarters that he should offer 'pastiche'. But Rogers countered that the repair of a damaged urban fabric was a justifiable part of a development scheme and would enhance the impact of the new work. At Lloyd's, he did not question that the Adam boardroom (originally at Bowood House in Wiltshire) should be installed in the new building. He was, however, dismayed when the client firstly shied away from the 'wonderfully garish' original Adam colour scheme and then decided to commission the fit-out which provides its setting from another architect, in the process totally sacrificing the dramatic effect of new juxtaposed with old which the practice intended in favour of a pseudo-historic compromise.

It is the essential integrity of RRP's architecture which allows their buildings to contribute, forcefully but positively, to a historic setting, notably the dialogue between Lloyd's and the Victorian ironwork of Leadenhall Market. In the case of Europe House (or K2 as it is now known), a project which has extended over some 15 years, the early 19th-century St Katharine Dock provided an equally inspiring location. The new

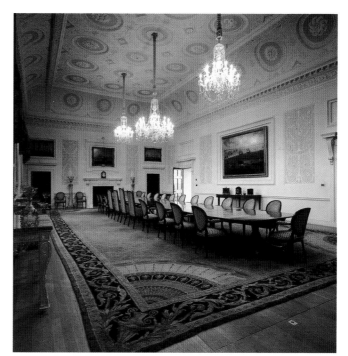

The Robert Adam dining room at Lloyd's of London.

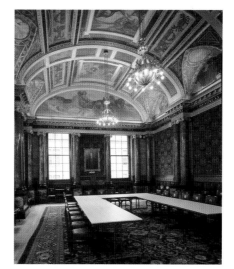
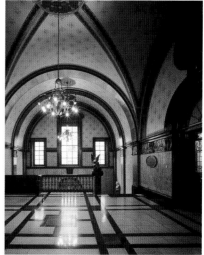

Two views of the refurbished 1901 building at 71 Fenchurch Street, which was an integral part of the Lloyd's Register project.

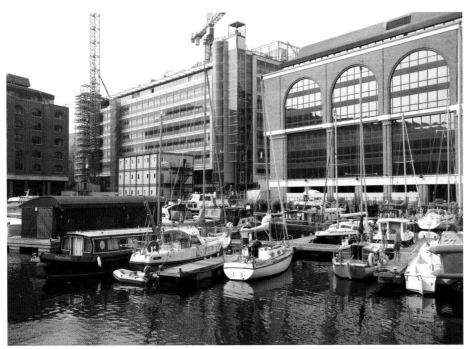

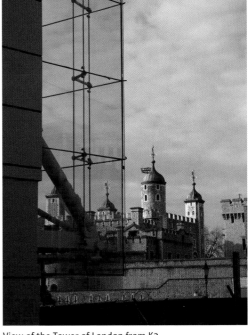

View of K2 from St Katharine Dock, London, UK.

View of the Tower of London from K2.

building, which replaces an inadequate 1960s block, is a masterpiece of the 'functional tradition' next to the Tower of London. Whereas the 1960s building responded to the setting formally – echoing the vocabulary of columns and massive walls in the old warehouses – RRP's replacement attempts something very different: a recognition of the new role of the dock as a public place and an attempt to establish a link with the street beyond the enclosing dock walls. The practice's proposals for Paternoster Square were equally radical, with no artificial respect for the proximity of Wren's masterpiece. Rogers saw his scheme as 'carving space out of a compact urban fabric'. He has commented: 'there are important visual, technical and social lessons to be learnt from the past, but merely copying the outward forms belittles history'. It is not the comment of a man for whom history does not matter. In the case of the National Gallery in London, history was to become an obstacle to achieving a successful outcome. The project absorbed Rogers and the practice's proposals were widely acclaimed. In the event,

however, the practice's scheme was not taken up and the extension was eventually built to jokily Classical designs (by Venturi/Scott Brown) which deferred rather lamely to Wilkins' somewhat indecisive Regency frontage.

The National Gallery scheme was designed while Lloyd's was on site and displayed the practice's confidence in the strongly expressive language of the great City project, itself derived from the Kahnian dichotomy between served and servant spaces and the tension between technological determinism and architectonic expression. Everything about the designs was self-confident, optimistic, expansive and uncompromising. Failure to win the competition – where victory, in fact, turned out to be pyrrhic – was a serious disappointment. Next door to Lloyd's itself an equally expressive office scheme fell foul of City of London planners, whose predilections were increasingly towards Post-Modernism and revived Classicism. Indeed, it was to be more than a decade after the completion of Lloyd's before the practice completed another building in the City.

Tokyo International Forum, Tokyo, Japan.

New directions

In recent years, the practice's architecture has been seen at its most expressive and unequivocal in the Japanese projects led by Laurie Abbott and Graham Stirk – above all in the remarkable Tokyo Forum project. Here the post-1968 radicalism of the Pompidou Centre has been revitalised with a tour de force of architecture in motion, open to the streets of the metropolis and remarkable for balancing massiveness of scale with elegance of form. Of the other Tokyo projects by the practice, only the competition entry for the Saitama Arena approached the scale of the Forum, but all have a vigour, even a flamboyance, which derives from a vigorous response to the complex physical, economic and planning circumstances of the Japanese capital. Though Tokyo has the reputation of a city without planning, it has inspired in RRP a calm experimentalism which has embraced many of the issues the practice explored in the later 1980s and 1990s, most notably those related to the environment. The Turbine Tower project of 1992 was the most ambitious of the Tokyo schemes, based on the premise that 'buildings should not be static or dumb, but should interact dynamically with the environment in order to take advantage of free energy.' RRP's collaboration with Ove Arup and Guy Battle resulted in a sleek, sculptural form that would increase wind velocity powering the turbines; had the

scheme been realised, the team claimed the building would have proved self-sufficient in energy terms.

In a sense, the Japanese projects stand apart from the general run of recent schemes. It is hard to apply Western humanist values to the extraordinary urban form of Tokyo. The clear line of development in much of the post-Lloyd's work is towards a new lightness, fluidity and economy of expression which doubtless reflects a clear debt to earlier modern masters like Mendelsohn, Aalto and the later work of Frank Lloyd Wright. Wright had, of course, influenced the young Rogers, who had seen most of the master's buildings during his period at Yale and been indelibly impressed by his ability to build in tune with the natural landscape. Though most of Wright's work was accomplished in suburbs or natural landscapes and despite his oft-pronounced scorn for the traditional city, his Guggenheim Museum is an assured piece of urban architecture for which Rogers has a special affection. Rogers has always expressed strong admiration for the work of Mies van der Rohe and never with more passion than when he appeared as an expert witness at the 1984 public hearing over the plans to erect Mies' posthumous 'Mansion House Square' tower at the heart of the City of London. Though a defender of historic buildings and areas, Rogers judged the issue to be one of obsessive preservation versus the cause of

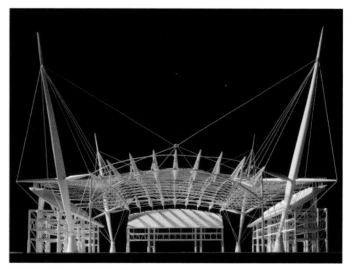

Saitama Arena, Saitama, Japan.

Sketch view of the experimental Turbine Tower research project.

The next chapter

Despite the completion of two major buildings – the European Court of Human Rights in Strasbourg (Ivan Harbour and Amarjit Kalsi) and the Channel 4 TV headquarters in London (John Young) – the practice suffered along with many others from the effects of economic recession during the early 1990s. Graham Stirk's Zoofenster project in Berlin fell into limbo and a major project for SmithKline Beecham in outer London was also cancelled, while it was not until 2002, 13 years after the initial competition victory, that work finally started on the new Terminal 5 at Heathrow Airport (although more modest airport projects were completed at Heathrow and in Marseilles).

Nonetheless, key unbuilt projects of the 1990s – Graham Stirk's competition schemes for the Tokyo Forum and the Centro Congressi in Rome, Richard Paul's Saitama Arena and Ivan Harbour's proposals for the redevelopment of London's South Bank arts centre – all developed ideas which would inform subsequent schemes. And for Richard Rogers personally, as has been seen, the 1990s proved to be a decade of intense activity in terms of his public, political and professional life.

By the late 1990s the mood in the office was once again buoyant. In 1998 the Bordeaux Law Courts opened. A landmark in terms both of form and environmental programme, the scheme by Ivan Harbour and Amarjit Kalsi clearly reveals its function and organisation: rather than being overly deferential to its historic setting, the building creates a feeling of transparency and a positive perception of the French judicial system. 1999–2000 saw

modern architecture and strongly endorsed the cause of would-be tower builder Peter Palumbo. Yet in formal terms none of the great modern masters is further in spirit from Rogers' own work than Mies. Although Mies' skeletal, light-filled frameworks have greatly influenced Rogers, such formal, static compositions could not be further from the spirit of RRP's work. Indeed, part of the legacy of Mies is the proliferation of dull and bland glass towers in every western city – no more than 'skins stretched across repetitive, spatially efficient, supposedly economical structures', in Rogers' words. This is the very modern architecture against which Rogers has rebelled from the beginning, believing that it is linked to Modernist disdain for the complexity and spontaneity of city life. The International Style has an icy perfection, even at its best, which is at odds with the dynamic qualities Rogers seeks to express in his own buildings.

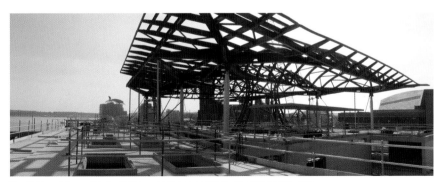

The National Assembly for Wales under construction, Cardiff, Wales, UK.

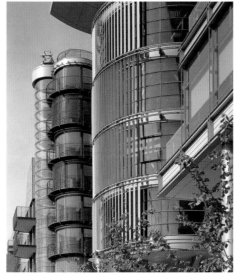
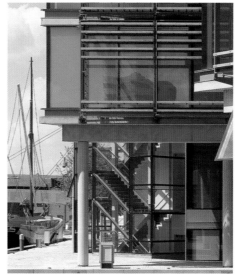
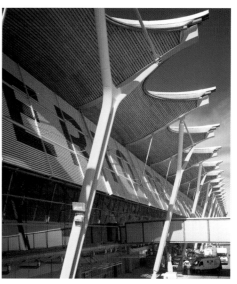

Daimler Chrysler Office and Retail, Berlin, Germany.　　Waterside, London, UK.　　Barajas Airport, Madrid, Spain.

the completion by Graham Stirk and his team of two key London office projects, 88 Wood Street and Lloyd's Register – the latter a classic RRP project, 'knitting' a new building within a complex historic site. In Europe, Laurie Abbott and Richard Paul designed an acclaimed group of three buildings in Potsdamer Platz, Berlin, while in 1997 the practice together with Estudio Lamela won the commission for the new terminal at Madrid's Barajas Airport. When completed this will be Spain's largest airport, handling 35 million passengers per annum as one of Europe's key transport hubs.

Other important recent competition victories include two Ivan Harbour schemes – the new law courts in Antwerp and the National Assembly for Wales in Cardiff – the latter offering the chance to design a truly democratic building on a commanding site overlooking Cardiff Bay. The practice has also made its mark in west London, with major office projects by Graham Stirk's team at Paddington – Waterside and the Grand Union Building. Although the Millennium Dome project was tainted somewhat by the exhibition content, the strengths of RRP's masterplan for the Greenwich Peninsula became apparent as housing and commercial development colonised what had been a polluted industrial wasteland. In Japan, the Techno Plaza at Gifu and an elegant design for a primary school near Kyoto

both demonstrated a remarkable fusion of architecture and landscape, while the practice has also been resurgent in the USA and in Europe. In 2002 RRP opened an office in Barcelona, where Laurie Abbott now plays a key role. RRP with co-architects Alonso Balaguer y Arquitectos Asociados have together won a string of Spanish projects, many of them in or near Barcelona (including a high-rise hotel and conference centre and the conversion of one of the city's former bullrings), as well as a commission for a new winery building near Valladolid. On Mallorca, the ParcBIT project on which RRP has worked since 1994 has finally begun to be realised, while in west London the practice was given the opportunity of radically redefining the concept of a business park: the award-winning Chiswick Park will, when all phases are completed, provide 167,000 square metres of offices served by excellent public transport links and benefiting from a magnificent landscaped park by the Dutch firm West 8.

The proposed 80,000 square metre, 48-storey tower at 122 Leadenhall Street in the City of London is a slender tapering wedge, respecting key views of Wren's St Paul's Cathedral and minimising the impact of the development on the tight network of City streets. At ground level, the building encloses a very large public space which is a covered extension of an existing open piazza which has proved to be a rather bleak place in inclement weather.

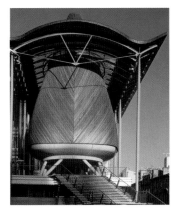
Law Courts, Bordeaux, France.

Broadwick House, London, UK.

122 Leadenhall Street, London, UK.

On a relatively small scale (4,000 square metres), John Young's office building at Broadwick Street in London's Soho, completed in 2001, reflects many of the practice's preoccupations, not only in its diagram, with services and circulation animating the facades but also in its dynamic image of modernity within a historic district. Similarly, Ivan Harbour's proposal for a small cancer care centre within the grounds of the Charing Cross Hospital reflects the practice's commitment to a range of more modest projects that will continue to sit alongside the more prominent masterplans, towers and airport terminals.

Public buildings always generate a passionate response from the team. Ivan Harbour's scheme for the new Antwerp Law Courts, is on an altogether grander scale than his design for the Bordeaux Law Courts but develops earlier ideas for low energy servicing, using natural ventilation, controlled natural lighting and the insulating effects of landscape and structure to drastically cut the energy demands of the

building in comparison with most court buildings of recent vintage. Visually, the building will be a striking landmark, consciously designed as a symbolic gateway to the city at a point where the urban fabric is currently shattered by a motorway. The tendency towards strong, even sculptural form seen in RRP's recent work (Bordeaux was certainly a marker in this direction) is vividly reflected in the paraboloid roofs of Antwerp, constructed over a timber grid. The extensive use of timber is another feature shared by the two courts projects. Environmental responsibility and resource efficiency become key drivers and influence previous open-ended, geometrically driven structures. For Bordeaux, the emphasis is on effective passive control systems – the 'containers' beneath the undulating roof and the manually operated brise-soleil along the western facade.

Graham Stirk's design for Birmingham's new city library, a project won in international competition in 2002, is characterised equally by dynamic form. Birmingham is a great city intent on renewing itself and casting off a somewhat mundane image. The library is intended as an icon of urban renaissance, located in the Eastside quarter, formerly isolated from the city centre by post-war planning blunders but now being reclaimed. It will also redefine the idea of a major library in tune with the needs of a changing, but still knowledge-hungry, society. The practice's proposals for Birmingham are a direct continuation of the thinking that created the Centre Pompidou – the idea that a dynamic new building could have a wider, beneficial impact on its surrounding area. Just as Beaubourg succeeded in providing the catalyst for the dramatic regeneration of the Marais district, so the new library has been conceived as an integral part of the revitalisation of Birmingham's Eastside area. The building sits in a new linear park – a pedestrian green route linking the new library to the heart of the city. The defining feature of the building is its great roof, oversailing the library itself to embrace the park and street and supporting a rooftop 'sky park'. Lower levels offer exhibition areas, foyers and an auditorium – a linear bar of accommodation contains cafés, shops, offices and conference space along the galleria-like internal 'street'. The library is thus part of a

new urban quarter, not a monument set apart: the aim is, in essence, demystification.

It was in Birmingham, in fact, in autumn 2002, that Rogers made a speech virtually relaunching his campaign for the city. The occasion was an 'Urban Summit' convened by the government, the context a widespread feeling (which Rogers shared) that the impetus for an urban renaissance in Britain was being lost. England's cities, Rogers argued, were still in decline, despite many remarkable examples of regeneration and renewal. The focus, he insisted, had to be on cities for all, with the demand for new homes being the driver to renew worn out and derelict city quarters rather than to consume the remaining countryside. A 'new deal' for cities was needed, with renewed conurbations 'based on the principles of easy human contact, the encouragement of walking, cycling and the use of public transport'.

RRP – a democratic community in microcosm

It is hard to separate Rogers the man from Rogers the architect. He has led a practice which has succeeded in retaining the experimentalism and enthusiasm of its early days. Nor has success blunted the practice's early idealism: it still operates within the framework of a constitution that brings a moral dimension into the business, enshrining ideas about community, teamwork, equity, collaboration and social responsibility. The practice is entirely owned by charities, so no director has direct equity or can pass control on to non-executive shareholders. Similarly, the salaries of senior directors are linked at a fixed ratio to those of the lowest paid architects of two years' standing and the company's profit is divided between employee profit-sharing, investment and contributions to charity (all employees of two years' standing are allocated a sum to be donated to the charity of their choice). The practice also avoids work on military projects, for arms manufacturers, or any scheme that could be considered overtly damaging to the environment.

Rogers' own working method can best be likened to the work of an orchestral conductor. Although he has, like other leading architects, assumed the role of a negotiator and figurehead, he is an acute critic, sitting in on early presentations and helping to pull a scheme into shape – or towards a redesign. Rogers' real flair lies in his extraordinary capacity to isolate the key issues while encouraging a team effort to resolve them.

Rogers is rightly proud of the prodigious talents of the practice: 'Most of the key projects of recent years have been driven to a large extent by the significant contribution of the younger generation at RRP'. The practice continues to evolve – a dynamic and innovative 'think tank' generating a remarkable range of work: what comes next is eagerly awaited.

The team on site at Barajas Airport, Madrid, Spain.

Domestic

1

Creek Vean

"The house offers long views internally and also engages with the surrounding landscape – it has a highly expressive, sculptural quality, infused with a sense of light and space." Richard Rogers

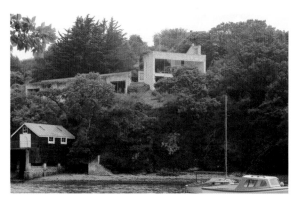

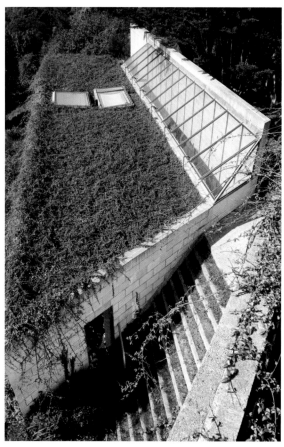

In this, the first major work by Team 4, Rogers and his partners responded to the strong character of the site (sloping steeply to a Cornish creek) with a design reflecting the influence of the American houses of Frank Lloyd Wright and Rudolf Schindler (which Rogers and Norman Foster had discovered while studying at Yale). Built for Marcus and Rene Brumwell, the house is richly textured, 'organic' in spirit, open to light and fine views, and spatially inventive: a classic of post-war domestic architecture in Britain.

While Creek Vean appears, at first sight, to represent a passing phase in Rogers' work – which was soon to turn in other directions – it has the flexibility and adaptability which are at the core of his philosophy of architecture. Sliding screens blur the division between rooms, while provision was made for the house to be extended – Rogers has never designed a finite monument. The house equally prefigures themes which were to emerge powerfully in Rogers' architecture two decades later: the response to location and a concern for nature and ecology.

A striking tour de force by a young practice, Creek Vean must also be reckoned a landmark in Rogers' career.

Opposite: A broad flight of steps leads down to the boathouse and the creek. Above Left: View of the house with the creek below. Above Right: Rooftop planting and the sky-lights over the gallery.

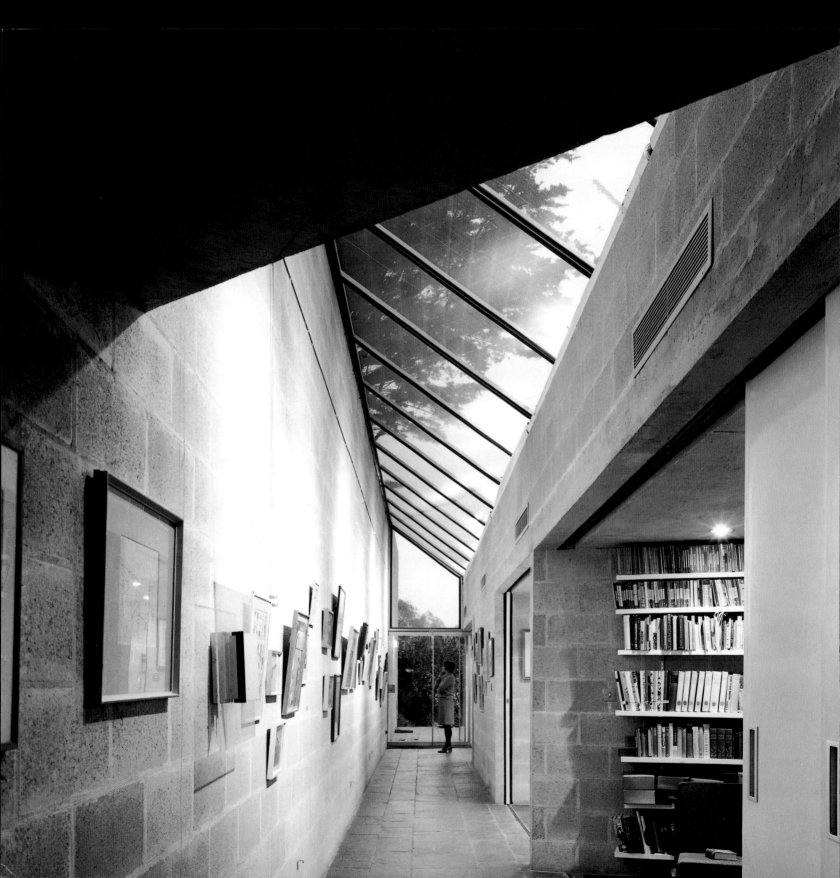

Opposite: The top-lit gallery.
Top Left: View from the
north with the entrance to
the gallery. Top Right: Roof
and ground floor plans.
Bottom Left: The entrance
bridge. Bottom Right: The
kitchen and dining areas.

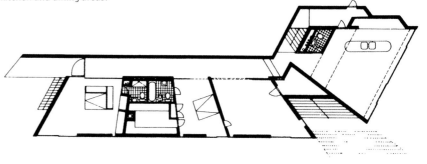

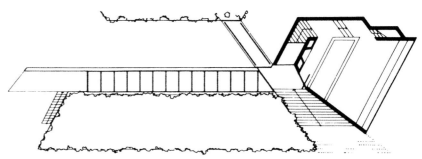

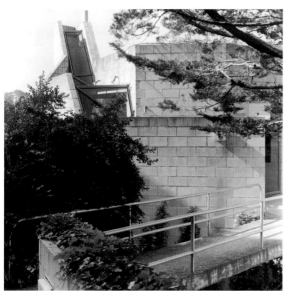

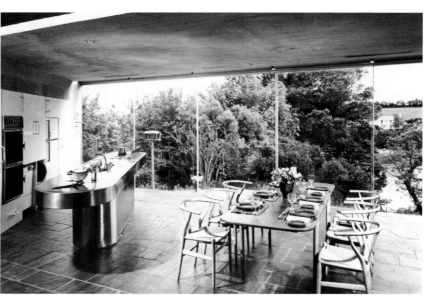

Zip-Up House

Rogers' interest in adaptable, affordable housing has persisted over three decades of practice. His work in this field is closely linked to the exploration of themes, notably those of flexibility and energy efficiency, that emerge equally strongly in commercial and public projects, such as Lloyd's and the Nottingham government offices.

The Zip-Up House was designed in response to a competition, sponsored by Dupont, for 'The House of Today' and was exhibited at the 1969 Ideal Home Exhibition in London. The aim was to offer the user a wide range of choice at low building costs with minimum maintenance and running costs and a high degree of environmental control. The structural panels had an insulation value seven times that of a traditional house so that one 3-kilowatt heater was sufficient to heat the whole house.

The name 'Zip-Up' derived from the choice of a mass-produced panel system for roof and walls that could be rapidly assembled into 'rings' using Neoprene 'zips' as fastening, up to a maximum nine-metre clear structural span. Within the basic container there were no fixed divisions. The interior layout could be rapidly changed at will and the house extended simply by adding another section of the system. The use of adjustable legs rather than conventional foundations allowed it to be sited anywhere and easily removed to a new site.

The designers also intended the Zip-Up concept to be applicable to factories, offices and even hotels – all of which could be assembled using standard parts in a fraction of the time and cost required for a conventional building.

"With no internal structure, the design allows for maximum flexibility and a completely fluid plan. The Zip-Up concept pointed the way to factory-produced housing, offering tremendous adaptability and choice." John Young

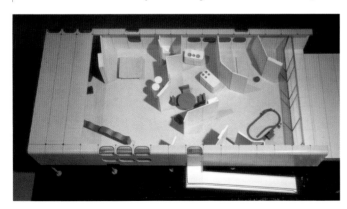

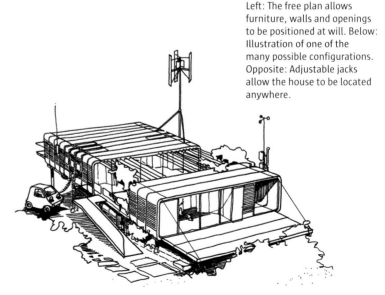

Left: The free plan allows furniture, walls and openings to be positioned at will. Below: Illustration of one of the many possible configurations. Opposite: Adjustable jacks allow the house to be located anywhere.

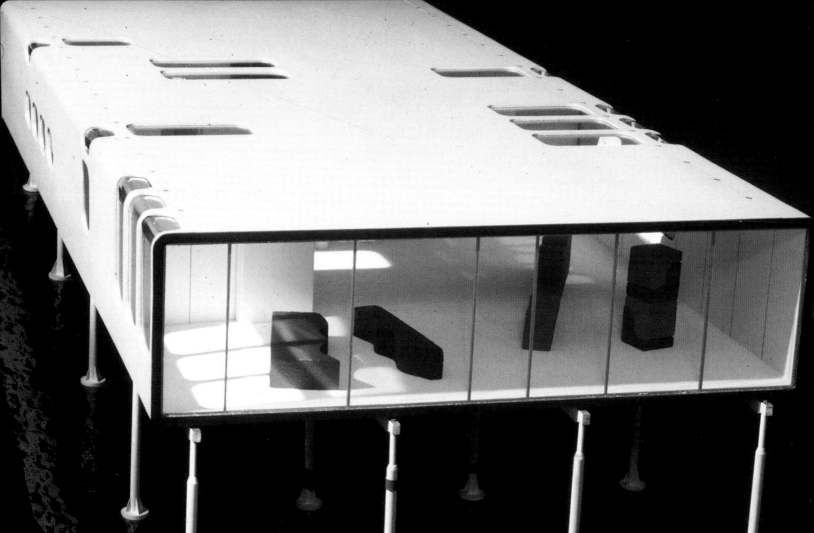

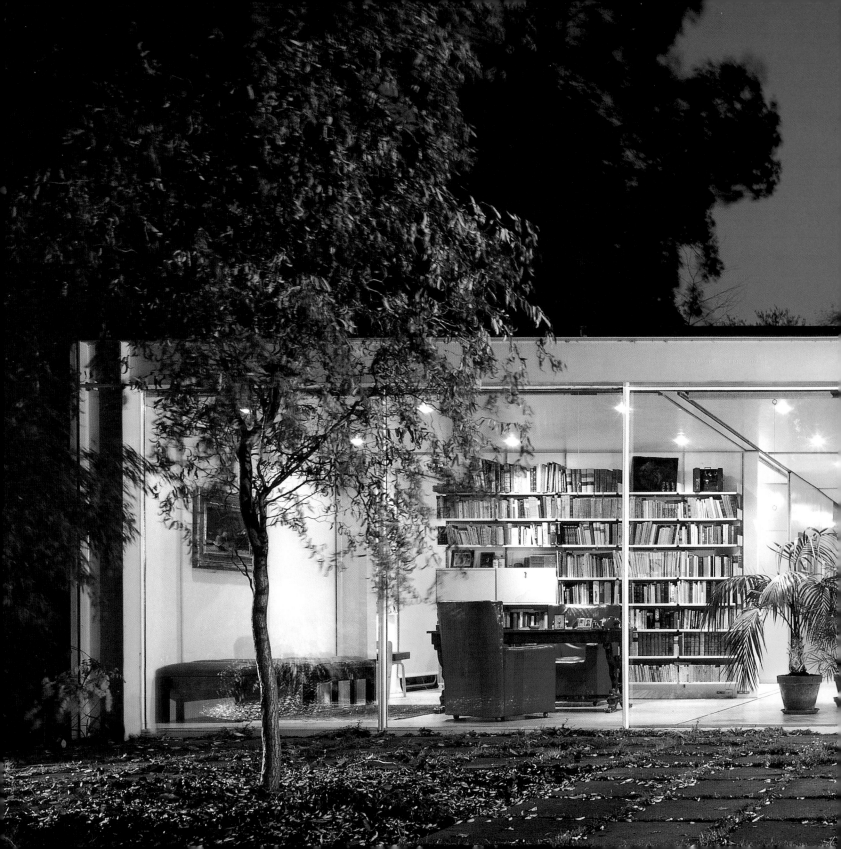

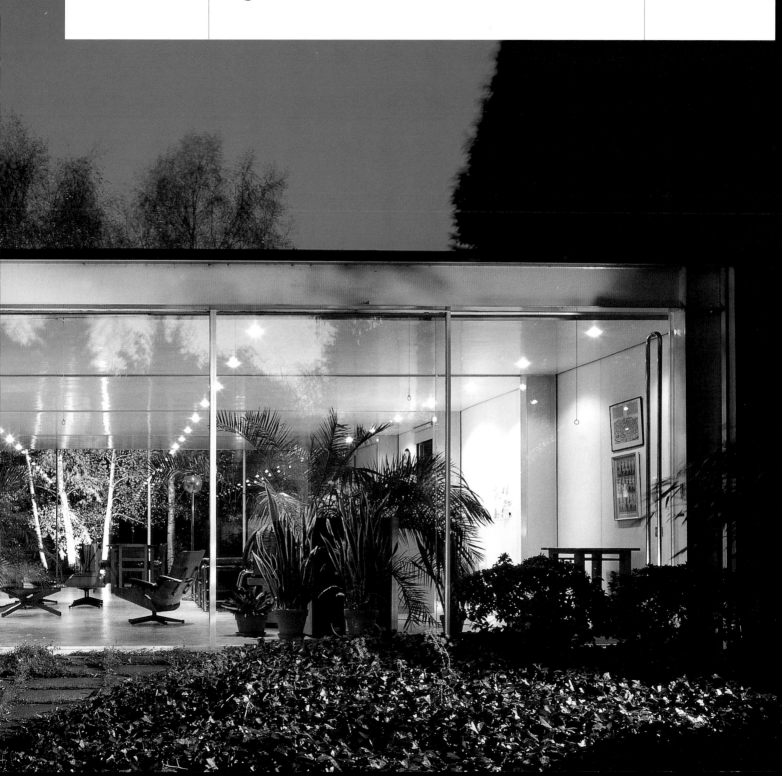

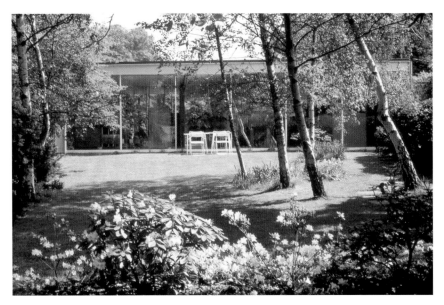

Previous Pages and Top: The study and living area seen from the garden courtyard. Above: The pre-fabricated insulated panels that make up the non-glazed facades.

This house, built for Rogers' parents, developed the vocabulary of Reliance Controls and of a slightly earlier house in Essex designed for Humphrey Spender. Now working independently of Team 4, Rogers again recalled the Case Study houses he had seen in California, especially the work of Raphael Soriano, and created a radical living space.

The scheme consists of two, simple single-storey pavilions carefully arranged within a deep garden plot opposite Wimbledon Common. The idea was that the house would be assembled rather than built – the framework consists of eight steel portals, three for the studio and five for the main house, with two portals removed to create a central garden courtyard (this area could be in-filled should the needs of the owners change). The internal divisions and utilities were designed for maximum adaptability – the side walls are of plastic-coated aluminium panels joined with a neoprene zip system used on the Zip-Up house (the original technology was developed in the USA for refrigerated trucks). Similarly, the windows were off-the-shelf items used in contemporary bus design: sourcing components in this way optimised on both energy and mass-manufacturing quality.

Rogers sees a house as an exercise in overall design. It must incorporate the possibility of growth and change but be self-sufficient in itself. The Wimbledon house is, at the same time, ruthless in its straightforwardness and uncompromising use of mass-produced materials and beguiling in the elegance of its spaces, its carefully considered detailing, manipulation of scale and the relationship between the interior and exterior.

For Rogers, designing houses has been an important catalyst in the development of his architecture. In the hands of other modern architects, a house can be a perfect object. Rogers has never separated the design of individual houses from his concern for housing more generally. A private house, whether large and costly or small and economical, is a component in a new social architecture.

Right: Ground floor plan.
Below: The living and dining
areas viewed from the kitchen.

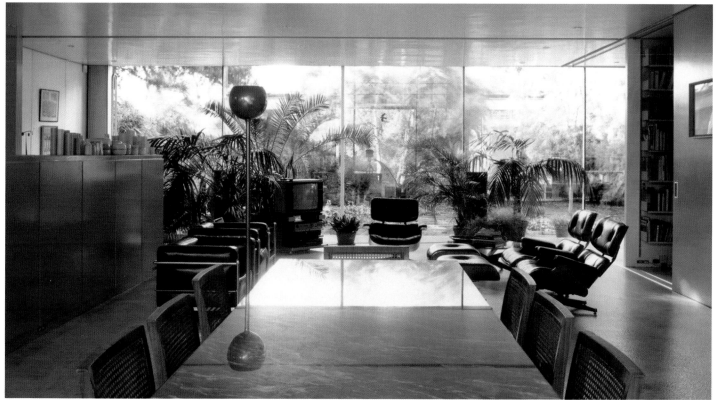

"The whole house was designed as a transparent, flexible tube which could be adapted and extended, or completely opened up to involve everyone – guests, friends and family. The close relationship between the house, the garden, Ernesto Rogers' furniture and Dada Rogers' pottery made this perhaps the most successful small project I have been involved in." Richard Rogers

Thames Reach Housing

"Floor-to-ceiling glass walls address the impressive sweep of the Thames – generous cantilevered balconies are set between each block, so as not to interrupt the view." John Young

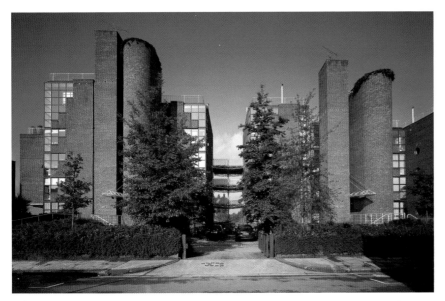

The housing scheme at Thames Reach contains 25 units and is located adjacent to the warehouse complex housing the Richard Rogers Partnership and the River Café. The design takes its cue from these warehouses, rather than the surrounding streets of two-storey houses, and has a scale and form appropriate to the riverside. The use of brick, unusual in the practice's mature work, reflects the attention paid to the context.

By breaking the scheme into three blocks, views are provided through from the street to the river, where there is a generous public promenade. To the street – very much the 'rear', with articulated stair and lift towers – the scheme is restrained to the point of sobriety. On the river frontage, where living rooms are placed to take advantage of the fine views, a regular grid of glazing is broken up by an expressive pattern of cantilevered balconies. The 'nautical' theme is deliberate but applied with a lightness of touch which recalls the bridges and piers of the 19th century.

Top: The spaces between the blocks allow views to the river beyond. Left: Suspended steel balconies overlook the Thames. Opposite: The entrance bridge from the street.

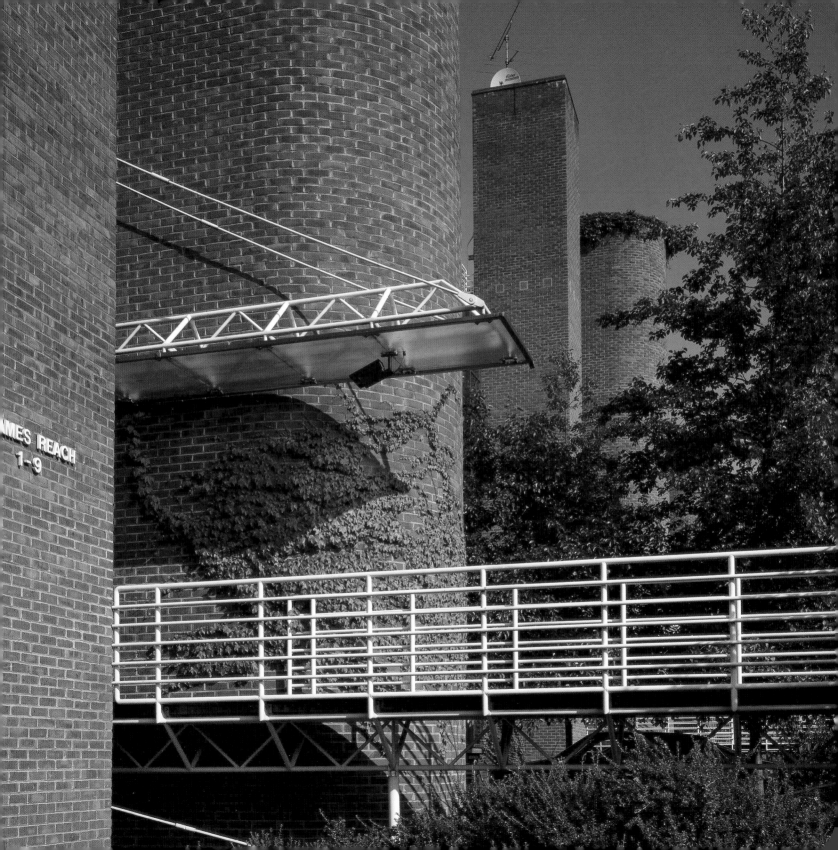

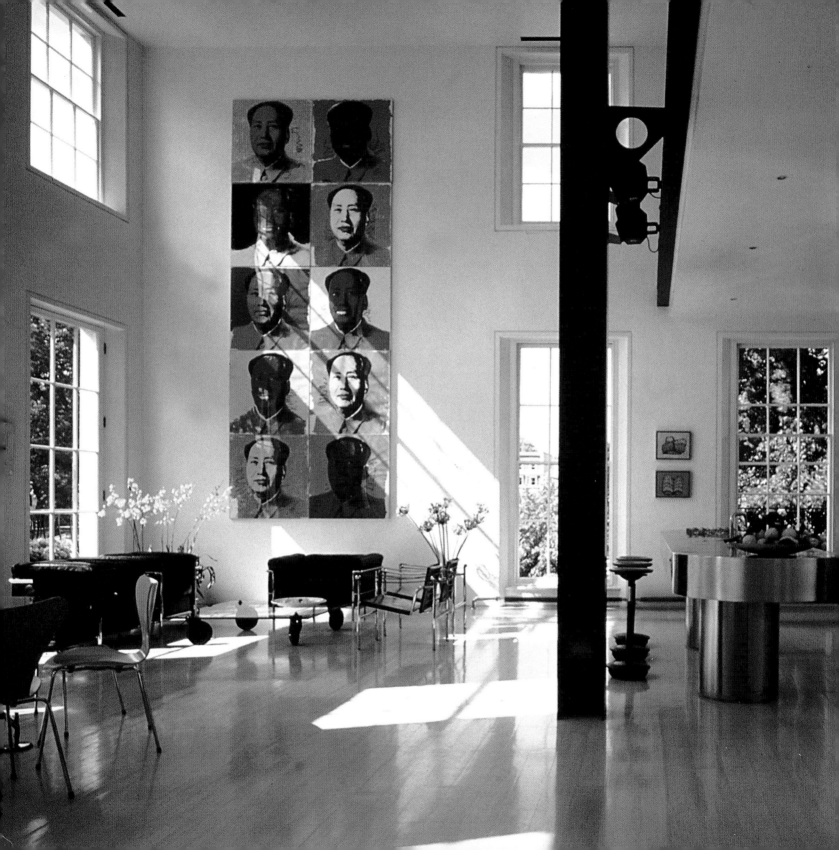

Opposite: The double-height living and kitchen space. Above: The restored early 19th-century facade. Right: A top-lit staircase leads to the mezzanine study and the bedroom above. Below: The living space is the heart of the house, ideal for large informal gatherings.

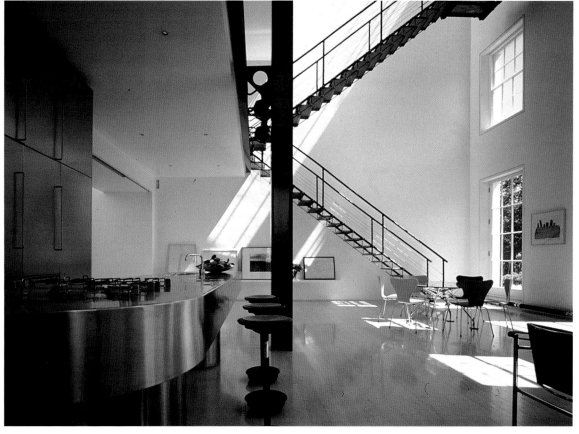

Domestic

Royal Avenue

London, UK
1987

Richard Rogers' own house faces one of Sir Christopher Wren's masterpieces, the Royal Hospital, Chelsea, and is itself a handsome Victorian structure. Externally, the house (actually two terraced houses, one at the street corner, run together) is unchanged: Rogers greatly values the traditional civility of this part of London. Inside, however, there have been radical changes. The conversion inevitably recalls Chareau's 'scooping out' of a historic Paris house to create the Maison de Verre, a building which Rogers has always found a source of inspiration.

Rogers' own living space occupies a double-height volume, with sleeping accommodation on the top floor. The kitchen area acts as the heart of the double-height living area. Ruth Rogers is a professional chef and co-owner of the celebrated River Café in London – even at home the stainless steel kitchen fittings are of an industrial toughness and rigour. Eight south-facing sash windows allow light to flood this dramatic space while framing views out over the Hospital and its gardens. The main living area is conceived as a kind of 'piazza' with a constant flow of friends and family – it is ideal for large family gatherings and parties and provides a striking backdrop for Rogers' collection of modern art.

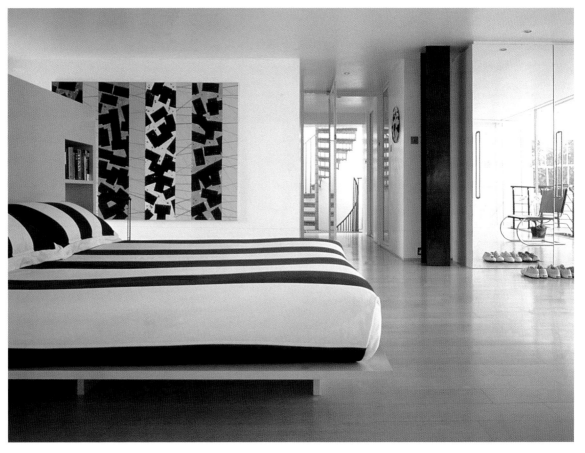

Above: Entry from street level is via a translucent glazed conservatory. Right: The top floor bedroom. Below: Main floor plan. Opposite: The stainless steel kitchen with mezzanine above.

"Light, views, the theatre of living – these are the driving forces of the house." Richard Rogers

A beautiful steel stair designed by Laurie Abbott connects the living area, study and bedrooms above, continuing down through a glazed area that was formerly a small courtyard and connecting to the small entrance at street level.

The conversion reflected Rogers' desire to live 'en famille'. The ground floor is set aside as an apartment for his mother-in-law. A roof terrace affords stunning views over the Royal Hospital Gardens and the King's Road. A concealed spiral stair connects all the floors, from the roof right down to the basement.

In its coolness and rationalism – and inherent sociability – as well as its bravado, the house expresses some of the most basic principles underlying Rogers' architecture.

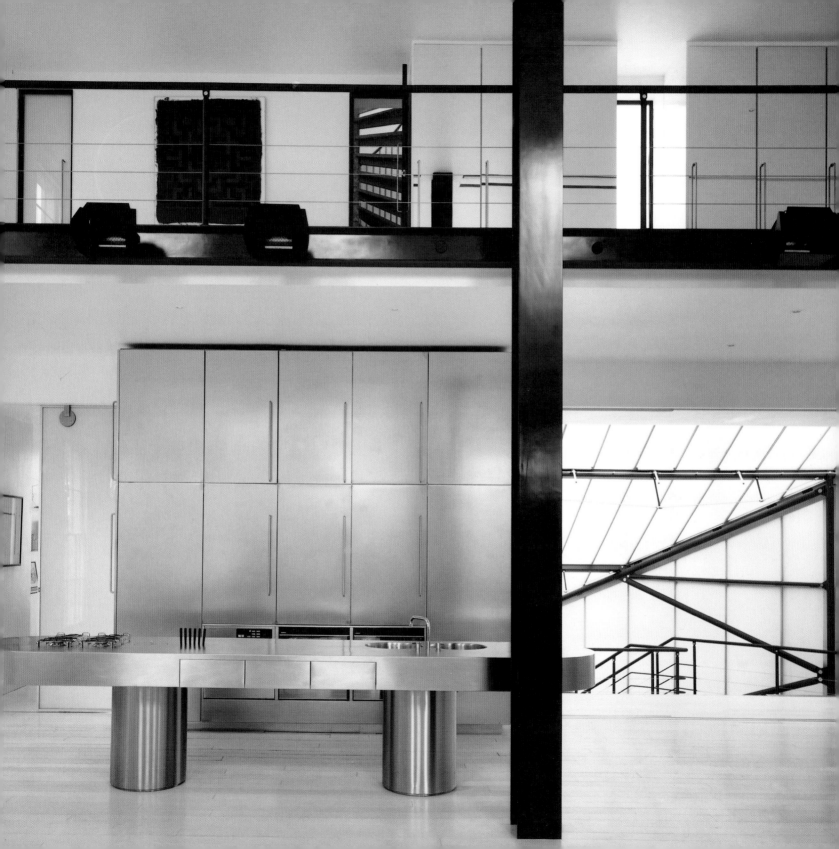

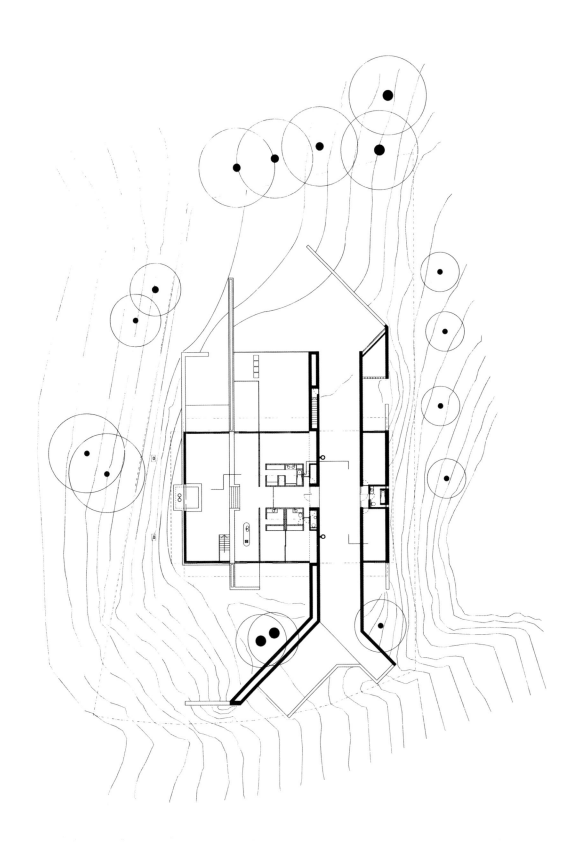

Michael Elias House

"The house has a highly expressive, sculptural quality, contrasting the monolithic character of the concrete plinth with the dynamic expression of the suspended roof system." Laurie Abbott

Opposite: Ground floor plan. Above: Two cable-stayed masts support a floating roof over frameless floor-to-ceiling glazing. Below: Concept sketch.

The project for a three-bedroom house for a member of Rogers' family produced a dramatic design with a double-masted steel structure suspending a floating roof plane measuring 18 by 27.5 metres. The accommodation, in an elevated position and with the body of the house sunk into the terrain, comprises master bedroom, two guest bedrooms, kitchen, dining area, double-height lounge, four bathrooms, swimming pool, spa pool and a basement. Beyond the pool, provision was made for a self-contained study, while separate staff accommodation was to be located adjacent to the main entrance drive and car port.

The house was designed to be light and spacious, with sliding glass doors giving access to external terraces adjacent to the swimming pool and a spa pool. The living area was situated to take maximum advantage of the spectacular views overlooking the Pacific Palisades.

Servicing is by means of a passive heating system – the house was designed to capture the prevailing winds and sea breezes. Cool air was extracted from tunnels below the house to provide basic air-conditioning, whilst conversely heat stored in 'air floor' cavities below the terrace decking during the hot California day could be made available for use during the cooler evenings.

Future flexibility was also a priority – internal walls were designed to be moveable, constructed of pre-fabricated steel panels. The house – yet to be built – may be seen as Rogers' homage to the Californian school of house design, particularly the Case Study houses, which he came to admire in the 1960s.

Right and Far Right: The
apartments come complete
with modular bathroom,
kitchen, stair and lobby units
(day and night views). Below:
The pre-fabricated kit of parts.

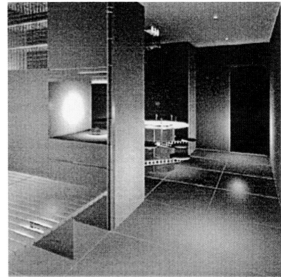

| Domestic | Industrialised Housing System | South Korea 1992 |

"The aspiration was a freedom of composition and
form – a highly industrialised system of pre-fabricated
units slotted into an independent structural
framework dealing with load-bearing issues. The
towers avoid the normal constraints of conventional
construction methods, responding to individual client
and site requirements." Laurie Abbott

Rogers' abiding concern for the social objectives of
modern architecture is reflected in this project, intended
to provide large numbers of homes at a cost one-fifth
that of more conventional construction methods. The
basis of the project is the use of high-quality, factory-
produced units on a modular system which, due to
minimal connection points between one unit and the
next, can be quickly assembled on site.

High-performance, low-energy mechanical and
electrical systems are part of an environmentally
friendly programme. In addition to the normal services
– such as heating, lighting and air-conditioning – the
design envisaged provision of security systems, as well
as communication, information and entertainment
systems appropriate to 21st-century living.

The units were designed to be used in a flexible way,
providing for the needs of a wide range of potential
inhabitants. They can form towers or low-rise schemes,
depending on the local terrain which in South Korea is
often very hilly.

Below: Elevation showing the units being delivered and craned into position on site, and typical floor plan illustrating alternative configurations of individual units. Right: Model view of a high-rise configuration.

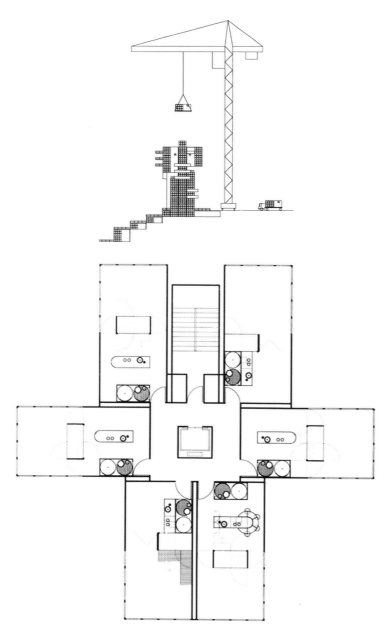

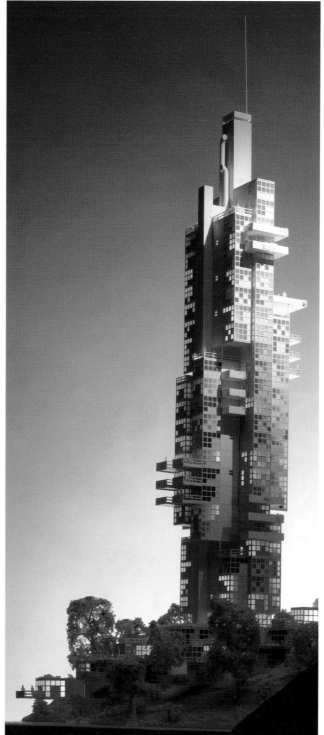

Residential Building B8

"The building's form was generated by using a heliodon which simulated the sun's trajectory. By cutting away at a foam model we arrived at a design that optimised sunlight and views." Laurie Abbott

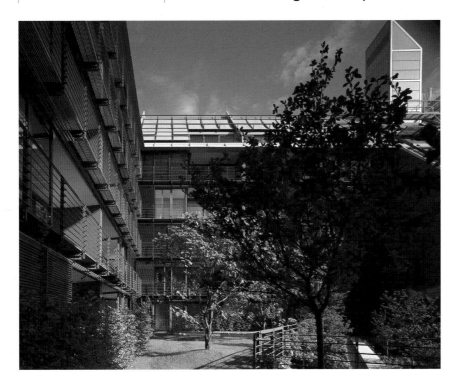

Above: The courtyard garden.
Below: Sketch demonstrating how sunlight reaches deep into the courtyard.

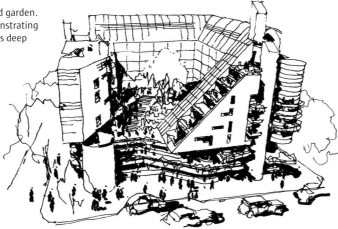

The three buildings designed by RRP for Daimler Chrysler on Berlin's Linkstrasse form part of the the Potsdamer Platz masterplan by Renzo Piano. B8 is predominantly residential, with retail areas on the ground, first and second floors.

In the original masterplan the three buildings are shown as closed blocks measuring c.50 metres square, but the RRP design opens up the south-east side of the blocks facing the park. This building form allows light to penetrate into the courtyard, atrium and internal spaces, as well as providing all apartments with unobstructed views out over the park.

The ratio of glazing areas to solid wall construction is determined by the orientation and analysis of heat losses and solar gains. Whereas the north-east and north-west facades have comparatively little glazing in order to minimise heat loss during the winter months, the south-west and south-east elevations are generously glazed, with living areas opening onto the garden courtyard.

Conservatories or 'winter gardens' adjacent to these living areas maximise the passive use of solar energy. The winter gardens act as direct solar gain spaces and buffer zones, with pre-heated air used to ventilate or warm the internal accommodation space in winter. Sun shading provided by aluminium louvres on sliding tracks prevents overheating in summer.

The double-height penthouses are fully glazed to the courtyard side. The glazing system is supported by a water-filled steel structure which acts as a radiator during the winter. Electronically operated sun-shading devices and opening windows minimise solar gain and maximise natural ventilation during the summer.

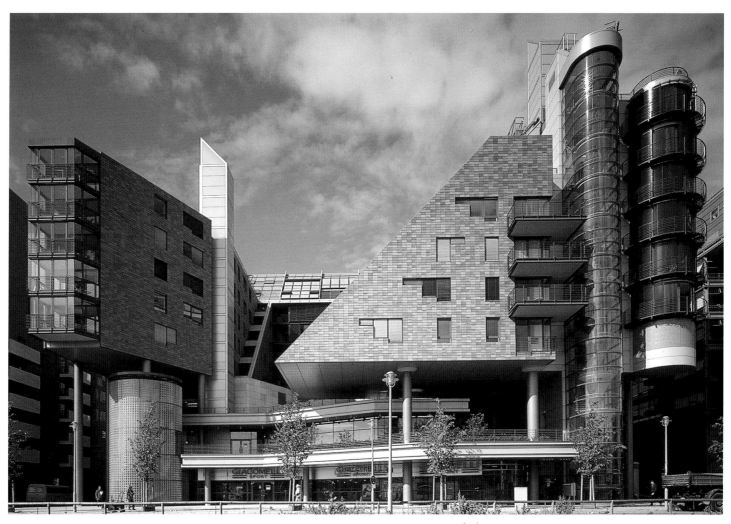

Above: Street facade. Far Left:
Floor plan. Left: Section.
Following pages: Balconies and
'winter gardens' overlook the
central courtyard or the park.

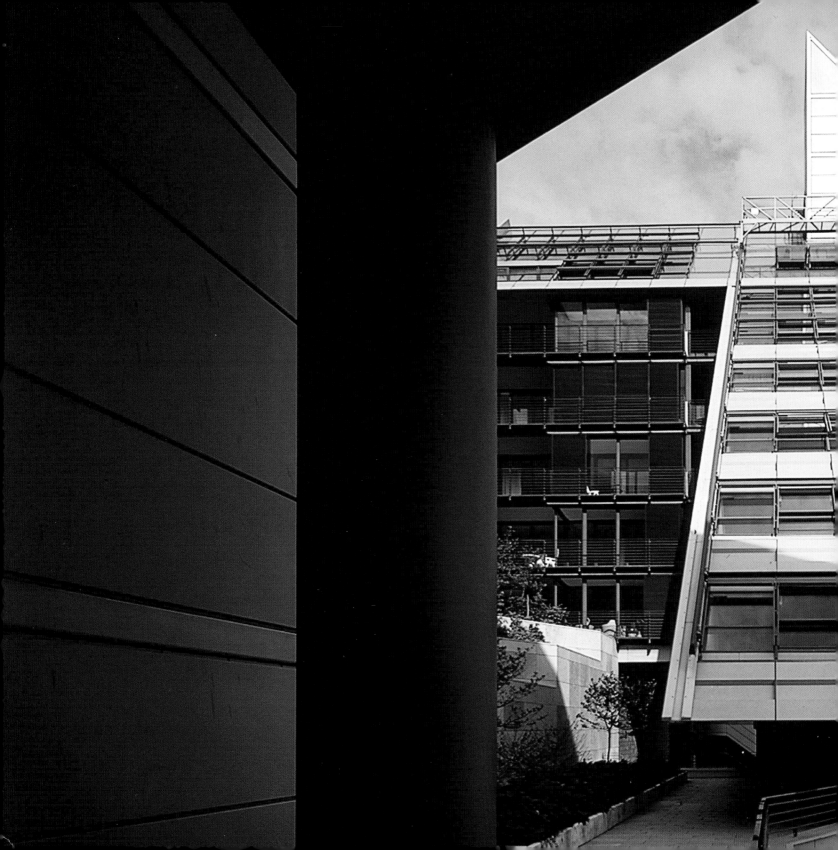

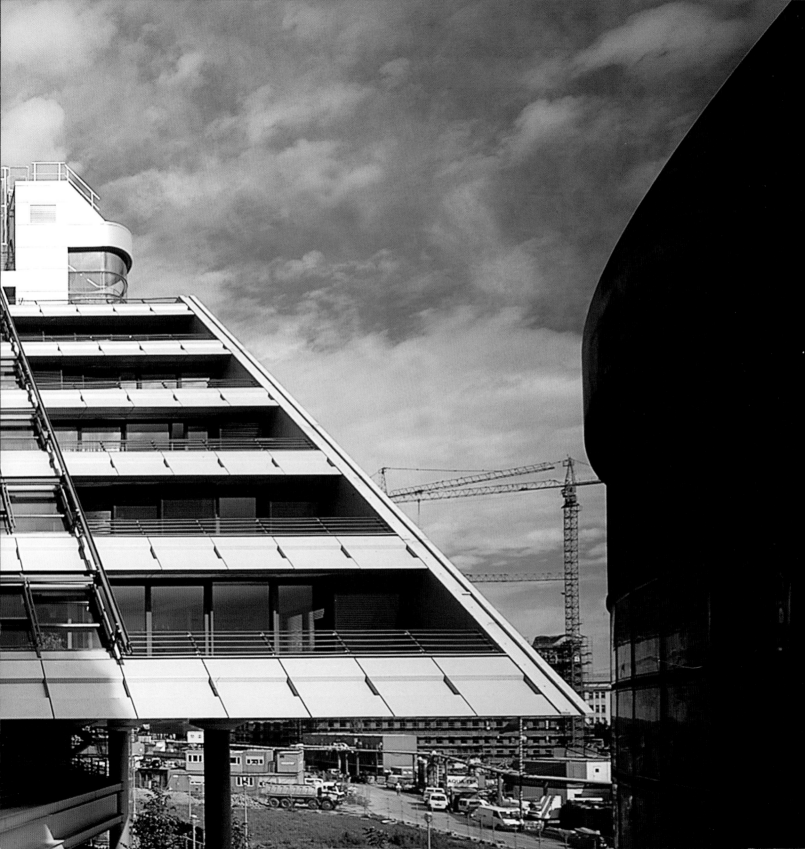

Montevetro

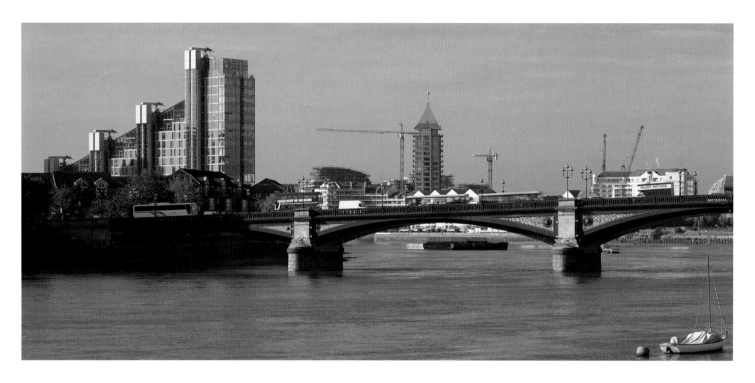

"The orientation was a key issue – the scheme is designed so as to afford stunning river views, with all living areas facing west. The massing was also carefully considered – five linked buildings stepping away from the church and towards the river." Mark Darbon

Above: View from the River Thames. Right: Site plan. Opposite: The building profile steps down to four storeys in a contextual response to St Mary's church.

The Montevetro residential development occupies a site at Battersea Reach, south of the Thames and looking across to Chelsea's Cheyne Walk. The site was formerly occupied by an early 20th-century flour mill, closed during the 1980s. Its context is extremely varied – to the east, high-rise 1960s housing, surviving older terraces and villas and, to the west, the listed 18th-century church of St Mary at the river's edge.

By inflecting the new building, RRP aimed to create variety along the river-walk. The major public gain is the riverside park which has created a continuous route between Wandsworth and Battersea bridges, while also

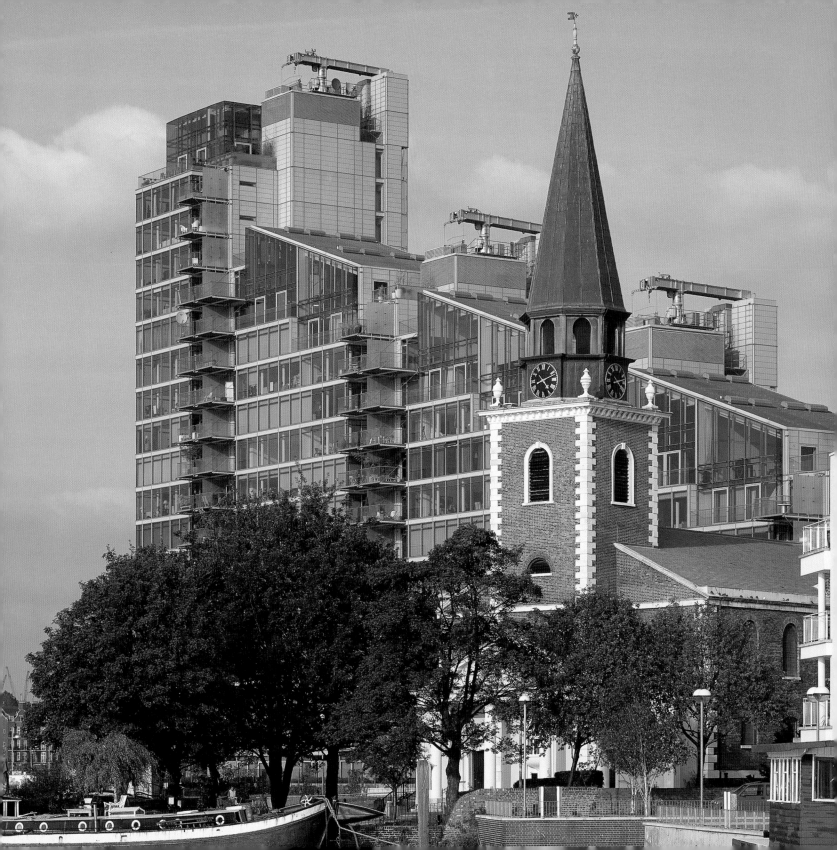

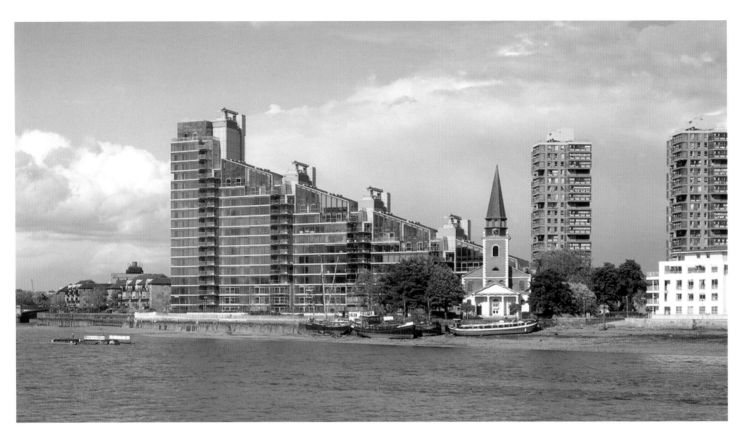

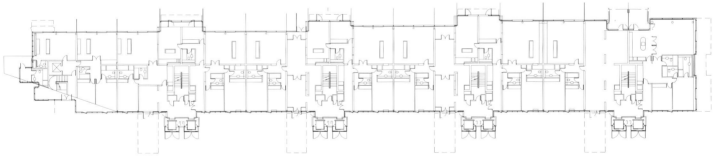

Top: The glazed western facade with views over the garden and river. Above: Floor plan. Bottom Row: The building as a finely tuned machine – Montevetro demonstrates RRP's characteristic attention to detail.

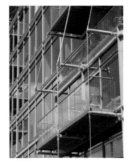

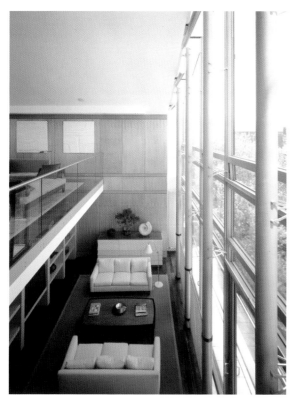

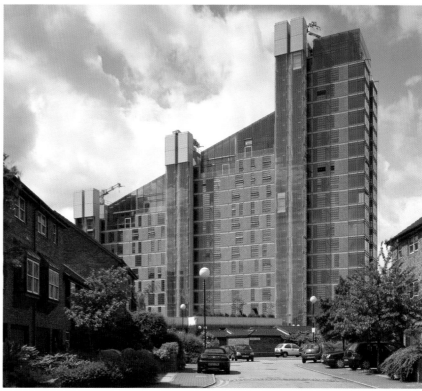

Above Left: Double-height living space. Above Right and Right: Terracotta panels and glazed lift towers animate the east facade.

enhancing the setting of St Mary's.

The scheme consists of five connected blocks which step down to four storeys where it abuts the church, rising to a full 20 storeys on the north-eastern extremity of the site. Lift and staircase towers connect the blocks, giving Montevetro a strongly modelled profile and providing access to all apartments without resort to internal corridors. The western facade of the development is heavily glazed, providing magnificent views over the river, Chelsea and, from upper floors, much of west London. The 103 apartments which range in size from approximately 95 to 230 square metres are all provided with generous balconies overlooking the river. The east facade, animated by the lift towers, has a more solid aesthetic with panels of terracotta cladding. Health and leisure club facilities are provided in a low-rise block adjacent to the street.

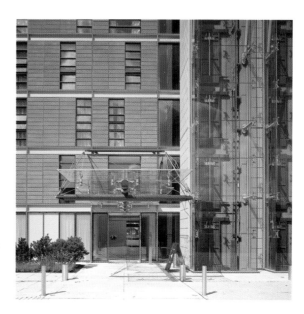

Sagaponac House

Like Creek Vean, a bespoke house on a rocky headland in Cornwall, the house at Sagaponac makes a strong response to its natural context – a wooded site on Long Island, New York.

The house forms part of a development of 34 houses commissioned from leading contemporary architects, including Zaha Hadid, Shigeru Ban and Richard Meier. The protection of the natural setting of the new community is a key element in the project, master-planned by Richard Meier.

In contrast to the site at Creek Vean, that at Sagaponac is quite flat and screened to the east by dense planting. The drama of the house is architectural rather than scenic. Two walls/screens, set at right angles, define the internal and external spaces. Inside, they form structural elements, supporting the roof, and a division, on one axis, between the main living space (highly flexible and opening to the garden) and the bedrooms. On the other axis, the cross wall defines the entrance front to the house, with its entrance courtyard and service space for parking and deliveries. Behind are two garden areas, one intended for entertaining and

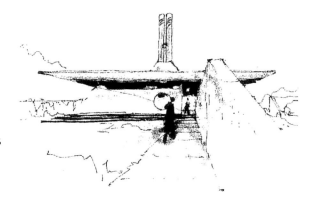

Top: Concept sketch. Above: View from above showing the oversailing roof. Below: View from the street where an almost solid wall ensures privacy and security.

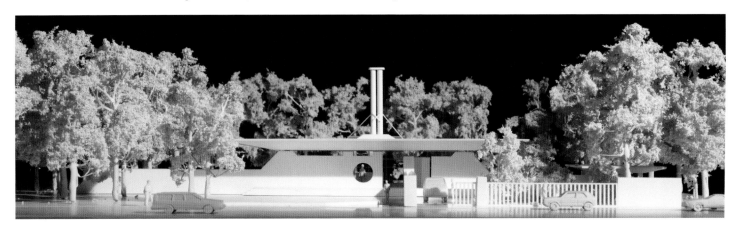

relaxation, the other a more private space overlooked by the bedrooms. The designs embody the classic balance between community and privacy which characterises other Rogers house projects and derives, perhaps, from the teachings of Serge Chermayeff.

The insulated timber roof overhangs the external walls of the house to provide shade and shelter and embrace the landscape. Adjustable external louvres allow the penetration of light into the house to be altered according to the season. With the glazed external walls opened, the swimming pool can provide additional evaporative cooling to the living areas. The house is designed for low-energy running with an undercroft, acting as a plenum, helping to cool the house in summer and insulate it in winter.

Left: Floor plan. Below: View of the entrance and car port.

"The aim was to achieve a simple design, low-key and discreet. The restrained choice of materials – wood, stone and glass – ensures the building blends in with the surrounding wooded landscape." Laurie Abbott

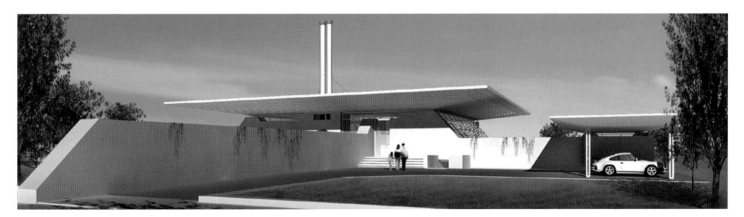

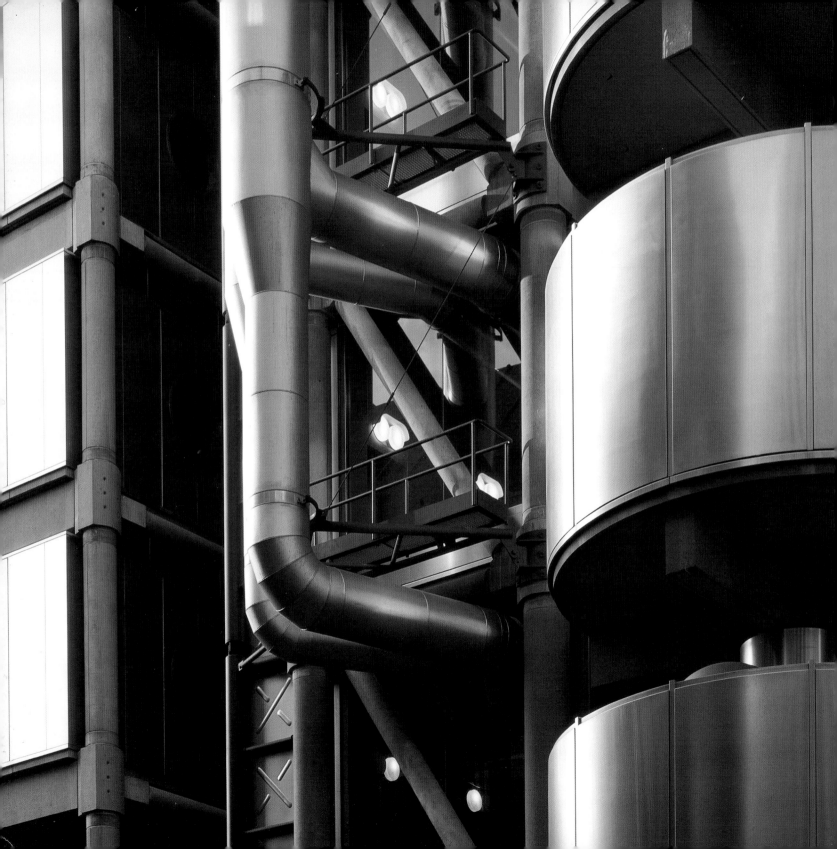

Workplace

2

Reliance Controls Factory

"Reliance was a turning point in the way we constructed buildings – it had an enormous influence on our subsequent approach to design." Laurie Abbott

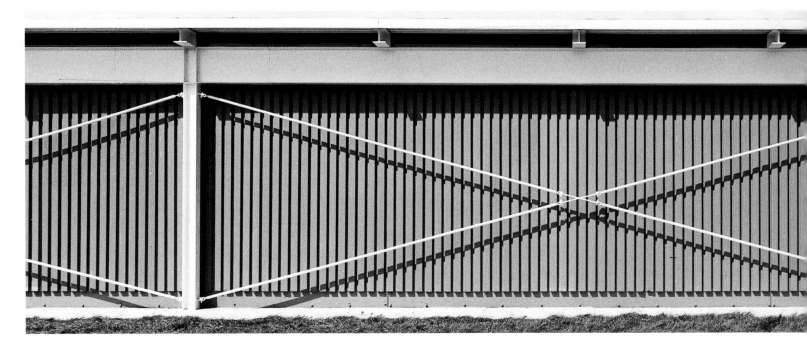

With Reliance Controls, Team 4 changed the course of architectural history. It was neither a factory, nor an office building nor a research station but a combination of all three. After its completion, the work of Rogers and of Norman Foster turned in increasingly radical (if divergent) directions.

Though it has become one of the models for the new industrial and commercial architecture of the late 20th century (it was clearly the progenitor for later developments such as Stockley Park), Reliance Controls took its inspiration initially from the Case Study Houses, especially Charles and Ray Eames' famous Californian house of 1949 (which, in due course, inspired several early Rogers houses), although the water-tower, a quotation from Alison and Peter Smithsons' famous

Hunstanton school, can be related to the modernist tradition in Britain.

The brief demanded economy, speed of construction – the client laid down strict cost guidelines and insisted that the building be ready within ten months: it was finished early and to budget. The building also had to reflect the changing relationship between 'worker' and managers: it is essentially a 'democratic', anti-hierarchical shed which made a nonsense of the old division of factories into 'shop floor' and managerial space.

The idea of the building was clearly expressed in its structure – with everything contained within the grid of the steel frame and sheltered by one large roof. The intention was to create a common-sense model for the workspace of the future. Reliance Controls made use of

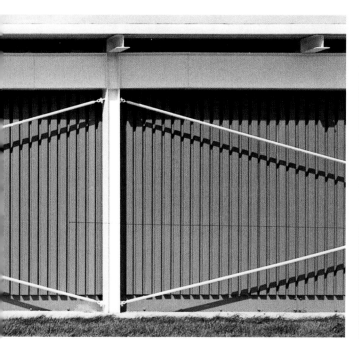

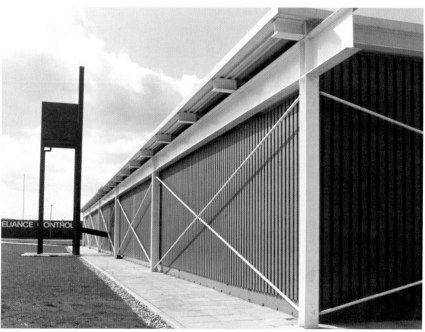

ordinary, cheap materials yet the result was a building of extraordinary elegance and integrity. The steel sheeting used for the cladding had never been used in this way before in Britain – 3.6-metre-high panels without intermediate support were considered daring.

The building was in essence a highly flexible building, with moveable internal partitions allowing production, research or managerial space to grow or contract as required, but when Reliance Controls vacated the factory and it faced demolition, Rogers accepted the situation stoically: he deplores the idea of preserving what is functionally obsolete.

B & B Italia Offices

"The idea was to reduce everything to a very slender structure, a sort of filigree: it required a great deal of patience and some acrobatics."
Richard Rogers

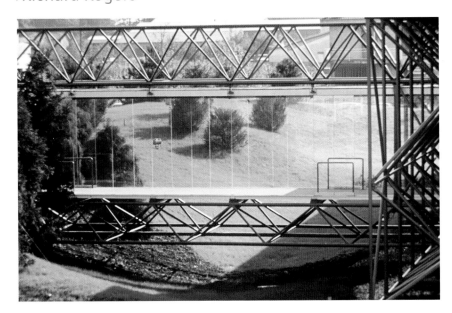

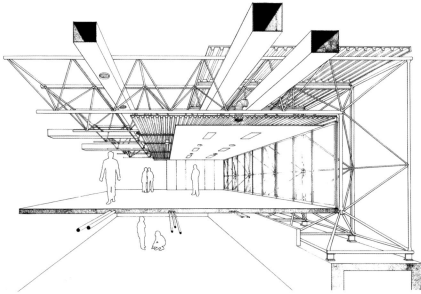

Piero Busnelli, the Managing Director of a large Italian furniture manufacturer, so admired the designs for the Centre Pompidou that he commissioned Piano + Rogers to design his company's new offices.

The brief called for a high degree of flexibility and this building reflects the practice's enthusiasm for open-ended systems that can be added to or subtracted from – it has a clarity and sense of order coupled with an elegant economy of means.

The structure consists of a series of lightweight portal frames from which the highly glazed office container is suspended, with servicing occupying the space between the two. The interior of the building is entirely column-free, contained within a box suspended from a series of twenty tubular steel portal frames spanning 30 metres. Services are restricted to the perimeter, obviating the need for fixed internal elements – walls and partitions can be freely moved around. The elevation of the office floor provides for electronic information services, plant-room and storage. In the bridge which links the offices to the existing factory lightness is taken to a new extreme.

The building is a little-known classic and the only project so far completed by Rogers in the country of his birth.

Above: A glazed bridge links the office and the manufacturing facility. Left: A series of portal frames defines the internal space and encloses the services. Opposite: Detail of the latticed portal frame.

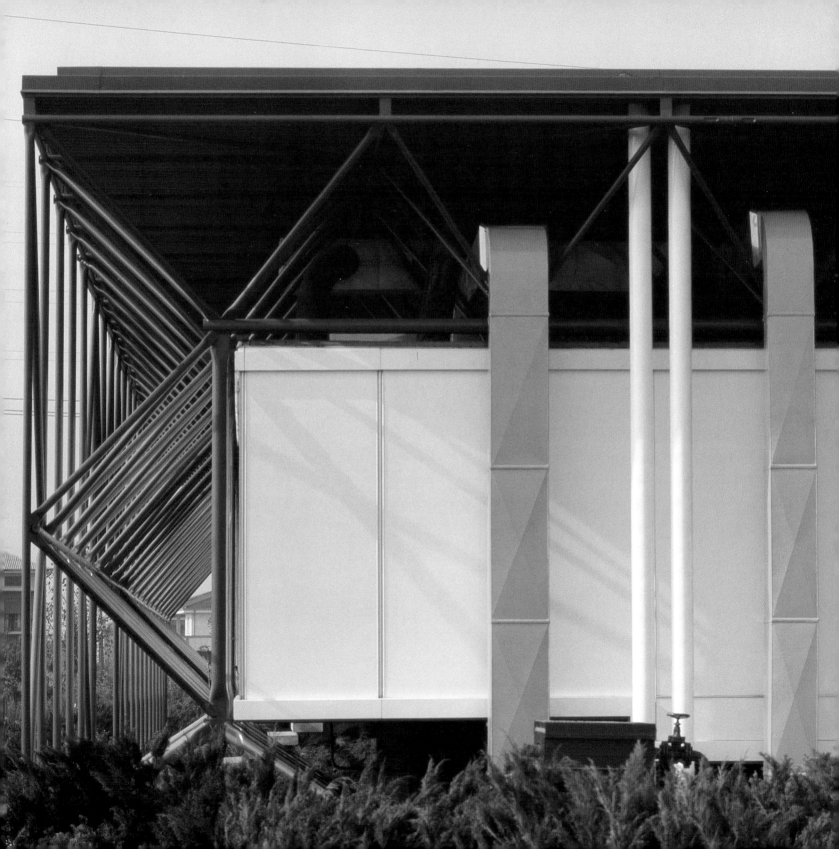

PA Technology Laboratory

> "Our belief in growth and change as key design generators for all our work was vindicated by Patcentre which expanded three-fold over a seven-year period, including major internal reconfiguration."
> John Young

Opposite and Following Pages: The interchangeable cladding system provides a striking contrast with the surrounding landscape. Below: Section showing parking, loading facilities and bunker zones on the lower level and laboratories above.

RRP's approach to design has had a consistent appeal to companies involved in high-technology research, development, and production. For PA Technology, the practice created, in three phases of work, a prestige headquarters and laboratory complex which is a quiet masterpiece of modern commercial architecture, located close to the university city which has become an internationally recognised centre of research and development.

Specialised functions of the sort the complex houses require specialised spaces and specialised services: a simple open-plan shed was inappropriate. But the building incorporates the lessons of earlier projects, notably the ARAM module study. The floor space inside is divided into laboratories, which are enclosed at the centre of the building, and support space, but all partitioning is made moveable to provide for changing requirements. The structure consists of a solid concrete slab with a light steel roof frame.

The elegance of this scheme is notable – the building is elevated on columns above ground level, leaving parking and loading space underneath. This arrangement has the advantage of allowing the surrounding landscape to envelop the building.

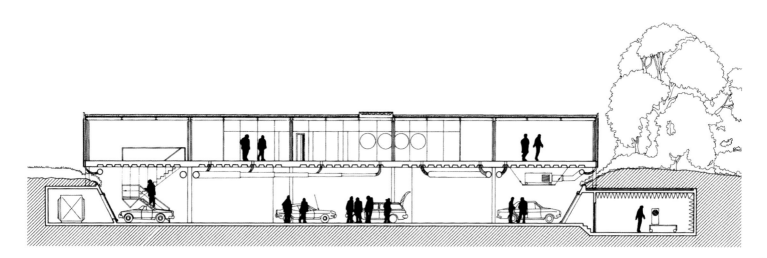

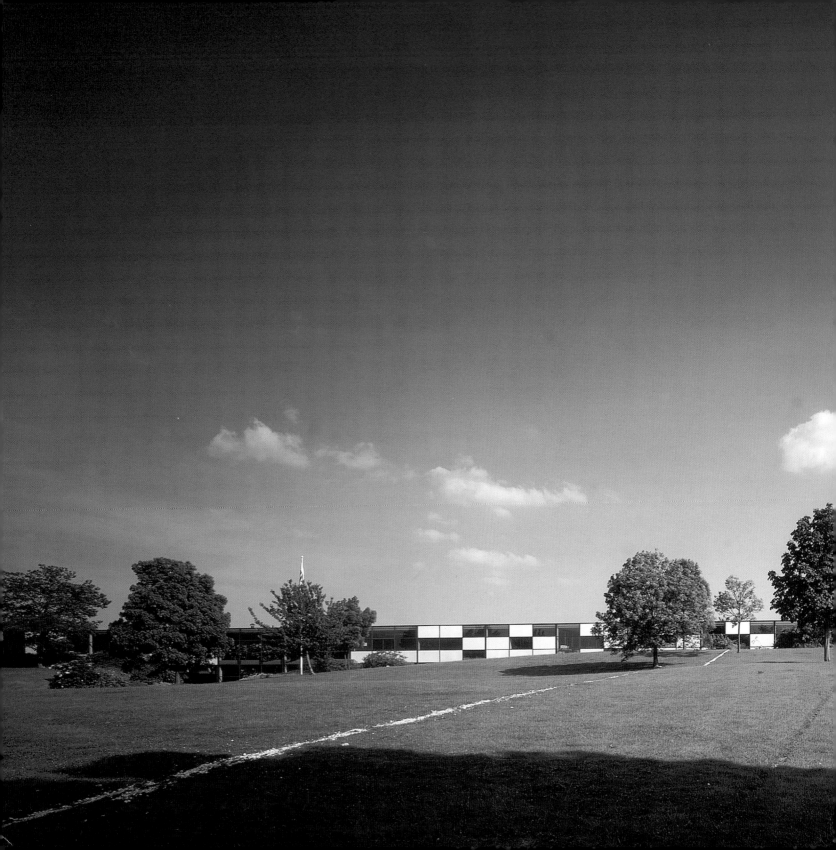

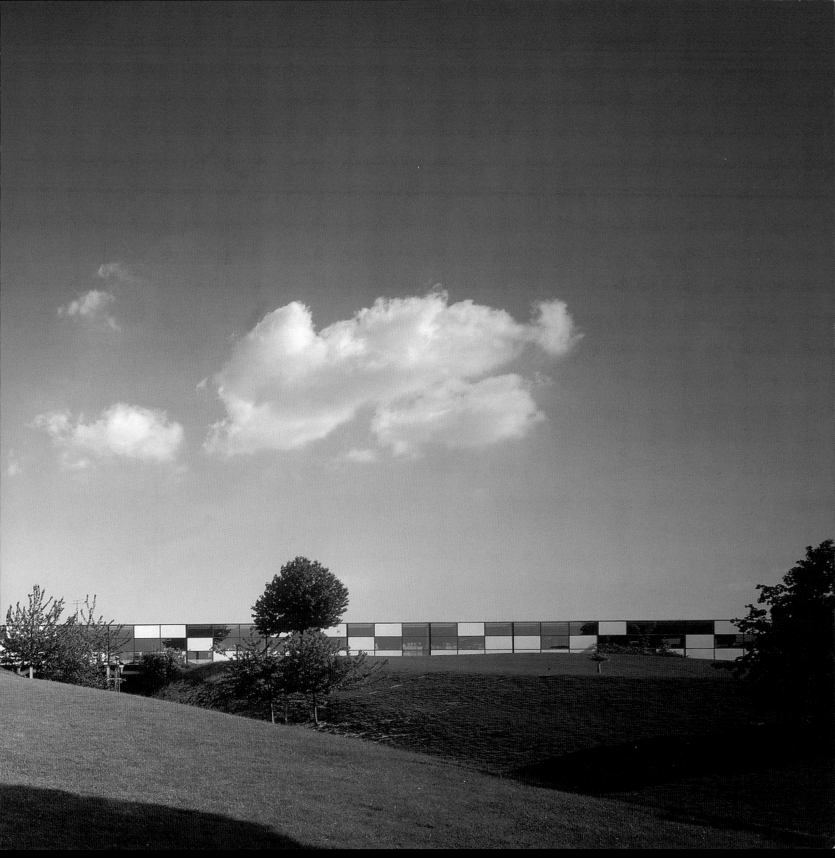

Above: The double-height
reception area. Right:
Exploded axonometric of the
construction elements. Below:
First floor plan. Opposite:
Roof lights and large panels of
glazing illuminate the interior.

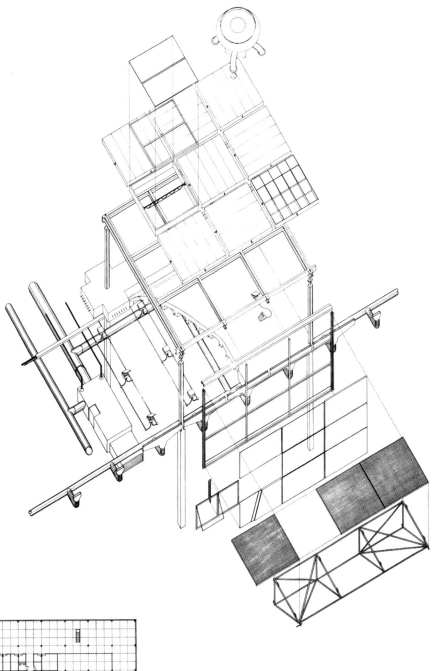

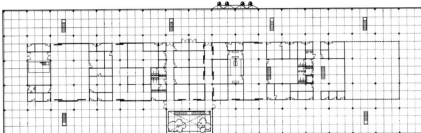

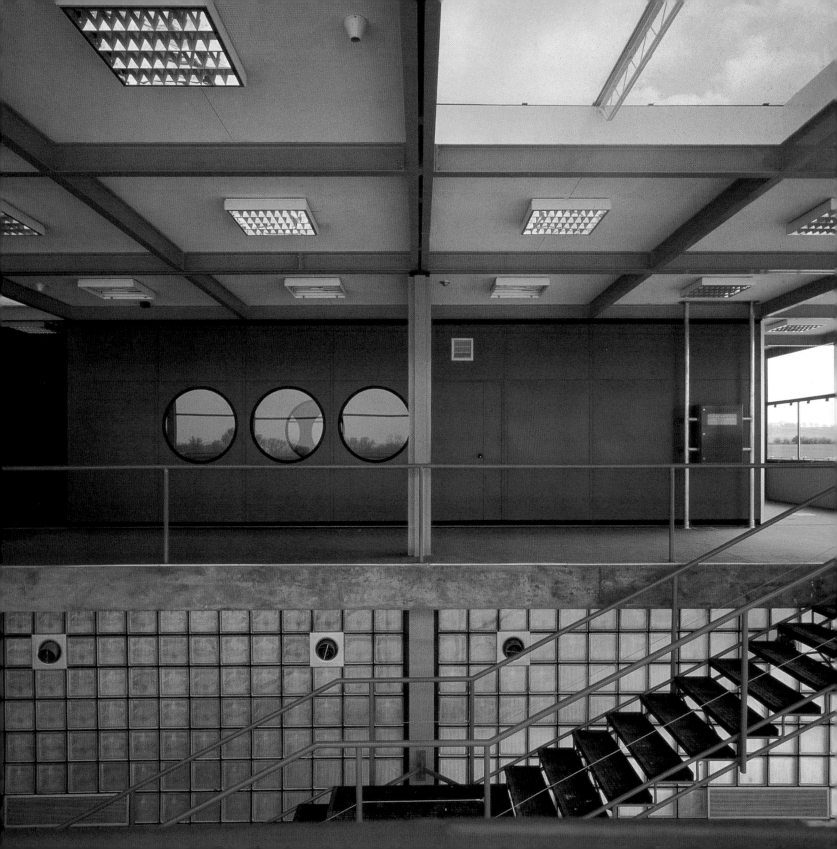

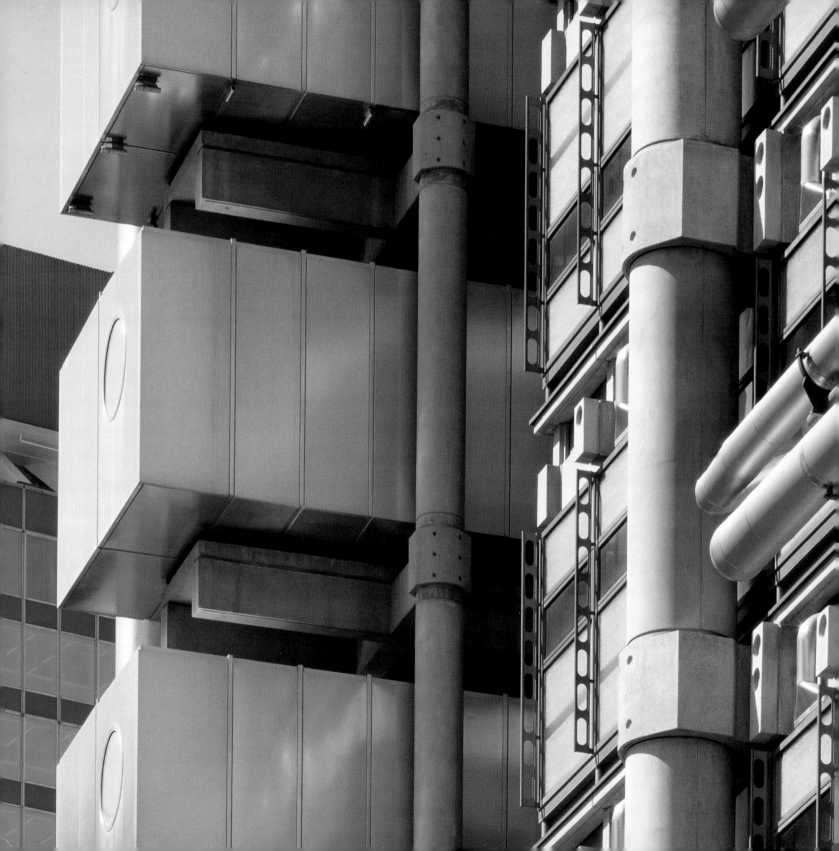

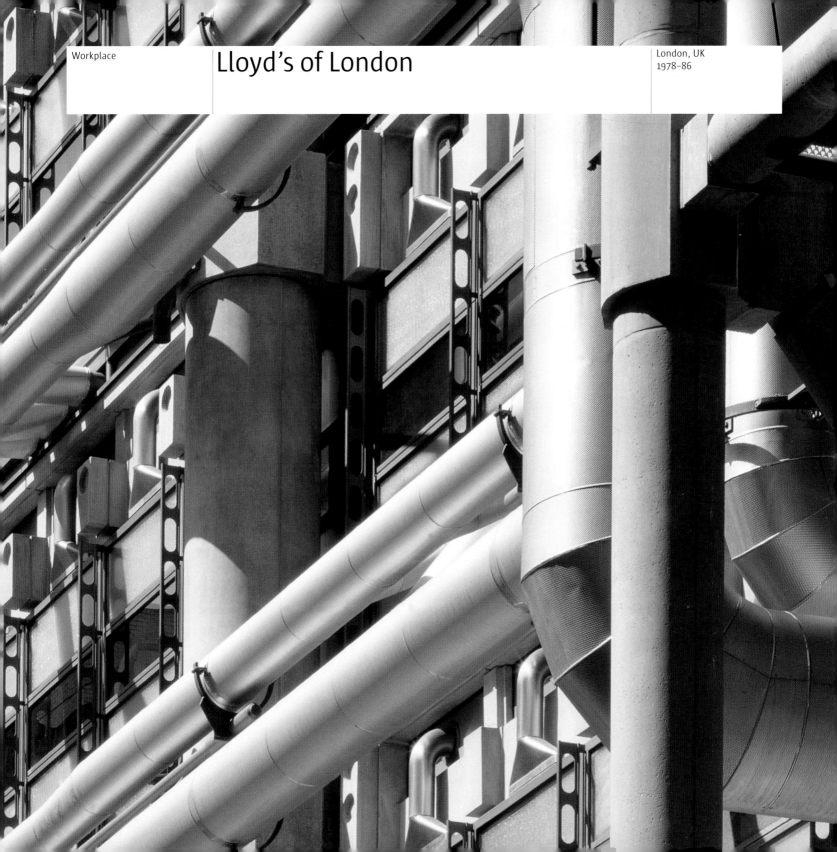

Lloyd's of London

"Turning the plan inside out by placing service cores outside the main envelope offers two principal benefits – freeing the building of all internal obstructions, and making lifts and servicing systems more accessible for maintenance and future upgrades without disturbance to the occupants." John Young

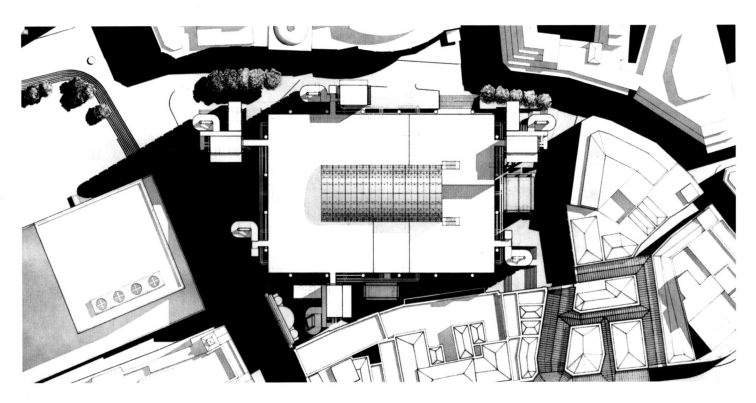

Lloyd's of London is the world's greatest insurance market – a true market where insurance, rather than tangible goods, is traded. The competition for a new Lloyd's was won on the basis not of an architectural proposal but of a convincing strategy for the future of this key City institution.

Lloyd's had moved the 'Room' – the centre of dealing operations – twice in 50 years and wanted a building which would provide for its needs well into the next century. It was also imperative that the members of Lloyd's could continue their operations unhindered during the rebuilding operation, which almost inevitably, involved the demolition and replacement of the existing 1928 building.

RRP proposed a building where the Room could expand (or contract), according to the needs of the market, by means of a series of galleries around a central space, with escalators and lifts providing easy access between floors. To maximise the usable space in the building, the practice banished the services to the perimeter. Servicing includes a high degree of air-conditioning reflecting the large population, intensive use of computers and the need to exclude noise.

Initially, it was proposed to construct Lloyd's, like the Centre Pompidou, in a steel frame but fire safety requirements made this impossible and concrete was used. The building was extensively clad in stainless steel. As the architectural form of the building

Previous Pages: Detail view of the facade with expressed services and structure. Opposite: Site plan showing the constrained site. Below: Diagram of the development illustrating the strategic communications and environmental systems. Right: The services towers located at the corners of the building give the building a highly articulated presence.

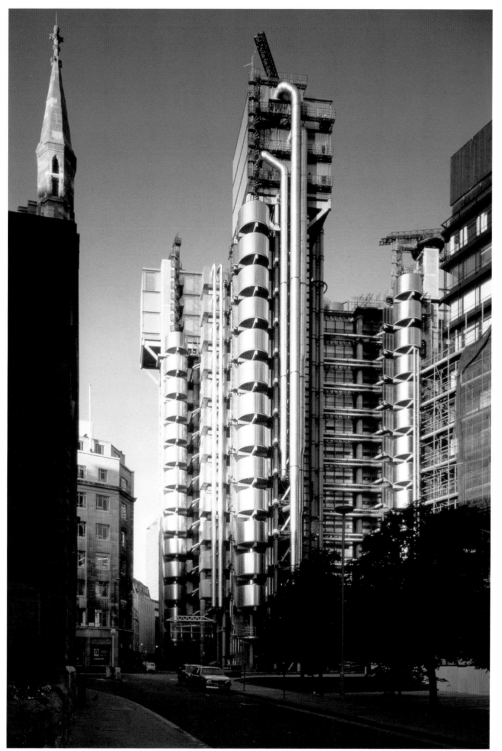

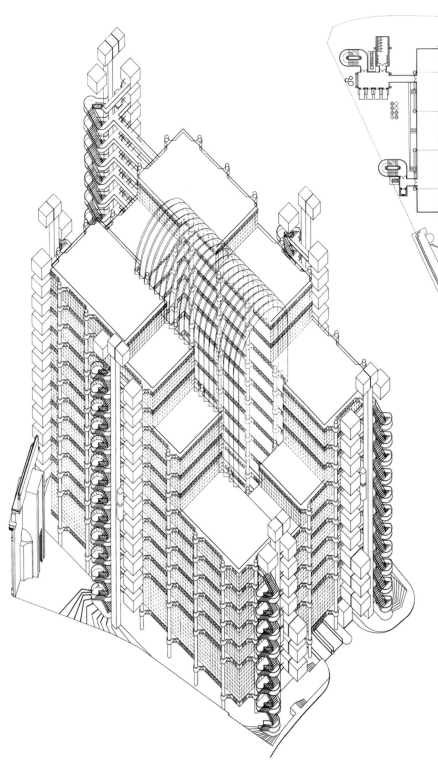

evolved, particular attention was paid to its impact on the surrounding area and especially on the listed 19th-century Leadenhall Market, a structure which Rogers held in high regard. Instead of the great rectangle of Pompidou, Lloyd's became a complex grouping of towers, almost Gothic in feeling – an effect further enhanced when the upgrading of services meant the growth of the plant-room towers.

Lloyd's brought together the inspirations which had underlain RRP's architecture from the beginning. The plan was derived from Frank Lloyd Wright's Larkin Building, via Louis Kahn, while the look of the building was Futurist. The internal atrium, staggering in its scale and verticality, owed something to Paxton's Crystal Palace, a lost monument Rogers had venerated as one of the first modern buildings. The use of opaque glass, producing a subdued light, harked back to Pierre Chareau's Maison de Verre in Paris, which Rogers had discovered while a student. The accretive, ad hoc quality of the building was obviously prefigured in Pompidou but is even more determined and uncompromising at Lloyd's – what had been a visionary dream in the 1960s had come to reality, and at the heart of the supposedly reactionary City of London.

Opposite Left: Axonometric view. Opposite Right: Typical upper level floor plan. Right: Elevational view of one of the service towers. Far Right: The building rises above the surrounding context of lower buildings and narrow streets. Below: Service tower floor plan.

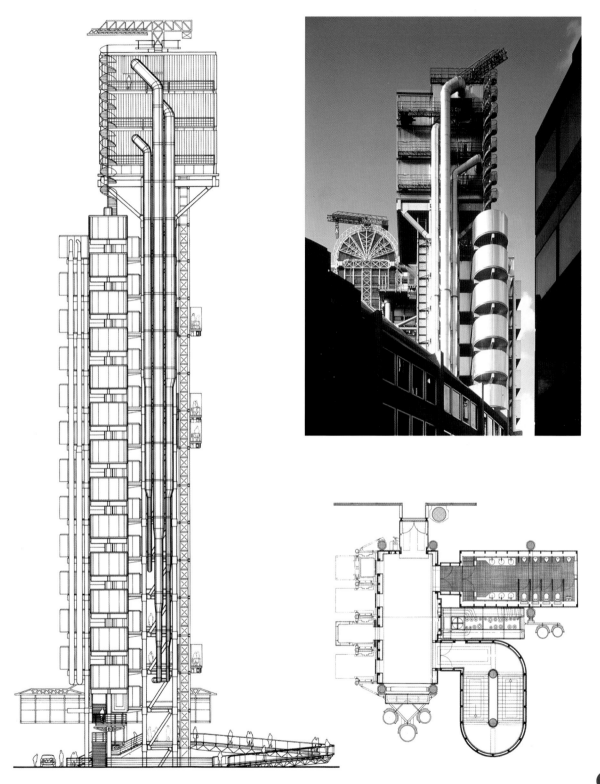

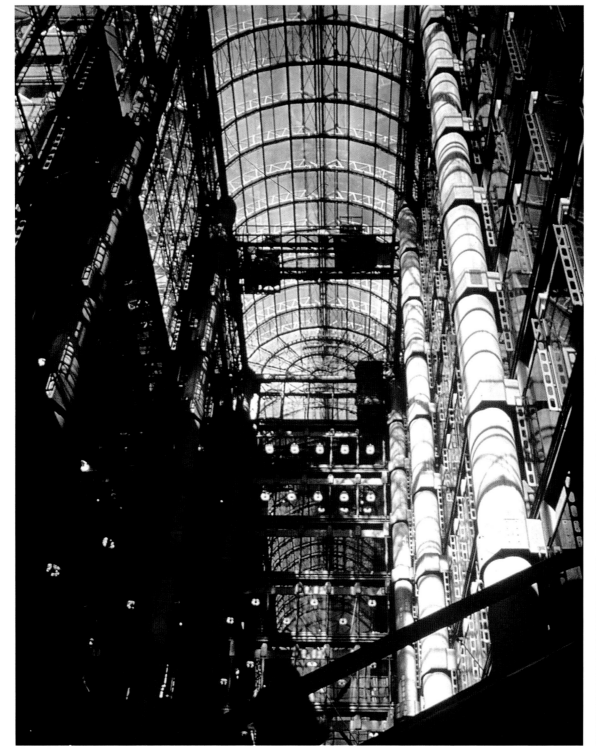

Left: Internal view of the full-height atrium. Below: View of escalators providing vertical connection within the atrium. Bottom: External view of the barrel-vaulted atrium. Opposite: Section through the atrium.

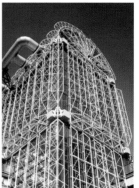

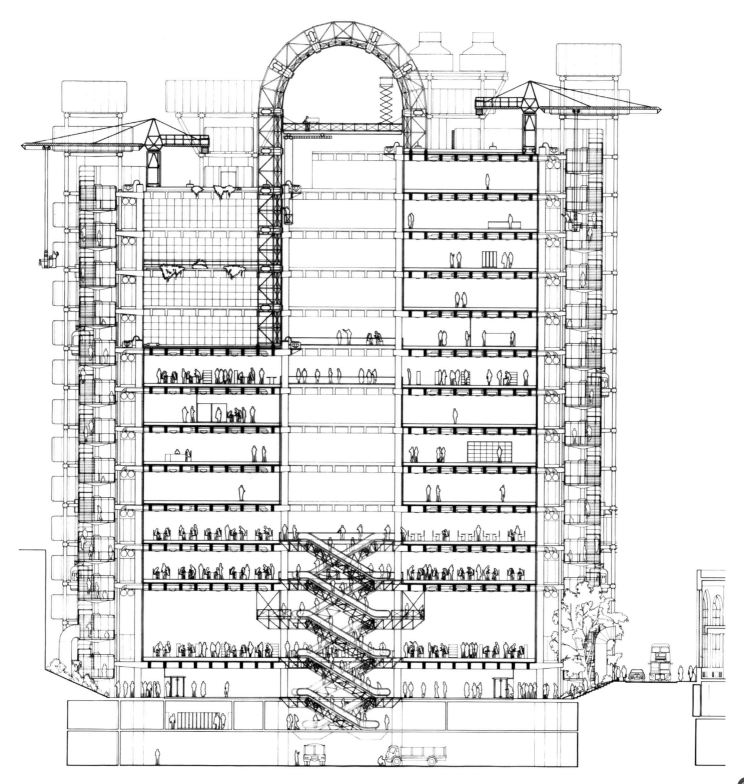

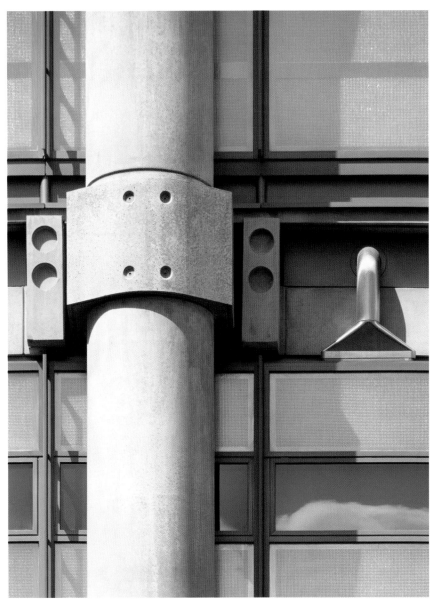

Far Left and Below: Details of the concrete structure. Left: The aluminium-framed modular glass panels were made by passing molten glass through dimpled steel rollers to create a texture that both reflects and refracts light.

A failure of nerve on the part of Lloyd's management led to some compromises in the internal fit-out – the Lloyd's chairman now presides from a pseudo-Georgian office – but the 'boxes' where the insurance business is conducted are a happy reworking of the traditional arrangement. A further compromise reduced the degree of public space in the project – public lobbies of the Manhattan sort are alien to British traditions.

Lloyd's is one of the great architectural achievements of the 1980s, one of the buildings which confirmed Rogers' position in the front rank of British (and indeed international) architects. By the time of its completion, Post Modernism and Classicism were growing influences on the architectural scene in Britain and radical designs were suppressed, not least in the City. Yet Lloyd's has weathered a long period of design and construction to emerge as one of the greatest modern British buildings, one which balances technical efficiency with architectural expressiveness to produce an effect which must be called highly romantic and judged a very positive addition to the London skyline. Lloyd's has recast the image of modern architecture in Britain.

Right and Below Right: The pre-fabricated steel toilet capsules were craned into position. This accelerated construction and ensured a high degree of finish.
Far Right: Night view from Commercial Union Plaza – the dramatic lighting scheme was designed by Gary Withers and his team at Imagination.

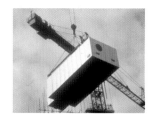

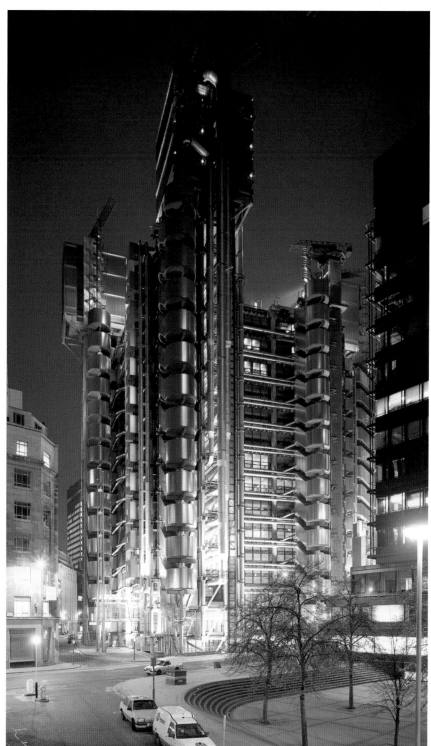

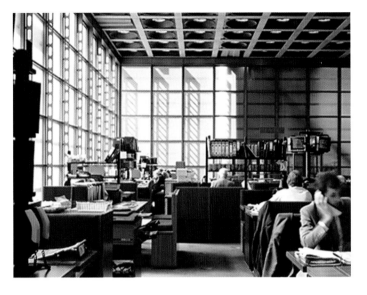

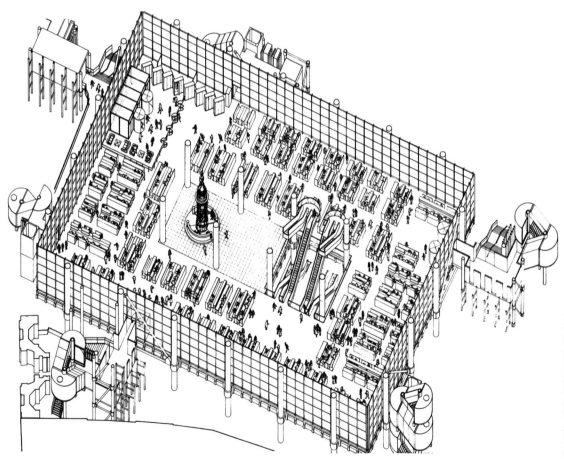

Above Left: Floor plan showing the generous area allocated to 'The Room' (yellow) and the service/circulation towers (blue) arranged around the perimeter of the building. Above Right: RRP also designed all the furniture for Lloyd's. Left: Cutaway axonometric view of 'The Room'. Opposite: A bank of escalators animates the atrium.

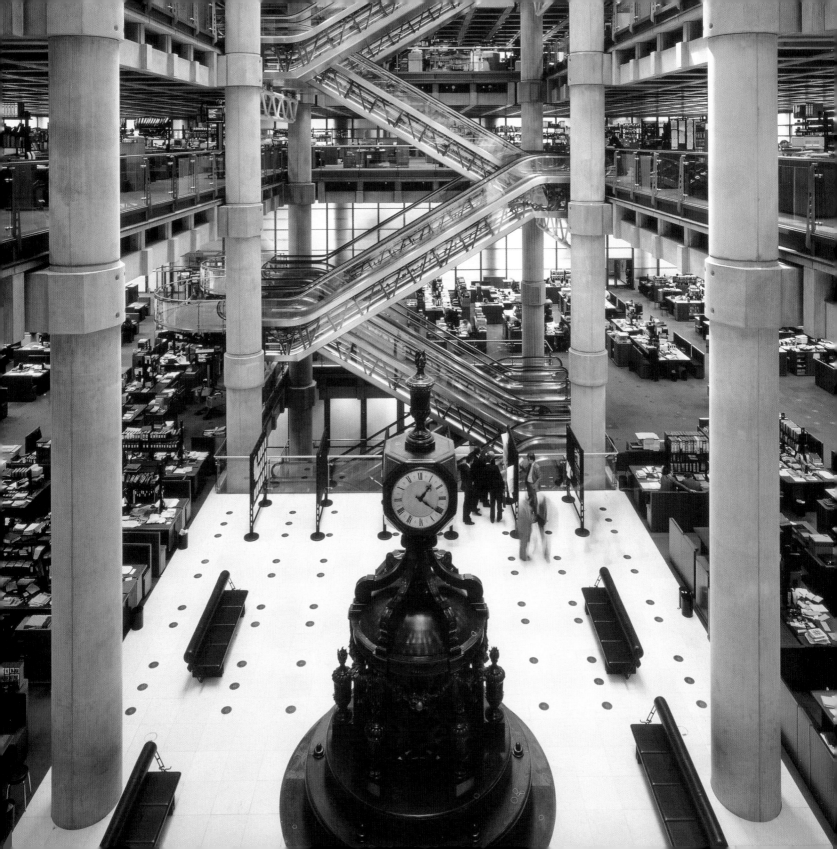

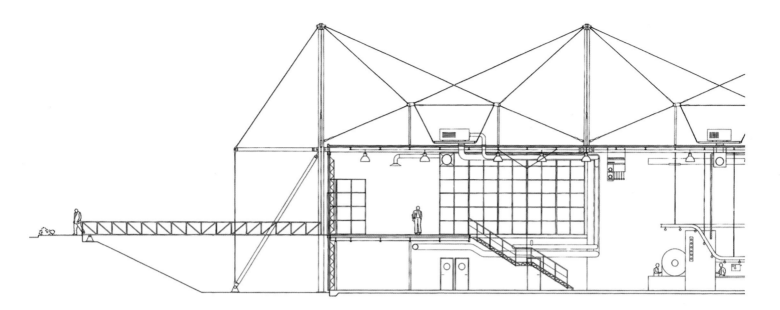

Fleetguard Manufacturing and Distribution Centre

Quimper, France
1979–81

"The tension structure, using 15 percent less steel than a conventional design, gives the building a legible, spare and dynamic expression which grows from the basic and key principle of least effort for maximum return." John Young

Opposite: The red-painted structural masts. Above: Section through the mezzanine office level and warehouse below with the double-height production space.

With this project the practice demonstrated yet again that it could lead industrial architecture in new directions, producing a building which is as visually stunning as it is functionally advanced.

The brief was for the provision of a production facility for engine filters, along with warehousing and office space – 8,750 square metres in total with expansion potential for a further 30,000 square metres. Adaptability and expandability were key issues, but the site was also sensitive, close to the historic town of Quimper and the coast and in full view of a main road. There was some pressure to keep the building light and as unobtrusive as possible.

Working with the engineer Peter Rice, RRP evolved a masted roof structure which diminished the (real and apparent) bulk and weight of the building, produced economies in construction and created a stunning skyline. Slender steel columns, stayed with cables, were the key element, while the absence of a conventional roof frame allowed the roof area inside the building to be used as the location of main services distribution. Bands of glazing are elegantly introduced into the cladding to provide a high degree of natural light inside.

Internal arrangements, while providing for a division between production and office space, are in the democratic spirit pioneered at Reliance Controls fifteen years earlier. Fleetguard was to greatly influence other architects and provided the basis for another masterpiece, the INMOS factory.

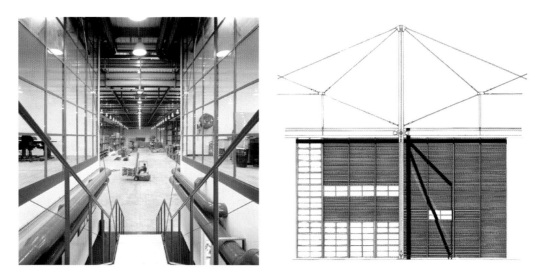

Above Left: The office overlooks the production space. Above Right: Elevation. Right: Detail model of the suspended roof.

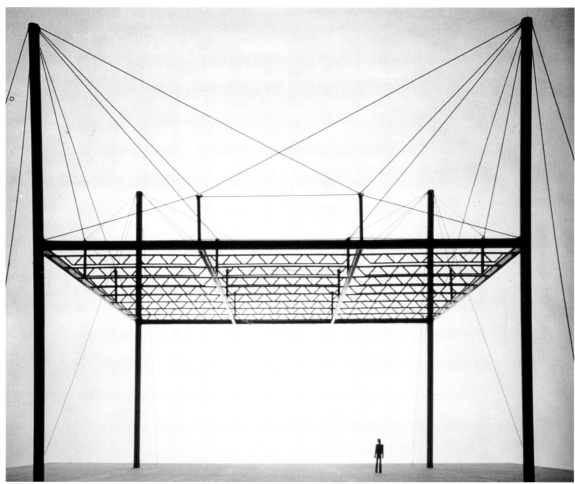

Below: Sectional details of the
steel structure. Bottom: Detail
view of the structure. Right:
The rhythm of the red-painted
structure animates the simple
rectilinear form beneath.

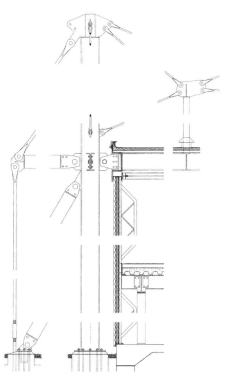

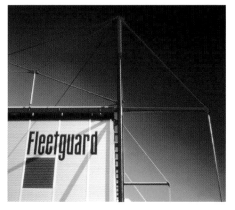

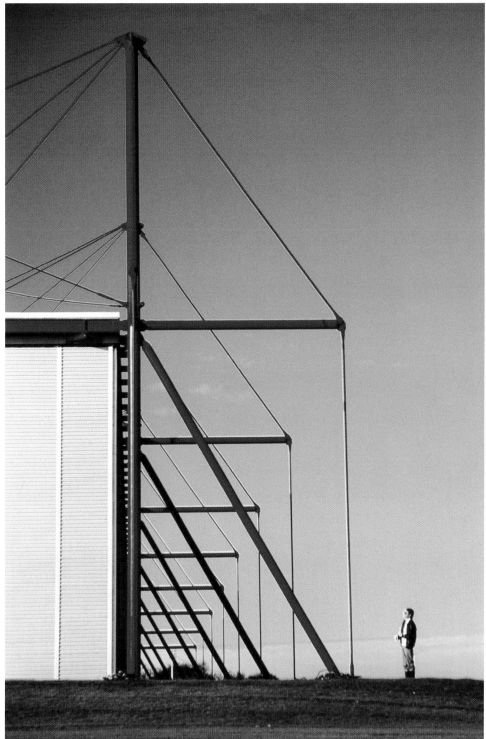

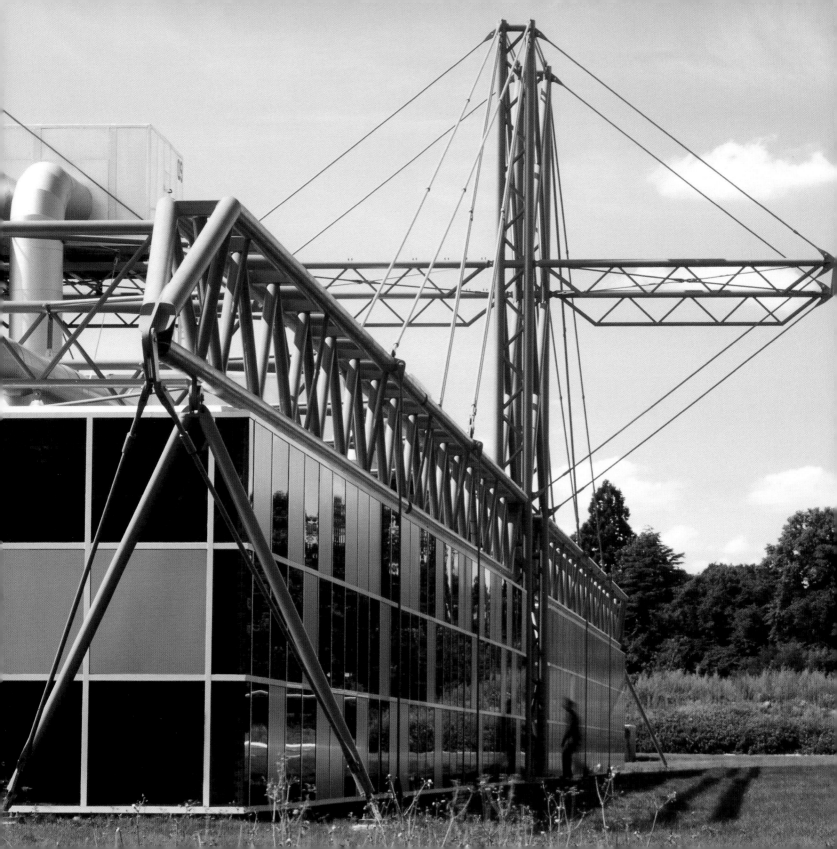

INMOS Microprocessor Factory

"The concept drivers for INMOS were, as for the Centre Pompidou, large, column-free, flexible and universally serviced open operational spaces. The heart of the scheme was a strong, central circulation spine and central meeting space for all employees." Mike Davies

Opposite: The steel-masted structure creates a strong presence in the landscape. Right: The structure allows for large areas of column-free space.

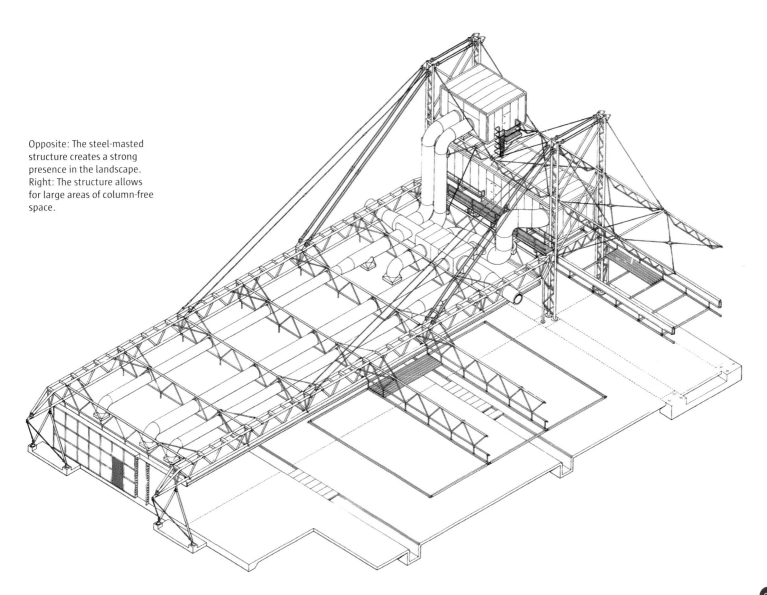

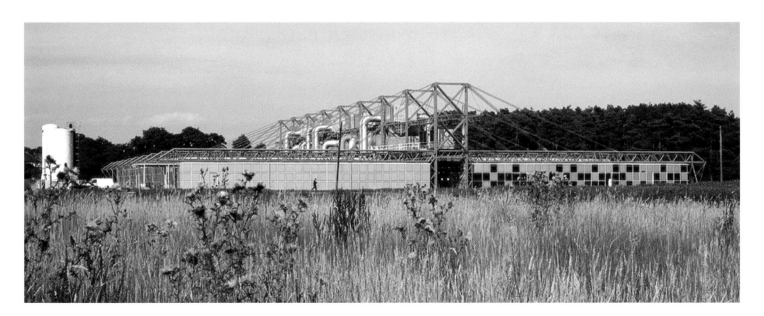

Above: The building sits lightly in its rural landscape. Below: An internal 'street' joins the two halves of the building, with services disposed along the central spine. Opposite: View of the banks of service machinery located above the central spine of the building, buttressed by the roof masts.

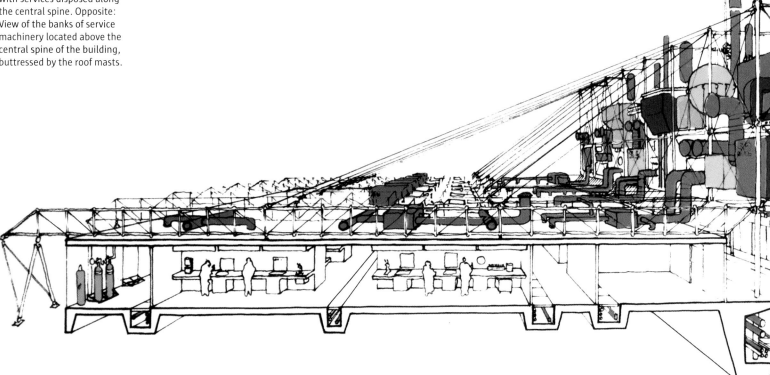

While Fleetguard had been designed with the needs of a sensitive site in mind, the INMOS scheme was seen as a model factory, suitable for construction in a wide variety of locations. The technical brief was demanding. Highly controlled conditions were required for the production of electronic microchips, with more conventionally serviced space housing offices, staff canteen and other facilities under the same roof.

The building had to be designed for fast construction (ready for operation within one year of starting on site) – which implied a high degree of off-site fabrication – and great flexibility. The context of the commission was a government-backed drive to expand the British microchip industry: the need was for specialised production space, to be available at the earliest possible opportunity.

RRP responded by producing a scheme which not only met the brief fully but was architecturally striking. The resulting building has great external presence and a strong sense of identity inside for those who work there.

The scheme is divided into 'clean' areas (that is, for microchip production) and 'dirty' (normally serviced ancillary) areas along a central promenade (or 'street') of more than 100 metres. Surmounted by banks of serving machinery above the spine and buttressed by the main roof masts, the building has a strong vertical emphasis.

Logical, efficient, flexible and durable, and in its expressive use of services as sculpture, INMOS has something of the poetic quality of Pompidou and Lloyd's.

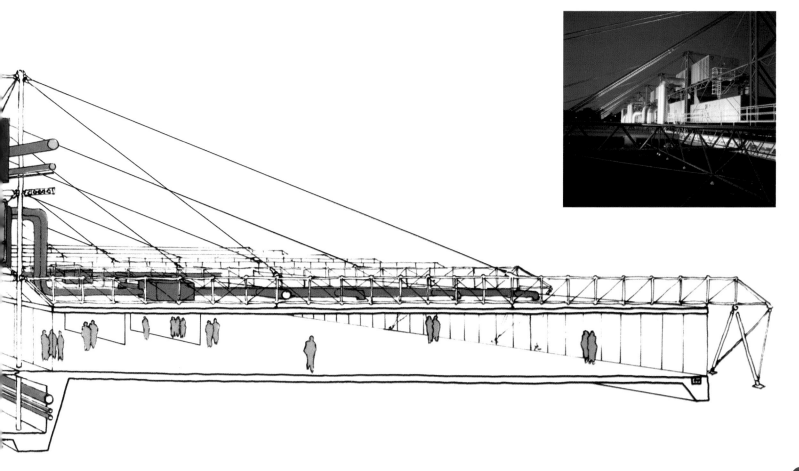

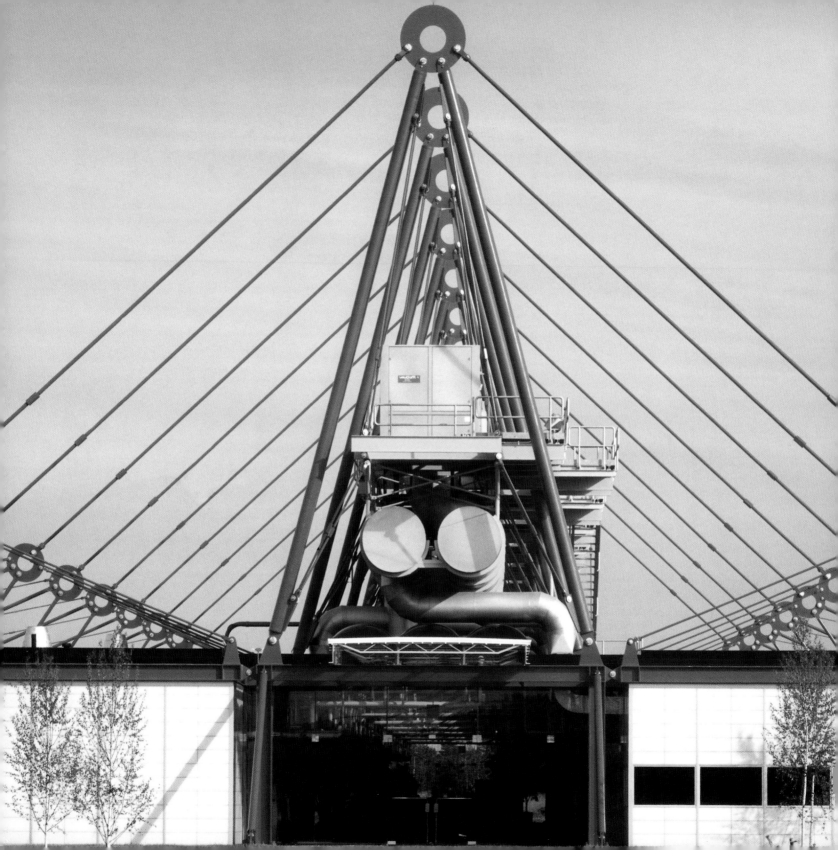

PA Technology Laboratory

"The superstructure, the central spine, the circulation and social space for all occupants together created absolute clarity of both means and function." Mike Davies

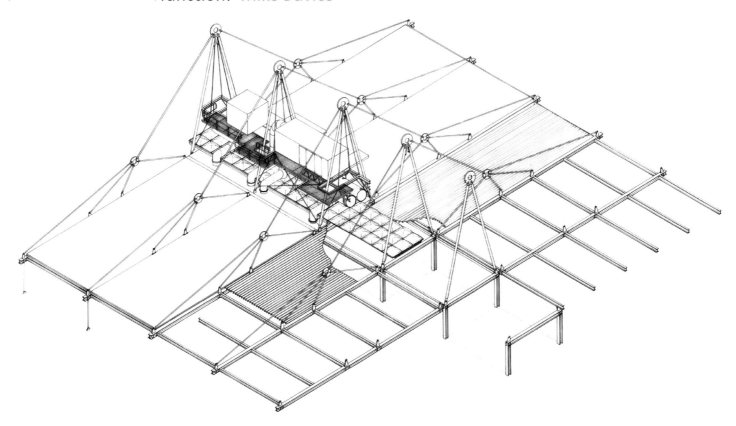

Opposite: Service ducts, plant and access gantries are exposed within the triangular space defined by the open-masted structure. Above: Axonometric illustrating the central spine and open-plan, column-free working space on either side.

PA Technology returned to RRP for their American research base, on a new industrial park close to the university town of Princeton. The assisted-span tension structure derived from the similar solutions used at Fleetguard and the INMOS factory and the plan closely resembles that of INMOS, with a central spine/arcade on an A-frame which provided circulation, staff restaurant and other services and is flanked by the working spaces, in this case laboratories and offices.

While INMOS had required a very high degree of servicing, PA Technology Princeton produced a less-

demanding servicing requirement – the exposed structure, while entirely functional, is equally symbolic and expressive of the image of the company. (The client had specifically demanded a scheme which reflected PA's innovative approach.) Ducting and air-conditioning plant is boldly exposed. Services are equally frankly expressed inside the building.

The building was designed for pre-fabrication off-site and rapid erection. The cladding is carefully considered to provide diffused light through translucent panels, with a strip of clear glass offering views out. In theory,

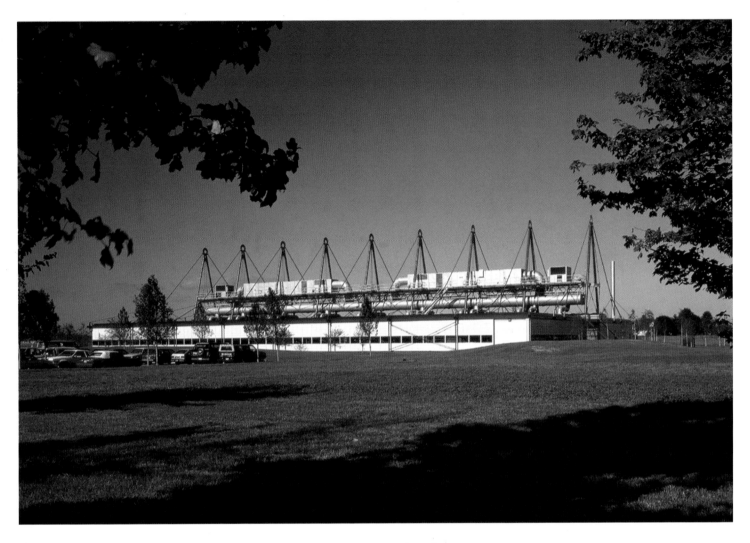

Above: The compact arrangement of services and the bright red structure create a striking landmark. Right: The luminous quality of the interior, lit by the translucent cladding. Opposite: The horizontality of the main elements of the building is offset by the verticality of the red masts.

this is a 'kit-of-parts' building which could be replicated. In practice, it is a well-crafted custom-made landmark, like the Centre Pompidou or Lloyd's. RRP's long line of industrial research building expresses the tension between mass production and expressive individuality which is at the core of the practice's work.

Like its precedent INMOS, the desire was for internal spaces free of columns with scope for rearrangement and expansion. In addition, the use of translucent cladding provided a remarkable quality of daylight, while at night the building glows gently.

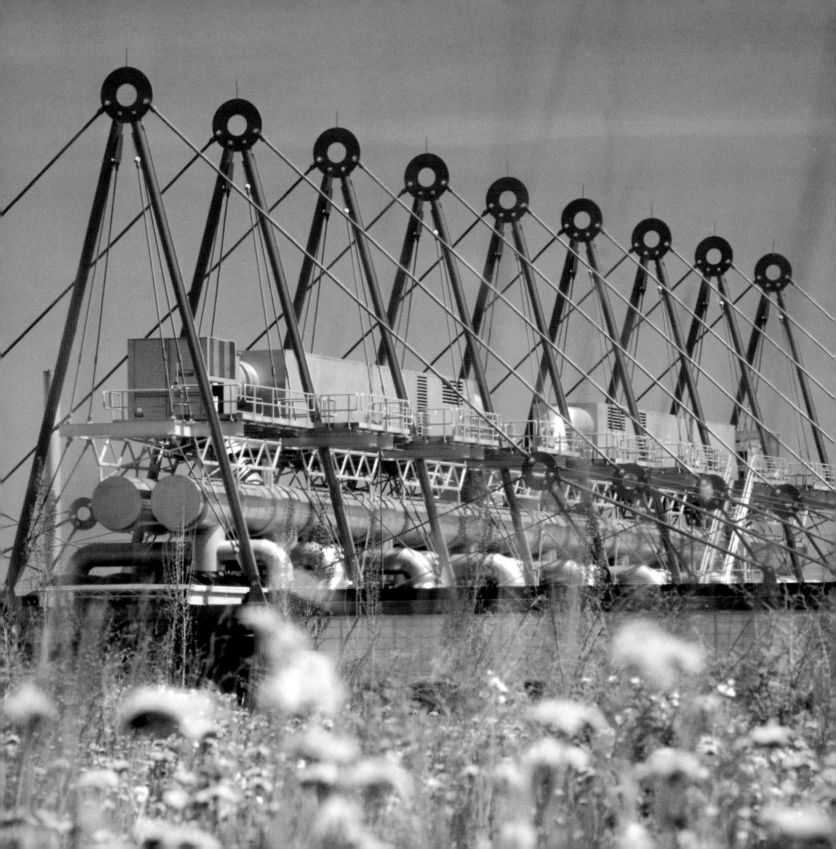

Thames Wharf Studios

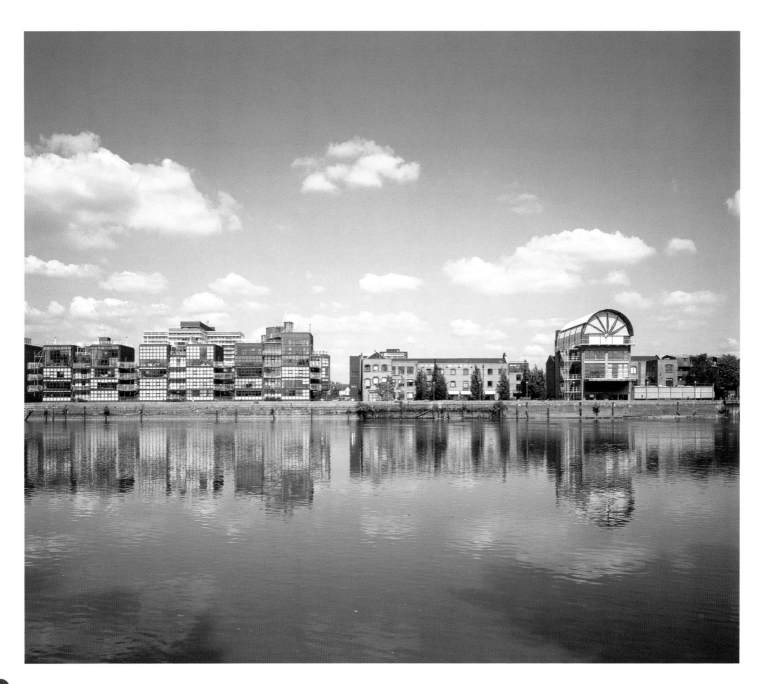

"The conversion of the warehouses is unfussy and economical, with existing features retained wherever possible and new elements designed to a frankly industrial aesthetic and painted in primary colours. The development has been a positive influence on what was an unprepossessing area of London." John Young

Opposite: The early 20th-century brick warehouses flank a 1950s building now housing the architectural practice; to the left is the Thames Wharf housing scheme designed by RRP. Above Left: Interior of the barrel-vaulted, glazed roof extension. Above Right: The restaurant dining space spills out into the central garden.

The relocation of the RRP offices at Thames Wharf, Hammersmith, in west London, was significant in several ways – as a gesture towards the regeneration of London's riverside and as evidence of the practice's commitment to the re-use of worthwhile old buildings. The site was a redundant industrial complex, containing some good early 20th-century warehouses but cluttered with oil tanks and other temporary structures and completely inaccessible to the public.

The strategy was to divide the site between a new-build residential scheme and a development of offices, studios and light-industrial space housed in the existing warehouses, one block of which was earmarked as office space for the practice. The garden courtyard forms the centrepiece of the scheme – an attractive public space linked to a riverside walkway. The River Café, run by

Rogers' wife Ruth and her partner Rose Gray, enjoys views across the garden to the river beyond.

The building occupied by the practice dates from the 1950s – it has been extended upwards with a spectacular lightweight rooftop structure designed by the practice in association with architects Lifschutz Davidson. A double-height entrance lobby is the other key intervention, creating an informal gallery for key architectural models. A recent addition has been a new mezzanine kitchen above the reception area – providing home-made lunches for the RRP staff and popular as an informal meeting place throughout the day.

"Our brief was to deliver a contemporary transformation of the old fish market. This required a radical intervention that still managed to remain sensitive to the original fabric." Richard Rogers

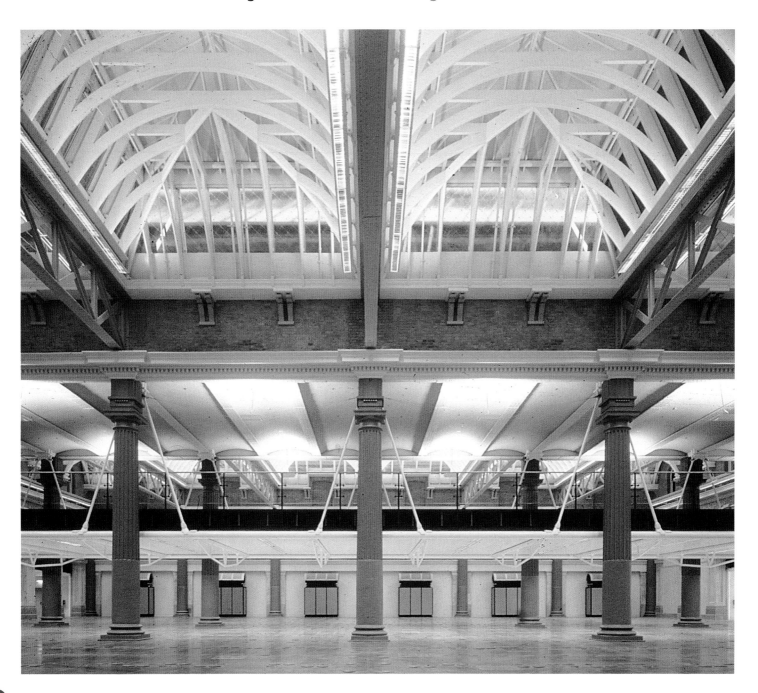

Billingsgate Market

Opposite: Crisply detailed glass and steel elements add a new dynamic to the original structure. Below: The elegant Victorian structure fronts directly onto the river.

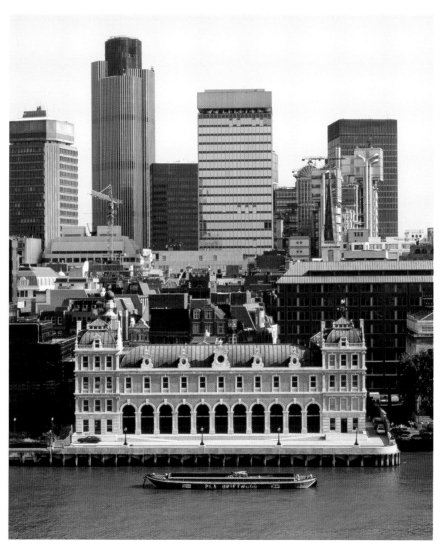

Having completed Lloyd's, Rogers found that attitudes in the City of London had changed, with a strong emphasis on conservation and a predilection on the part of the planners for 'contextual' – often Post-Modernist – designs where new buildings were concerned. Rogers, however, strongly favoured the retention of historic buildings of quality and agreed to advise the conservation group SAVE on its campaign to preserve the redundant Billingsgate fish market, owned by the City (which proposed to demolish it for redevelopment).

In the event, the market was retained and acquired by a major bank for conversion as a financial-services building. The client sought a large area of open dealing floor space – to which the Victorian structure was ideally suited. Externally, the aim was to restore lost details and to clean and repair but to add nothing new. Inside, some changes were needed, chiefly to open up and use the huge basement vaults (which entirely lacked natural light). The main floor of the market was, however, uncompromised by the addition of the new galleries, lightweight and structurally independent of the existing building. One of the most striking internal spaces is the former 'haddock gallery', which was left intact and converted to office use. Close attention was paid to detailing to ensure an immaculate junction between old and new. Rogers commented on the scheme: 'we sought harmony of modern with old in a single building'. Sited quite close to Lloyd's, Billingsgate has come to epitomize Rogers' views on urbanism.

Many old market buildings have been converted to new use, but few so successfully as this. This is an immaculate blend of old and new and the conversion has highlighted the quality of the original building.

K2, St Katharine Dock

The commission for K2 dates back to 1987, just after the completion of Lloyd's of London. The project demonstrates the practice's ability to draw on the lessons of Lloyd's, adapting them to the requirement of the commercial market. As with any RRP building, however, response to the client brief (for 24,000 square metres of offices) was balanced by a clear concern for the urban and public implications of the scheme, given its position adjacent to the Tower of London and Tower Bridge.

St Katharine Dock was constructed in 1825–28 to the designs of the great engineer Thomas Telford.

Though recognised as classics of the 'functional tradition', the great warehouses, opening directly on to the dock wharves, suffered from neglect and random demolition following wartime damage, so that only one remained completely intact. The building which RRP was commissioned to replace dated from 1964 (itself replacing the dock offices destroyed by German bombs) and was judged inadequate both as a modern workplace and as a marker for this key corner site on the approach to Tower Bridge.

Since 1987, the project has undergone a number of permutations, with current planning consent granted

> "The basic idea is a landmark building that, while providing an outstanding working environment, will open up to the streets and offer legibility and transparency." Mark Darbon

Opposite: The principal west-facing facade overlooking the Tower gardens. Far Left: Occupants will enjoy impressive views over the docks. Left: Detail view of a stair tower during construction. Below: Site plan.

in 1999. The design has responded to the changes demanded by market conditions and the developments in building technology. The scheme features a giant 'window' facing west to the Tower of London. This all-glass facade reveals the activities within, and is animated by the constantly moving lifts and escalators. A prominent tower marks the gateway to St Katharine Dock and Tower Bridge. The long north and south elevations of the building are strongly articulated to create a sense of depth and layering – on the south (dock) side extensive use of solar shading gives it an appropriately solid look.

The new scheme reinforces the lower-level public realm, linking public access from Tower Hill tube station to St Katharine Dock. A new recessed colonnade encourages public movement past the building and on into the new development, enlivening the public space around the docks. A new public piazza with retail areas and cafés looks out over the dock basin itself.

Reuters Data Centre

"The design evolved as a series of 'layers' in elevation – lower level plant rooms, opaque technical levels, glazed office levels and roof-based plant in an open grillage – but with the ability to reconfigure the indeterminate number of office and technical levels through the development of a highly flexible cladding system." John Young

Top: Ground floor plan. Right: The low recreation block and data processing tower lie parallel to the old dock. Opposite Left: The facade is composed of an interchangeable system of solid and glazed cladding panels. Opposite Right: Covered circulation zones link the various elements of the building. Opposite Below: Concept sketch illustrating the main plant concentrated on the roof.

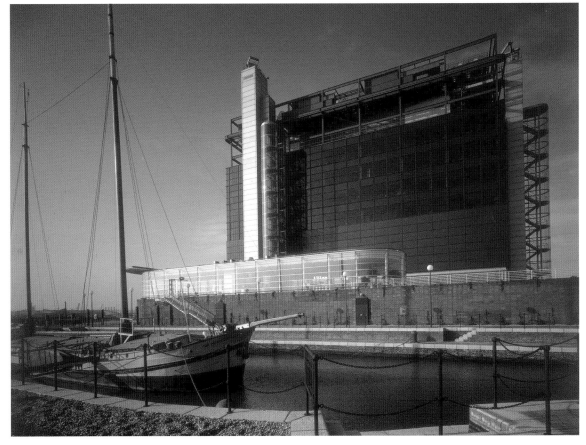

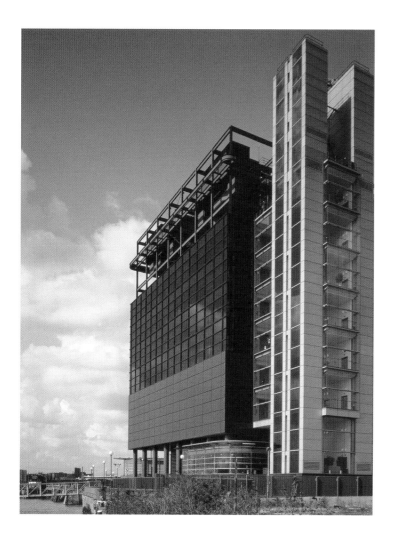
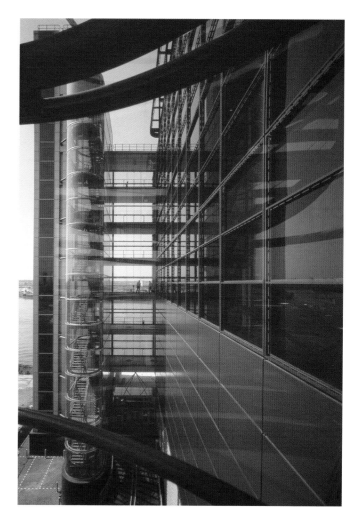

This 28,000 square metre building was intended as the first phase of a speculative office scheme set around a restored 19th-century graving dock near the Isle of Dogs. In the event, the other three phases of the development were not built. Phase 1 was pre-let as a 'shell-and-core' building to the news agency Reuters, for use as a secure data centre. RRP was also commissioned to design a separate restaurant/recreation block close to the old dockside.

The building is used for processing data and a high degree of artificial servicing was required. The internal space is divided between offices and plant rooms full of computers. Scope for rearranging the spaces and bringing in heavy machinery had to be built into the scheme. An interchangeable cladding system of solid and glazed panels reflects the flexibility of the interior. As usual in RRP buildings, lifts and staircases are concentrated in perimeter towers. Main plant is placed at roof level and services distributed downwards through internal cores. Cranes are made into features and colour used to denote the various functions. Though essentially a 'functional' building – rigorous, economical and rational – constructed to a strict time schedule, Reuters incorporates clear references back to the romantic modern style of Eric Mendelsohn – the restaurant block recalls his Bexhill Pavilion – and Frank Lloyd Wright.

Iikura Building

"This scheme, with its emphasis on transparency, was the antithesis of its neighbour – a fortress-like black structure almost devoid of windows. The contrast would have been striking." Laurie Abbott

The Ikura building was intended as the Tokyo headquarters for Rover UK – one of several schemes designed by RRP for the K-One Corporation. RRP's proposal was a sleek, highly engineered building communicating the quality of the tenant's products. Less deliberately expressive than the practice's large buildings of the 1980s, Iikura was nonetheless designed to meet specific technical challenges. The exposed steel frame is designed to withstand the effects of earthquakes – the bracing allows for very slender columns, increasing the perceived elegance of the scheme. The structure uses a special fire-resisting steel with welded, forged connections, produced in Japan, and would have been the first exposed steel structure in that country.

By concentrating lifts, stairs and main services in a separate tower – a variation on a familiar RRP theme – the building would have fulfilled the client's brief for a high degree of natural lighting throughout the office floors.

Although modest in scale, the scheme is distinctive – escape stairs are made into a striking architectural feature while the car showroom, projecting above pavement level, was intended as a strongly articulated, transparent glass bubble.

Falling property values in Tokyo halted construction – the extensive basement areas were already in place and all the steelwork was about to be transported to site when the project was stopped.

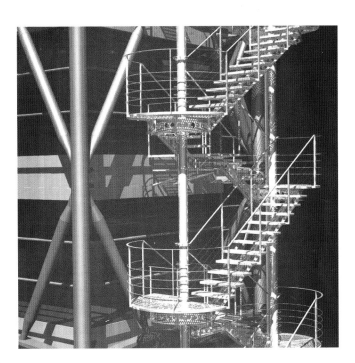

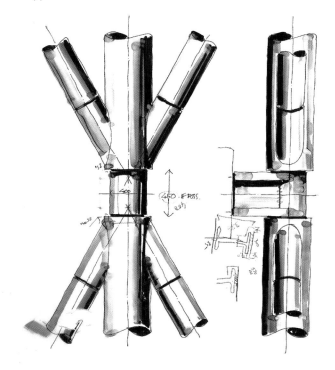

Opposite Left: Detail of the
fire-rated steel structure and
external staircases. Opposite
Right: Sketch details of the
steel structure. Right: The con-
centration of circulation and
services in a separate tower
allows for a high degree of
natural light throughout the
office floors. Below: Typical
floor plan.

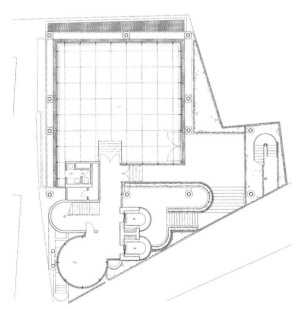

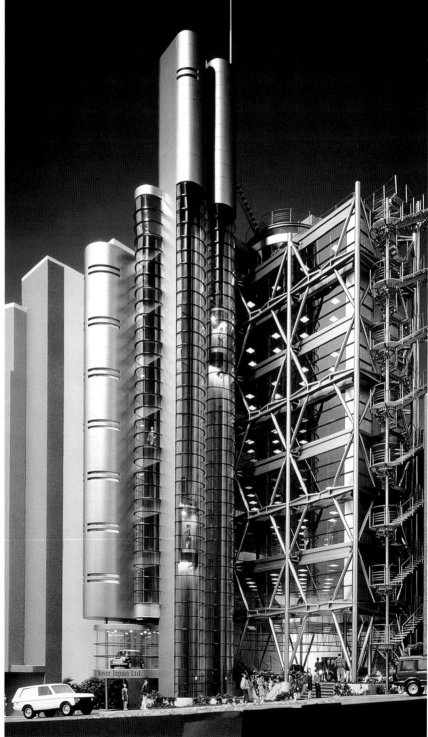

Kabuki-cho Tower

The Kabuki-cho project provides a vivid example of a response to a very specific urban context – an area of small-scale streets close to Shinjuku commercial district. The site was extremely constrained, with daylight a precious commodity in the narrow road onto which the building fronts. Although the building is small in scale, great attention was paid to the detailing of the facade, using repetitive functional elements to define the lightweight language of the building.

The final scheme (after the abandonment of initial plans for a hotel) was a twelve-storey office building (two floors below ground level), its main floors canted out over a void which is infilled with a dramatic glazed roof, lighting a public basement area which contains restaurants and bars. The roof is hung off the main structure. The frame, engineered in line with local fire safety and seismic protection regulations, is a composite structure of steel and concrete. As usual, lift, stairs and other services are concentrated in a strongly modelled tower, which terminates in a viewing platform above a penthouse apartment.

Kabuki-cho demonstrates the influence of early Japanese architecture, with its elegance, translucent light and flexibility. The project is a specific response to the character of Tokyo – far more varied and intimate than is generally imagined. RRP's technology-rooted architecture turns out to be remarkably in tune with traditional Japanese streets.

Below: Staircases are assembled from steel rods and cables supporting perforated steel treads. Right: The highly articulated scheme responds to the scale of its context and to rights-of-light requirements. Far Right: Site plan. Opposite: A filigree of secondary structural components articulates the facade.

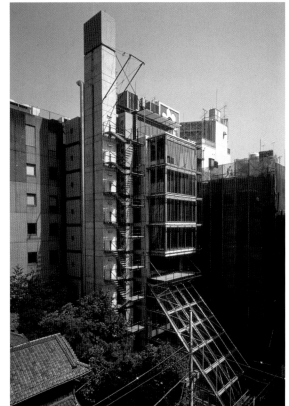

"The building's form was entirely dictated by planning constraints and rights of light – its profile and area conform exactly to the available light cones." Laurie Abbott

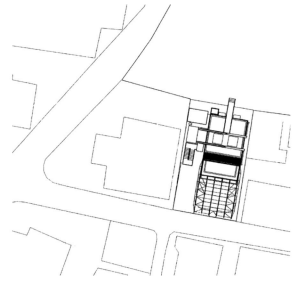

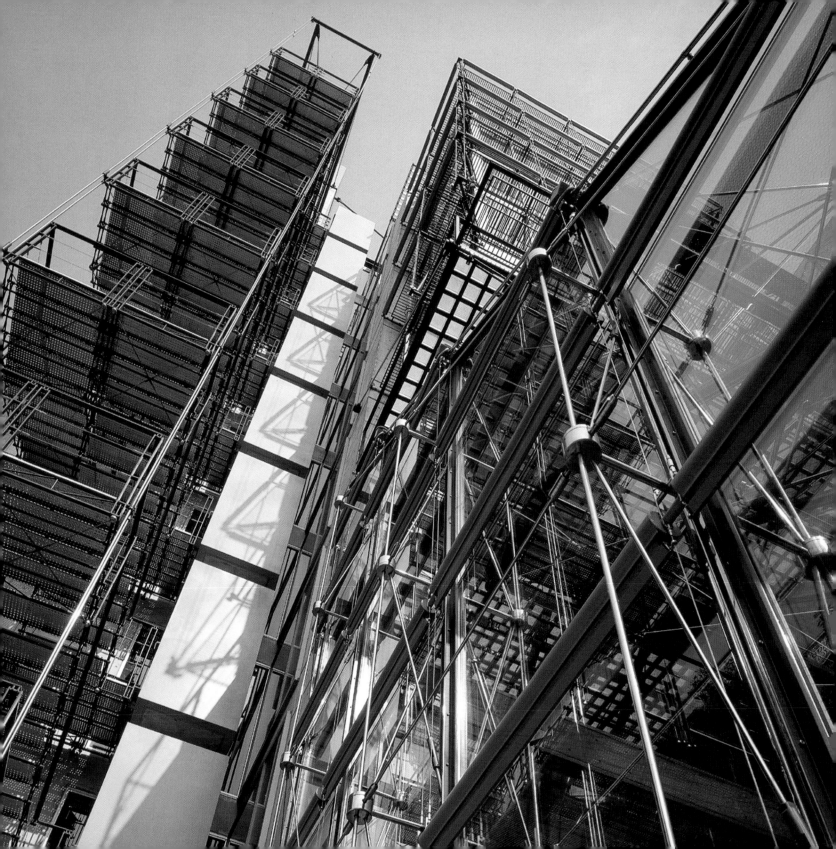

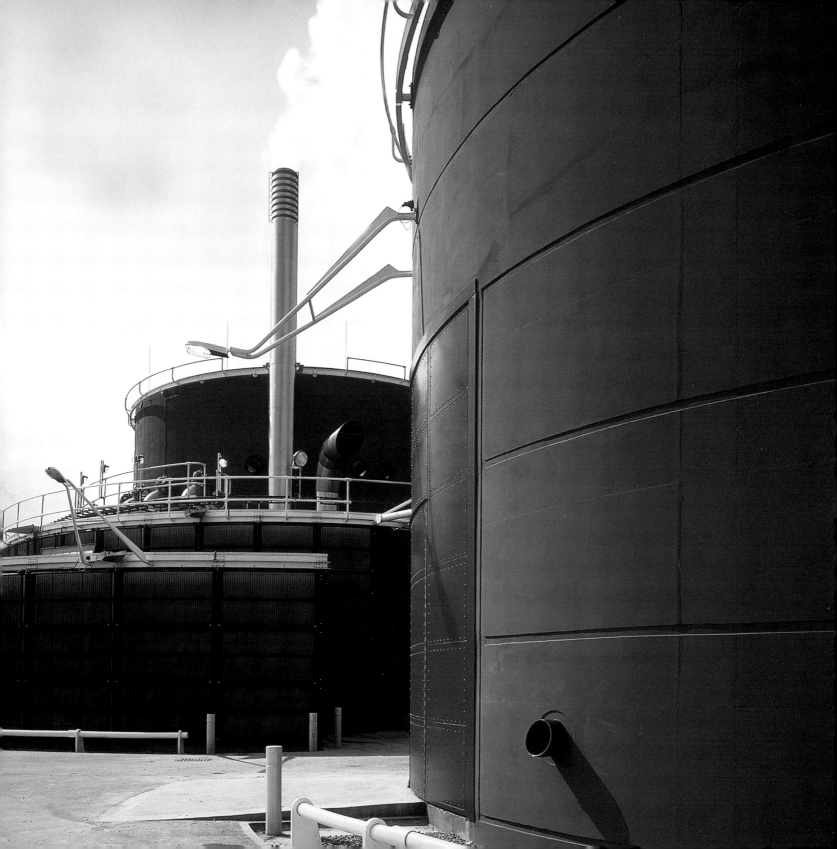

Tidal Basin Pumping Station

London, UK
1987–88

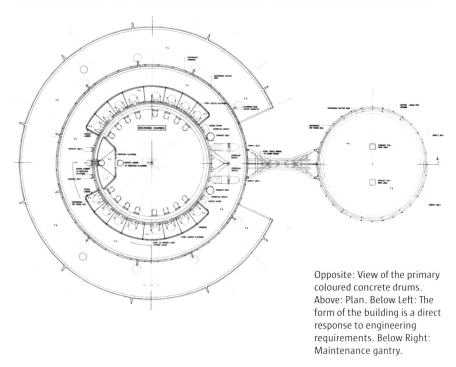

Opposite: View of the primary coloured concrete drums. Above: Plan. Below Left: The form of the building is a direct response to engineering requirements. Below Right: Maintenance gantry.

A series of new storm-water pumping stations were required as part of the development of London Docklands. The buildings are effectively containers for pumping machinery; durability and security are the principal requirements.

Most of the machinery is 25 metres below ground level, so that the image of the building as a submarine is not altogether inappropriate. The main structure is of brightly painted concrete – one circular drum placed concentrically within the radius of another. The innermost drum contains the pumping equipment and the discharge chamber into which waste water is drawn, the outermost being a service and control zone housing switch gear and transformers. The curtain walls of the outer circle are made of translucent polycarbonate, providing a view of the 'keep' within this 20th-century industrial castle.

The form of this building was generated through the close collaboration between architect and engineer, in this case Halcrow & Partners. Other aspects of the design evolved in response to maintenance, security and Thames Water requirements. The end result clearly expresses the nature of the operations performed within, while at the same time celebrating the best of Victorian engineering traditions.

"From the outset the building was meant to be a visual delight, an oasis in the drab industrial environment of Silvertown." Amarjit Kalsi

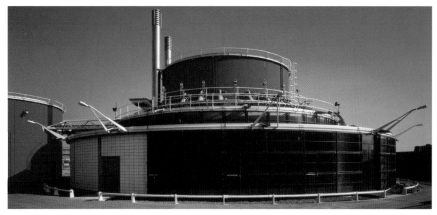

Alcazar

"Alcazar is a very particular response to the urban grain of historic Marseilles. The new public galleria was intended as a continuation of a powerful existing axis which, in turn, would organise a number of programmatic and site-specific volumes." Graham Stirk

Right: The wedge-shaped building provides a glazed pedestrian link between the principal entrance and a small garden square at the extremity of the site. Opposite Top: Floor plan. Opposite Middle: Aerial view of the site model demonstrating the scheme's integration with the dense urban grain. Opposite Below: A full-height wall of glass connects the interior of the building with the activity of the street outside.

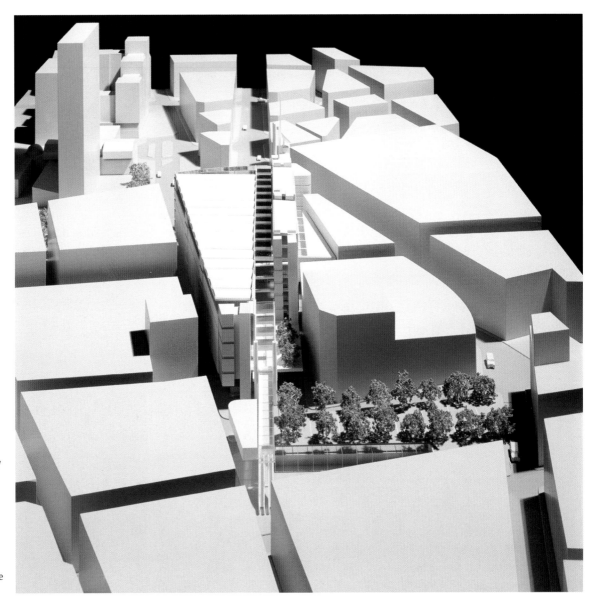

This project was an early opportunity for RRP to work within the dense urban grain of an historic inner city area. The site for the Alcazar development is close to the old port of Marseilles, but in an area compromised by insensitive post-war rebuilding. The proposed project would have formed part of a programme of major new public buildings in the city, providing a multi-purpose development comprising 12,000 square metres of offices, workshop/atelier facilities and shops as well as a 1,000 square metre exhibition space. Alcazar was also intended to be a new centre for the city's clothing and textile industry. The brief called for the upgrading of the existing Place de la Providence with provision for shops and cafés. A limiting factor was the presence of a number of existing listed buildings adjacent to the site.

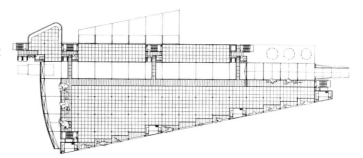

The practice's approach was typically incisive, with a strong bias towards the regeneration of the existing urban form. The design strategy set out to exploit the shopping activity along the frontage of the Cours Belsunce as well as the Place de la Providence to the rear, a quiet public piazza in need of upgrading. The design proposed to cut a direct pedestrian route through the site to strengthen the link between these two contrasting areas – a great arcade along the axis of the rue Colbert reinforced the importance of the intersection with the Cours Belsunce. A vertical circulation tower signals the entrance, flanked by a great wall of glass, allowing views into a curved atrium to bring public and private worlds together. This transparent facade was conceived as the main window through which to view the activities within.

The public route through the site was seen as the 'spine' around which the three main areas of the scheme were organised – the ateliers, offices, vertical circulation cores, shops and exhibition areas. The main shopping route rises to first floor level to achieve uninterrupted pedestrian movement over delivery areas, to continue as a bridge link over the existing road to the Place de la Providence.

This scheme demonstrates the practice's long-standing pre-occupation with issues of urban regeneration, in particular the process of identifying the potential of under-used urban spaces.

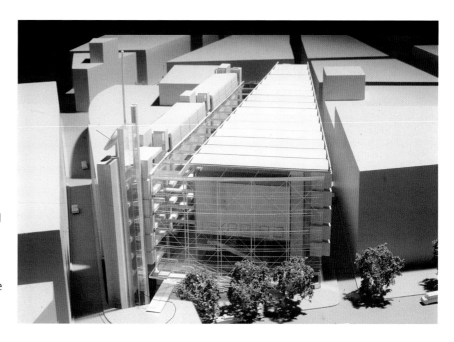

Channel 4 Television Headquarters

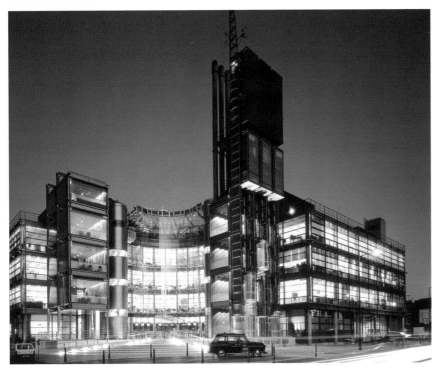

"The key guiding principles for the design are reinforcing the existing street pattern of this corner of Westminster, enclosing a public square at the heart of the scheme, and creating a striking headquarters building which is light, energy efficient, rationally organised and a pleasure to work in."
John Young

Above: The curved four-storey entrance acts as an anchor on the corner site. Right: Illustration of the glazed entrance. Opposite: The entrance flanked by stair towers, meeting rooms and lifts.

The Channel 4 headquarters building occupies a prominent corner plot near Victoria Station, and comprises c.15,000 square metres of headquarters, broadcasting suites and a studio, an underground car park and a landscaped garden square. The building, clad in pewter-coated powder-grey aluminium and glass, occupies the northern and western sides of the site. Residential developers, using their own architects, built the apartment blocks that form the southern and eastern edges of the site.

The two four-storey wings contain office space accommodating up to 600 staff and are arranged in an L-shape, addressing the corner of the street with a curved connecting space framed by two 'satellite towers'. To the left are four conference rooms stacked one on top of the other, and to the right lifts, boiler flues, and chiller plant, topped by transmission

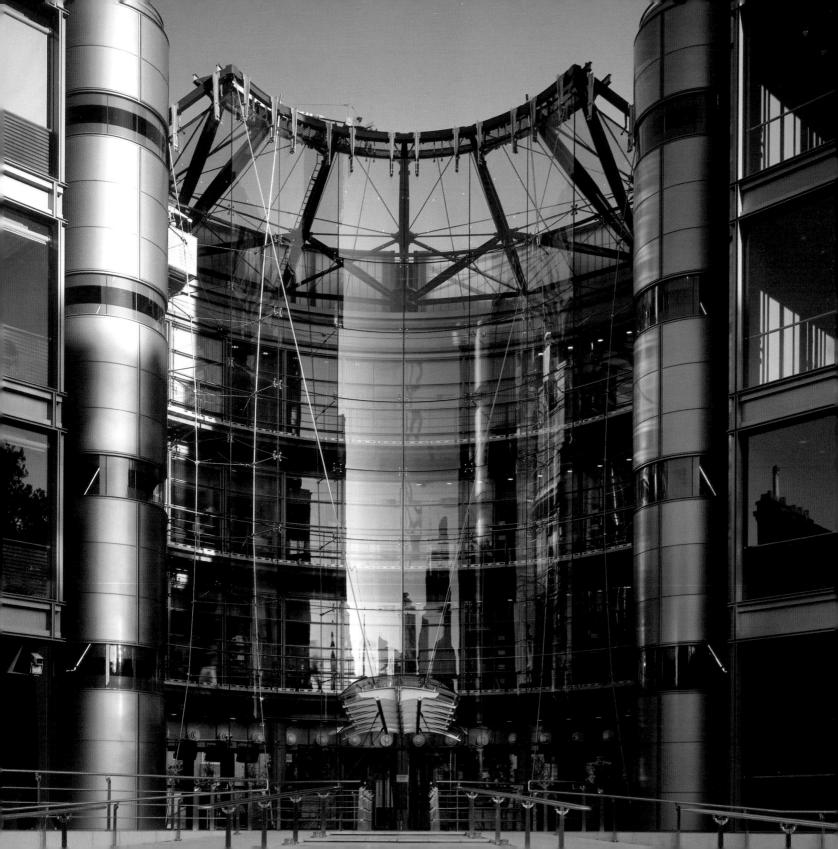

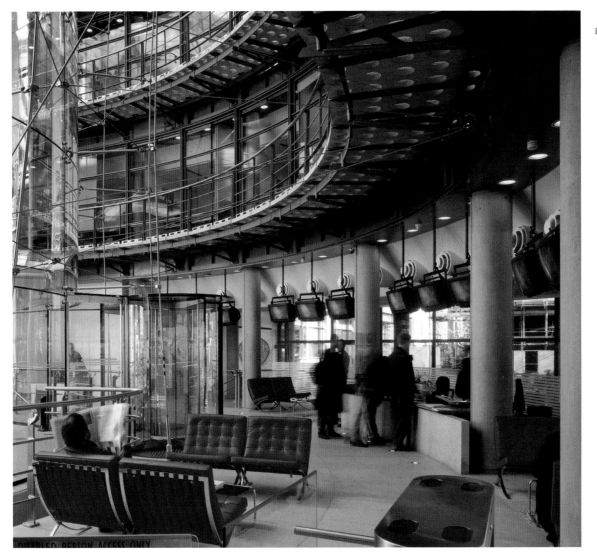

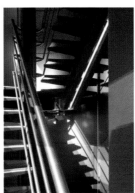

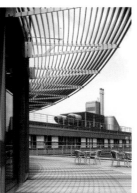

Above Left: Interior of the entrance atrium. Above Right: The glass facade is supported on adjustable springs to absorb movement. Far Left: Detail view of the open-tread stairs. Left: The top floor terrace. Opposite: A network of tension cables hold the wall of curved glazing in place.

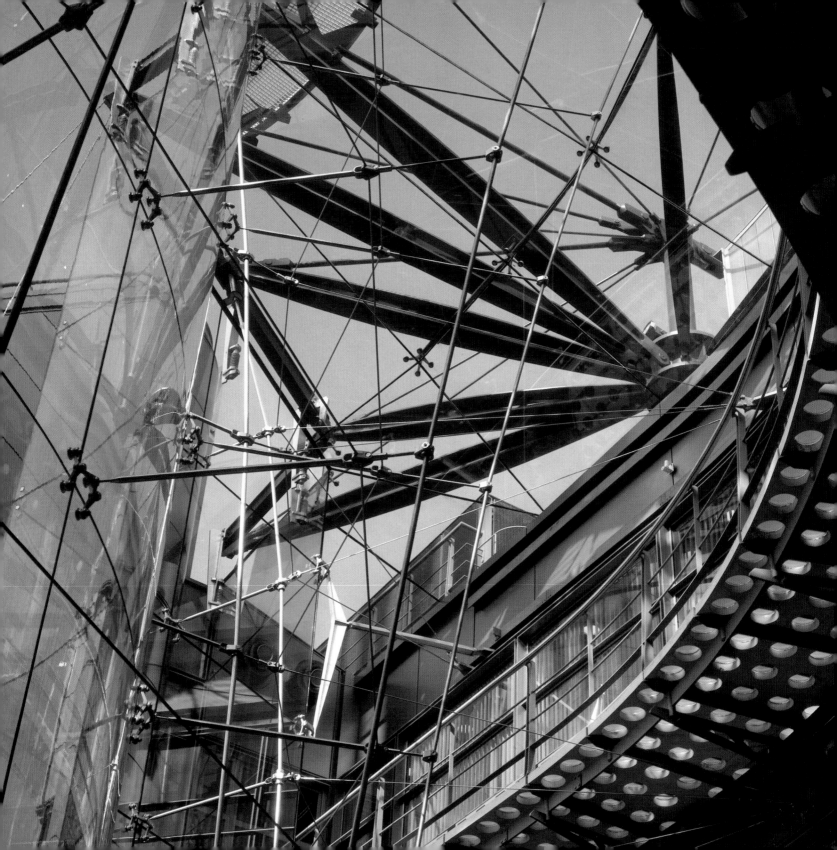

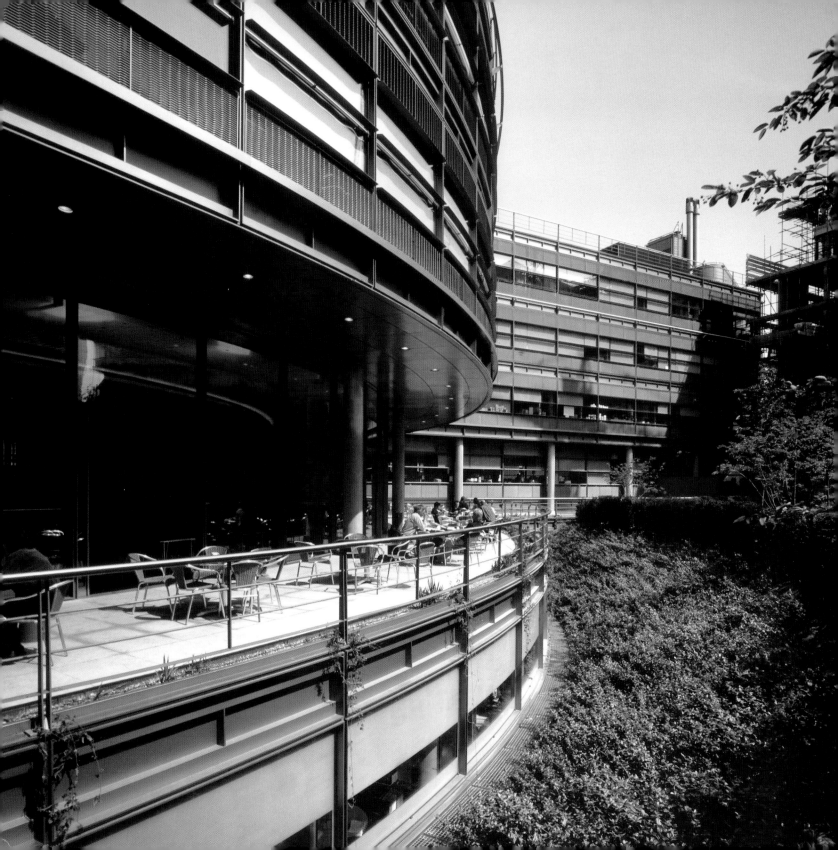

Opposite: The staff restaurant overlooks the garden. Below: Floor plan. Right: The circular entrance to the basement-level cinema. Below Right: Interior of the cinema.

antennae. The entrance, through a dramatic concave suspended glazed wall, is the predominant feature of the scheme. A stepped ramp leads from the street over a glass bridge spanning the roof-light of the foyer/cinema complex below. Beyond the reception area a restaurant fills the curve with views over the garden. A sweeping roof-top terrace extends from the top-level board room.

The clients were looking for a scheme which expressed the character of their operations – innovative, socially aware and willing to take risks. The building admirably expresses the perceived identity of the organization while reflecting civic and contextual values which are central to RRP's urban architecture.

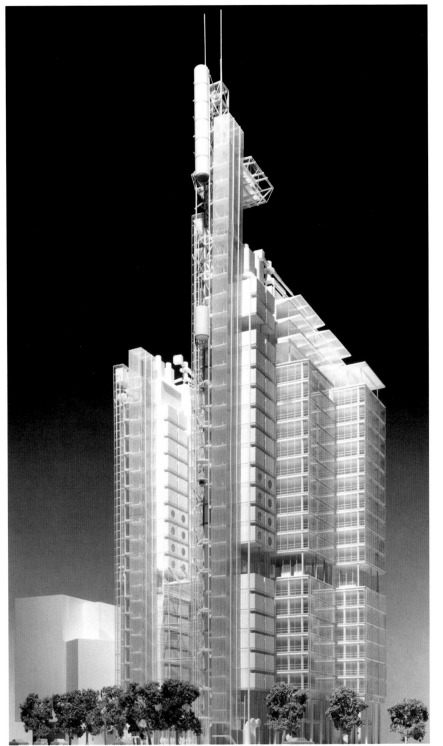
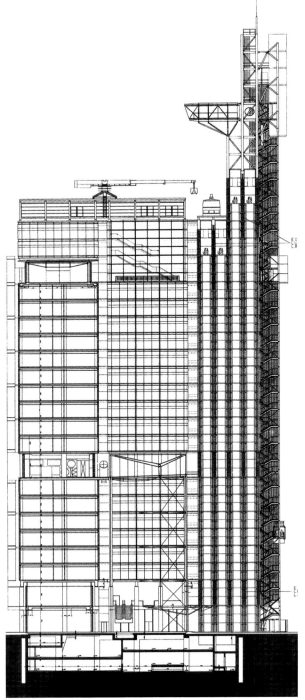

Zoofenster

"The building was envisaged as a permeable object in the cityscape, an extension of the city which offered marked public benefits." Graham Stirk

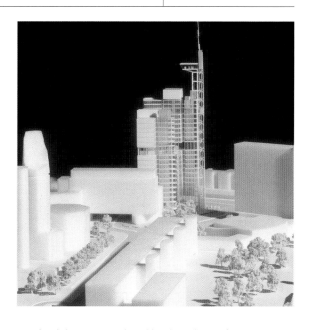

Opposite Left: Model of the proposed building, surmounted by its observation tower. Opposite Right: Front elevation. Right: Floor plan. Far Right: Context model.

RRP's competition-winning scheme was widely seen as a milestone in the post-war architectural history of the city – the lightness and inventiveness of the scheme's architectural language was intended as a powerful retort to the image of Berlin as a grey and monumental city. It marked the practice's first involvement with Berlin and opened the way for RRP's contribution to the debate about the rebuilding of the former German capital after the removal of the Wall. In particular, the proposed observation tower created a powerful termination to the Berlin skyline.

The tower was designed as a light and dynamic structure, its primary constituent elements clearly expressed and articulated. Although a private building, it was to allow public access both at ground and roof-top levels. The site, formerly occupied by a routine 1950s block, is close to the Kurfürstendamm Zoological Garden, and would have formed an interesting counterpoint to the shattered tower of the nearby Kaiser Wilhelm Church (the latter often seen as a symbol both of Berlin's past history and its continuing regeneration).

The debate engendered by the scheme focused on the issue of its height – at the time (prior to the Potsdamer Platz redevelopment) this would have been one of the city's tallest buildings. The 'gateway' nature of the design was highlighted by the dramatic mast-like service towers carrying lifts and communications technology and framing the vast 10-storey central atrium which gave the scheme its name – 'Zoo Window'. Designed for fast-track construction on a concrete frame, the building features a highly economical approach to climate control.

Key to the scheme was the intention to create a mixed use landmark – much more than just an office tower for the client, a major brewery company, the project included conference facilities, a hotel, a public restaurant, a great public retail plaza and an observation deck. It shows RRP dovetailing public and private activities to create one of the 'people's places' which have been a central concern of the practice's work from the beginning.

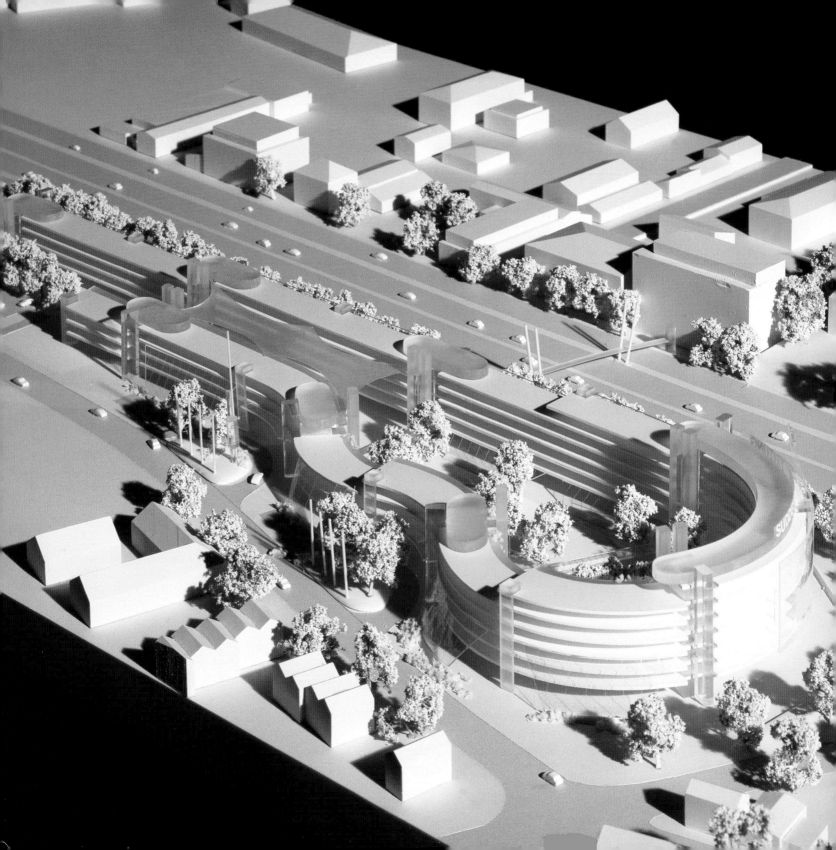

Süddeutsche Zeitung Offices

"The form is directly influenced by the motorway on one side and a suburban street on the other. As a result, the enclosed spaces vary in scale, allowing for a variety of uses." Mike Davies

This proposal for a headquarters building for Bavaria's leading newspaper group is sinuous, expressive and elegant, reminiscent of the great Modernist housing schemes of the 1930s, most obviously the Karl Marx Hof in Vienna and the work of Erich Mendelsohn. The form of the scheme is, however, equally appropriate for a large office complex, flexible enough to be subdivided for multiple tenancy or combined for a single client. The landscaped 'heart' of the scheme, with its leisure and community amenities, was intended as the focus of the development – a green oasis for the occupants, showing the practice's commitment to 'people places'.

The scheme steps up from three storeys – responding to the scale of neighbouring residential areas – to nine storeys where the building abuts a busy motorway. The external wall was designed with a metre-wide cavity, acting as a ventilation stack as well as an acoustic barrier against the busy traffic outside. The facades are designed to respond to the changing conditions around the site – energy saving is central to the whole concept.

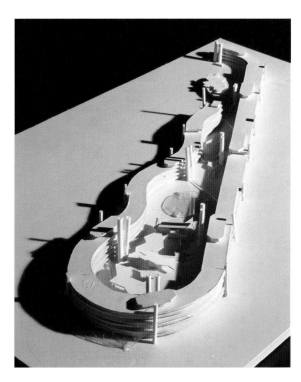

Opposite: The sinuous form responds in height to the neighbouring residential area and the busy motorway. Above Right: The central garden is the focus of the scheme. Right: Site plan.

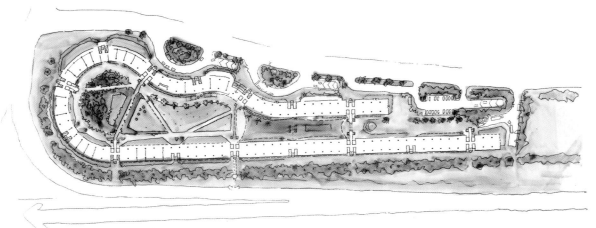

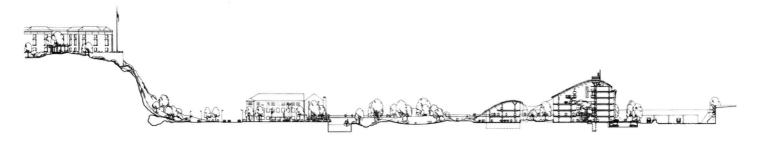

Inland Revenue Office

"The aspiration was a low-energy, naturally ventilated building that would not require high levels of servicing. This scheme was a prime expression of the way in which environmental design generates architectural form." Laurie Abbott

The competition for a new headquarters for the Inland Revenue in the Midlands city of Nottingham produced diverse responses from the six invited practices. RRP's entry reflects the growing emphasis on ecology and 'green' issues which had become a feature of the office's work in the late 1980s.

The building's gently expressive form arises from the energy and servicing strategy but is equally in tune with the practice's growing interest in the alternative modern tradition represented, in particular, by the work of Alvar Aalto. The offices are arranged in a great arc, facing a riverside park and looking towards the city

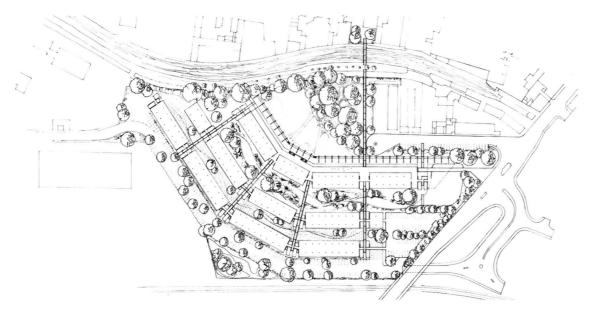

Above: Site section. Left: Site plan. Opposite: Model section of the two parallel wings that enclose a landscaped park.

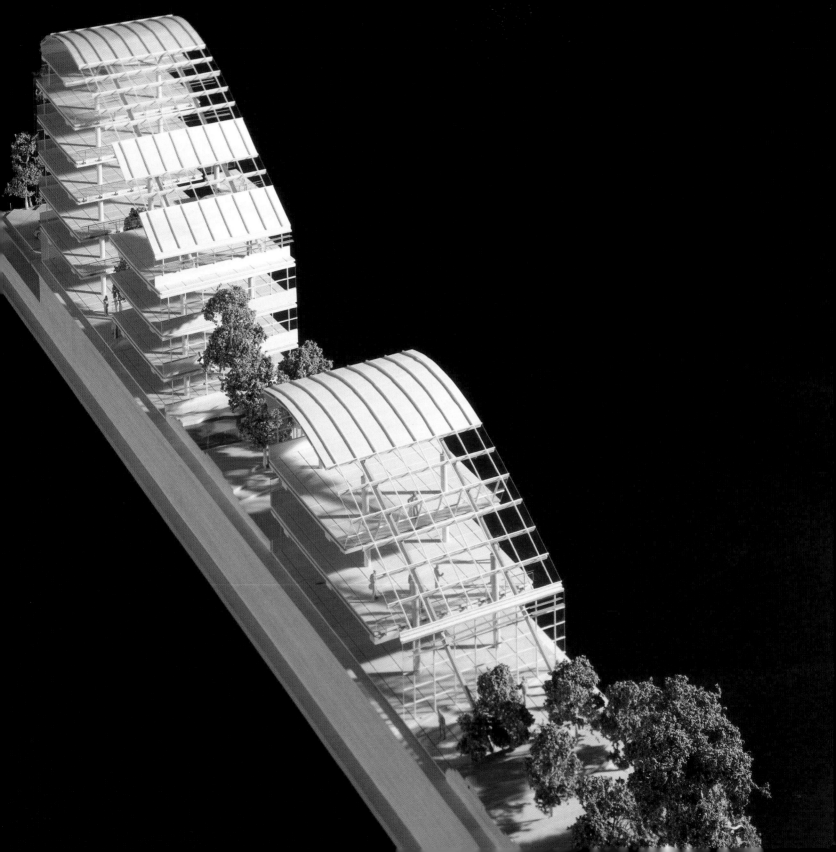

centre and mound of the ancient castle. To the south, a trombe wall deflects solar gain, noise and pollution from a main road and railway track.

The working spaces sweep down in two parallel stepped blocks, separated by a planted zone containing trees and water. The lower block is serviced with a mix of natural and assisted ventilation. The larger building has a central glazed spine which is used to generate a heat-stack effect, drawing out stale air from the office floors and drawing in fresh. Solar gain is controlled both by the use of tree planting and by screening devices on the facades. The scheme was an ambitious attempt to humanise the large office block and to create, in effect, a horizontal office village.

Above Right: Sketch illustrating the air-flow and ventilation strategy derived from the curved form of the building. Right: Aerial view of the site model showing the three parallel bands of building.

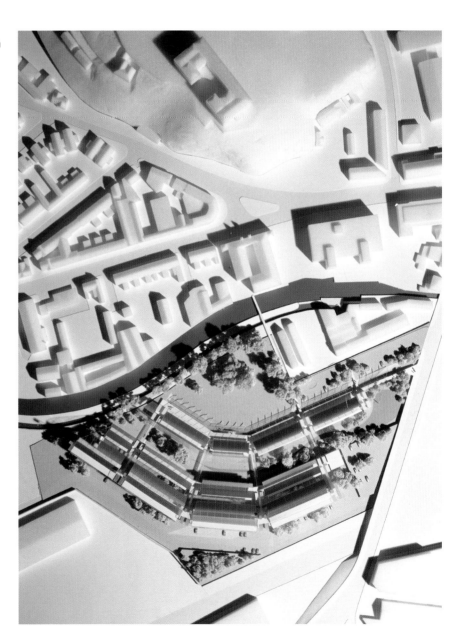

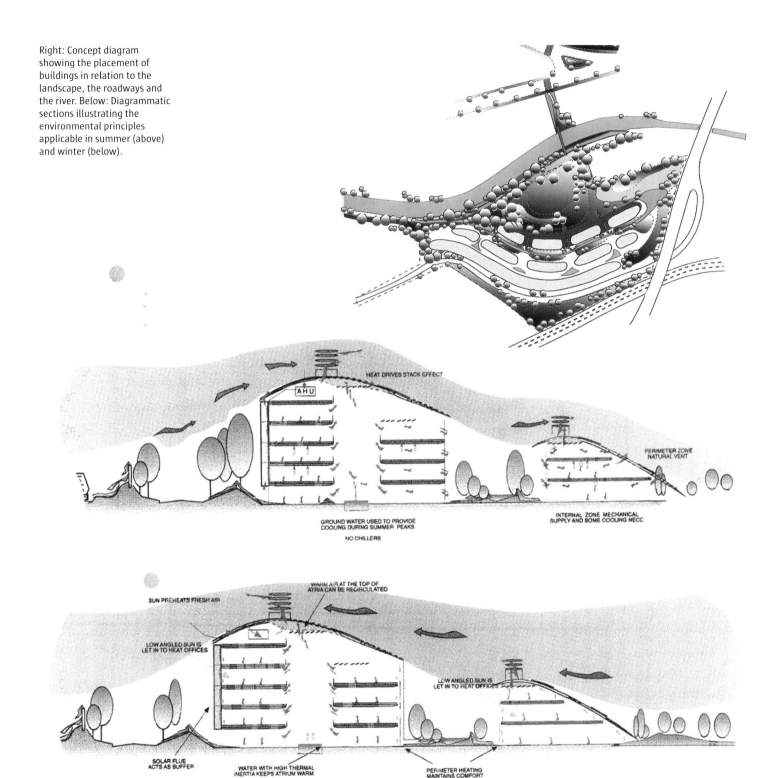

Right: Concept diagram showing the placement of buildings in relation to the landscape, the roadways and the river. Below: Diagrammatic sections illustrating the environmental principles applicable in summer (above) and winter (below).

HEAT DRIVES STACK EFFECT

AHU

PERIMETER ZONE
NATURAL VENT

GROUND WATER USED TO PROVIDE
COOLING DURING SUMMER PEAKS

NO CHILLERS

INTERNAL ZONE MECHANICAL
SUPPLY AND SOME COOLING NECC

WARM AIR AT THE TOP OF
ATRIA CAN BE RECIRCULATED

SUN PREHEATS FRESH AIR

LOW ANGLED SUN IS
LET IN TO HEAT OFFICES

LOW ANGLED SUN IS
LET IN TO HEAT OFFICES

SOLAR FLUE
ACTS AS BUFFER

WATER WITH HIGH THERMAL
INERTIA KEEPS ATRIUM WARM

PERIMETER HEATING
MAINTAINS COMFORT

Turbine Tower

"We used wind tunnel testing to optimise the form of the building. In due course I am convinced we will have the opportunity to put into practice the knowledge we gained from this scheme." Laurie Abbott

This project was seen as primarily theoretical – in the midst of the recession in Japan in the early 90s RRP explored the potential of environmentally friendly building technology. The design was based on the premise that buildings should interact dynamically with the environment, taking advantage of free energy to provide comfortable living and working space. Working with Arup the practice engaged in detailed research into the climatic and servicing requirements of what was intended to be a low-energy building.

This project was significant in the context of the practice's move towards natural servicing and a generally ecological approach to architecture – using the environment as an architectural generator. Features of the building included reactive facades that respond to changes in the weather, an exposed concrete structure absorbing heat gain, the use of water for

cooling purposes and the generation of power from a wind turbine set within the service core. The aim was to exploit the building's dynamic form – sleek and sculptural, the building's profile was intended to maximise wind power potential, producing 130 kilowatts of energy per hour. There was the potential, according to the design team, for the scheme to be 100 percent self-sufficient in energy terms.

Right: Sectional diagram of the main heating and cooling systems. Far Right: Models of the building were subjected to intensive wind tunnel testing. Below Right: Plan showing the aerodynamic form. Opposite: Schematic model of the Turbine Tower.

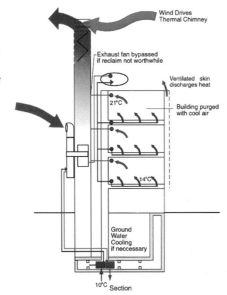

Wind Drives
Thermal Chimney

Exhaust fan bypassed
if reclaim not worthwhile

Ventilated skin
discharges heat

21°C

Building purged
with cool air

14°C

Ground
Water
Cooling
if neccessary

10°C Section

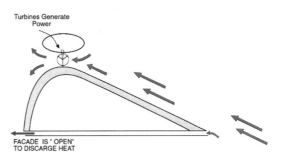

Turbines Generate
Power

FACADE IS " OPEN"
TO DISCARGE HEAT

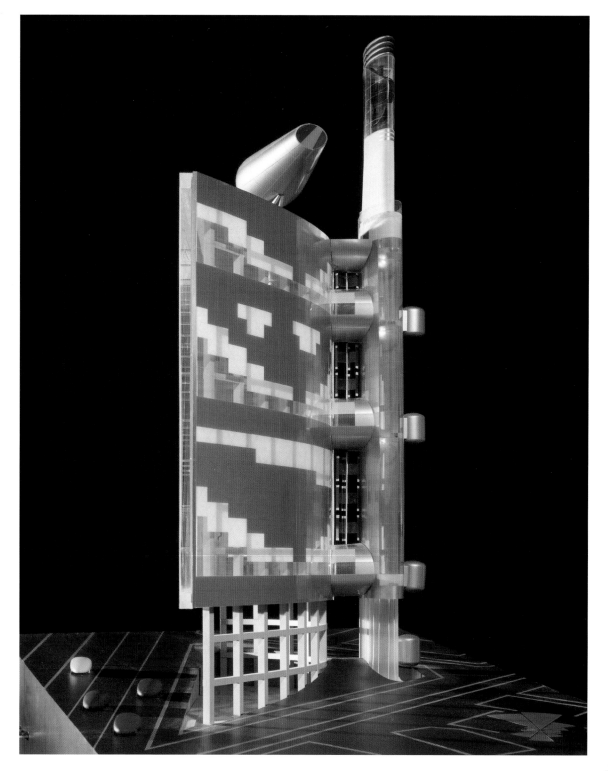

Daimler Chrysler Office and Retail

Below: Concept sketch.
Opposite: The glazed facades allow views out over the park.

In 1991 the city authorities opted for a thoroughly conservative masterplan for the redevelopment of the devastated Potsdamer Platz quarter of Berlin (close to the former line of the Berlin Wall), rejecting more radical proposals including those by RRP. A further competition for the Daimler Chrysler site was won by Renzo Piano and Christoph Kohlbecker. RRP was subsequently commissioned to design three buildings on the site with a total area of 57,800 square metres.

The brief stipulated that RRP work within the context of the traditional Berlin square block, with buildings no more than nine storeys high formed around potentially oppressive internal courts. To one side, the buildings had to address an enclosed retail arcade raised several storeys above ground level. Working within these constraints, the practice was able to subtly subvert the municipal masterplan to produce buildings of strikingly

contemporary appearance which, most significantly, utilised a low-energy servicing agenda.

The key to this strategy was the erosion of the blocks at their south-east corners to allow daylight to penetrate the central courts, which were turned into covered atria to illuminate interiors, and to facilitate views out of the buildings. The atria are naturally ventilated throughout the year, with heating mechanically augmented in winter. The two office buildings and one residential block were designed for natural ventilation throughout, with intensive research by the RRP team and specialist consultants into the servicing programme partly funded by a European Union grant. As a result, it was estimated that energy consumption in the office buildings would be half that generated by a conventionally air-conditioned building. The facades of the buildings incorporated clear and opaque glass panels, solid areas of ceramic tile cladding, and external and internal blinds, a sophisticated mix which allowed the internal environment to be adjusted in response to the requirements of users. Visually striking, RRP's contribution to the Potsdamer Platz development challenged conventional wisdom, producing a pioneering low-energy environment for business accommodation.

"Integrating low-energy design within a dense urban environment, the buildings are designed to optimise passive solar energy, natural ventilation and daylight. All office spaces are naturally ventilated, making use of night-time free cooling and solar radiation in the atria." Laurie Abbott

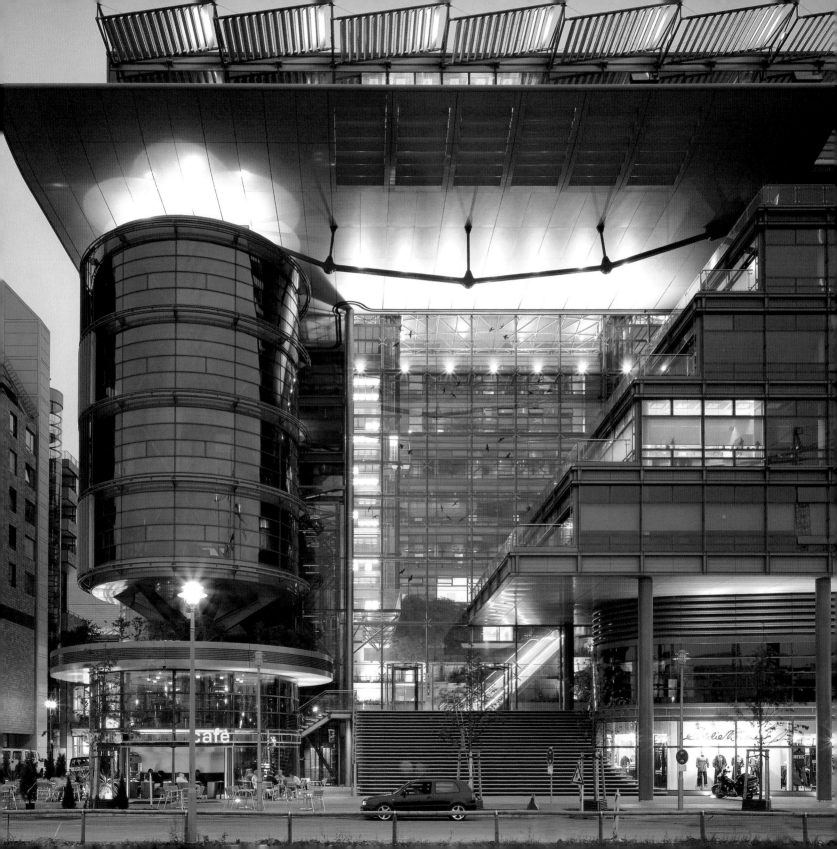

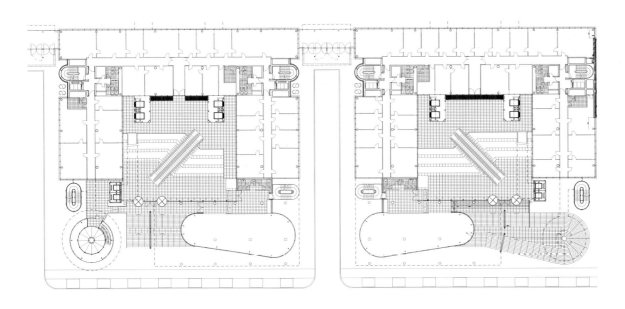

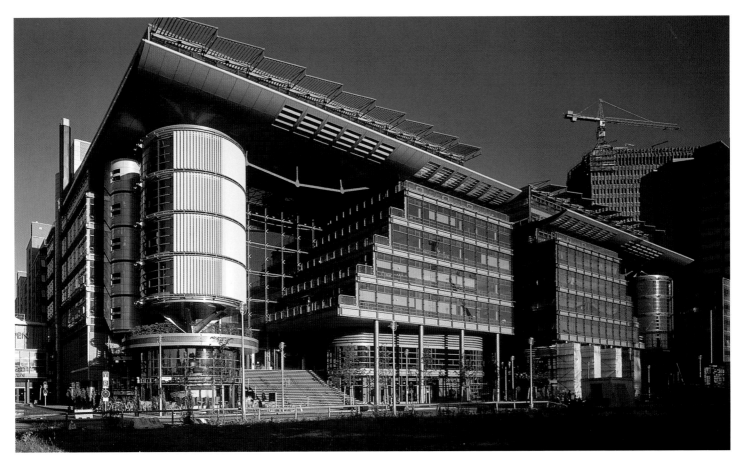

Opposite Top: Ground floor plan of the office blocks. Opposite Below: Entry into the office atria is framed by the conference room drum with its bright yellow louvres that rotate according to the position of the sun, and the stepped office floors. Below: Detail of the integrated glazing and ventilation system. Bottom: Detail view of the steps and covered entrance. Right: The public realm is enhanced by shops and cafés at ground level.

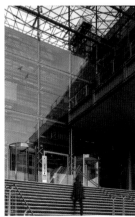

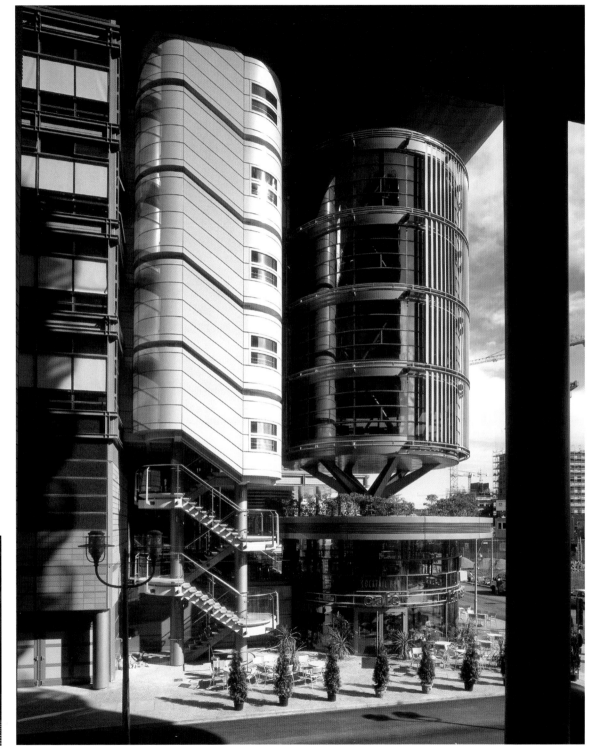

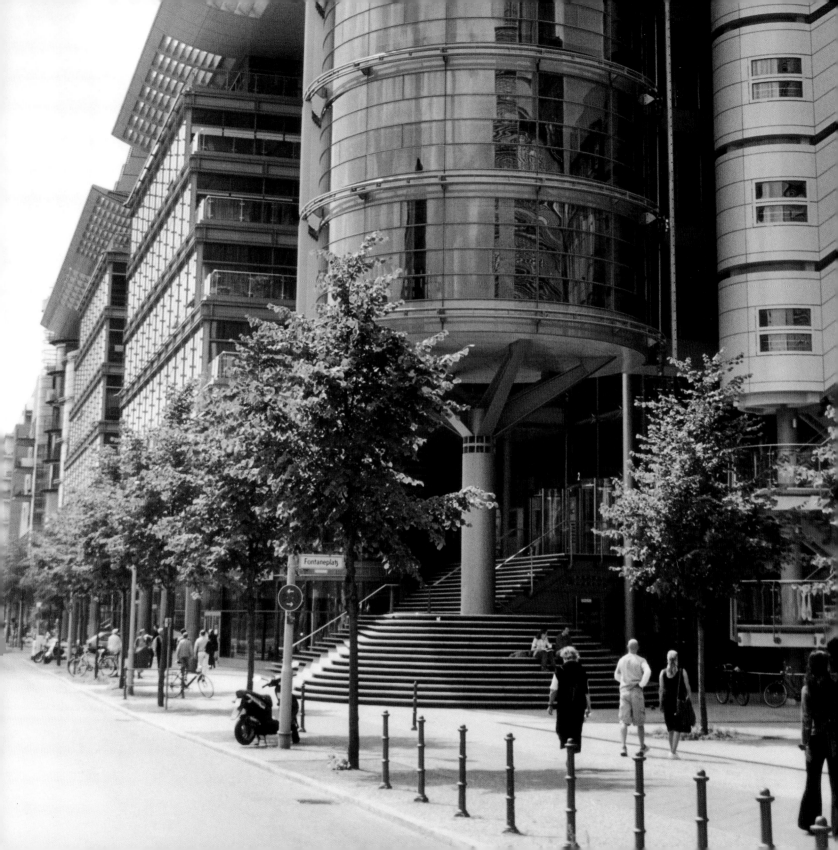

Opposite: View down
Linkstrasse showing the
two office buildings and the
residential complex beyond.
Right: The enclosed atria are
naturally ventilated all year
round and heated in winter.
Offices overlook the generous
atria animated by escalators
and clear-glazed lifts.

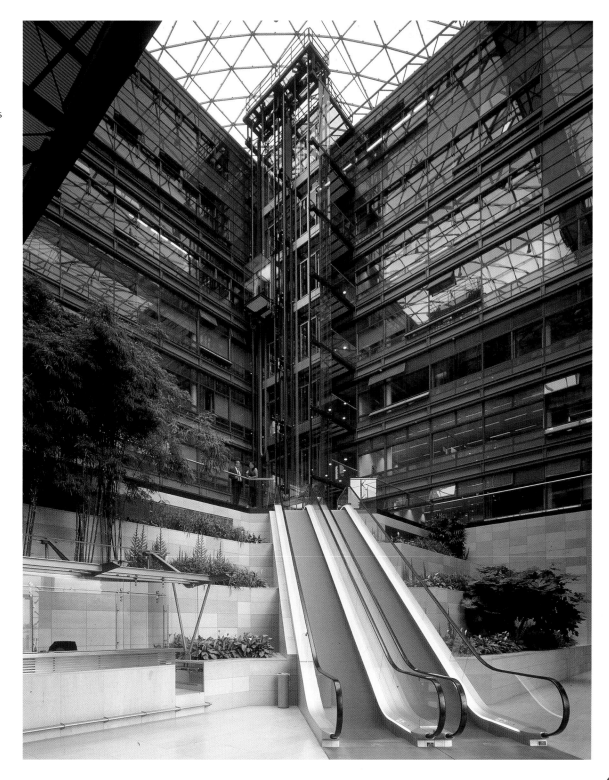

> "This project is representative of a broader search for an architecture that responds to ecological concerns. The building blurs the relationship between natural landscape and the man-made and benefits environmentally from this arrangement."
> Ivan Harbour

Workplace

VR Techno Plaza

Gifu, Japan
1993–95

Above: Double-height entrance. Above Right: Aerial view showing the stainless steel-clad curved roof, with the terraced laboratories cascading down the hillside. Opposite: The sinuous curves of the building echo the contours of the topography. Following Pages: The roof slabs are partially buried and landscaped to increase thermal mass, creating views out over the planted terraces.

Rogers' initial role in the development of the VR Techno complex at Gifu was to prepare a masterplan to accommodate ten buildings on the steep hillside site, covering around 16 hectares, retaining where possible the natural contours of the land.

VR Techno is a government-led research centre providing facilities for advanced technology companies with a special interest in virtual reality issues, providing educational, communal and laboratory/office spaces as a resource for private research bodies and the general public.

RRP was commissioned to design two buildings on the site, the Techno Plaza and a subsequent research building for the Amano pharmaceutical company. Techno Plaza is a strong response to the natural landscape, with two distinct elements – offices and research laboratories. The building has an exposed concrete frame with retaining walls and floor slabs partially buried or planted to enhance thermal mass, ensuring maximum benefit from the stable ground temperatures and discouraging rainwater run-off. Glazed facades are equipped with louvres to control solar gain and a stainless steel clad ventilated roof further reduces the energy load on the building. External, planted terraces provide views across the valley.

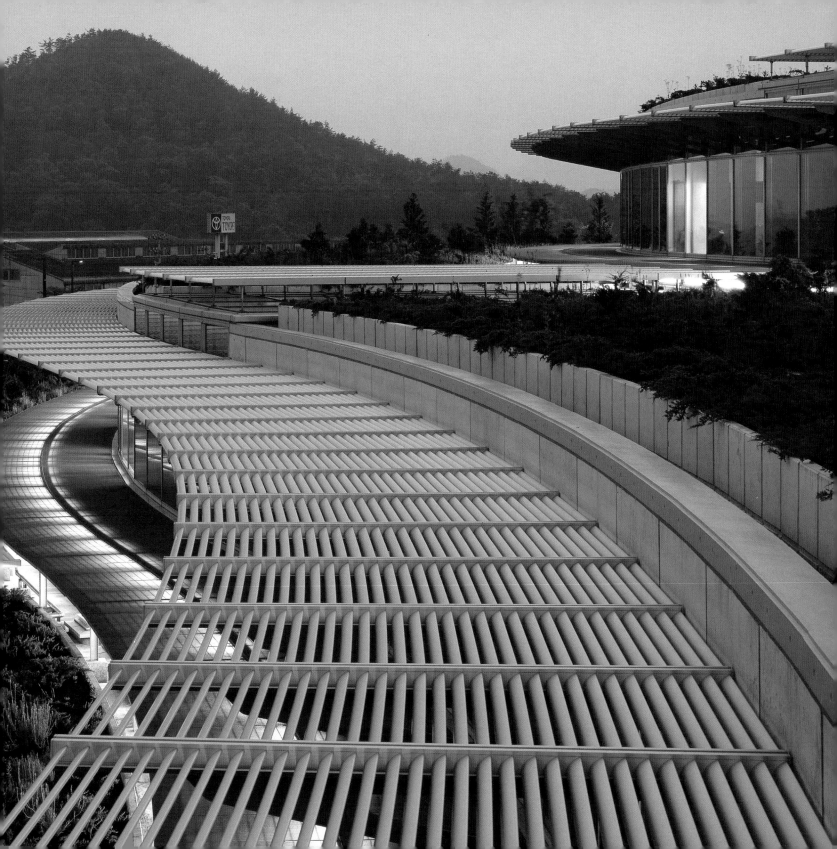

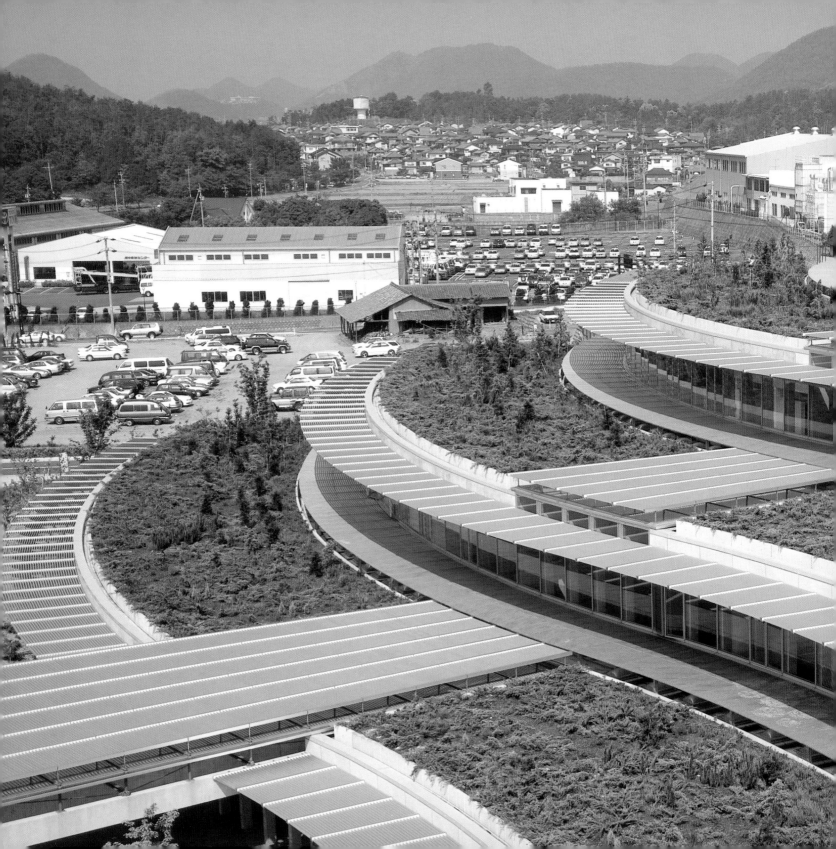

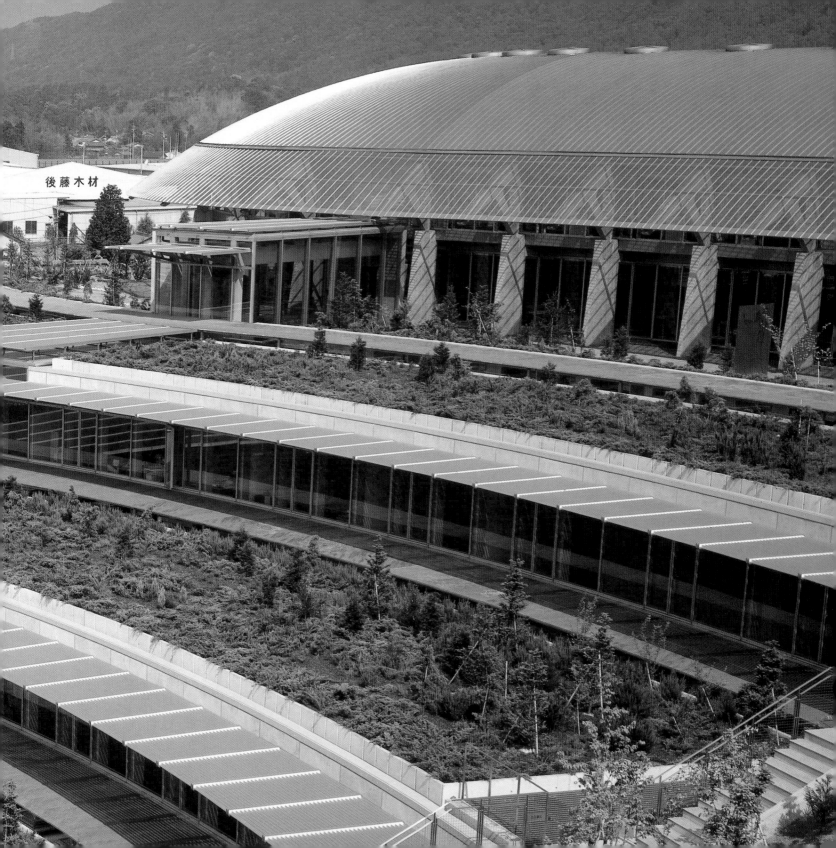

Amano Research

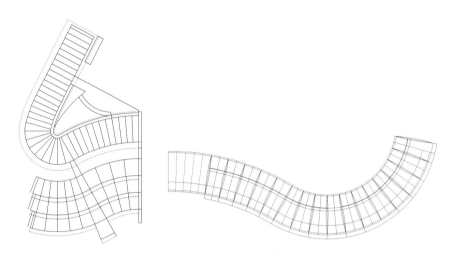

In 1997, RRP and co-architects Kisho Kurokawa & Associates were approached by Amano Pharmaceutical to design a low-budget building at Kagamigahara City, Gifu, to accommodate the company's enzyme research group. The building, which has an area of 6,352.95 square metres, was required to incorporate not only specialised laboratories but also offices and a restaurant.

The building form is strongly influenced by its hilly site, hence the curved plan. The surrounding landscaping is integral to the building design and the impressive views which it affords are maximised by the positioning of the building within the site and its glazed facades.

The roof's steel structure is expressed externally. Rooflights following each structural bay allow natural daylight to penetrate laboratory space. As a consequence of placing the roof structure outside, the design succeeds in minimising dust in laboratory areas.

By partially sinking the building into the hillside, the resultant thermal mass considerably reduces energy consumption whilst glazed facades are protected from solar gain by external shading.

"Amano's pedigree belongs to INMOS and Pat Centre Princeton, but instead of adopting a rigorous orthogonal plan, the building follows the sinuous contours of the site." Amarjit Kalsi

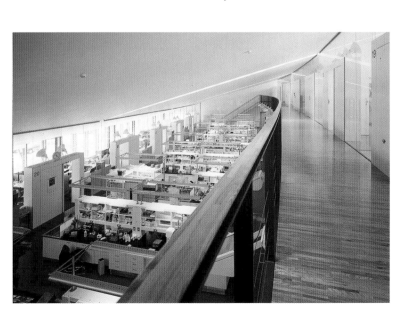

Opposite: The glazed entrance under the expressed bright red steel structure. Top: Site plan showing VR Techno Plaza (left) and Amano Research (right). Left: A mezzanine level of cellular offices overlooks the open-plan work area below.

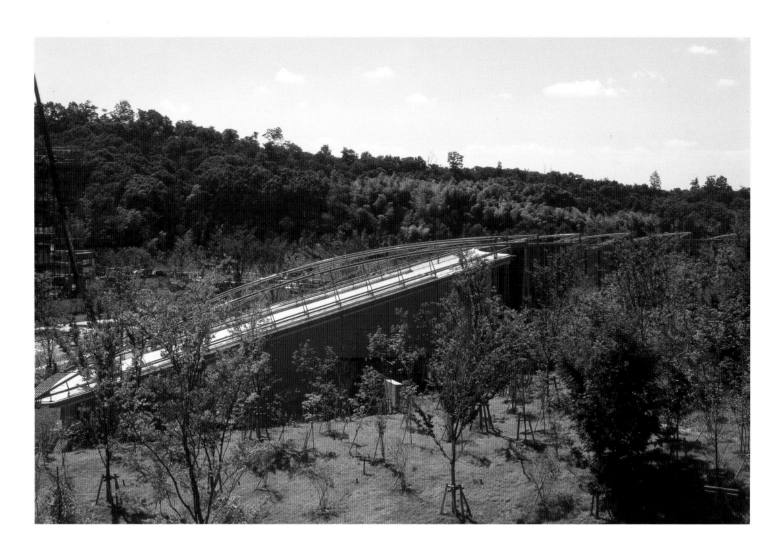

Above: The mono-pitched roof
follows the slope of the site.
Right: Section and floor plan.

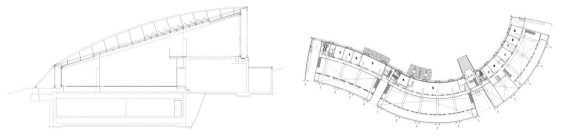

Right: Detail of the steel structure. Far Right: The glazed roof over the double-height entry. Below: The Amano building complements the neighbouring VR Techno Plaza (behind), both schemes echoing the natural contours of the site.

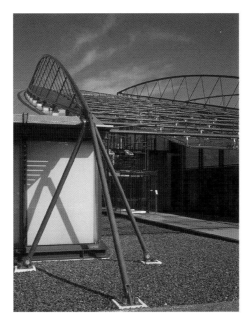

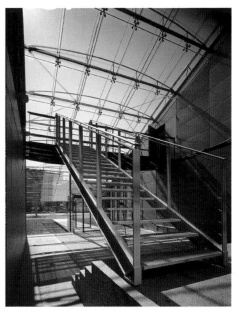

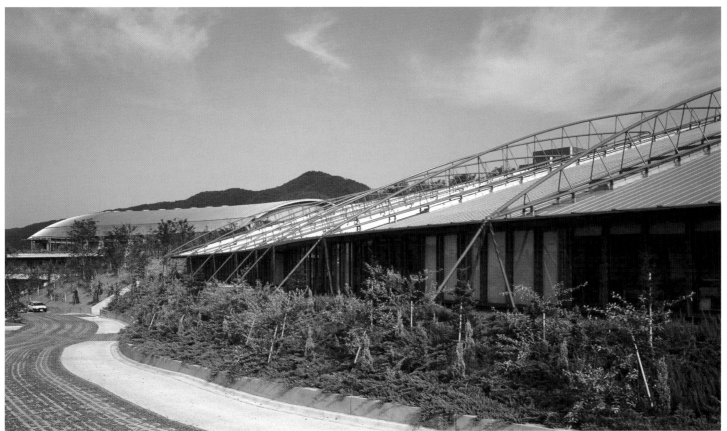

Thames Valley University
Resource Centre

"We wanted to create a light, sunny, dynamic space – somewhere that inspired a desire for learning. Transparency was key – TVU consists of simple, legible elements, the opposite of stuffy academe." Amarjit Kalsi

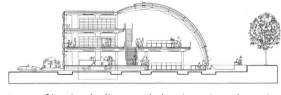

Thames Valley University (TVU) is one of a number of new British universities developed from former further education institutions in the 1990s. The existing campus at Slough, developed from the 1950s on, was undistinguished, with poor public spaces and indistinct circulation routes, and isolated from the town centre by a main highway and railway line.

The practice was asked to carry out a masterplan for the future development of the campus and to identify a site for the proposed learning resource centre, essentially a library but with provision for the use of computers, videos and other new information technology as well as books. The university wanted a clearly accessible building which could be built to a tight budget and a fast construction programme.

The completed building is both straightforward (in terms of its simple diagram, balancing a 'warehouse' storage area with an open reading and reception space) and highly memorable. The linear, three-storey bookstack block is contained within a fair-faced in-situ concrete frame. The reception and reading area is covered by a curved steel roof structure, fully glazed at each end and with a 40-metre-long window opening extending the length of the reading room and providing views of a new external pond. Solar control is provided by internal motorised fabric blinds. Ventilation is primarily non-mechanical. The tough finishes and strong colours of this striking building, which cost just £3.6 million including new landscaping, recalls Rogers' work of the 1960s and early 70s, not least in its references to the metallic aesthetic of the Case Study Houses programme.

Top Right: Section. Right: The curved steel roof of the reading room. Far Right: Ground floor plan. Opposite: The mezzanine level with views out through the fully glazed end wall. Following Pages: Night view highlighting the building's transparency and legibility.

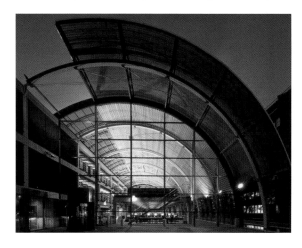

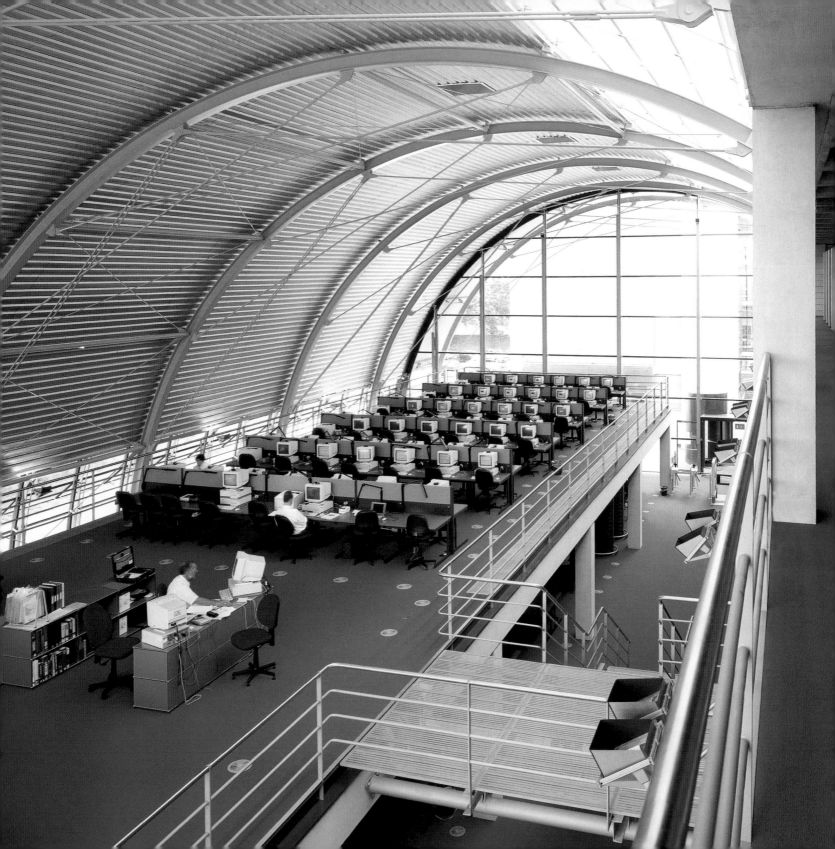

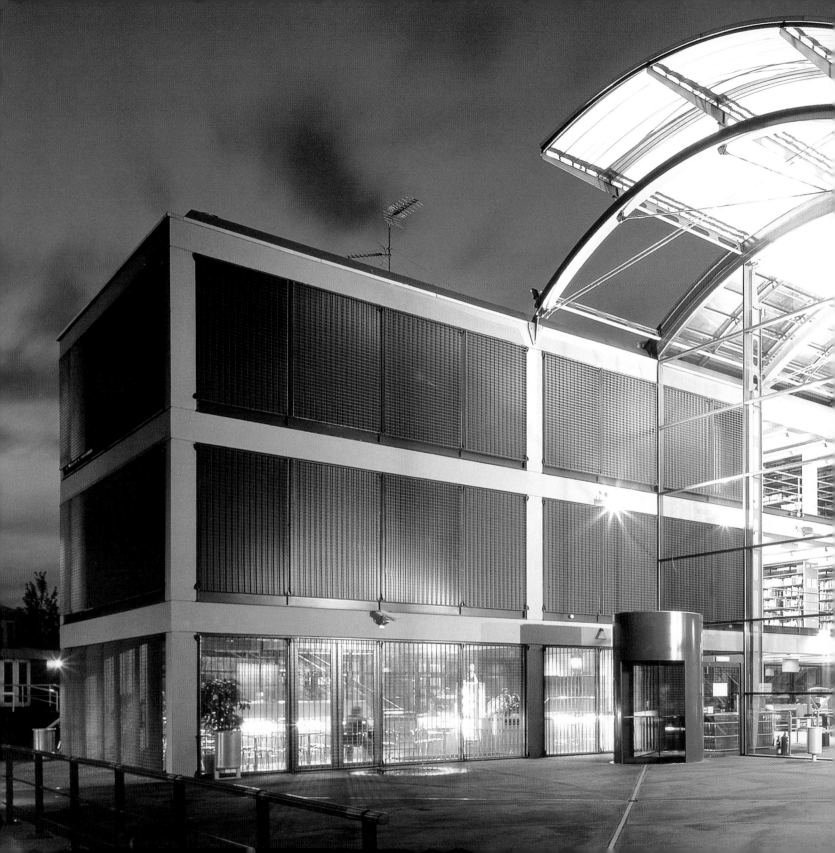

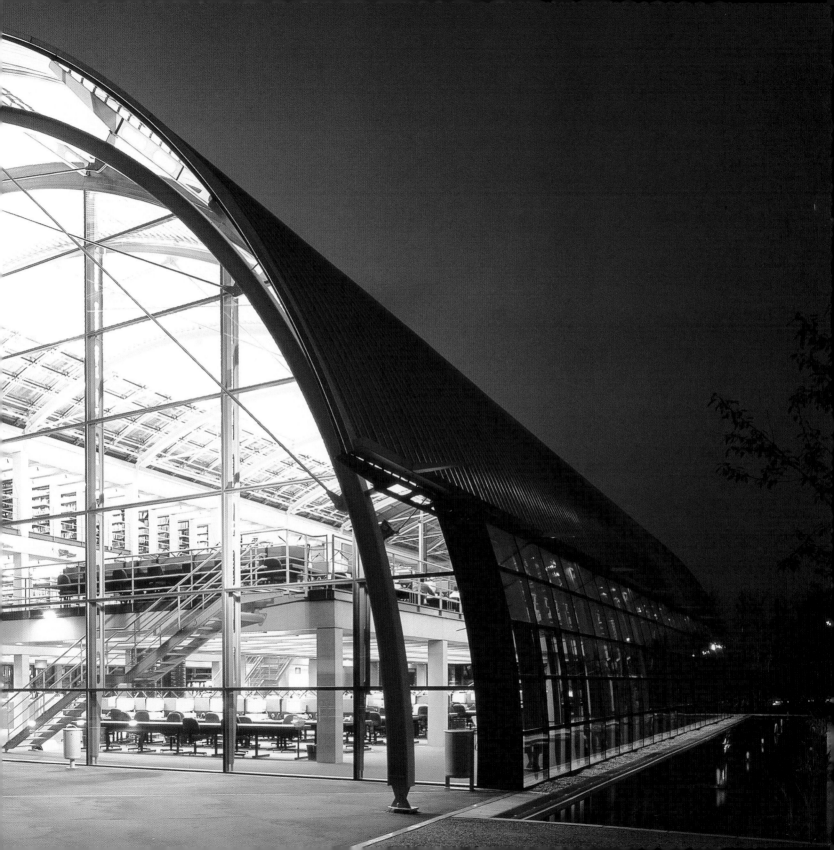

Right: The London Wall facade.
Opposite: View of a steel-framed
stair tower.

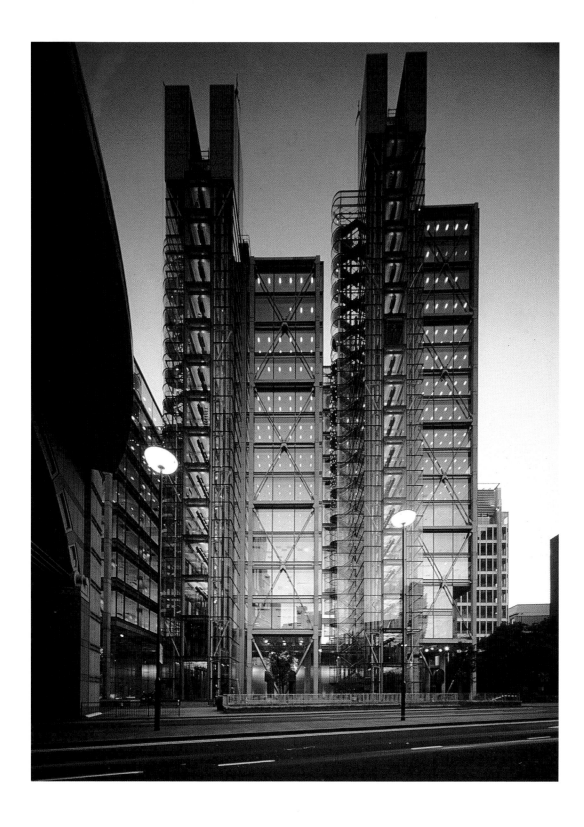

88 Wood Street

The first City building completed by RRP since Lloyd's of London in 1986, 88 Wood Street demonstrates the potential for speculative commercial development that does not compromise on quality and enhances the public domain.

The site, at the junction of Wood Street and London Wall, was formerly occupied by a 1920s telephone exchange. Delays in securing the demolition of this supposedly 'historic' building, combined with the onset of an economic recession in the 1990s, led to the cancellation of a 1990 scheme for a prestige new headquarters for banking corporation Daiwa. A larger scheme was designed in 1993–94, with speculative letting in mind.

The 33,000 square metre building is arranged as three linked blocks of office accommodation that step up from eight storeys on Wood Street, where the context includes two listed buildings, to 14 and finally 18 storeys to the west, responding to the taller built topography towards London Wall. By using the extensive basement of the demolished telephone exchange for plant, roof levels were kept largely free. The office wings are constructed of in-situ concrete which contrasts with the lightweight, steel-framed service towers containing toilets, lifts and dramatic,

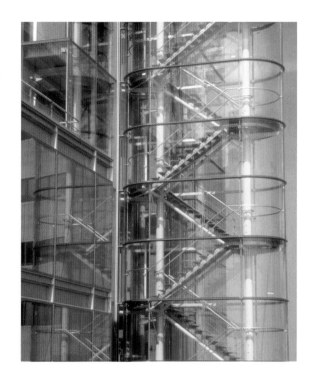

"88 Wood Street has been designed to create a light, pleasant and flexible working environment, incorporating the latest advances in technology and energy conservation. The key to this building is its transparency allowing a startling level of legibility of its technology and constituent parts. The vertical movement of people animates the building, creating a dynamic impact on the immediate surroundings." Graham Stirk

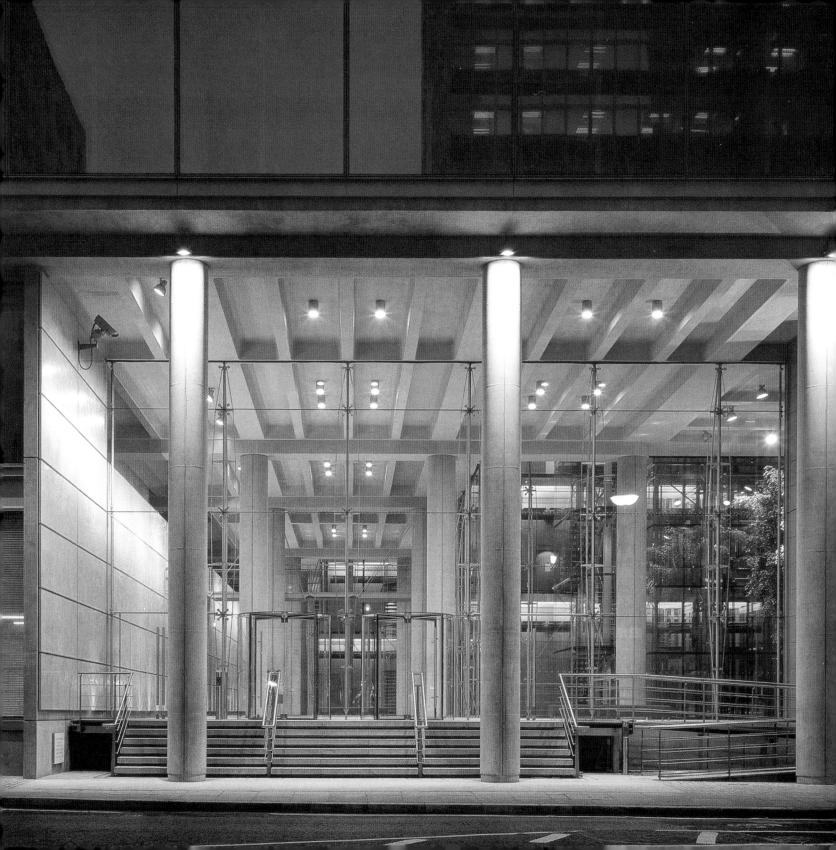

Opposite: The Wood Street entrance. Right: Interior of the double-height reception area. Below: Clarity of function, legible structure and meticulous detailing are hallmarks of RRP's work at Wood Street.

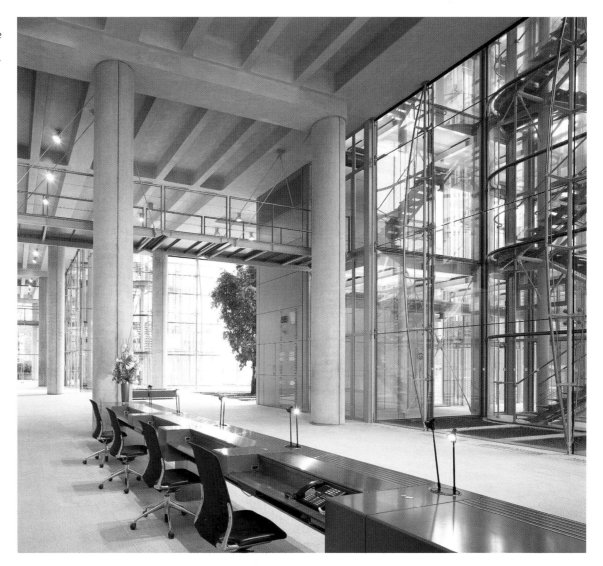

Right: The building steps up from eight to 18 storeys in a considered response to its urban context.

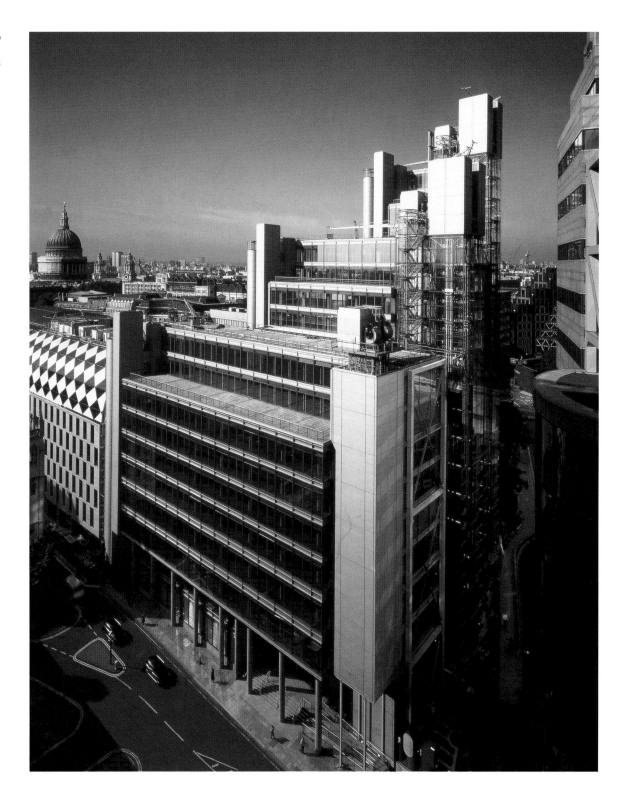

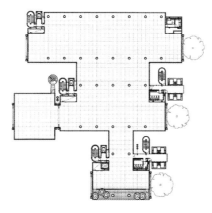

fully glazed stairs. The use of brilliant colour enhances their impact – air intakes and extracts at street level are also brightly coloured, contrasting with the neutrality of the occupied floors.

The generosity of the scheme is reflected in the spacious, eight-metre-high entrance lobby, floored in granite as an extension of the external landscaping. This reception area features a 54-metre-long wall running the length of the building. The facades of the main office floors are glazed from floor to ceiling to maximise daylight and views – in addition, levels 8,12 and 16 lead directly onto roof terraces with spectacular views over the City skyline.

Though built to a strict commercial budget, 88 Wood Street contains many innovative elements. The massing of the building allows controlled daylight to penetrate the office floors. Its triple-glazed active facade is formed of single panels, each three metres by four metres, of highly transparent float glass. The inner faces of the external panes have a low emissivity coating which further reduces internal solar gain, while the cavity between the double-glazed units and the third panel is fitted with motorised, integral horizontal blinds with perforated slats. Photocells on the roof monitor external light conditions and adjust the angle of the blinds, thus minimising sun glare, heat gain and energy consumption.

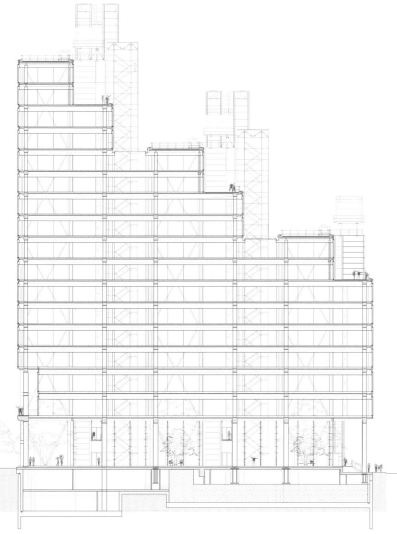

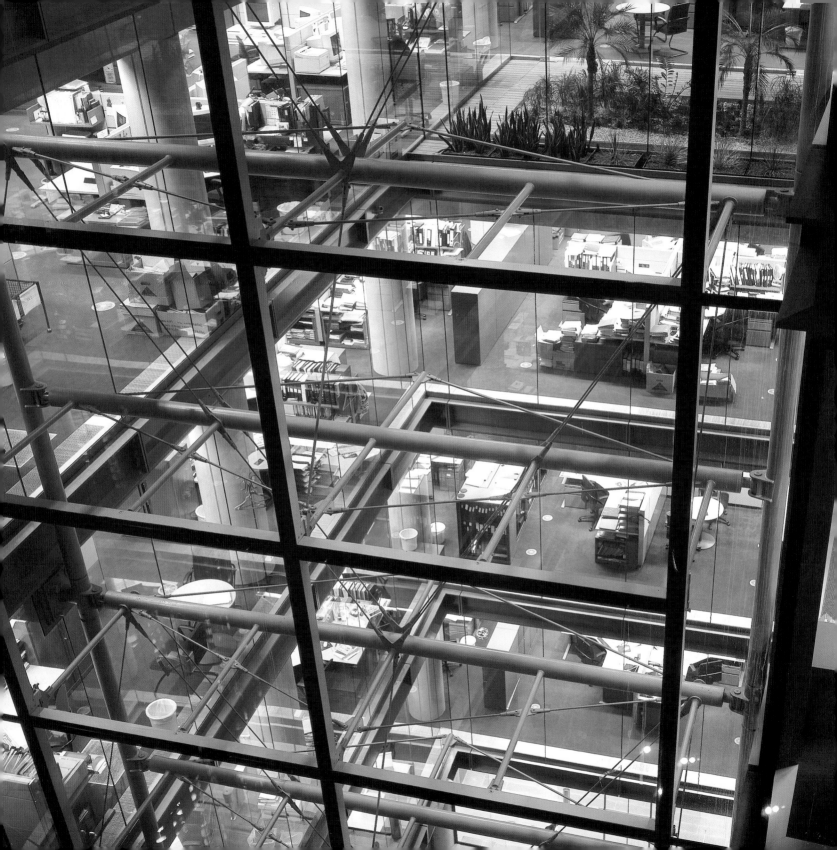

Lloyd's Register

Opposite: View into the office space from one of the glazed atria. Right: Typical office floor plan showing the integration of the existing 71 Fenchurch Street building (bottom right).

"Fully glazed wall-climber lifts and stairs mean that the building's exterior is continually animated by the movement of people within it. Clarity of architectural language is the key to this development, where the function of all constituent elements is celebrated, revealing the secrets of their manufacture and operation." Graham Stirk

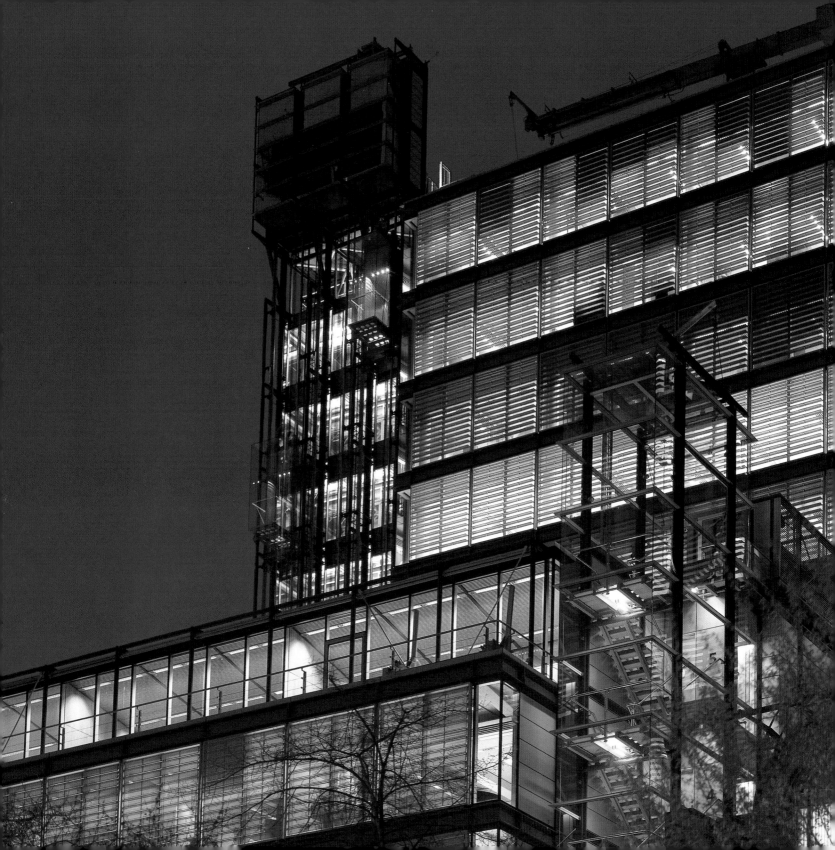

Opposite: Night view of
the west facade. Right: The
restored entrance lobby of
71 Fenchurch Street. Below
Right: View from Fenchurch
Street through the courtyard
garden to the new building
beyond.

Lloyd's Register (an organisation totally separate
from that of Lloyd's of London) is an established City
institution, its Fenchurch Street headquarters the
centre of a worldwide operation. The growth of the
business during the 1980s and the planning constraints
on developing the congested Fenchurch Street site
made Lloyd's Register consider moving out of London.
In 1993, RRP was commissioned to prepare proposals
for developing a greenbelt site at Liphook in Hampshire.
The Liphook scheme, featuring low-rise, naturally
ventilated pavilions sunk into a mature landscaped
park, marked a significant phase in RRP's developing
interest in low-energy, sustainable design. The scheme
was, however, abandoned in the face of planning
objections and in 1995 Lloyd's Register commissioned
RRP to prepare proposals for its City site.

Set within a conservation area, access to the
headquarters is through a landscaped churchyard.
The site is largely surrounded by existing buildings,
including 71 Fenchurch Street constructed for Lloyd's
Register in 1901. This Grade II listed building has been
incorporated into the new headquarters and extensively
restored. The original building retains a general
committee room, chairman's office and smoking room,
and now includes a conference suite with a 50-seat
auditorium. The new building comprises 14 stories of
office space and two basements. The brief called for a
net lettable area of 24,000 square metres.

The floorplates of the new building taper in response
to the awkward geometry of the site, creating a fan-
shaped grid composed of vaults formed around two
dramatic atria spaces. This design allows daylight
penetration and provides thermal buffers between
the offices and the external environment. The building
steps up from six levels to 14 levels within the centre
of the site.

Service cores are expressed as towers – two primary
circulation cores face the churchyard, while secondary
cores to the rear house toilets, goods lifts and staircases,
as well as main services risers. Highly transparent
glazing offers instant legibility – people using the
fully glazed wall-climber lifts and stairs animate the
building's exterior.

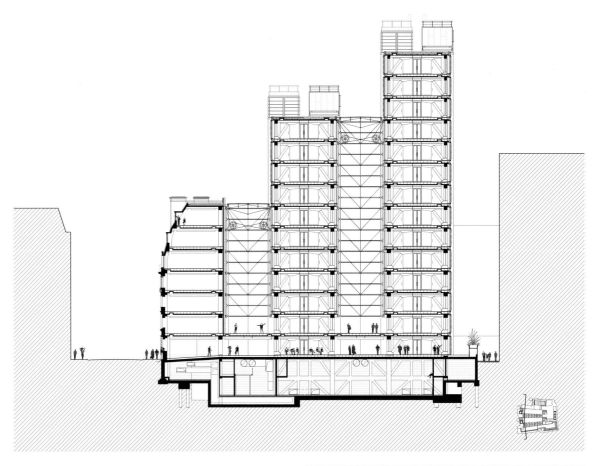

Above: Section. Right: Typical office interior. Opposite: View of the two central wings overlooking the landscaped courtyard.

The main glazed facade is designed to maximise daylight while limiting solar heat gains in summer and heat losses in winter. In addition to double glazing, the east and west facades feature panels of motorised louvres which control solar energy ingress. Activated by photocells mounted at roof level, when the louvres are angled at 45 degrees the facade system reduces solar heat gain by 90 percent.

Working in conjunction with the louvred facades, chilled beams incorporating sprinklers, lighting and a PA system cool the air in the office space. Treated fresh air is supplied through a floor plenum and extracted at high level. The building's energy efficiency means a reduction of carbon dioxide emissions by 33 percent and of costs by 40 percent when compared with those of a conventionally air-conditioned building.

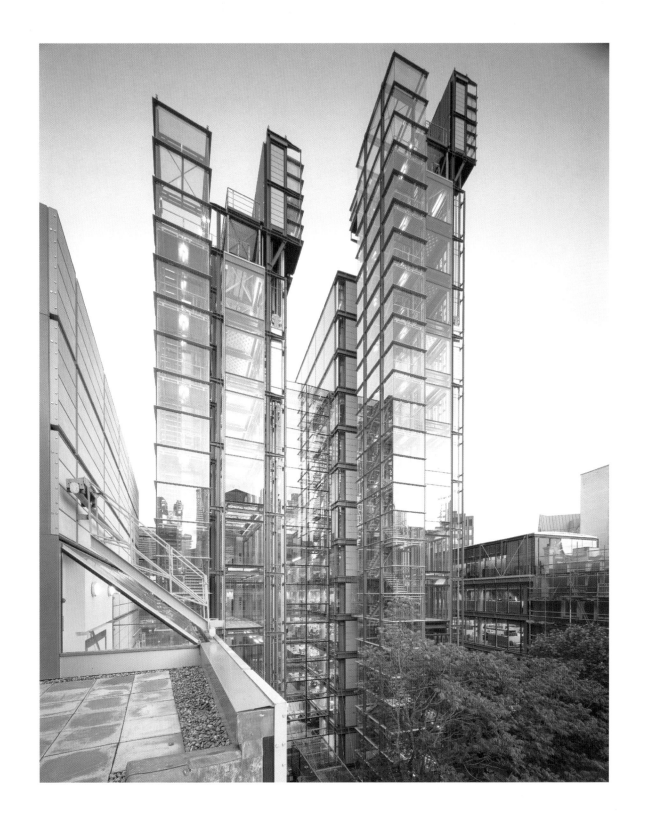

Right: The landscaped entrance courtyard.

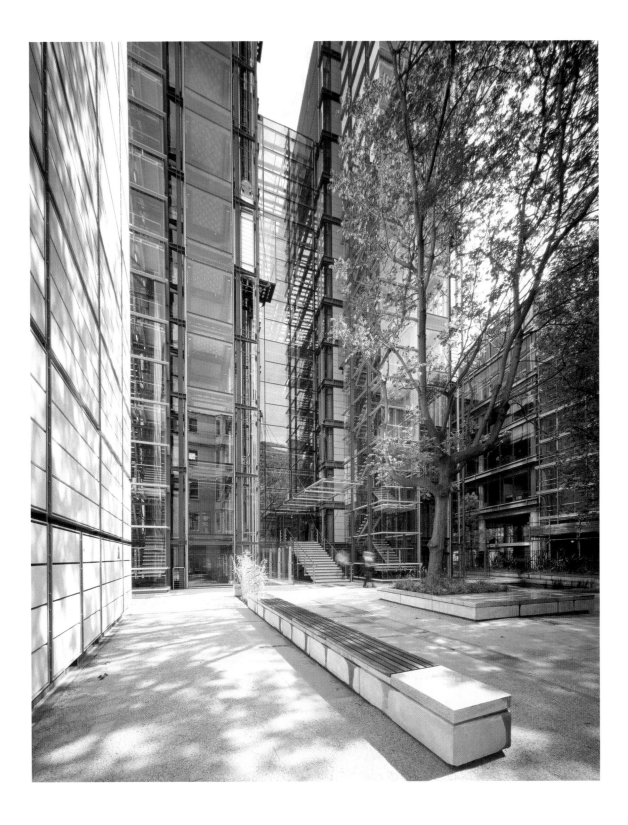

Right: One of the glazed atria that allow natural light deep into the office space. Below: A judicious use of colour brings added clarity to the scheme.

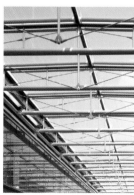

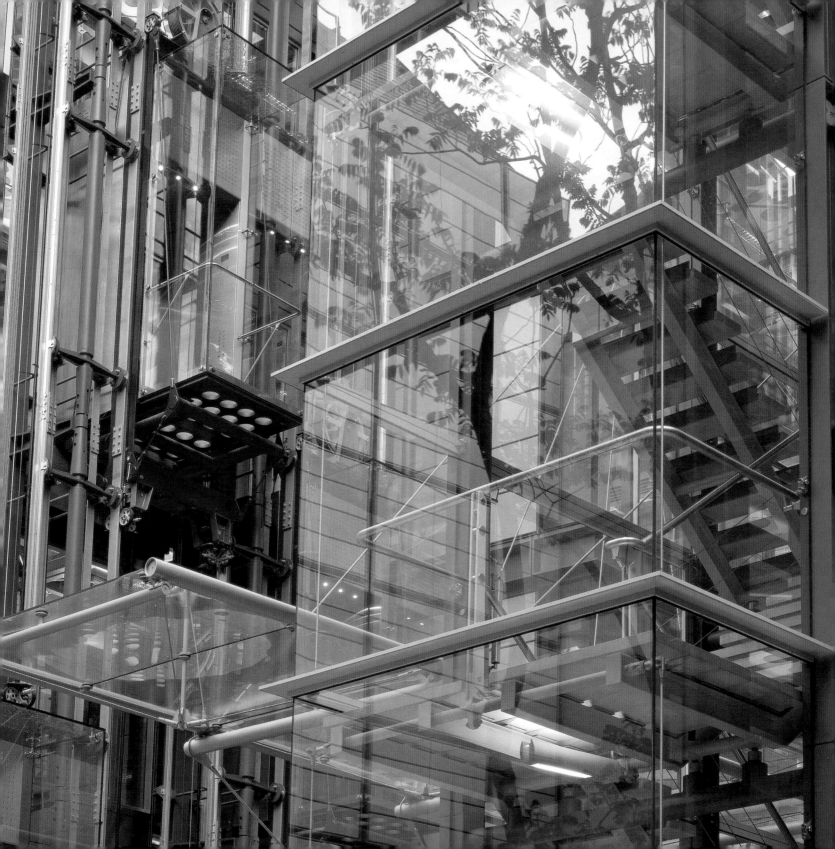

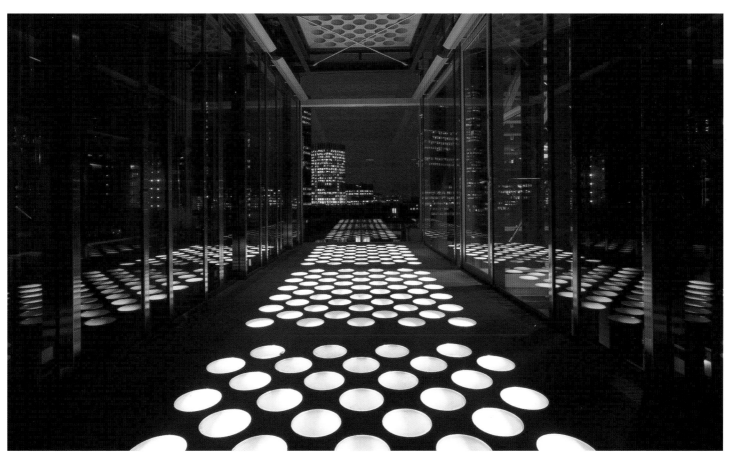

Opposite: Detail view of the glazed lifts and stairs. Above: Dramatic lighting in the lift lobbies at night. Right and Far Right: The clear glazed facades are clad with motorised aluminium louvres.

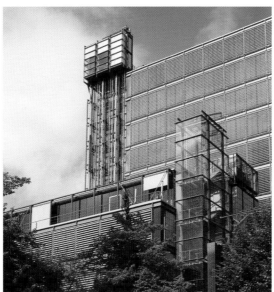

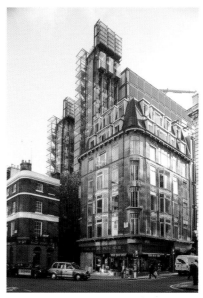

Seoul Broadcasting Centre

Seoul, South Korea
1995

"The reorganisation vertically of what is typically a low-rise assembly of interrelated buildings became the most challenging part of the project." Richard Paul

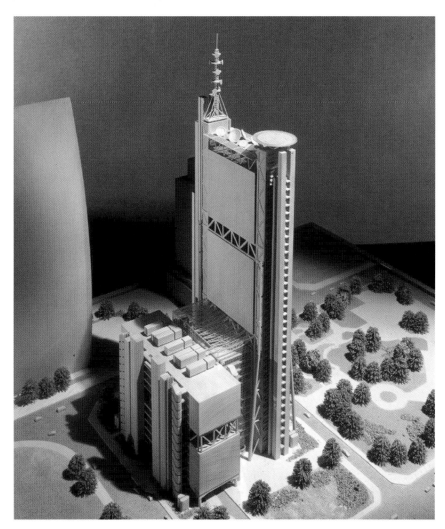

Above: Model of the scheme with the studio building on the left and the administration and transmission tower on the right, connected by a glazed atrium.

RRP won an international competition to design new headquarters for Seoul Broadcasting Systems, comprising news, education, music and radio studios as well as supporting production and programming areas. This building was to occupy a focal position within the new Mok-Dong area, located on the northern boundary of Omok Park. Initially a twin-tower scheme, RRP subsequently modified the design to provide a single, 82,000 square metre, 24-storey tower with five levels of basement separated from the seven-storey studio building by a transparent 13-storey atrium. An underground station at the south-eastern corner of the site provides links to the city centre.

The design provided the client with a distinct identity in the world of media business and television production. RRP's scheme is light, open and sufficiently flexible to respond to the needs of the constantly changing world of television. The tower houses the administrative and transmission functions of SBS while the studio accommodates productions and the operation of the television station. In order to articulate these disparate functions, the atrium introduces light and provides a public face for the organisation.

A high level of acoustic separation is required for the studio, necessitating additional slabs, ceilings and walls. The roof and walls of the atrium are clad in planar glazing and supported by a system of trusses fabricated from steel tie-rods and pipe sections. In some areas of the building, the proximity of noise-sensitive production areas required high-performance sound-insulating structures for the walls, ceiling and floors. Service areas are located outside the studios, facilitating easier access and maintenance. Following the evolution of the scheme design, the project was executed by Ilkun C & C Architects and completed in 2003.

Below and Bottom: Detail of
the top of the tower and an
overall view of the scheme
as executed by the local
architects. Right: Computer
rendering of RRP's competition
design.

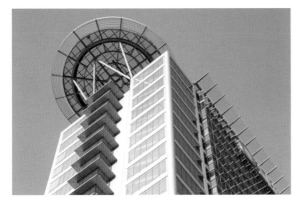

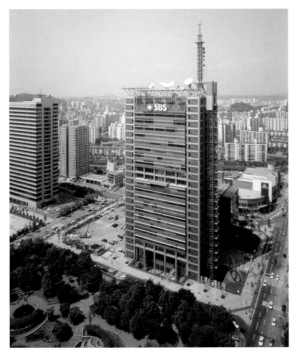

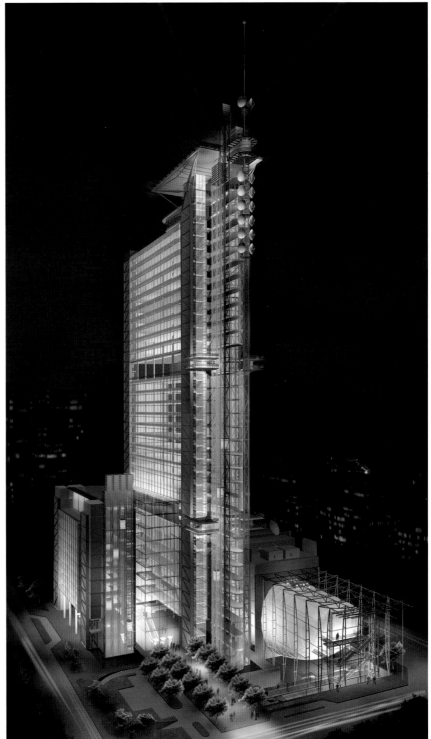

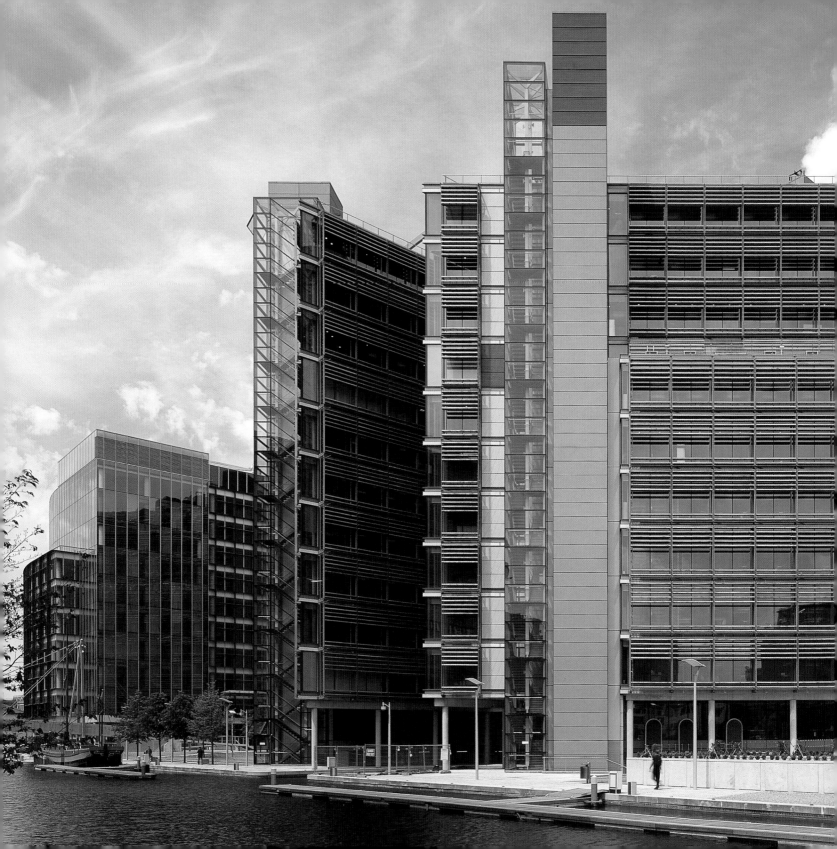

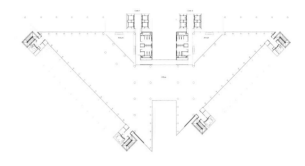

Opposite: The building overlooks the waterway of Paddington Basin. Left: Site plan. Below: Eighth floor plan.

Workplace	# Waterside	London, UK 1993–

"That the finished building is so close to the original concept is testament to a highly methodical and intense early design development." Graham Stirk

This scheme is located within the new masterplan for Paddington Basin – adjacent to Paddington station it will offer a revitalised, mixed commercial, residential and retail waterside environment. The basin has excellent rail, road and London Underground connections with a direct link to Heathrow Airport via the 15-minute Heathrow Express service.

Waterside, the new corporate headquarters for Marks & Spencer, comprises 13 levels of accommodation, including plant and parking facilities at basement level. Large triangular floorplates provide good levels of daylight and oblique views along the

canal. The forms are cut back on plan to create simple, contained external spaces fronting onto the canal that benefit from increased levels of sunlight. Public pedestrian ramps provide a natural route from North Wharf Road, through the lower ground level to these new spaces.

The building comprises served space – the main occupied floorplates – and servant spaces providing the essential support that allows the office floors to function. These elements are distinctly expressed in the form of the building. The floorplates are formed by a simple structural system that creates

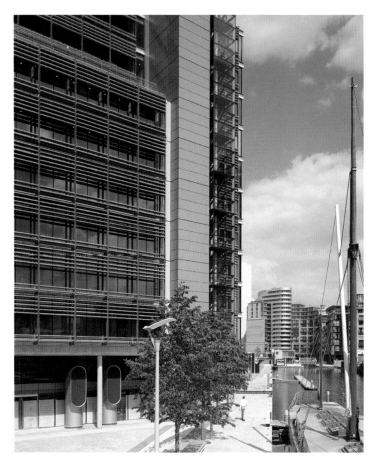 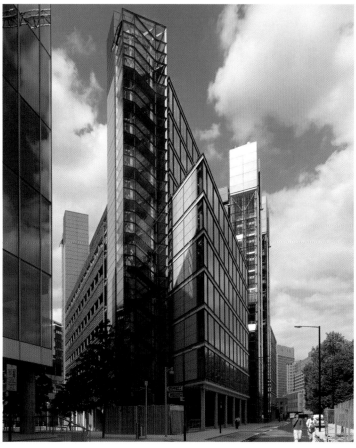

Above Left: The canal basin is a significant public amenity and the building is set back to provide a generous pedestrian route along the basin edge.
Above Right: Stair and service cores define the geometry of the building.

a good quality, flexible working space. Two full-height atria with circulation bridges facilitate daylight penetration and create a secondary aspect to the north of the site.

The secondary service elements are distinctly expressed in the form of corner towers that service the main accommodation, creating emphasis to the canal edge and to the main entrances from North Wharf Road. The principal vertical circulation towers contain the main passenger lifts and give a strong dynamic identity to the development.

Massing datums from the overall Paddington Basin masterplan identify and organise the building form into clearly delineated elements. These comprise a setback at the lower level; a middle shoulder section

and a setback at level six comprising terraces that articulate the upper floor levels.

The building is designed to meet present and forecast environmental legislation. In reconciling the need for low operational costs and the provision of an excellent working environment, RRP has considered a range of environmental issues.

Waterside has remained true to what was originally a very robust, flexible and considered architectural response to a difficult brief for a high-value commercial development on a demanding inner city site. That the finished building is so close to the original concept is testament to a highly methodical and intense early design development.

Below: Attention to detailing and the careful use of materials result in a building that, despite its scale, conveys a sense of clarity and lightness.
Right: The building's symmetry and flexibility allows for two separate tenancies or for single occupancy (the current configuration).

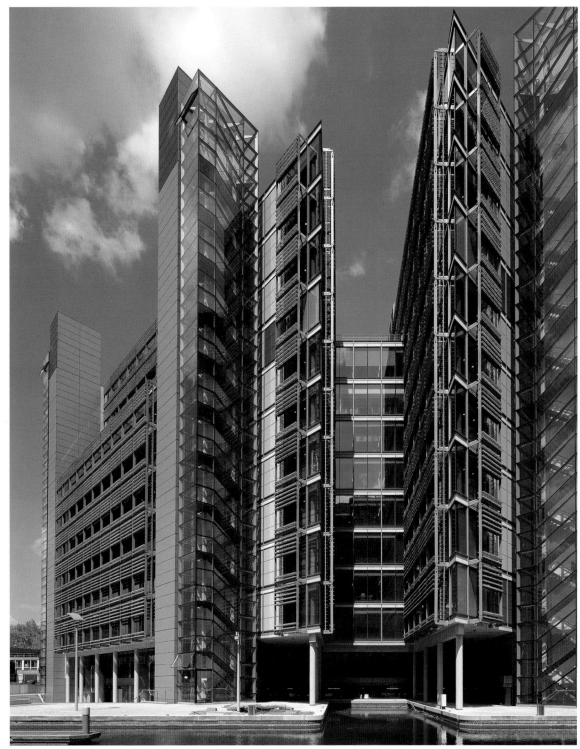

Grand Union Building 1

"The scheme reinforces the rhythm and variety of urban spaces immediately adjacent to Paddington Basin." Graham Stirk

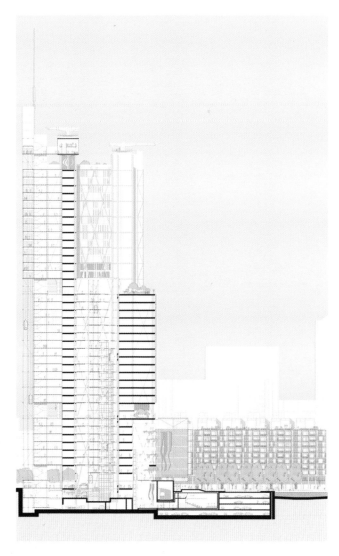

Above: South elevation.
Opposite: The tower was designed as a landmark building at the termination of the Grand Union Canal.

This initial scheme for the Grand Union Building formed part of an overall masterplan for ten acres of largely vacant and underused land to the north of Paddington Basin, which terminates the Grand Union Canal. Strategically the site is at the heart of the largest designated regeneration area in central London, within walking distance of excellent public transport connections. Seeking to enhance the original first phase masterplan submitted by the Terry Farrell Partnership, RRP reinforced the rhythm and variety of urban spaces and experiences immediately adjacent to the basin towpath, creating pedestrian routes which inform the footprints of the proposed buildings, spaces and bridge links across the basin. Generous space is provided for canal barges and other watercraft, while varied building uses will sustain day-long, year-round activity.

The project was conceived as a substantial mixed-use development with a significant proportion of commercial accommodation, creating a high-quality 'landmark' building. Designed as a defining symbol and marker for the whole 80-acre Paddington Regeneration Area, this environmentally conscious building was intended as a pre-eminent example of high-density brownfield development.

This high-rise scheme integrated a number of mixed uses: hotel and office accommodation, a health club, three sky gardens, retail space, space for 400 bicycles and 600 cars, community theatre/dance facilities, basement plant, delivery bays, coach parking and tenant plant/storage. The commercial development included offices at the lower levels with a hotel above. The high-rise element is adjacent to the A40 roadway on the most northerly edge of the site, while the lower-rise residential development, with retail at ground level and studios on the first floor, was arranged around a new piazza to the south. This maximised residential

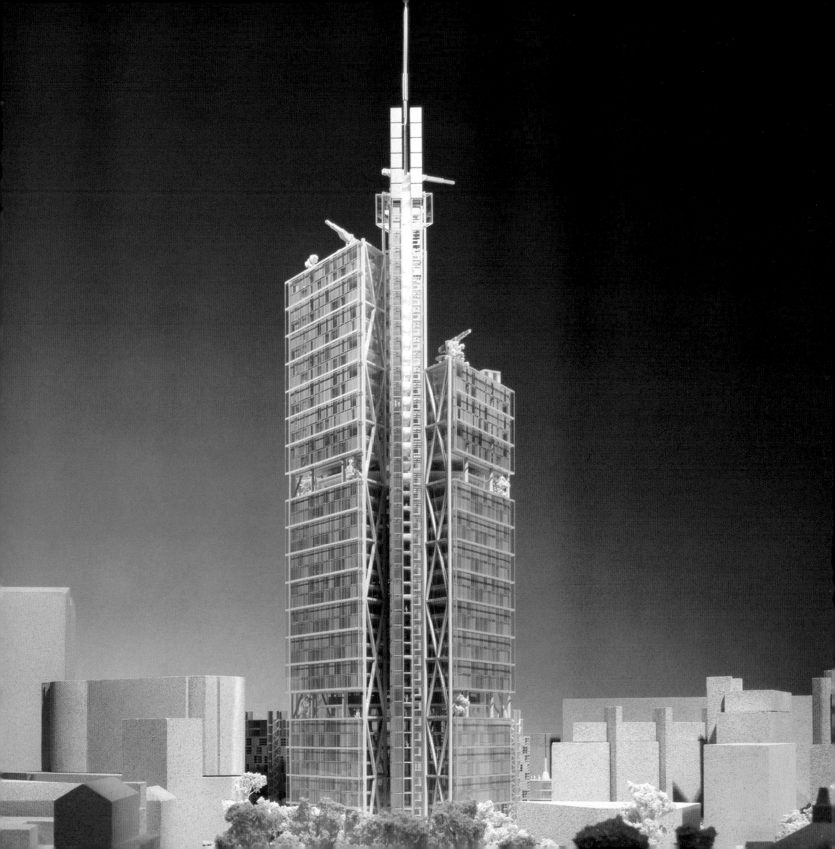

frontage and a sense of enclosure, creating a quiet place for pedestrian activity. A large winter garden space, inserted between the two residential buildings on the axis of the high-rise building behind, provided a large enclosed year-round space for office, reception, restaurants and exhibition purposes, providing a window to the new piazza and basin beyond.

The massing strategy for the high-rise element consisted of three structural towers connecting three floorplate segments of 24, 32 and 40 floors respectively, creating a varied skyline profile which is rotational in its composition. This dynamic design allows the building floorplate to decrease in size as the building gets higher. In this way the building profile would always change depending on the angle of view, adding vibrancy to the London skyline.

A variety of lightweight cladding panels were designed to meet various performance and aesthetic criteria. The main glazed facade to the office areas was designed to maximise daylight in the building whilst limiting solar heat gain in summer and heat losses in winter. The external facade incorporates an integral solar shading system contained within a climate-moderating triple-glazed wall system – a single-glazed outer leaf, a metre-wide cavity (incorporating an automated blind control system) with a double-glazed inner leaf. This allows the shading to be protected from high winds and also naturally ventilates the outer metre-wide cavity. This system removes solar heat from the blinds and opening office windows while protecting the occupied zone from wind. The vertical timber louvres complement those used throughout the Paddington Basin development.

The central atrium was intended to operate as an environmental buffer allowing the internal facade to be naturally ventilated during mid-season periods. Opening windows from the office floor levels would use the stack effect of the south-facing atrium roof which would exhaust air at high level. Supply air to the space is via vents at entrance lobby level. The facade system was also specified for the hotel, but with manually opening shutters to each room. These timber shutters enable the room to be 'closed off' when not in use, with environmental systems switched off to conserve energy. When the shutters open, rooms would be naturally ventilated. The high-performance nature of this facade system also allows flexibility in the type of low-energy environmental control systems that can be used.

In the event, this initial design did not receive planning permission after concerns were raised regarding the scheme's height and perceived impact.

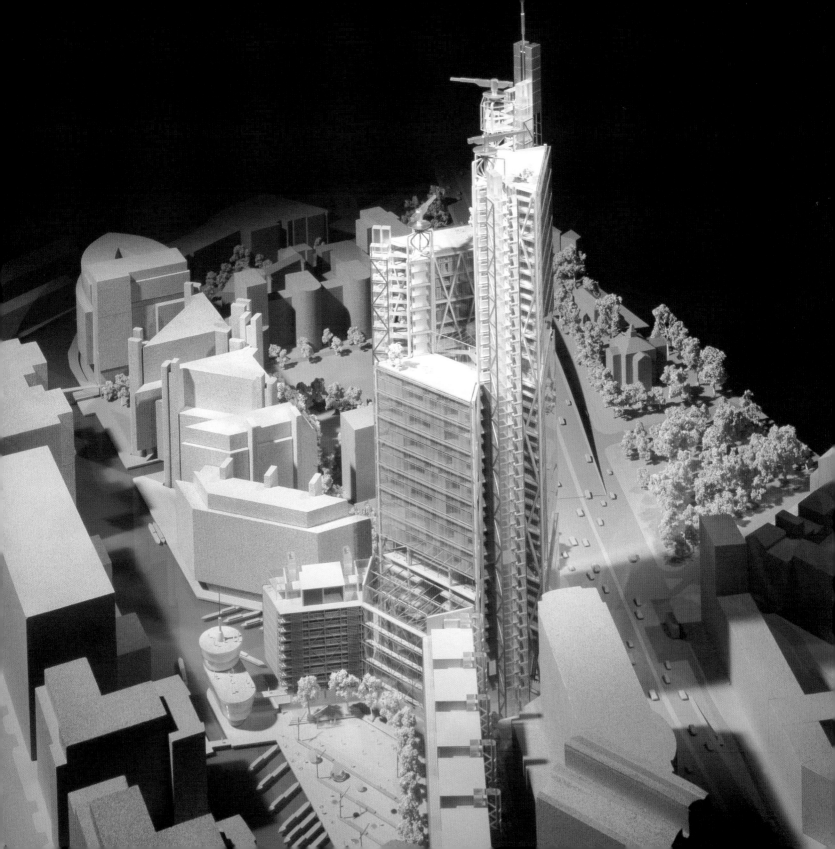

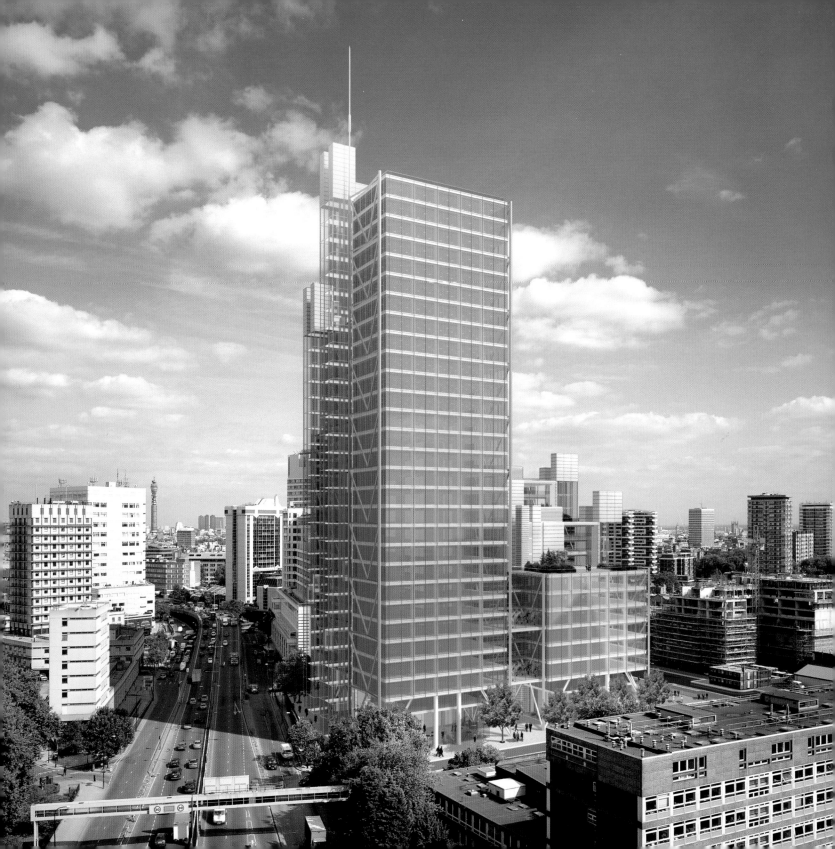

Grand Union Building 2

"The scheme's systematic composition creates a considered transition of scale, animated by vertical circulation and public space." Graham Stirk

Opposite: The building was conceived as a variable composition mediating between the canal to the south and the motorway – one of the main arteries into London. Below Left: Typical floor plan conceived as a series of interlinked pavilions that can accommodate variable uses. Below Right: Model view showing how the drama of the stepping profile is articulated by the north-facing elevator towers.

The practice's revised scheme for the Grand Union Building offers a high-quality mixed-use development in excess of 100,000 square metres (1.1 million square feet), including office and residential space with some retail accommodation, together with a major public space adjacent to the canal basin. Benefiting from Paddington Basin's excellent public transport connections – rail, underground and bus networks – Grand Union Building will form a major new gateway to London's West End.

The revised design strategy of the new scheme reflects the detailed site analysis prepared for the earlier proposal, responding sympathetically and imaginatively to neighbouring street patterns and the varied urban grain. The new skyline composition offsets the larger floorplates at lower levels with light transparent vertical elements such as stairs, lifts and risers. These core elements create focus, drama and legibility, as well as a clear sense of hierarchy. Careful attention has also been paid to the roofscapes: all terraces are landscaped and mechanical/electrical equipment has been located either in the basement areas or on-floor, leaving only heat rejection plant and window cleaning equipment at roof level. Planted terraces at every roof level provide a series of elevated gardens – an attractive amenity for occupiers of both residential and commercial buildings.

This scheme demonstrates the practice's ongoing commitment to high quality design and sustainable development. Providing maximum flexibility for future letting strategies, the floorplates are conceived as two sets of three rectilinear plates – either medium-sized plates in separate buildings or linked via an atrium to create a far larger floorplate. This allows the possibility of one large single tenancy or up to six separate tenancies. In addition, the building can be vertically split to accommodate any combination of floor configurations without compromising essential servicing requirements. The staggered floorplates also maximise natural daylight to the buildings and views over the surrounding area. The building will be constructed to meet the highest standards of sustainability.

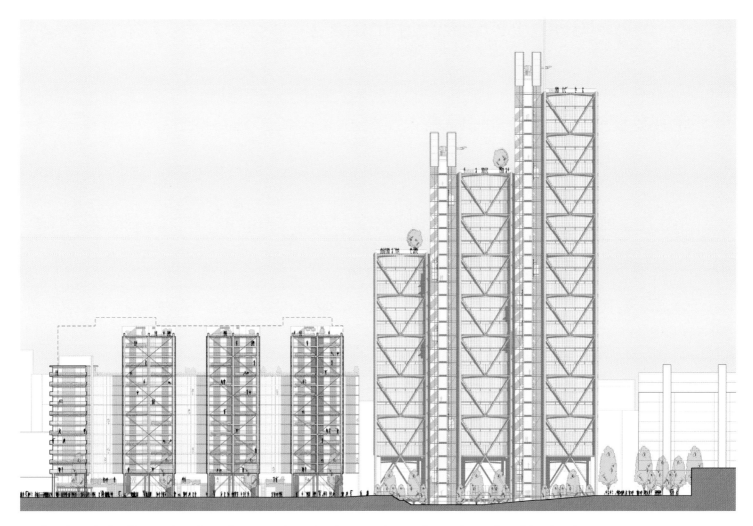

The scheme's detailing, scale and massing respond sensitively to the immediate urban context – the external stability structure to the north and south elevations is a scaling device adding grain and filigree to the facade treatment. In addition, the building steps up from a 36-metre datum in the lower-rise southern building at 12-metre-high intervals of three storeys, increasing on the northern block to 24-metre-high intervals of six storeys. This reduces the impact of buildings to the south facing the basin edge, acknowledges the intermediate height of the adjacent hotel extension and progresses up with three further steps to the 120-metre-high block to the north-western edge of the site. By locating the highest part of the

development close to the northern edge of the site, the impact of shadows cast is minimised. In addition, the tallest part of the scheme screens out the toxic fumes and noise generated by the A40M – one of London's major arterial routes.

The high-performance nature of the scheme's facade system achieves thermal comfort through flexible, low-energy environmental control systems. Lightweight cladding panels are designed to meet a range of performance and aesthetic criteria. The scheme also features a climate-moderating triple-glazed wall system – mechanically operated blinds in the ventilated cavity offer protection from solar heat gain and glare. The facade is designed to work in conjunction with

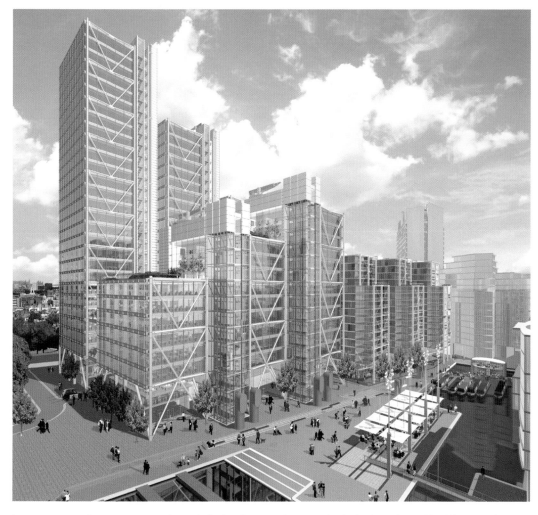

Opposite: The composition was conceived as a sequence of 'organ pipes' enriched by the expression of their separate functions. Left: The buildings to the south respond to the scale of the immediate urban context and form the northern enclosure to a new public realm.

low-energy cooling systems such as chilled ceilings and beams, a system consistent with other buildings being constructed at Paddington Basin, notably the practice's recently completed Waterside development – the new headquarters for Marks & Spencer.

The revised proposals maintain the original objective to create a major public space at the eastern end of Paddington Basin. Unrestricted public access throughout the site and to the waterside remains a key feature, with pedestrian routes linking all residential and commercial buildings (accessibility for people with disabilities is a primary design criteria for all open spaces and connections). Shops, restaurants and leisure facilities will offer a new range of amenities to the existing community.

The linked residential buildings to the eastern edge of the site offer 291 units, including 115 affordable housing units – 30 units of social rented housing, 29 units of low-cost shared ownership and 56 small units for key workers. Almost all apartments feature balconies to maximise views over the canal basin.

Elegantly proportioned, this major development is an ingenious response to a complex brief and will undoubtedly make a dynamic and positive contribution to the capital's newest commercial and residential quarter.

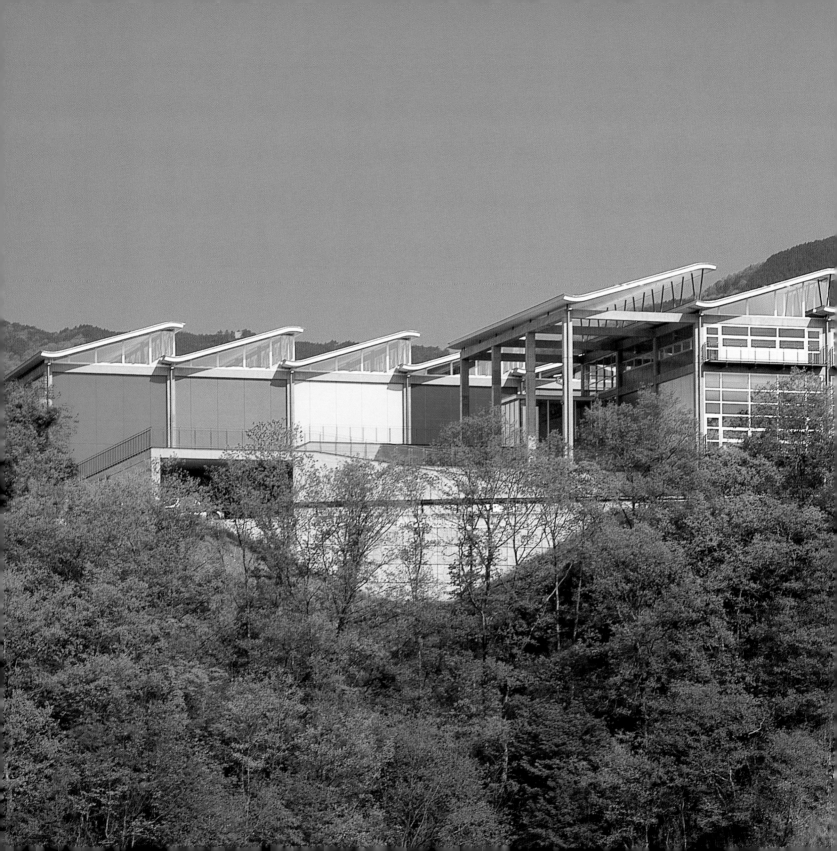

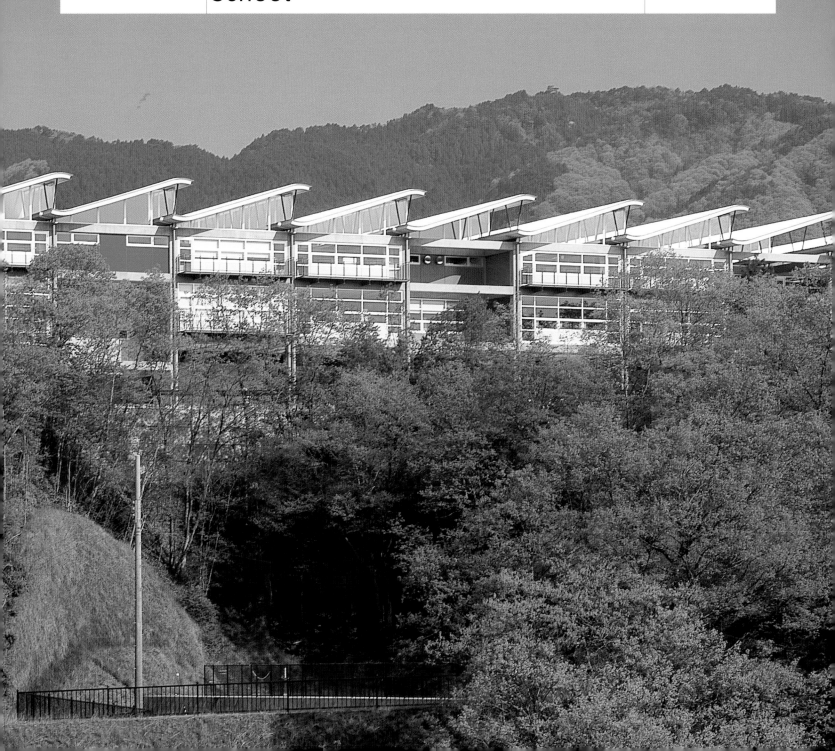

Minami-Yamashiro Elementary School

Previous Pages: The school
stands on the brow of a hill
with extensive views over the
surrounding landscape. Below:
The repetitive angled roof
lends a rhythm to the long
facade and brings natural light
down into the interior spaces.
Opposite: View of a circulation
gallery, shared break-out space
and classrooms below the
glazed roof-lights.

Minami-Yamashiro is a remote village in the Kyoto Prefecture nestling in the mountainous region south of Kyoto. Recognising a growing decline in rural population, the local mayor was anxious to reverse this trend by initiating a project that would reunite and regenerate the local community – a school with an extended role as a community centre. After a protracted political battle (originally designed in 1995–96, the building was finally constructed in 2001–03) the result is a building that has restored a sense of identity and civic pride. Prominently located on the main road to the village, the school stands on the brow of a hill, with panoramic views over the countryside beyond.

The brief called for a low-budget school for 6–12-year-olds that would also provide community centre facilities for the village – a radical departure from the Japanese norm. The 6,200 square metre building has been conceived as 'a big house', offering not only day-time schooling but evening classes/life-long learning for the community's adult population.

The heart of the school is a large common hall that mediates between the outdoor playing fields and two levels of flexible classroom spaces arranged within a repetitive framed grid of 8.1 by 8.1 metres. This multi-level top-lit space is similarly organised within the expressed structural grid and contains all circulation and classroom breakout spaces. Specific spaces for art, science and music classes are grouped at the lower level. A sequence of modular north lights bringing light deep into the heart of the building. An adjacent gymnasium/village hall, built from the same kit of parts, frames the approach to the school and the playing field (including an outdoor swimming pool) which it contains on two sides. Bright wall colours within the grid frame are coded for children and adults, defining different areas and functions.

Detailed and implemented by RRP's Tokyo office, this project uses simple, durable, low maintenance materials to achieve elegant results. The building has a strength of its own, yet can be read within the classic Japanese constructional tradition which has long inspired modern architects.

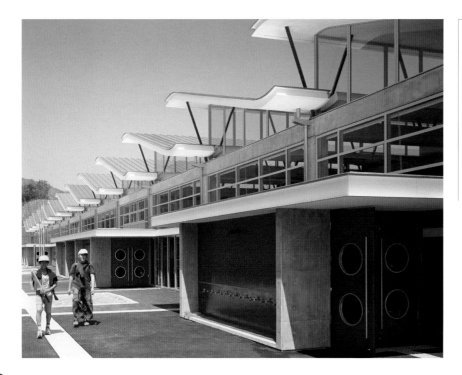

"The design uses the discipline of an economic modular grid to accommodate a variety of spatial experiences for both children and adults. The fun experienced in the building arises from our playing with this grid in many different and surprising ways." Ivan Harbour

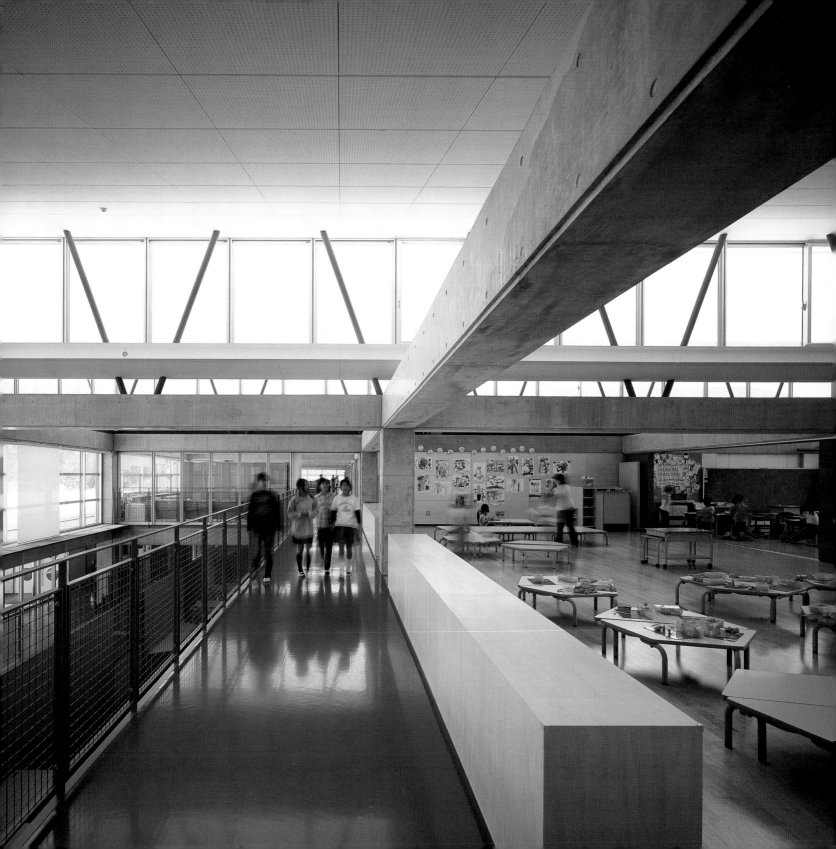

"With its sweeping arched roof enclosing double-height studio space, and slender glazed lift tower marking the main entrance, Broadwick House is an unashamedly contemporary landmark which will make a significant contribution to the character, townscape and life of Soho." John Young

Bespoke office buildings, like Lloyd's of London or Lloyd's Register, are often mould-breakers. The speculative development sector tends to be more cautious and certainly less likely to challenge planning constraints which reduce the potential for innovative design. In this light, Rogers' Broadwick House comes as something of a surprise. The building was commissioned by a developer and stands in the Soho conservation area, where straightforwardly 'contextual' design has been the norm. The planning negotiations for the project were protracted but the result is a strikingly contemporary structure that enhances the neighbourhood.

The site is an island, with thoroughfares on all four sides. To the east, it abuts Berwick Street, with one of London's best-known street markets. Neighbouring buildings range from Georgian town houses to 1960s high-rise flats and crass 1980s Post-Modernist office blocks. Into this diverse scenario, the Rogers scheme introduces an element of calm, rationality and urbanity. By concentrating service cores on the western edge of the block, clear, well-lit and highly transparent office floors are created behind fully glazed facades.

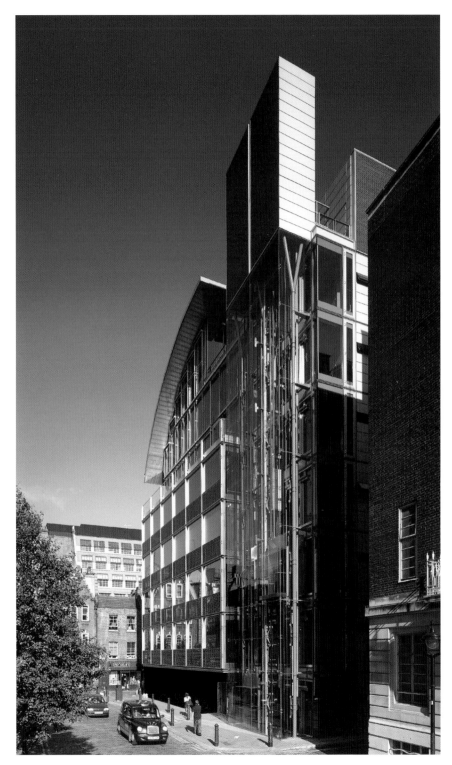

Energy efficiency is ensured with the provision of solar performance glazing, in conjunction with external shading devices and motorised blinds. Ground floor facades are set back to facilitate passage along the crowded streets – ground floor and basement areas are allocated for retail and restaurant use, whilst at the fifth floor, the building steps back to provide outdoor terraces. The most distinctive element of the scheme is the double-height space set below the great arched roof, affording spectacular views over London's West End. The glazed lift tower on Broadwick Street is a memorable urban marker, a celebration of movement typical of RRP.

Crisply detailed and using a carefully selected palette of materials, this modest (4,252 square metres), but distinguished addition to the Soho scene has been let to the London design studio of motor giant Ford.

Opposite: Concept sketch.
Left: The glazed main facade, topped with the sweeping curved roof. Above: The Broadwick Street elevation.

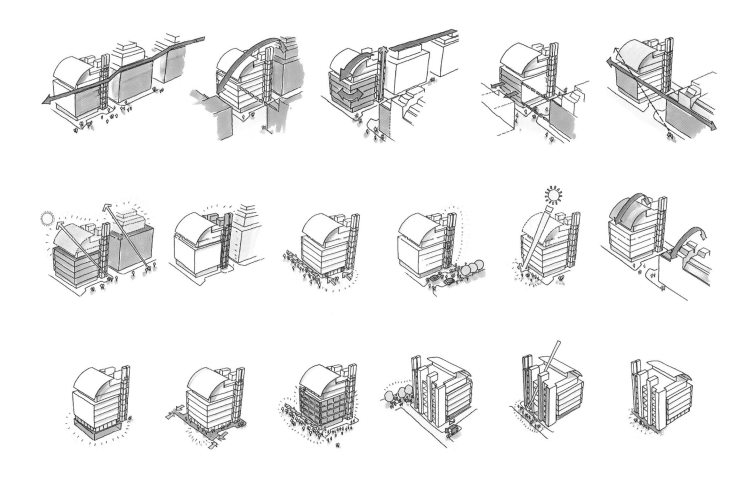

Above: Diagrammatic exploration of contextual and environmental factors influencing the design. Right: Lift motor and control rooms are stacked to give a strong vertical emphasis. Far Right: Structural steel element supporting the great arched roof.

Right: Interior of the double-height studio space. Below Left: Concept sketch of the glazed roof-top studio. Below Right: Early concept sketch showing the lower ground floor restaurant with spatial and visual links to Berwick Street above.

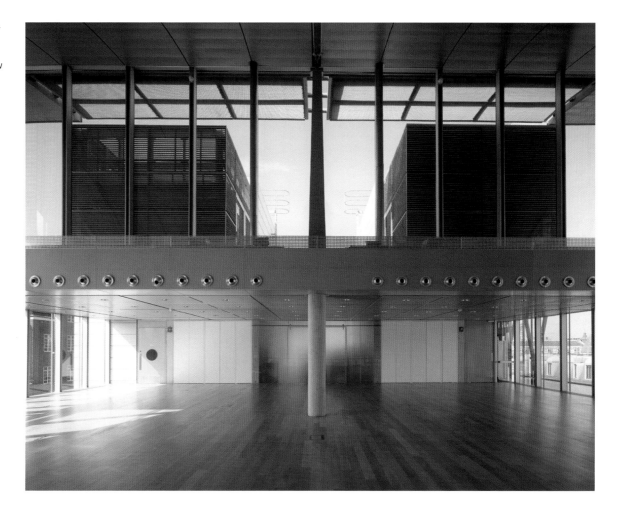

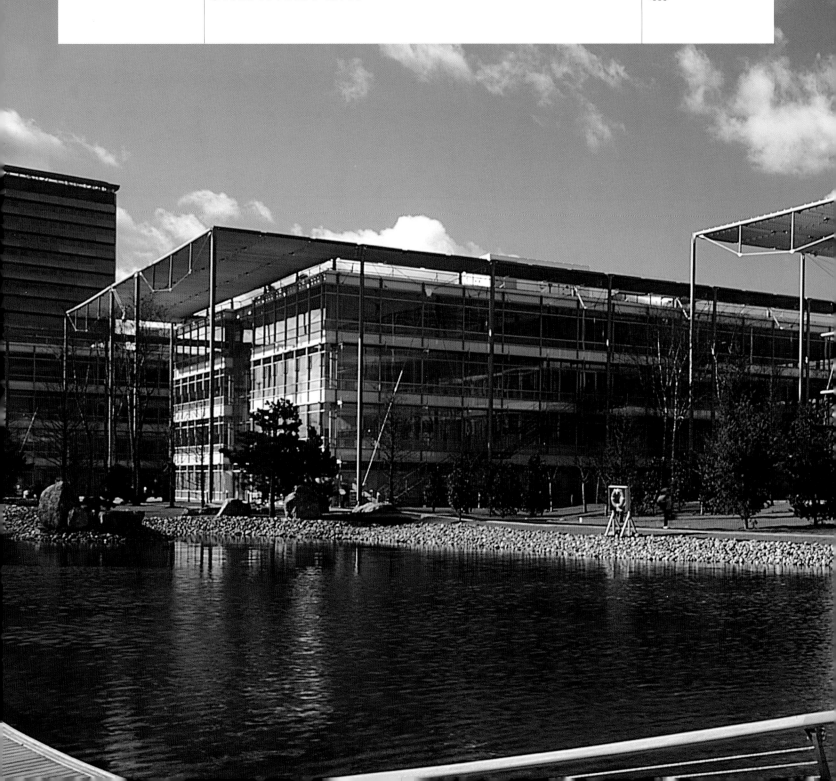

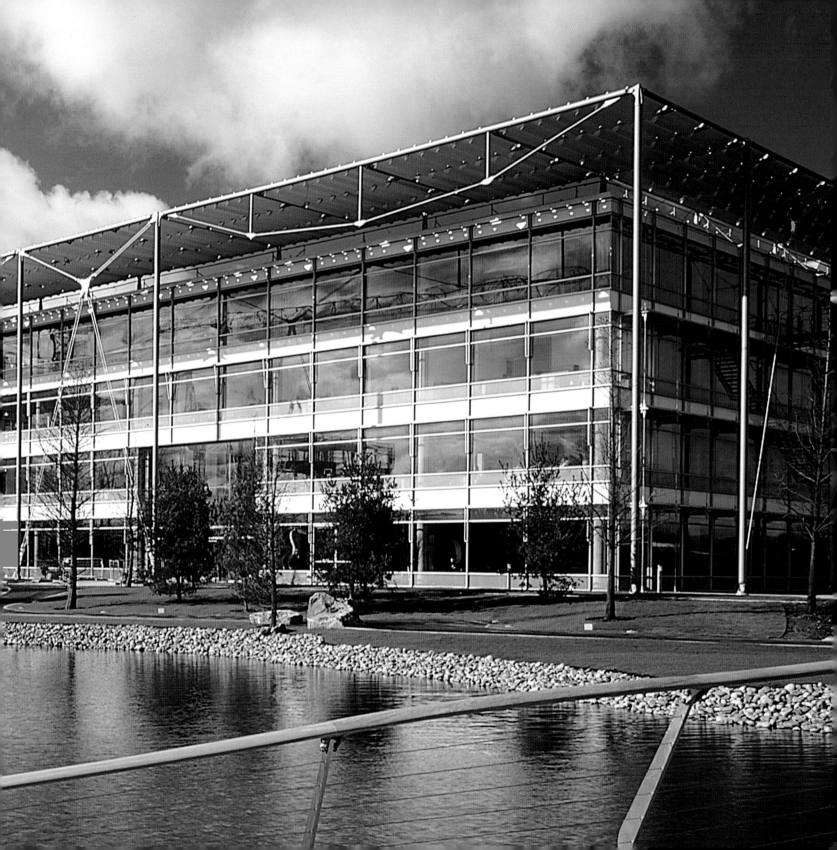

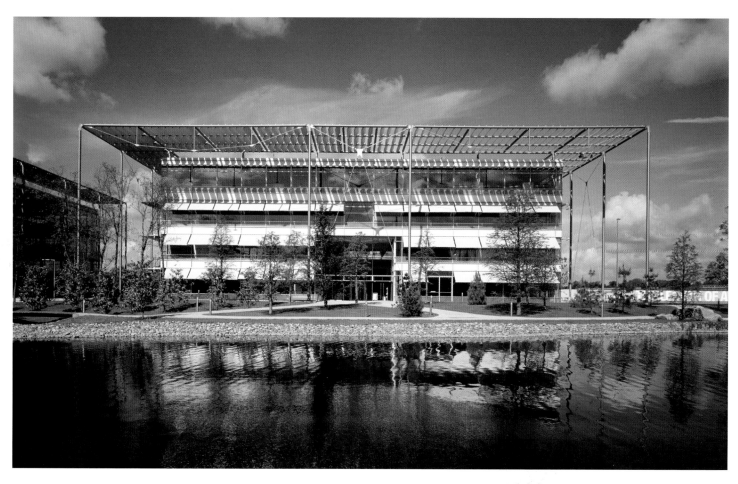

Previous Pages and Above: The park looks over a lake set within an eco-friendly landscaped park. Right: The layered facades include banks of fixed louvres protecting the building from solar gain. Far Right: The reception area.

> "The team's focus was entirely on the efficient delivery of a high-quality environment within the constraints of a rapid construction programme."
> Richard Paul

Below Left: The landscape redefines accepted notions of the business park, offering a range of complementary leisure activities. Below Right: Site plan.

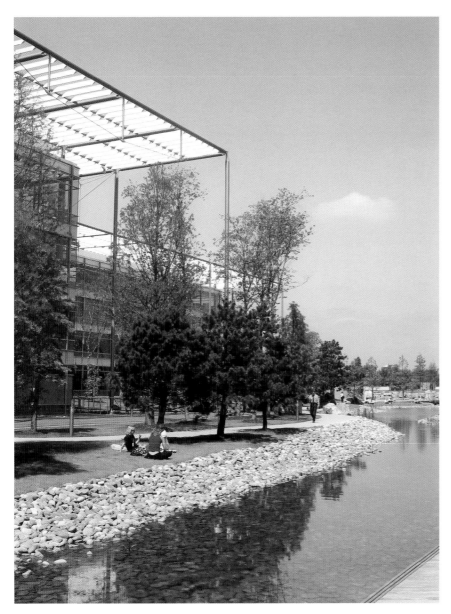

The business parks created in such large numbers during the 1990s – Stockley Park, near London's Heathrow Airport was probably the best of its breed – were generally out-of-town developments dependent on the private car. The worst examples were typified by buildings stranded in large expanses of parking.

Chiswick Park is a business park developed on a different theme. It is located within an existing built-up area on a brownfield industrial site and is largely dependent on public transport – when complete, 75 percent of those working there will arrive either on foot, or by bicycle, bus or train. The spectacular green parkland forming the heart of the site, managed on eco-friendly lines, is public space, open to all and includes an open-air performance area, a lake and nature reserve.

The 33-acre site was formerly a bus works (demolished in the 1980s) and is located off Chiswick High Road in west London, close to Gunnersbury Station and within easy reach of other Underground stations.

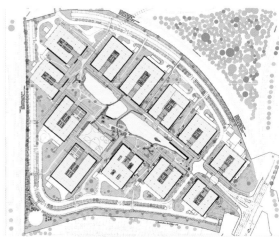

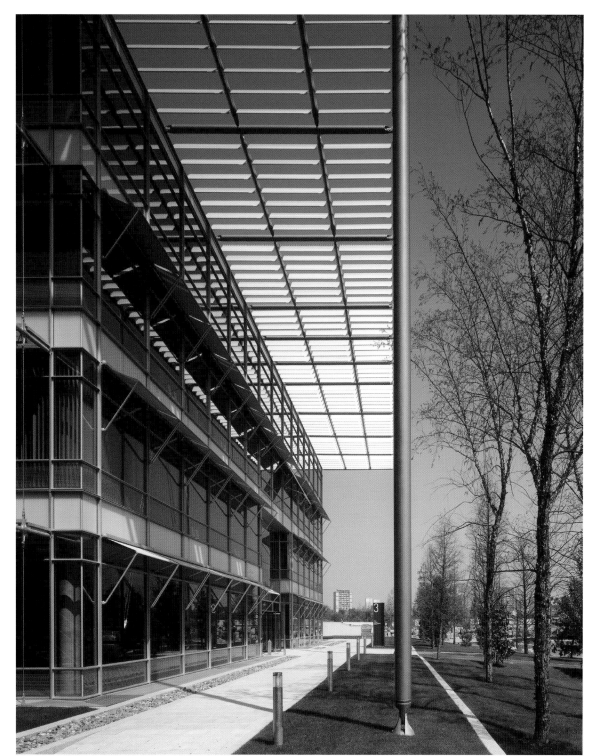

When complete, the project – which has already won numerous awards – will offer c.140,000 square metres of office space spread between 12 buildings, plus restaurant/bar, swimming pool and fitness centre. Beneath each building provision is made for car-parking and plant. Six four-storey buildings have so far been completed; subsequent phases will include a mix of five, nine and 12 storeys.

In contrast to those at Stockley Park, the buildings at Chiswick are standardised, using off-site construction technology, securing economies of time and cost – to date the six buildings have taken approximately nine months to construct. The project reflects the conviction of developer Stanhope that high quality can be achieved using standardised components and construction management procurement. The aim was to produce a development that is highly distinctive and yet buildable within commercial constraints. The office buildings contain highly flexible space that can be configured in open plan or cellular form.

The clarity of the building plan – a central core surrounded by uninterrupted 18-metre-deep office plates – is assisted by the use of external escape stairs which contribute to the scheme's distinctive identity. Central atria give views out into the landscaped park and bring light into the heart of each building.

The energy strategy is designed for economy and environmental responsibility – fixed external aluminium louvres and retractable external fabric blinds activated by light sensors together shade 90 percent of the buildings' surfaces. This significant reduction of solar gain makes possible the use of a displacement ventilation system – Chiswick Park's energy efficiency will result in low running costs in the long term.

Opposite: Retractable fabric blinds are activated by light sensors and together with the louvres, shade 90 percent of the glazed facades. Right and Far Right: Structural elements animate the facade and highlight the elegance of the integrated architectural and engineering solution.

Robert Bosch Foundation

The competition brief called for the creation of permanent office space for the Robert Bosch Foundation and educational/conference space for the executive personnel of Robert Bosch GmbH. The new accommodation was to be housed in an extension to the existing Robert Bosch Villa, a 19th-century building surrounded by landscaped gardens on a hill-top site overlooking Stuttgart.

The proposal comprised a discreet addition, sympathetic to the contours of the landscaped gardens and orchards of the original villa. It was decided that the existing stone base of the villa should define the roofline level of the new complex, which would extend eastwards from the villa in the form of an elongated 'galleria', with a series of pavilion-like buildings arranged beneath it. In this way the base of the villa becomes the common link between the old and new elements.

Small courtyards located between the pavilions create intimate spaces while the 'galleria' acts as the backbone of the composition, containing receptions for both the Bosch foundation and Bosch GmbH as well as other communal areas. Office and conference facilities for both institutions are provided on the level below. The roofs of the pavilions are accessible from the galleria level, subtly integrated within the landscape. The galleria roof is clad in a continuous surface of photovoltaic elements (supplying the new building's total energy requirements) which is then covered with a shallow water surface intended to clean and cool the cells whilst also providing a key element of the overall landscape concept.

The building consists of a set of pre-fabricated sculptural concrete elements with a standardised set of details for all interfaces with superstructure, facade and services – creating an efficient construction process without loss of quality. The aim of the energy concept of the building is to maximise the use of renewable sources of energy. All offices and communal spaces are naturally light and ventilated. The RRP competition entry was awarded joint first prize with Peter Kulka Architektur, Cologne.

"Extending and reinforcing the existing terraced landscape allowed us to develop a contemporary building typology that sits comfortably juxtaposed with the 19th-century villa."
Ivan Harbour

Left: Conceptual diagram showing the schematic heating and cooling systems.
Opposite: Site plan.

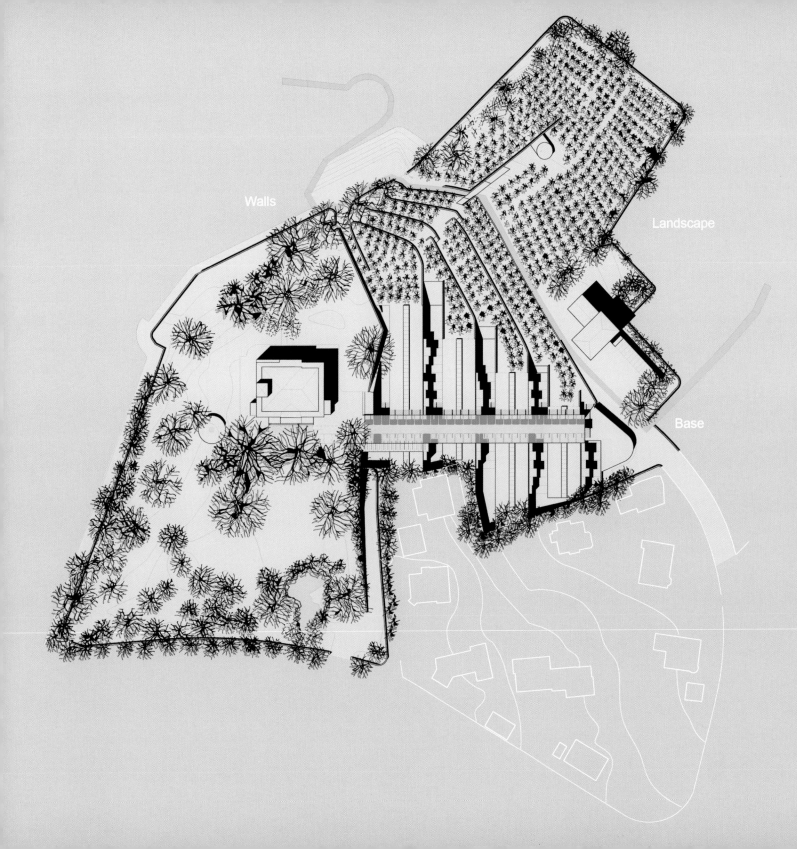

Walls

Landscape

Base

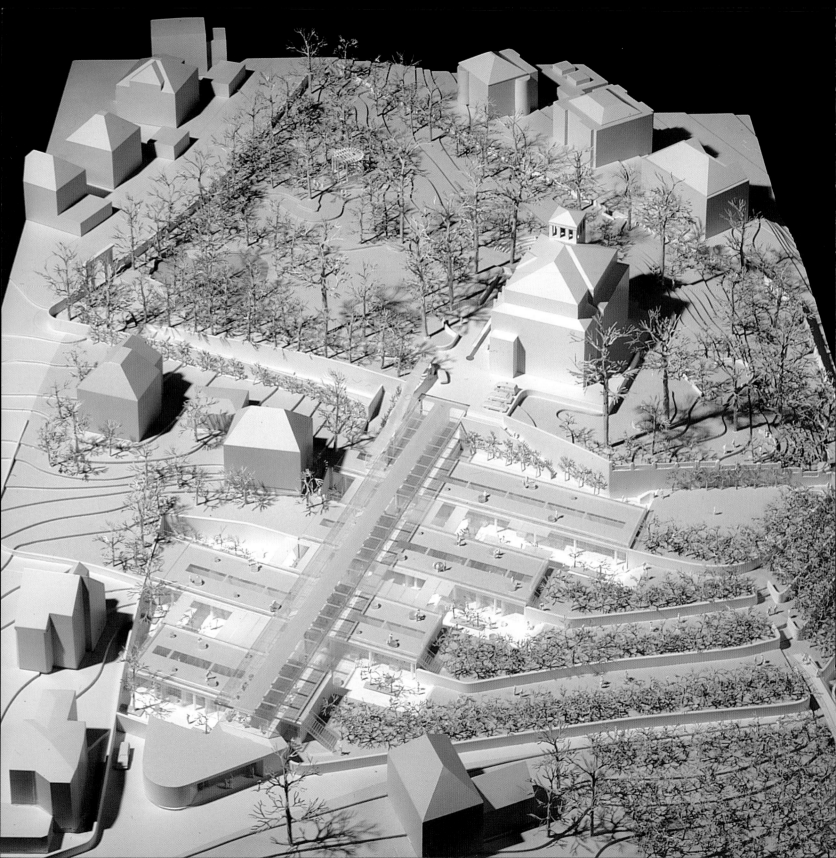

Opposite: Site model showing
the relationship between the
existing villa and the new
building. Below: Section.
Bottom: Site plan.

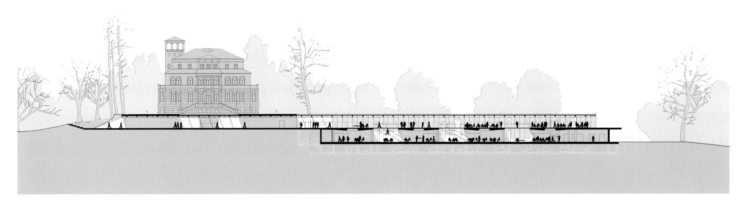

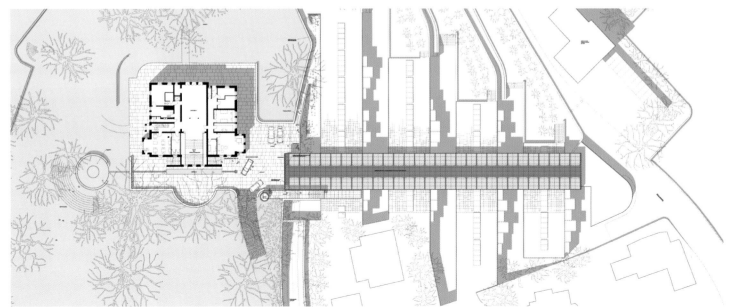

Left: The final scheme for Canary Riverside – the slipped profile and footprint respond to the diagonal site geometry. Below: Rendering of the initial proposal. Opposite: In the initial design, and the final scheme, the towers open up to the river and command views back towards the City. The two towers are separated by a link building containing trading floors and retail accommodation.

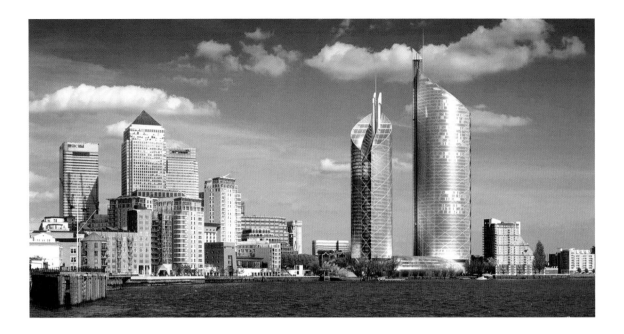

Canary Wharf–Riverside South

London, UK
2001–

The Riverside South development is part of the ongoing evolution of Canary Wharf (on the site of former docks in the Isle of Dogs) from a purely business quarter (60,000 people are currently employed there) into a mixed-use business, residential and leisure district of east London.

The mixed-use development of retail, restaurants, cafés, state-of-the-art and highly flexible offices and commercial trading floors is located on one of the last sites directly alongside the Thames, close to the heart of Canary Wharf. It consists of two dramatic towers, of 42 (218 metres high) and 36 storeys, separated in plan by a link building of trading floors and retail facilities, offering a total of 223,000 square metres (gross) of above-ground accommodation, and the plan includes extensive areas of new public riverside landscape. The plan is oriented to respond to the urban organisation of the wharf's buildings and the resulting slipped form plan is developed further in section and elevation to form its characteristic silhouette.

Restaurant, cafés and retail areas are located at the ground level of the three buildings along the river-walk esplanade and extend around the southern taller tower to a new public waterside park. Trading floors span contiguously between the lower tower floors and, if required, can extend to provide facilities of 8,800 square metres net. The upper floors in each tower provide typical lettable areas of 2,657 square metres, with floorplates diminishing at the uppermost levels to provide for corporate conference rooms and executive suites. The scheme is intended to be flexible in its occupancy. Entrances are located so that each tower and central building may be occupied by independent tenants. An access road loops beneath the central building providing a covered drop-off to all three buildings. Parking and servicing is beneath the ground and continues the Wharf's principle of prioritising the ground level as a pedestrian realm.

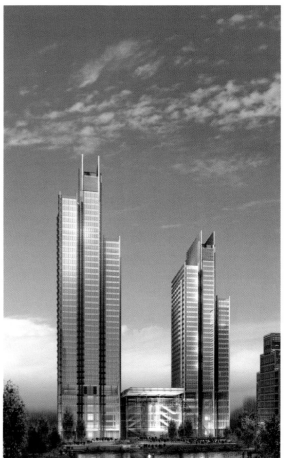

"The placement of the towers continues the urban grain established by the docks at Canary Wharf. The insertion of a public entrance between the towers is aligned with the Eastern Dock and Jubilee Park, giving a 'window' view west to the City of London."
Richard Paul

Above: Site plan indicating the way in which the scheme responds to the east–west axis of Canary Wharf. Far Left: The final proposal seen from Heron Quays. Left: Typical floor plan. Opposite: Sequence of development models showing the evolution of the scheme.

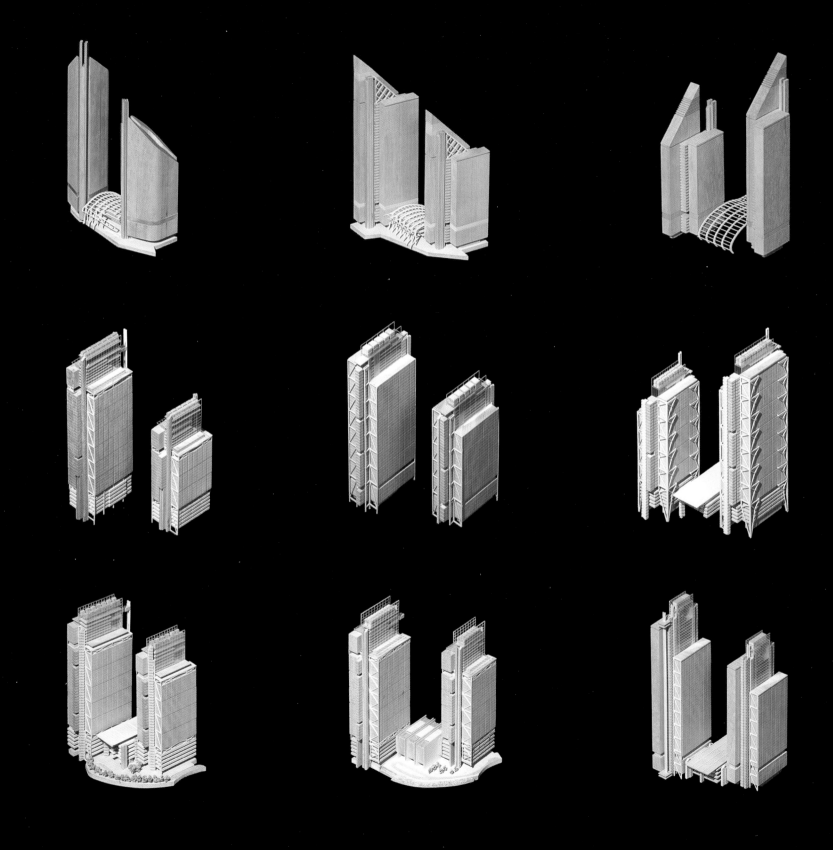

Viladecans Business Park

"The strong modelling takes advantage of the dramatic shadows cast by the intense sunlight, and the exaggerated overhang of the roof clearly expresses the environmental strategy inherent in the design." Laurie Abbott

Below Left: Site plan. Below Right: Located in a park setting, the buildings create an enclosure around a formal landscaped space. Opposite Top: Large roof overhangs, banks of louvres and adjustable blinds control the ingress of solar heat. Opposite Below: Elevational view.

The site is located to the north of the airport and adjacent to the motorway leading into the city centre. Towards the west, a large park is being established with a river running through the community of Viladecans and down to the sea.

The buildings' design, by RRP with Alonso Balaguer y Arquitectos Asociados, is a direct response to the specific location of the site. The prevailing wind is from the north with sea breezes from the south. In addition, the winds travelling down the river valley are directed through and around the buildings to provide night-time cooling and good ventilation. To provide effective shading on the south side of each building the scheme includes a combination of roof overhangs plus angled solar panels. The latter will provide a limited amount of electricity but would be in accordance with the current requirements for Barcelona. RRP also suggests the use

of solar collectors to be located conveniently on the roof. A grey-water tank will be supplied to each building, providing a grey-water system and also irrigation for the park areas. A centralised heating plant is also being implemented for the buildings. RRP is keen to establish an environmental strategy for the whole area.

The brief required a unit size of 5,000 square metres for each office building – by connecting adjacent buildings the scheme is adaptable enough to offer the potential for spaces of up to 10,000 square metres.

The growing population of this new development is sufficient to support a series of bars, restaurants and health centres – it is proposed that these amenities might be located at ground level facing the park, offering a valuable facility for both office and factory personnel, and for the general public. The buildings are very simple and flexible in their plan.

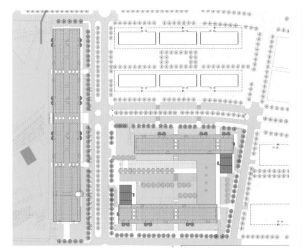

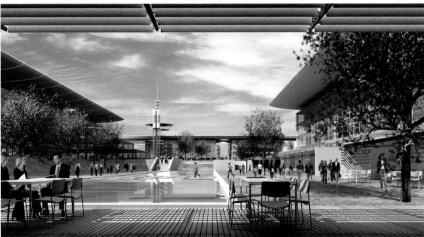

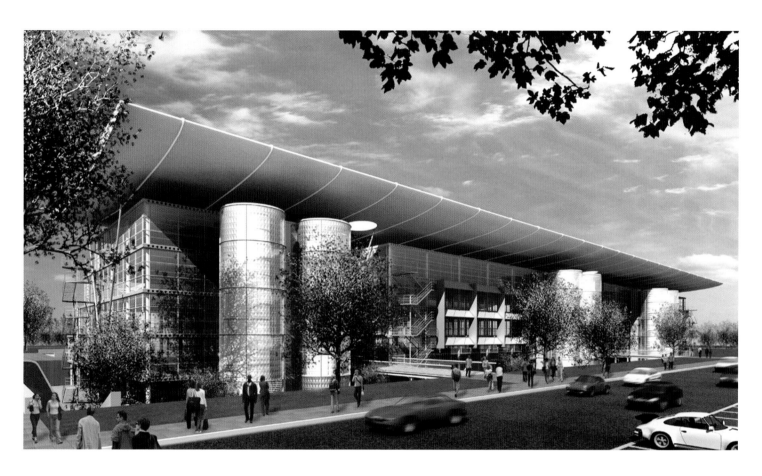

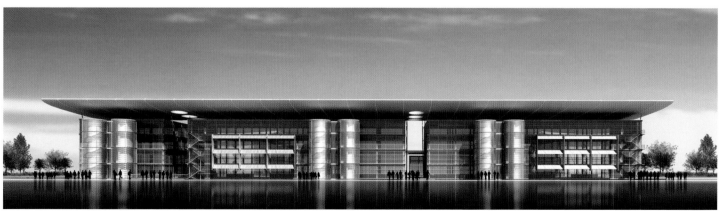

Torre Espacio

"The Torre Espacio proposal was envisaged as a system of vertical villages organised within a powerful structural form. Communal and public spaces are interspersed with offices to create an integrated working environment." Graham Stirk

Below Left: Site diagram illustrating response to sunlight, orientation and views. Below Right: Site plan showing the tower's setting within a system of formal gardens and informal landscape. Opposite: Model views showing the building's constituent components and the way in which the external bracing forms an integral part of the scheme's identity.

The Paseo de la Castellana is the backbone of modern Madrid, the dynamic 19th- and 20th-century metropolis that has grown beyond the well-preserved (and now regenerated) core of old Madrid. RRP's Torre Espacio was intended as a symbol of Madrid's determination to achieve recognition as one of the leading world cities of the 21st century – an aspiration equally reflected in the spectacular new airport terminal at Barajas, also designed by RRP.

Torre Espacio is unashamedly a landmark building, designed to take its place in the changing skyline of the Castellana. The 45-storey, 215-metre-tall tower (with a gross area of 56,250 square metres) offers office space of the highest quality in tune with Madrid's growing significance as a leading European business centre. However, a range of internal and external spaces are integrated within the overall proposal, allowing the

evolution of leisure and social activities for office users and visitors alike. The scheme also offers positive gains in terms of the public realm and is notable for its progressive energy strategy.

The design of Torre Espacio reflects the importance of structure in relation to a tower of this height – two A-frames brace the building and are an expression of the tower as a vertical cantilever, providing the requisite degree of lateral stability. Linked concrete sheer walls connect the A-frames and contain the service cores on the east and west boundaries of the building: this arrangement offers uninterrupted views of Madrid to the south and the hills to the north. The building is envisaged as a 'vertical village', with strategically located double-height spaces containing sky gardens, restaurants, cafés and conference spaces, as well as the client's own suite complete with a pool and a glazed,

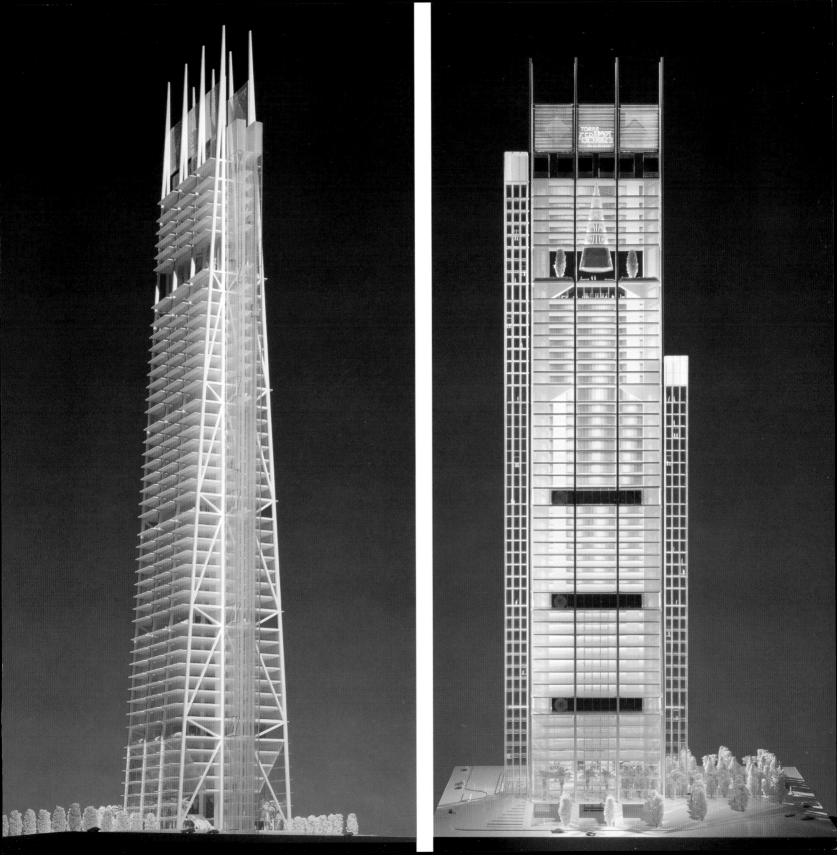

East–West Stability Frame

North–South Stability Frame

Floor Structure

Servicing Strategy

Fire Fighting – Escape – Goods – Risers

Lift Strategy

WC Strategy

Facade Design Strategy

Vertical Villages Strategy

Separate Entrance to Suite –
Grupo Villar Mir Top Management

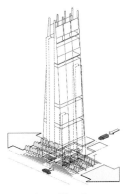

Lower Ground Floor Context –
Landscape Relationships

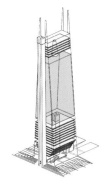

Letting Strategy

Left: Diagrammatic sequence illustrating the scheme's key components and functions. Below: Typical office floor plan. Opposite Left and Right: Elevation and section through the tower.

conical board room – all of the facilities that make up an integrated modern business environment.

At street level, the entrance is an inflection of the north and south facades, creating a public galleria with shops, cafés and exhibition spaces, which acts as an extension of the neighbouring park. Main reception is at first floor level. The low-energy services are designed to cope with the extremes of the local climate. The building is oriented north–south, so that a high degree of shading is necessary on the south elevation, with manually controlled blinds supplementing pre-cast concrete louvres. On the east and west facades, ventilated cavities with interstitial blinds provide shading and glare control.

Torre Espacio offers a progressive recipe for the prestige office building of the 21st century, though its powerful architectural imagery has developed from the classic high-rise buildings of the last century.

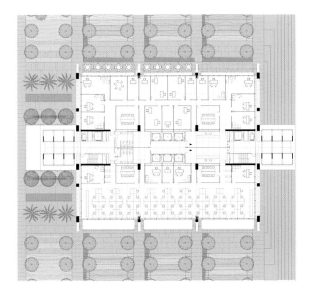

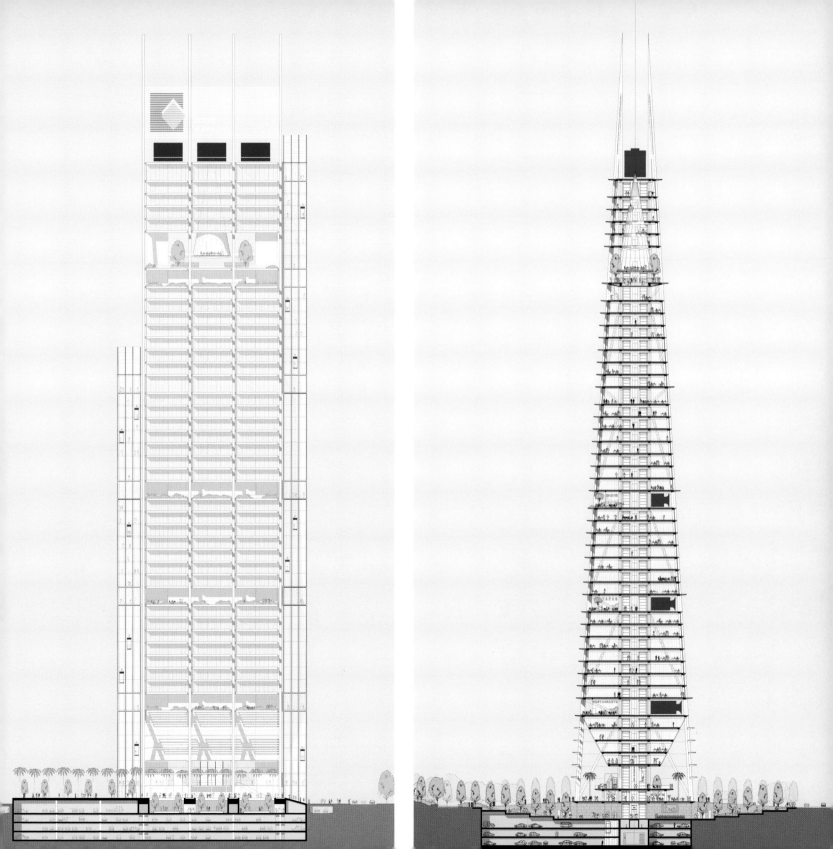

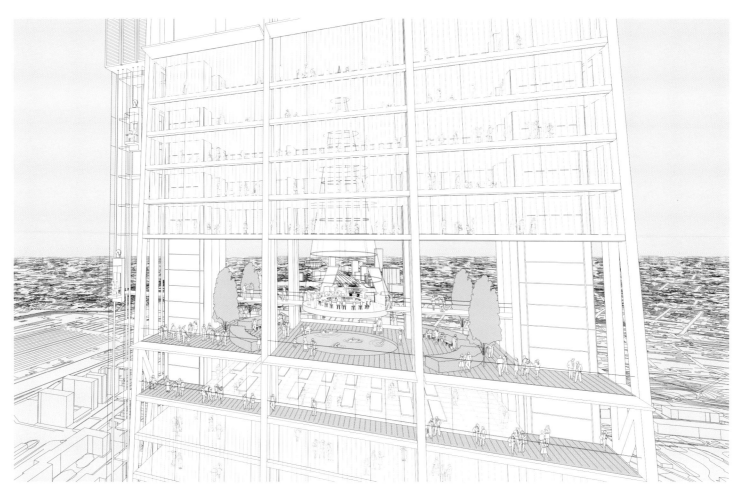

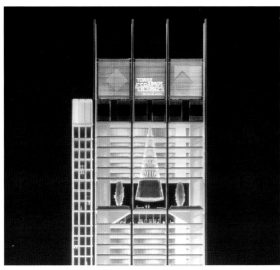

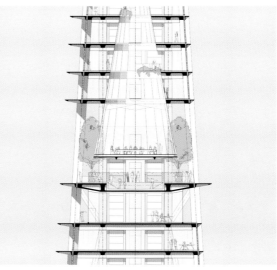

Far Left and Left: Details of model and section showing client's suite. Above: Detail view of the client's suite with pool, landscaping and conical boardroom. Opposite Left: The dramatic ground floor foyer features landscaping that is integrated with that of the overall masterplan. Opposite Right: Elevation.

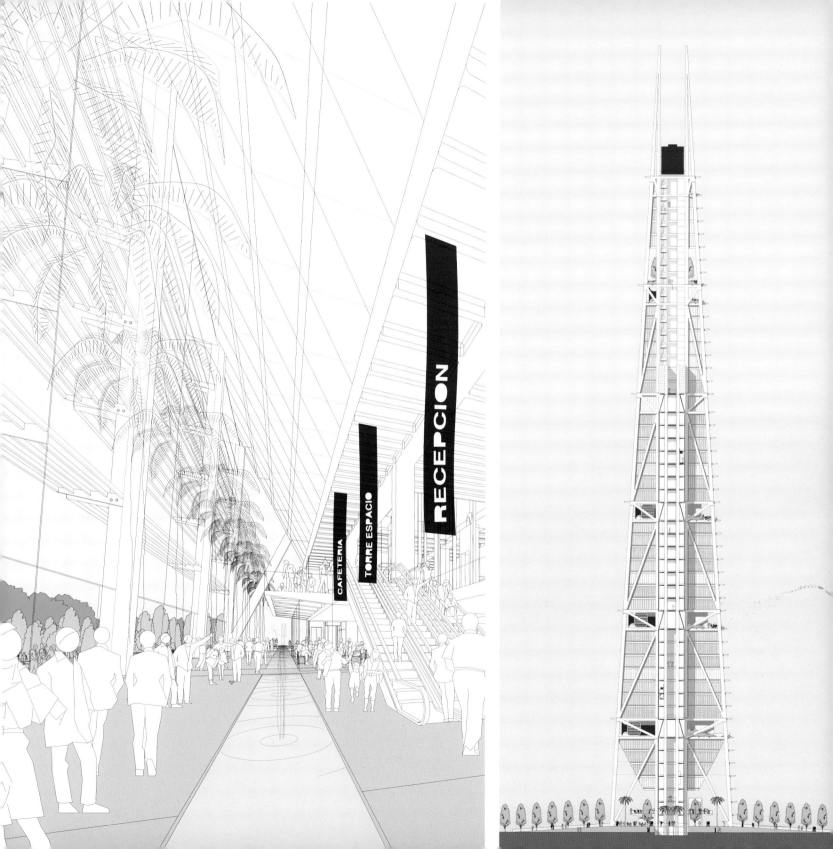

RECEPCION

TORRE ESPACIO

CAFETERIA

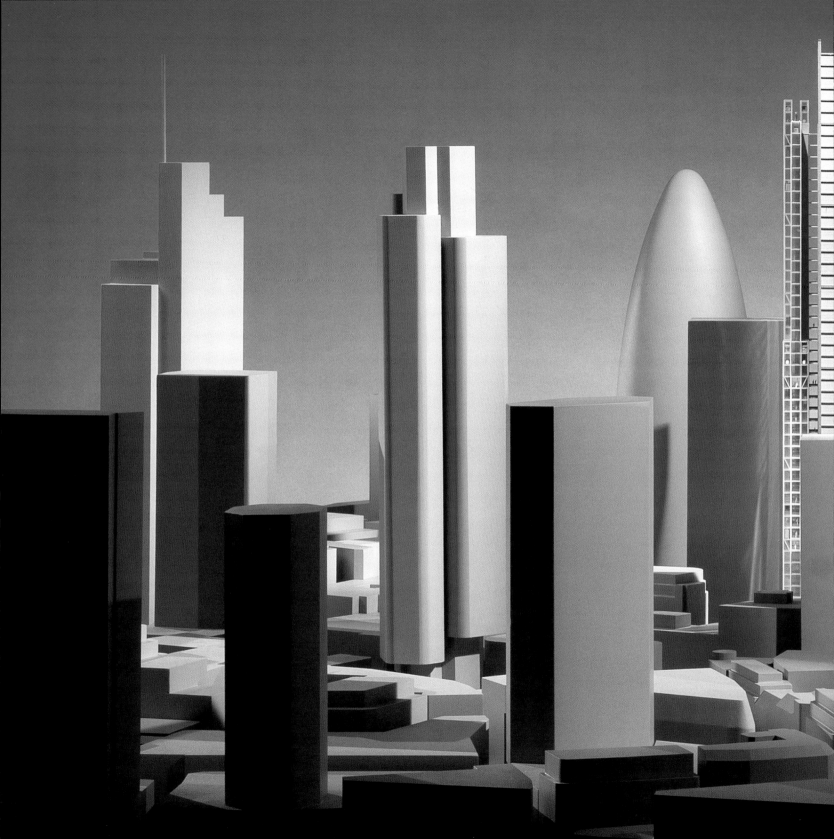

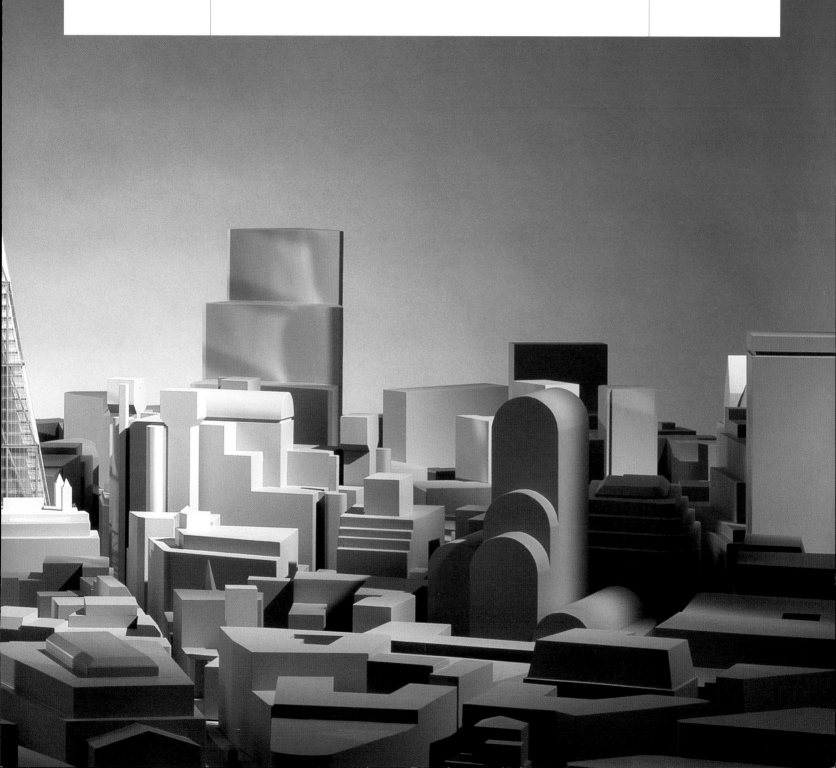

"This addition to the London skyline is a light, transparent structure with a strong sense of identity and character – its spire-like profile would form the apex of an emerging cluster of towers in the City of London." Graham Stirk

Having completed the City's only post-war building of international significance – Lloyd's of London – in 1986, Richard Rogers Partnership returned to the Square Mile in the 1990s with 88 Wood Street and Lloyd's Register, both major, award-winning works by the practice. RRP's latest proposal for the City of London is a 48-storey tower which would replace a 1960s block opposite Lloyd's of London. Rising to a height of 224.5 metres, its slender form complements the Swiss Re building nearby and other proposed towers, creating its own distinctive profile within an emerging cluster of tall buildings in this part of the City of London. The building's elegant, tapering profile is prompted by a requirement to respect key views of St Paul's Cathedral, in particular from the processional route along Fleet Street: the tower's design ensures that from this key vantage point the cathedral's dome is still framed by a clear expanse of sky.

With a gross internal area of 908,750 square metres, the building comprises 56,333 square metres of the highest quality office space, providing flexible and adaptable accommodation with floor sizes ranging from 583 to 1,982 square metres. The office floors take the form of simple rectangular floorplates which progressively diminish in depth towards the apex with larger flexible floors on the lower levels. The scheme offers lower level retail areas of 1,676 square metres.

Instead of a traditional central core providing structural stability, the building employs a full perimeter braced tube which defines the perimeter of the office floorplates and creates stability under wind loads at high levels. The circulation and servicing core is located in a detached north-facing tower, containing passenger and goods lifts, service risers and on-floor plant and WCs, giving legibility to the overall composition. The building's external envelope expresses the diversity of what it encloses, reinforcing the composition without decoration but providing legibility of the primary elements.

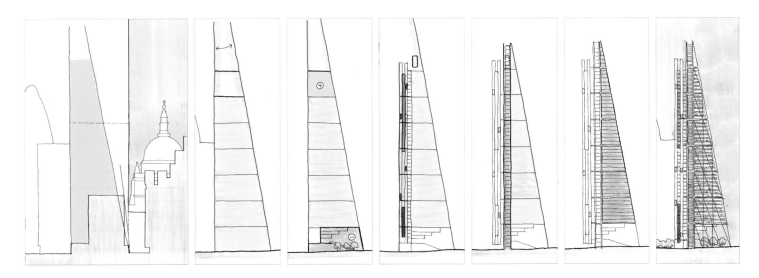

Previous Pages: Model view showing the tower in the context of the emerging cluster of high-rise buildings in the City of London. Opposite: Diagrammatic sequence illustrating the evolution of the building's design and the expression of key components. Right: Early site response diagram. Below Left and Right: Model views in context showing the north (left) and south (right) facades.

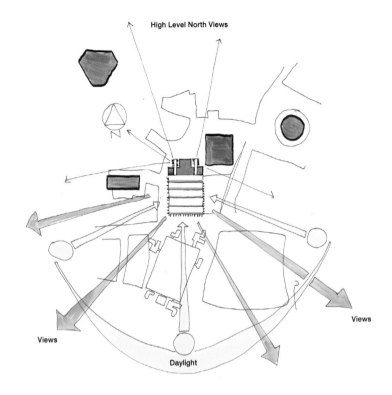

High Level North Views

Views

Views

Daylight

Right: Site plan. Below:
Rendering showing the
unrestricted public realm
at the base of the tower.
Opposite Left: Three plans
illustrating the changing
dimensions of the floorplates
as well as variable lift and
WC configurations for low,
mid and high-rise parts of
the building. Opposite Right:
North elevation, colour coded
to graphically express the
organisation of the support
core.

Although the tower occupies the entire site, the scheme delivers a generous and unprecedented allocation of public realm: the lower levels of the building are recessed on a raking diagonal to create a spectacular, sunlit seven-storey high space complete with mature trees. This significant public space offers a half-acre extension to the adjacent piazza of St Helen's Square; overlooking the public space will be a public bar and restaurant at levels two and three respectively which will be served by glazed public lifts, with generous terrace areas providing animation and views into the space and beyond. This public area will be unlike anything else in London, representing a major attraction within the dense urban character of the City, an important new meeting space where people can sit and relax, eat, or enjoy a programme of events and entertainment – art exhibitions, music performance and cinema screenings.

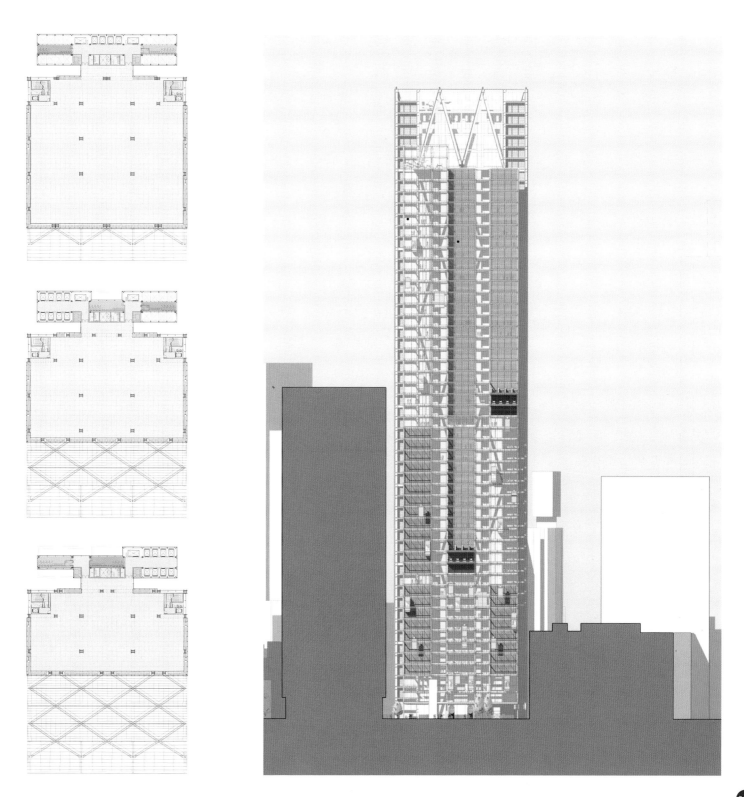

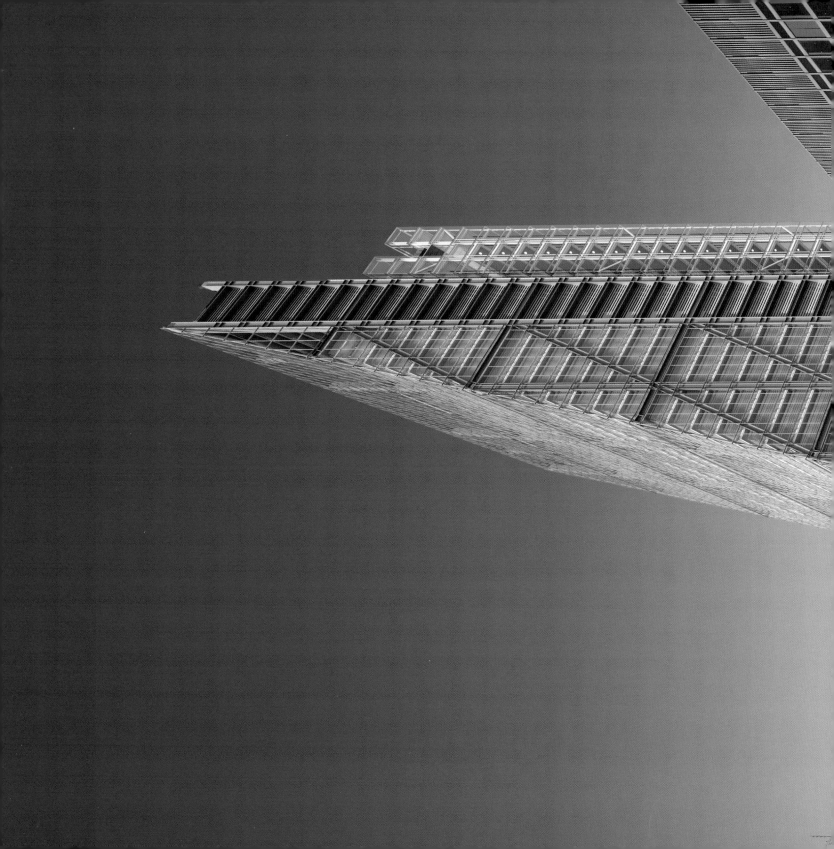

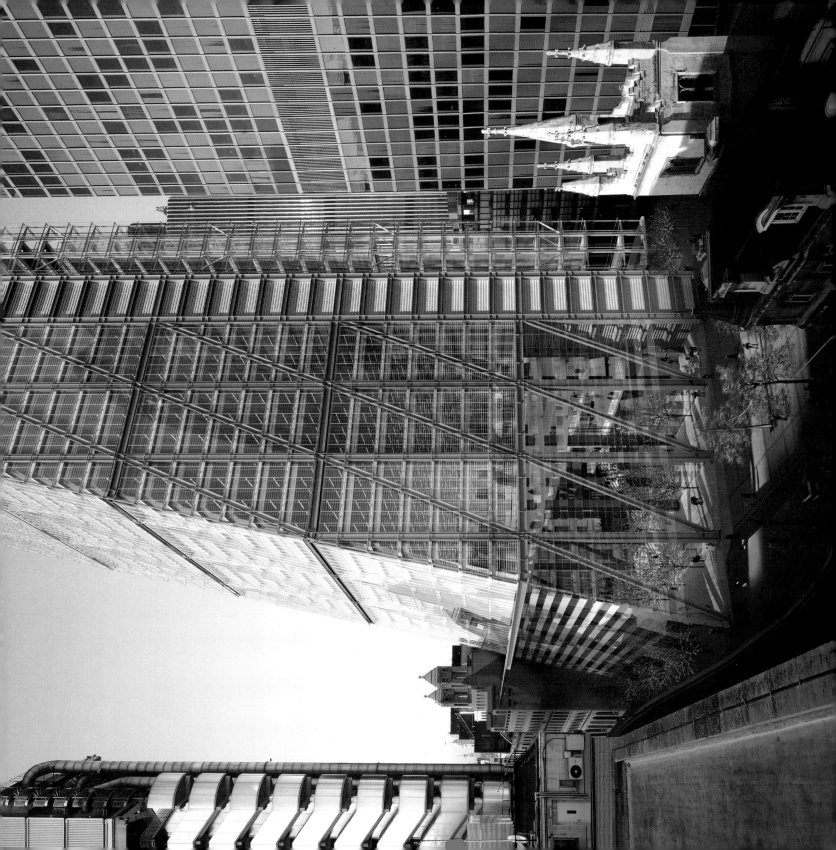

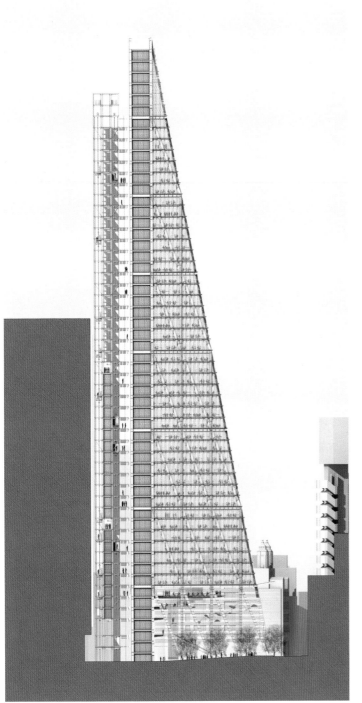
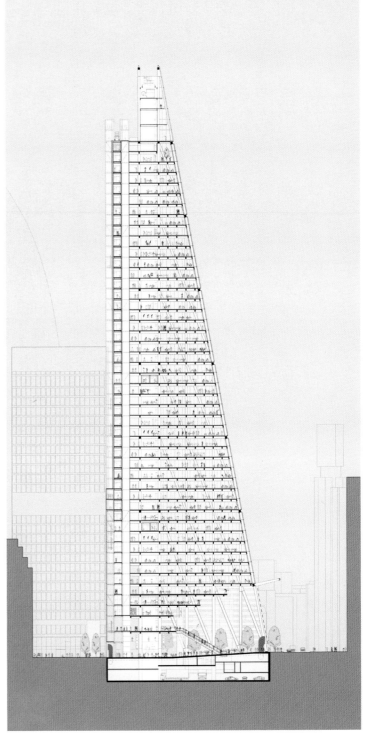

Previous Pages: View of the tower looking down Leadenhall Street. Opposite Left: Elevation demonstrating the composition of the building's primary elements. Opposite Right: Cross-section indicating the disposition of the occupied space. Right: View of the northern services core – a clear expression of the way in which the building functions, celebrated in its graphic legibility.

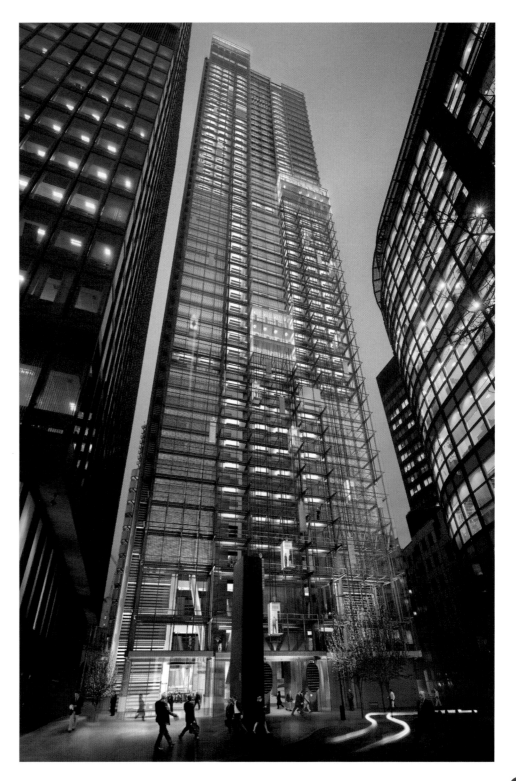

Mossbourne Community Academy

"This project is all about putting pride back into a community. It is about ownership, equality and heart. It is about genuine approaches to sustainability through environmental design and material choices." Ivan Harbour

Above: The angular form of the building wraps around the edge of the site, framing views across to Hackney Downs. Right: Concept sketch illustrating the boundary conditions (two railway lines and a road), and recreational space at the heart of the campus. Opposite: The school is located in one of London's most deprived boroughs and is symbolic of the government's commitment to regeneration.

RRP's design for the Mossbourne Community Academy replaces the former Hackney Downs School and will accommodate 900 pupils aged 11 to 16, with a special focus on teaching information and communication technology, as well as offering learning facilities to the wider community.

It is a new sort of school for a new century, located in one of England's most deprived boroughs, and a powerful engine of regeneration in its own right – the architecture of the building expresses its significance and embodies key themes of accessibility, openness and social inclusion. The project is in tune with the aspirations of the Urban Task Force (chaired by Richard Rogers) and with ideas of urban renewal generated at grassroots level.

"Open Arms to the Downs"

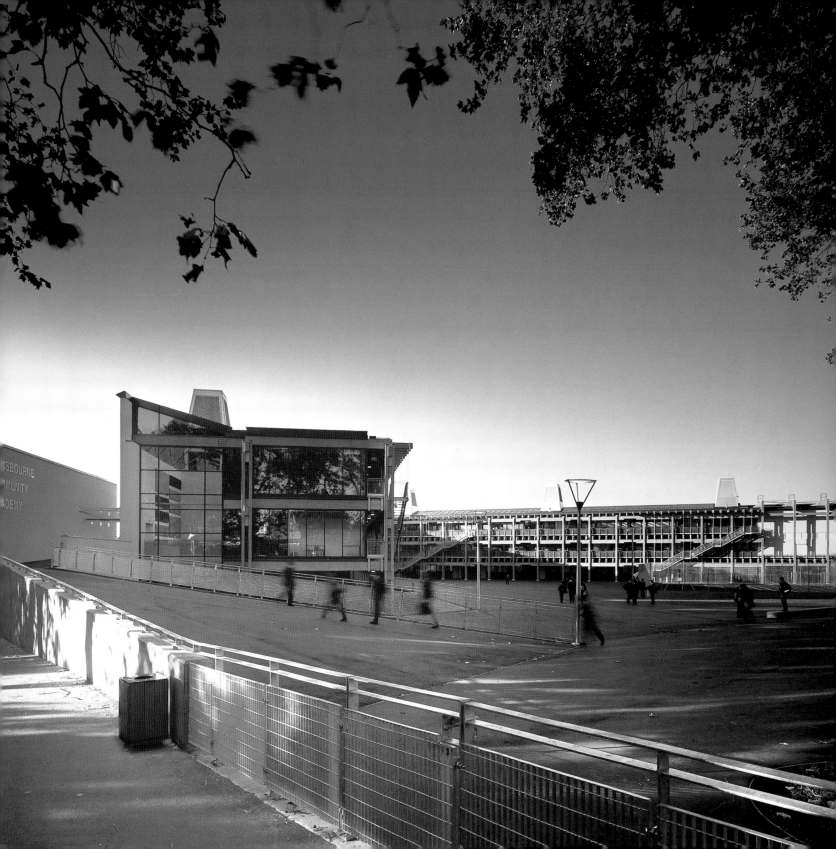

Far Left and Left: Galvanised steel balustrades and suspended stairways contrast with the warmth of the primary timber structure. Robust detailing and repetitive components bring a distinctive rhythm to the facade. Below Left: Site plan. Below and Bottom: The three-storey building is layered from front to back, where a full-height wall and circulation route provides an acoustic barrier. The space between the boundary wall and the classrooms is glazed to allow daylight deep into the building. Opposite: The playground forms the heart of the school.

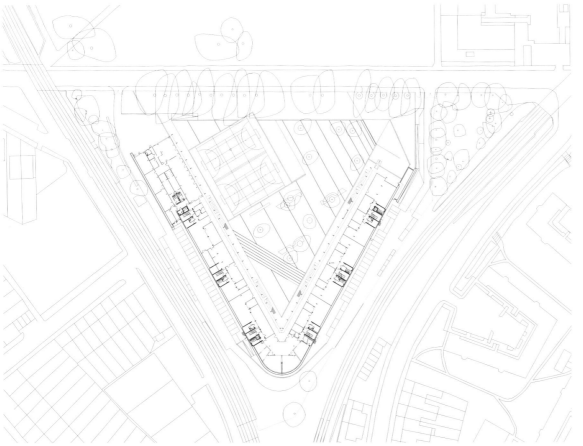

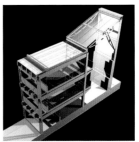

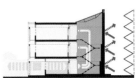

The triangular site for the Academy is confined and subject to high levels of noise from the busy railway tracks that enclose it on two sides – on the third side (to the north) it looks out to Hackney Downs, one of the very few treasured green spaces in the borough. In response, the 8,312 square metre, three-storey building – one of the largest timber-frame buildings in the UK – is conceived as a broad 'V', its back to the railway track, its focus the generous external space to the north.

Teaching spaces look out to a new play area that is visually linked to the parkland beyond. The various faculties/bases for year groups are housed in sections of the building configured as terraced houses, with access from a broad covered cloister, with internal circulation via an intermediate zone. Each house consists of a ground floor of common space, designated staff areas (there is no specific staff room in the school), with a top-lit IT resource space and two levels of more traditional classrooms looking out over the Downs.

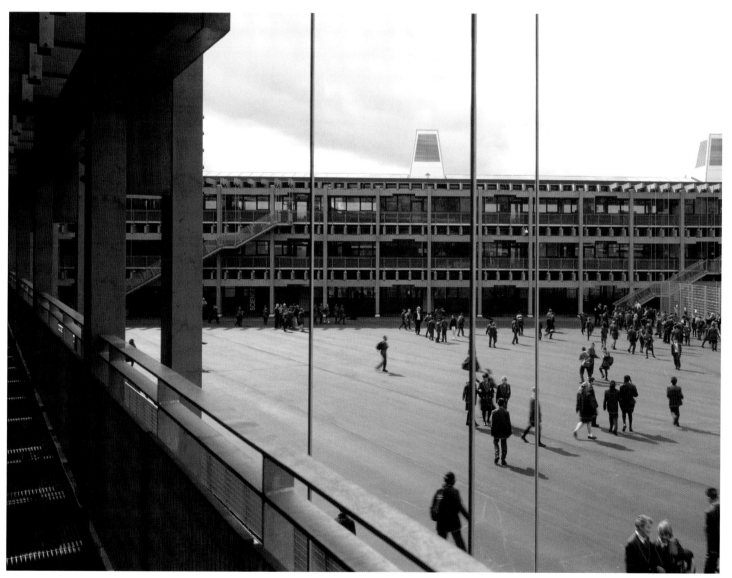

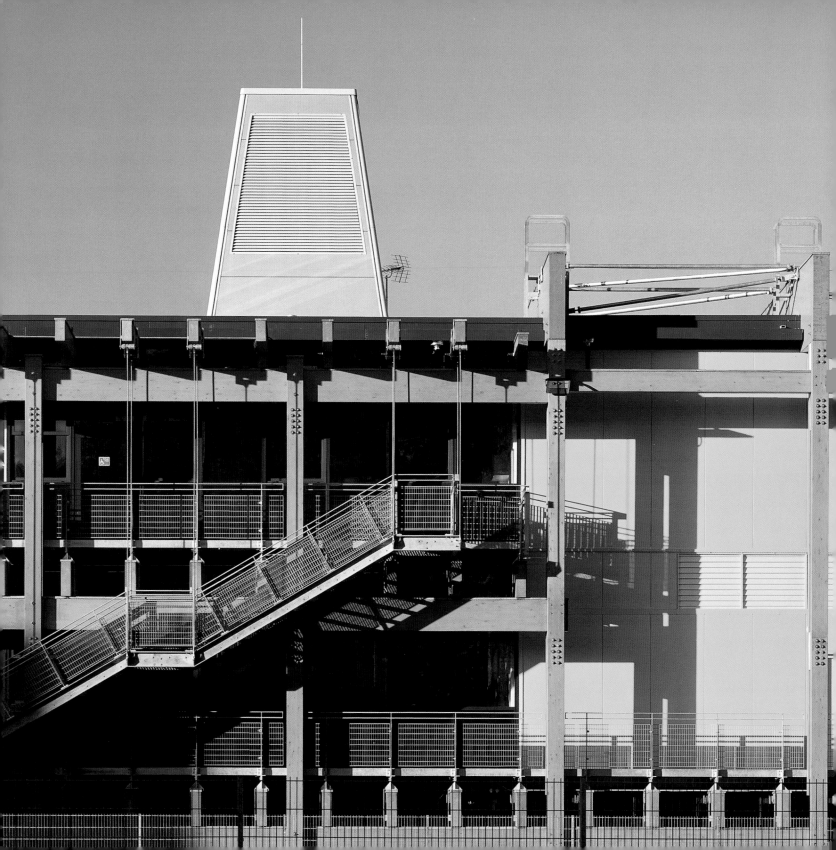

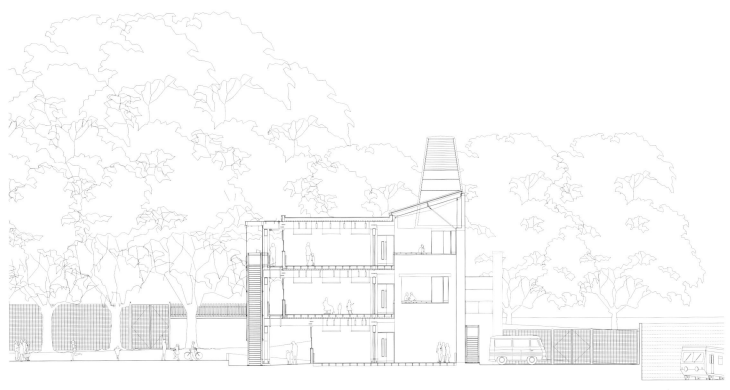

Opposite: The school derives much of its expressive power from the timber frame. The roofs are punctuated by ventilation towers placed above the circulation cores. Above: Section through a classroom area. Right: A top-lit computer resource space where umbrellas are used to reduce glare. Far Right: The main hall/auditorium is located in the space created by the junction of the two wings – a multi-purpose performance and assembly space, here arranged for an informal music and drama lesson.

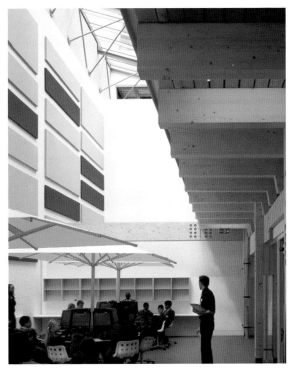

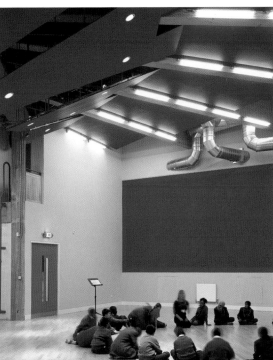

Protos Winery

"A series of simple parabolic roofs create a form that is sensitive to the grain of the town." Graham Stirk

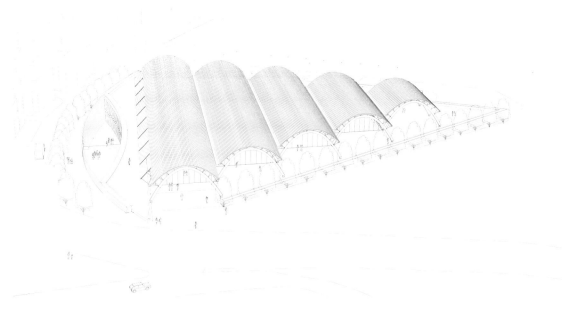

Right: The building is composed of five parabolic timber arches, arranged within the triangular site. A stepped sunken garden (left) frames views of the castle and brings natural light into the office spaces.

RRP and Alonso Balaguer y Arquitectos Asociados have been commissioned to design a new winery facility for Bodegas Protos, a long-established firm of wine-growers producing Ribera del Duero wine.

The new building, which presents a modern reinterpretation of traditional winery construction, is located at Peñafiel, a small village near Valladolid in Castille, northern Spain. The winery sits at the base of a small hill surmounted by a medieval castle. Bodegas Protos already utilises the subterranean area beneath the castle – more than two kilometres of tunnels and galleries are used for ageing wine.

The new winery will process one million kilos of grapes and will be complete by February 2006. Linked by a tunnel to the existing wine-making facility, the new building will consist of an underground cellar with a constant temperature of 14–16 degrees celsius for storage of barrels, as well as for bottles that are maturing and those containing the finished product.

The production level is situated above, partly buried in the ground and accommodating the fermentation and storage vats as well as the bottling plant, packaging equipment, various technical areas and vehicle access bays.

The production and cellar floors also accommodate administrative and social facilities, wine-tasting areas, and a small auditorium for presentations and marketing events. The scheme also includes a stepped sunken garden which frames views of the castle above whilst also bringing natural light down into the office space.

The main entrance level is for both workers and visitors and also includes vehicle bays for delivery of grapes, as well as space for visitors to view the production floor below.

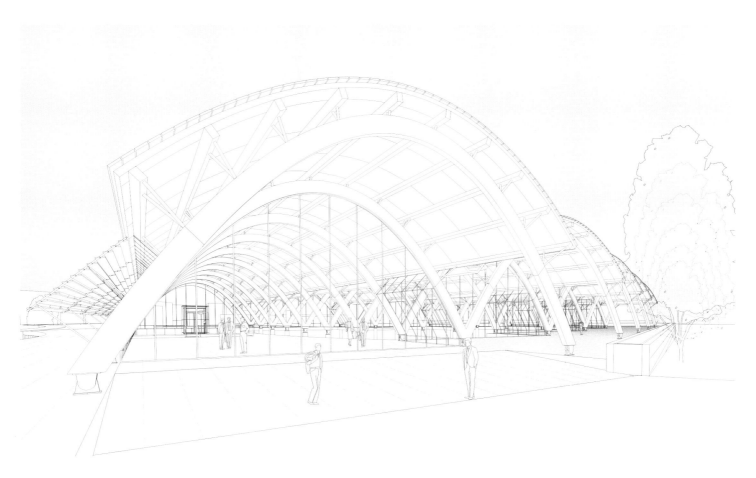

Above: Drawing highlighting
the elegant timber structure.
Left: Site plan.

Compositionally, the building sits on a triangular plinth which fills the site. Five interlinked parabolic vaults, supported by large laminated timber arches, are clad with large terracotta tiles to create a light, articulated structure. This modular form breaks down the overall mass and scale to create a structure that is sympathetic to the surrounding buildings and countryside.

Cool storage for the wine is created by effective use of the thermal ground mass. The south facade is protected by a nine-metre roof overhang while the west facade is further shaded by a system of large, fixed brise-soleils. Underground water aids night heat exchange and a mixed-mode air system allows use of free night-time cooling in autumn and spring.

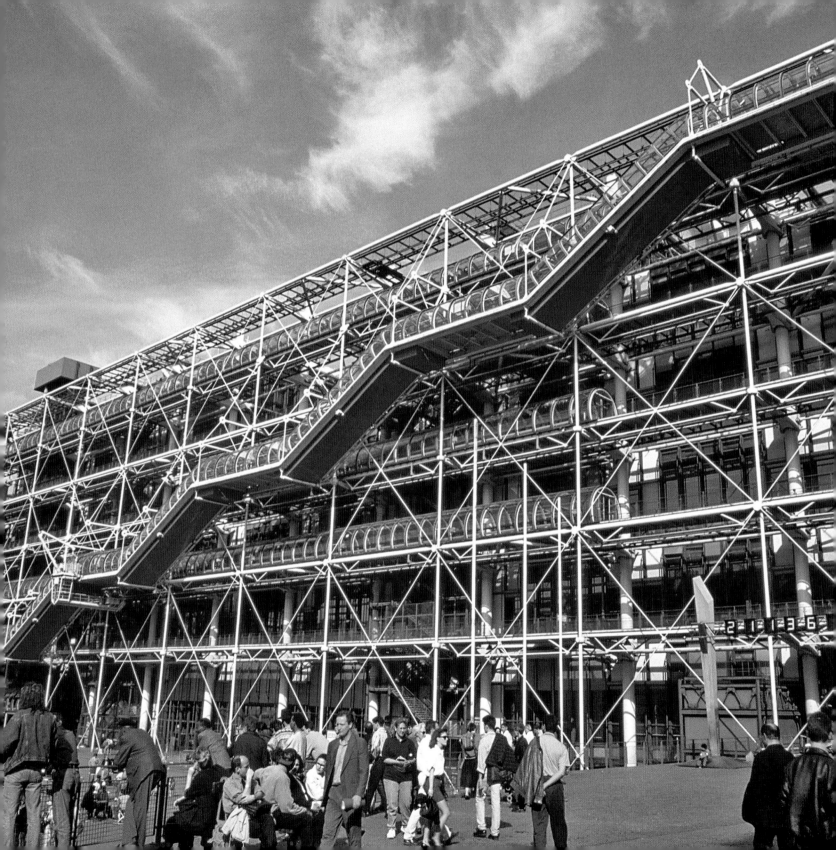

Public Buildings

3

ARAM Module

The ARAM project (Association for Rural Aid in Medicine) – one of the first fruits of Rogers' collaboration with Renzo Piano – arose from a commission to design a readily transportable, quickly assembled hospital for use in underdeveloped countries and in times of natural disaster or war. In the event, no hospital was ever constructed but the practice benefited from its research on tension structures.

The INMOS factory and the Fleetguard distribution centre subsequently utilised the division between a freestanding structure and the space and services suspended from it to striking effect. Structurally, the module consisted of latticed steel columns with light-weight trusses supporting space decks suspended from

high-tensile cables. Four masts penetrate the 'activity floor' and support the permanent cranes which both assemble and change the service module. Services were to be mounted in voids above and below the 'activity' floor.

While this was intended primarily as an economic medical system for a high-density population, the module is more: a dynamic community structure housing systems that can give order to a neighbourhood or a group of villages of about 100,000 people.

The product of Rogers' persistent experimentalism, the ARAM module marked a step towards a new expressive drama in his work. It was a matter of regret to him that the idea behind the project remained unrealised.

Above: Plan. Right: Section. Opposite: Model of the module illustrating the simple four-masted structure from which a triple-layered, flexible space is suspended. The permanent cranes could add services into the voids above and below the middle layer – the 'activity' floor.

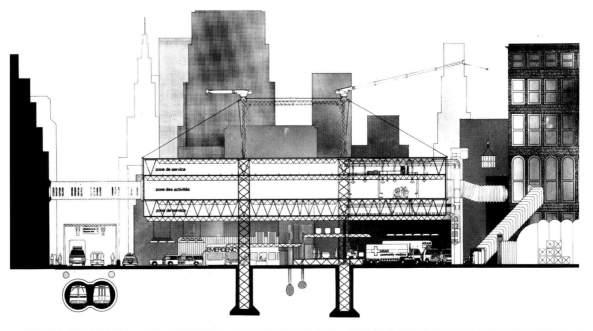

"The service module was designed to be a technical constant throughout the world, with the world market supplying its know-how. Support systems, schools and wards would be provided locally, reflecting ethnic structure and economy." John Young

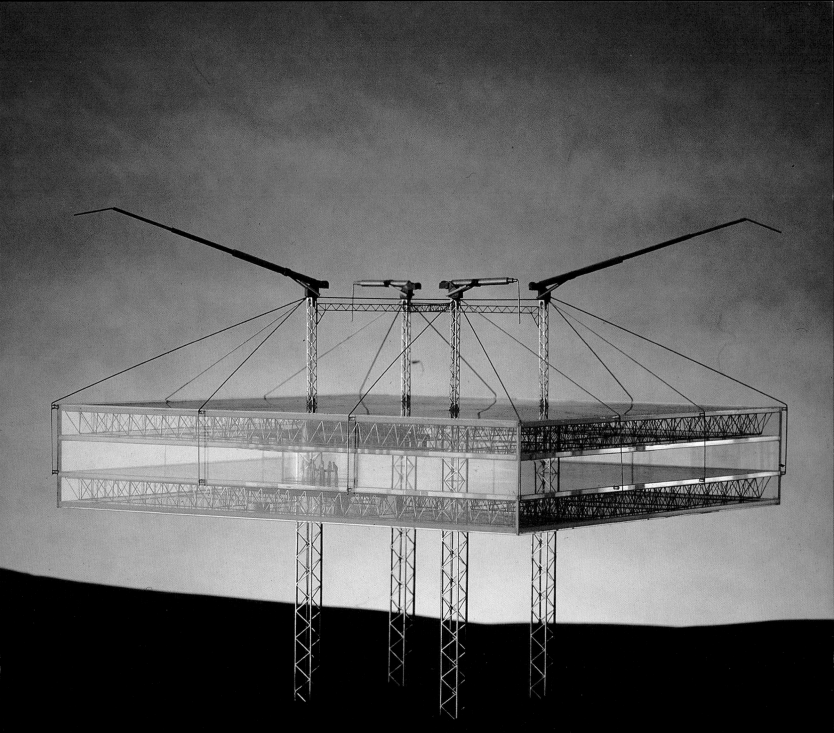

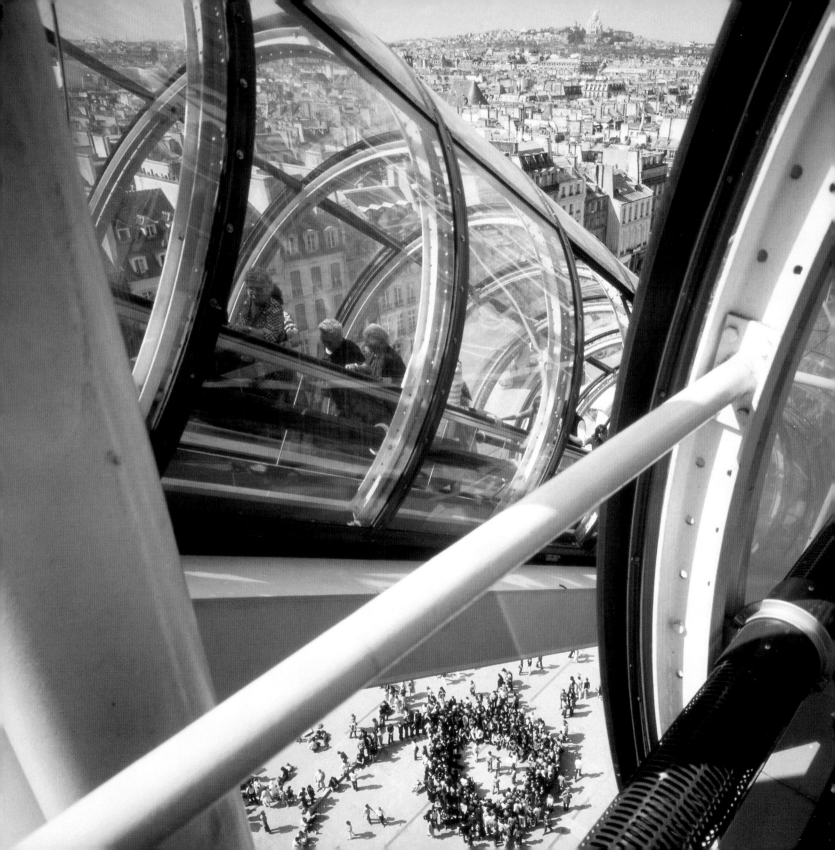

Public Buildings	# Centre Georges Pompidou	Paris, France 1971–77

Opposite: Activity in the plaza viewed from the principal circulation system. Above and Following Pages: Elevation (top) and section (over page) from the competition entry illustrating the concept of the building as an information centre for Paris and beyond.

Designed in partnership with Renzo Piano, the Centre Pompidou was the building which brought Richard Rogers international fame. The scheme (won in competition) brought together the themes – skin and structure, technology and flexibility, movement and anti-monumentalism – which have characterised Rogers' architecture from the mid 1960s.

The architects envisaged their building as a cross between 'an information-oriented computerised Times Square and the British Museum', a democratic place for all people, all ages and all creeds, simultaneously instant and solemn, and the centrepiece of a regenerated quarter of the city. It was to be 'a giant climbing frame', the antithesis of existing cultural monuments. The completed Centre fully realises their intentions, miraculously fusing the spirit of 1968 with the ostensible aim of commemorating a conservative head of state.

Since half of the total available site was set aside by Rogers and Piano as a public square, the Centre had to be tall to accommodate the 90,000 square metres (one million square feet) of space demanded by the brief. The decision to place structure and services on the outside was driven primarily by the need for internal flexibility – the scheme provided huge expanses of uninterrupted space on massive, open floors nearly 50 metres deep. The staggering scale of these internal spaces took to extremes Rogers' concern to create space free from the intrusion of services and stairs (reflecting the influence of Kahn's doctrine of 'served and servant spaces') and these areas have proved to be highly adaptable, their character and use changing freely within the life of the Centre – there is no obvious hierarchy which separates art and learning from more mundane activities.

The structural system provided for a braced and exposed steel superstructure with reinforced concrete

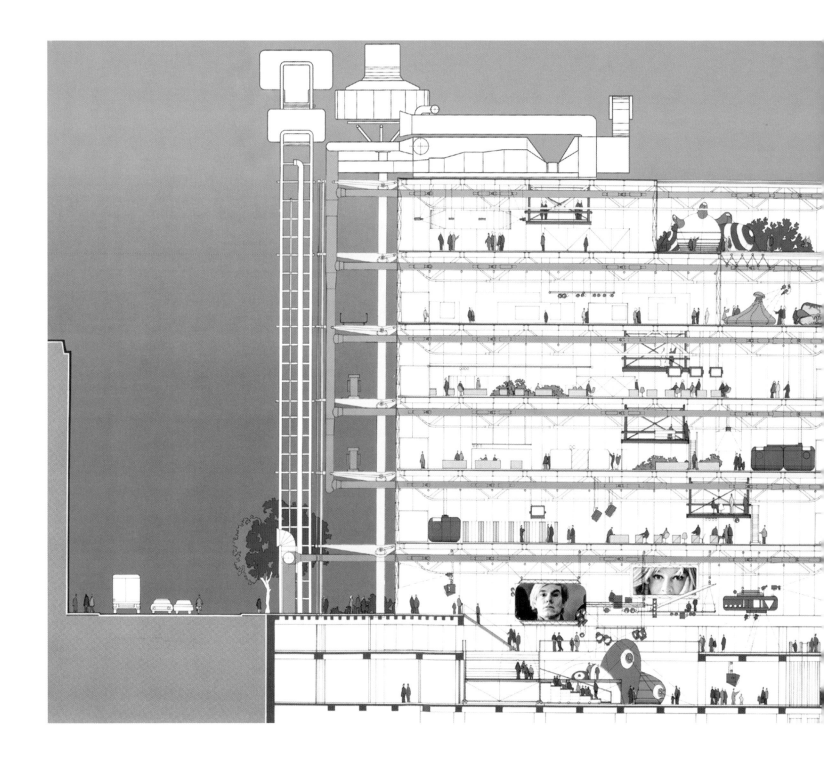

floors, realised with the help of the brilliant engineer Peter Rice. External services give scale and detail to the facades, while celebration of movement and access is provided by lifts and escalators which, like the services, were outside the covering of the building. The result is a highly expressive, strongly articulated building which came to be seen as a landmark in the development of High Tech (a term Rogers loathes).

Yet the achievement of Rogers and Piano at Beaubourg was broadly urbanistic as much as architectural. The building and great public square were intended to revitalise an area of Paris that had been in decline. The neighbouring Marais district, now vibrant and multi-cultural, underlines the enormous success of the Pompidou's role as a catalyst for urban regeneration, changing the character of Paris and laying the foundations for the later Grands Projets. It is as a place for people and a restatement of the fundamental

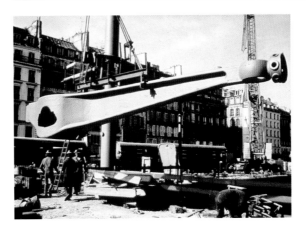

"Beaubourg was conceived as a live centre of information and entertainment – a flexible container and a dynamic communications machine, highly serviced and made from pre-fabricated parts. Cutting across traditional institutional limits, we created a vibrant meeting place where activities would overlap in flexible, well-serviced spaces, a people's centre, a university of the street reflecting the constantly changing needs of its users – a place for all people of all ages, all creeds, for young and old." Richard Rogers

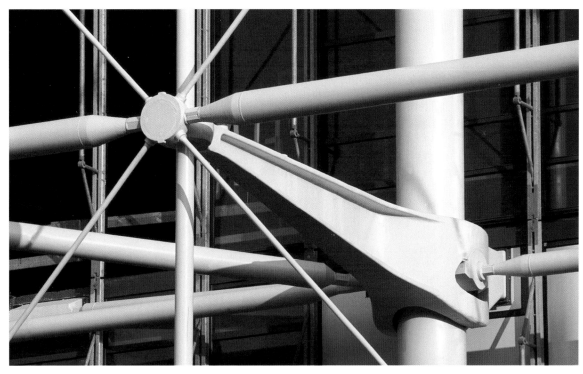

Left and Below Left: 800-millimetre-diameter spun-steel columns support the gerberette. The narrow end of each gerberette is connected to a tension column. Finally, diagonal bracing ensures the stability of the building. Below Right: Part of the structure seen from the water sculpture to the south.

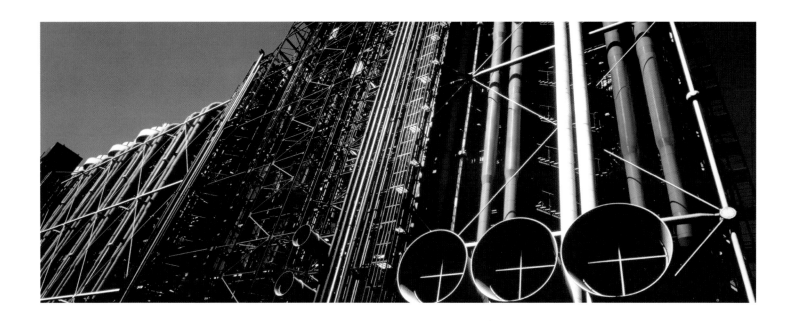

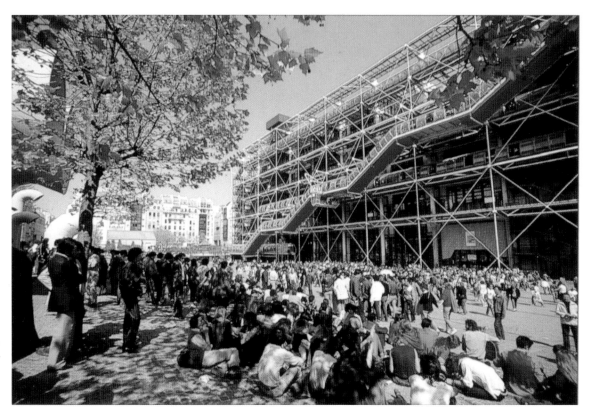

Top: The seven-metre-wide structural zone reserved exclusively for services on the Rue de Renard facade. Left: The piazza is a popular meeting place in the city. Above: Glimpses of the services facade from the surrounding streets. Opposite: The glazed escalator tube which traverses the full height of the building, offering views over the piazza and the city beyond.

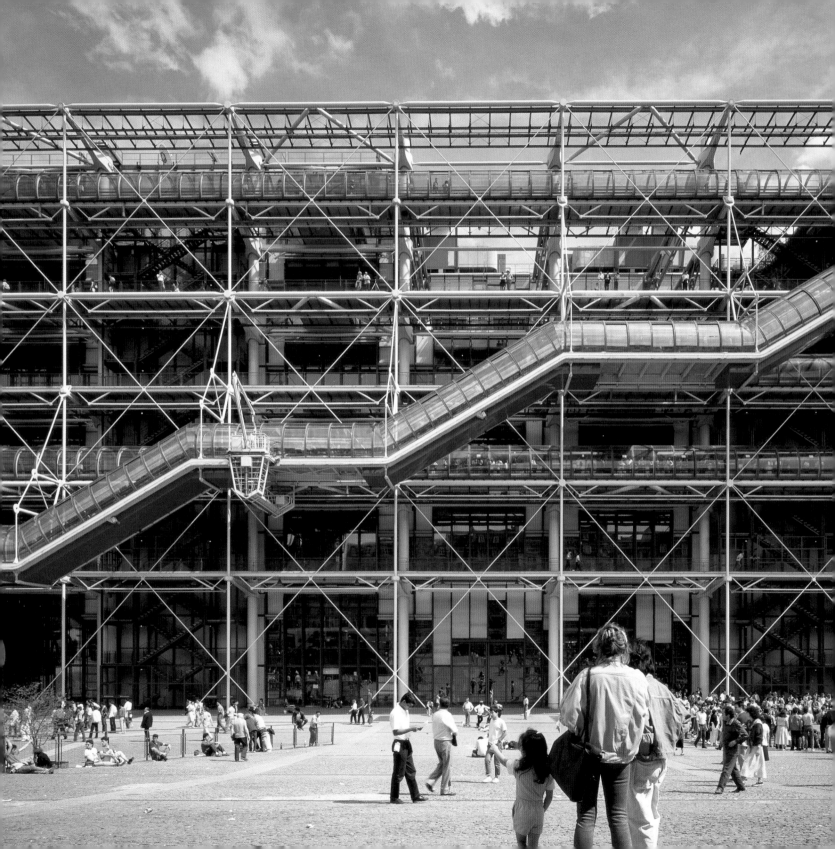

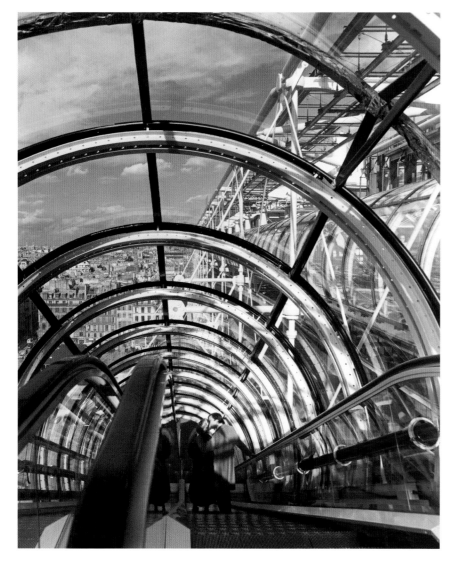

Rogers belief that cities adapt to the needs of people (not vice versa) that the Centre must be counted one of the most significant post-war European buildings.

The Pompidou's radicalism is still striking and has proved attractive to a vast public: more than seven million people visit the building every year. The recent renovation prior to re-opening in 2000 significantly compromised the original design. Escalators have been installed from the foyer to the library, permanent exhibition spaces have been introduced and the public is now charged to use the escalators rising up the facade. That said, the building and its extraordinary contents remain as popular as ever, while crowds fill the square, clustering around musicians, acrobats and fire-eaters. Beaubourg – inside and out – remains as magnetic as ever.

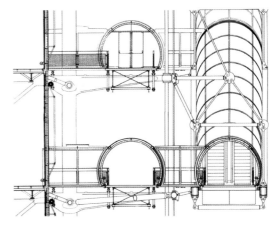

Above Left: Inside the escalator tube. Above Right: Section through the principal facade of glazed galleries and the escalator system. Left: Gallery floor plan.

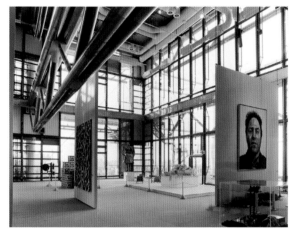

Above Left: One of the luminous gallery spaces. Above, Centre and Right: Furniture designed for the museum is based on a simple kit of parts including wire mesh, steel tube, perforated metal and natural hide. Right: The double-height ground floor space acts as an extension of the piazza beyond.

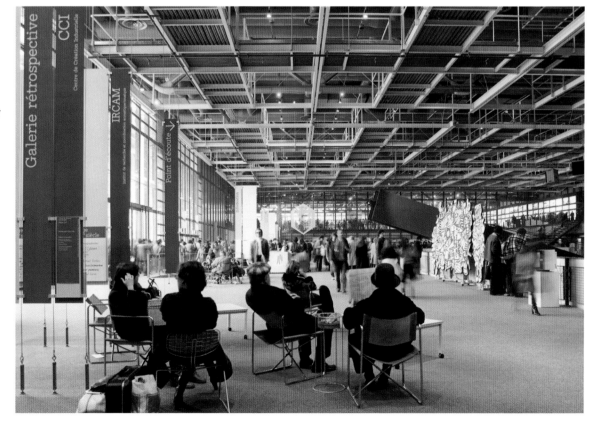

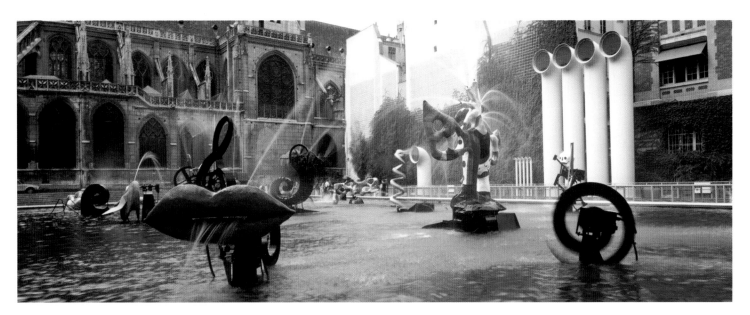

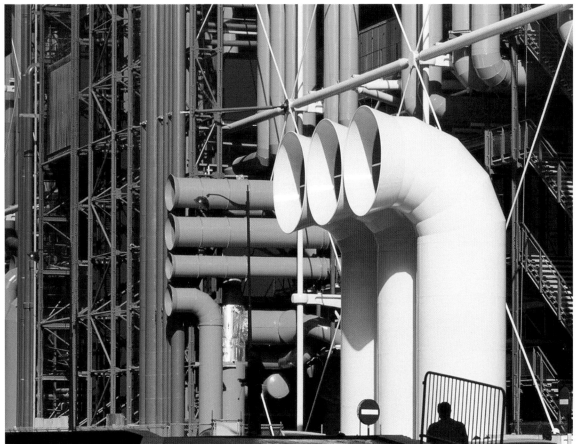

Above: A new square was created to the south of the Centre, with views of St Merry across a striking water sculpture by Jean Tingueley and Niki de St Phalle. Left: The colour-coded services facade on Rue de Renard. Below: The piazza acts as a magnet stimulating street performances and spontaneous theatre. Opposite: Aerial view showing the urban context and the extent of the piazza.

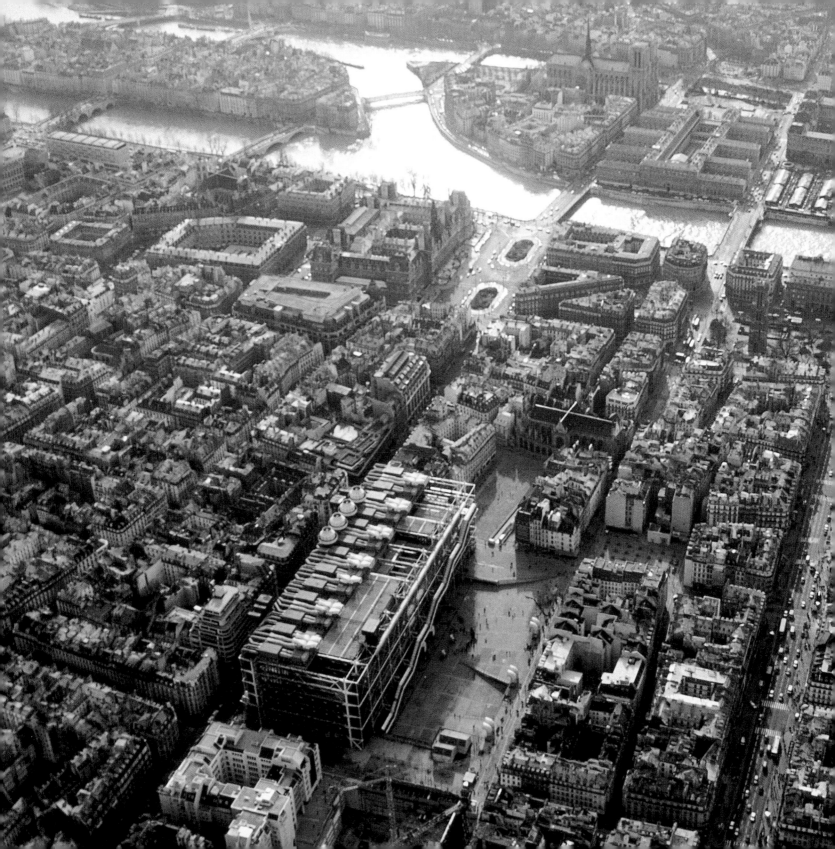

IRCAM

"We designed a space that could modulate sound, either electronically or by continuous surface property change or by a remarkable 400 percent volumetric variability change, creating a concert hall that can itself be played along with the music generated inside – the space becomes a unique musical instrument." Mike Davies

IRCAM (Institute for Research and Co-ordination in Acoustics and Music) was built as the domain of the presiding genius of modern French music, Pierre Boulez, and as a centre for leading-edge musical research and experimentation. Research is carried out by scientists and musicians into psycho-acoustics, electronics, computer science, artificial intelligence, neuro-psychology, linguistics and sociology, in addition to more traditional musical disciplines.

Though open to the public, IRCAM did not easily fit within the Centre Pompidou. In particular, a high degree of sound insulation was necessary to eliminate external noise and permit a wide range of concerts and rehearsals to take place simultaneously. The flexibility of the spaces within the Centre was neither possible nor desirable. The result was that the Institute's accommodation was created as a highly serviced subterranean building beneath the Place Igor Stravinsky next to Beaubourg. The concert halls and studios are approached via a 'cascade' of stairs which is the inversion of the escalators which crawl across the front of the Centre Pompidou.

IRCAM has four main departments: instrument and voice, electro-acoustics, computer, and general acoustics research and co-ordination, each with its own offices, labs and studios. The building is divided into compartments housing suspended studios and high-performance inner acoustic shells, within which the main research and experimental activities take place. The choice of studio types with variable properties allows for a wide range of acoustic flexibility. The main product of the building – sound – can be piped anywhere. Any combination of spaces, listeners and sound inputs can be linked together as one participatory unit, giving virtually total acoustic flexibility within the building. The main studio is a superbly equipped experimental facility – suspended within the main structure and thus isolated from airborne sound and external vibrations. Measuring 18 metres in height, it can accommodate 400 people and is equipped with an acoustically variable, vertically mobile ceiling in three elements, programmable by computer.

IRCAM has worked well but the addition of an above-ground extension designed by Renzo Piano (1989) as a complement to the brick 19th-century architecture which surrounds it has given IRCAM a welcome street presence.

Right: A minimal presence at street level, the centre is entered via a cascade of steps leading down from Place Igor Stravinsky.

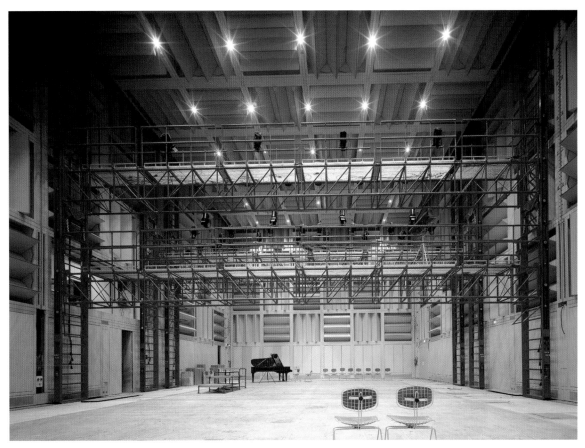

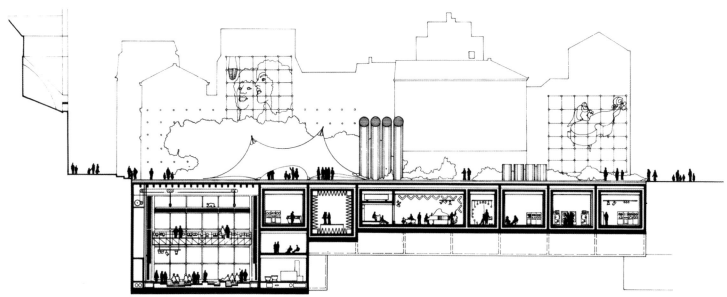

Coin Street

With the Centre Pompidou complete and Lloyd's under way, Rogers seemed the obvious choice as the architect for a mixed development on the south bank of the Thames, close to the West End and the City. The site was an area of mostly cleared land close to Denys Lasdun's National Theatre and to Waterloo and Blackfriars bridges. In the event Rogers' proposals for Coin Street fell victim to a fierce planning battle and were abandoned. This must be reckoned as one of the great unbuilt schemes of modern London.

Drawing strongly on the architectural language of the Lloyd's building, Rogers proposed to connect Waterloo station to the City with a lofty glazed pedestrian arcade and a new footbridge across the river. The great glazed arcade was inspired by the Galleria Vittorio Emanuele in Milan – full of light and shade and a vibrant meeting place appropriate to the changeable British climate. Pontoons were to house bars,

restaurants and other amenities. The mixed scheme – 92,500 square metres of offices, 18,500 square metres of housing, 6,500 square metres of leisure facilities and 10,500 square metres of retail and restaurants – was intended to bring new life to the South Bank. Ground level space was largely public. Rogers offered a vision of a new London, where public and private domains were well balanced – commercial profit combining with public benefits on a huge site and against a taut political backdrop.

RRP's drawings for the scheme look forward to the practice's proposals for London's Paternoster Square, Berlin's Potsdamer Platz and even the ambitious scheme for Shanghai. Within a few years, the good sense of Rogers' proposals became obvious as London's Docklands were sacrificed to a planning philosophy which largely ignored the general public interest in favour of unchecked commercial development.

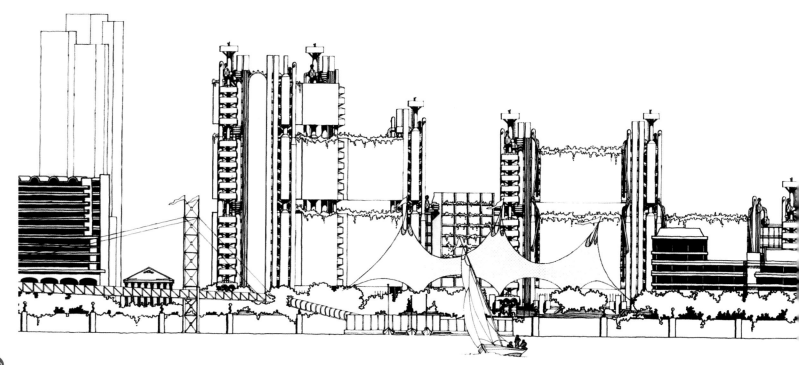

"The South Bank cultural centre opened up this key area to public access and is the most successful example of urban regeneration in post-war London. The Coin Street scheme was spearheaded by an exceptional developer – Stuart Lipton – and was intended as a complementary project, further revitalising this derelict area by providing a variety of public and private uses." Richard Rogers

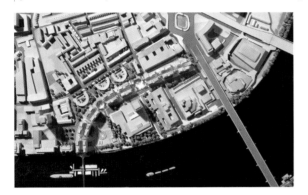

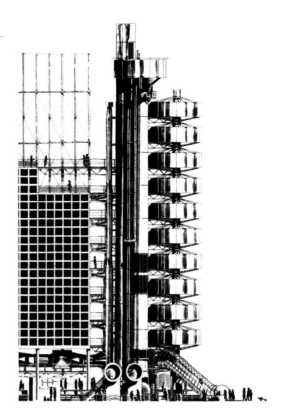

Above Left: Site plan. Above: Elevation of one of the towers. Below: Elevation overlooking the Thames.

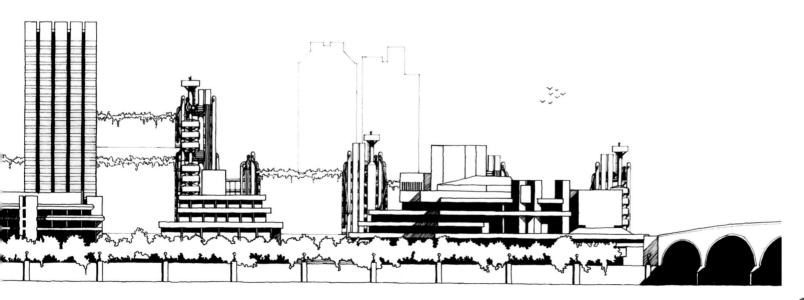

National Gallery Extension

Below: Section. Bottom: Site plan. Opposite: The top-lit galleries, suspended over the curved office building, are expressed as a distinct architectural element.

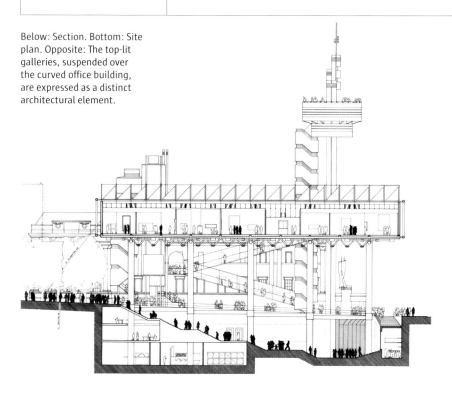

"More significant, perhaps, than the architecture of our scheme was the strategy for public space – our aim was to weave together key pedestrian areas of central London into a continuous, dynamic public realm." Richard Rogers

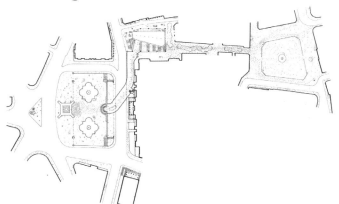

The practice's scheme for an extension to the National Gallery had to provide commercial, as well as gallery, space – a controversial formula which had been laid down by the British government as a means of funding the new galleries. RRP drew on its experience of the Coin Street project, paying particular care to the issue of balancing public and private domains.

RRP's design was a development of the ideas behind the Centre Pompidou but also drew on the architectural language of Lloyd's. The practice proposed a new landmark for London, a cultural building which made a clear statement about change and was inspired by a radical view of the capital. The new top-lit galleries were elevated above the offices, which were given a clearly subordinate position, with services and access concentrated in 'servant' towers, leaving the main spaces clear of obstruction. A tall tower, located at the west end of the National Gallery and housing a restaurant and viewing gallery, was intended to provide a vertical counterpoint to the spire of St Martin-in-the-Fields at the north-east corner of the square, while a sunken pedestrian piazza and arcade led under the road to Trafalgar Square (which until the recent pedestrianisation of its northern edge was totally surrounded by traffic).

The National Gallery scheme offered London a glimpse of a bold new public architecture, a statement, as Rogers saw it, about the London of the future and key to his master plan for this part of the West End. The vision proved too bold. After much political manoeuvring and an acrimonious public debate, the competition was cancelled. A Post-Modern Classical-style extension, containing only galleries, was later built to the designs of Venturi Scott Brown. Although the RRP scheme remained unbuilt, it established Rogers as a major force in the re-planning of late 20th-century London.

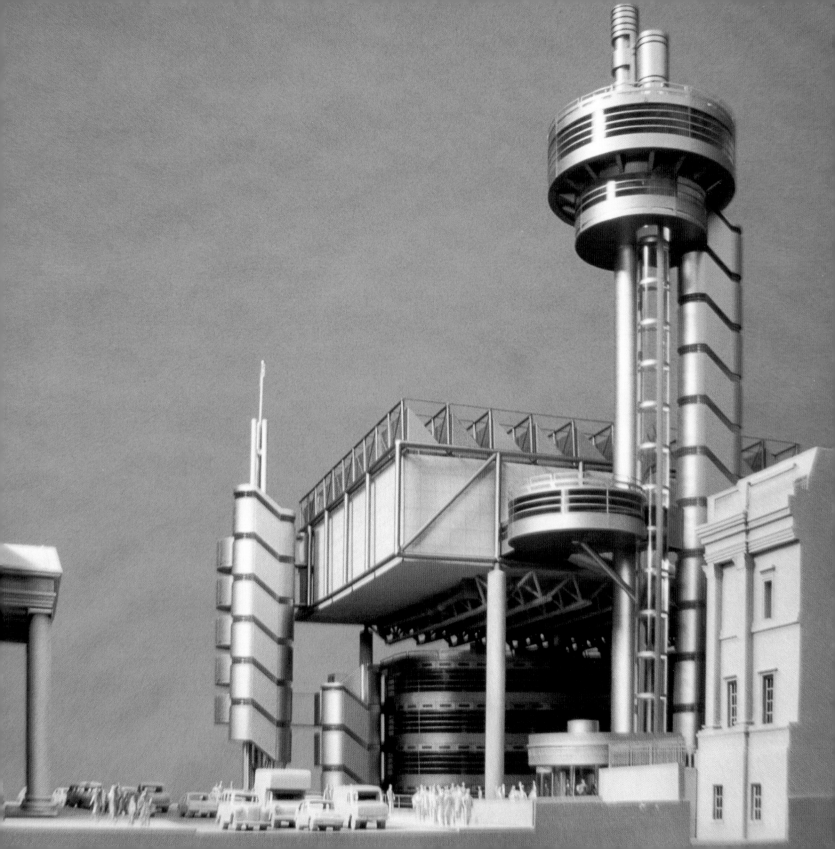

Centre Commercial
St Herblain

Right: A bridge marks the approach to a double-height entrance space. Below: Primary colours are used to code the principal elements of the building. Opposite: Escalators link the retail levels.

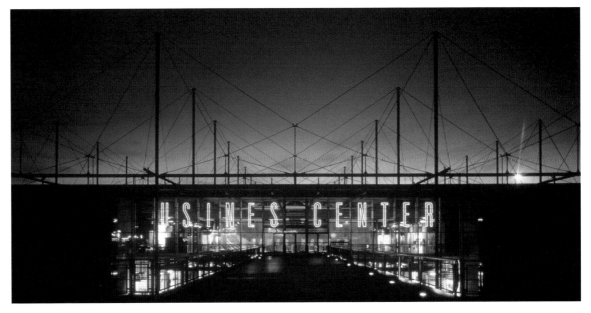

"We devised a simple, legible external structure highlighted in vibrant colours. The flying entrance bridge makes a strong welcoming gesture – despite the modest budget, we gave what might have been a non-descript warehouse a real sense of individuality and identity." Mike Davies

The shopping centre at St Herblain, near Nantes, was built to a very strict brief. The client wanted a low-cost building in record time – one which projected the dynamic retailing operation it was to contain and could at the same time be adapted to other sites. A simple and clear architectural statement was required.

The client was familiar with the Fleetguard factory and the suspended structure of Fleetguard re-emerged at St Herblain, with a forest of slender masts giving what could have been a basic shed a genuine architectural grace. Inside, the plan is remarkably clear and well organised. The Centre is entered, as at Fleetguard, by way of a steel bridge, leading into a double-height reception area. A strong use of colour adds to the appeal of the building, while exposed servicing provides visual interest inside. The lightness of the construction and the provision of generous quantities of daylight make the Centre a clear counterpoint to the typical cluttered, claustrophobic out-of-town shopping centre.

At only 21,000 square metres, St Herblain is a modest masterpiece, clear and logical, achieved at low cost.

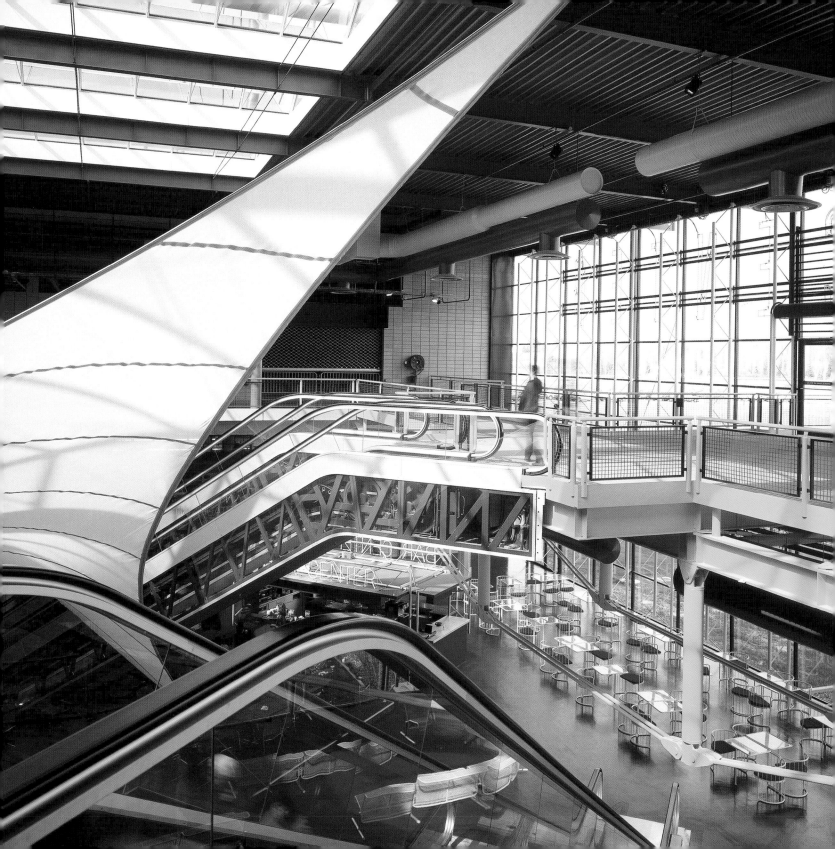

Autosalon

The idea behind the Autosalon was to develop a car supermarket, with large numbers of vehicles displayed in a covered environment. The scheme (on the edge of Paris, close to Orly Airport) was intended to provide a vast 20,000 square metre hall, a one-stop emporium for the sale of new cars and the storage and auctioning of used cars.

Like the much later Millennium Dome, the Autosalon was to be a masted structure, a building where the roof defines the space enclosed and there are few walls. For Mike Davies the scheme was a vital precursor to the Dome.

The project came at a time when the practice was occupied with a number of French projects in the aftermath of the Centre Pompidou and the Fleetguard factory. In particular, the Nantes shopping centre (1986–87) demonstrated the potential of externally masted structures to provide large areas of flexible covered space at modest cost. This building, designed in close consultation with engineer Peter Rice, consists of an arched roof stabilised by masts supporting a series of 18 steel arches spanning 100 metres. The result was a vast space, more than 250 metres long, with only minimal internal interruptions. At the centre of the building, a clear space 15 metres high was achieved, with offices and other facilities provided in additional free-standing boxes within the space.

The scheme remained unbuilt, but its super-span technology became part of the 'structural lineage' of the practice. RRP's interest in using innovative structural solutions to provide flexible enclosed space has been a constant factor over the last four decades. Equally significant is the application of memorable form to an inherently matter-of-fact use.

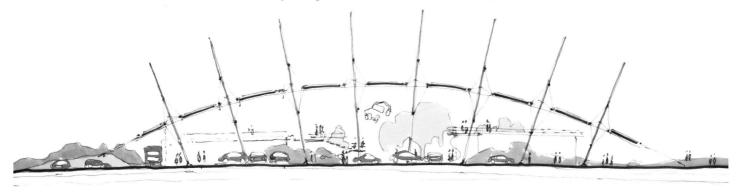

"The Autosalon concept explored the provision of universal, large-span space. The flowing roof, propped and suspended, can follow any shape and absorb any span. At Massy, it formed a single, unidirectional gentle curve, whereas in later projects it has evolved into three-dimensional roof forms expressing the same idea." Mike Davies

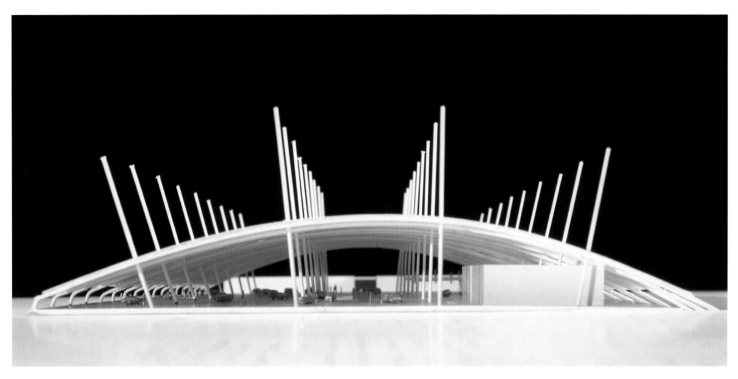

Opposite Top: Floor plan.
Opposite Below: Sketch section
through the showroom. Above:
Model view of the arched
structure with cable-stayed
masts. Below: The simplicity of
the diagram, seen in section,
creates the maximum amount
of showroom space.

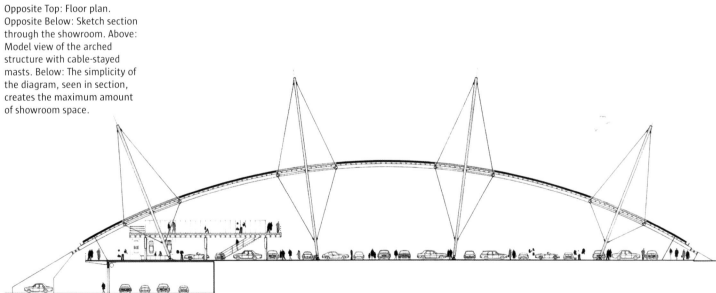

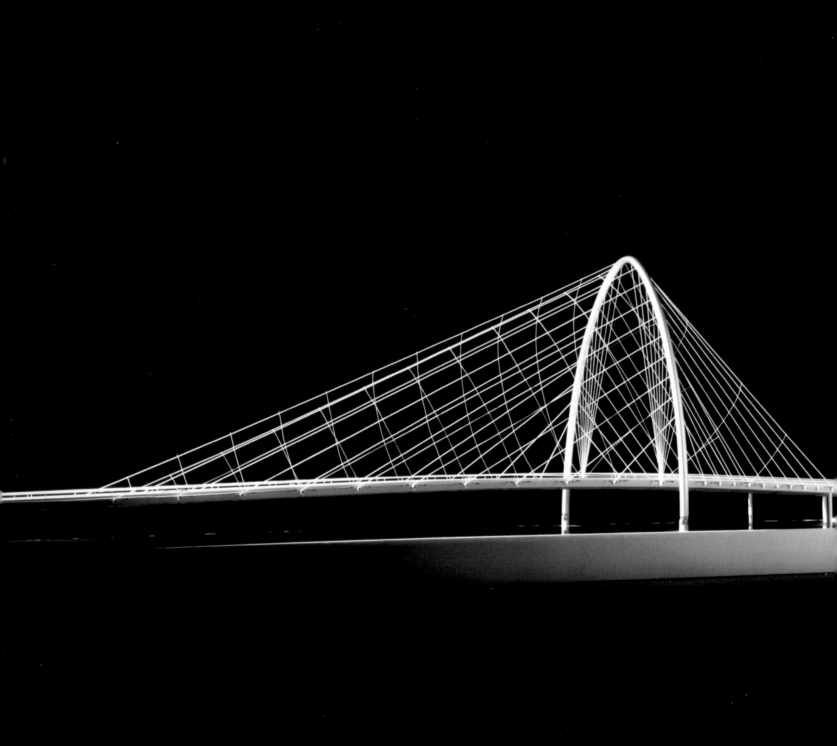

Pont d'Austerlitz

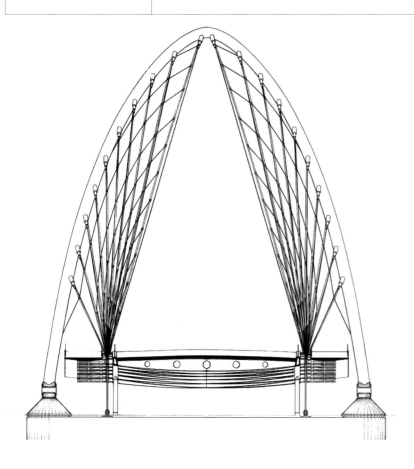

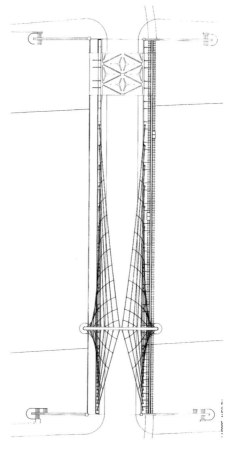

Opposite: Model view. Above Left: Section. Above Right: Plan.

The competition for a new bridge across the River Seine, close to Austerlitz Station, formed part of a long-term plan to regenerate the area east of the station (where Dominique Perrault's new library now stands) and link it with the Right Bank and the Gare de Lyon. The RRP scheme was designed for maximum lightness and transparency, so as to protect fine views along the river.

Working with Peter Rice, RRP proposed a cable-stayed bridge with a single tower – in the form of an arch sitting in the river – from which cables spring to support the roadway. This was an excellent example of the application of architectural principles to the realm of 'civil engineering'.

"The scheme's strength lay in its clear expression of structure and the clarity of its detailing." Laurie Abbott

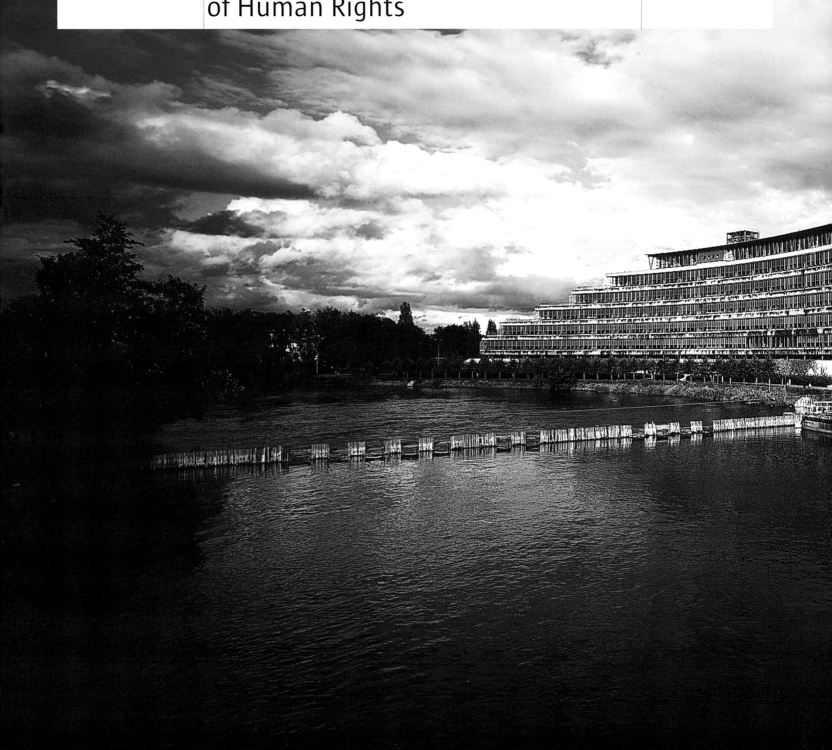

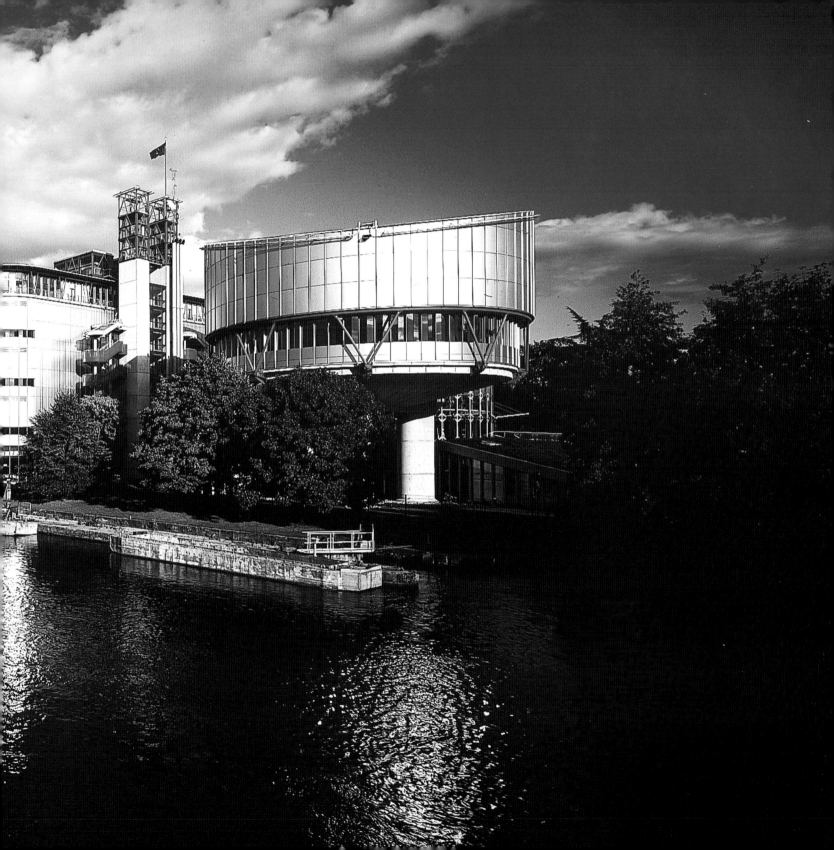

The Strasbourg court is a key building in the history of RRP and one of the few landmarks which provide a credible architectural image for the new Europe. The site is away from the historic centre of the city but close to the river. RRP aimed to create a symbolic landmark but not a monument: the nature of the Court's business implies that its premises should be anything but intimidating or fortress-like. Rather it should be welcoming and humane, while preserving an appropriate dignity. Protecting and enhancing the quality of the site was another prime objective, while economy of running and a 'natural' environment were almost equally important.

The basic diagram of the scheme was tested to the limits during the design process – the collapse of the communist bloc greatly increased the European 'family': the building's office provision had to grow by some 50 percent and the public spaces by 25 percent.

The two main departments of the European court, the Court itself and the Commission, occupy two circular chambers, clad in stainless steel, at the head of the building. The entrance hall is a classic RRP interior, light-filled and with fine views out over the river. The 'tail' of the building, divided into two parts, contains offices and administration and the judges' chambers. Functions are clearly legible. Only the main public spaces, focusing on a stone-paved rotunda, are air-conditioned (using an economical heat-exchange system). The remainder of the building relies on natural ventilation (and light) and opening windows – marking a new era in the practice's work. Facades provide for a high degree of planting: greenery is now well established and spills down from the roofs.

The building is a powerful and highly rational expression of the function it serves but is imbued too with a Mendelsohnian streak of romantic expressionism.

"The scheme's success stems from our response to the site – the form of the building was dictated by the sweep of the River Ill. We were also incredibly lucky with the intervention of the legendary American landscape architect Dan Kiley: his bold gestures resulted in a scheme where building and landscape interact seamlessly." Amarjit Kalsi

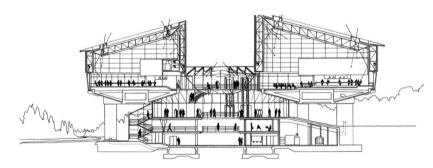

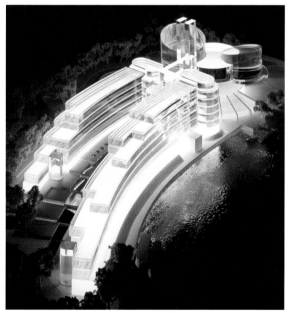

Previous Pages: The 'tail' of the building follows the sweep of the river. Above: Cross-section through the entrance drum. Right: Model view showing the overall composition with the circular entrance and courtrooms and the two wings of administrative accommodation. Opposite: The entrance pavilion flanked by the two courts.

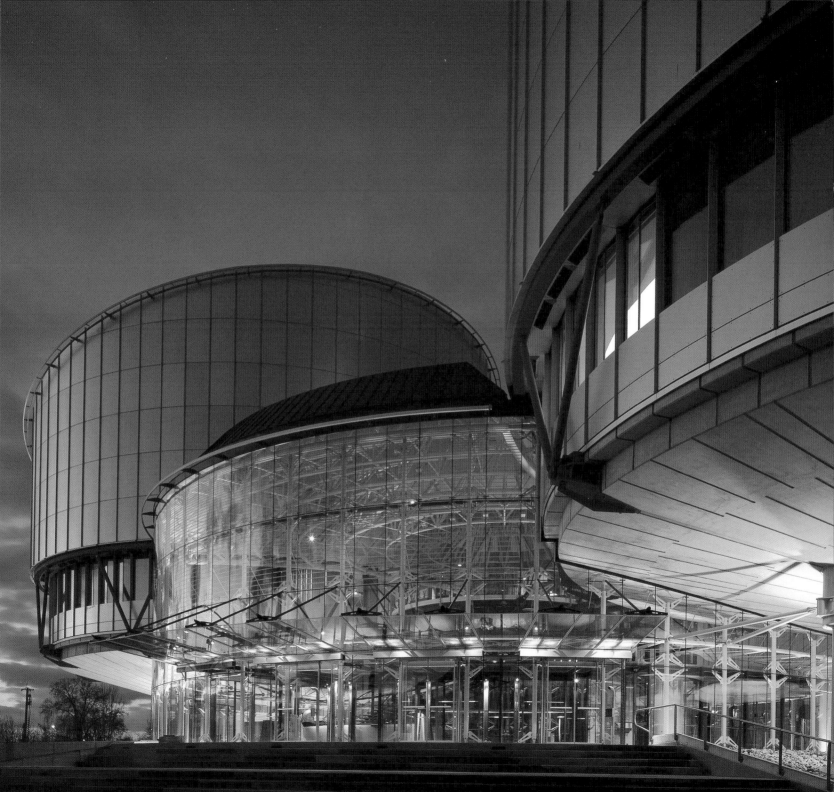

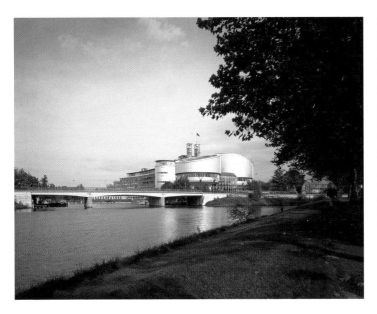

Left: The riverside approach to the building is bordered by trees and planting as part of an integrated strategy to maintain the parkland setting. Below Left and Right: The courts are finished in a lightweight steel frame clad in stainless steel. Secondary structural elements are picked out in bright red. Opposite: The administration wings have continuous planter boxes to integrate the building with the landscape, while a water feature cools the central space.

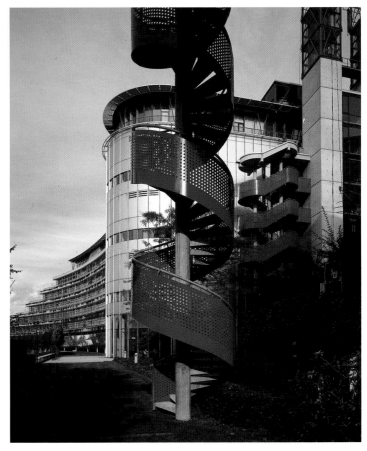

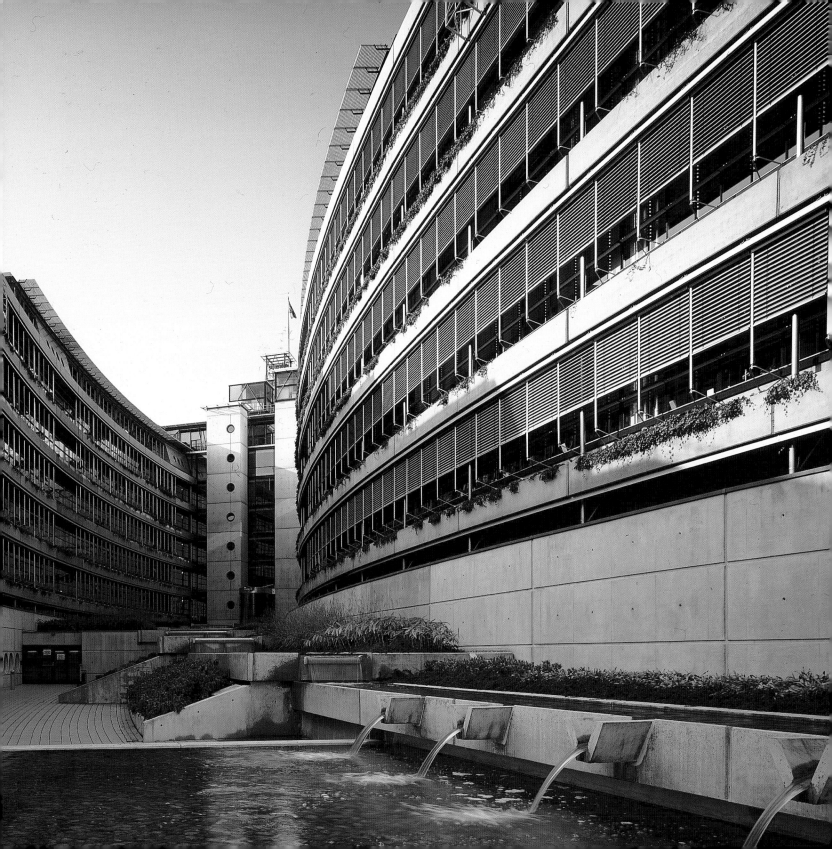

Right: Interior of the Salle de Commission where specially designed sculptural wall and ceiling elements create speech-perfect acoustics. Below Left: Worms-eye view of the entrance atrium. Below Right: Movement through the circular entrance space is via a brightly coloured tubular steel staircase. Opposite: Detail view of the entrance atrium.

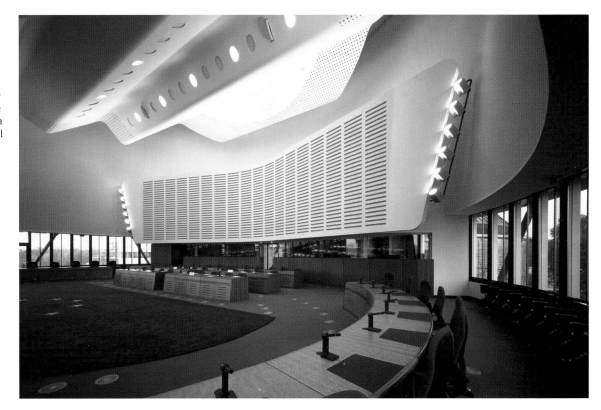

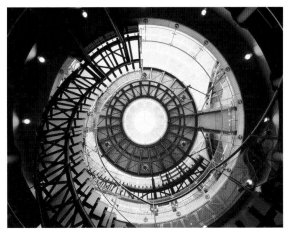

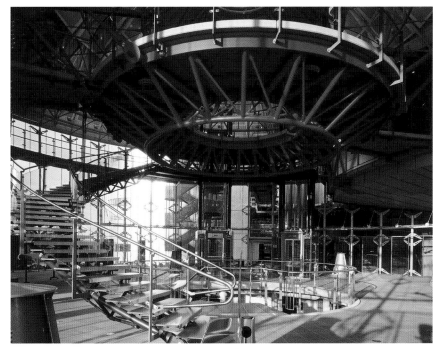

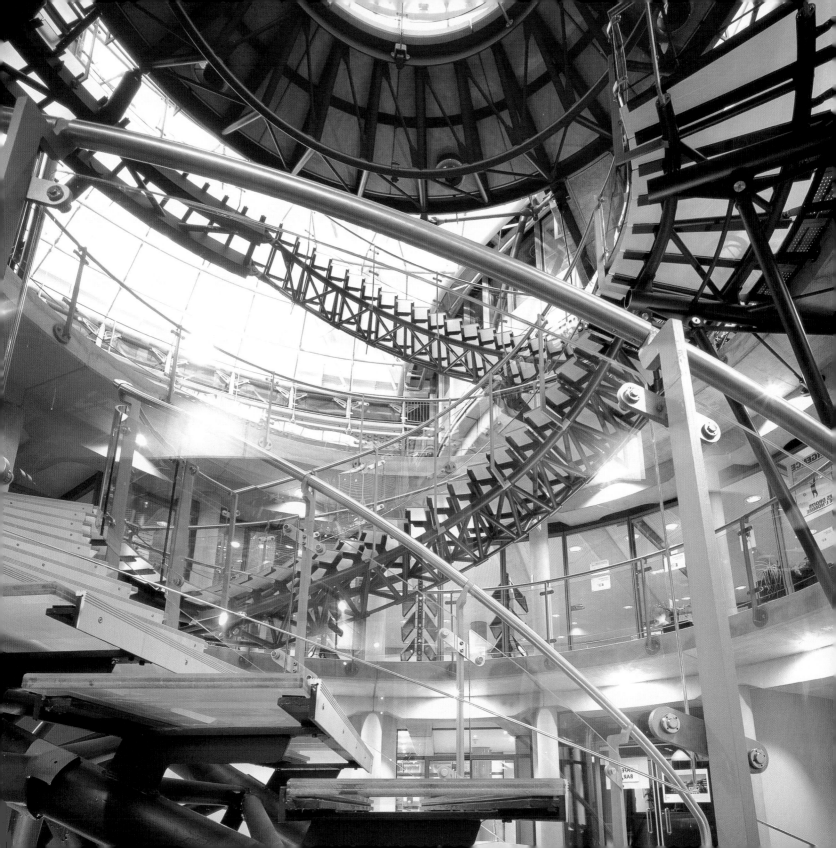

Tokyo Forum

"Our scheme offered three great flexible containers for human activity – Tokyo Forum was intended to be a dynamic organism teaming with life." Graham Stirk

The Tokyo Forum competition entry produced 'an urban people's meeting place' which could have been one of the practice's greatest buildings. The competition called for a huge cultural and conference centre, with auditoria and exhibition space in the commercial heart of Tokyo, close to the Imperial Palace.

The proposal aimed to distil a complex brief within a simple enclosure. The controlled, introverted environment typically required for auditoria were placed within three great airborne, flexible containers – shining steel shells providing super-graphic legibility to the served spaces. The sculpted ground mass provides the forum for a vibrant public realm – three linked piazzas partially sheltered by the overhead auditoria accommodate exhibition spaces, cafés, restaurants, information centres, studios and shops in one animated, continuous urban landscape. Great glazed escalators take people through the open space between the piazzas and up to the suspended auditoria and roof-level gardens.

In other words, RRP wanted to recapture the spirit of Beaubourg, but with a new radicalism of expression and sheer structural daring, reflecting the dynamic life of Tokyo. The very concept of a 'building' is challenged. The main spaces are suspended in a huge steel frame, like giant pieces of sculpture (the largest auditorium could accommodate up to 10,000 people). Services and means of circulation are slotted between them. The space underneath is not an undercroft, but a focus for public life, a precious commodity in a famously crowded city.

The entire scheme was conceived as a continuous public realm through which people could move horizontally, vertically and diagonally. The project demonstrated RRP's determination to restate the need for an innovative architecture in an age of confusion and doubt.

Above: Floor plan. Below: Six diagrammatic representations of the primary structural and architectural elements. Opposite: The three auditoria are suspended in a large steel frame with servicing and circulation accommodated in the four towers.

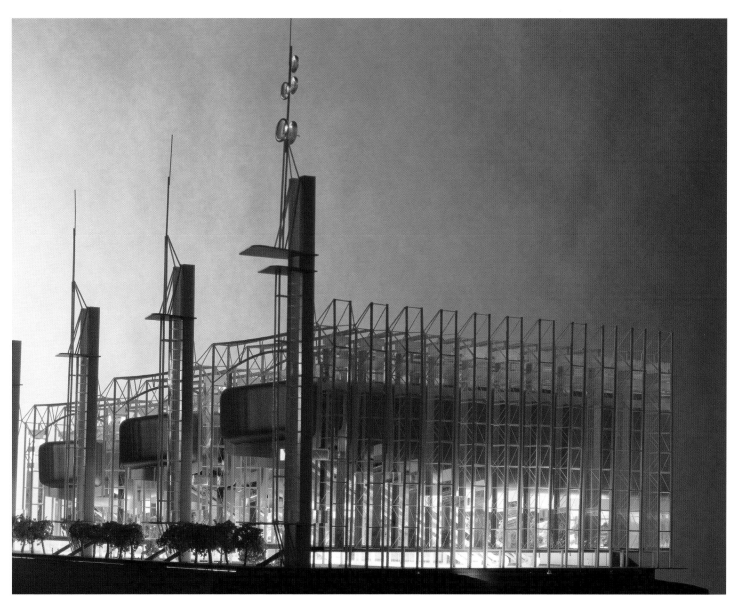

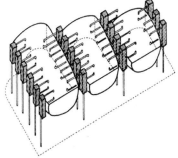

269

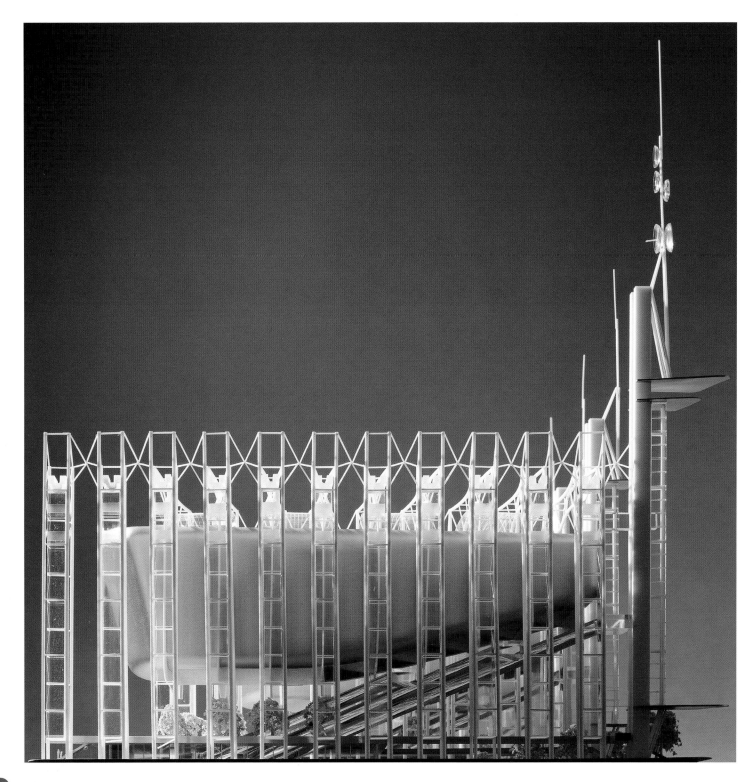

Opposite: Model view. Below:
Section through one of the
three auditoria.

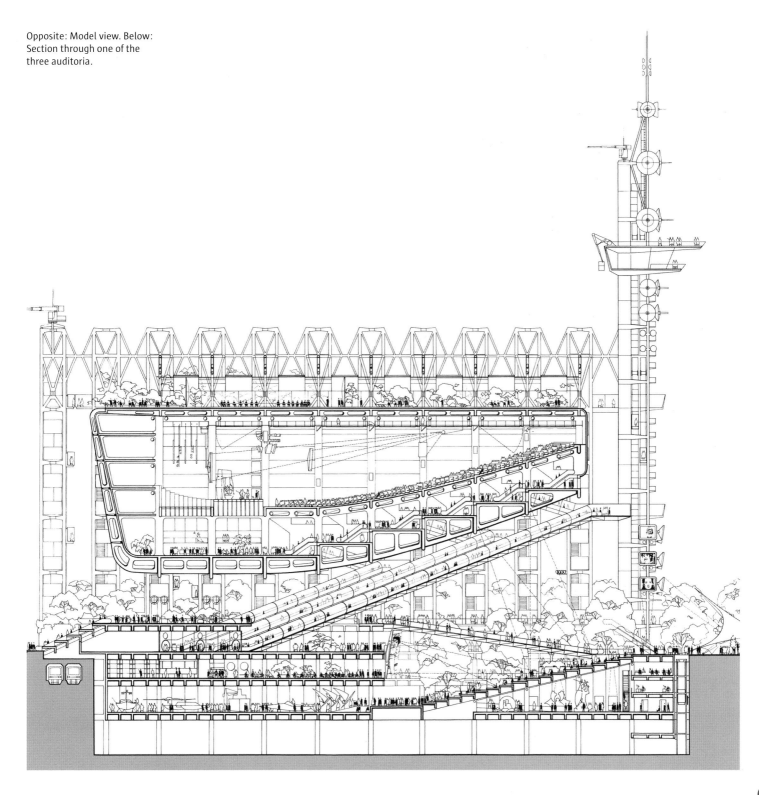

Below: Long-section through
the three auditoria. Opposite
Above and Below: Model views
illustrating the legibility of the
three auditoria 'containers'.

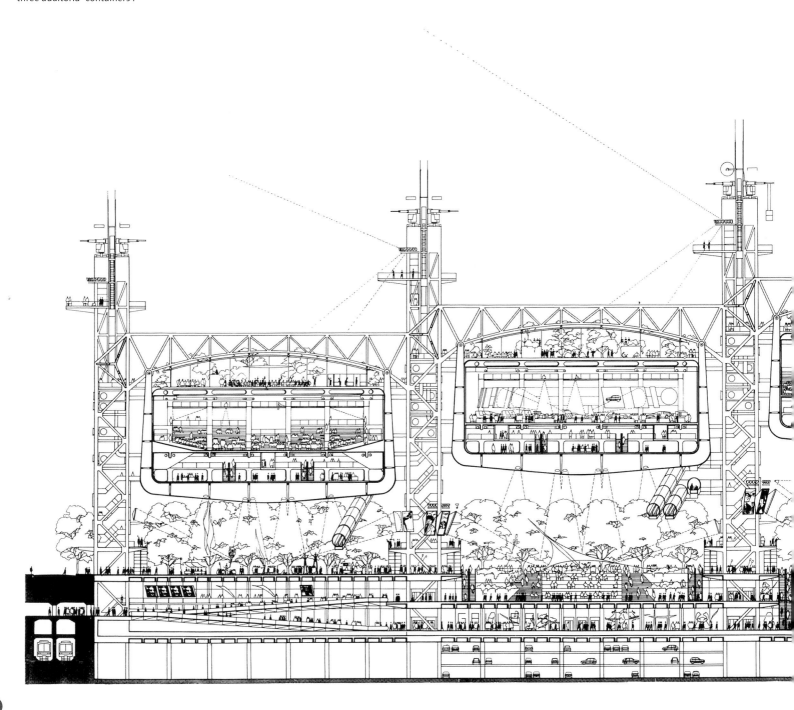

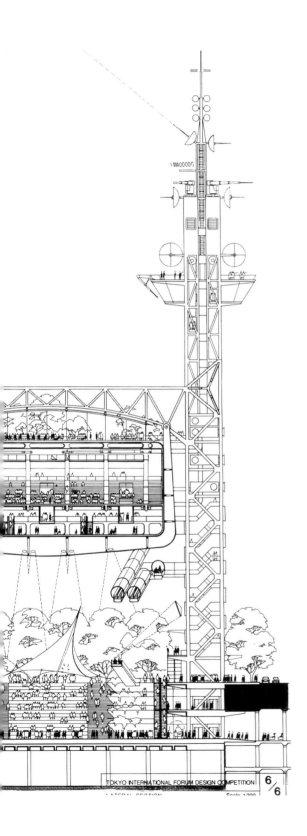

TOKYO INTERNATIONAL FORUM DESIGN COMPETITION
LATERAL SECTION Scale 1:200 6/6

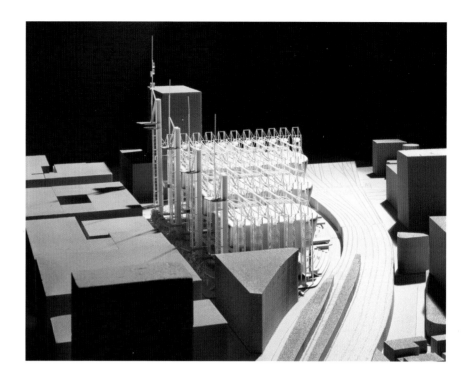

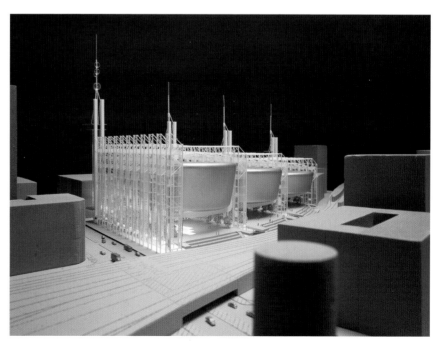

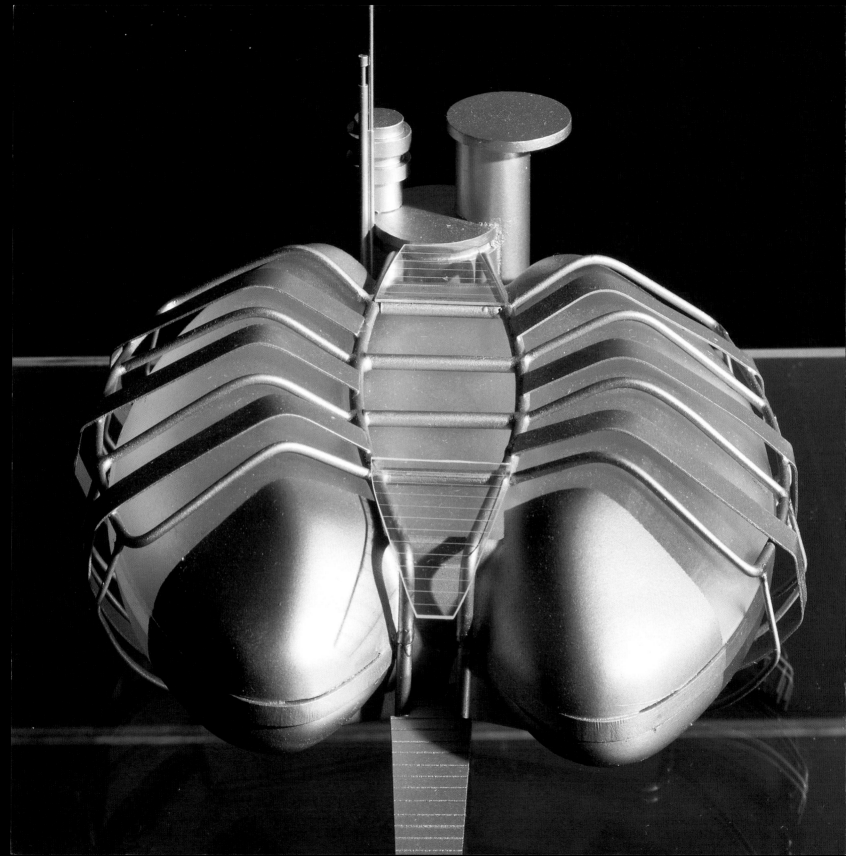

Opposite: The design
for the fully-equipped,
pre-fabricated module
draws on the technology
and aesthetic language
of Airstream trailers and
space capsules. Right:
The symmetrical plan
incorporates an entrance
ramp and service pods
containing kitchen and
bathrooms at either
end of a central space
surrounded by the dining
area.

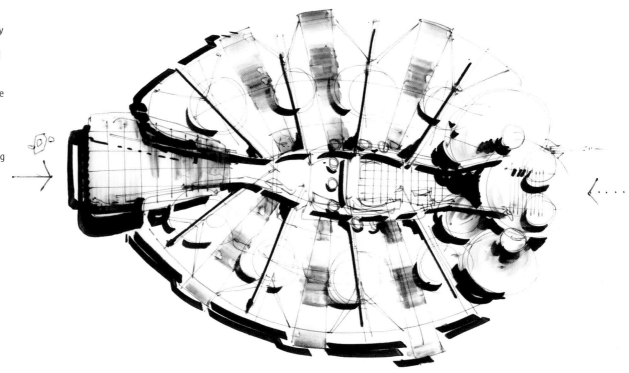

Public Buildings	Futurum Diner	Project 1990

"The imagery of the American diner was always strongly linked to the railcars from which they had evolved. This project attempted to rethink the concept of a diner as part building/part product design, more akin to the timelessness of Wally Byam's design for the Airstream trailer, still going strong after more than half a century." John Young

The first American diner is said to have opened in 1872 in a converted horse-drawn wagon. Later examples made use of redundant railroad cars and buses. Working with a consortium which proposed to revive the concept on an international scale, RRP developed a prototype for the diner of the future.

Like the Zip-Up House or the ARAM module, the diner was intended as an industrial product, rather than a building in the conventional sense. The standardised units were to be mass-produced, clad in stainless steel and glass, fully fitted out and assembled on a production line from pre-fabricated components. The diners were to be demountable and could potentially be moved from site to site in line with demand. The commission resulted in designs for a piece of portable architecture in the Buckminster Fuller tradition.

Christopher Columbus Center

"We sought to give architectural expression both to the public and private areas of a highly technological institution where the primary activity was scientific research beneath the waves." Graham Stirk

RRP was commissioned to design a multi-purpose building, including marine research laboratories, conference facilities and exhibition spaces, as part of the regeneration of Baltimore's harbour, close to the downtown business district and the National Aquarium. The building, dedicated to marine biology, was to include both private and public spaces as well as an interface for public education – raising the profile of the work of the laboratories and the research programmes undertaken – thus transforming the centre into a major visitor attraction.

The scheme was arranged as a group of four linear bars of 'high-tech' laboratories separated by canyon-like spaces which also introduce daylight into the heart of the building and act as a sequence of giant stepping stones. High-tech laboratories are traditionally private buildings but the brief called for the introduction of a public realm composed of exhibition areas beneath the wave-form canopy of the roof and providing strategic views down into specific areas of activity. In this way the aspiration was to encourage the public to view the laboratories as a sequence of real-time experiences of marine life – their visitor 'journey' resembling a continuous trajectory over the lab spaces, the marine archaeology dry dock and the giant water tanks below, culminating in a high-level view over the harbour. This scheme offered an inverse public realm diagram to that of the Tokyo Forum project.

The design marked a move away, however, from the explicitly technological and mechanical imagery of the Centre Pompidou towards a sinuous expressiveness reminiscent, perhaps, of the work of Alvar Aalto, with sweeping, folded roofs and glazed walls enclosing public space in a sequence of dramatic and lofty interiors. A similar aesthetic underlay the competition-winning scheme for the new Terminal 5 at Heathrow Airport.

Right: Site plan. Opposite Top: Longitudinal section. Opposite Below: Located parallel to the waterfront, the building incorporates an enormous public space covered by a great 'wave' roof.

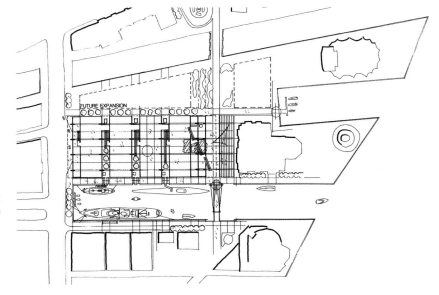

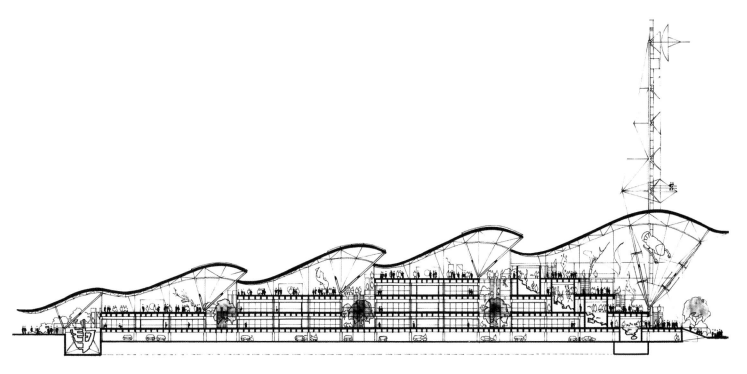

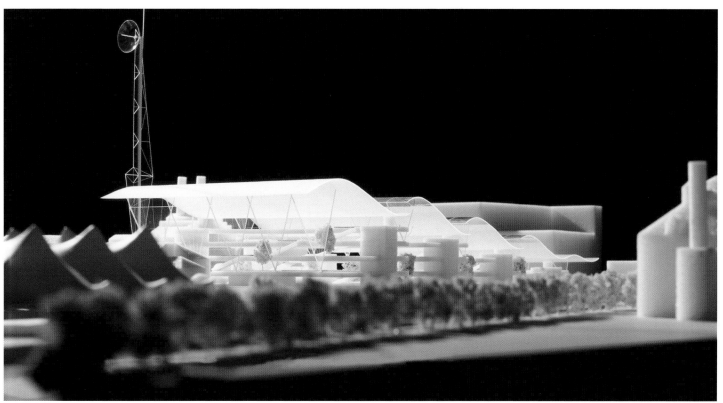

Tomigaya Exhibition Building

Below: Section. Opposite:
Two gigantic steel trusses
hung from the main structural
towers define the sheer glass
wall planes enclosing the
exhibition space.

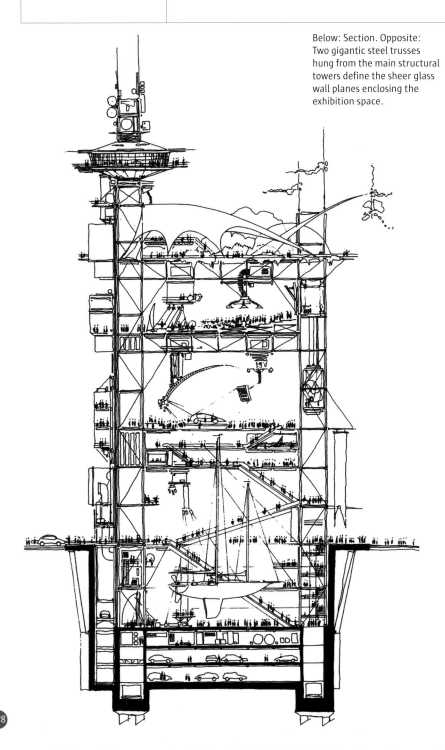

The Tomigaya project provides an illustration of the problems and opportunities offered by Tokyo and of the way in which RRP tackled the issues raised by the unique urban form of the metropolis. The result was one of the most satisfying and dramatic of the practice's smaller schemes of recent years, but the drama is linked, as usual, to a calm analysis of functional requirements and the overall ingenuity of the structural diagram.

The project site was a tiny, triangular area of land surrounded by low-rise housing. Only three floors were allowed by the planning permission, but RRP demonstrated how extra floor space could be created by means of moveable platforms within the building, while the top floor, with fine views and intended for restaurant use, would be covered only by a fabric canopy and could thus be excluded from the planning equation (the basement was also to be deeply excavated and naturally lit). Everything is cantilevered off two supporting towers, to which stairs, lifts and services are also attached. Inside are tall, brilliantly lit, highly flexible spaces capable of holding very large objects – yachts or aircraft, for example.

The project was initially presented by means of a Meccano model. If it had been built, it would have resembled a huge shelving system: a display cabinet on the street.

"Our scheme was a radical response to the constraints of extremely tight planning restrictions – optimising the space potential on this tiny site was the driver." Laurie Abbott

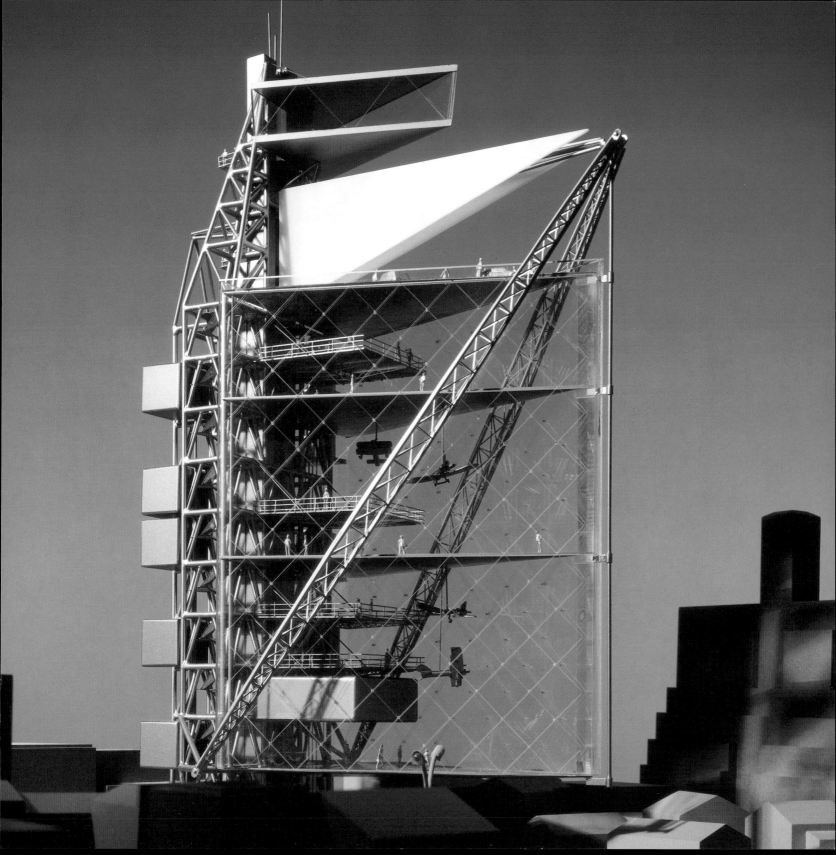

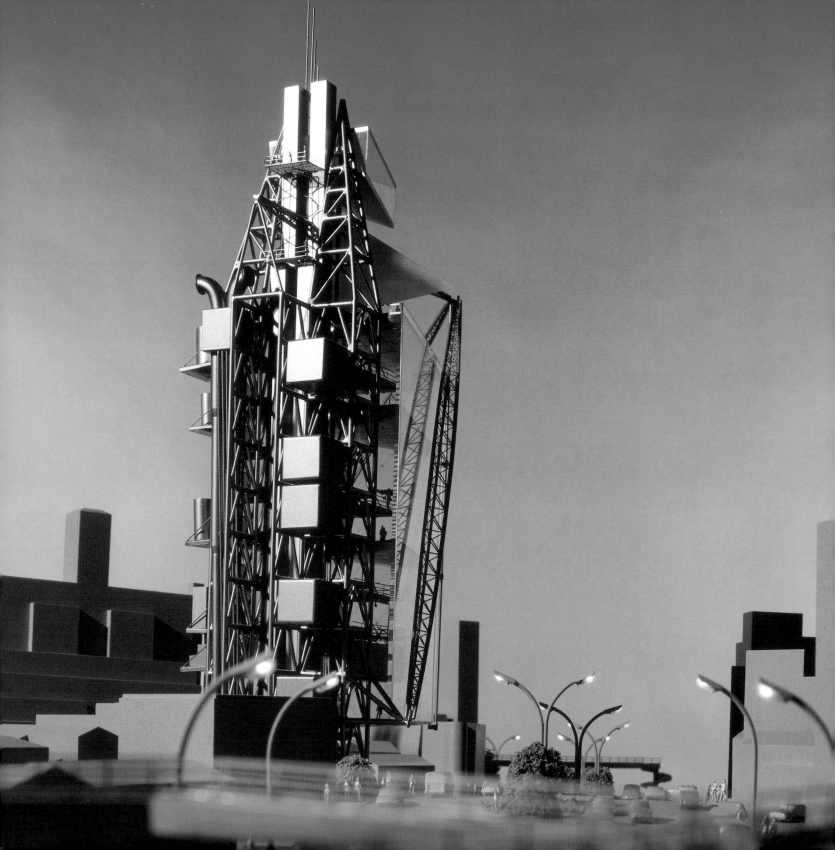

Opposite: The structural tower at the rear of the building incorporates stairs, lifts and other services in a densely packed vertical stack. Below: Concept sketch. Right: A Meccano model was used to explain the structural principles of the design. Below Right: Site plan.

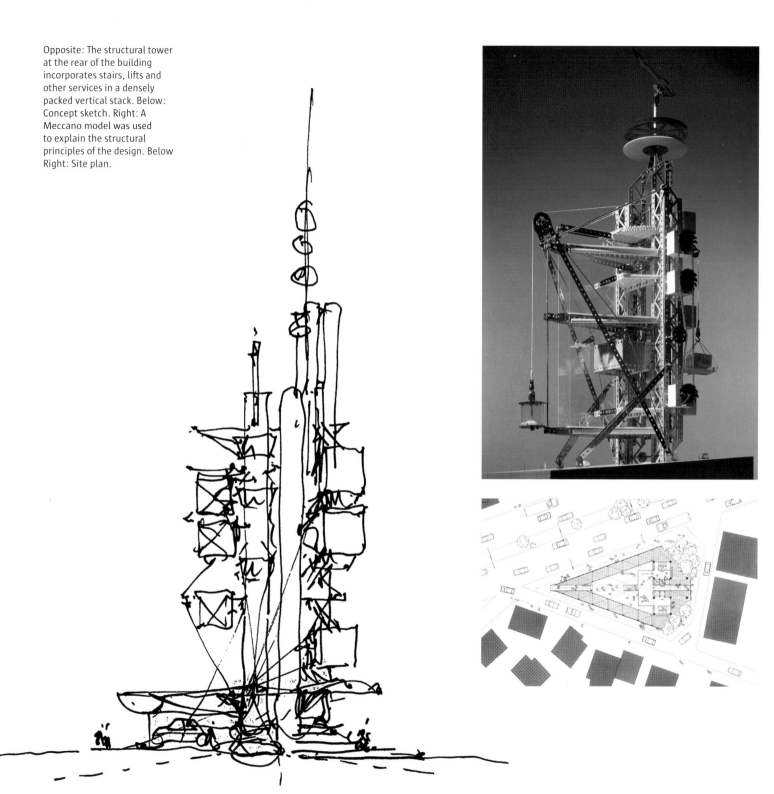

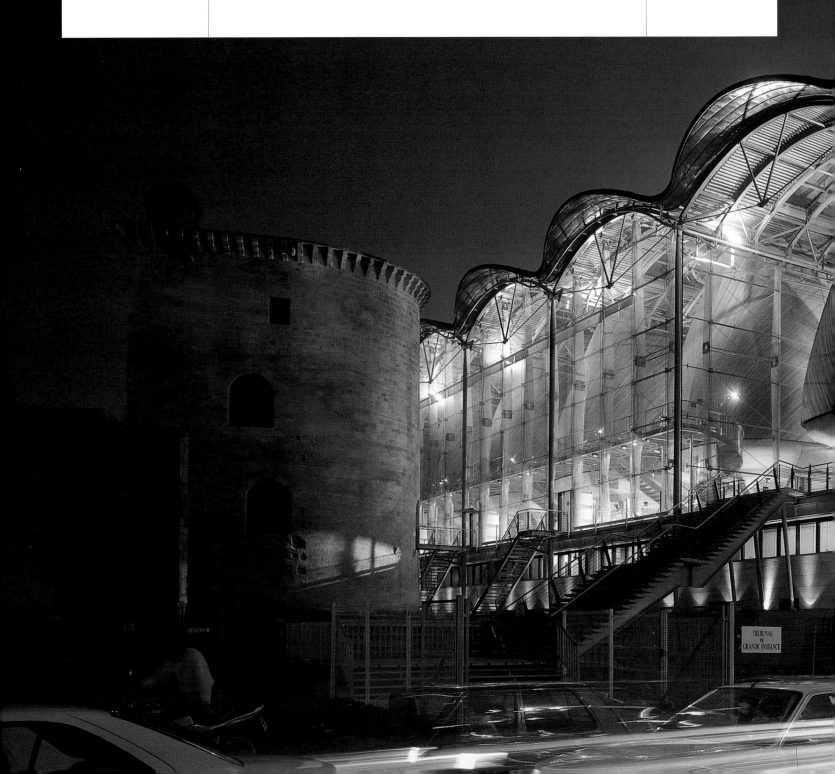

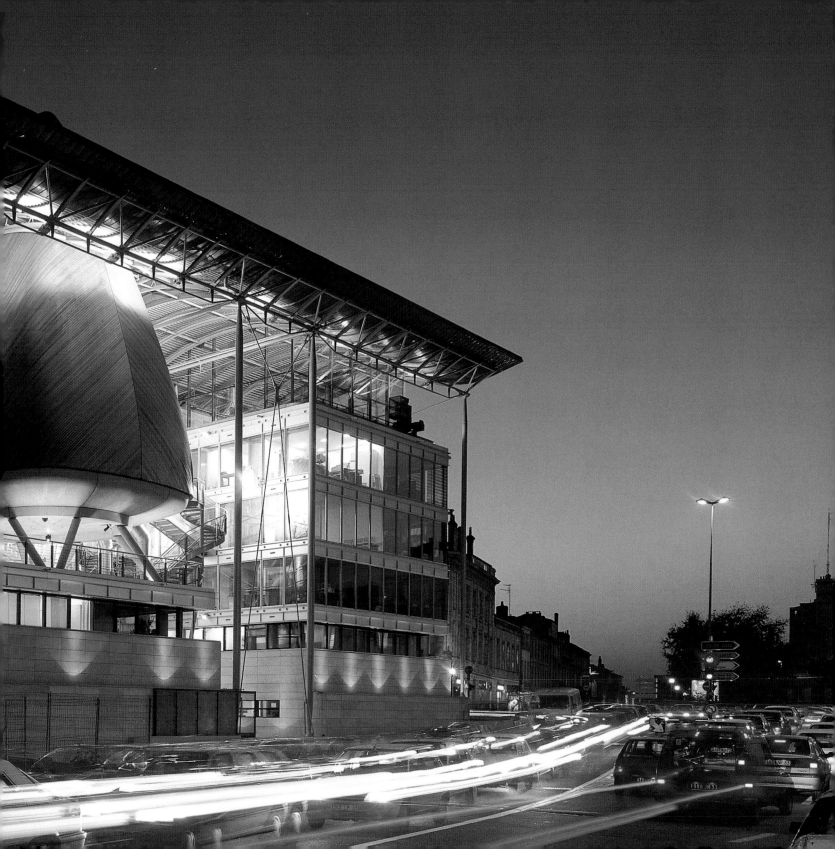

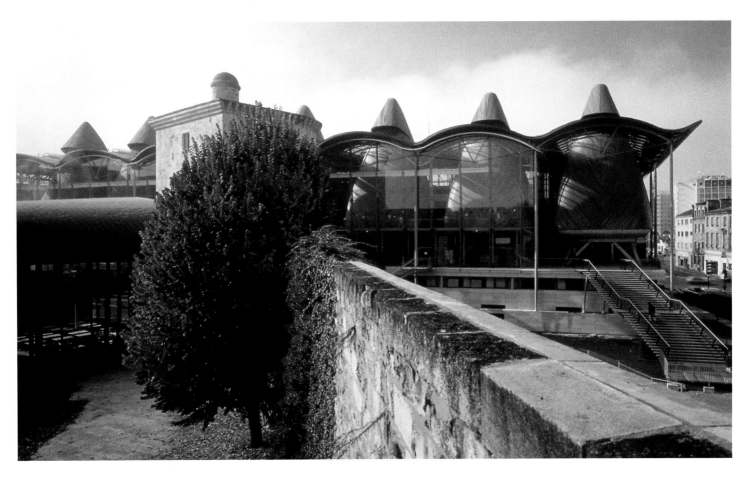

In 1992 Richard Rogers Partnership won the international competition to design new law courts for the historic city of Bordeaux. The team designed a building that would, through its feeling of transparency and openness, create a positive perception of the accessibility of the French judicial system, whilst also incorporating significant sections of the medieval city wall and towers. This is one of the most significant projects by RRP in recent years and marks a distinct phase in the design philosophy of the practice.

While respecting the historic setting and recognising the civic significance of the new building, the practice was anxious to produce a design that was not overly deferential – the intention was to design a simple box, like Beaubourg, that clearly reveals its function and organisation. The brief was complex, requiring complete separation of public and judicial

circulation patterns – by pulling the building into its constituent parts, the resulting transparency was intended to encourage a sense of orientation, rendering a historically imposing institution more open and accessible. The result is a powerful conjunction of clear formal concerns that ensures that justice is seen to be done.

Key elements of the design are the creation of public space and integration with the existing urban landscape – the function of the building is legible to all, both from within and without. Public entry to the building is facilitated without pomp, via a flight of stairs placed to the side. The great 'Salle des Pas Perdus' is the core of the building, where lawyers, their clients and the public meet and converse. The seven courtroom 'pods' are clad in cedar wood, raised on pilotis above the limestone plinth within a great glass curtain wall under

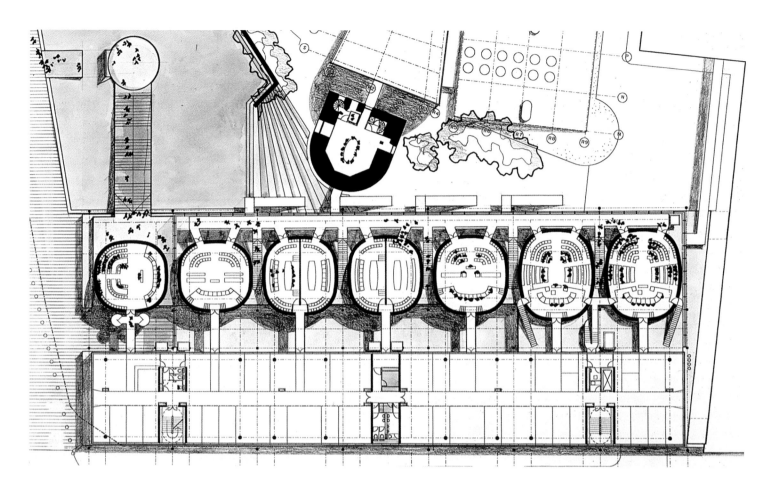

Previous Pages: The building responds imaginatively to its historic setting, continuing the dominant line of the medieval ramparts. Opposite: The courts complement an important historical site. Above: Floor plan. Right: Elevation.

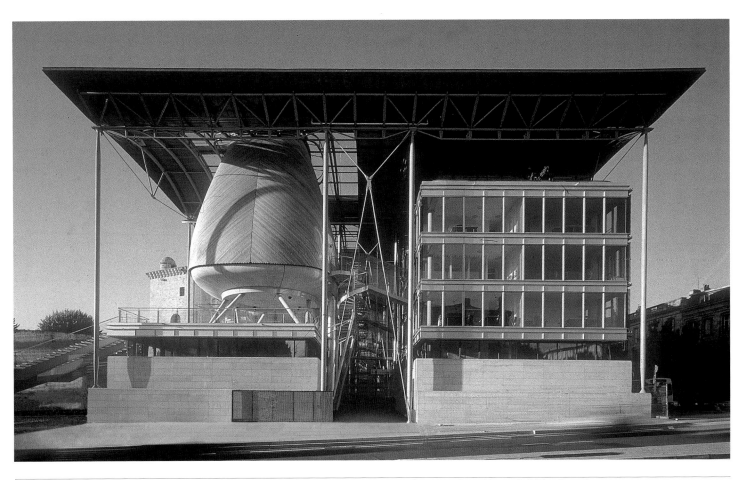

"The key decision was to 'liberate' the courtrooms from the 'box'. We had no preconceptions about construction and generated several concepts. The timber-clad solution was developed using a mix of high technology, computer-controlled machine work and traditional craftsmanship." Amarjit Kalsi

an undulating copper roof. Members of the public can look directly down the atrium 'spine' separating the courtrooms from the administrative block behind – an acoustic buffer screening the internal environment from the busy street outside. The administrative offices are reached by bridges spanning the atrium and the clarity of the plan ensures that different routes across the atrium are maintained for both public and magistrates – emphasising function whilst ensuring sufficient levels of security. A new restaurant and restored medieval tower

provide a dining space for the judges and magistrates. With its use of irregular forms and natural materials, the building successfully complements its sensitive environs, including a section of the city's medieval wall and the great gothic cathedral opposite.

The long-standing themes of the practice – environmentally-conscious design, clarity/transparency, expression of the tectonics of construction – have all at various times assumed greater or lesser importance. In the case of Bordeaux, the practice has revisited the issue

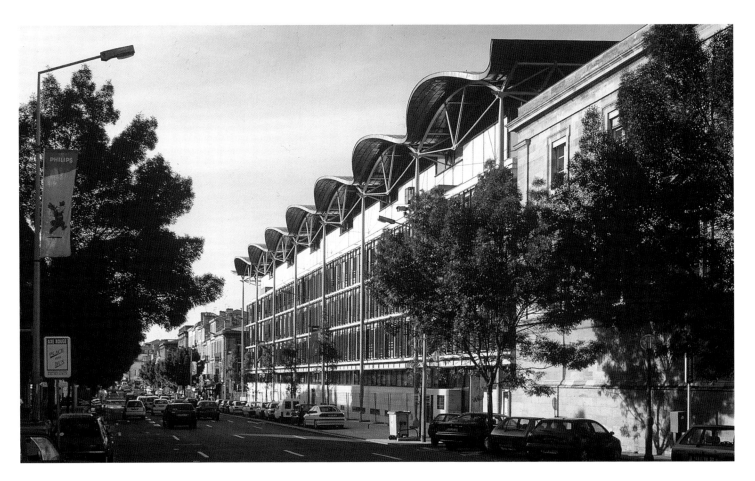

Opposite: The deceptively simple programme is comprised of seven courtrooms parallel to the administration block, under a sculptural roof. Above: The office accommodation fronts onto the busy street, protecting the courtrooms behind. Following pages: Glass bridges and stairs are used by the judiciary to cross the central 'canyon' between the administration block and the courtrooms.

of services, capitalising on the significant advances in 'green' technology. The emphasis is on effective passive control systems: the 'containers' beneath an undulating roof and the fenestration systems (manually operated brise-soleil along the western facade). The flask-like volumes of the courtrooms allow daylight deep into the internal spaces and, through their great height, ensure temperature control through stratification. Their form was continually refined through three-dimensional modelling so as to be justifiable on geometric, technical and constructional grounds – that said, there is a certain serendipity (given the geographical area) in their similarity to wine-flasks. By optimising all practical considerations, the design solution for the courtrooms is appropriate aesthetically, socially and iconographically. The great glazed box wrapping around the chambers, with its sun-screening and ventilation systems

incorporated within the roof, functions as a 'breathing' container. In addition, the podium and offices are built in heavyweight concrete construction – resulting in an effective passive heat control system.

The High Tech aesthetic of the building places great emphasis on assemblage – how the distinct parts fit together, with particular attention paid to the junctions of elements which have been attenuated and honed. Highly modelled, these junctions take on a sculptural quality with every nut and bolt carefully considered and organised. Nothing is left to chance, everything is minutely positioned, aligned and individually designed. The intention is an organic completeness established throughout the entire building – perhaps a subconscious reference to the Centre Pompidou, the building which marked the beginnings of the Richard Rogers Partnership.

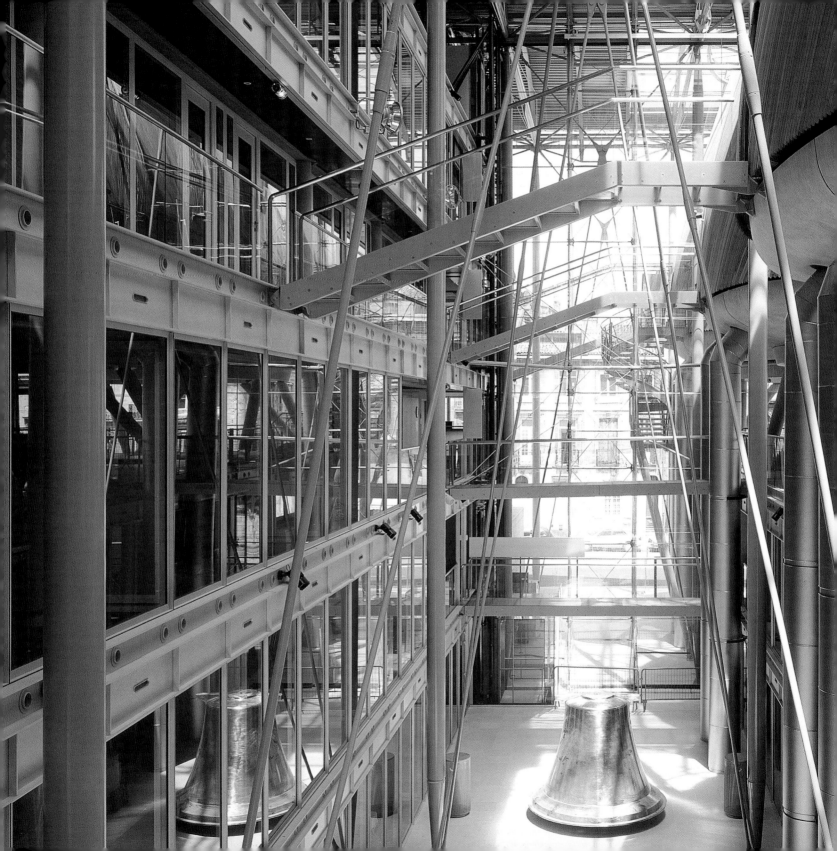

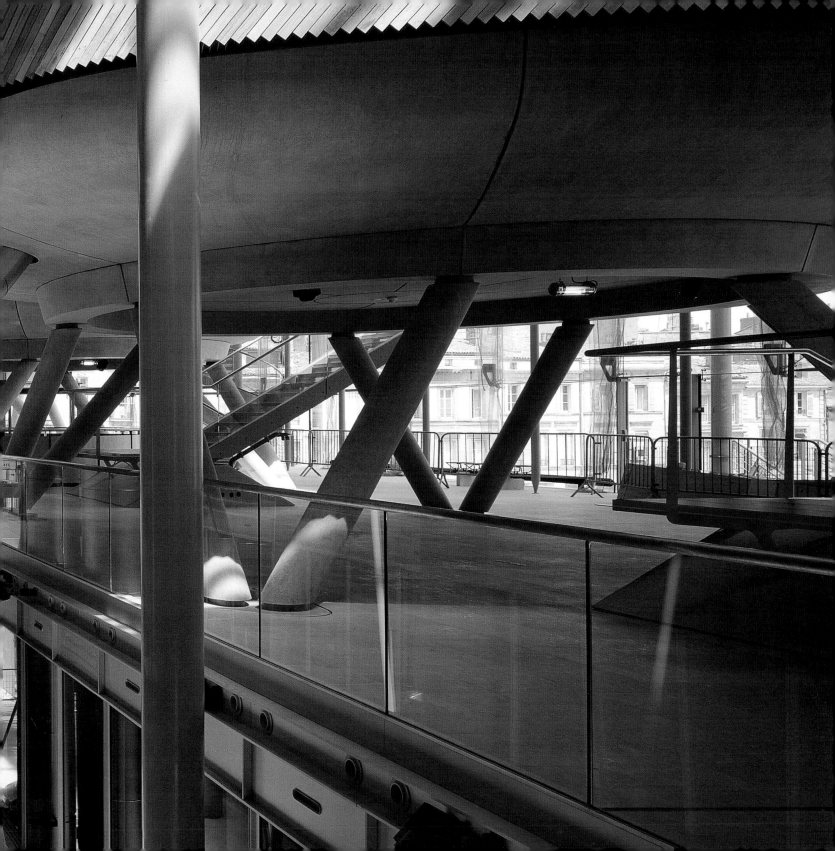

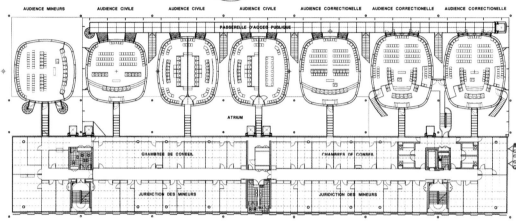

AUDIENCE MINEURS — AUDIENCE CIVILE — AUDIENCE CIVILE — AUDIENCE CIVILE — AUDIENCE CORRECTIONELLE — AUDIENCE CORRECTIONELLE — AUDIENCE CORRECTIONELLE

PASSERELLE D'ACCES PUBLIQUE

ATRIUM

CHAMBRES DE CONSEIL — CHAMBRES DE CONSEIL

JURIDICTION DES MINEURS — JURIDICTION DES MINEURS

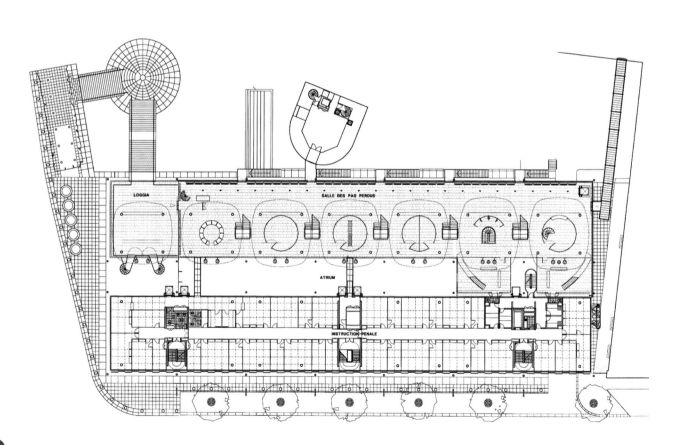

LOGGIA

SALLE DES PAS PERDUS

ATRIUM

INSTRUCTION PENALE

290

Opposite Top: Courtroom floor plan. Opposite Below: Lower level floor plan. Right: Concept sketch using the metaphor of wine bottles to represent the courtrooms. Far Right: The timber structural elements were sized digitally, cut on a computer-controlled machine, and then assembled by craftsmen on in-situ concrete plinths. Below Left: Public access to the courts is via an internal gallery. Below Right: Access for the judiciary is via a series of bridges and stairs that cross the central space.

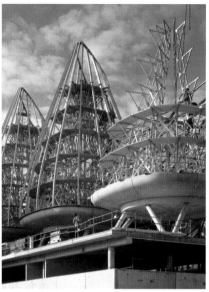

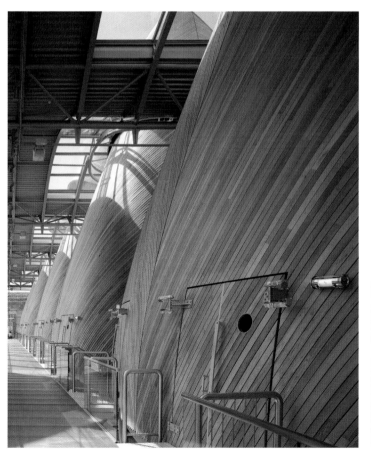

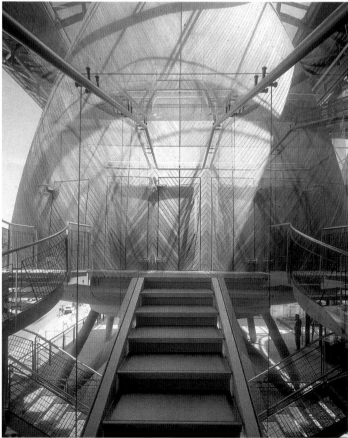

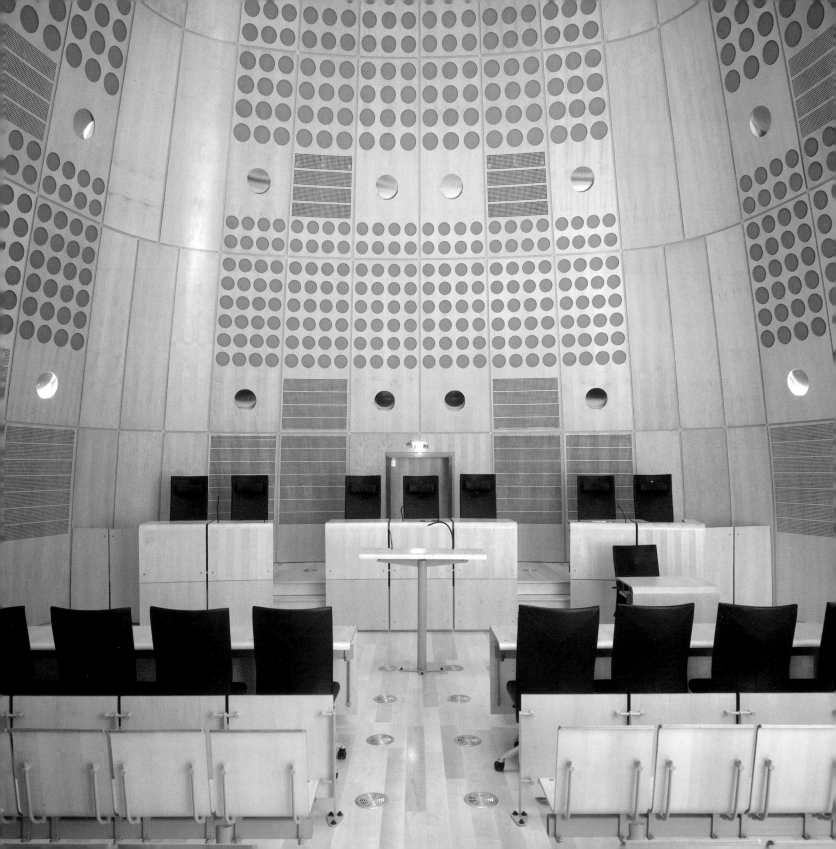

Opposite: The textural timber surfaces of the courtroom interiors have speech-perfect acoustics. Right: The all-timber courtroom interiors are naturally lit from above via a glazed oculus in the centre of the courtroom roof. Below: Diagrams of the environmental systems. Below Right: Computer diagram of the structural frame of the courtrooms.

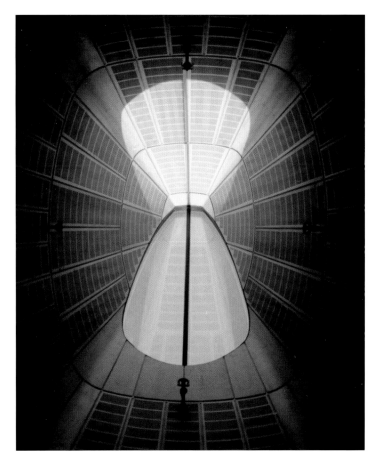

Saitama Arena

Right: Diagrams illustrating
the various flexible modes of
use. Below: Elevation.

RRP's proposals for a landmark arena for Saitama (close
to Tokyo) were developed for a high-profile international
competition. The arena project was part of a masterplan
intended to transform the city from a dormitory of
the capital (it is on the route of the Bullet Train) into a
significant regional centre.

Flexibility was a key requirement of the brief, with
the internal spaces capable of being reconfigured to
seat anything from 5,000 to 40,000 spectators at a
wide variety of events. RRP's submission was developed
with engineer Arup and a team of Japanese consultants
and provided for a dramatic masted roof structure,
extending over the whole space, independent of the
seating stands, so that the internal arrangement of
the arena could be configured to suit the needs of a
wide range of simultaneous events. Environmental
services were equally designed to respond to the
incremental growth of the event space, reducing energy
consumption wherever possible.

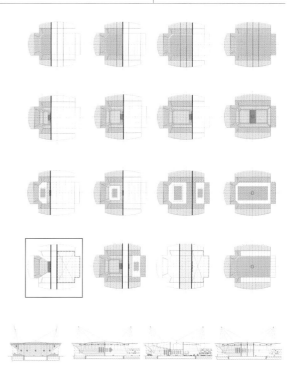

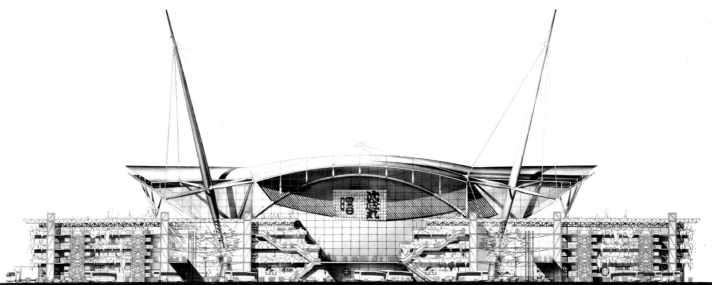

"The client was keen to ensure that the building would have wide and varied usage. Most arenas have a typical annual usage of no more than 30 days – our scheme, through its potential for multiple subdivisions, offered up to 1,000 days per annum." Laurie Abbott

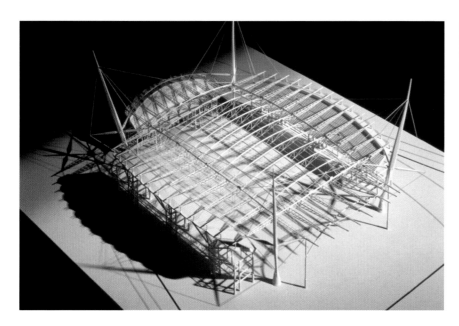

Left and Following Pages:
Model views showing the
dramatic masted structure.
Below: Floor plans.

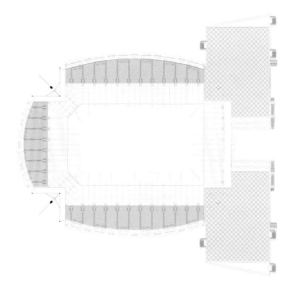
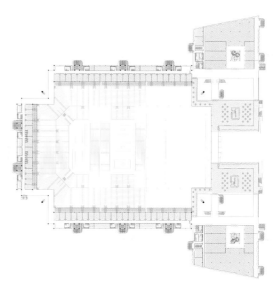

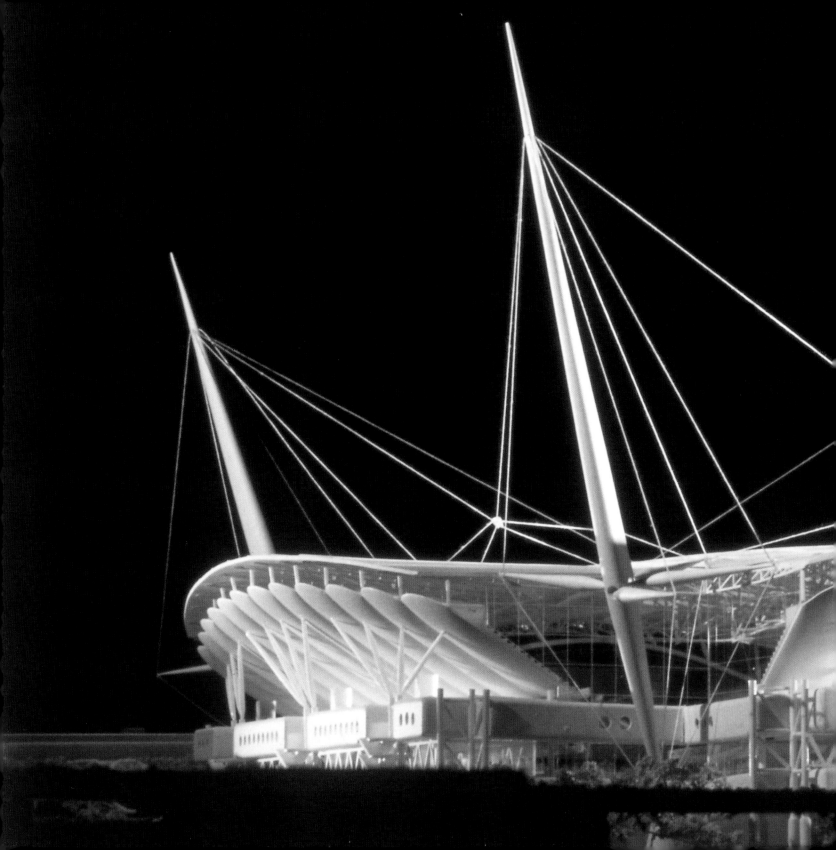

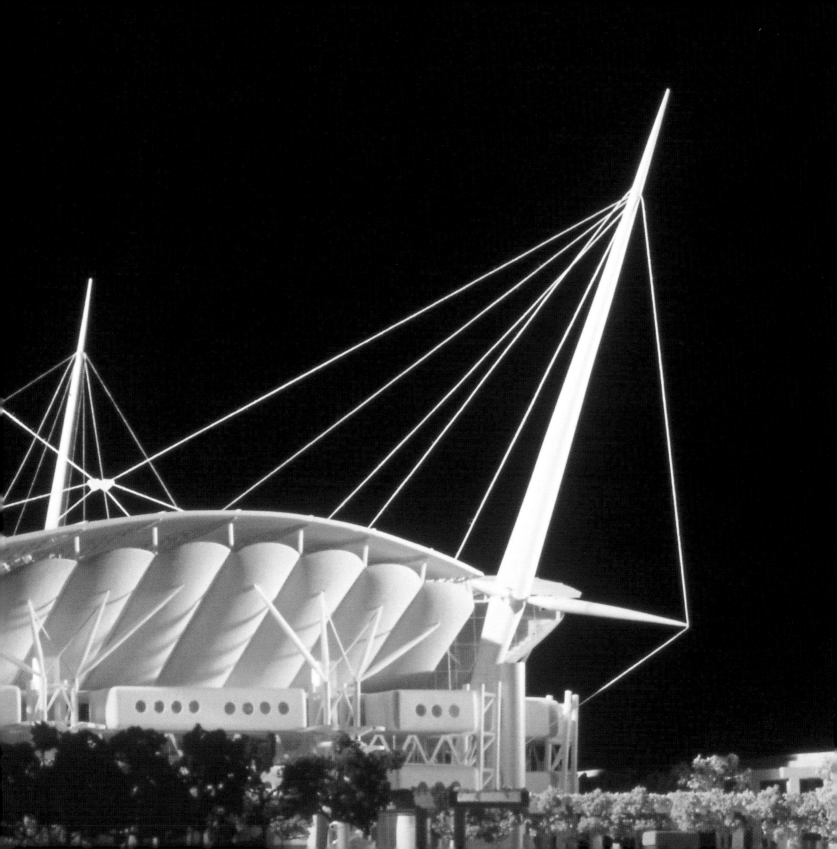

Millennium Experience

"The ultimate inspiration for the Dome was a great sky, a cosmos under which all events take place – the radial lines and circles of the high-tensile roof structure recall the celestial reference grid of astronomical maps throughout the ages." Mike Davies

Commissioned to mark the beginning of the new millennium, the Millennium Dome was intended as a celebratory, iconic, non-hierarchical structure offering a vast, flexible space. Although a high-profile project in its own right, the building also formed a key element of the masterplan by RRP for the future development of the entire Greenwich Peninsula.

The Dome attracted intense media coverage and generated more political and public debate than any other British building of the last 100 years. For RRP, the project was a resounding success – the building itself was remarkably inexpensive (£43 million for groundworks, perimeter wall, masts, cable net structure and the roof fabric) and the practice devised a non-adversarial procurement route involving standardised components that delivered the building within 15 months and under budget. Its content, however, was altogether less successful and was savaged by the press.

Mike Davies, project director, and Gary Withers of 'Imagination' together plotted the projection of the comets and stars, dawns and dusks onto the Dome's surface prior to its detailed structural rationalisation. For Davies, an enthusiastic astronomer, the idea of time was uppermost in his mind – the 12 hours, the 12 months, and the 12 constellations of the sky which measure time are all integral to the original concept. Indeed the 12 towers are intended to be perceived as great arms, out-stretched in celebration.

Designed in association with engineers Buro Happold, the key objectives were lightness, economy and speed of construction. The Dome is firmly rooted in the early work of the practice, in particular INMOS, Fleetguard, Nantes, the dome which formed part of the Royal Docks masterplan and the Autosalon at Massy, all of which are assisted span structures.

Below: Concept sketch.
Opposite: The Dome is dramatically lit by night, highlighting various elements of the structure. Following Pages: Essentially festive in spirit, the masted structure sits elegantly on the edge of the Thames.

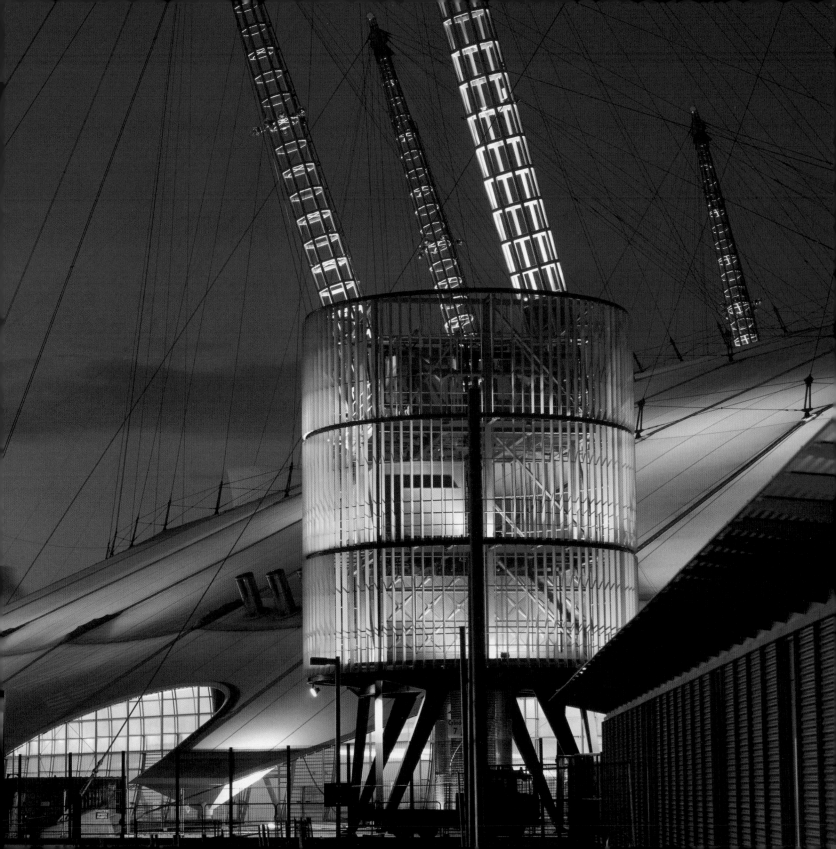

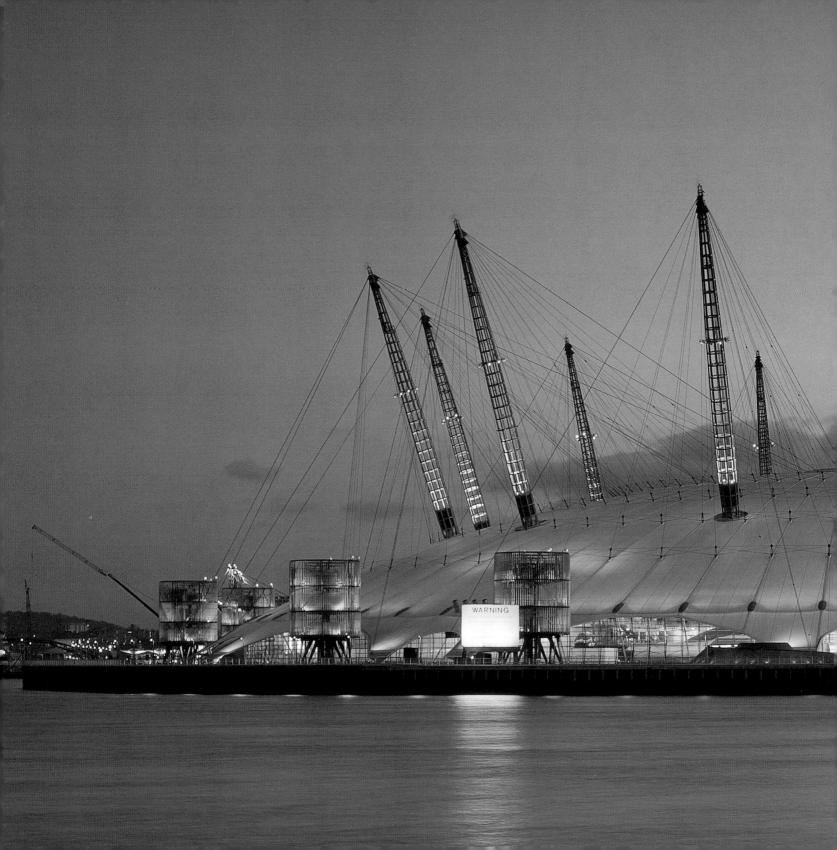

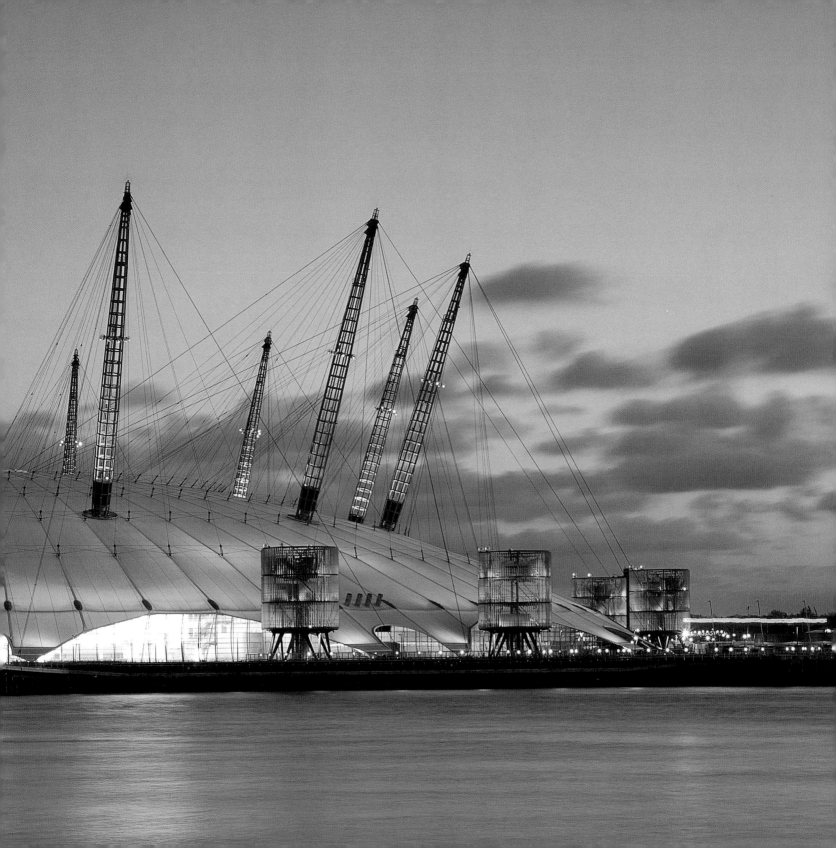

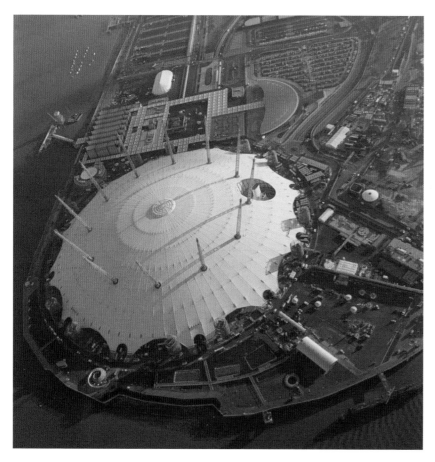

The structure solved with great elegance the problem of how to enclose and protect the separate exhibition 'zones' from the vagaries of the British climate. Providing 100,000 square metres of enclosed space (2.2 million cubic metres), the structure is 320 metres in diameter, with a circumference of one kilometre and a maximum height of 50 metres. The Dome is suspended from a series of twelve 100-metre steel masts, held in place by more than 70 kilometres of high-strength steel cable which in turn support the Teflon-coated glass-fibre roof.

The Dome is now being converted into a sports, leisure and entertainment complex, with the potential to become an Olympic venue should London's bid for the 2012 Games be successful.

Above: The completed building sits in a vast landscaped park. Below: The construction sequence involved the erection of the masts followed by the glass-fibre roof. Opposite: Workmen connect the steel cables that support the roof.

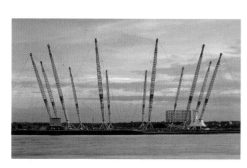
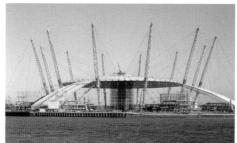
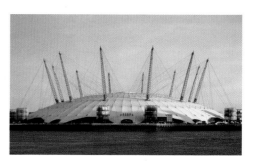

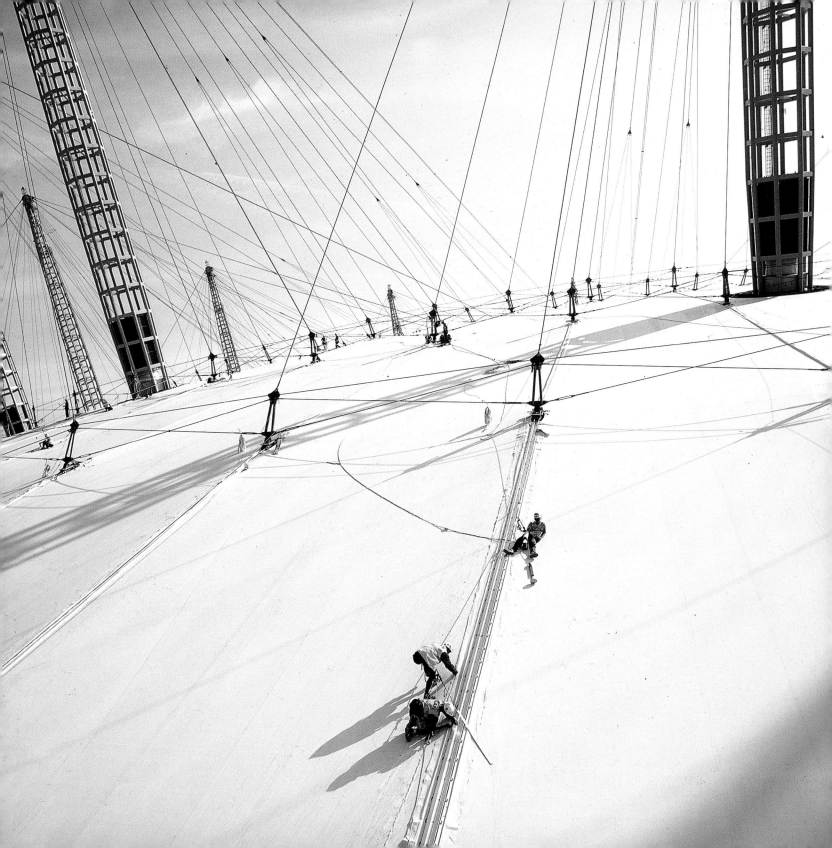

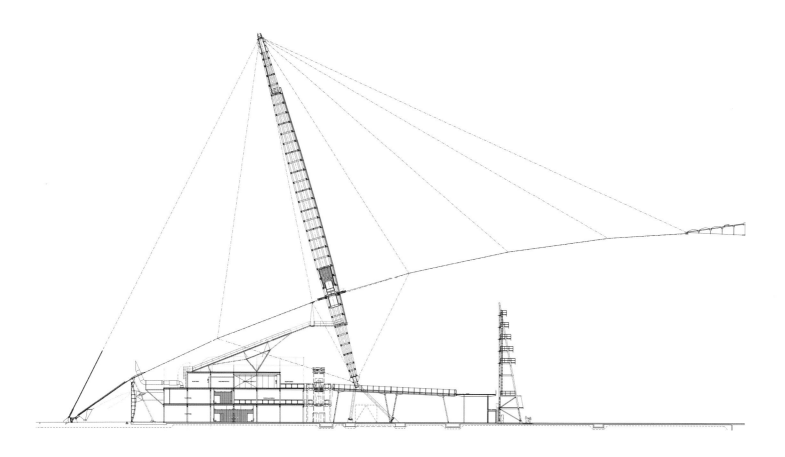

Above: Section through the perimeter. Below Left: Detail of the lower section of one of the twelve masts. Below Right: Detail of one of the cable connection assemblies. Opposite: Floor plan.

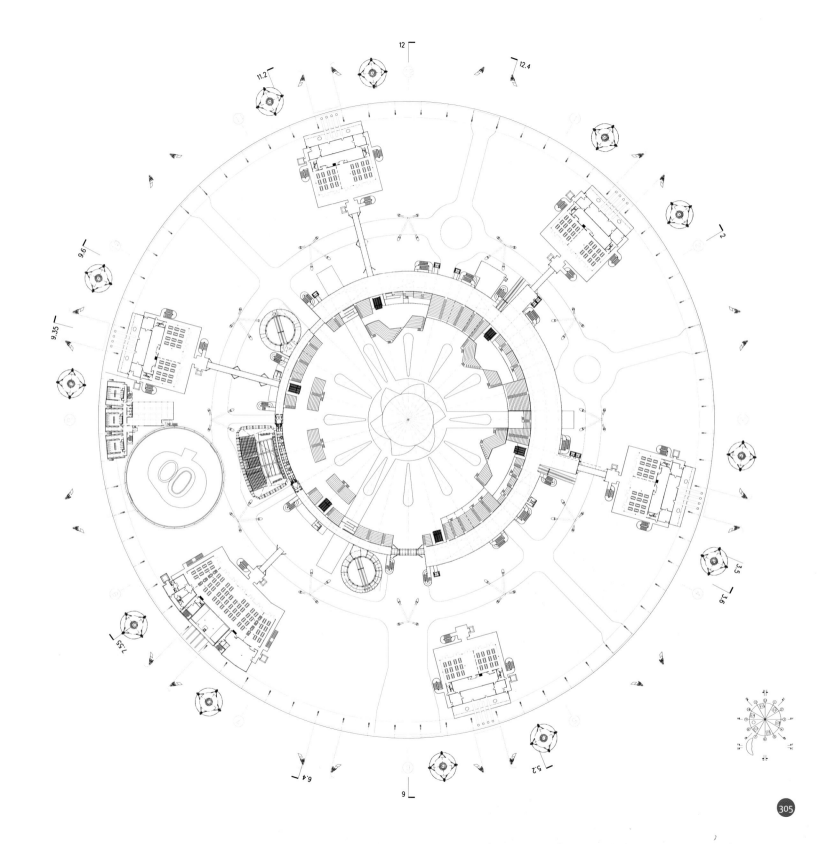

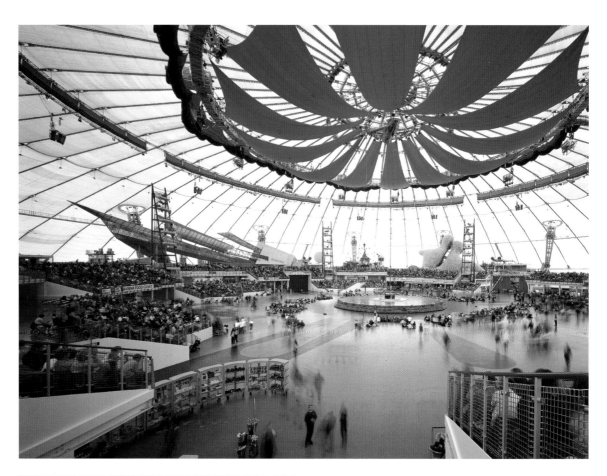

Above: Interior of the Dome
during the Millennium
celebrations. Right: Detail
of one of the masts as it
penetrates the roof. Opposite:
View of the central performance
space on the opening night,
31 December 1999.

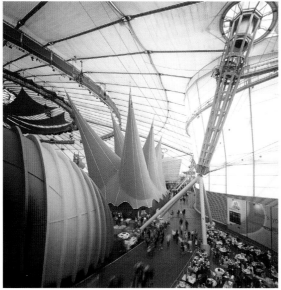

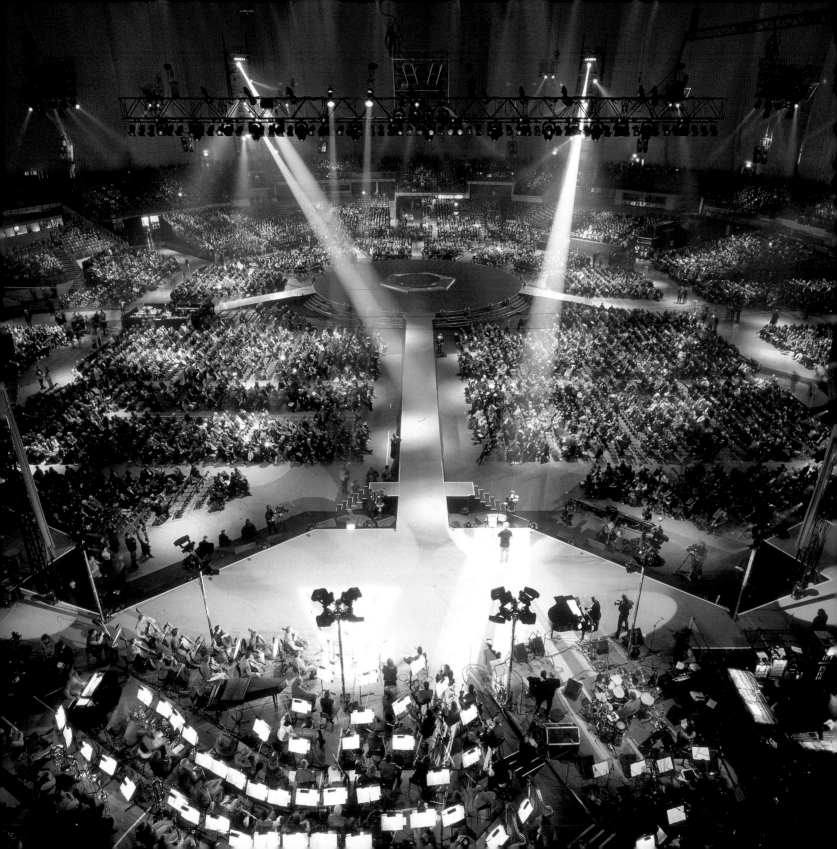

Designer Retail Outlet Centre

Ashford, UK
1996–2000

Above: Concept sketch. Right: View of the inside face of the retail units where the tented roof provides a covered circulation route. Opposite: Aerial view of the leaf-shaped ring of retail accommodation enclosing the central car-park.

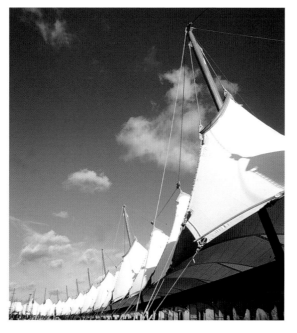

The proliferation of out-of-town retail developments on the American model is a contentious issue in Britain and in Europe generally. This retail development at Ashford reverses the trend, occupying a prime piece of brownfield land – a former railway and engineering site – adjacent to a major public transport hub, Ashford's International Station, with connections to the Channel Tunnel and London.

In architectural terms too, the development is innovative, eschewing the monumental and inflexible character of many recent retail schemes. Instead, the single-storey retail units shelter beneath a 30,000 square metre high-tensile fabric roof, one kilometre in length and supported on 22 bright orange steel masts. The centre can accommodate 3,000 visitors at any one time (there are parking spaces for 1,400 cars) and includes a food court, tourist information centre and exhibition space. The design allows for future flexibility – the retail outlets can be easily relocated and reconfigured as required.

"The design challenge was to create a sense of place using single-storey accommodation and still provide a degree of shelter for the external retail environment. The white, undulating tent form defines the unique identity of this public building, providing a visual contrast with the flat landscape of Ashford whilst also creating a sense of enclosure and unity." Mark Darbon

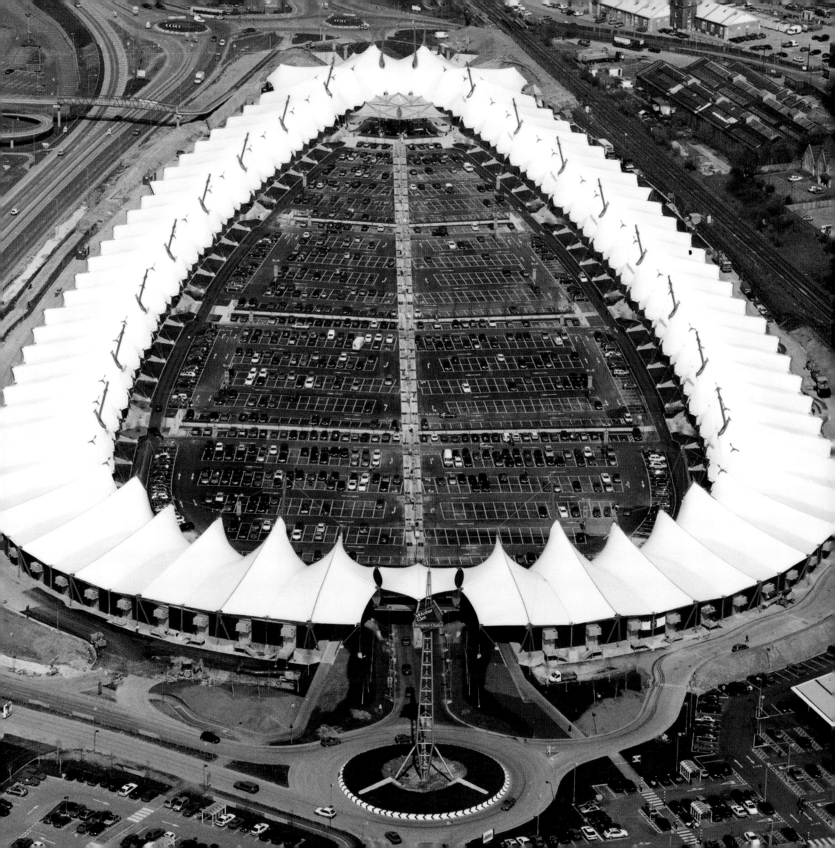

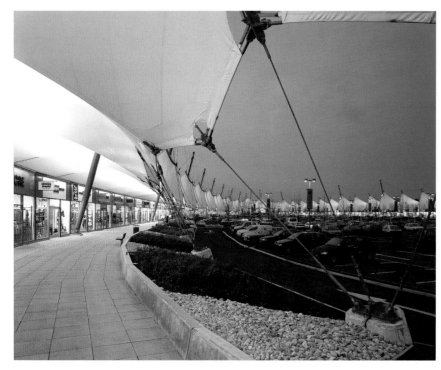

The distinctive tent structure is festive in spirit, unites the centre and announces itself proudly within the 30-acre site. It is undulating in form, rising to high points whose vertical masts act as counterpoints to the horizontal nature of the development and local topology. It wraps around the edge of the leaf-shaped plan and joins the northern end of the site.

Servicing to the retail outlet centre is accessed by a road at the rear of the retail units, which is concealed from view by the three-metre-high landscaped embankment. This embankment gently slopes up to the eaves-line of the retail units providing a compositional springboard for the tented structure. To the outsider, an impression of self-containment and privacy is given for what is, in reality, an ever-changing public space.

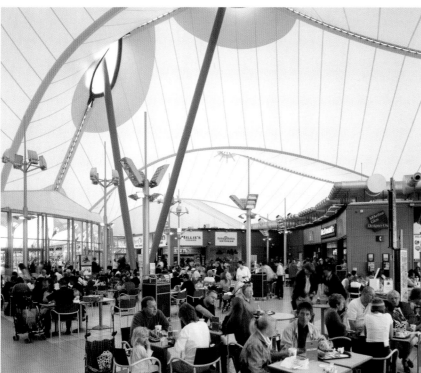

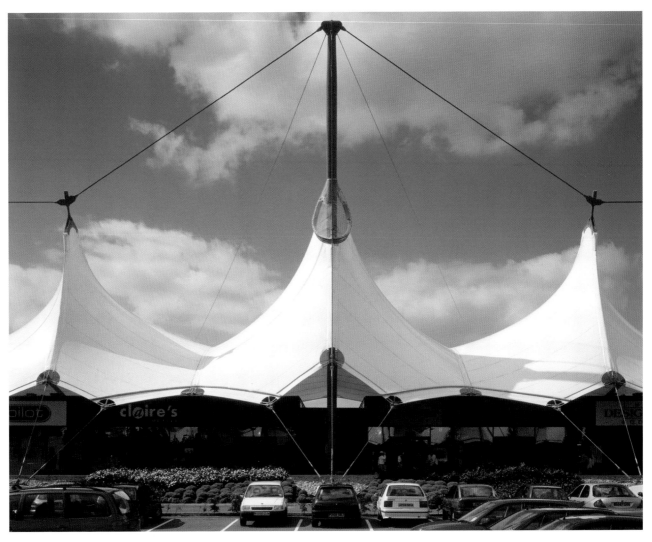

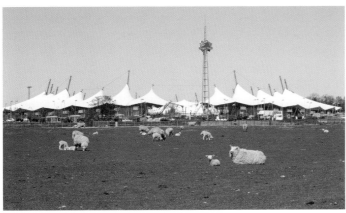

Antwerp Law Courts

"Despite the building's massive area, we wanted to create a structure that was sympathetic to the scale of the city. The result is a long, low building with a roofscape animated by the hearing room enclosures. We placed public spaces above the office areas so as to provide views across the city to the north." Ivan Harbour

Above: Concept sketch.
Opposite: View looking towards the new law courts.

The new law courts for the Flemish city of Antwerp is one of RRP's major public buildings of the early 21st century. Like many projects by the practice, it reflects a vision of the city as a humane and democratic place with a commitment to the regeneration of urban life.

The site for the law courts is at the Bolivarplaats, on the southern edge of Antwerp's central area, where the urban fabric is broken by a massive motorway interchange, cutting off the boulevard that leads into the city. The new building is one of the catalysts for RRP's long-term masterplan of 'the new south' of the city, currently in progress.

The new building, designed in conjunction with Belgian architects VK Studio, is conceived both as a gateway to the city and to provide a link across the motorway between the city centre and the Schelde River. It houses eight distinct civil and criminal courts

and includes 36 courtrooms plus offices, chambers for judges and lawyers, library and dining room, with a great public hall (the space traditionally known as the 'Salle des Pas Perdus') linking six radiating wings of accommodation. This space is capped by a striking roof structure, crystalline in form, rising above the paraboloid roofs that cover the courtrooms.

A low-energy services strategy is fundamental to this project – natural light is used to optimum effect, natural ventilation is supplemented by low-velocity ventilation for the hearing rooms and rainwater is recycled.

The building, straddling a major highway, looks out to a large area of parkland – the design creates 'fingers' of landscape that extend right into the heart of the building. The landscape is configured and planted to shield the building from the noise and pollution of the motorway.

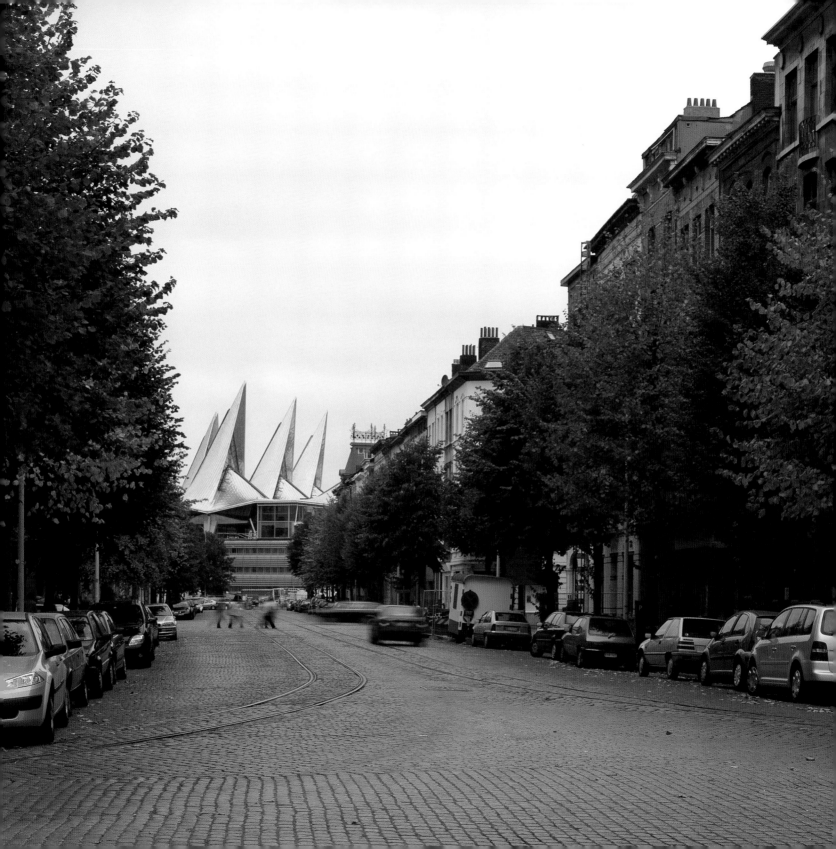

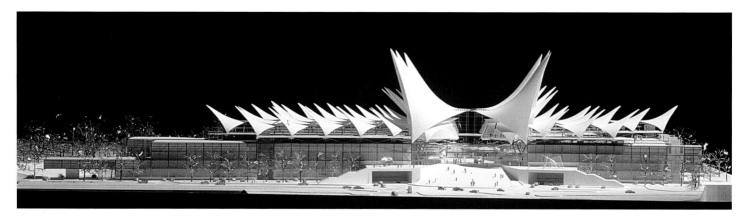

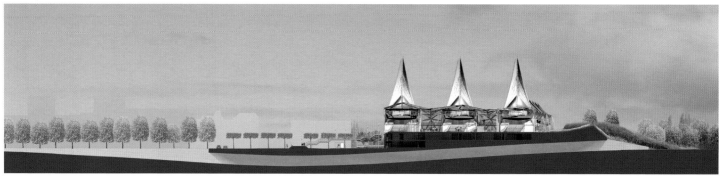

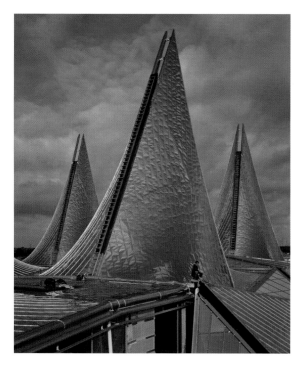

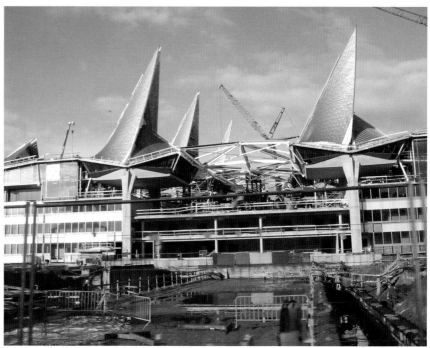

Opposite Top: View of the phase 2 competition model, c.1999. Opposite Centre: Cross-section through the final scheme indicating the way in which the building straddles the motorway. Opposite Bottom Left: View of the large courtroom roofs. Opposite Bottom Right: View from the square showing the roof of the 'Salle des Pas Perdus' under construction. Right: Aerial view of the law courts nearing completion. Below: Courtroom level plan showing the landscaping scheme and the relationship to the park and the edge of the city.

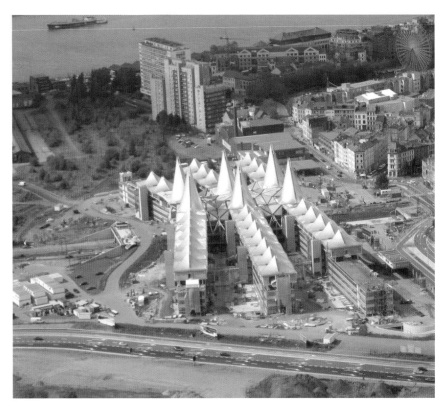

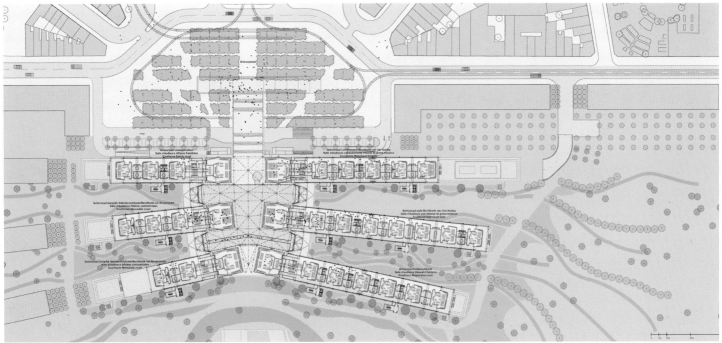

Right and Below Right: Interior of the 'Salle des Pas Perdus' under construction. Below Left and Centre: Interior of one of the large courtroom roofs. Opposite: The building defines the edge of the city.

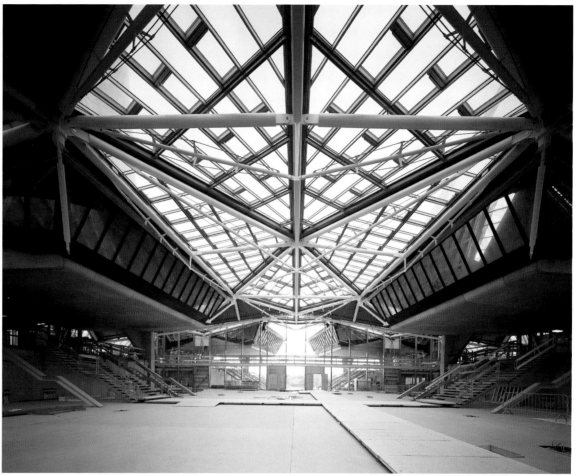

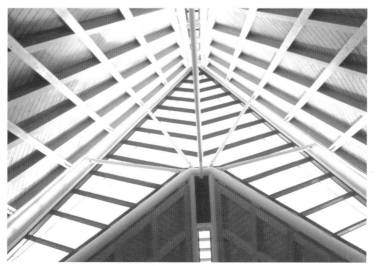

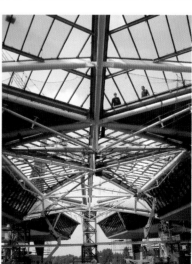

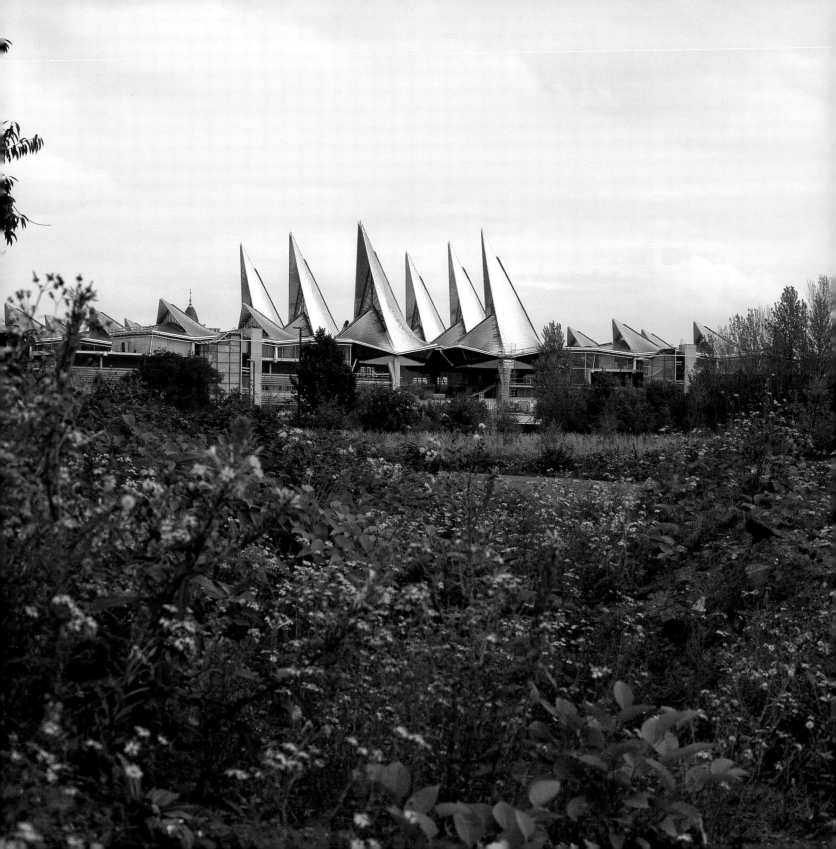

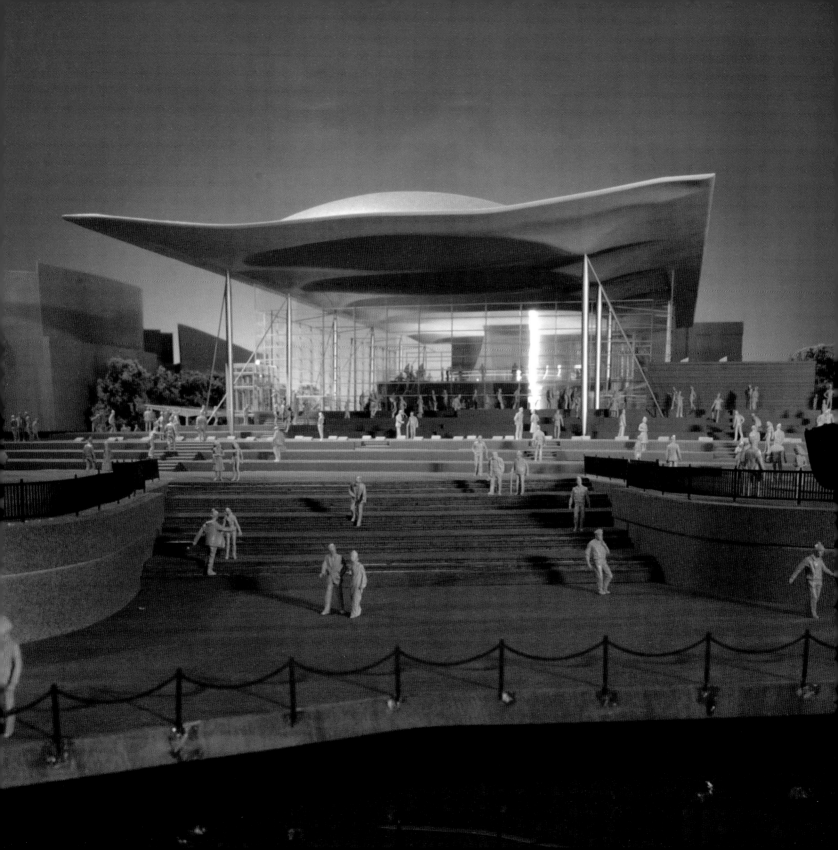

National Assembly for Wales

The election of the Welsh National Assembly, the creation of which was approved by a referendum in 1999, was a turning point in the history of Wales. Its home, currently under construction in Cardiff's former docklands, is a striking addition to the local scene and a statement of faith in the regeneration process. Architecturally, the Assembly building seeks to embody democratic values of openness and participation, while its highly progressive environmental agenda will establish a new standard for public buildings in Britain.

The setting is the Pierhead, around a mile from the city centre and once the centre of the coal exporting trade that was fundamental to the rise of Cardiff. Nearby are the Victorian Grade I listed Pierhead Building and the new Wales Millennium Centre, which includes the permanent home of the Welsh National Opera. The building has an open aspect over Cardiff Bay to the Bristol Channel.

The idea of openness is exemplified by the transparent form of the building. Public spaces are elevated on a slate-clad plinth stepping up from the water and cut away to allow daylight to penetrate the administrative spaces at lower level. A lightweight, gently undulating roof shelters both internal and external spaces, pierced by the protruding extension of the 60-seat debating chamber.

Opposite: The building occupies a spectacular site overlooking Cardiff Bay. A monumental slate-clad plinth steps up from the bay, sheltered under a lightweight, undulating roof. Below: Concept sketch. Bottom: Section through the site. Following Pages: Computer generated image showing the relationship of the Assembly to the existing Pierhead Building (left) and the Bay.

"The site has a powerful presence, with its uninterrupted view out over Cardiff Bay. This impressive vista of sky and water has influenced the building concept in a straightforward but powerful way. The result is a building that looks outwards to Wales and beyond." Ivan Harbour

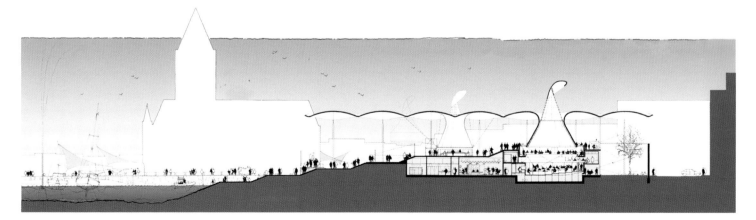

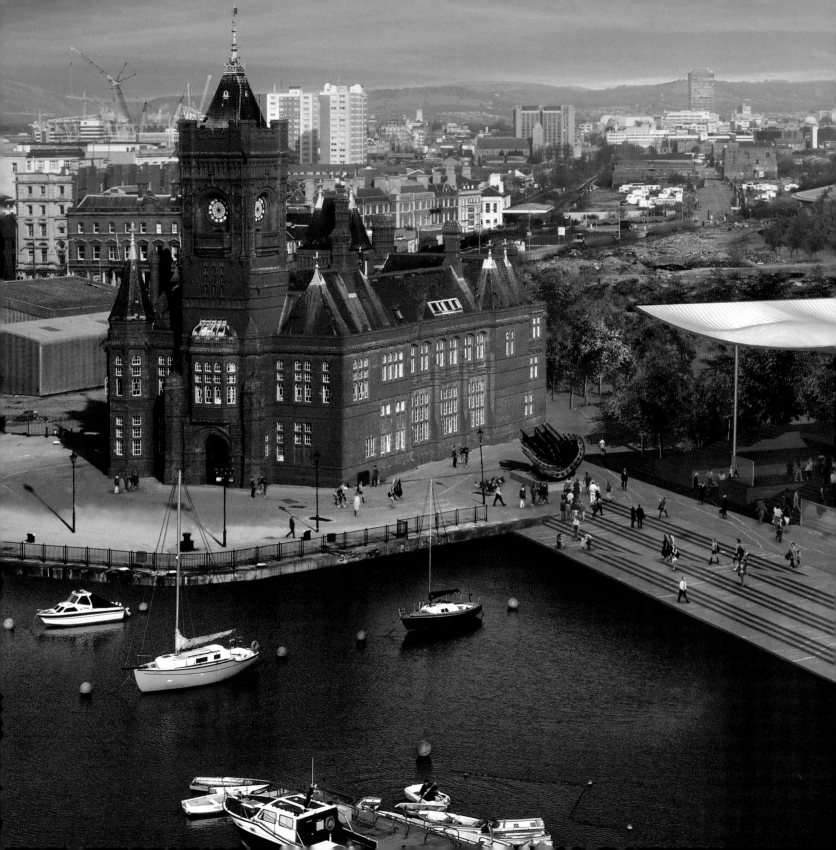

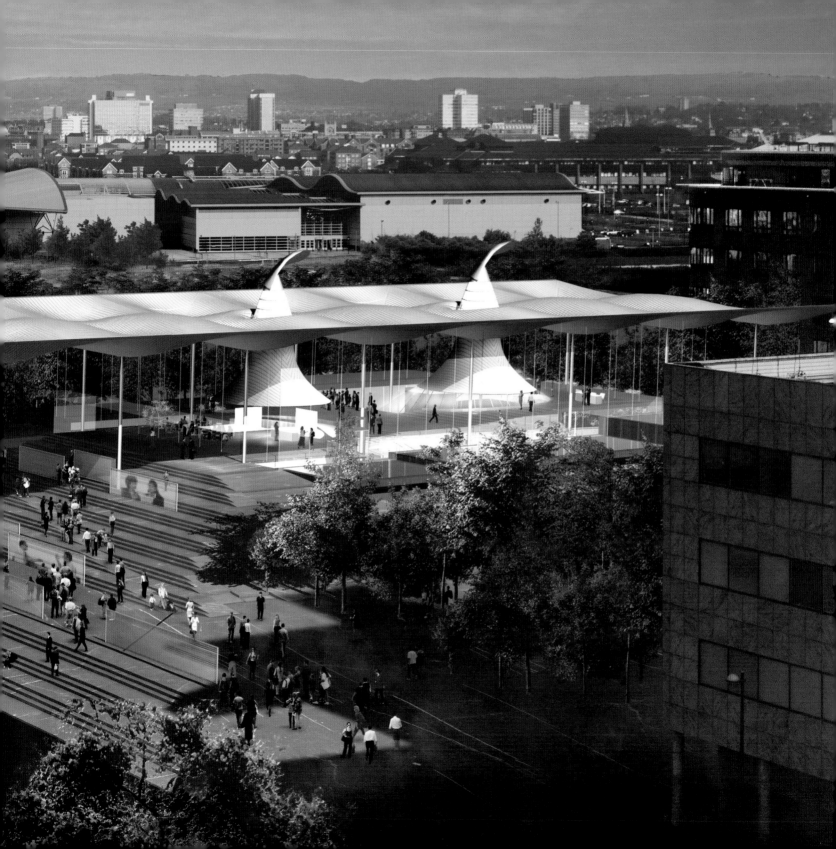

A large, circular space at the heart of the building, the Chamber is defined by the dramatic roof form which is drawn down from the roof above to form the enclosure. The Assembly building will also include exhibition and education spaces, a café, committee and meeting rooms, press facilities, offices for the principal officers of the Assembly and a members' lounge.

The servicing strategy is designed in tune with the varying demands of the internal spaces – air-conditioning is supplied in the debating chamber, while the public lobby is naturally ventilated. Heat exchangers capitalise on the potential of the ground as a cooling mechanism, while the thermal mass of the plinth itself tempers fluctuations in the internal environment of the building. In this way, the design will achieve significant energy savings as compared with a traditional building.

Hard landscape extends from the plinth to touch the adjoining buildings. This, together with a canopy of trees, creates a close for the Assembly and completes the jigsaw of new development in this part of Cardiff Bay. Neither grandiloquent nor lacking in presence, this is a building closely in tune with the institution it houses and promises to be the first major architectural landmark of 21st-century Wales.

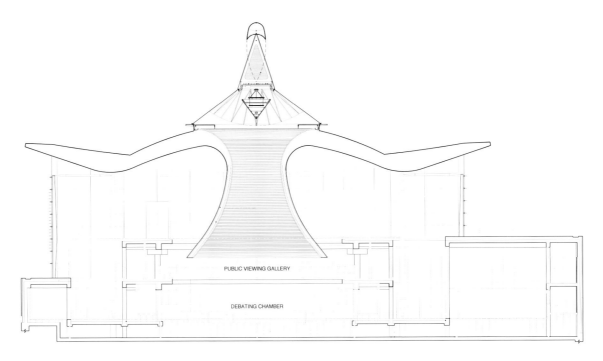

PUBLIC VIEWING GALLERY

DEBATING CHAMBER

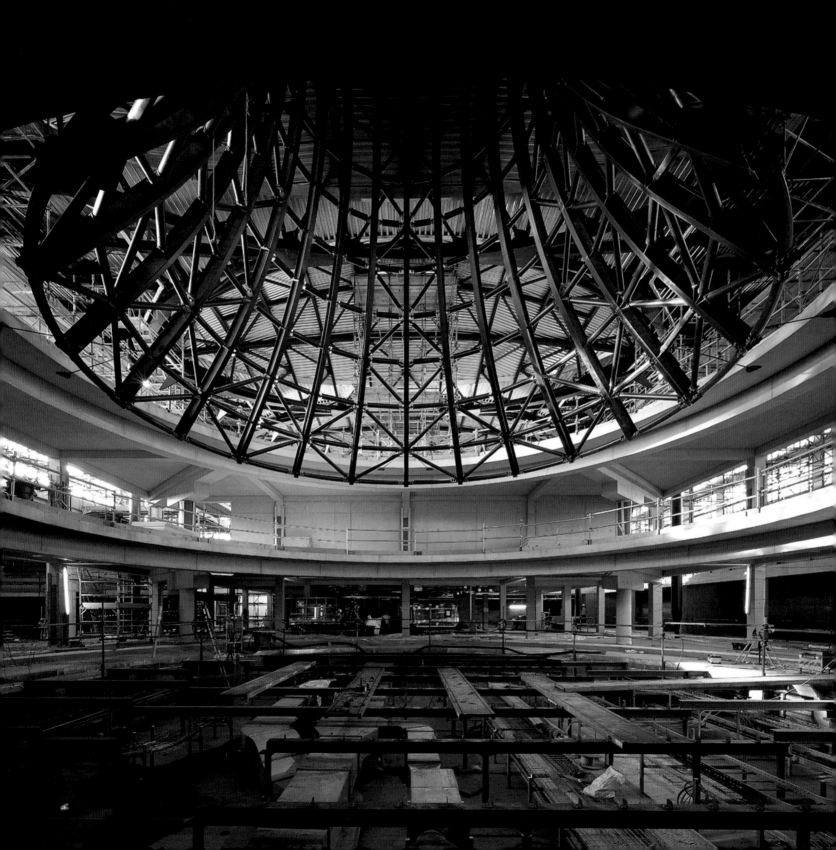

Shin-Puh-Kan Shopping Centre

In 1999, RRP was commissioned to design a relatively low-budget building as part of the renovation of an old telephone exchange. The brief called for retail area plus offices and restaurants.

The design aspiration was to create a successful fusion of old and new, sensitively transforming a disused building into a new, vibrant public amenity.

The shopping centre is three storeys high with retail on the first and second floors. The old L-shaped building is complemented by a new wing which together create an urban square – a pleasant courtyard space surrounded by a mix of building styles – a connecting space and link zone.

The multi-purpose hall is enclosed by a gallery connecting the retail areas and providing a sheltered

Below: View of the new entrance alongside the existing building. Above Right: Sketch showing the relationship between the new extension (top) and the existing building (below) and the central courtyard. Right: Aerial view looking down into the central courtyard.

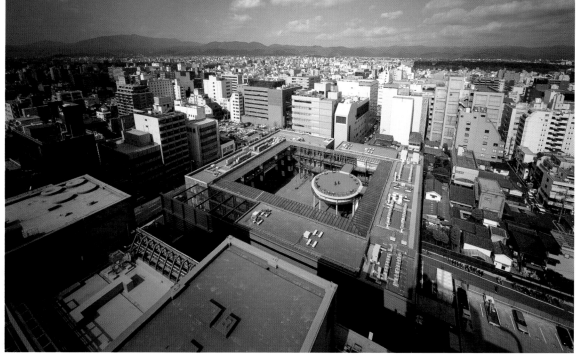

"The design aspiration was to create a successful fusion of old and new, sensitively transforming a disused building into a new, vibrant public amenity."
Ivan Harbour

view out over the courtyard. The centre of the courtyard is designed to accommodate a variety of events such as opera performances, street theatre and fashion shows. The courtyard capacity is 200 people, but this can be radically increased by using the gallery area as additional audience space. Materials utilised are simple – a steel frame structure that is durable and low maintenance.

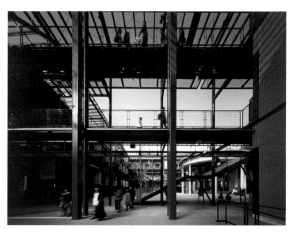

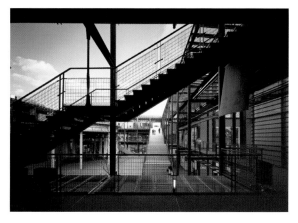

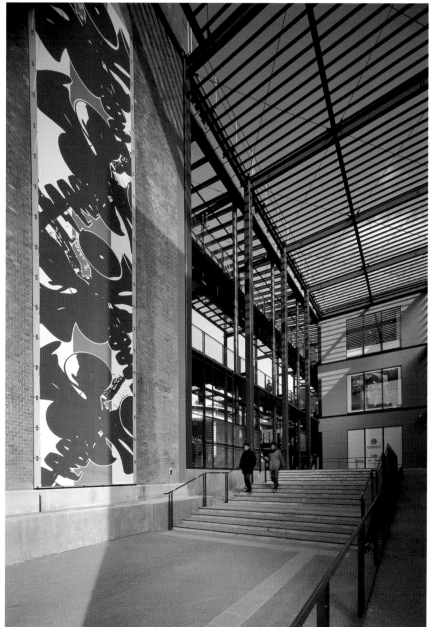

Hespería Hotel and Conference Centre

"The major programmatic elements within the design are architecturally expressed through the separation and articulation of each element." Laurie Abbott

Right: Model view of the tower, complete with its roof-top glazed 'dish' restaurant. Below: Interior of one of the hotel rooms. Opposite Top: The tower under construction. Opposite Left: Section. Opposite Middle: Tower and conference centre/sports club floor plan.

The Hespería Hotel, designed in collaboration with Barcelona-based architect Alonso Balaguer y Aquitectos Asociados, will form a new landmark in the rapidly developing urban centre of L'Hospitalet, Catalonia's second largest city with 240,000 inhabitants. The brownfield site is ten kilometres west of Barcelona, flanking la Gran Via, a motorway which leads out to the airport and is to be transformed into an attractive boulevard. Fast traffic will be contained in a sunken section, minimising cars at street level to local traffic. The possibility of decking over the sunken section offers the potential for a sequence of vibrant new public piazzas.

The project places lift and services towers at the edge of the building as 'servant spaces', with the lower floors of the 30-storey tower devoted to public spaces within an open and transparent container. The scheme comprises a five-star 304-room hotel, a 3,000 square metre conference centre accommodating 1,800 people, a 500-seat auditorium, a 1,500 square metre headquarters for the Hespería company and a 4,500 square metre sports club. A public square extends below the tower connecting it to the adjacent low-rise buildings. One of the restaurants is housed in a striking glazed 'dish' located at roof level.

Detail design work started in September 2000, with groundworks, basements and the tower now finished; construction is scheduled to complete in 2006.

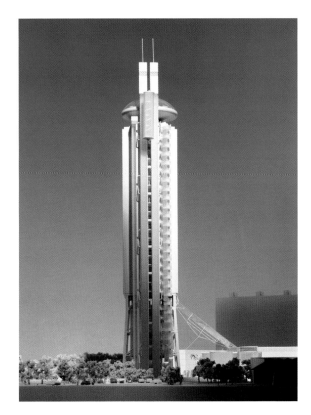

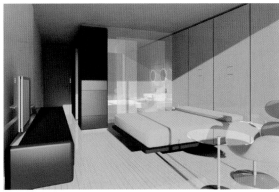

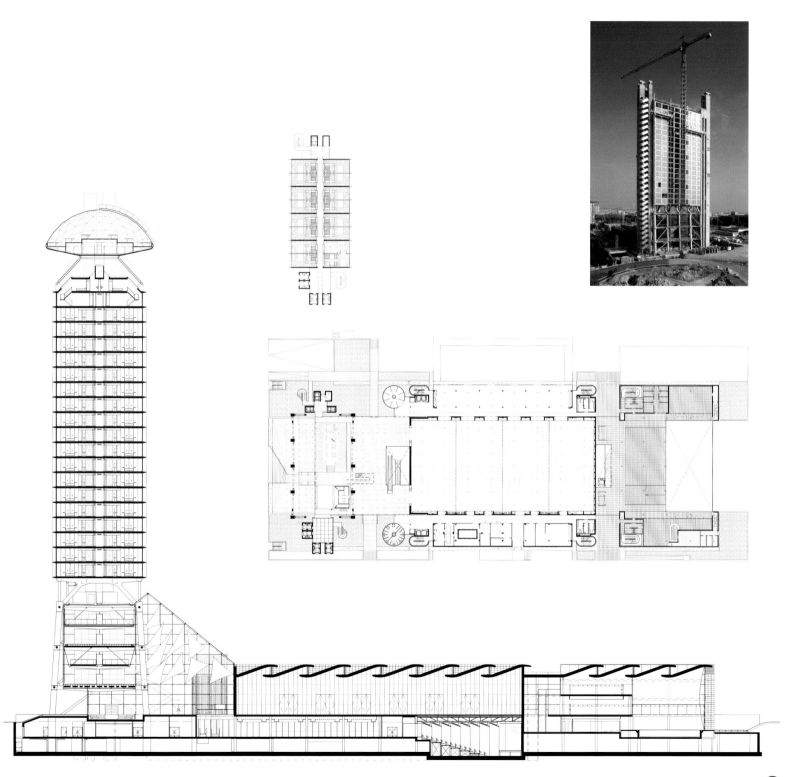

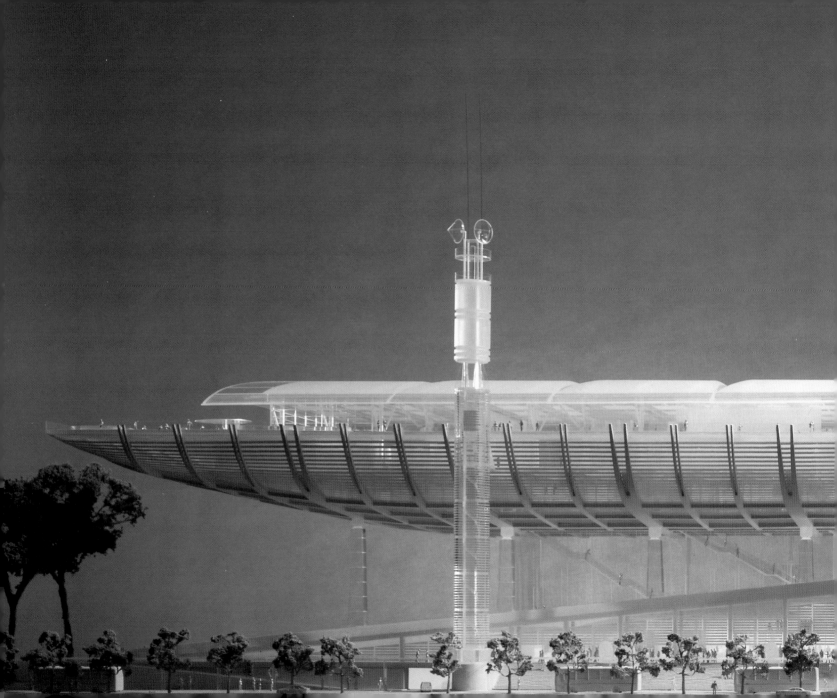

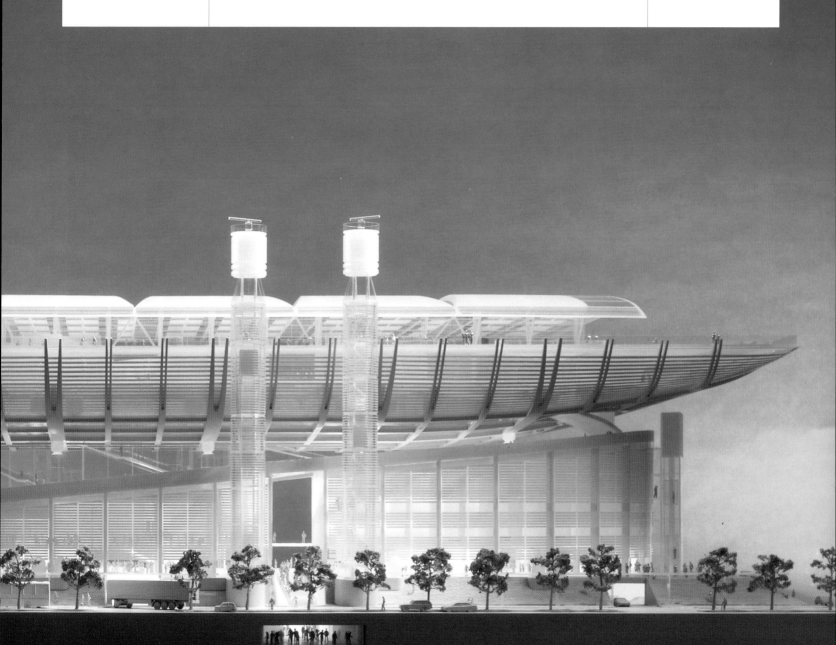

"A clear and legible urban response to a highly complex national facility. The public and private activities form the visible elements of the architectural expression." Graham Stirk

This project develops some of the themes explored in the earlier Tokyo Forum competition scheme. The distillation of primary activity areas allowed the practice to define the constituent parts of the building – in particular private and public spaces – with RRP's customary clarity of architectural expression.

Placing a large exhibition and conference space within an urban setting is a complex challenge – a key aspiration was to avoid the pedestrian barriers and inactive frontages that can typically define the public realm. The context of the proposed Centro Congressi Italia was the EUR district of Rome, developed during the Fascist era as an extension of the capital in a style reflecting the Classical and Rationalist tendencies of the period – the formal and processional nature of many of the public spaces reflects the heavy emphasis placed on discipline and national unity in 1930s Italy.

The site for the Centre, intended as Italy's prime conference venue and an element of renewal for EUR, is on the Viale Cristoforo Colombo, the broad central spine of the entire quarter – imposing but far from people-friendly. The Centre is placed across the route leading from the main public transport node, the Enrico Fermi station, to the existing Palazzo dei Congressi and it was vital that this route be incorporated into the scheme.

The practice's submission placed the new complex, with its conference halls and retail, restaurant, administrative and other support spaces, beneath a great oversailing roof, formed as a shallow vault and structurally free of supporting columns. This dramatic canopy provides a distinctive visual foil, connecting the terraced public piazza, congress square, auditorium and retail facilities.

The inclined ground mass provides generous public space, partly enclosed, partly open-air, animated by escalators and wall-climber lifts serving the conference halls above and the various support spaces (including restaurants and two retail arcades) beneath. Surrounding terraces contain cafés and provide break-out facilities for the conference spaces. The public space culminates in a dramatic external amphitheatre, positioned below the main 2,000-seat auditorium and incorporating the pedestrian route from Enrico Fermi station. A large multi-purpose hall sits on top of the great roof.

A sophisticated services programme was developed for this project, exploiting the thermal mass of the concrete underbelly of the building as a climate moderator, optimising the use of controlled natural light and natural ventilation, and potentially using photovoltaic cells as a source of power. Ventilation within the conference halls is provided by a low-velocity displacement system rather than conventional air-conditioning.

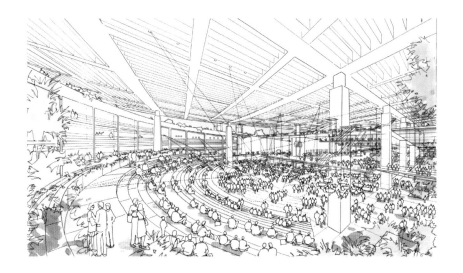

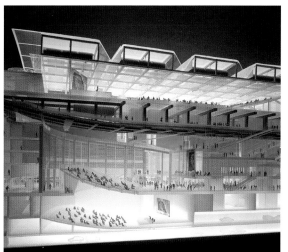

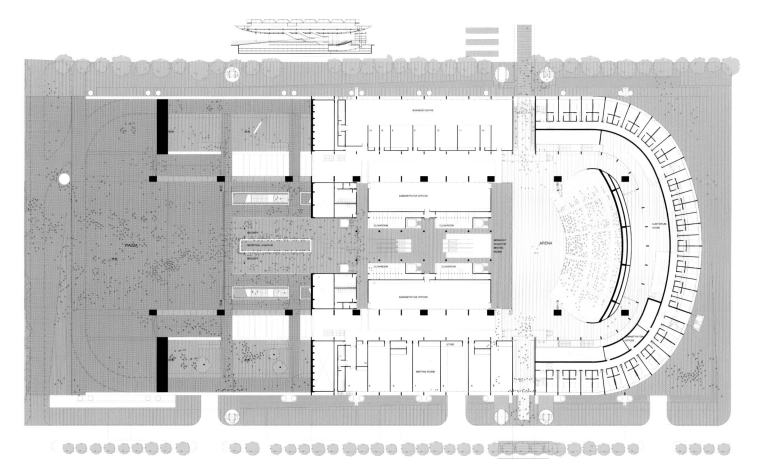

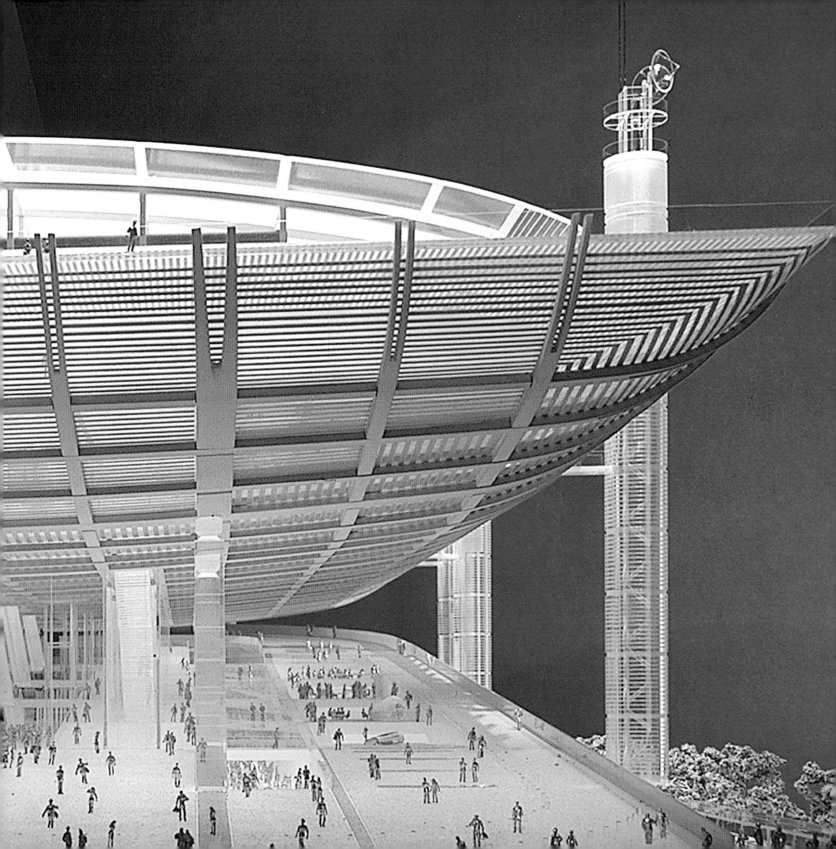

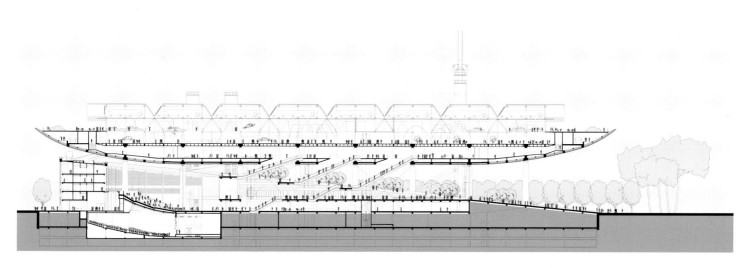

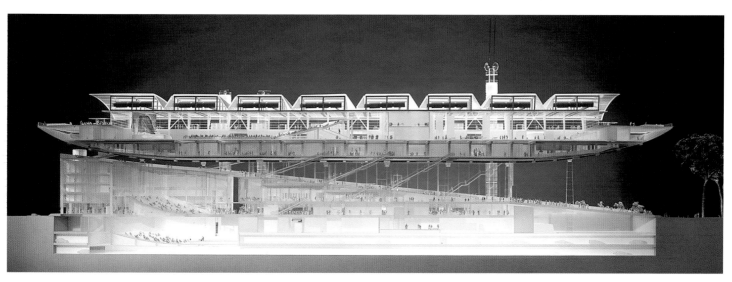

Opposite: Detail view of
the monumental roof over
the civic-scaled public space
below. Top: Site section.
Middle: Section. Above:
Sectional model.

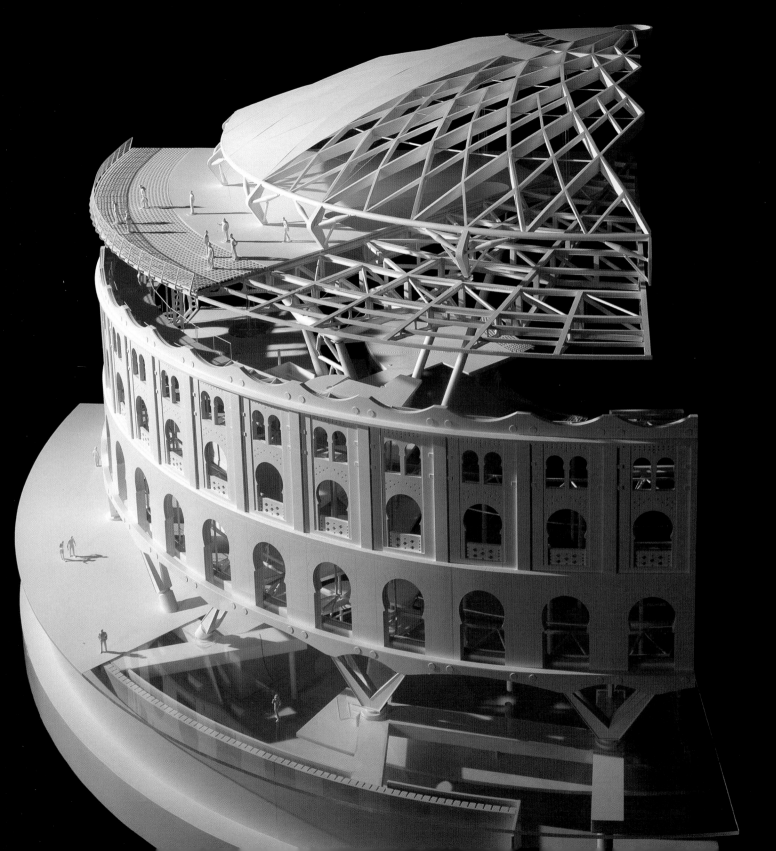

Las Arenas

"The scheme proved to be an interesting engineering exercise. All the constituent parts – the facade, the roof-level auditorium, the four internal 'segments' and an adjacent eight-storey building are all structurally independent, allowing for future flexibility and change." Laurie Abbott

The Las Arenas project, undertaken with co-architect Alonso Balaguer y Arquitectos Asociados, transforms a redundant bullring into a mixed-use leisure and entertainment complex. The 19th-century structure is located close to Montjuic, at the intersection of two major city boulevards, on the Plaça Espanya, giving the city a new 'gateway' from the west.

The existing facade will be retained and restored as part of the project and forms the enclosure for a vibrant mix of activities. In order to create a public domain at ground level, the base of the facade is being excavated. This represents a major engineering exercise, involving the insertion at the base of the existing walls of composite arches which will support new spaces for shops and restaurants. New piazzas are created at ground level providing a connection to existing metro stations and to the Parc Joan Miró. A giant roof terrace will form a 'piazza in the sky' with panoramic views over the city. Internally, the 70,000 square metre scheme provides a series of commercial, entertainment, health and leisure spaces focused on a central event space. The basement will contain a parking facility for 1,250 cars.

The aim is to provide a high degree of flexibility, accommodating future change and allowing a wide variety of activities to take place in the building. The energy strategy for the project is progressive, with natural energy sources used as far as possible.

Opposite: Model view showing the new car park below ground level, the restored bullring facade and the new roof. Right: View of the model showing a block of new office accommodation to the right and a communications tower to the left.

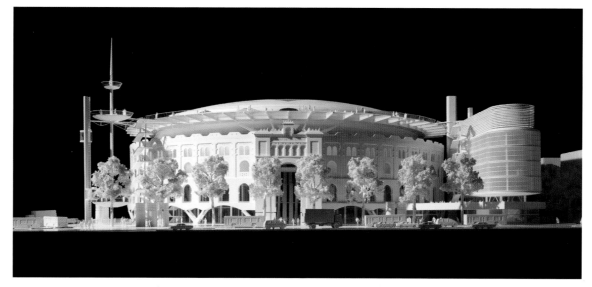

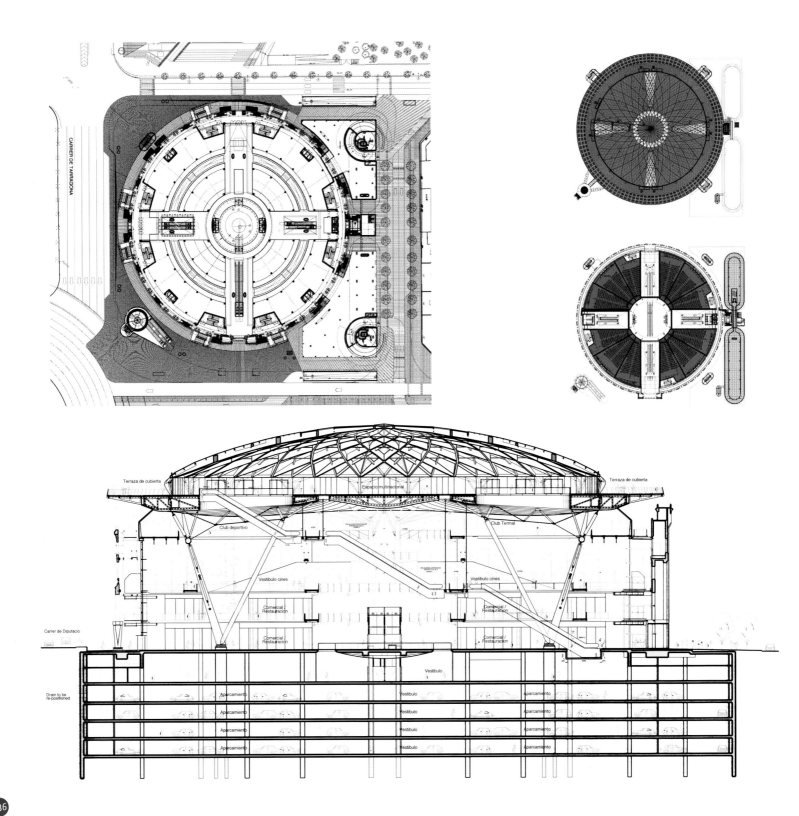

Opposite Top Left: Site plan.
Opposite Top Right: Roof plan
and auditorium-level plan.
Opposite Below: Section.
Right: Computer-generated
image highlighting the
scheme's prominent position
adjacent to a large public
park. Below Right: Diagram
illustrating the scheme's
flexibility, comprising seven
structurally independent
elements.

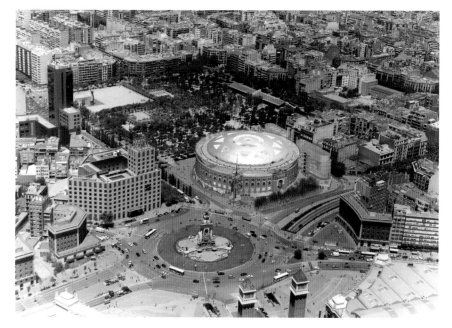

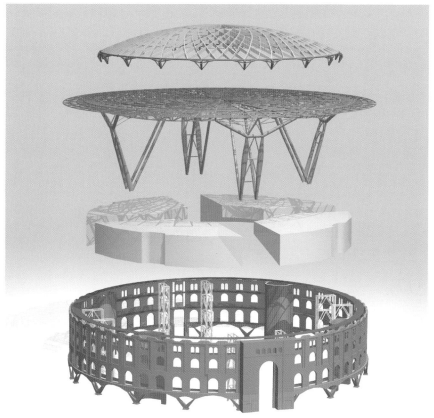

Maggie's Centre

"The London Maggie's Centre needed to create its own sequence of internal and external environments cocooned from its inhospitable surroundings – a welcoming beacon in this busy London streetscape."
Ivan Harbour

The Maggie's Centre offers support for all people affected by cancer at any stage, be they patients, family members or friends. The charity's work is in complete support of conventional medical treatment.

Maggie's Centre Charing Cross is conceived to contrast with the main hospital building. It is a 'non-institutional' building, an 'open house' of 370 square metres, arranged over one and a half floors. It is both flexible and adaptable. It can be transparent or opaque, noisy or quiet, light or dark. The kitchen is the heart of the structure. The practice hopes to create something that is more than a house – more welcoming, more comfortable, more thought-provoking and more uplifting.

The entrance is approached from within the hospital grounds. The building is made up of four components: a wall that wraps around four sides, providing protection from its exposed location; the kitchen – a double-height central space which will be the main focus and heart of the building; annexes off the main space, conceived as meeting, sitting and consulting rooms; and a 'floating roof' that oversails the outer wall and acts as the enclosure to the heart of the building. Small courtyards are formed between the building and the wall.

The landscaping strategy knits together the existing hospital and the new Maggie's Centre. Wrapping the building with trees will filter the noise and pollution of the surroundings whilst providing a leafy backdrop from the inside.

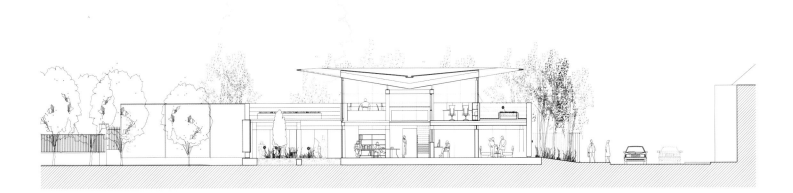

Opposite Top: Concept sketch.
Opposite Below: Section.
Right: Ground floor plan.
Below: Model view.

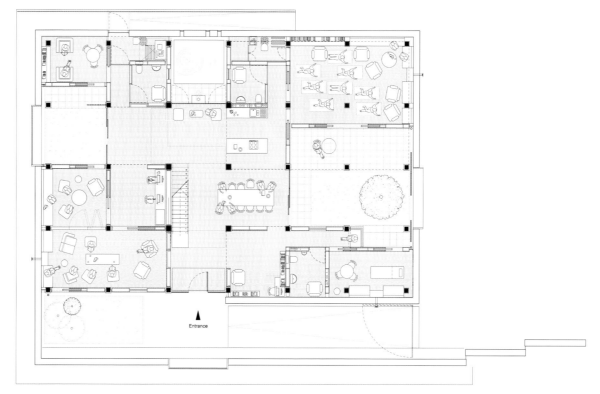

Entrance

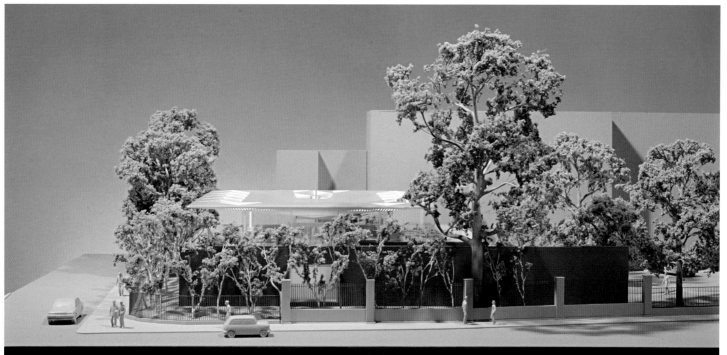

City of Justice of Barcelona and L'Hospitalet de Llobregat

Barcelona, Spain
2002

"The scheme offers a strong response to the surrounding city context and offers clear delineation of the various functions that it contains." Graham Stirk

Below: Section through the central landscaped amphitheatre. Opposite: View of the model showing the two concentric rings of accommodation that form the perimeter of the scheme.

RRP'S law courts complex at l'Hospitalet, a rapidly growing municipality within the Barcelona conurbation, was designed to give the city a striking new landmark that is explicitly a public building, reflecting RRP's perennial concern for public space. The 264,500 square metre development, designed with co-architects Alonso Balaguer y Arquitectos Asociados, is designed to provide accommodation for the judicial bodies of Barcelona and l'Hospitalet de Llobregat, bringing together activities formerly dispersed across 17 separate locations.

The building accommodates two clearly defined types of spaces: offices (for 15,000 people) and court rooms. Their relationship and the magnitude of the scheme (184 courtrooms) make for a highly complex organisation, with independent circulation systems for public, judges, detainees and juries.

The scheme offers a strong response to the surrounding city context. A series of linked buildings, varying in height from six to 16 storeys, are aligned to the existing street lines. Articulation is dictated by the different urban conditions at the corners of the

site. An inner ring of buildings surrounds a large central landscaped amphitheatre, a contained space at the heart of the proposed scheme that offers a new north–south pedestrian link between the neighbourhoods of Santa Eulàlia and Pedrosa of l'Hospitalet.

By creating a level site as the base for the complex, the scheme allows for a clear delineation of the various functions that it contains. A 'Law Galleria' creates the central spine of activity that binds all the buildings together. The courtrooms with detainee access are located in the cascading floors of the inner ring under the roof of the landscaped amphitheatre, while non-detainee courts are located in the outer ring facing the surrounding streets. Above the tiers of courts, two parallel blocks of offices enclose the central space with a central atrium allowing natural light to penetrate to the Law Galleria. The amphitheatre provides a dynamic inclined roof enclosure to the inner court tiers with circulation areas around the criminal courts, allowing natural light into the very heart of the building. Landscape and planting define the nature of this central space.

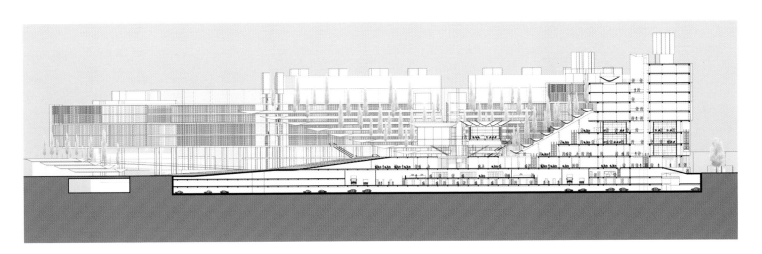

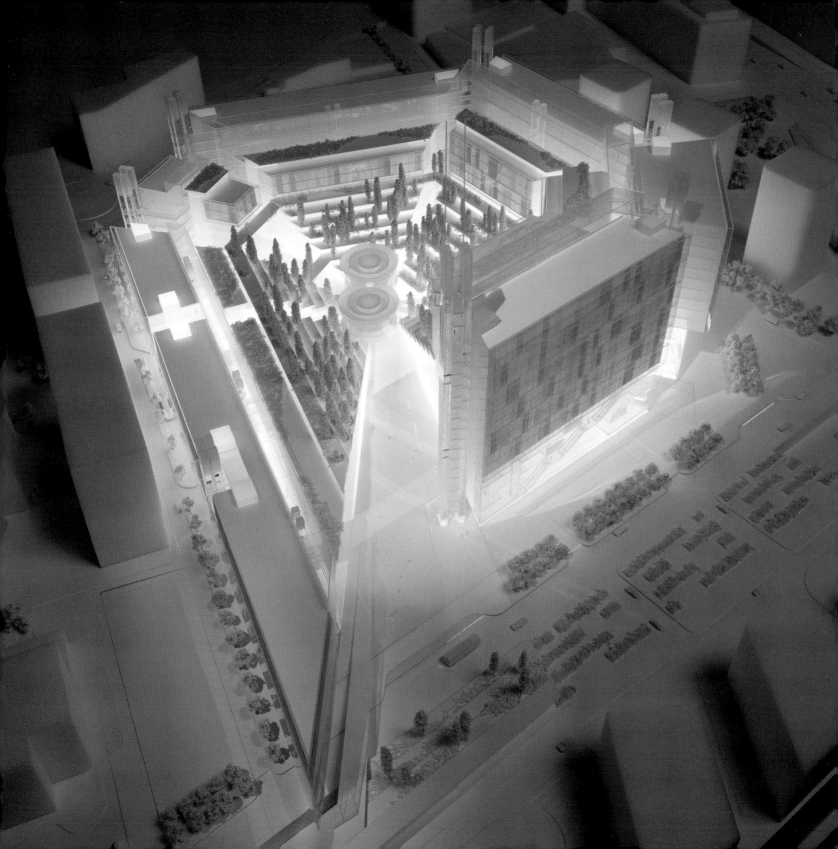

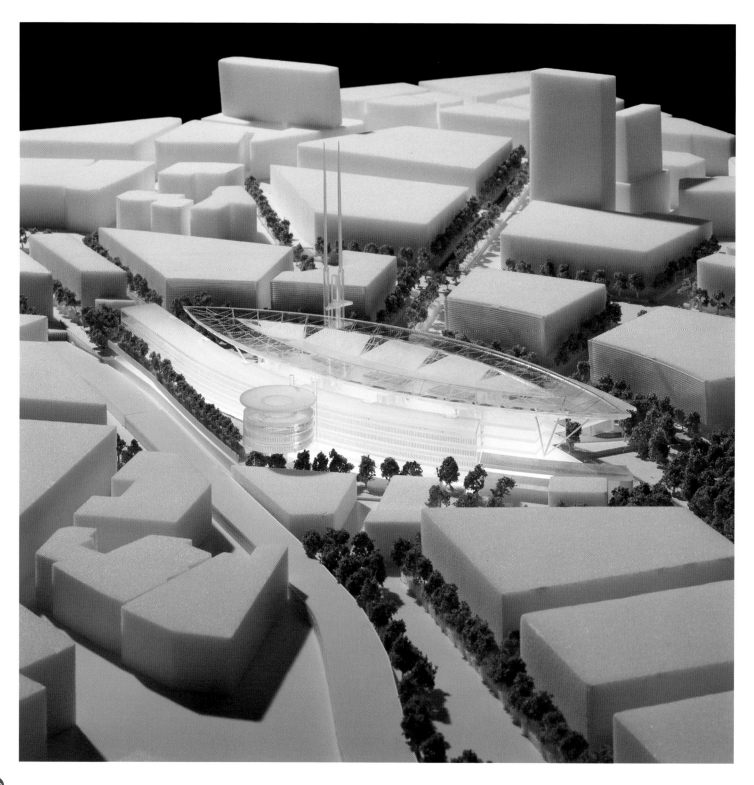

Library of Birmingham

Left: Diagram showing the library as the heart of Birmingham's new quarter, with key routes leading back into the city. Below: Diagram showing the importance of environmental factors affecting the site.

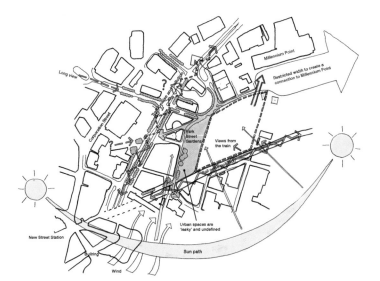

The new Library of Birmingham will be a major cultural and educational resource for England's second city and a potent engine of urban regeneration. The library, replacing the city's failing 1960s building, is to be located in Birmingham's Eastside, a quarter of the city previously isolated by the urban motorway that surrounded the central area and now the subject of radical development proposals that will reintegrate it into the life of the city.

The brief for the project was far more than the replacement of the existing facility (which is one of the best-stocked and most heavily used public libraries in Britain) – it also incorporated a vision of the public library as a learning resource open to all, an inviting place where books are provided alongside a wide variety of other media, a brief to which RRP responded enthusiastically. The local collections include the remarkable Shakespeare Library and a photographic archive of international importance. The practice's aim was to respond to and anticipate the ongoing needs of a large and growing body of users, while also creating a building that will be a cultural landmark and symbol of renewal.

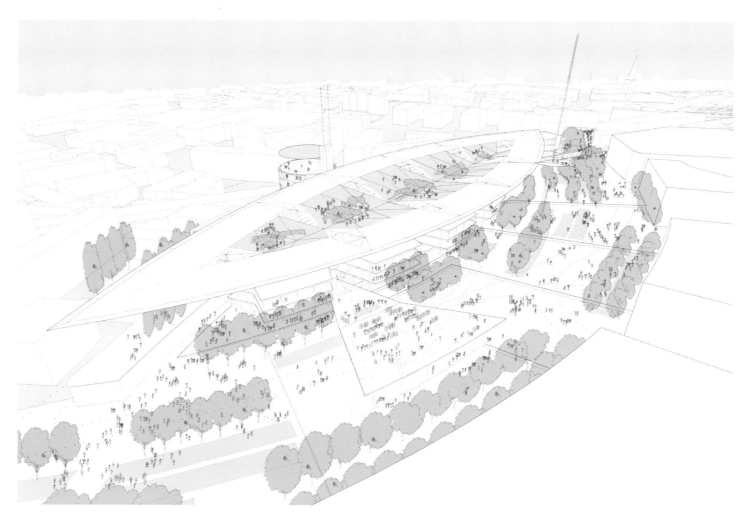

Above: The great oversailing roof contains a sky garden – a continuation of the parkland setting. Right: Aerial model view. Far Right: The new building is located in a public park.

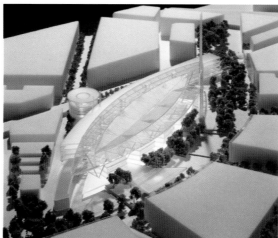

> "The new Library will be a major cultural and educational resource for England's second city and a major catalyst for urban regeneration."
> Graham Stirk

The new library, elliptical in form, is located in a new green park that will be the heart of the re-born Eastside – the aspiration is to achieve a strong synergy, with park-related activities drawing people into the library and library events animating the park. The main pedestrian route from the city centre passes through the site, assuming the form of a great galleria between the main library and a separate block and allowing glimpses of the library's internal activities. This secondary block may house a wide range of community and cultural activities including artists' studios, a writing academy, a school of speech and drama and healthcare facilities; it will also form a visual and acoustic barrier against the adjacent, heavily used railway viaduct.

A great roof spreads across the whole complex, an oversailing canopy supported on structural 'trees' and topped by a 'sky park', from which there are fine views of the city. The roof serves to protect the south facade of the building as well as creating an elegant, powerful form that defines the urban presence of the library and provides a high degree of interior flexibility. The reference library occupies the three upper floors, with lending and children's libraries, exhibition spaces, foyers and auditorium below. Reading rooms and offices are placed around the edge of the building, where they benefit from views of the park, with book stacks and archive storage spaces at its heart, visible but enjoying secure, controlled climatic conditions. The groundmass will contain a combination of public and private facilities, including an auditorium and meeting spaces, as well as plant rooms, parking and delivery areas.

The library is intended to make a vital contribution to the physical and cultural landscape of a dynamic European city that has already established a lead in the campaign for urban renaissance in Britain.

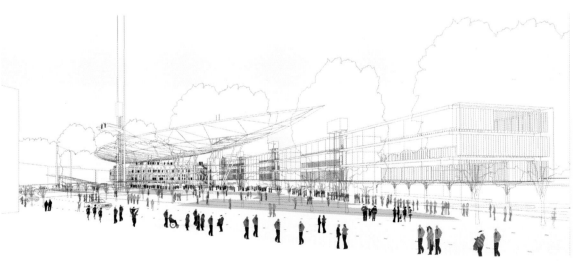

Left: With a clear separation between the key architectural elements and a bold expression of the constituent parts, clarity and transparency are key characteristics of the design. Following Pages: Cross-section.

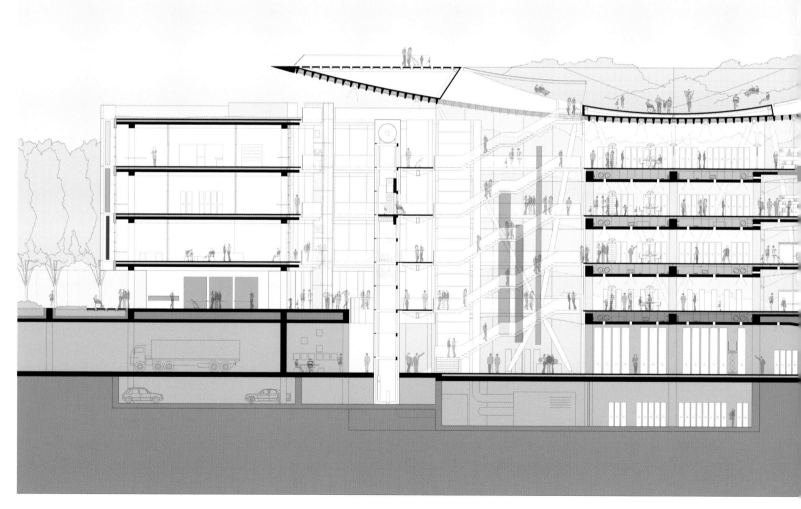

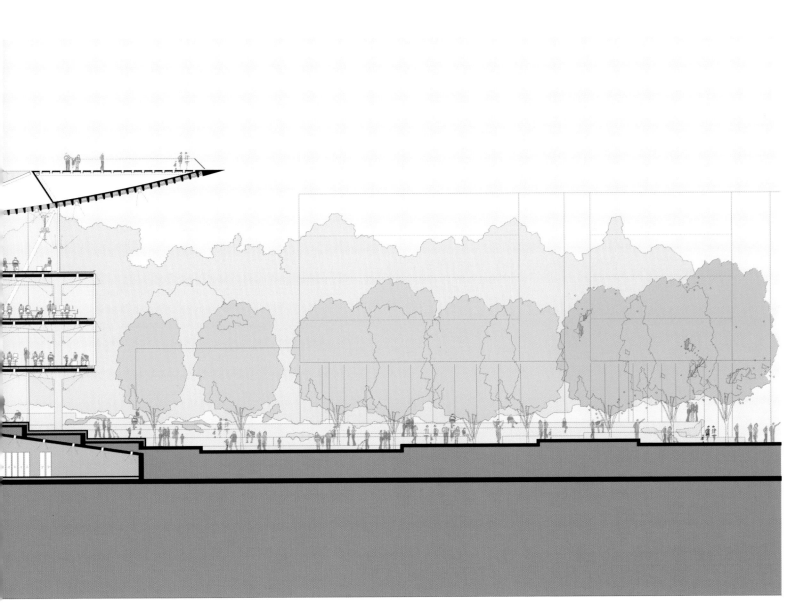

Sabadell Cultural and Congress Centre

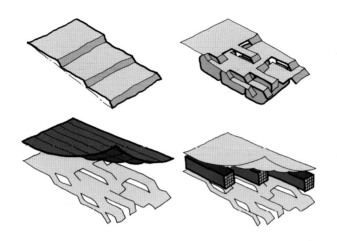

Above: Diagram showing the key constituent parts of the scheme. Below: Side elevation. Opposite Top: The various activities are housed on a great 'stage' overlooking a new park. Opposite Below: Concept sketches.

"We were aiming to give a distinct, unifying and welcoming identity to a diverse brief ranging from a relatively expensive auditorium space to a low-cost trade expo shed." Ivan Harbour

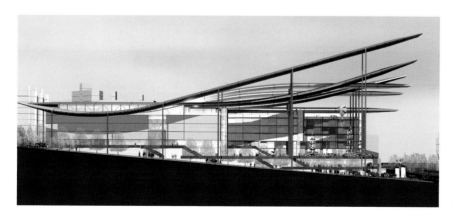

RRP's competition scheme for a 50,000 square metres arts and congress complex in Sabadell was intended to give this growing city of 185,000 inhabitants (20 kilometres inland from Barcelona) a new cultural hub. The essence of the scheme is its open, non-monumental character.

The Centre is situated close to the new Parc Catalunya in the Eix Macià district of Sabadell – the city's economic and civic centre. The brief for the complex was to create a landmark public space, with a range of facilities including a flexible auditorium seating 1,000 (suitable for opera, theatre, ballet and dance) and a smaller auditorium holding 300 people. In addition, the complex houses a four-star, 200-room hotel and conference centre of 9,500 square metres, a music school for 650 students, a 5,400 square metre retail area, a 1,000 square metre exhibition space, a 5,000 square metre car park for 400 cars and a large exhibition/trade fair/sports area of 6,600 square metres.

The client wanted a building that welcomes visitors to the city as well as serving local needs. RRP's project accommodates the varied functions it houses in clearly identifiable 'pavilions' beneath a dramatic, floating roof. These constituent elements are sited both on and in a large stepped plinth – conceived as a vast 'stage' overlooking the neighbouring park. The 'stage' is animated by vast video screens and installations announcing the cultural programmes and events offered by the centre itself as well as the city's rich cultural network. The separation of functions also allows the building to be developed in phases, responding to possible changes in the brief. The use of an orthogonal, repetitive plan and structural system allows for the use of standardised components and simplifies the construction process.

The distinctive geometry of the roof has been developed in response to the way in which the building addresses the park. The roof also protects the 'stage' from wind, rain and the summer sun while allowing lower winter sun to reach deep within the scheme and to illuminate the facades during early daylight hours.

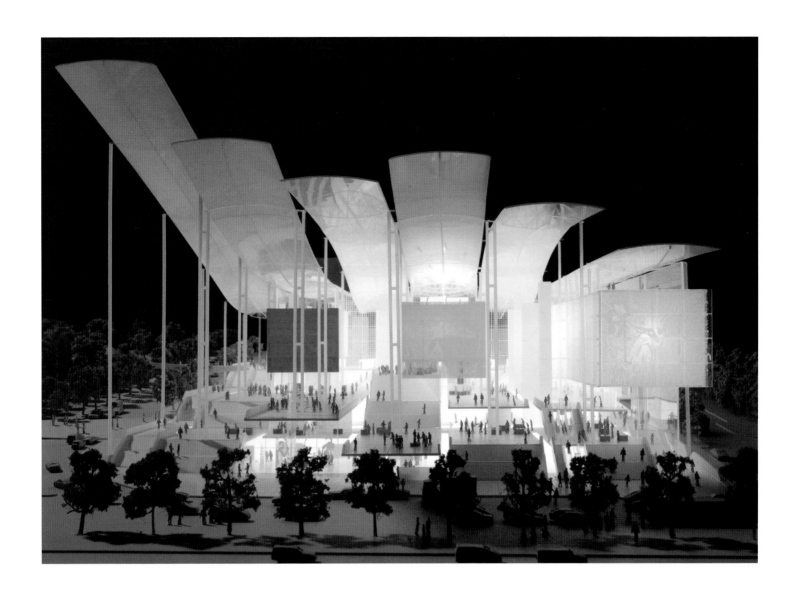

Fourth Grace

"The roof defines a new, vibrant public space in a difficult location, its form creating a distinct, identifiable composition which would provide Liverpool with a unique landmark building." Mark Darbon

The brief for the Fourth Grace called for a symbol of Liverpool's future, a landmark building that would complement the three existing civic buildings on the waterfront whilst also providing a dynamic and flexible venue for major public activity, exploiting the prominent riverside location. The site is exceptional with expansive river views but is open and environmentally challenging. The practice's design proposed a serpentine roof form with ribbons of glazing creating a sheltered and tempered environment for diverse activity while framing views of the River Mersey. The scheme was intended to provide a contemporary identity for the city, building on its heritage while also acting as a catalyst for Liverpool's ongoing urban regeneration.

Integration of public transport systems was key to the future success of the scheme – tram links from north to south, connections between the commercial, retail, educational and cultural quarters, links to James Street Station and the underground and rail network, full integration with bus routes, maximising transportation opportunities offered by the waterways and enhancing the Cruise Liner Terminal and ferry links.

By strengthening public transport, particularly to the university area, and creating multi-functional venues capable of use for performance, exhibition and educational purposes, the scheme created a lively, vibrant '24/7' environment providing a mix of retail, conference, office, accommodation, entertainment and leisure amenities.

This proposal also increased pedestrian priority and reduced dominance of the car, animating streetscapes with cafés, bars and restaurants along the dockside and providing covered waterside environments for pedestrians. People who work in the City, as well as shoppers and visitors, were intended to benefit from the new business and retail areas, while the apartments provided a unique opportunity for city living – wonderful views over the Mersey, with bars, restaurants, markets and museums all on the doorstep.

This scheme makes full use of the site and surrounding area – the two towers, one 20 storeys and the other 30 storeys, together forming a gateway to the city from the river, and providing vertical emphasis to the project. The public space is created at dock level under a large sweeping roof draped behind the two towers, extending its coverage over the Canning Graving Docks to the Museum. The large distinctive roof sweeps up from Strand Street and Mann Island Road to a peak, equivalent to the Port of Liverpool building. When lit at night, the great translucent roof would provide a great

Create a new public space
for museum

Protect the space
with tempered environment

Creating a setting for exhibitions and
performance venues

Roof form creates enclosure for
public activities

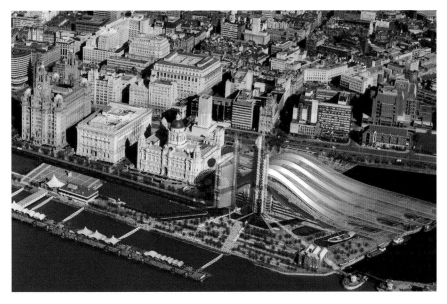

wave of light rolling from the Port of Liverpool building to Albert Dock while the towers provide a distinctive addition to the city skyline.

Central to the building is a 2,500-seat venue for performances and exhibitions, a state-of-the-art multi-functional space, accommodating everything from rock concerts to sports events, corporate promotions to festivals, opera to covered markets, tennis tournaments to conferences. This auditorium is complemented by the smaller 300-seat music and comedy venue. The ground floor of the building was designed to house cafés and restaurants as well as 15,000 square metres of floor space for the Museum of Liverpool. This flexible space would provide headroom ranging from four to 16 metres to enable the display of a range of larger exhibits, such as boats and trains. The museum makes use of the dry docks, with additional accommodation adjacent to them, covered by the unifying sweep of the roof.

Sustainability is a key driver of the design, maximising the use of daylight, natural ventilation, mixed-mode comfort cooling, combined heat and power, river water for cooling, occupant control over temperature and daylight, heat recovery and exposed thermal mass.

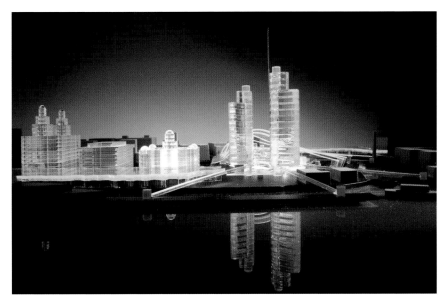

A new landmark building which complements the Three Graces

The Fourth Grace will address both the city and the waterfront

A new gateway for Liverpool

Creating a setting for a new public building

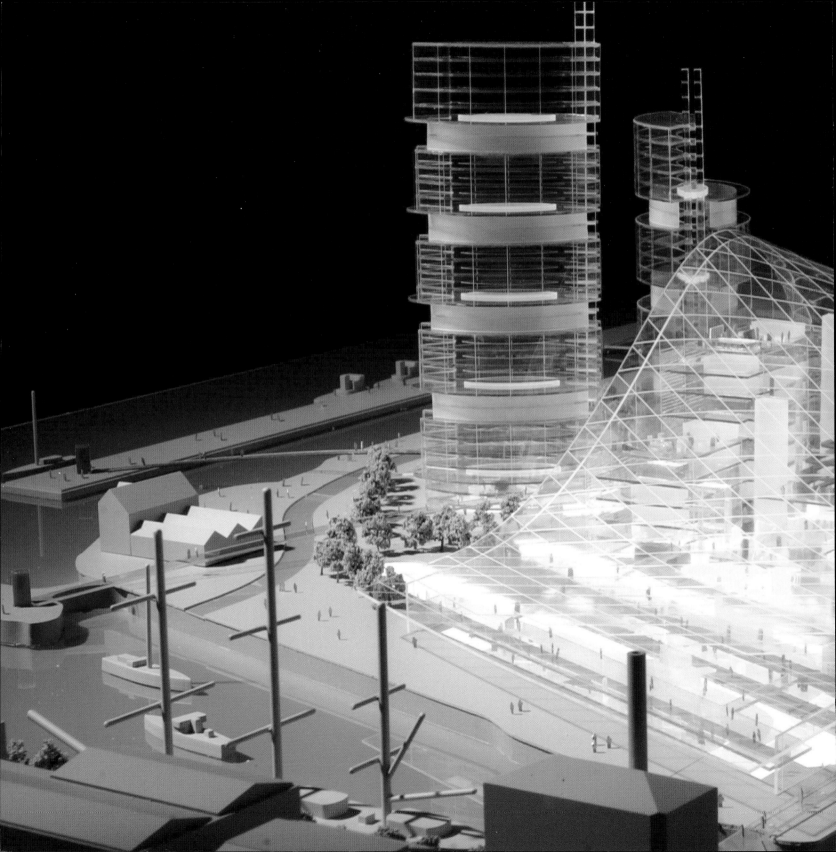

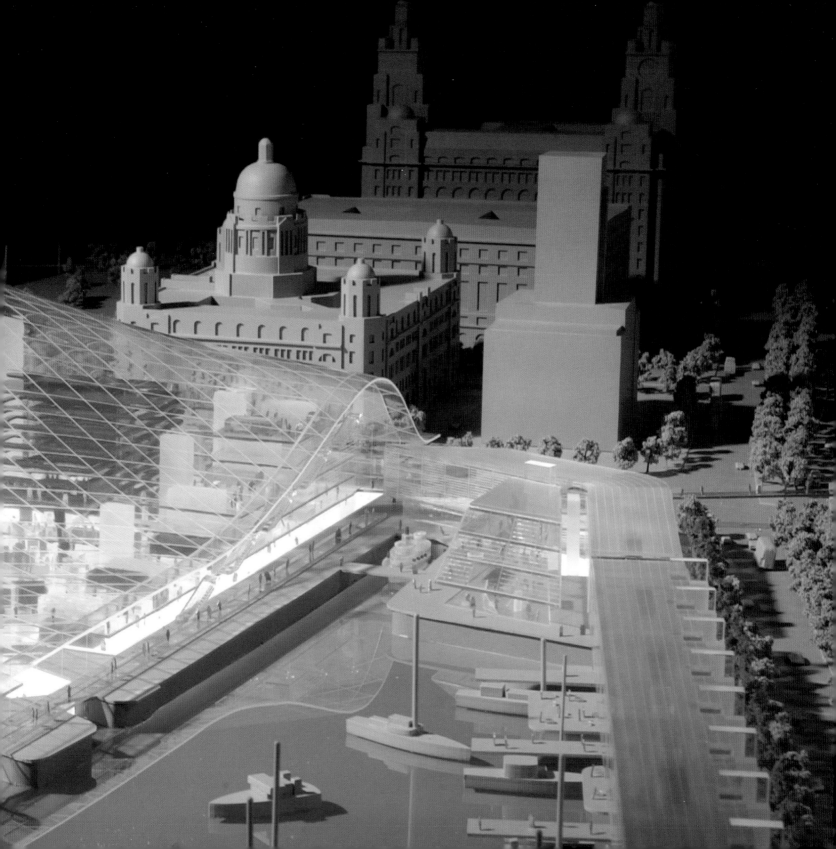

Glasgowbridge.com

"This bridge seeks to celebrate the level changes required of a river crossing as a graceful, ramped promenade." Graham Stirk

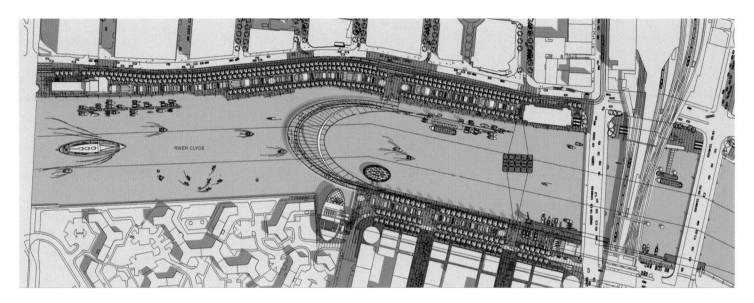

RIVER CLYDE

Glasgowbridge.com, won by RRP in competition in 2004, will be one of the most dramatic new bridges in Europe and a landmark in the ongoing transformation of Glasgow, formerly a centre of traditional heavy industry and commerce, into a European business and cultural capital. The pedestrian and cycle bridge connects two areas of the city, Broomielaw and Tradeston, that are both being transformed by the regenerative process.

This project is about far more than simply urban connections – it is a key element in the creation of a new city quarter in the centre of Glasgow. The proposals incorporate a public pontoon for mooring leisure craft,

landing points for the river taxi service and major landscape proposals for the river banks to the north and south. Although the bridge provides a clearance of six metres in the middle of the river at high tide, it does away with the usual apparatus of access stairs, ramps and lifts. Instead, it sweeps up on a gently ascending curve, forming a great arc that offers access for all, irrespective of physical ability, as well as creating a striking feature along the river. Structurally, the bridge uses the principle of a cable-stayed compression arch with suspended deck – the result is a dynamic and memorable icon for the city.

Above: Site plan. Below: Elevation. Opposite: Model views of the sculptural prow-shaped bridge.

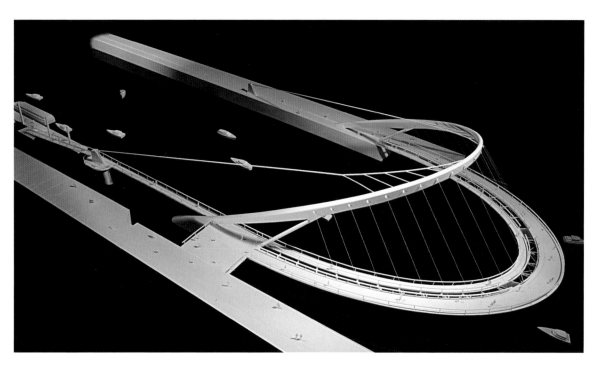

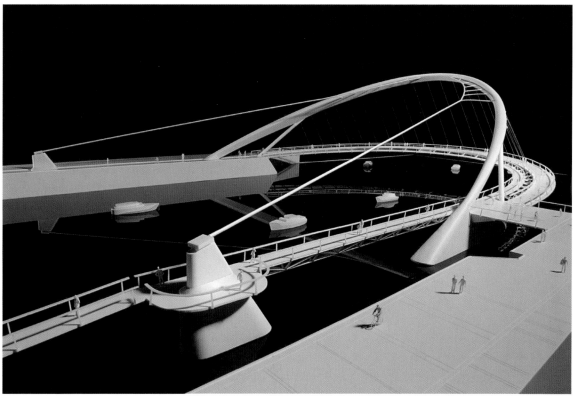

Sightseeing/Television Tower

Guangzhou, China
2004

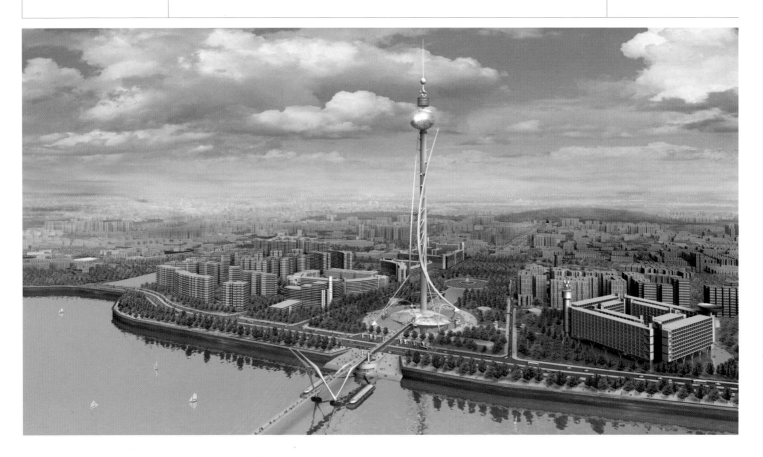

Above: Aerial view of the tower. Opposite Left: Site plan. Opposite Right: Detail view of the glass 'eye' containing observation decks and a revolving restaurant.

The competition for a new Sightseeing/Television Tower in Guangzhou was an opportunity to design a focal landmark for the evolving urban landscape of central Guangzhou. The site selected for the tower is a prominent location with views back to the city centre as well as across the broader urban landscape. This new landmark structure, located on the southern bank of the Pearl River, is intended as an icon for the city.

The 475-metre tower is symmetrically balanced on the central north–south axis with two 350-metre super high-rise towers located in Zhujiang New Town on the north bank. It also provides a visual foil for the 88-storey Civic Plaza located further to the north behind the Tianke Sports Stadium.

The main access to the site will be via metro lines; from the metro concourse visitors will access the retail and leisure components at the base of the tower to the main tower core. Located below the tower is an area of 5,000 square metres containing main exhibition, banqueting and conference facilities. In addition, restaurants and cafés are located on the first and second basement floors. These are positioned around a central, top-lit exhibition space and comprise an area of 31,000 square metres. Two further basement floors directly below contain 51,000 square metres of parking for 1,728 cars.

At the tip of the tower is an oval glass 'eye', situated 310 metres above ground level; three public observation levels (including cafeterias, bars and a revolving

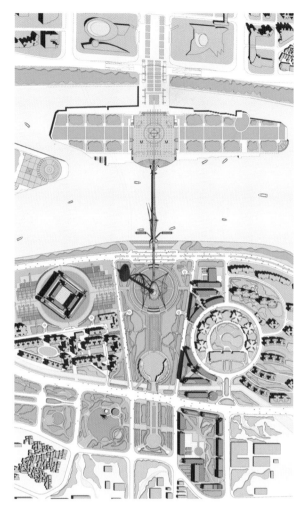

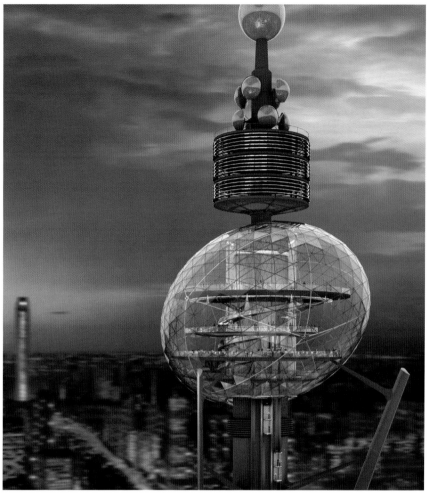

restaurant) give panoramic views across the city, with two lower floors containing kitchen areas. Each level will be connected by a ramp spiralling around the central core.

The specification for the 'eye' form was a diagrid of steel members, creating a framework of triangular glass units. Fritted glass addresses the issue of solar gain, the pattern varying in density from virtually opaque on the upper surface to transparent at the level of the upper revolving restaurant. The main antenna will extend approximately 100 metres above the 'eye'.

"The structural challenges set by the brief enabled the design team to re-evaluate the principle of high-rise mast structures and to develop a response which maximises the structural efficiency within an elegant sculptural form." Richard Paul

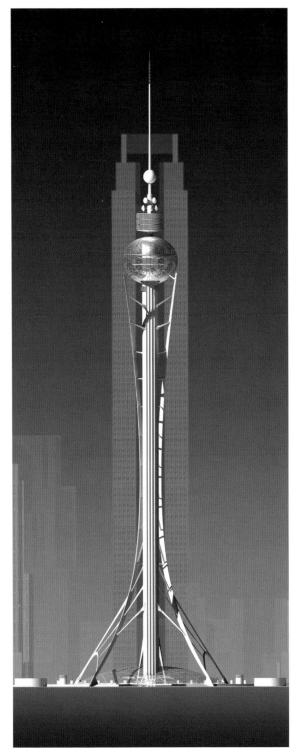

Left: Elevational view.
Below: Diagram showing the comparative heights of other international tower projects.
Bottom: View of the tower on the south bank of the Pearl River, with the new bridge that links the development to Zhujiang New Town on the north bank.

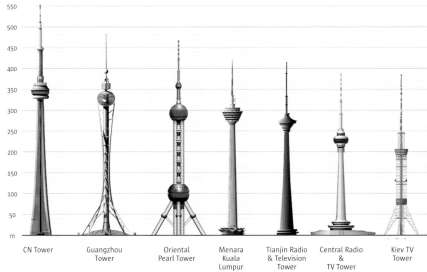

| CN Tower | Guangzhou Tower | Oriental Pearl Tower | Menara Kuala Lumpur | Tianjin Radio & Television Tower | Central Radio & TV Tower | Kiev TV Tower |

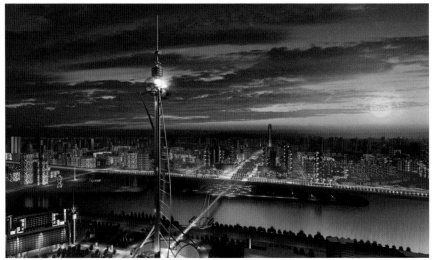

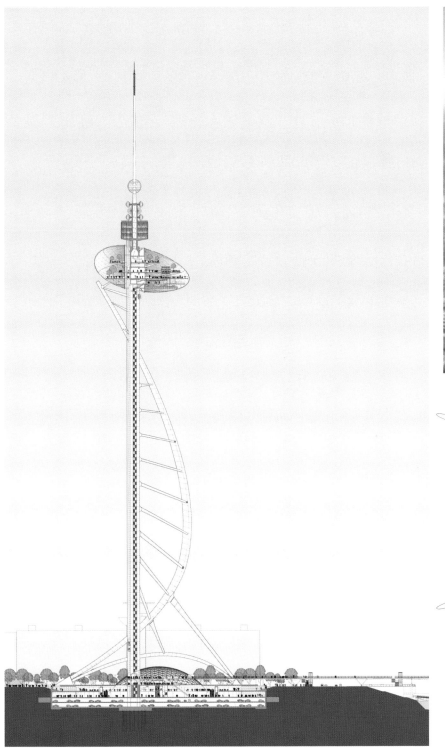

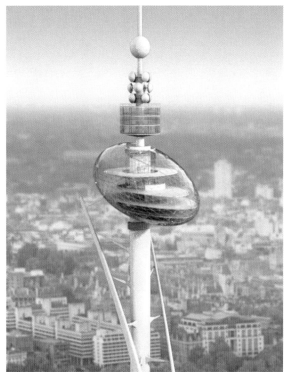

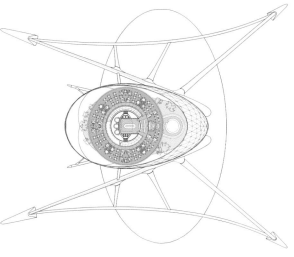

Left: Section. Top Right: Detail view of the 'eye'. Above: Floor plan of the 'eye'.

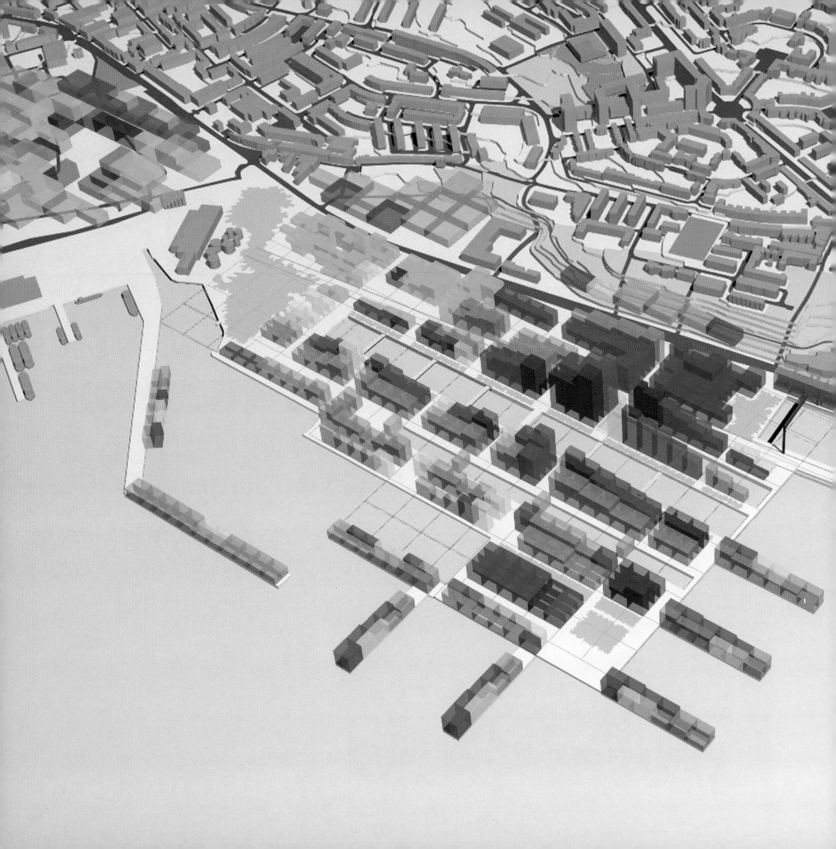

Masterplanning

4

Arno Project

"Our scheme focused on a pedestrian and greening strategy along the banks of the Arno, creating a vibrant public realm quite separate from the car-choked streets of Florence." Richard Rogers

Commissioned by the City of Florence to suggest how street life in Florence could be improved, the practice's strategic study focused on the banks of the River Arno – cut off from city life by busy roads and anti-flood barricades, the river was increasingly used as a rubbish dump rather than a vibrant extension of the public realm. This study proposed to revive the neglected river banks by creating an eight-kilometre pedestrian promenade on one bank and a green park on the other, the promenade or 'passeggiata' extending out into the suburbs and linking two existing parks. The new linear park was intended to complement and enhance existing public spaces, bringing people into closer contact with the river. The idea of using green linear spaces to extend and consolidate the public realm is key to many of the practice's urban strategies, notably in London, Berlin and Shanghai.

In addition to making use of existing stairs (once used to board riverboats), a range of new structures was proposed, mostly lightweight and designed not to challenge the dominance of Florence's historic buildings. At intervals along the river-walk, the practice proposed a sequence of small piers or pontoons to bring people closer to the water. The scheme also acknowledged that for a few critical weeks each year the river is in flood. The pedestrian bridge designed by Peter Rice could resist the flood waters by pivoting, lying at the bottom of the river bed rather than acting as a barrier to the fast flowing water. This ability to identify an alternative strategy – turning a potential liability into an asset – is a characteristic of the practice's problem-solving approach.

While still unexecuted, this study provided the basis for Rogers' famous proposals – presented at the 'London as it could be' exhibition in 1986 – for the development of the banks of the River Thames.

Left: Map showing the heart of Florence with open green space related to the river.

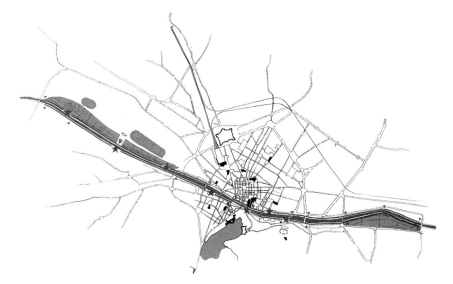

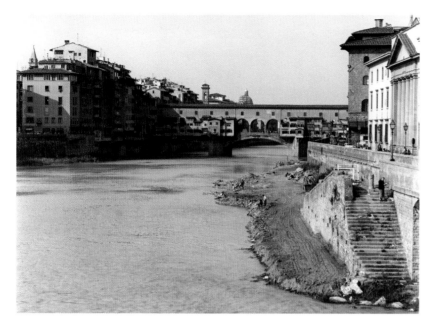

Far Left: A contemporary view of the River Arno illustrating the separation of the street from the river. Left: A series of three plan illustrations showing various possibilities for creating a lively pedestrian edge fronting directly onto the river. Below Left: New urban elements enhance riverside activities. Below: Illustration of the right bank between Ponte Vecchio and Santa Trinità Bridge.

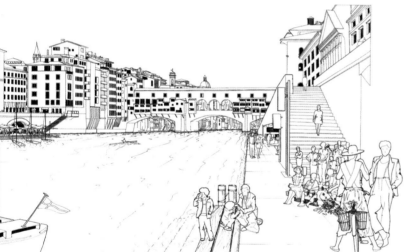

Royal Albert Dock

Below: The docks in their current condition, after decommissioning in 1980.

The 'Royals' – the Royal Victoria, Royal Albert and King George V Docks – were the largest and most modern of London's dock complexes and the last to close. The last ship left the docks in 1980, leaving a vast tract of land and water – over 400 hectares – available for development. The area stretched from Barking to the Isle of Dogs, comparable to the distance between the Houses of Parliament and Tower Bridge.

Key to RRP's masterplan for the Royal Docks was the creation of an effective public transport system, in order to facilitate the creation of an area of international importance that would generate investment and employment. RRP's design strategy also included services, landscape, development nodes and a clear public domain, alongside major commercial developments – all vital components of what would be a 'unique waterside city'.

Initially, only the infrastructure for this vast scheme was realised, but RRP was subsequently commissioned by developers Rosehaugh Stanhope to design a major mixed-use development along the Royal Albert Dock and adjacent to London's City Airport.

Bordering the 2.5-kilometre-long dock, the scheme culminated in a great glazed galleria arcing around a marina. Intended to be the most impressive shopping centre in Europe, the scheme offered a spectacular vista along the entire length of the Royals. Based on the concept of a dynamic public domain, with tented structures along the waterside housing restaurants and other leisure activities, the development was designed as the commercial magnet for the entire Royals complex but the faltering economy of the late 1980s meant that this great civic scheme was abandoned.

"The sheer scale and majesty of the great waterscape of the Royal Docks requires a bold response – our scheme celebrated a unique waterside location and the great vistas it offered. Key to our concept was a curving arcaded galleria encircling a great public place on the waterside."
Mike Davies

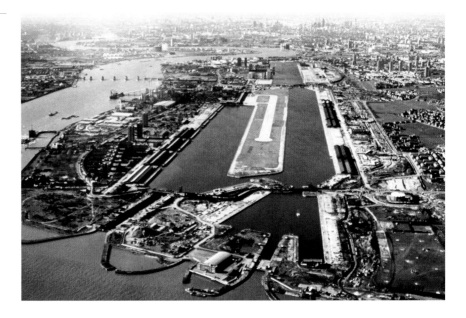

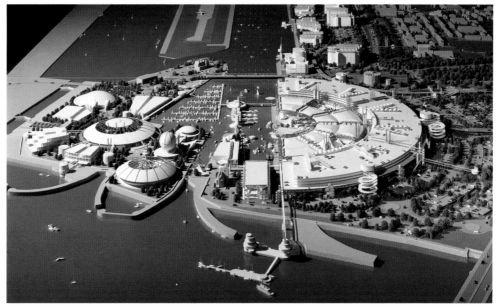

Above Left: The scheme includes three levels of retail units, bisected by a central galleria. Above Right: Model view of the proposed crescent-shaped shopping centre at the eastern end of the dock, located conveniently for transport links. Right: The strategic masterplan for the docks is at the core of a major redevelopment plan for the entire area. Following Pages: The docks are located on a vast tract of land that lies parallel to the Thames.

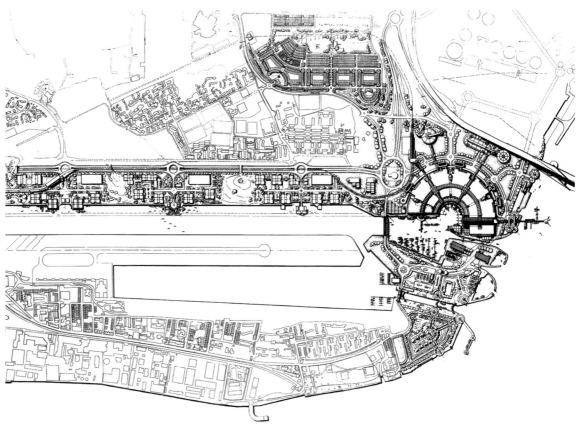

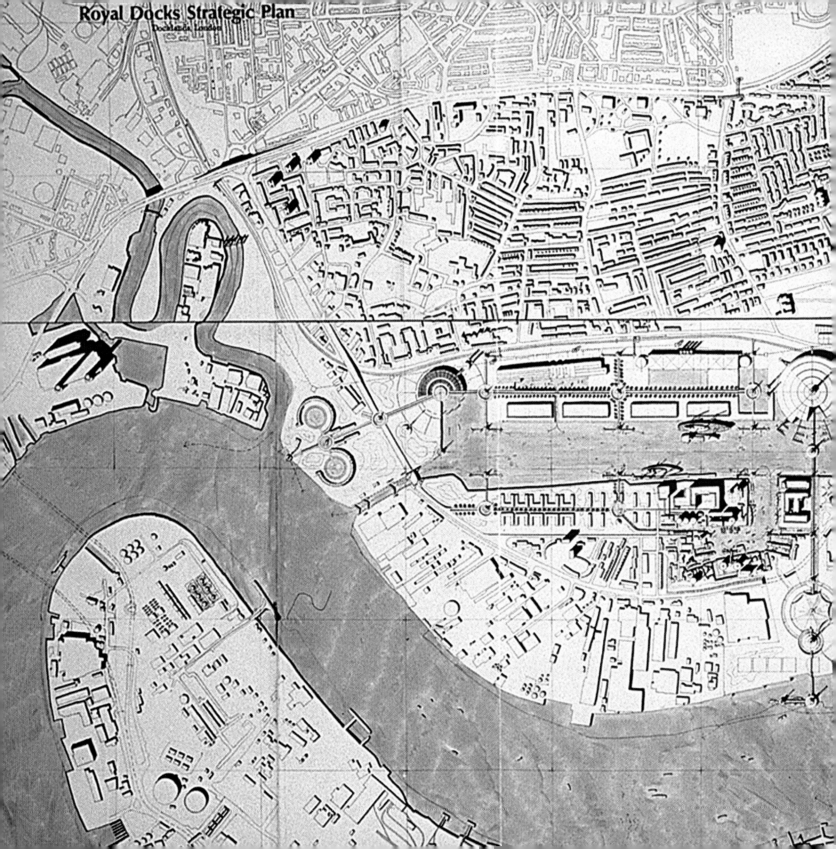

Royal Docks Strategic Plan
Docklands London

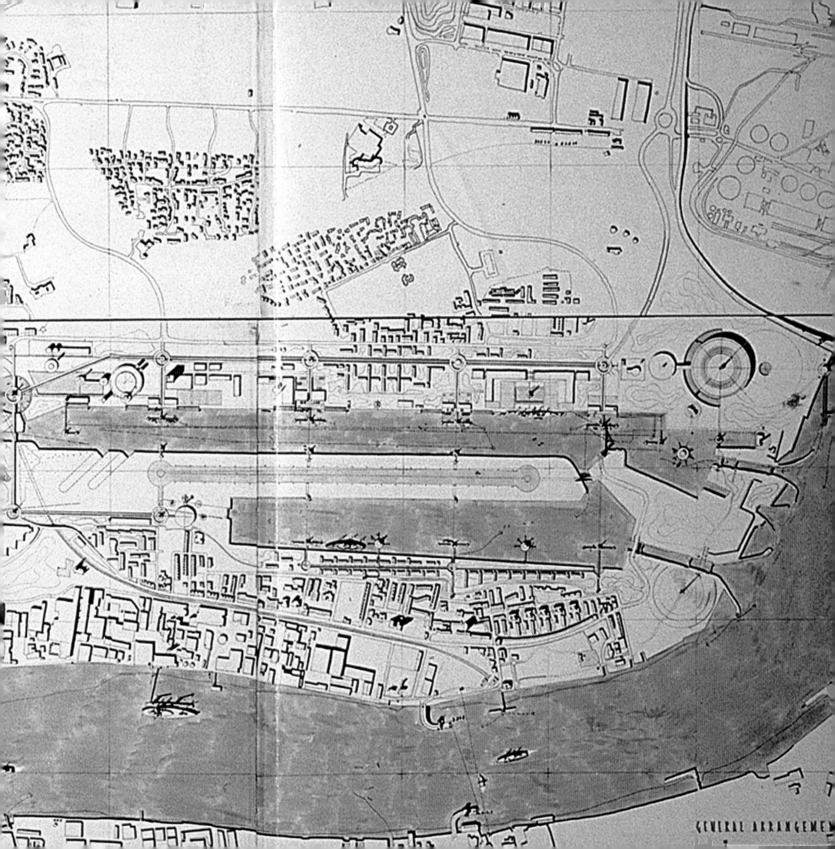

GENERAL ARRANGEMENT

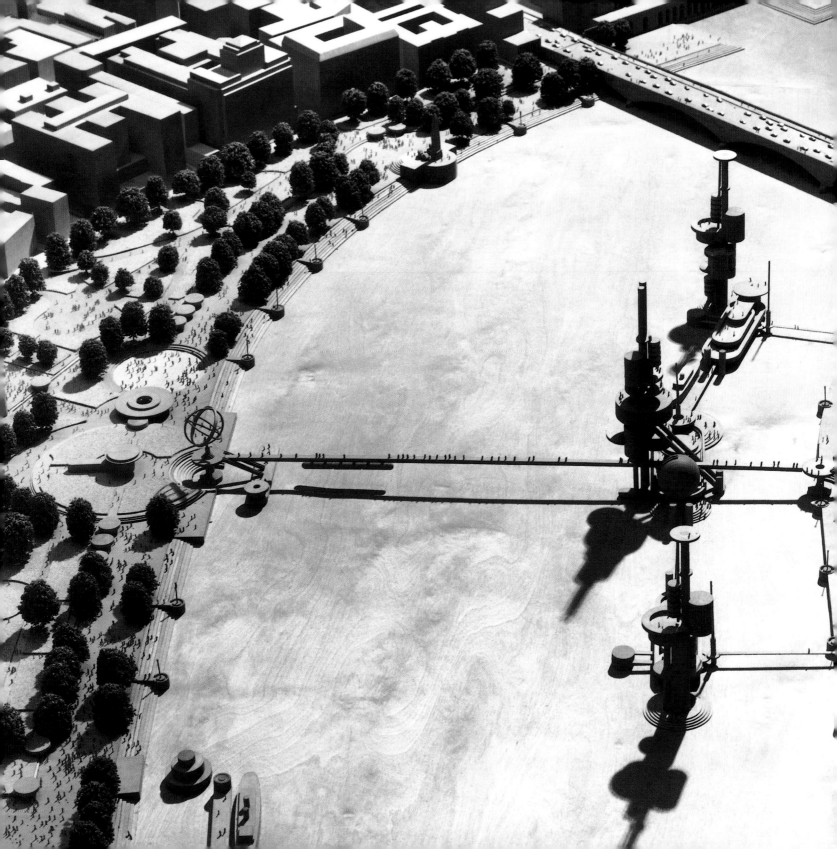

London as it could be

"At the heart of our urban strategy lies the concept that cities are for the meeting of friends and strangers in civilised public spaces surrounded by beautiful buildings." Richard Rogers

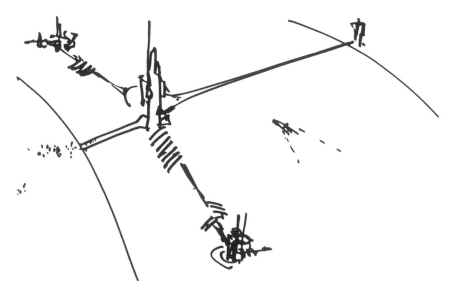

The election of a Conservative government in Britain, followed by the greatest property boom of the century, led to massive redevelopment in London. Rogers felt great opportunities to improve the capital were being ignored in favour of a piecemeal approach to planning, led by market forces rather than by any consideration of the wider public interest. 'In Britain', declared Rogers, 'the highest bidder wins', whereas in other European countries urban life was undergoing a renaissance with the encouragement of far-sighted politicians.

The exhibition at the Royal Academy of Arts in 1986, featuring the work of Rogers, together with that of Norman Foster and James Stirling, gave the practice the opportunity to put forward a series of visionary, but not impractical, proposals for transforming a large area of central London. The plan revolved on two axes: the Embankment along the Thames from Westminster to Blackfriars and the route across the Thames from Waterloo station (already projected as the terminus of the new Channel Tunnel rail link) to Trafalgar Square, perhaps the best-known public space in London but at that time surrounded by traffic and suffering consequently from noise and pollution.

Rogers proposed, in the spirit of the Embankment's creator, Bazalgette, that the road along the embankment be sunk in a tunnel, allowing the riverside to become a new linear park. The Charing Cross terminus on the Thames' north bank was relocated to the south bank Waterloo Station, and a new lightweight pedestrian bridge, replacing the bulky Hungerford railway crossing, led directly to the heart of Trafalgar Square.

Opposite and Above: The model and drawings exhibited at the Royal Academy in London presented a vision of the metropolis in which the Thames became a focus for activity rather than a gulf between the northern and southern banks. Right: The new bridge and floating islands contained shops, galleries and restaurants on the water.

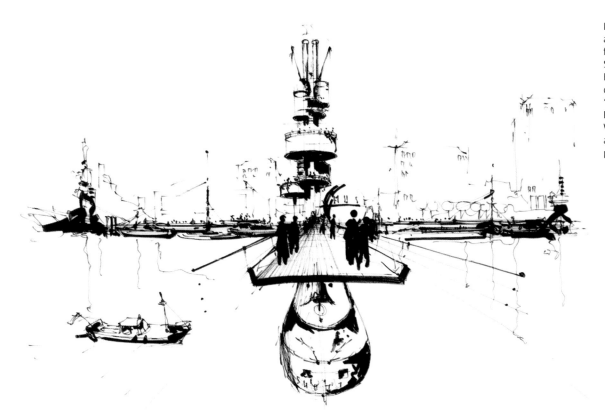

Left: The bridge incorporated an underslung shuttle, ferrying people from Waterloo Station to Trafalgar Square.
Bottom Left: Sketch of the clusters of accommodation, 'anchored' to the riverbank.
Bottom Right and Opposite: Views of the building clusters and bridge from a pedestrian's perspective.

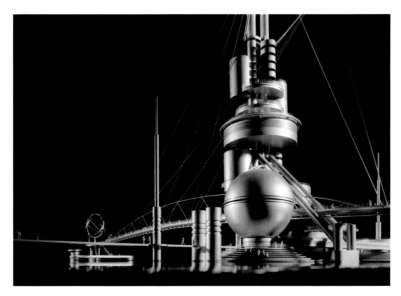

The proposals aroused a great deal of public interest, but were dismissed as impractical by those in power. Rogers' frustration at the state of London and, in particular, at the absence of a central planning authority for the whole city, led to his involvement in the 1992 general election campaign, where he sided with the Labour Party and published a book (with shadow minister Mark Fisher) critical of government policies and suggesting a series of alternatives. This was a brave move, at a time when architects were widely seen as mere facilitators of development, but reflected Rogers' conviction that the practice of architecture cannot be detached from social and political issues.

'London as it could be' represented a radical development of Rogers' urbanist thinking from the days of Coin Street and highlighted his continuing campaign for better cities.

Above: The study concentrated on two main axes: north–south from Piccadilly Circus to Waterloo Station and east–west from Parliament to Blackfriars Bridge.

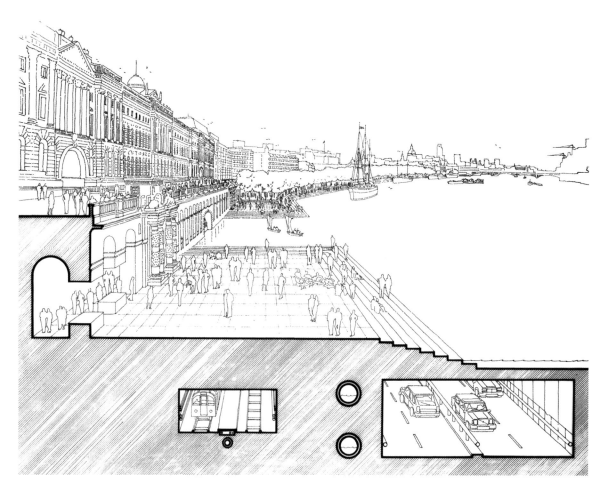

Above: A radical approach was taken to traffic which was no longer allowed to dominate the riverside but relegated to a new below-grade highway. An alternative RRP study re-routed the traffic along the Embankment in order to avoid the cost of the tunnel. Right: With the traffic removed, the riverbank was reclaimed as a linear pedestrianised park, open to the river and weaving together existing public gardens.

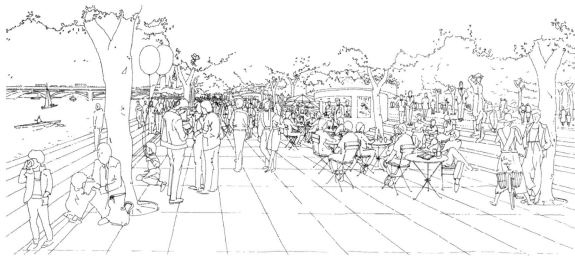

Right: Opening a terrace in front of the National Gallery (far right) allowed free pedestrian movement and the possibility of a sculpture garden. Below Far Right: A view of a traffic-choked Trafalgar Square, now semi-pedestrianised. Below Left and Right: A network of pedestrianised places and routes reclaims Trafalgar Square as a public meeting place.

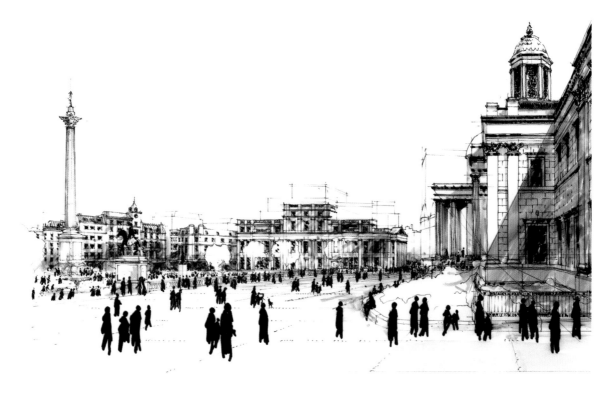

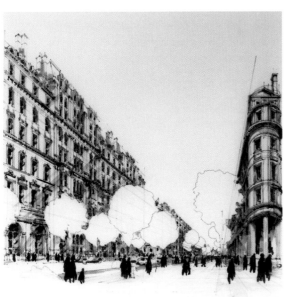

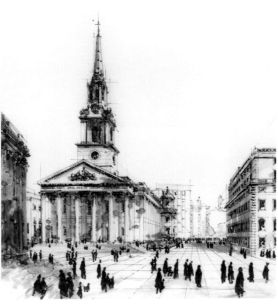

Paternoster Square

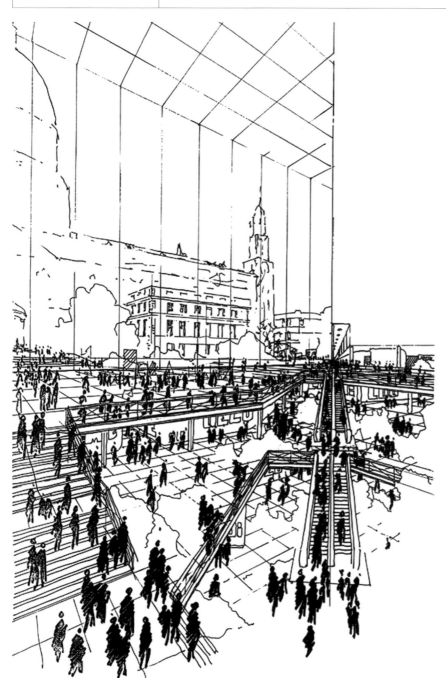

RRP was one of a number of leading practices (including Foster, Stirling and Isozaki) invited to submit proposals for the total redevelopment of this area of 1960s offices adjacent to St Paul's Cathedral. The aim was to replace the existing blocks with accommodation more suitable for modern financial operations. At the same time, it was recognised that public spaces providing a worthy setting for Wren's cathedral were necessary.

The ground plan of the RRP scheme resembled, albeit in a more regular, grid like form, that of the historic area which had been flattened by Second World War bombs. RRP's proposal recognised that buildings isolated in space would not work – instead the project was driven by the concept of a solid morphology of buildings cut through by public routes. The scheme devoted all ground-floor space to public uses, including extensive cloisters, with offices above. Roof gardens were to provide dramatic City views, while the excavation of a glazed lower level piazza adjacent to the north transept of St Paul's maximised public space and provided a striking entrance to the Underground

Left: A key generator of the scheme was to make the Underground station the major focus of the scheme. Opposite: A model of the masterplan with St Paul's Cathedral in the foreground.

"What was needed was a scheme with real integrity – not a dogmatic piece of modernism or an eclectic pastiche. Our proposal focused on creating attractive pedestrian routes and compact, highly charged public spaces."
Richard Rogers

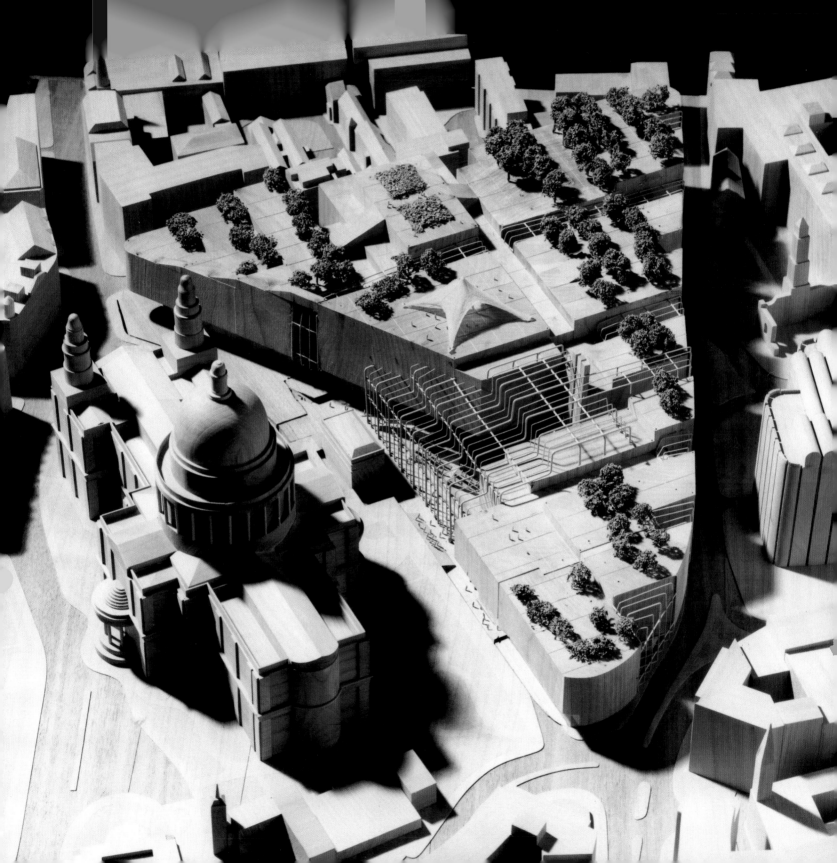

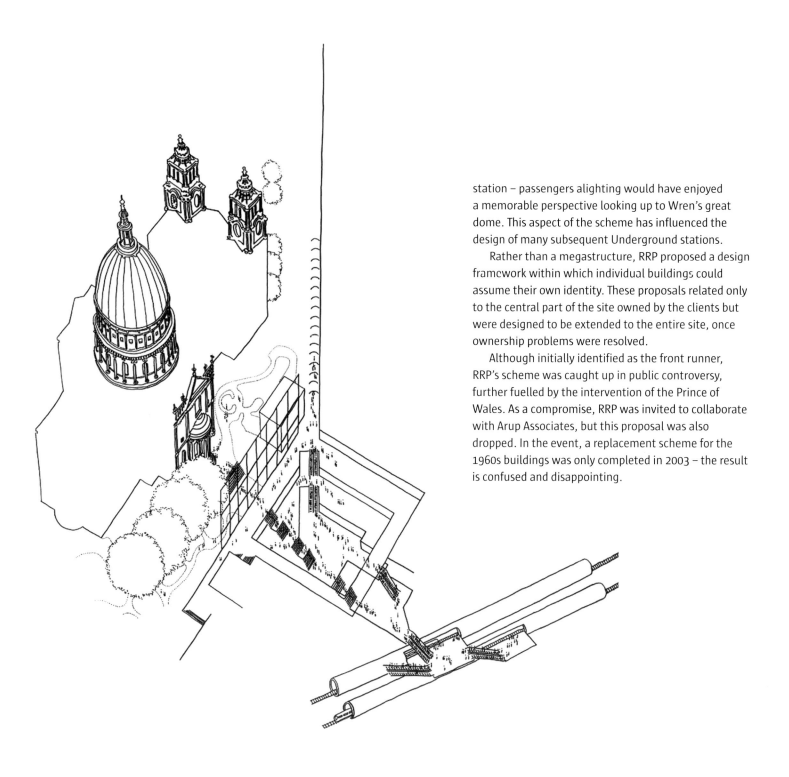

station – passengers alighting would have enjoyed a memorable perspective looking up to Wren's great dome. This aspect of the scheme has influenced the design of many subsequent Underground stations.

Rather than a megastructure, RRP proposed a design framework within which individual buildings could assume their own identity. These proposals related only to the central part of the site owned by the clients but were designed to be extended to the entire site, once ownership problems were resolved.

Although initially identified as the front runner, RRP's scheme was caught up in public controversy, further fuelled by the intervention of the Prince of Wales. As a compromise, RRP was invited to collaborate with Arup Associates, but this proposal was also dropped. In the event, a replacement scheme for the 1960s buildings was only completed in 2003 – the result is confused and disappointing.

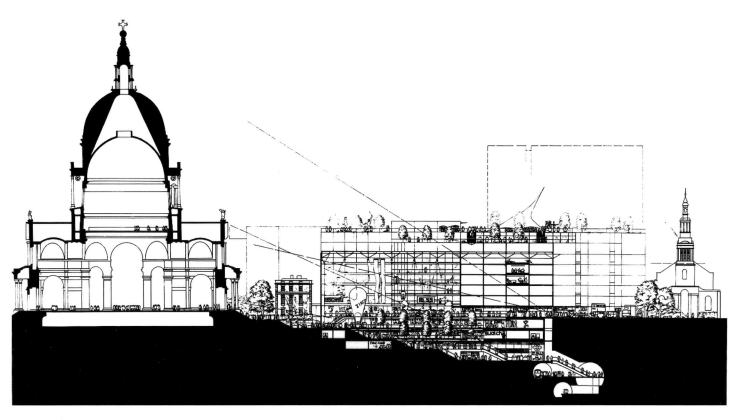

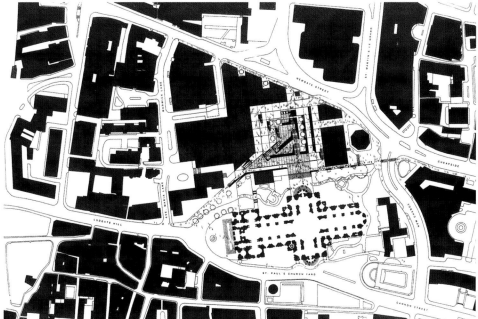

Opposite: Diagram analysing
public space from the
forecourt of St Paul's to the
Underground station. Above:
Section through the cathedral
and the new development.
Left: The proposed masterplan.

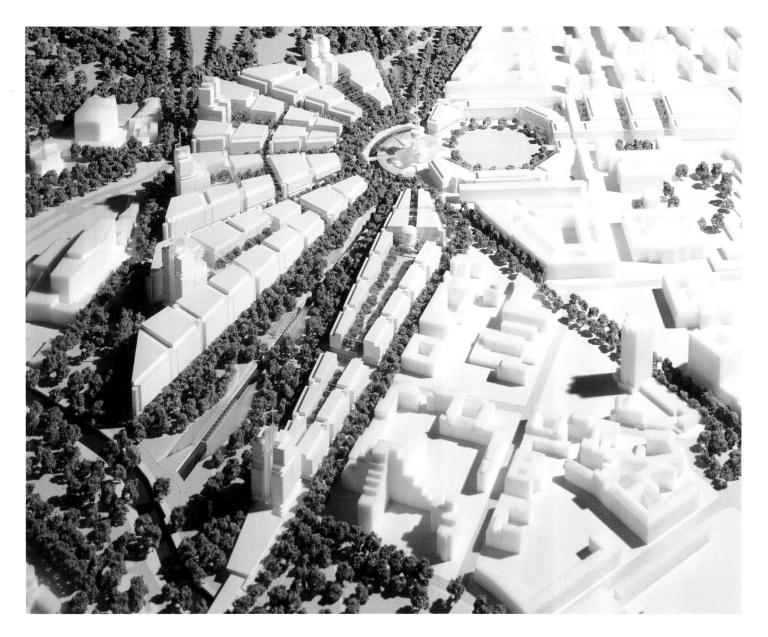

Potsdamer Platz Masterplan

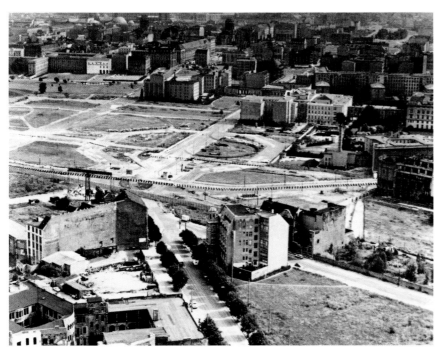

This historic 100-hectare site is situated at the heart of reunited Berlin between Alexander Platz and Kurfürstendamm. The brief's objective was to transform one million square metres of urban waste land into a dynamic mixed-use development that would re-establish Potsdamer Platz as a key destination at the centre of the re-united city.

The proposed masterplan places Potsdamer Platz as the focus of the historic radial street pattern, creating four zones of development each with their own balance of offices, residential, retail and cultural activities. The built form of the envelope rises from heights at Potsdamer Platz that respect the traditional building typology of the old centre, to taller buildings at the back of the site that can take advantage of views across the Tiergarten.

The site benefits from a major public transport interchange beneath Potsdamer Platz accommodating some 250,000 people per day. Analysis demonstrated that main traffic flows could be diverted away from Leipziger Platz and Potsdamer Platz, thus creating a people- and pedestrian-friendly environment.

The development zones are anchored in a clearly defined public realm, including major green spaces in the form of a series of linear parks that act as an ecological link passing right through the heart of the scheme, from the Landwehr Canal to the Tiergarten and all the way to the banks of the River Spree. By limiting vehicular traffic, defining the size and range of activities, opting for centralised heat and power production and imposing strict environmental parameters for future development, the practice's proposals for the Potsdamer Platz masterplan created the opportunity for an exemplary sustainable development in a city centre location.

Opposite Top: The mixed-use scheme radiates from Potsdamer Platz. Opposite Below: Section from Scharoun's Library to Leipziger Platz. Above: Postdamer Platz was once a major hub in pre-war Berlin. It was levelled in the war and became part of 'no man's land' with the construction of the Berlin Wall. Right: Diagram illustrating the massing principles with buildings increasing in height to the rear of the site. Far Right: Activity also extends to the rear of the site.

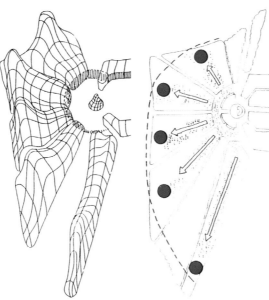

"This masterplan was not intended as an architectural statement or blueprint: it provides a suggested framework within which other architects and designers could contribute to a varied, rich and humane environment." Richard Paul

Below Left: The masterplan creates a new address directly onto Potsdamer Platz. Below Right: The masterplan included a north–south green corridor. Opposite: The redevelopment proposal was an opportunity to re-unite East and West Berlin within a new neighbourhood.

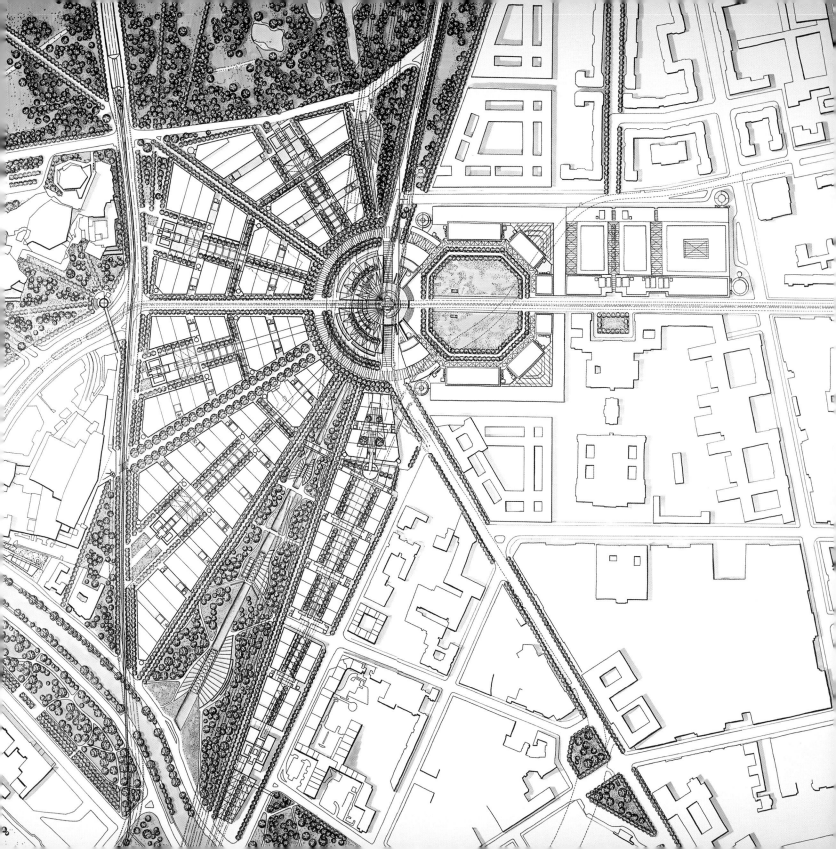

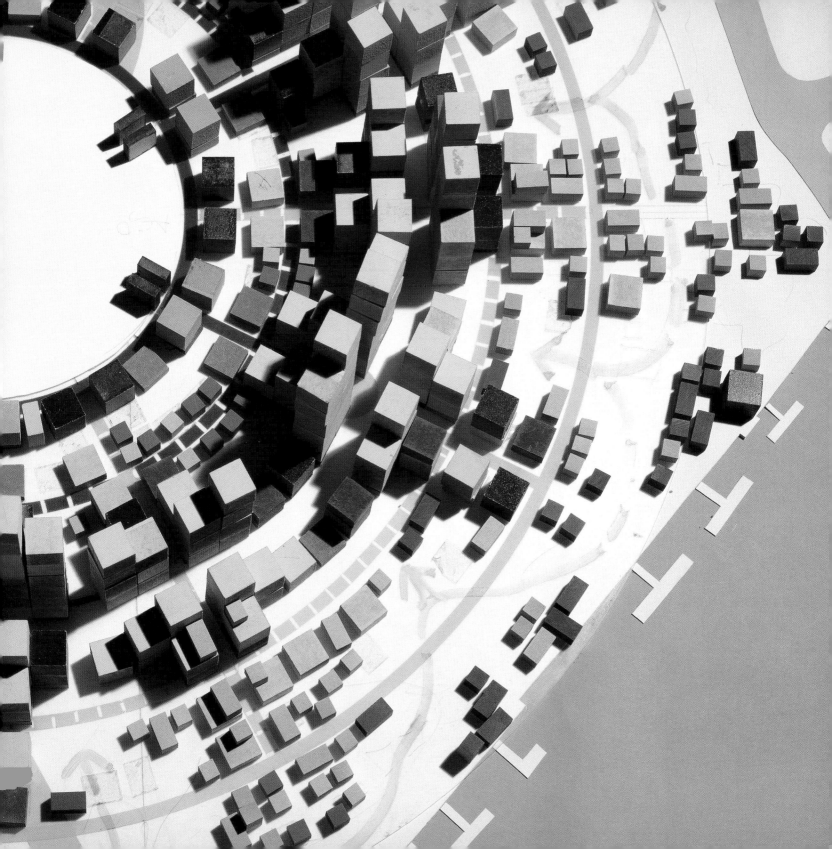

Shanghai Masterplan

"Our scheme offered the possibility of a truly sustainable, compact, 24-hour city." Richard Rogers

The Lu Jia Zui sector of Shanghai was an isolated area cut off from the city centre by the River Yangtze. With plans for tunnels and bridges providing necessary links to the city centre, the Shanghai Development Corporation invited six international teams of architects to propose ideas for the development of a new business sector for the city of Shanghai. RRP responded by formulating a strategic framework for this new district, exploring and applying the principles of a sustainable compact city. The environmentally driven proposals were rooted in the belief that the design of cities must reflect the growing global environmental crisis and that urban designers must approach cities as places of dynamic change.

The plan resembles a series of palimpsests imposed on one another – transport and circulation, landscape, built form and energy provision – creating a new kind of city. RRP's masterplan was based on an extensive and integrated network of public transport, offering a hierarchy of transport modes. The practice devised a vast wheel with the central park at its hub, with landscaped connections to a linear riverside park. Avenues radiate outwards, crossed by three concentric rings. The first carries pedestrians and cyclists, the second trams and buses, while the third

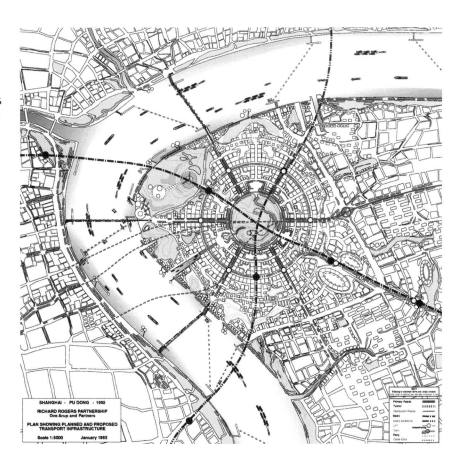

SHANGHAI · PU DONG · 1992
RICHARD ROGERS PARTNERSHIP
Ove Arup and Partners
PLAN SHOWING PLANNED AND PROPOSED TRANSPORT INFRASTRUCTURE
Scale 1:5000 January 1993

Opposite: The masterplan was designed as a mixed-use development with offices and shops concentrated around underground stations. Above: Located on a peninsula created by the river, Lu Jia Zui would become the nucleus for Pudong and form a focus for the future growth of Shanghai. Left: View of Lu Jia Zui before redevelopment.

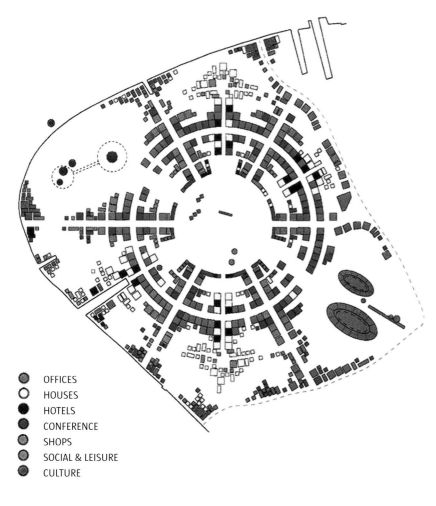

- ⬤ OFFICES
- ⭕ HOUSES
- ⚫ HOTELS
- ⬤ CONFERENCE
- ⬤ SHOPS
- ⬤ SOCIAL & LEISURE
- ⬤ CULTURE

is reserved for main car routes. In this way, the needs of commercial and residential areas are located within walking distance, away from all through-traffic. Major commercial developments are concentrated around six underground stations, while six residential areas, each containing 80,000 people, cluster along the river. Hospitals, schools and community facilities are also sited near the central park and river.

The urban grid provides a rich grain and texture in tune with the dense character of Shanghai's business district, resulting in an organic urban composition. The varied building heights create a distinctive urban skyline, reinforcing visual and physical connections with historic Shanghai.

By devising a scheme which minimises traffic congestion and pollution and incorporates low-energy, naturally ventilated buildings, the practice calculated that the new district would reduce overall energy consumption by 70 percent compared with that of a conventionally designed commercial development of similar scale.

Inner ring of development is formed by dense clusters of buildings which provide views across the river

Above: The aim of the masterplan was to create a diverse commercial and residential quarter with a mix of uses to create a 24-hour city. Right and Below: The massing ensures that a substantial percentage of buildings will benefit from river views. Opposite: The scheme's starting point is an overall transport strategy, with new connections to the city above and below the river, creating an overlapping system of separate but interrelated networks.

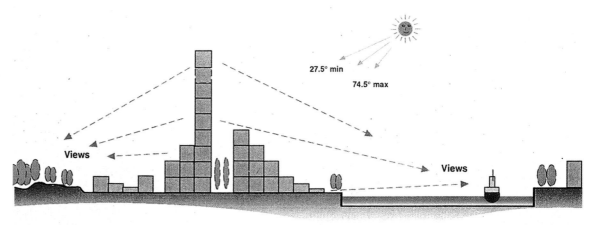

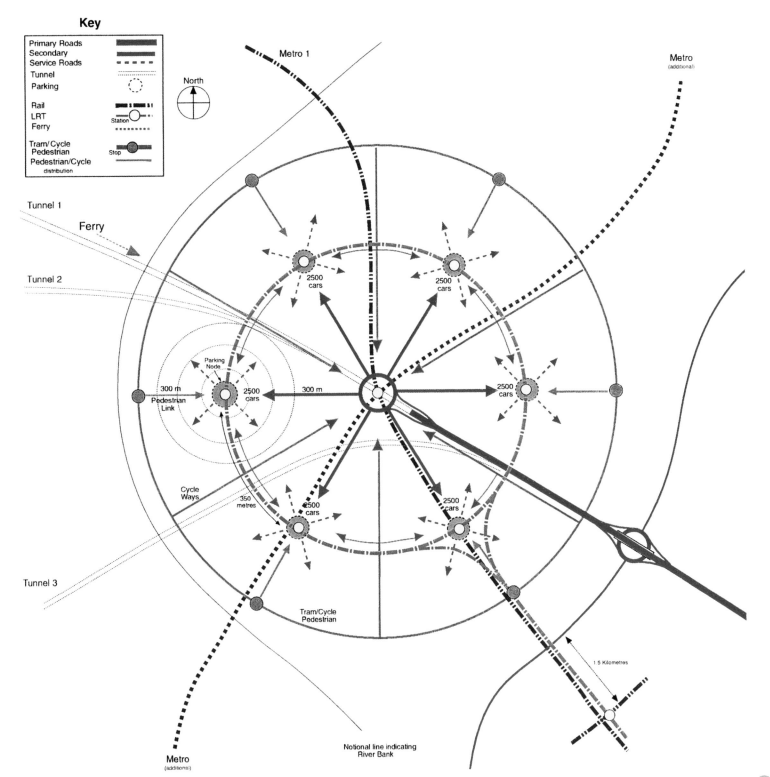

Key

Primary Roads	
Secondary	
Service Roads	
Tunnel	
Parking	
Rail	
LRT	
Ferry	
Tram/Cycle	
Pedestrian	
Pedestrian/Cycle	
distribution	

Station

Stop

North

Metro 1

Metro (additional)

Tunnel 1

Ferry

Tunnel 2

Parking Node

2500 cars

2500 cars

300 m Pedestrian Link

300 m

2500 cars

2500 cars

Cycle Ways

350 metres

Tunnel 3

2500 cars

2500 cars

Tram/Cycle Pedestrian

1.5 Kilometres

Metro (additional)

Notional line indicating River Bank

385

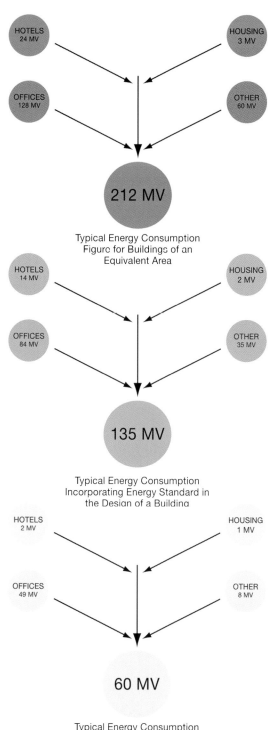

HOTELS
24 MV

HOUSING
3 MV

OFFICES
128 MV

OTHER
60 MV

212 MV

Typical Energy Consumption
Figure for Buildings of an
Equivalent Area

HOTELS
14 MV

HOUSING
2 MV

OFFICES
84 MV

OTHER
35 MV

135 MV

Typical Energy Consumption
Incorporating Energy Standard in
the Design of a Building

HOTELS
2 MV

HOUSING
1 MV

OFFICES
49 MV

OTHER
8 MV

60 MV

Typical Energy Consumption
Incorporating Energy Standards and
Combined Heat and Power Generation

Left: A diagram showing comparative energy use for Lu Jia Zui. These estimates are based on a total of 5.3 million square metres, 50 percent of which is office accommodation. Below: Preliminary massing studies were carried out using computer modelling. By introducing a series of peaks and troughs in the building massing, daylight can be accessed from more than one orientation. Bottom: Model view of the new community of a million people.

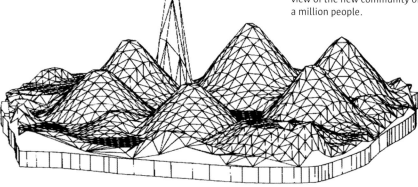

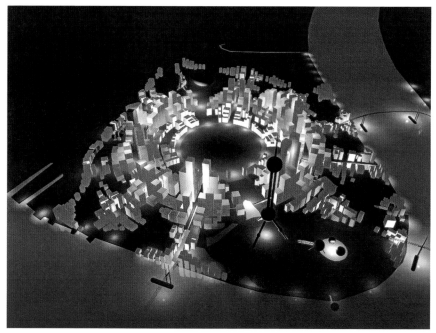

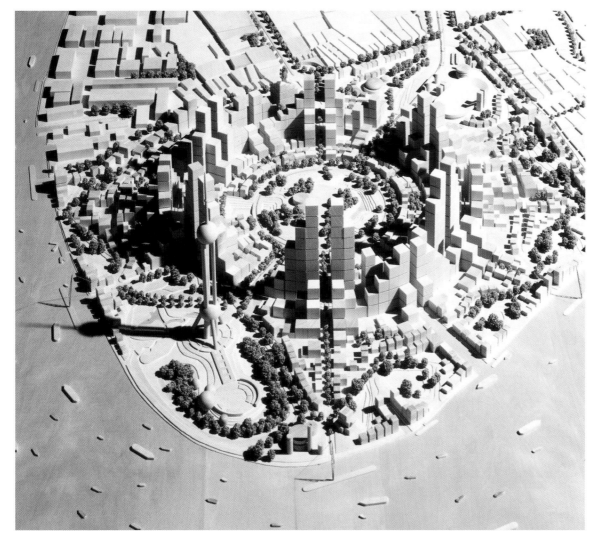

Left: View of the final massing model. Below: View of Lu Jia Zui across the river from the city centre.

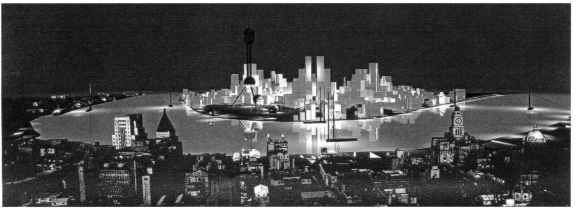

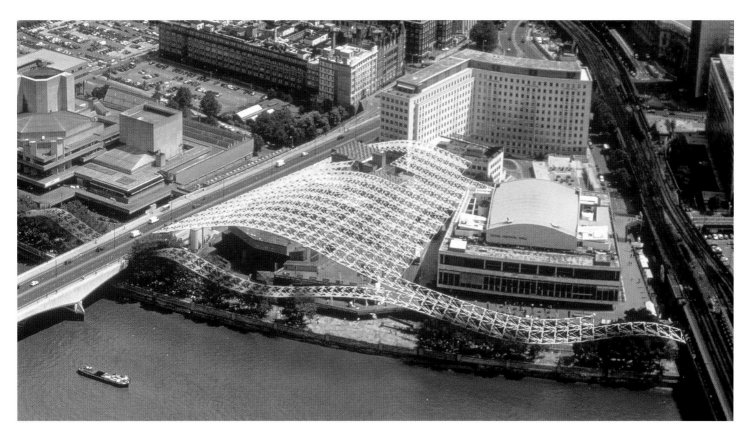

Public Buildings	# South Bank Centre	London, UK 1994

"This scheme is about reinvigorating London's centre for the performing arts, integrating it with its neighbourhood and the West End, and creating a venue which attracts a wider audience and is financially self-supporting." Ivan Harbour

Above: The existing site.
Below: Concept sketch.

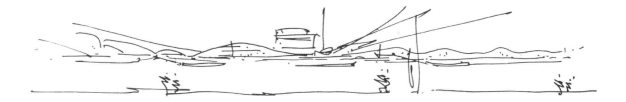

In 1994 the practice won an international competition to revitalise the area surrounding the South Bank Arts Centre, a complex of post-war arts buildings adjacent to Leslie Martin's Royal Festival Hall (RFH). The site is bounded by Waterloo and Hungerford bridges and close to Denys Lasdun's National Theatre. The complex is notorious for the poor quality of its public spaces – overhead concrete walkways and empty terraces are exposed to wind and rain. The principal design objective of the practice's winning scheme was to integrate the South Bank Centre into the heart of London life – opening up the centre to the river, reconstructing a pedestrian link on Hungerford Bridge, improving connections to Waterloo and upgrading performance and visitor facilities.

The scheme envisaged a complete regeneration of the site including the renovation of the listed Royal Festival Hall. Key to the proposal was a bold architectural gesture – a crystal palace which paid homage to Paxton's earlier essay for the Great Exhibition of 1951. This great wave of glass and steel sheltering the Hayward Gallery, the Queen Elizabeth Hall and the Purcell Room was designed to have a marked regenerative impact on the wider South Bank neighbourhood, just as the Centre Pompidou enlivened and transformed the surrounding Marais district. The vast roof would give a unified architectural expression to the disparate buildings while increasing usable area by 300 percent; the undulating forms of this vast canopy would also assist patterns of air, driving ventilation throughout the non-air-conditioned volume. The bulk of the proposal, however, addressed the complexities of improved access to and support of existing venues, the expansion of new informal performance areas which would attract a far wider audience and ancillary spaces to support this, including retail areas, cafés and restaurants.

In the end, despite grants in excess of £10 million, the Arts Council could not agree on a strategy for the arts centre as a whole and the project was abandoned. Renovation of the RFH is now proceeding independently, and new pedestrian links on either side of Hungerford Bridge are already in place.

Left and Below: Perspective views of the proposed enclosed and semi-covered public space underneath the dramatic curved glass canopy. Opposite Top: Aerial model view showing the relationship of the new canopy to the existing buildings. Opposite Below: Computer-generated image illustrating the complex geometry of the canopy roof. Following Pages: Model view of the dramatic roof as it undulates along the river front.

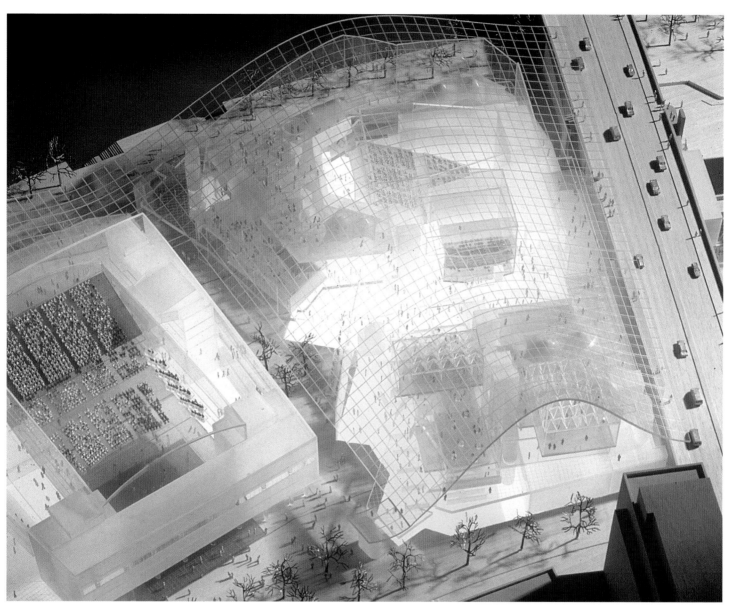

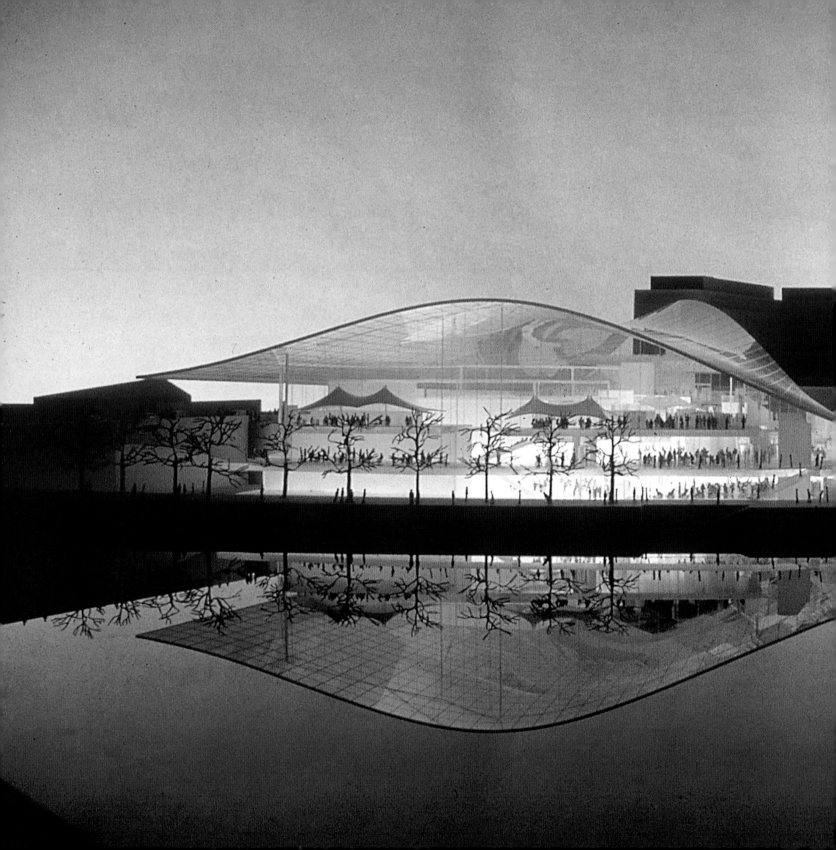

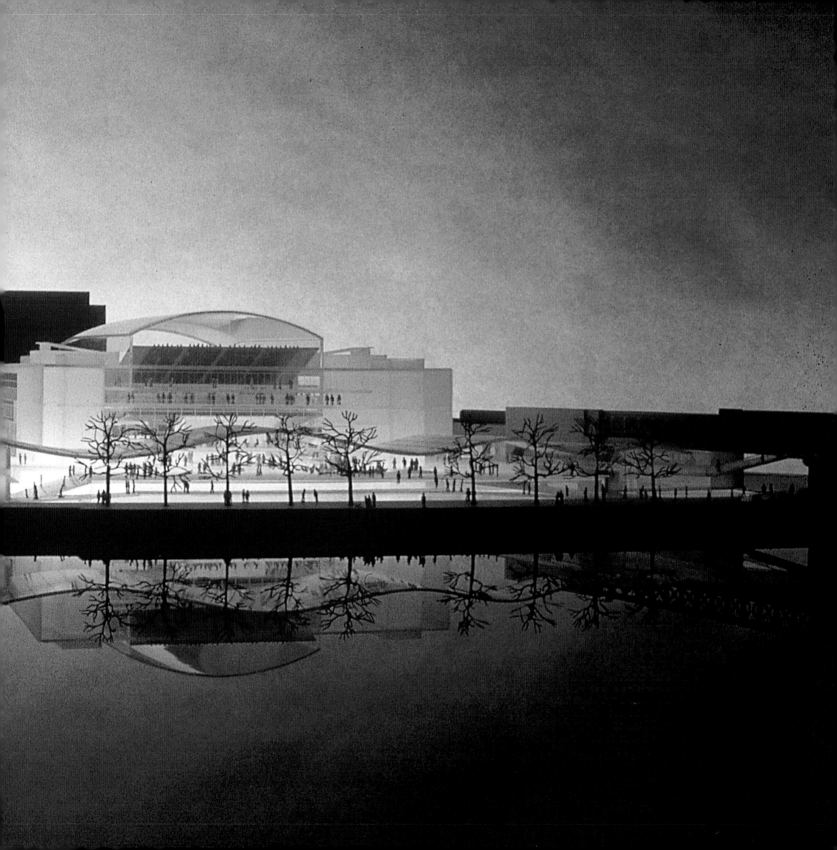

ParcBIT

"Our masterplan was generated by careful analysis of the site and landscape. The plan is designed to preserve native landscape features and to maintain the site's ecological value." Lennart Grut

Below Left: The site consists of agricultural land on which an existing Finca (farmhouse) is located. Below Right: Diagram showing the various existing site conditions.

Parc Balearic Information Technology (ParcBIT) is an initiative by the Balearic Government, as part of the ExpoCities Project under the European Union Thermie Programme, to generate a new approach to living and working environments. Drivers of the scheme are the provision of leading-edge telecommunications links, a modern, sustainable and efficient infrastructure, and a high-quality built environment.

After winning an international competition in 1994, the practice was commissioned to plan a mixed-use live/work community for some 5,000 inhabitants on a site that lies 12 kilometres north of Palma. Located on agricultural land next to Mallorca's university campus, ParcBIT, is bounded to the east and west by development but by open country to the north. An existing Finca (farmhouse) which is preserved in the new plan is sited on the brow of the ridge in the centre of the

site, between two torrent valleys which take water run-off from the mountains to the sea.

Responding to the client's manifesto, the proposal is highly sustainable, implementing systems that balance the cycle of supply and demand within the community. The scheme can also be 'read' as a physical manifestation of the age of telematics – ParcBit recognises that work location is no longer defined by historic centres of occupation but will increasingly be determined by key issues such as the quality of life and the environment. The scheme is deferential to the existing terrain, recognising that landscape is the collective memory of a culture. The new development complements rather than compromises the landscape and its local ecology – the existing topography has played a significant role in the definition of built form and circulation patterns, with buildings located on the

Dryland Field

Playing Fields shared with University

Pine Woods

Farming

Dryland Orchard

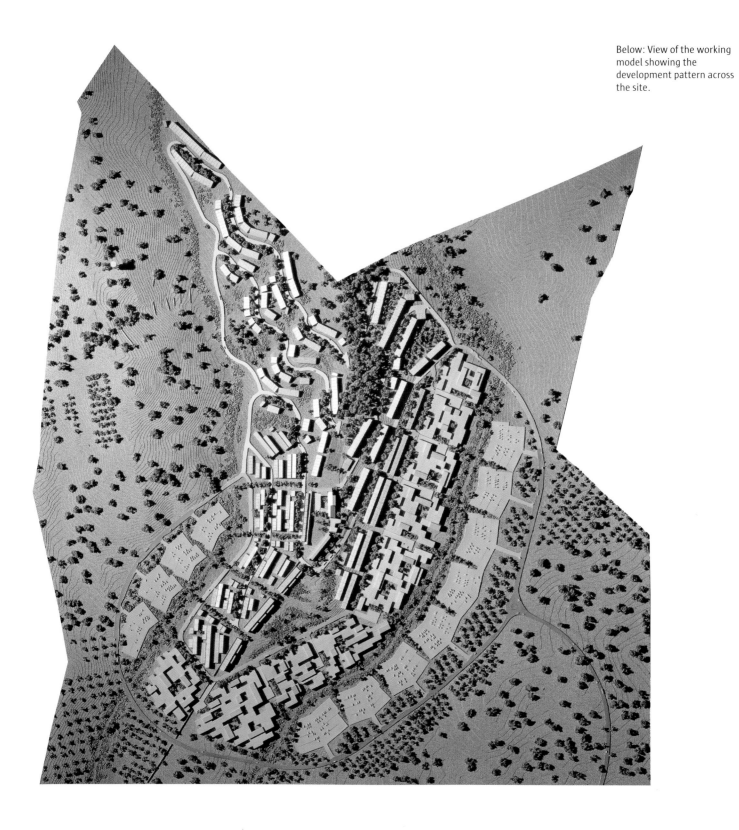

Below: View of the working model showing the development pattern across the site.

terraces which wrap around the Finca and the ridge, following the contours of the land. In addition the scheme gives clear priority to a pedestrian environment, with parking contained at the perimeter of the site.

ParcBIT reduces water use while providing a landscape which benefits both people and local ecology – tertiary treated water is used for irrigation. The masterplan's energy system ensures a high level of comfort in buildings while minimising environmental impact and carbon dioxide emissions. It does this through a high-efficiency central CHCP plant which incorporates an innovative approach to the integration of renewable solar energy.

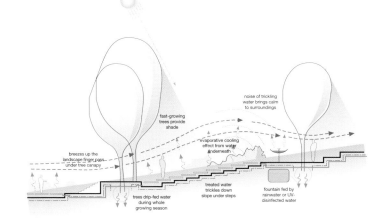

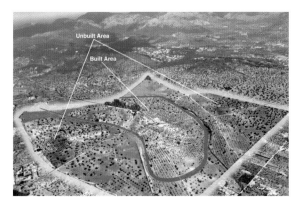

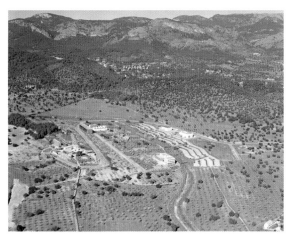

Opposite Top: Diagram of the environmental factors affecting the site. Opposite Far Left Above and Below: Aerial views of the site showing the existing condition (above) and with development underway (below). Opposite Below Right: Diagram of the energy system which allows a high level of comfort in buildings while minimising environmental impact. Right: Four diagrams showing, from clockwise top left, integration of the development with the landscape; water usage pattern which uses tertiary treated water for irrigation; parking, which is contained at the perimeter of the development; and a mix of living and working spaces.

Piana di Castello

"Our masterplan was about connectivity – an enhanced transport infrastructure provided links between Florence and key towns to the west while a pedestrianised central zone created a hierarchy of public spaces linked by a network of green pedestrian routes." Richard Rogers

Below Left: Location plan. Below Right: Density is built up along the main pedestrian spine and the main access into the site. Opposite: View of the model showing the curvilinear pedestrian spine.

Outside the heavily protected historic centre of Florence, the Piana di Castello site is an edge of city development – an ideal location for a new mixed-use urban quarter, a positive and well-ordered alternative to the uncontrolled sprawl that has extended along much of the Arno valley, west of the city. Piana di Castello is close to the airport, with excellent transport links (mainline train station and tram/bus routes) – a natural gateway from the west into Florence and also to the industrial region extending to Prato and Pistoia.

The masterplan, commissioned by the city authorities, includes the proposed new headquarters for the regional government of Tuscany, which will itself be a major source of employment, generating activity across the site. Half of the 160-hectare site will be devoted to a public park. The associated mixed-use, residential and commercial development (with a maximum population of 23,000) would total around 1.4 million square metres, a significant extension to the city.

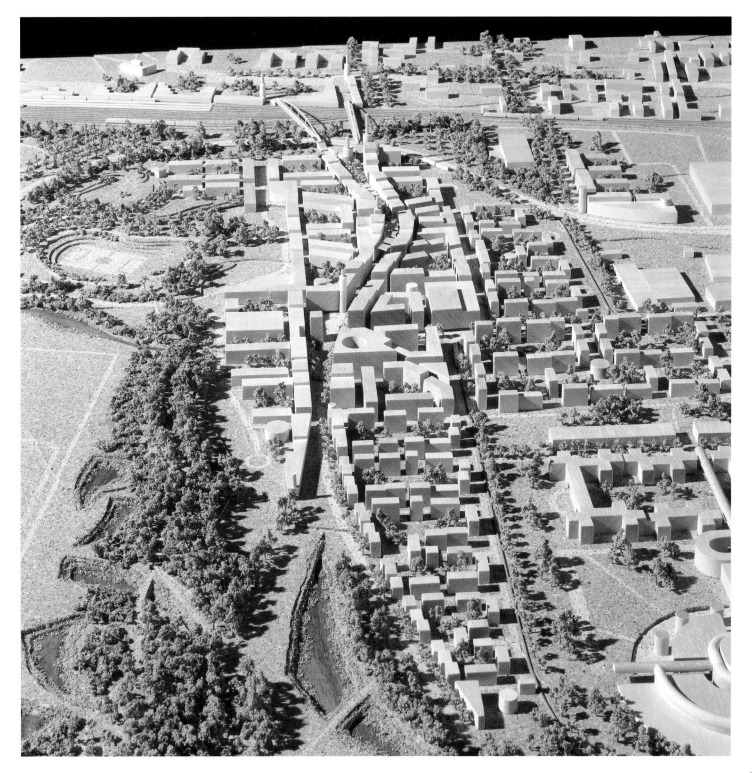

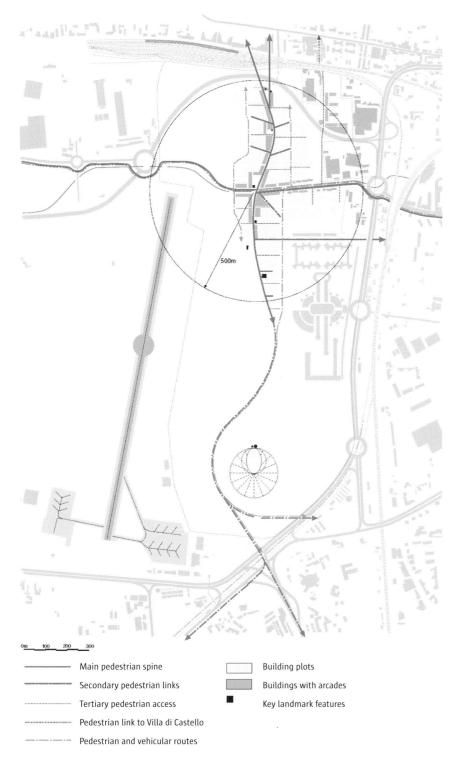

500m

0m 100 200 300

Main pedestrian spine

Secondary pedestrian links

Tertiary pedestrian access

Pedestrian link to Villa di Castello

Pedestrian and vehicular routes

Building plots

Buildings with arcades

Key landmark features

As in previous masterplans by the practice – for example, the scheme for the Potsdamer Platz quarter of Berlin – dense concentrations of buildings responding to wind, sun and the high water-table are woven into a landscape that combines areas of green space (providing an acoustic barrier and a degree of flood control) with urban squares and streets in the Italian tradition.

Within the site, the emphasis is on pedestrian circulation, with a central circulation axis connecting the three main squares. Car access from east and west respects this pedestrianised central zone, with primary distributor roads running parallel to the main spine. Residential neighbourhoods are largely arranged around the quieter perimeter of the site. With its woodlands, lakes and wildlife habitats, the landscape contributes strongly to the environmental quality of the site and is in tune with a low-energy servicing programme aimed at long-term sustainability.

Left: Pedestrian routes create a less car-dominated environment. The key objective is to encourage walking and cycling, and to discourage vehicular movement apart from the use of public transport. Opposite Left: The landscape masterplan results from an integrated approach to landscape which addresses the Tuscany context.

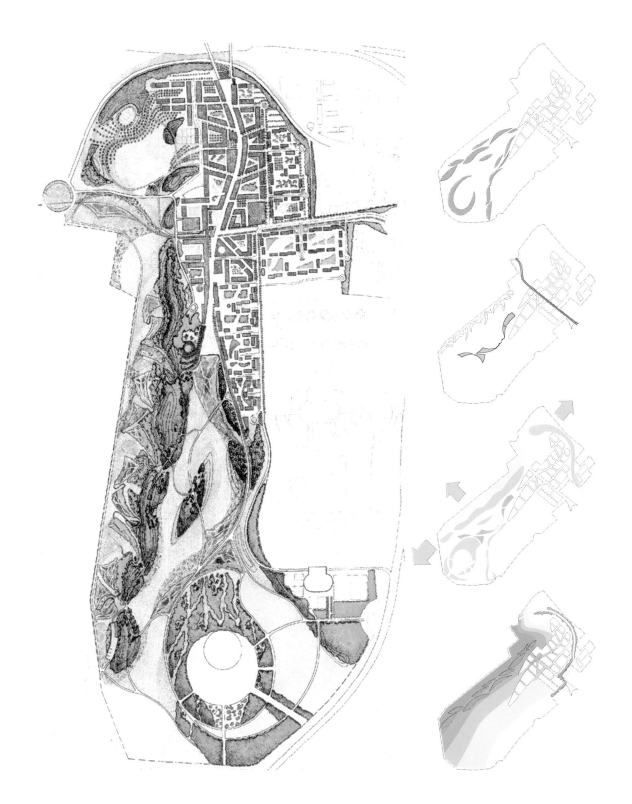

Breeze harvesting

The combination of landform and woodland planting is designed to harvest prevailing south-westerly breezes, directing them northward into the new development. These breezes would be cooled by newly created lakes. Planted courtyards are designed to maintain captured breezes at pedestrian level and to further reduce ambient temperatures by up to 5 degrees celsius.

Hydrology

The water strategy for the site is integral to the landscape design. Changing from agricultural use to large areas of hard surfaces will concentrate surface water run-off. Average annual rainfall could sustain two hectares of lakes. To prevent flooding downstream, seasonal flooding of meadows and other porous surfaces would allow ground water to be recharged. A further four hectares of wetland habitat could be sustained by the treatment of urban waste water produced by the new development. Treated by a series of ponds, the new water would filter into the water table via wet meadows which would also provide an additional wildlife resource.

Ecology

The landscape design of the new park and the spaces between buildings will feature trees and shrubs which are native to the locality, providing a richer wildlife habitat than currently exists. Three habitat types would be generated – woodland, managed grassland and wetland.

Noise

Landscaping is designed to mitigate noise from the nearby airfield. Tree planting provides shelter from the new road to the north of the development and existing infrastructure to the east. Planting is chosen for its year-round foliage protection, resulting in a new recreational zone for walking, jogging and other out-door activities.

East Manchester

"The aim of our scheme was a self-sustaining regeneration for East Manchester, fuelled by new economies rooted in places of urban quality." Richard Rogers

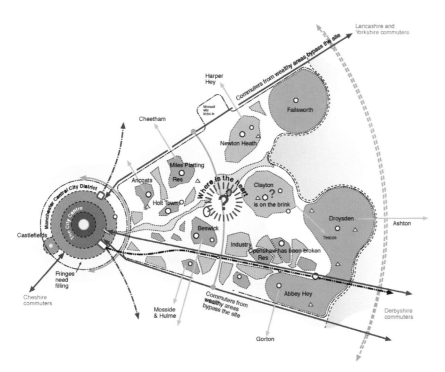

The challenge posed was to devise a masterplan that would effectively harness Manchester's heritage of economic strength and innovation in order to drive prosperity for the area in the 21st century. Key strategies identified by the practice included linking regeneration agendas in order to strengthen established neighbourhoods, creating new places of quality within areas of dereliction, and re-introducing the Infrastructure of economic growth.

The urban structure of East Manchester needs a strong centre – a new district core served by a strengthened network of public and private transportation using canal, road and tram. At the same time, the practice proposed to link this core closely to the city centre and inter-urban transport nodes. This new nucleus for the area would encourage a strong local economy to thrive. In addition, it was intended that the Sport City facilities designed for the Commonwealth Games would have a continuing legacy role as a major leisure facility for Manchester.

The scheme proposed strengthening the identities of existing neighbourhoods – with ease of movement between local facilities. In the longer term, employment and educational opportunities could be co-ordinated to upgrade the skills balance in the local communities and facilitate economic growth.

A sequential strategy would progressively regenerate each area, starting with a high-quality core and then using transport links to integrate nodes of regeneration. The plan also proposed a number of creative uses for vacant land between these communities.

Careful and progressive planning would be vital to ensure that key catalytic initiatives created maximum impact over time.

Opposite Top Left and Right: East Manchester suffers from serious dereliction with fragmented communities in which three out of four houses are boarded up. Opposite Below: Diagram analysing the existing structure. Right: Aerial view showing the boundary of the masterplan area. Below: Diagram illustrating how fragmented cities can be transformed into coherent neighbourhoods.

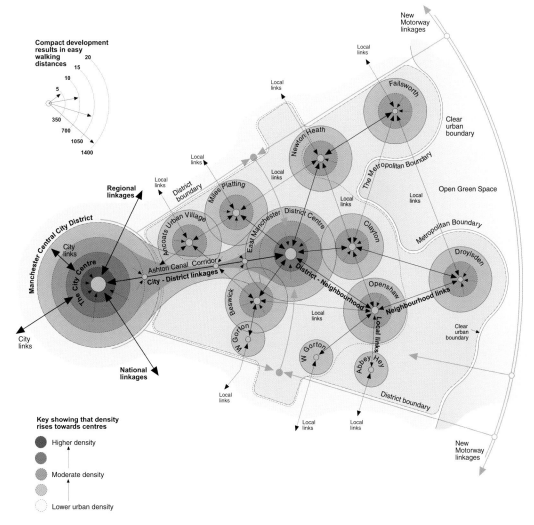

Compact development results in easy walking distances
20
15
10
5
350
700
1050
1400

Regional linkages

Manchester Central City District

City links

The City Centre

City links

National linkages

Local links

District boundary

Ancoats Urban Village

Miles Platting

Ashton Canal Corridor

City - District linkages

Beswick

W Gorton

New Motorway linkages

Local links

Failsworth

Clear urban boundary

The Metropolitan Boundary

Newton Heath

Local links

Open Green Space

Local links

East Manchester District Centre

Clayton

Metropolitan Boundary

District - Neighbourhood

Droylsden

Openshaw

Neighbourhood links

Clear urban boundary

W Gorton

Abbey Hey

Local links

Local links

Local links

Local links

Local links

Local links

District boundary

New Motorway linkages

Key showing that density rises towards centres
Higher density
Moderate density
Lower urban density

403

Below: Diagram of existing
key neighbourhoods and
transport infrastructure for
the East Manchester area. This
initial study established where
people still lived.

Regional and national
road links

The city
boundary

1 Kilometr

Collyhurts

Employment
areas

The district
of East
Manchester

Employment
areas

The city
boundary

Failsworth

Miles
Platting

Newton
Heath

A green lung for the city and East Manchester

Philips
Park

Ancoats

Clayton

Droylsden

Tram linkages
to Ashton

City
centre

Canal
basin

Holt

Beswick

District
Centre

Openshaw

Employment
areas

Employment
areas

West
Gorton

Abbey Hey

Gor

1 Kilometre

The city
boundary

Regional and national
road links

404

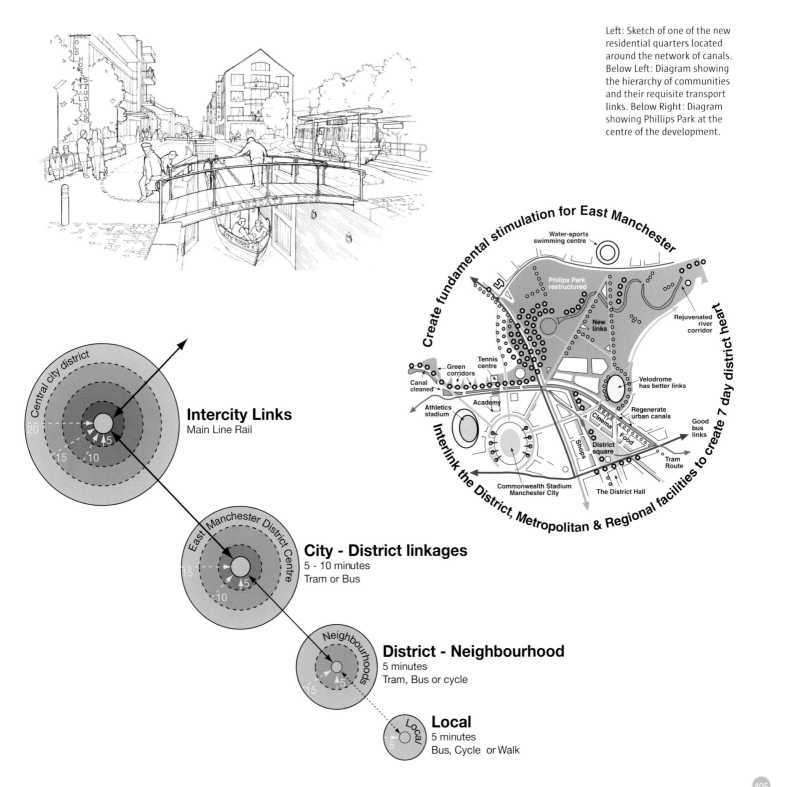

Left: Sketch of one of the new residential quarters located around the network of canals. Below Left: Diagram showing the hierarchy of communities and their requisite transport links. Below Right: Diagram showing Phillips Park at the centre of the development.

Create fundamental stimulation for East Manchester

Water-sports swimming centre

Philips Park restructured

New links

Rejuvenated river corridor

Green corridors

Tennis centre

Canal cleaned

Academy

Velodrome has better links

Athletics stadium

Cinema

Regenerate urban canals

Good bus links

District square

Food

Shops

Tram Route

Commonwealth Stadium Manchester City

The District Hall

Interlink the District, Metropolitan & Regional facilities to create 7 day district heart

Central city district

Intercity Links
Main Line Rail

East Manchester District Centre

City - District linkages
5 - 10 minutes
Tram or Bus

Neighbourhoods

District - Neighbourhood
5 minutes
Tram, Bus or cycle

Local

Local
5 minutes
Bus, Cycle or Walk

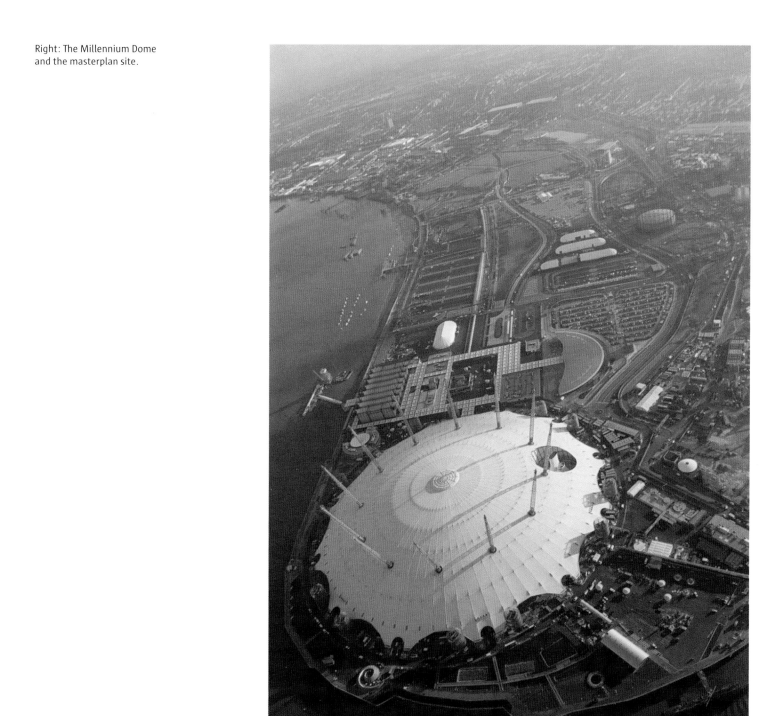

Greenwich Peninsula

The 300-acre Greenwich Peninsula, physically isolated, formerly occupied by a huge gasworks, and in a derelict and heavily contaminated state, was selected, in 1996, as the site for the Millennium Experience, the key celebration in Britain of the new millennium. In the same year, the land there was acquired by English Partnerships and RRP was appointed to lead a multidisciplinary team to develop a masterplan for the whole peninsula and make the temporary exhibition planned for 2000 the starting point for an ongoing regeneration process.

The aim was to develop a new mixed-use residential and commercial quarter, capitalising on the new fast link to Canary Wharf, the City and West End provided by the opening of the London Underground Jubilee Line Extension station at North Greenwich. The masterplan concentrated office and retail uses in a new central business district close to the Underground station and transport interchange, with larger scale commercial and industrial activities grouped along the southern edge of the site as a buffer to the A102M Blackwall Tunnel approach road.

Sustainability was key to the masterplan – at the heart of the scheme is a continuous two-kilometre-long public space and park system. This public armature represents roughly one-sixth of the total site area and runs from north to south along the whole length of the development, carrying the main pedestrian and cycle routes, with spectacular views out over the Thames, Canary Wharf and the Thames Barrier. Residential

Below: Perspective sketch of the view towards the Dome from the central park.

"The challenge of the Greenwich Peninsula was to turn a derelict, contaminated but physically spectacular site into a vibrant new mixed-use quarter for London. Its riverside location and its connectivity both by metro and road combined with the masterplan vision to transform the area into a lively, popular and rapidly growing neighbourhood." Mike Davies

areas, together with retail, schools and community facilities, are located around these public spaces. The objective has been a density of development that would support a robust public transport network, as well as an environmentally responsible approach. A smaller southern park, opening to the river, includes sports facilities and an ecology park with two lakes. Wildlife now enjoys an environment with more than a thousand new trees.

The overall development of the site was considered in the context of climatic conditions, with taller buildings along the north-eastern edge descending gradually in height to the parkland and the residential areas to the west – screening the heart of the site from prevailing winds was an important consideration. The river edge was designated as an area of permanent public access, with more than two kilometres of public walkway.

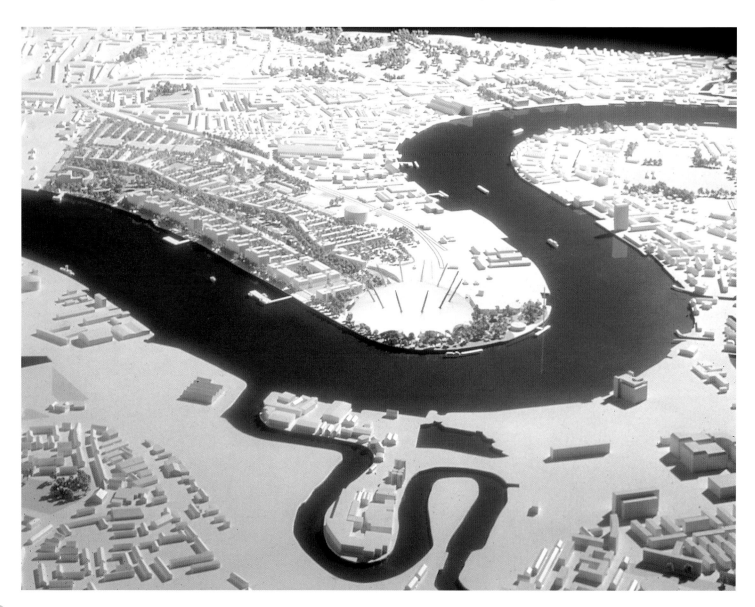

Opposite: View of the massing model. Below Left: Illustrative masterplan. Below Right: Diagram of the environmental factors affecting the site. Bottom: Diagram of the winter–spring strategy.

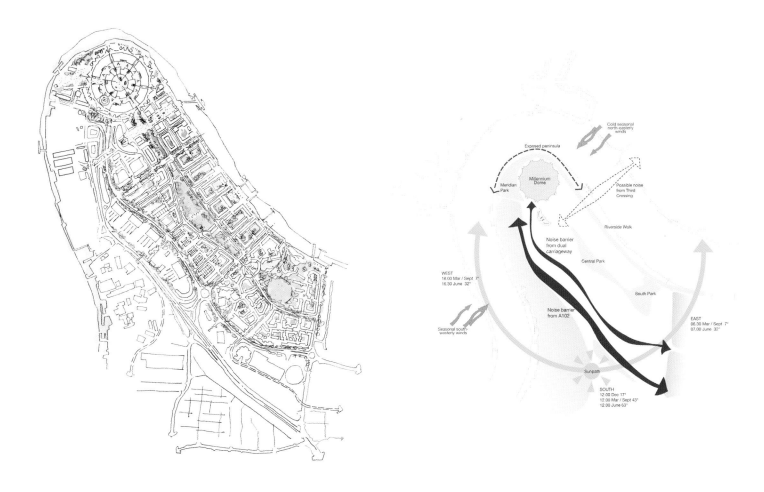

Cold seasonal north-easterly winds

Exposed peninsula

Meridian Park

Millennium Dome

Possible noise from Third Crossing

Riverside Walk

Noise barrier from dual carriageway

Central Park

WEST
18.00 Mar / Sept 7°
16.30 June 32°

South Park

Noise barrier from A102

EAST
06.30 Mar / Sept 7°
07.00 June 32°

Seasonal south-westerly winds

Sunpath

SOUTH
12.00 Dec 17°
12.00 Mar / Sept 43°
12.00 June 63°

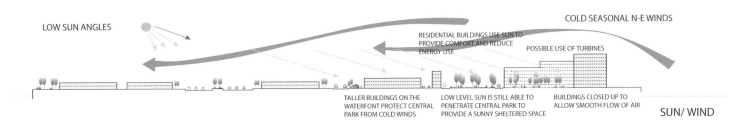

LOW SUN ANGLES

COLD SEASONAL N-E WINDS

RESIDENTIAL BUILDINGS USE SUN TO PROVIDE COMFORT AND REDUCE ENERGY USE

POSSIBLE USE OF TURBINES

TALLER BUILDINGS ON THE WATERFONT PROTECT CENTRAL PARK FROM COLD WINDS

LOW LEVEL SUN IS STILL ABLE TO PENETRATE CENTRAL PARK TO PROVIDE A SUNNY SHELTERED SPACE

BUILDINGS CLOSED UP TO ALLOW SMOOTH FLOW OF AIR

SUN/ WIND

Viareggio

Below Left: The Viareggio Carnival. Below Right: Aerial photo of Viareggio showing the location of the masterplan along the waterfront.

Viareggio, formerly an important beach resort, is strategically located between Pisa and Florence in western Tuscany. In recent years, there has been a steady decline in the city, particularly along the Passeggiata (central promenade) area which runs parallel to the seafront where most of the amenities are concentrated. Significant seasonal fluctuation in tourist trade and a lack of local investment have resulted in declining services and amenities, and the council of Viareggio has recognised the need to redevelop both the town and the Passeggiata in order to compete commercially with other seaside resorts in the region. In 1998 they commissioned RRP to draw up a strategic masterplan for the Passeggiata in order to help regenerate the city.

The proposal identifies some of the key assets of the city, such as the sea, the mountains and the fishing village, and how these elements can be rediscovered and organised to create new opportunities for activities throughout the year as well as better movement linkages between Viareggio and the surrounding area. Vehicular circulation and parking around the Passeggiata is arranged to give priority to pedestrians and cyclists. New pedestrian routes are established linking the northern residential area and the sea through the central park. The new pedestrian routes

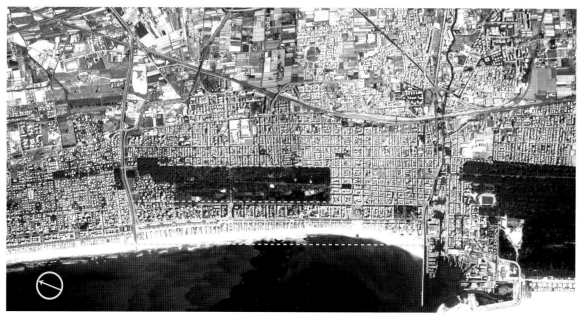

"Our scheme identifies ways of creating new opportunities for activities throughout the year in order to regenerate the town's commercial vitality." Richard Rogers

Below Left: A network of activity nodes links the different sectors of the Passeggiata and the town together. Below Right: View of the model showing the new conference centre and new landscaped Passeggiata. Following Pages: Masterplan.

also reconnect some of the key activities within the city, such as the market, the Town Hall, and the small fishing village, with the Passeggiata.

The core of the masterplan is the Passeggiata area which forms the spine of the city centre. The practice's proposals address the design of three existing piazzas along the Passeggiata, strengthening their uses and their relationship with the sea. New buildings such as a conference complex, centres for leisure, sports and culture, as well as an IMAX cinema, are all proposed around the piazzas. These year-round activities can also help to regenerate the declining commercial businesses along the Passeggiata. New interventions such as

sculpture courtyards, terrace cafés, smaller piazzas and landscape features form a series of magnets providing places for activities and relaxation. Particular attention is given to creating a comfortable environment in summer. The design also provides improved facilities for the town's key annual event, the Viareggio Carnival. A new pier with a viewing tower is proposed to strengthen marine activities and act a key focal point.

The urban plan was officially approved by council in 2003. Redevelopment of the Passeggiata began late 2003 with the introduction of a new traffic strategy and parking facilities to improve existing traffic congestion during the summer seasons.

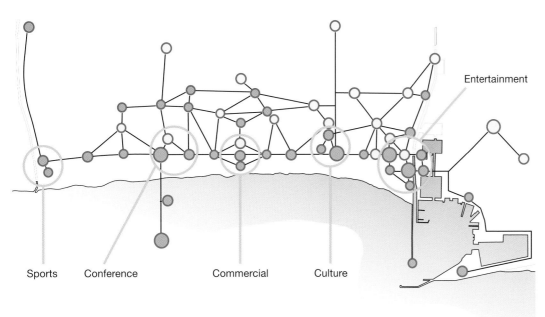

Sports Conference Commercial Culture Entertainment

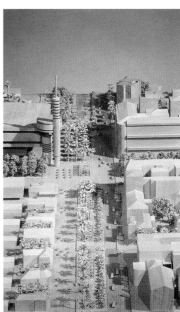

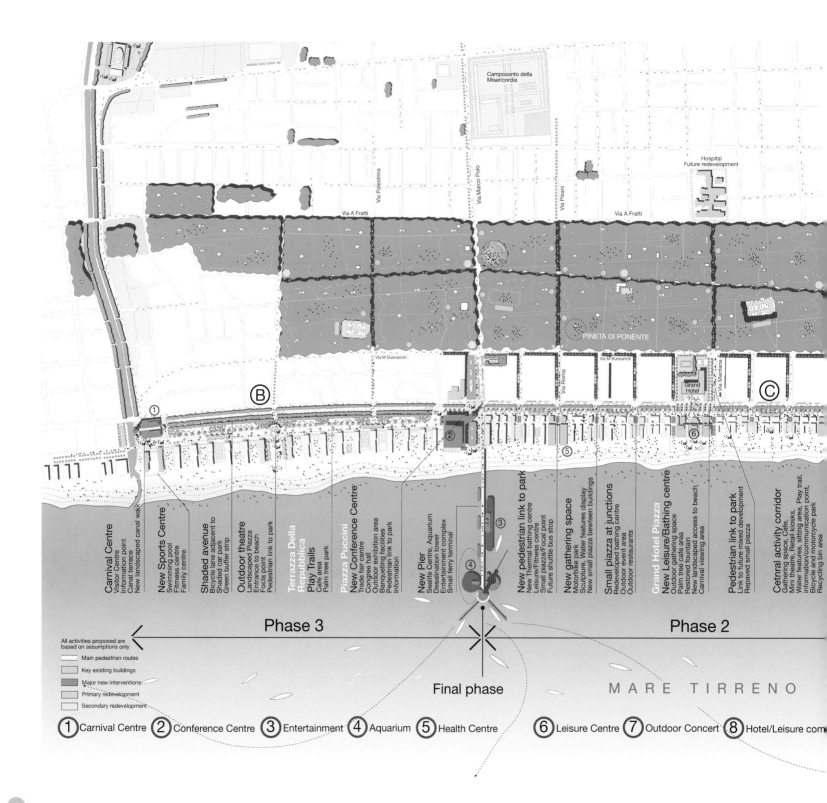

Camposanto della Misericordia

Hospital
Future redevelopment

Via Palestrina
Via Marco Polo
Via Pisani
Via A Fratti
Via A Fratti

PINETA DI PONENTE

Via M Buonarroti
Via Roma
Via M Buonarroti
Via Mentana

Grand
Hotel

Ⓑ
①
②
⑤
⑥
③
④
Ⓒ

MARE TIRRENO

Carnival Centre
Visitor Centre
Information point
Canal terrace
New landscaped canal walk

New Sports Centre
Swimming pool
Fitness centre
Family centre

Shaded avenue
Bicycle lane adjacent to
Shaded car park
Green buffer strip

Outdoor theatre
Landscaped Piazza
Entrance to beach
Focia point
Pedestrian link to park

Terrazza Della Repubblica
Play Trails
Cafe area
Palm tree park

Piazza Puccini
New Conference Centre
Trade fair centre
Congree hall
Outdoor exhibition area
Banqueting facilities
Pedestrian link to park
Information

New Pier
Sealife Centre, Aquarium
Desalination tower
Entertainment complex
Small ferry terminal

New pedestrian link to park
New Thermal bathing centre
Leisure/Fitness centre
Small piazza/Focal point
Future shuttle bus stop

New gathering space
Motorbike park
Sculpture. Water features display
New small piazza bewteen buildings

Small piazza at junctions
Redeveloped bathing centre
Outdoor event area
Outdoor restaurants

Grand Hotel Piazza
New Leisure/Bathing centre
Outdoor gathering space
Palm tree cafe area
Restored fountain
New landscaped access to beach
Carnival viewing area

Pedestrian link to park
Link to future mixed development
Repaved small piazza

Cetnral activity corridor
Gathering space, Cafe,
Mini theatre, Retail kiosks,
Water features, sitting area, Play trail,
information/communication point,
Bicycle and motorcycle park
Recycling bin area

Phase 3
Phase 2

Final phase

☐ Main pedestrian routes
☐ Key existing buildings
▨ Major new interventions
☐ Primary redevelopment
☐ Secondary redevelopment

① Carnival Centre ② Conference Centre ③ Entertainment ④ Aquarium ⑤ Health Centre ⑥ Leisure Centre ⑦ Outdoor Concert ⑧ Hotel/Leisure com

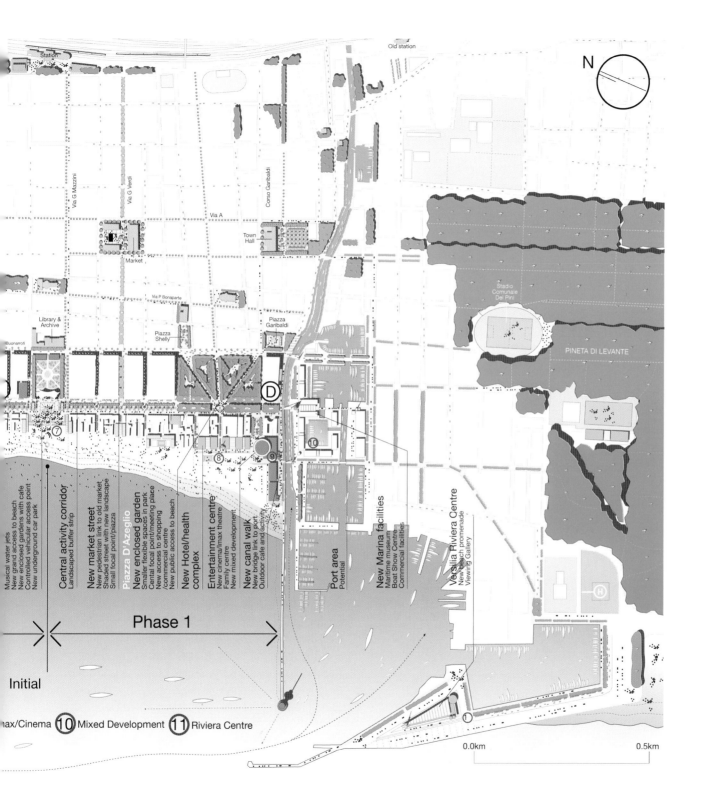

N

Old station

Station

Via G Mazzini

Via G Verdi

Via A

Corso Garibaldi

Town Hall

Market

Via P. Bonaparte

Library & Archive

Buonaroti

Piazza Shelly

Piazza Garibaldi

Stadio Comunale Del Pini

PINETA DI LEVANTE

Ⓓ

⑦

⑧

⑨

⑩

①

Musical water jets
New grand access to beach
New enclosed gardens with cafe
Controlled vehicular access point
New underground car park

Central activity corridor
Landscaped buffer strip

New market street
New pedestrian link to old market
Shaded street with new landscape
Small focal point/piazza

Piazza D'Azeglio

New enclosed garden
Smaller flexible spaces in park
Central focal point/meeting place
New access to shopping /commercial centre
New public access to beach

New Hotel/health complex

Entertainment centre
New cinema/imax theatre
Family centre
New mixed development

New canal walk
New bridge link to port
Outdoor cafe and activity

Port area
Potential

New Marina facilities
Maritime museum
Boat Show Centre
Commercial facilities

Versilia Riviera Centre
New beach promenade
Viewing Gallery

Phase 1

Initial

max/Cinema ⑩ Mixed Development ⑪ Riviera Centre

0.0km 0.5km

Bankside

Right: A new public square is created at the heart of the scheme. Below: Diagram showing the strategic circulation routes around the site. Opposite Top: Diagram of the mixed-use strategy proposed for the site. Opposite Below: Street level plan.

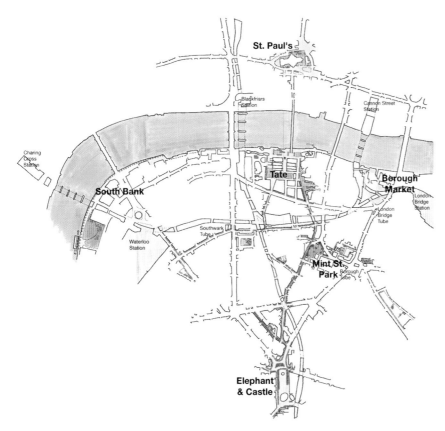

Bankside is currently the focus of some of the most exciting developments in the United Kingdom, in particular in the areas of the arts, tourism and physical regeneration. Tate Modern attracts millions of visitors every year, The Globe Theatre and many other visitor attractions are thriving and increasingly those in creative industries are looking to Bankside as a place to live and work. Bankside has the potential to be a major arts quarter for London. Although its recreational areas are limited, there is a well-developed approach to open spaces with many small parks and gardens.

This study mainly focuses on the triangle of land bounded by the River Thames to the north, Blackfriars Road to the west, Borough High Street to the east and Elephant and Castle at the southern apex. This area is ideally placed for future developments with some of the best transport connections in London, including four tube stations, two mainline stations and several arterial routes.

The practice has been asked to suggest strategic ideas for the wider area of Bankside and create a vision for the immediate context of Tate Modern. The masterplan proposes a new public urban space to the south of Tate Modern that engages with the surrounding buildings and will be the focal point of a major new urban quarter. This mixed-use environment will bring a wide range of activities to the area which will be more animated during the day and into the evening.

The scheme highlights the need for community facilities and increased retail opportunities. By creating clearer and better designed connections between the local neighbourhoods (in particular down to the Elephant and Castle), as well as direct links between transport stops, parks and the river, the plan will enhance the public realm in general. Improving public spaces, parks and community facilities and encouraging a broad mix of uses in new developments will reinforce local neighbourhood identity.

"A great public piazza, a new open south face to the monolithic Tate Modern and strong linkages to the existing community and through to the Elephant and Castle are the key drivers of our scheme." Mike Davies

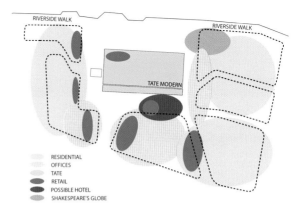

RESIDENTIAL
OFFICES
TATE
RETAIL
POSSIBLE HOTEL
SHAKESPEARE'S GLOBE

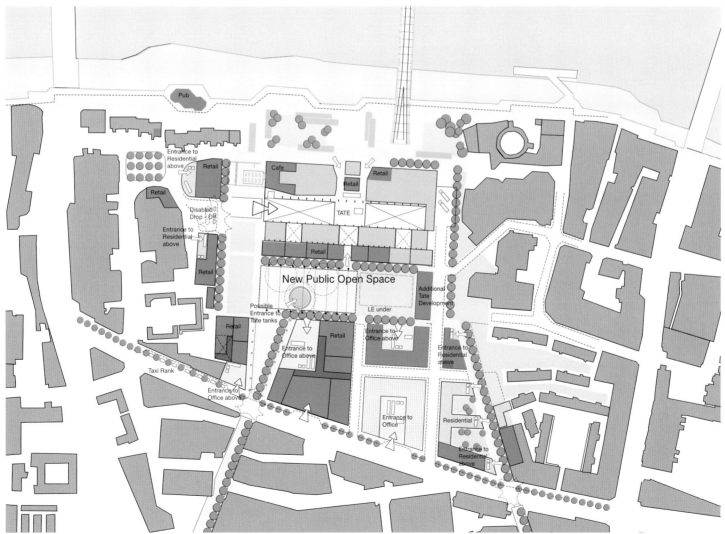

Buena Vista

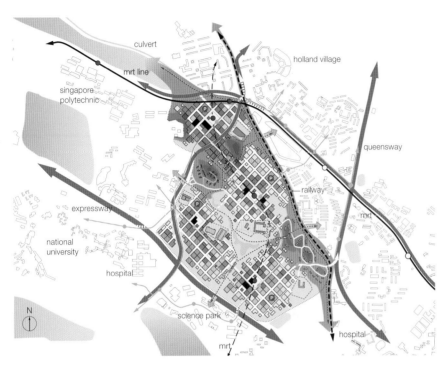

Above: The ground level strategy provides a phased, integrated transport system, preserves and links the mature trees and landscape on the hills and encourages active pedestrian links. Right: A plan of Singapore showing the location of the scheme in red.

Opposite Top: A typical section showing the environmental factors that effect the site. Opposite Below: A computer perspective of the site showing the various envelopes of development.

The practice's response to this competition was the creation of a new model for a mixed community, intended to be a place for living, working and leisure, with the planned development of a centre specialising in media, e-business and bio-sciences. This flexible strategic urban development plan was designed to adapt to rapid growth, in particular, providing an extensive, integrated transport system. The response attempted to frame an answer to the question of how to balance ideals of an exciting and comfortable low-energy living and working environment with the constraints of land use and climate that exist in Singapore.

The careful linking of the mass and light transit systems with buses and car use combined with the expectations of the residential and commercial mix underpinned the framework for urban density across the site. The framework created cooler shaded active streets that encouraged walking.

The plan covered four million square metres of mixed-use space, comprising five districts adjacent to a central ecological park. This leisure and relaxation space was to constitute the 'lung' of the community. The park served as an antidote to the hot, humid climate, while also providing water recycling facilities.

The ambition was to create a real-time development model on the Web, which would simultaneously, and with different levels of access, allow designers, local authorities and citizens to assess a series of urban design issues, in relation to the environment, energy, transport, mix of uses and cost. It was also envisaged that this model would offer a three-dimensional real-time visual display of the project from street level, to help understand the evolution of the site and allow maximum flexibility to accommodate change over time. As the demographics, economy or transport systems change, the masterplan could evolve intelligently and development and redevelopment could occur in a considered and controlled manner.

"The aim was to create a real-time web-based development model, offering a three-dimensional visual display of the project from street level: this model would clearly demonstrate the scheme's flexible approach to changing demographics, economy and transport systems." Lennart Grut

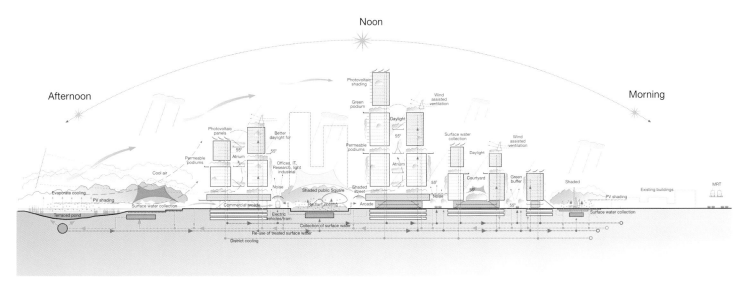

Noon

Afternoon Morning

Photovoltaic
shading

Green
podium Wind
assisted
ventilation

Photovoltaic Daylight
panels Better
daylight for 55° Surface water
collection Wind
55° assisted
Permeable Permeable Daylight ventilation
podiums 55° Atrium podiums Green
Offices, IT, Atrium buffer Shaded
Research, light Courtyard
Cool air industrial 55° PV shading
Photovoltaic Noise 55° Existing buildings MRT
shading Shaded public Square Shaded Noise
Evaporate cooling PV shading street Arcade
Radiant cooling
PV shading Commercial arcade Surface water collection
Surface water collection Electric
Terraced pond vehicles/tram Collection of surface water
District cooling Re-use of treated surface water

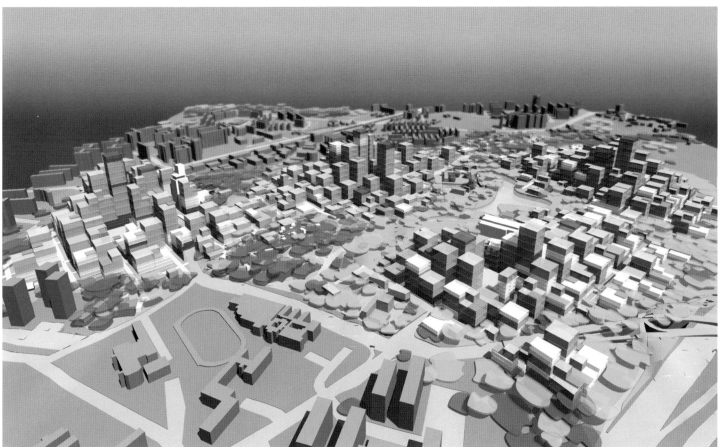

417

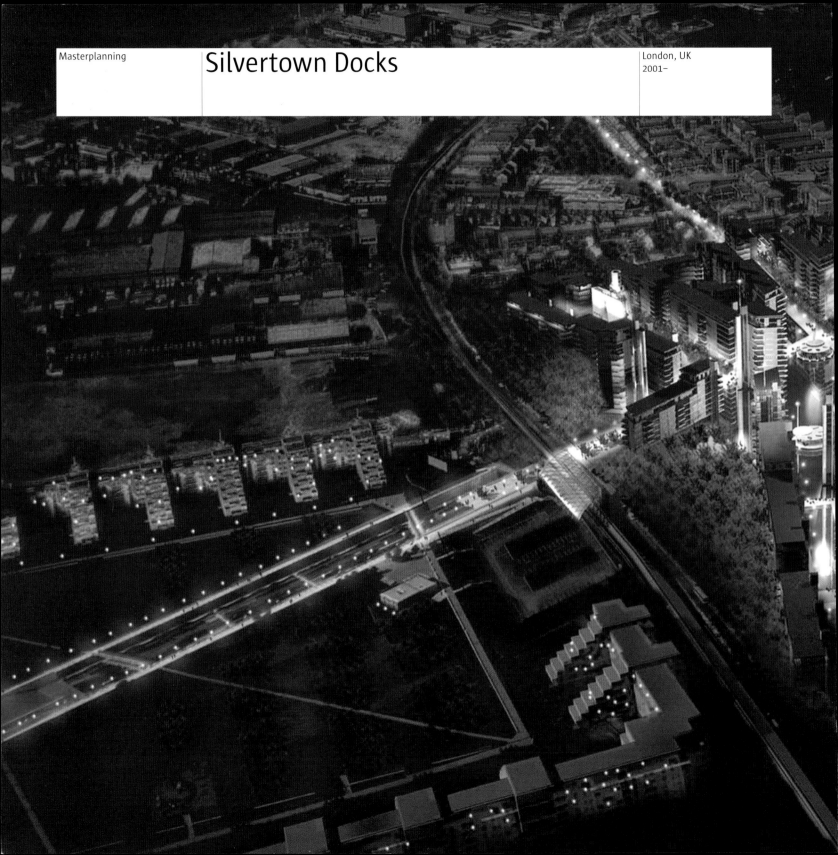

Silvertown Docks

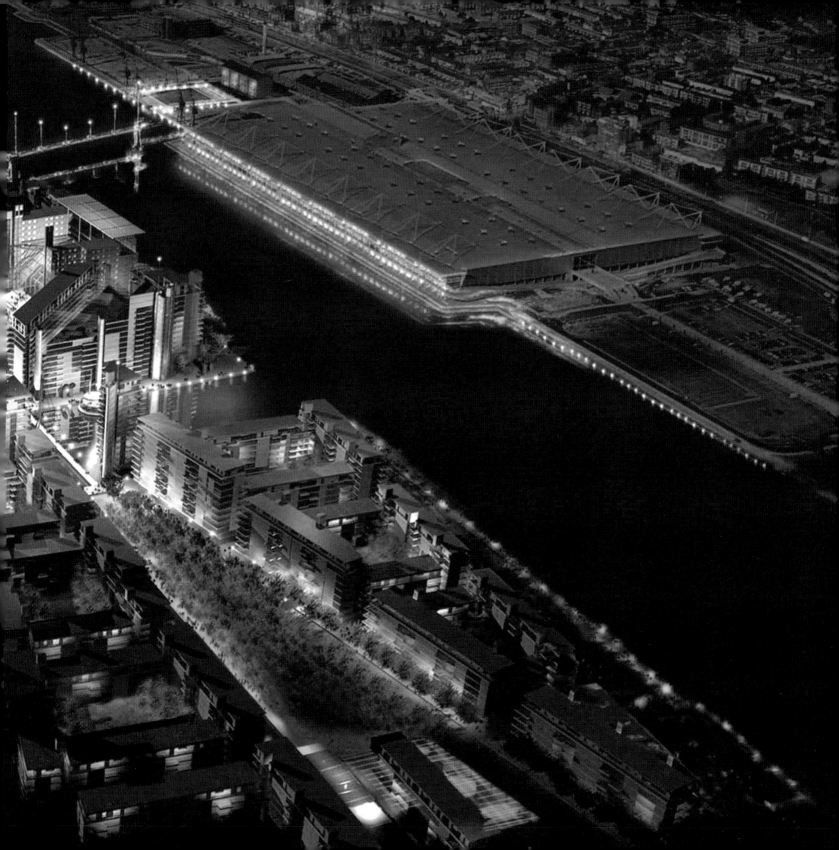

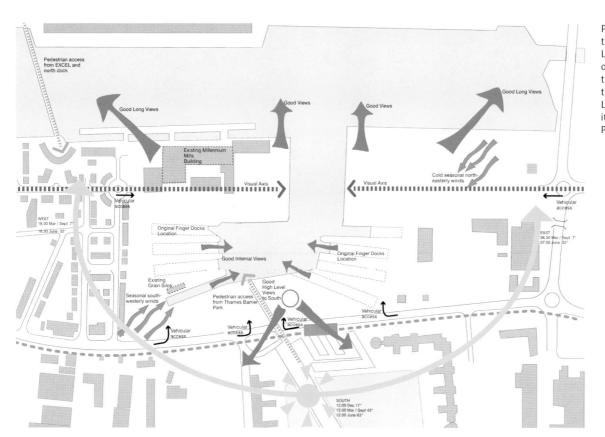

Pedestrian access from EXCEL and north dock

Good Long Views

Good Views

Good Views

Good Long Views

Existing Millennium Mills Building

Visual Axis

Visual Axis

Cold seasonal north-easterly winds

Vehicular access

Vehicular access

WEST
18.00 Mar / Sept 7°
16.30 June 32°

EAST
06.30 Mar / Sept 7°
07.00 June 32°

Original Finger Docks Location

Original Finger Docks Location

Good Internal Views

Existing Grain Silos

Good High Level Views to South

Seasonal south-westerly winds

Pedestrian access from Thames Barrier Park

Vehicular access

Vehicular access

Vehicular access

Vehicular access

Vehicular access

SOUTH
12.00 Dec 17°
12.00 Mar / Sept 43°
12.00 June 63°

"Our vision was for a new waterside community offering excellent live, work and leisure opportunities around high-quality public space and transport." Mark Darbon

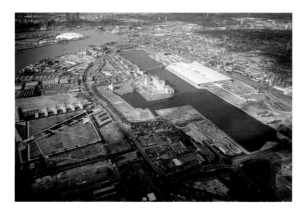

This masterplan is based on key principles set out in 'Towards an Urban Renaissance', the report published by the Urban Task Force (UTF). Chaired by Richard Rogers, the UTF called for vibrant urban places with mixed uses and tenures, creating inclusive, balanced communities with strong social integration and civic life.

The scheme places strong emphasis on pedestrianised areas and public transportation, and provides a wide range of public areas – open urban spaces, dockside walkways and enclosed landscaped gardens. At the heart of the proposal is Mill Square, a new public square for The Royal Docks, further enhanced by the refurbished Millennium Mill building which was intended to provide a high-quality residential and commercial space, bringing added vitality to this new square. Radiating from the square and surrounding an enlarged Pontoon Dock, the practice proposed a vibrant, high-density area (of approximately 200 dwellings per hectare) with shops, water-based

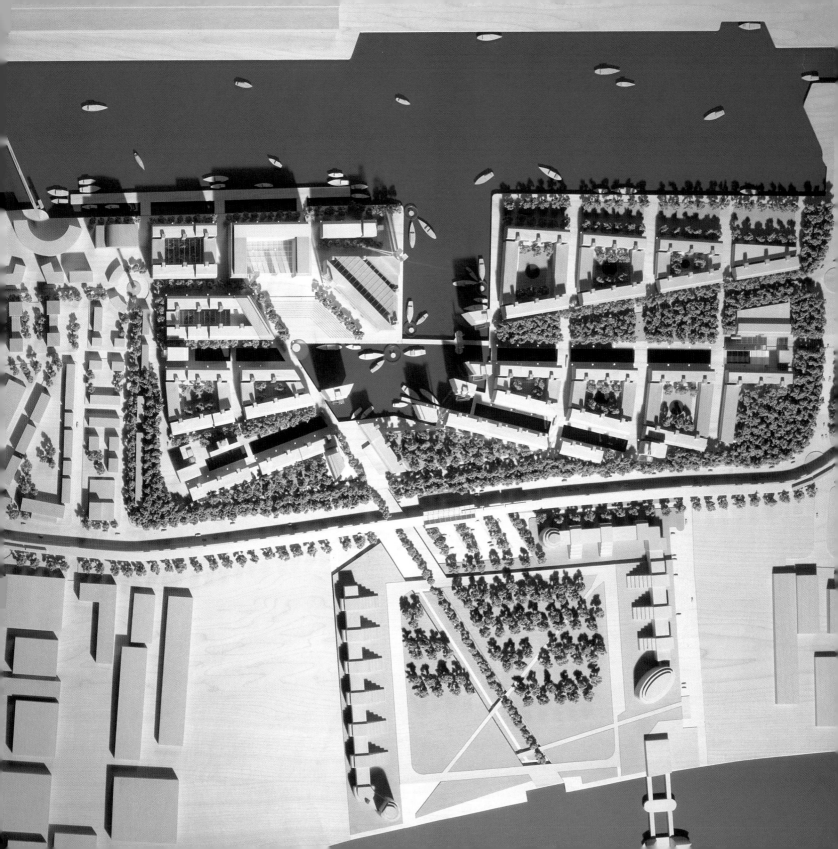

activity, workshops, galleries, exhibition spaces, studios, civic buildings, food and drink outlets, hotels, offices and schools, as well as living accommodation.

The square acts as the focal point for the two primary axes: east–west through Britannia village and on to the Airport roundabout, and a secondary axis established by the proposed new link to the Docklands Light Railway station at the south of the site, extending a public route via a bridge across the Victoria dock. The massing of the new buildings around the square is intended to complement the scale of the Millennium Mill, providing ideal sites for a new hotel, aquatic centre, commercial offices and civic buildings. Residential buildings, radiating from the dock along new water features, terminate in a series of 12- to 14-storey towers, surrounding the dock and enclosing this large expanse of water.

As the buildings radiate from the dock the massing reduces to four storeys at the periphery of the site, emphasising the dock's importance as a focal point. The lower two storeys of the buildings are double-height, allowing the flexibility for either commercial space or residential units. In this way the public realm can be continuous around the dock edge and throughout the site. Secure parking is accessed from street level, thus avoiding the need for excavation. The parking structure provides podiums for the landscaped courtyards – tranquil communal gardens for the residential units above.

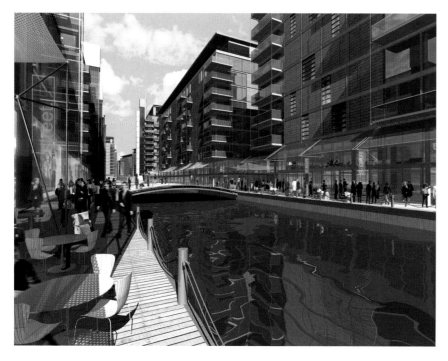

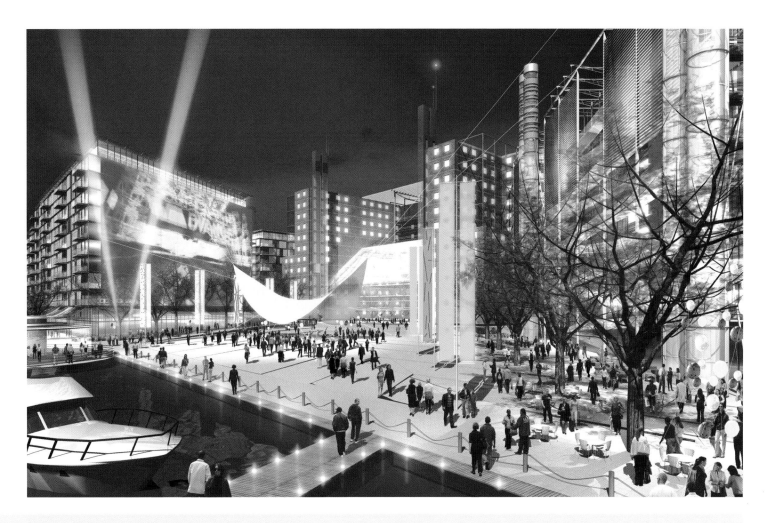

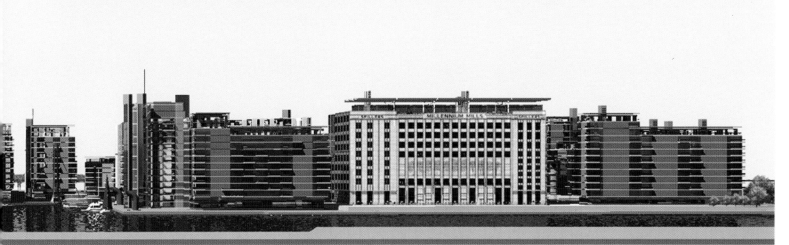

Wembley Masterplan

"Our scheme creates a sequence of high-quality civic spaces providing a new setting for the national stadium, while also providing better links with the existing transport infrastructure and the surrounding area." Mark Darbon

Below Left: Diagram of the organisational strategy for the masterplan. Below Right: Model view of the stadium from the new ceremonial approach route.

Wembley has always had a unique place in the UK's history, hosting national events such as the British Empire Exhibition in 1924–25, the Olympics in 1948 and the World Cup Final in 1966. With the construction of the new stadium, due to open in 2006, the need for a wider masterplan has become critical.

The practice's New Wembley Masterplan regenerates 44 acres of land identified by the Mayor of London as an opportunity area in the London Plan – a modern, urban people's place with the National Stadium as its centrepiece. New Wembley will offer high-quality, state-of-the-art, leisure, business and retail facilities, as well a centre for work with a wide range of job opportunities. The scheme also includes a mix of quality housing transforming the area into a world-class destination.

Key to the scheme is the creation of a major public route from Wembley Central Station to the stadium and then beyond to Wembley Park Station. An important new destination on this route will be Arena Square, bounded to the south-east by a five-star hotel and the Palace of Industry. Arena Square is designed to provide a dramatic setting for seasonal and cultural events – a space that it is intended to be in continuous use, a cosmopolitan place enlivened by public art, street performances and carnivals.

The masterplan will create 7,000 jobs, homes for 8,500 people including 40 percent affordable housing, and a new boulevard on the scale of Regent's Street, complete with restaurants, bars, leisure facilities, hotels and retail amenities. Some eight million people a year will visit Wembley.

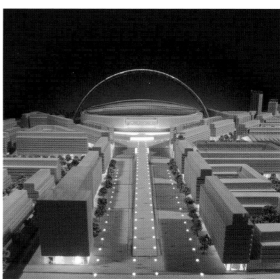

Right: The masterplan creates an urban setting for the new National Stadium. Below: Views of the proposed stadium piazza and approach to the stadium from Wembley Park tube station.

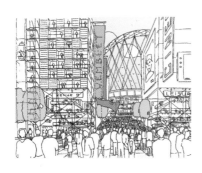

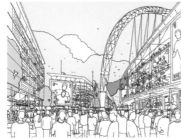

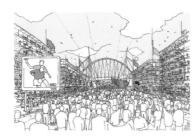

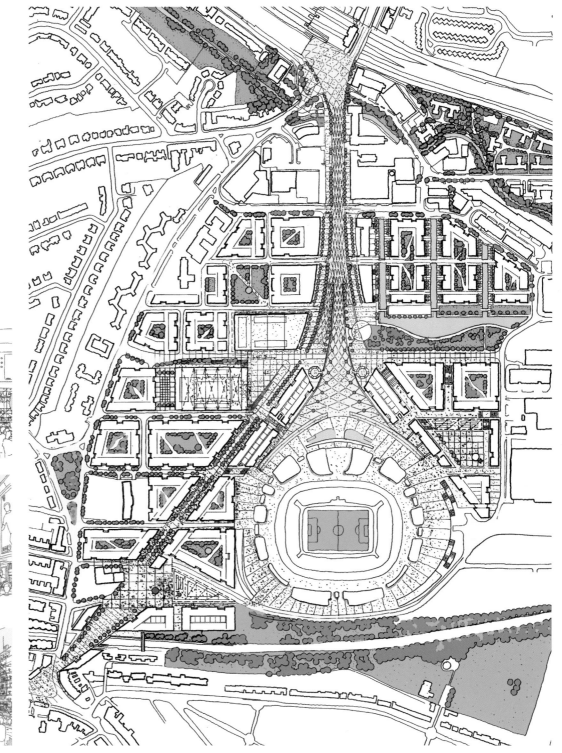

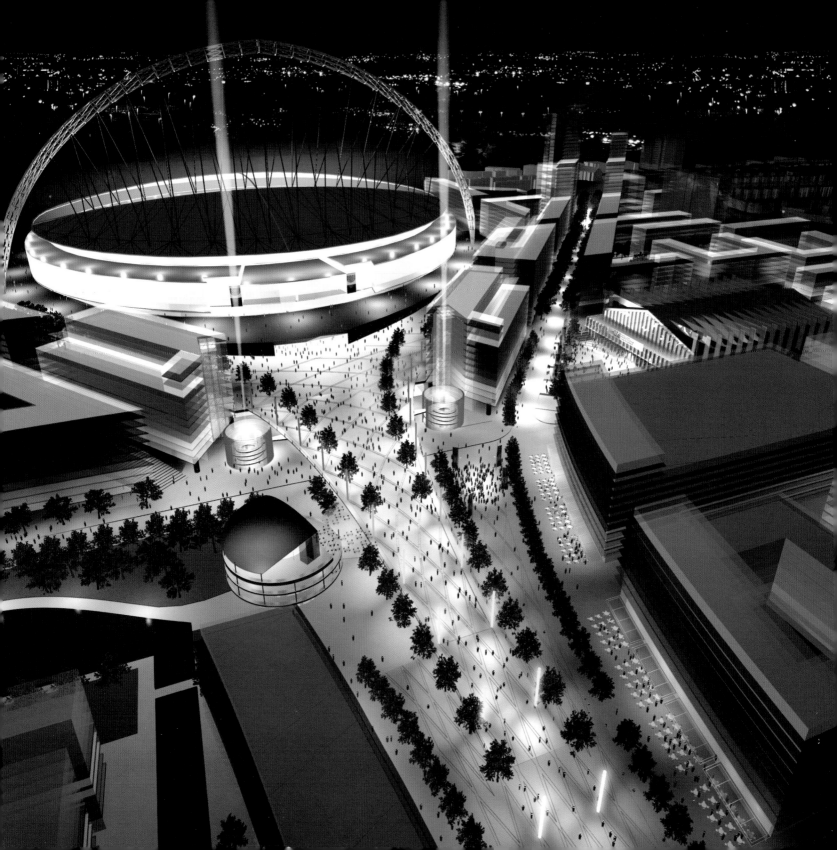

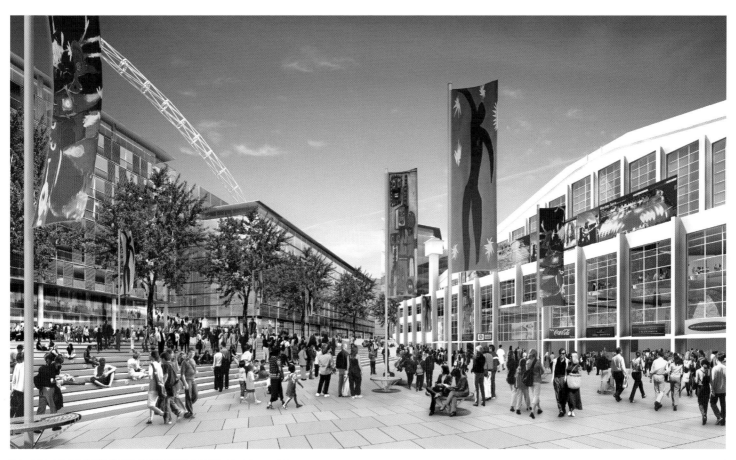

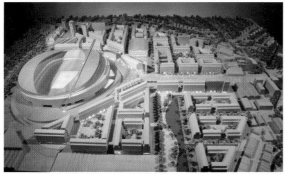

Opposite: Computer-generated view showing the stadium integrated within a vibrant new quarter. Top: The proposed piazza adjacent to the re-orientated and refurbished Wembley Arena.

Above Left: Model view of the masterplan illustrating the reinstatement of the east–west urban grain. Above Right: Section through the site showing the development and proposed ground plane rising upwards towards the stadium and its piazza.

Convoys Wharf

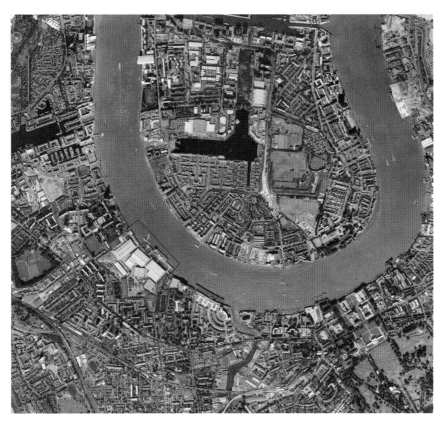

Above: Aerial view of the site.
Right: Concept diagram in
which the urban grain is
re-established.

This masterplan envisages the site as a destination along the River Thames. As the Thames finds a new role in the economic and social life of the city, there is the potential for Convoys Wharf to establish itself as one of the pearls on the necklace of key destinations along the river, the aspiration being a new cultural quarter centred on the Olympia Warehouse and the historic basin of 'Kings Yard'.

The unlocking of the riverside and the connection to Deptford High Street form the cornerstone of the design concept, directly linking the heart of the area to the riverside and creating a strong sense of identity as well as a central focus for cultural and social amenities. Convoys will become a new mixed-use neighbourhood balancing employment, culture, residential, educational, retail and leisure uses.

Employment is a key factor in creating a vibrant mixed community. Historic river-based job opportunities which existed on the site have evaporated with the changes in river-based industrial processes. The reinvigoration of the Thames as a working river, new riverside recycling and manufacturing processes, the creation of a new cultural area, provision for small businesses and for retail, leisure and community facilities will generate a wide range of employment. A mixed residential population is envisaged – key workers, shared ownership, rented accommodation, small and large family units – all combining to produce a thriving well-balanced community.

Emphasis on the public realm is key to this masterplan which is designed to be highly accessible and 'permeable'. The new public space at the heart of the masterplan will be the nucleus for all new routes. All public activities will benefit from this natural focus point, resulting in a strong link between the northern and southern parts of Deptford for the first time in over 50 years.

> "The Thames is London's central artery – its current divisive role must change if we are to link communities north and south. The river needs to become the heart of the capital – a unifying force." Richard Rogers

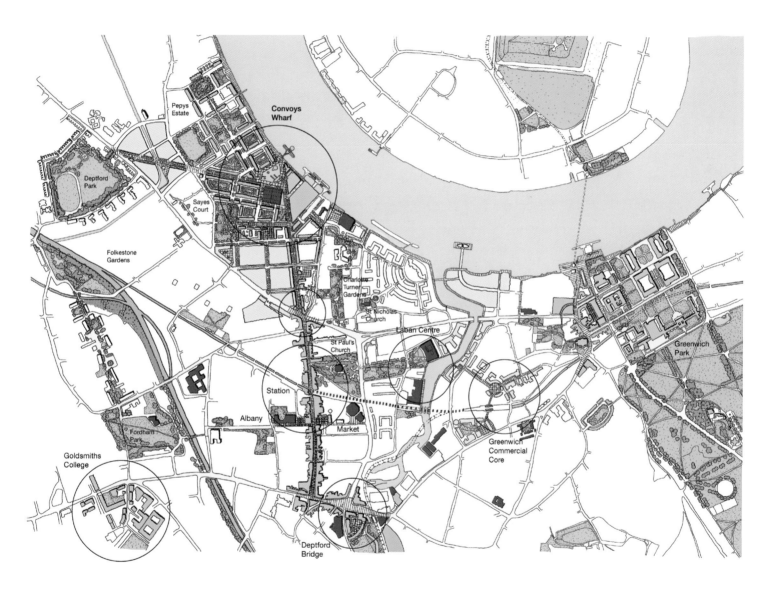

Above: Plan of the site in the context of the River Thames and Deptford. Circled areas denote existing or proposed regeneration initiatives. Red areas denote key civic/cultural buildings.

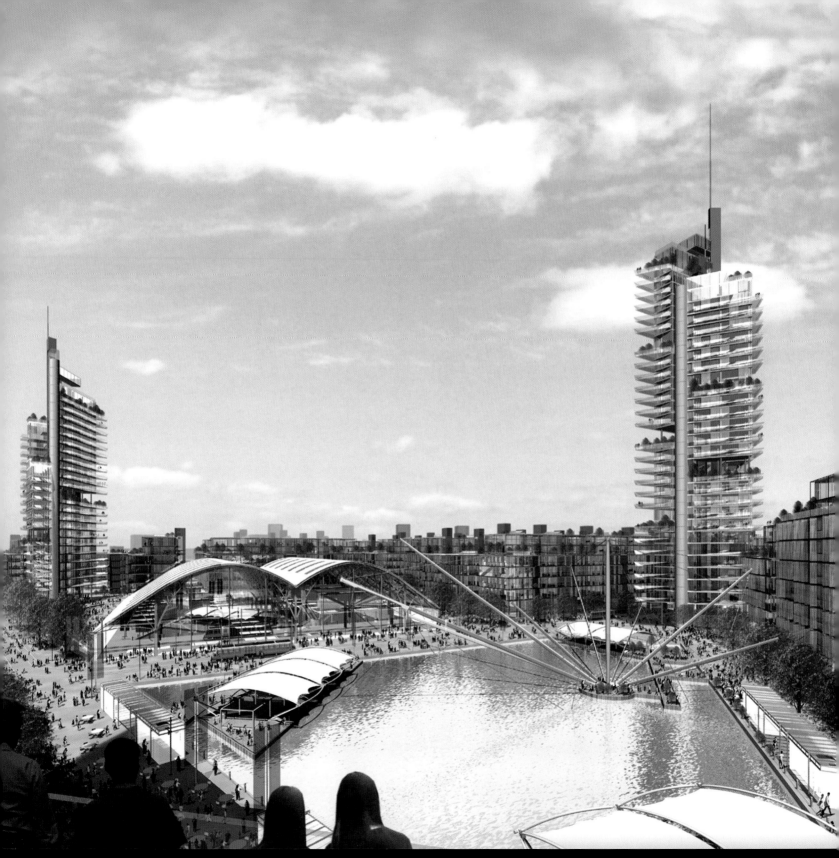

Opposite: Perspective view showing one option for the main square, with the historic basins reinstated. Right: The proposed masterplan. Below: Perspective view of the high street. Below Centre: Model of the masterplan. Bottom: Cross-section through the site illustrating the massing strategy.

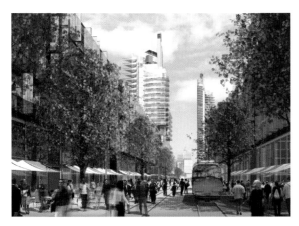

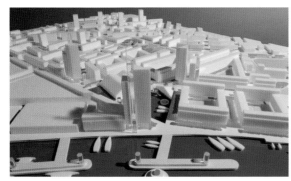

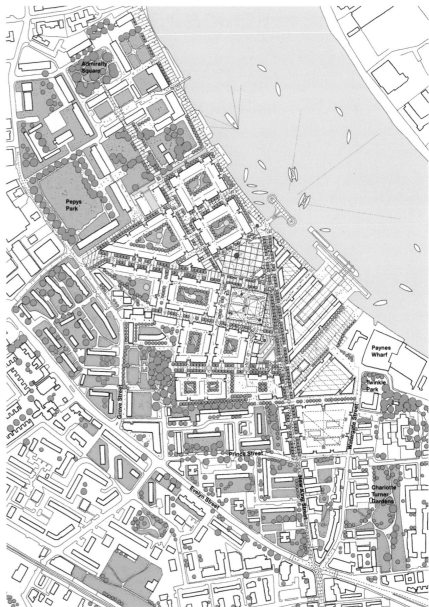

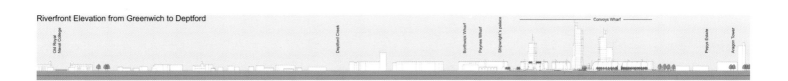

Riverfront Elevation from Greenwich to Deptford

Almada Masterplan

"Our proposals for Almada aim to create a showcase
for best practice in sustainability." Lennart Grut

The Municipality of Almada has commissioned the practice to devise a masterplan for a 115-hectare site encompassing extensive former dockyards and a part of Almada's conurbation along a two-kilometre stretch of river frontage. The location is an outstanding topographic feature of the Tagus Estuary, important both in terms of geography, history, economy and environment and the scheme aims to create a new urban centre that helps establish the Tagus Estuary as the focus of the Lisbon Metropolitan Area.

Originally a fishing village, Almada is now a major residential centre; its shipyard community was active from the 1960s until its decommission in the 1990s. The historic centre of Lisbon lies to the north of the site across the estuary, while to the south is an extensive nature reserve.

Sustainable development underpins RRP's approach for the area's regeneration, combining environmental, social and economic objectives. The team envisages an employment-led mix of uses, leisure and cultural activities while retaining a large allocation of residential use. Densities ranging from 800,000 square metres up to 1.5 million square metres

are planned, depending on the implementation of the proposed metro link to Lisbon.

The masterplan's initial phase focuses on a transport strategy for the Almada area to reduce dependence on the car. This includes extending the proposed MST (tram), a metro link from Lisbon, the expansion of an existing ferry terminal, and the creation of a river taxi service – strengthening existing connections with Lisbon and with the eastern Seixal area. The scheme also allows for new vehicular access to unlock the site's potential while using centralised parking and creating pedestrian priority streets.

Almada Riverside aims to set new environmental standards for the development. The possibilities to deliver zero carbon development will be explored through an integrated strategy for energy efficiency, on-site energy production, renewable energy harvesting and carbon sequestration. The environmental strategy devised by RRP and Atkins for the area includes maximising use of solar energy such as photovoltaics and solar panels; the use of the docks as heat sinks for heating and cooling purposes and the incorporation of CHP plant to optimise consumption of energy. It is

Below: View of the development in the context of the river and the rising topography.

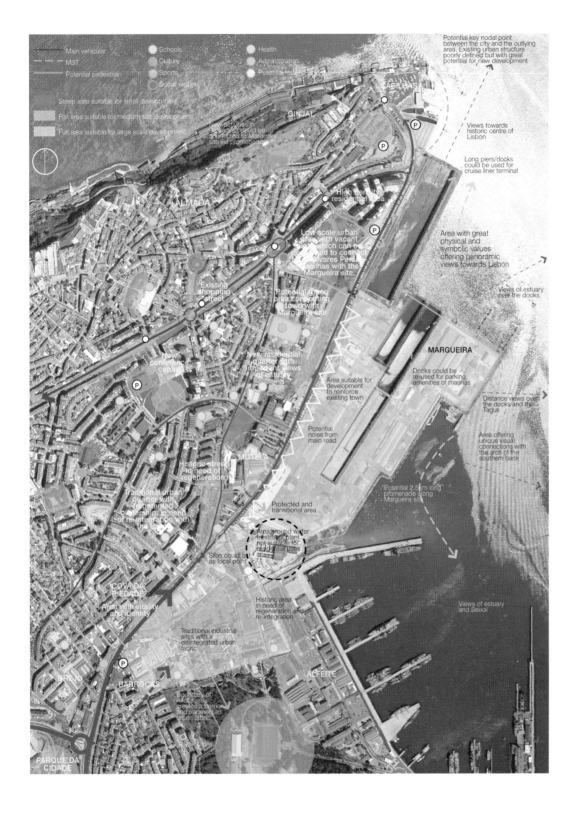

Left: Aerial view of the masterplan site.

Potential key nodal point between the city and the outlying area. Existing urban structure poorly defined but with great potential for new development

Views towards historic centre of Lisbon

Long piers/docks could be used for cruise liner terminal

Area with great physical and symbolic values offering panoramic views towards Lisbon

Views of estuary over the docks

New activities in Ginjal area could be connected to Margueira site via promenade

High density residential area

Low scale urban area with vacant sites which can be used to connect Olivares Perez-Cacilhas with the Margueira site.

Existing shopping street

Potential green area connecting town with Margueira site

Docks could be re-used for parking, amenities or marinas

MARGUEIRA

Distance views over the docks and the Tagus

New conference centre

New residential quarter with important views of estuary

Area suitable for development to reinforce existing town

Area offering unique visual connections with the arch of the southern bank

Historic street in need of regeneration

Potential noise from main road

Traditional urban quarter with fragmented ownership, in need of re-integration with the town

Protected and transitional area

Potential 2.5km long promenade along Margueira site

Area around water treatment plant not suitable for residential uses

Silos could act as focal point

COVA DA PIEDADE

Area with vitality and identity

Historic area in need of regeneration and re-integration

Views of estuary and Seixal

Traditional industrial sites with a disintegrated urban fabric

Boundary of Alfeite area creates a barrier and fragmented urban fabric

ALFEITE

BREJO

BARROCAS

PARQUE DA CIDADE

Main vehicular
MST
Potential pedestrian

Schools
Culture
Sports
Social welfare

Health
Administration
Potential historic street

Steep area suitable for small development

Flat area suitable for medium size development

Flat area suitable for large scale development

CACILHAS

GINJAL

ALMADA

MUTELA

envisaged that programmes for recycling waste will be implemented; in addition, rainwater will be collected for irrigation and grey water usage.

The masterplan layout is based on a linear arrangement of neighbourhoods running parallel to the existing docks and the new water channels; high-density developments around MST/transport nodes; mixed-use development focused around existing docks; public piazzas sited at strategic locations along the riverfront promenade and new east–west connections with Almada town centre.

The new masterplan aims to maximise use of existing docks for amenities and parking, establish an interlocking network of docks and new water channels, as well as creating compact waterside living and a new riverfront promenade along existing dock edges. To capitalise on the original maritime history of the site, the team proposes a maritime museum, marinas, as well as a cruise liner terminal and provision for small-scale ship repair industries. In addition there is scope for an academic and research community including a science centre, university departments, as well as media centres comprising studio facilities for young professionals and small businesses. The plan also features a new energy centre, an eco park and a water treatment plant.

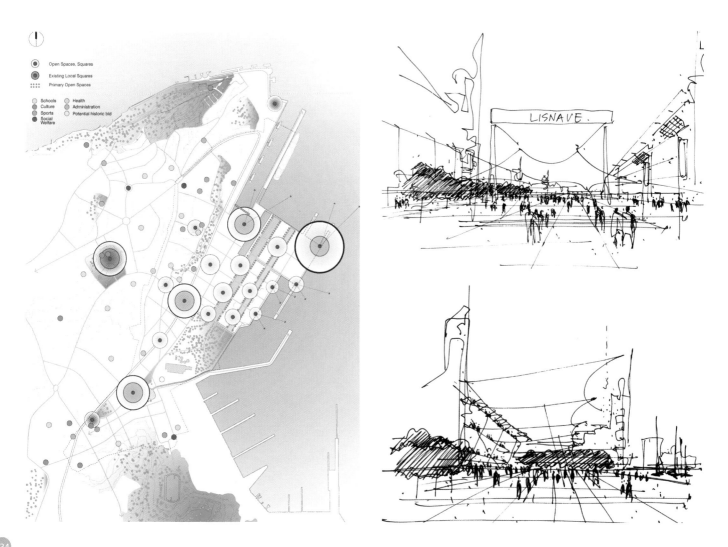

Opposite Left: Diagram
identifying open spaces and
landscaped areas. Opposite
Right: Concept sketches of
the new public spaces. Right:
Plan showing the allocation of
mixed uses.

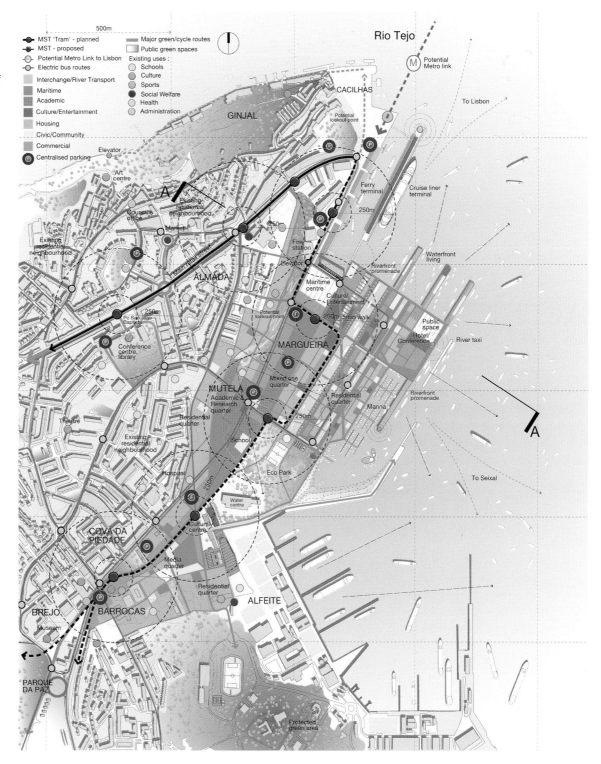

500m

MST 'Tram' - planned
MST - proposed
Potential Metro Link to Lisbon
Electric bus routes
Interchange/River Transport
Maritime
Academic
Culture/Entertainment
Housing
Civic/Community
Commercial
Centralised parking

Major green/cycle routes
Public green spaces
Existing uses :
Schools
Culture
Sports
Social Welfare
Health
Administration

Rio Tejo

Potential
Metro link

To Lisbon

CACILHAS

GINJAL

Potential
lookout point

Ferry
terminal

Cruise liner
terminal

250m

Waterfront
living

Riverfront
promenade

Art
centre

Council's
office

Existing
residential
neighbourhood

Market

Existing
residential
neighbourhood

ÁLMADA

Main retail street

250m

Fire
station

Elevator

Maritime
centre

Culture/
Entertainment

250m 5min walk

Public
space

Hotel/
Conference

River taxi

Pc Sao João
Baptista

250m

Conference
centre,
library

Potential
lookout point

MARGUEIRA

Mixed use
quarter

Residential
quarter

Marina

Riverfront
promenade

To Seixal

Theatre

Existing
residential
neighbourhood

MUTELA

Academic &
Research
quarter

Residential
quarter

School

Hospital

Eco Park

250m

Water
centre

COVA DA
PIEDADE

Cultural
centre

Media
quarter

Residential
quarter

ALFEITE

BREJO

Museum

BARROCAS

PARQUE
DA PAZ

Protected
green area

A

A

Woolston Shipyard

"Our proposals add significant new area to the existing nature reserve. The enhanced wildlife habitat will also greatly improve views out over the water – a sensitive ecological intervention that will create a truly unique site." Mark Darbon

The site presented the practice with a complex problem in terms of urban regeneration – a vacant shipyard on the River Itchen in Southampton, directly adjacent to both a 'Special Protection Area' (wildlife habitat) and an existing sewage works.

The approach to the creation of a masterplan for this 12-hectare area was to exploit the existing deep-water dock at the north of the site by retaining this as a shipyard, but with facilities tailored to emerging trends in the industry. Other smaller scale facilities (offices, welfare facilities, etc) surround the employment zone and create a buffer zone to the existing inland residential community.

To the south-west of the site, alongside the riverside wildlife reserve, a series of high-density residential blocks create dramatic vistas out to the river estuary. The layout of the residential areas creates a new, more indented shoreline, adding significant area to the existing nature reserve. This will enhance the wildlife habitat and improve views out across the water from the site. Further inland, the scale of residential blocks decreases to create a seamless relationship with the existing buildings and street patterns.

The existing retail centre north of the site is diverted and extended into the new masterplan area and culminates in a new town square, surrounded by a mix of building types and accommodation, and also opening out to the waterfront, where the scheme will include a new landmark multi-use complex formed from the refurbishment of one of the existing industrial buildings.

The overall proposal is intended to provide a framework for sustainable redevelopment which complements (rather than competes with) the existing town centre, enhancing the site's rich industrial heritage and providing a new vibrant quarter for the 21st century.

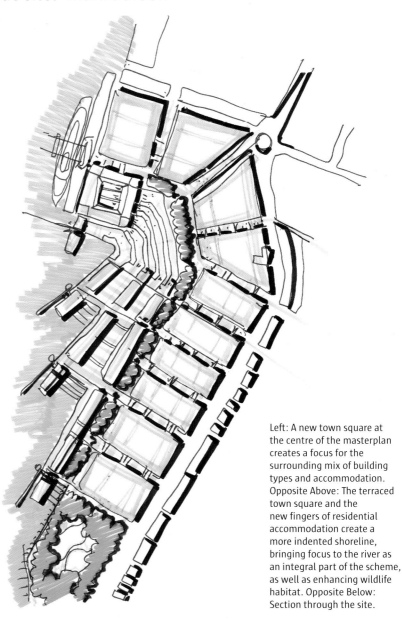

Left: A new town square at the centre of the masterplan creates a focus for the surrounding mix of building types and accommodation. Opposite Above: The terraced town square and the new fingers of residential accommodation create a more indented shoreline, bringing focus to the river as an integral part of the scheme, as well as enhancing wildlife habitat. Opposite Below: Section through the site.

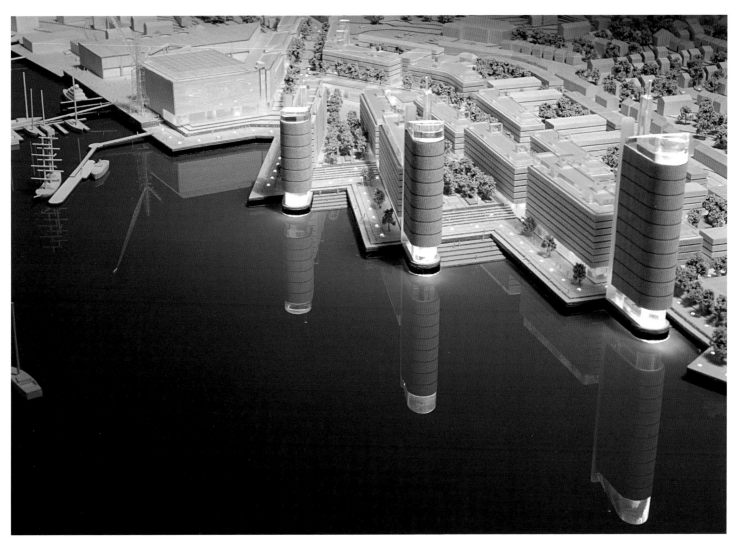

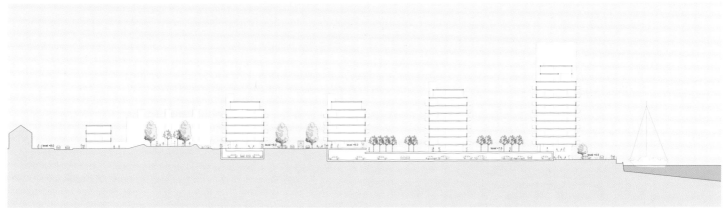

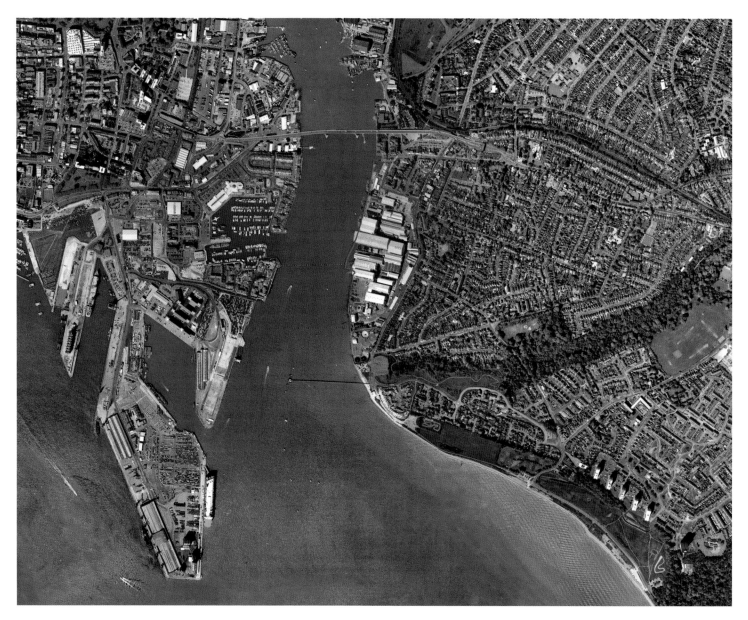

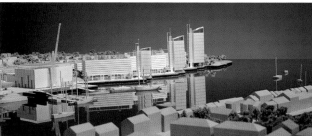

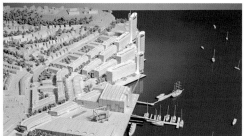

Above: Aerial view of the site, marked in red, in its present condition. Left and Far Left: Each finger of development culminates in a high-rise block creating dynamic vistas out over the river and beyond. Opposite: Site plan illustrating the main blocks of new accommodation and the landscape strategy.

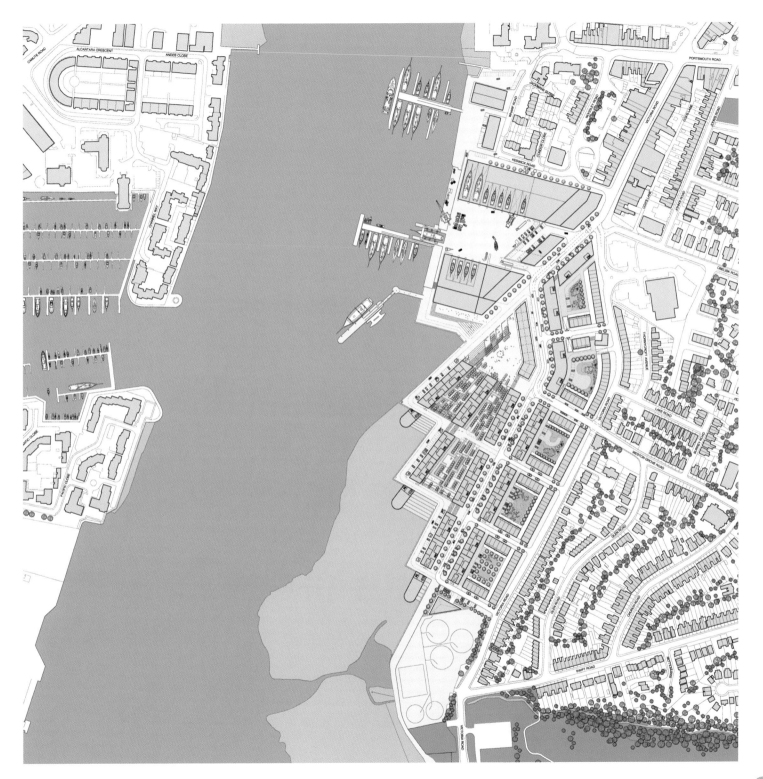

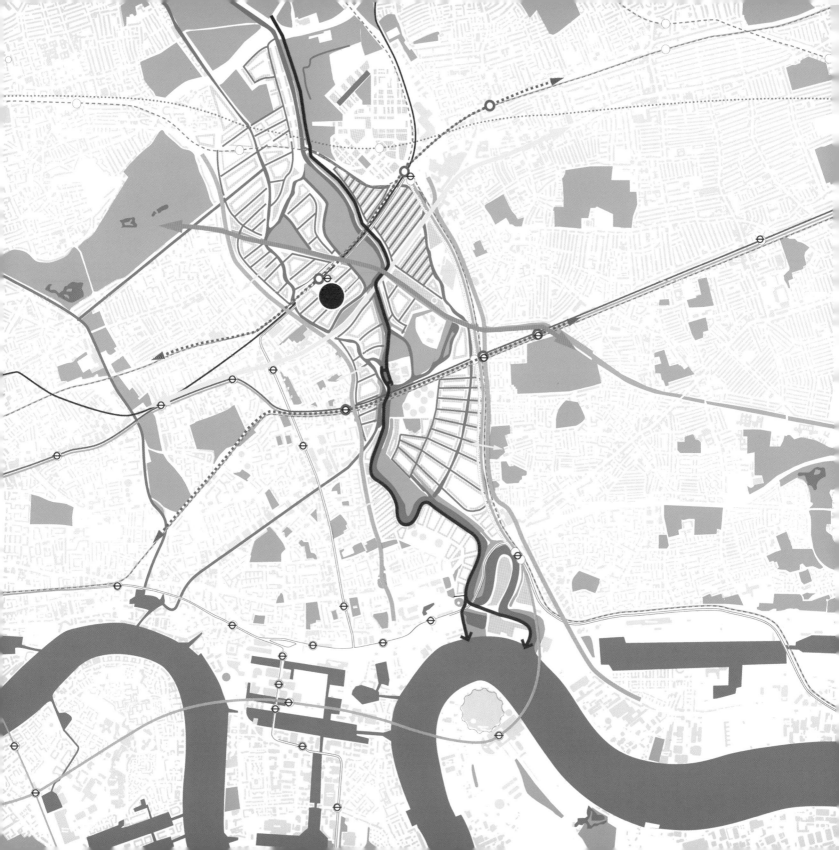

Lower Lea Regeneration and Olympic Masterplan

"The Lower Lea Valley, with its unique features and good public transport, should be developed as a high-density water city along the lines of Amsterdam or Venice, not as a sports-led new town. This would be the first step in the development of the Thames gateway, accommodating one million people." Richard Rogers

Opposite: The masterplan showing the major transport infrastructure and waterways on the site. Below Left: Concept sketch. Below Right: Model view showing fingers of massing converging on the primary facilities that will serve the wider community.

The Lower Lea Valley in East London has been identified as the preferred site for London's bid for the 2012 Olympics. The practice's proposal for this key development area seeks to deliver physical, economic and social regeneration benefits for a scenario with and without the Olympics: an emphasis on legacy development means that as many elements as possible offer post-Olympics value, including education and health, transport and utilities infrastructure, affordable housing, structured landscape, enhanced existing and new water areas, public open space and indoor and out-door leisure facilities. The key regeneration principle driving this masterplan was the creation of sustainable, connected communities in a unified city district,

supported by a comprehensive transport system.

The River Lea and its associated marshland waterways represent a unique amenity in terms of both plant and animal life. This masterplan builds on previous Docklands regeneration, revitalising those waterways and adjacent communities, making water an integral part of the lives and prosperity of local people. The scheme makes optimum use of the currently under-utilised river, canals and reservoirs that characterise the Lea Valley, enhancing existing watercourses and creating new waterways as part of a strong landscape framework.

The scheme identifies new high-density mixed-use development clustered adjacent to main transport

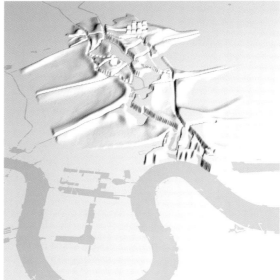

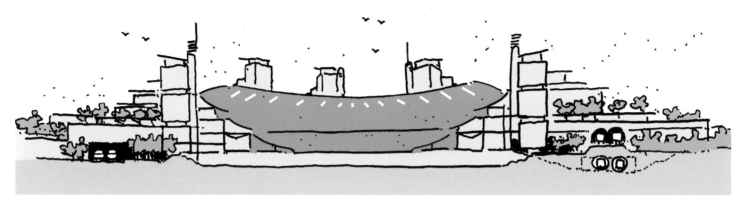

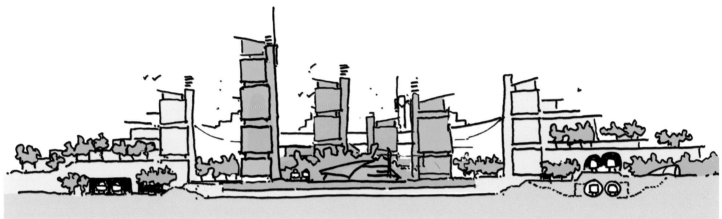

Above: Two views of the proposed development in Olympic (top) and post-Olympic (bottom) configurations.

nodes, reflecting the principles of a compact city, whilst ensuring the highest possible intensity of use and encouraging diversity of activity. The masterplan aims to create a high-quality environment, providing the highest standards of urban design and architecture. Transport and development hubs could also form the focus of the various Olympic events, with venues strung out like a 'string of pearls' along the valley.

The Lower Lea Arc as envisaged by the masterplan reinvents the urban community for the 21st century, setting new standards in sustainable development. The new sustainable neighbourhoods, within both the Olympic and non-Olympic options, would be based on a re-use of land and buildings, compact, medium to high-density forms, a mix of land uses based upon overlapping zones of living, working, leisure and shopping, and public transport-oriented urban

design – demonstrating an overall emphasis on flexibility and adaptability.

Public transport provision and, in particular, the tube and rail systems are key to the creation of new sustainable neighbourhoods. Density and development will increase around rail stations – the 'hubs' of a public transport system that also includes buses, cycles, and movement on foot. Development patterns are largely dictated by walking or cycling distances. Cars have their place but their penetration and physical presence is controlled.

The masterplan was intended to demonstrate clearly how the right strategic thinking would create opportunities for economic and social, as well as physical regeneration – a new piece of vibrant city using the Olympic challenge as a lever for a long-term legacy vision.

"The Olympic facilities are conceived as initial elements of a new city structure, which would temporarily house the Olympic activities and then become central foci and urban fabric for new city areas. Stadium as city – city as stadium." Mike Davies

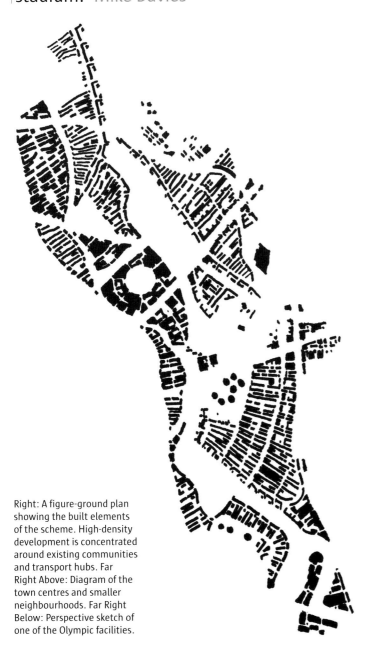

Right: A figure-ground plan showing the built elements of the scheme. High-density development is concentrated around existing communities and transport hubs. Far Right Above: Diagram of the town centres and smaller neighbourhoods. Far Right Below: Perspective sketch of one of the Olympic facilities.

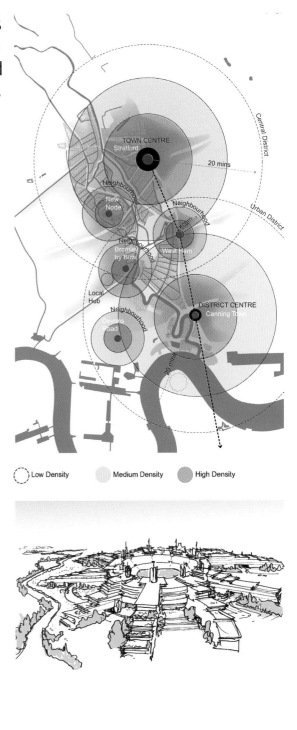

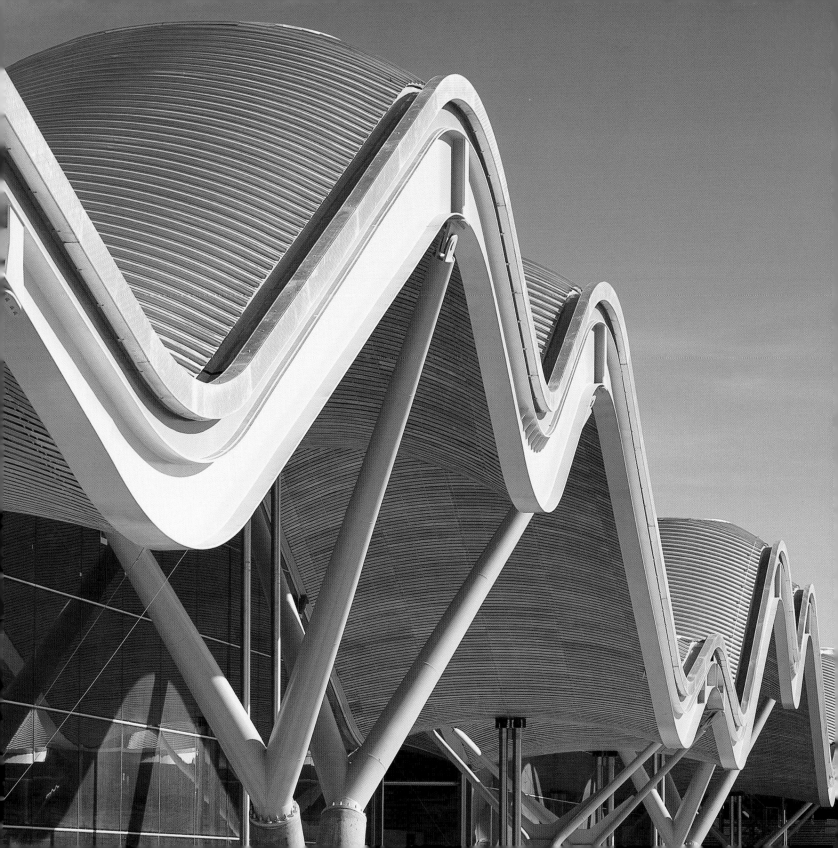

Transport

5

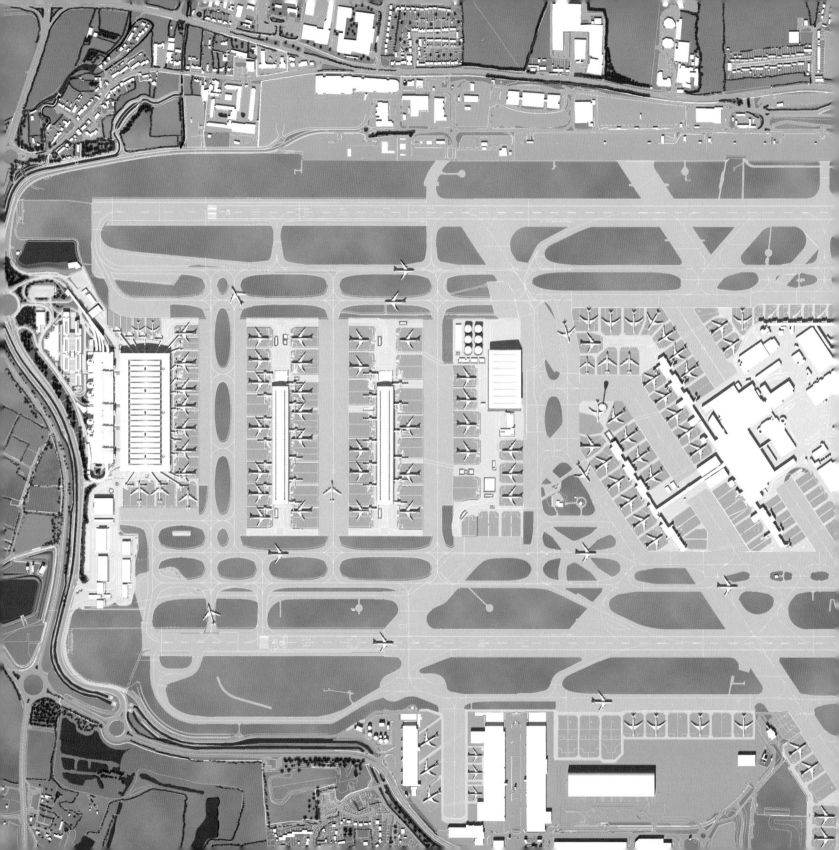

Terminal 5, Heathrow Airport

Opposite: The masterplan with the new terminal at the far left. Below: The main terminal (left) is linked by underground people movers to two satellites (right). Bottom: The form of the roof evolved throughout the project, from the initial proposal (left) to the final design (right).

The project to construct a fifth terminal at Heathrow – seen as critical to the airport's continuing position as the busiest in Europe – was the subject of a limited competition in 1989. The winning scheme is based on a projected capacity of 30 million passengers annually. The concept reflects the success of 'single-level' airport terminals, for example, at Hartsfield, Atlanta, and London Stansted, the latter designed by Norman Foster for the British Airports Authority, also the client at Heathrow. The principal passenger areas at Terminal 5 are all on one level, with plant rooms, baggage handling and other ancillary functions below, though passenger areas extend over two levels at both edges.

At landside, the road runs through the building – like the cab road at a 19th-century railway terminus.

The architectural form of the competition scheme – described by the architect as a 'magic carpet' – reflects the new diversity of the practice's work in the 1990s and makes obvious references to the work of Alvar Aalto. The immense roof is dynamically curved, with great bands of glazing flooding the interior with daylight and leading the passenger through the building from arrival point to embarkation. The building is effectively a dramatic progression of spaces, which vary in height according to their function. The structure is strongly expressed, with great structural 'trees' supporting the roof.

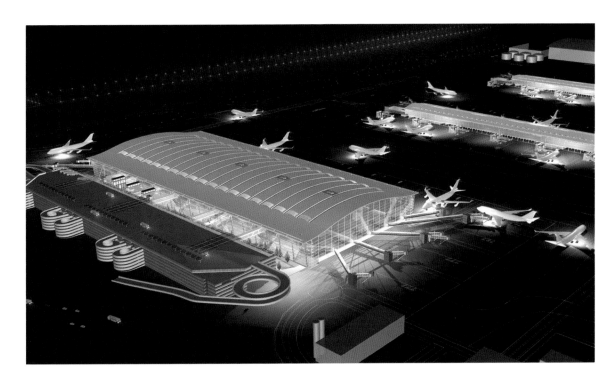

 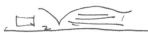

"The aim of the project is to celebrate the magic of travel – to create a memorable and beautiful place with a rich and varied public realm for travellers and those who serve them. Like London's great railway stations of the past, T5 has a civic role to play. Fulfilling the future demands of a world-class air terminal, it is designed to be a new gateway to Britain."
Mike Davies

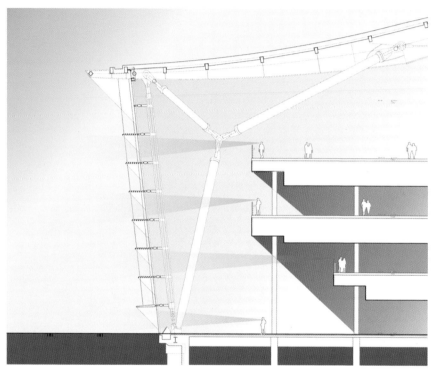

Aircraft load and unload at stands on the core building, as well as at two satellites served by a rapid-transit system. Provision is made for an underground and mainline rail link from central London, contained in deep tunnels.

Natural ventilation is impractical in view of noise and air pollution from aircraft, but the scheme adopts an energy-efficient strategy using a displacement air-conditioning system developed by Arup and shading by means of canopies and low eaves to reduce solar gain on the long east and west elevations. Heathrow Terminal 5 is likely to be one of the most striking examples of airport architecture in recent years and as significant a work in Rogers' œuvre as the Centre Pompidou in the 1970s and Lloyd's of London in the 1980s.

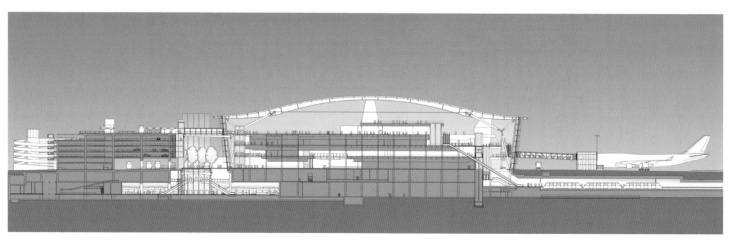

Opposite Top: The fully glazed facade offers dramatic views from all levels of the terminal out over the airport. Full-height 'canyons' at the perimeter of the building bring natural light deep into the heart of the terminal. Opposite Below: Section through the terminal. Right: A grand entrance between the terminal building and the forecourt/car park building breaks the mould of typical airport entrances, providing departing passengers with a dramatic open and light-filled space to make the transition from outside to inside. Following Pages: The design includes a number of spaces that are memorable for their scale and experience. The single span roof, uninterrupted floorplates and glazed facades provide a spectacular departures space.

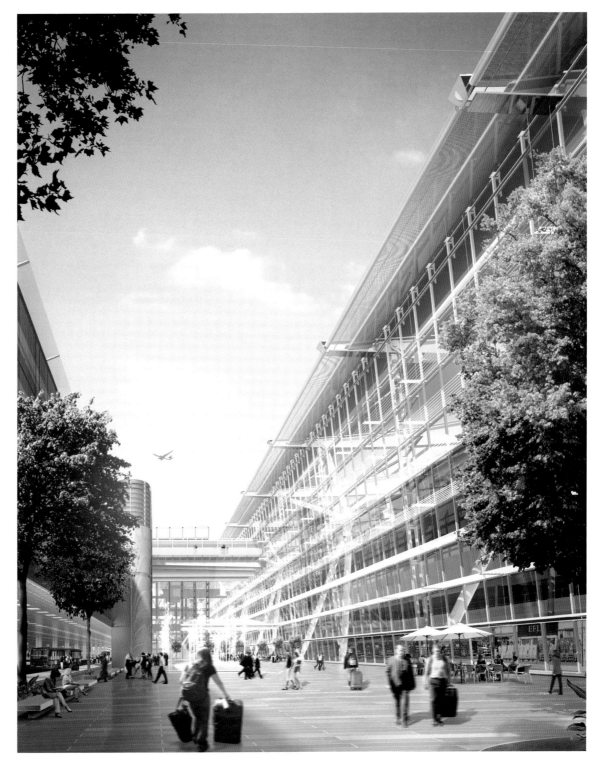

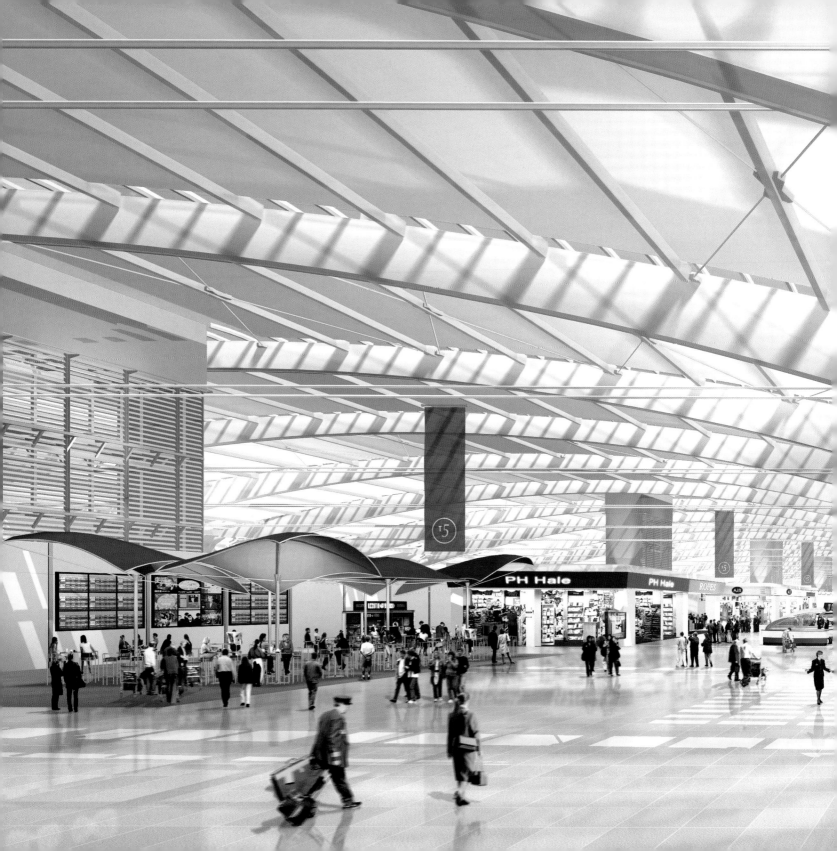

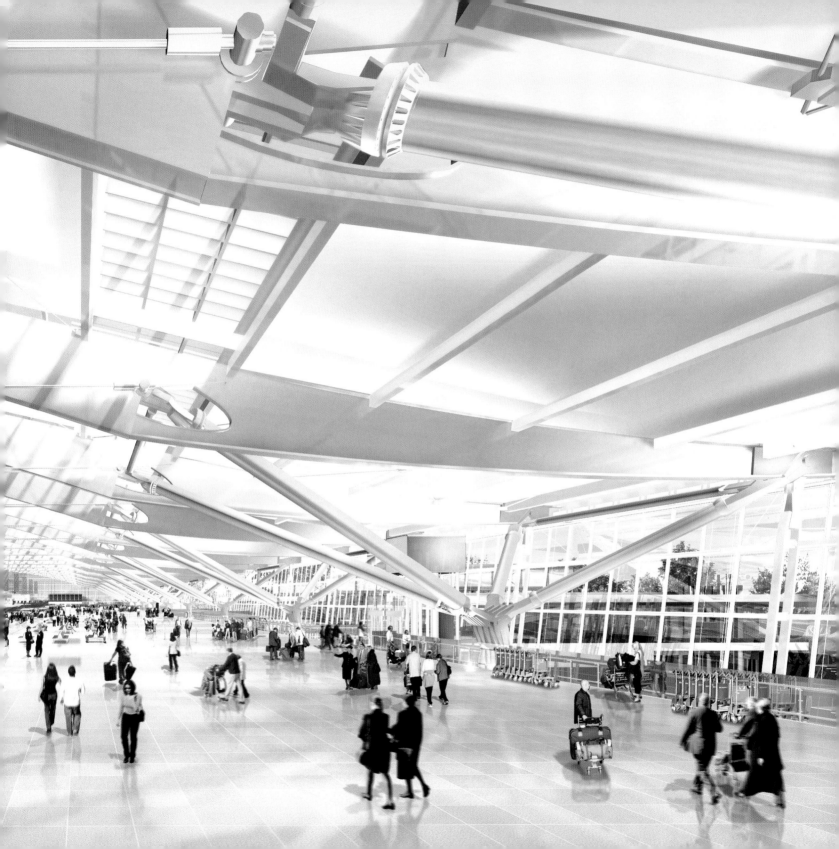

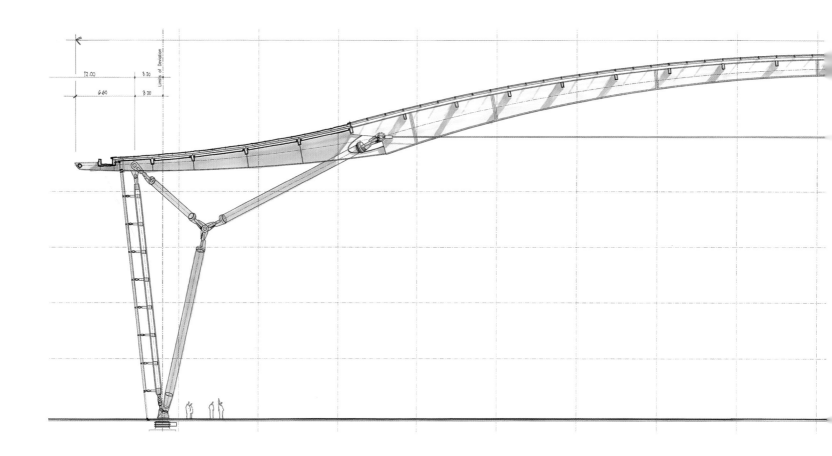

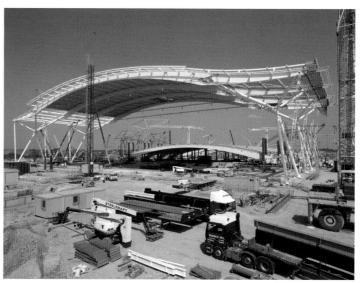

Above: Section through the 45-metre-high structure. The grand scale of the building is illustrated by the relative size of the people standing to the far left and right beneath the structural 'trees'. Right and Opposite: The roof under construction – aircraft operations do not allow any structures, permanent or temporary, above 39 metres, effectively ruling out the use of cranes to put the structure in place. The solution was to assemble whole sections on the ground, which were then jacked into place.

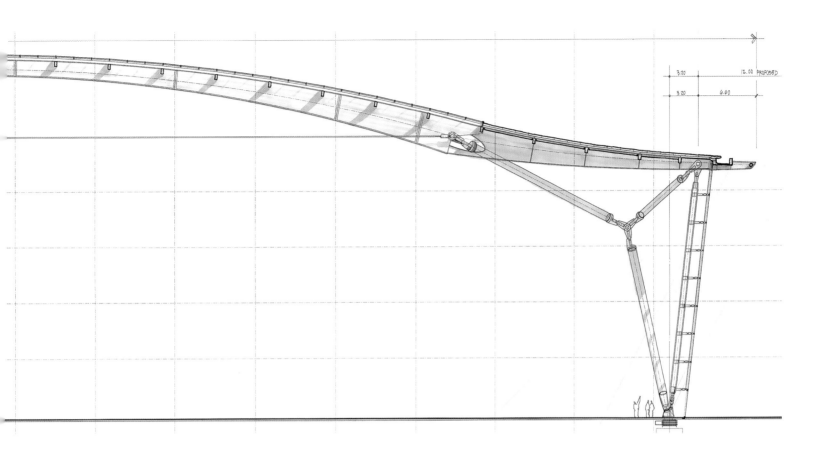

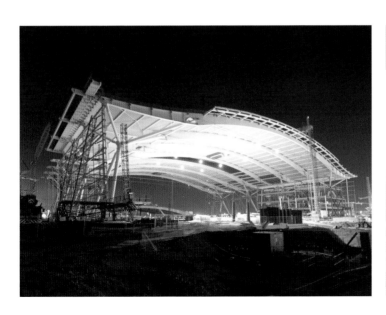

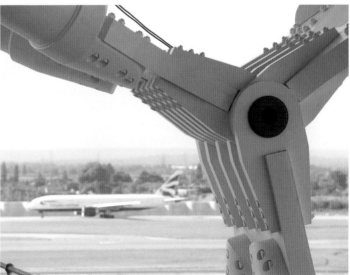

"The new control tower will provide a state-of-the-art platform for Air Traffic Control at Heathrow. This exciting, technically challenging and unique visual landmark, along with the new Terminal 5 development currently under construction, underlines BAA's commitment to Heathrow's world hub status in the 21st century." Mike Davies

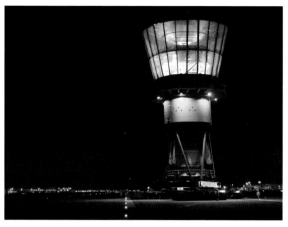

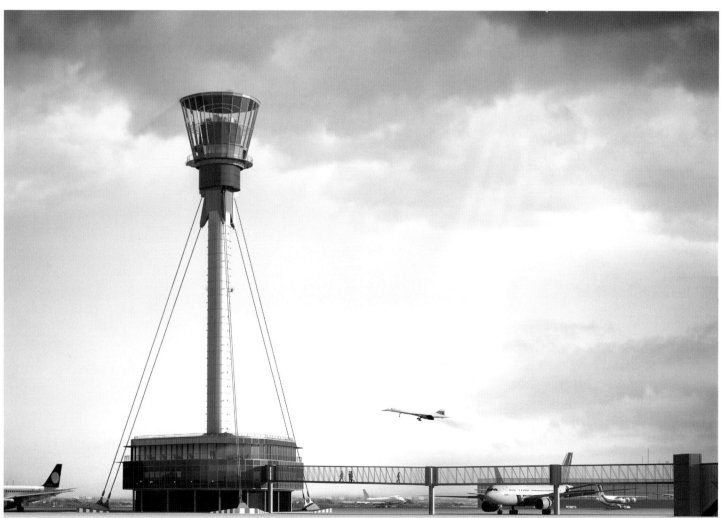

Control Tower,
Heathrow Airport

Opposite Top: The 900-tonne 'cab' being transported across Heathrow's southern runway. Opposite Below: Computer-generated image of the control tower. Below Left: Section through the 'cab'. Below Right: Perspective view of the interior and structure of the 'cab'.

The commission for a new control tower (or visual control room) at Heathrow Airport followed on from the practice's appointment to design the new Terminal 5 at Heathrow and reflects the growth in traffic at Europe's busiest airport.

The 87-metre-tall tower is the result of intensive research into the technical requirements of the brief – this is a 24 hours a day, seven days a week facility. The priorities of a live airport necessitated the construction of the control tower 'cab' on landside areas of the airport; the 650-tonne structure was then transported across the live airside area and lifted 90 metres into the air by a giant hydraulic jacking system. This unusual approach to pre-assembly allowed rapid erection with minimum disruption to airport operations.

Pre-assembled close to Terminal 3, the tower was constructed from 12-metre lengths of mast, triangular in section, which provide the necessary aerodynamic profile for the shaft (housing lifts, stairs and services risers).

Air traffic control demands unobstructed views of the airport and its approaches. The tower provides a clear 360-degree cone of vision using tapered glass panels engineered to counter condensation and glare and to ensure comfortable working conditions for controllers. A mass of technical equipment is accommodated at the base of the tower in a ring of space around a central daylit atrium.

The aim has been to create an elegant and memorable building that will be a symbol of the ongoing development of Heathrow.

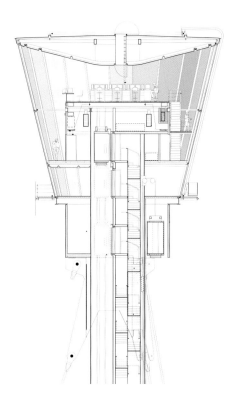

Marseilles International Airport

Below Left: Airside view of the terminal. Below Right: Plan. Bottom Right: Interior of the departures area.

The rebuilt Marseilles International Airport is one of the most significant of the new generation of airports serving front-rank European cities. RRP was commissioned to provide for the expansion of the airport to serve double the 1988 total of four million passengers annually and for possible future growth to cater for up to 15 million. The existing buildings were both inconvenient in arrangement and lacking any clear architectural imagery but had to be retained and kept in use during the expansion operation. RRP's scheme aimed to use them more effectively as part of a reconstructed airport. The practice has completed a

16,000 square metre pier, the first of three proposed phases – two piers and a central processor building.

The scheme provides a high-level arrivals route, an inversion of the conventional approach to airport circulation. This arrangement creates generous volumes for departure lounges and a high degree of clarity for all circulation routes. This concept of generous daylighting, spaciousness and economy of structure set a precedent for RRP's subsequent Europier project at Heathrow's Terminal 1 and for their current work at Barajas Airport, Madrid and the Terminal 5 project at Heathrow, also under construction.

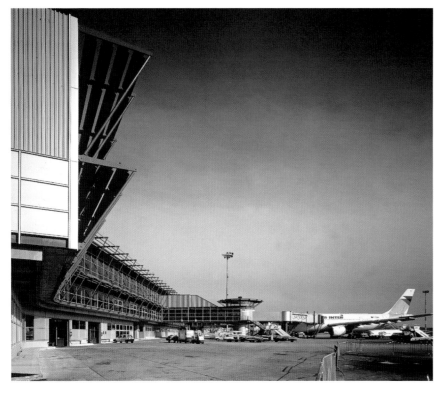

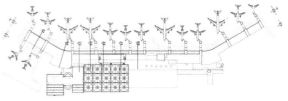

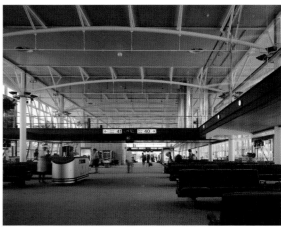

"Our scheme proposed a radical re-arrangement of traditional airport layouts – the result has been clear orientation through well-lit, generous spaces which impart a real sense of place." Lennart Grut

Below: The fully glazed facade provides views out over the aircraft stands. Right: View of one of the departure gates.

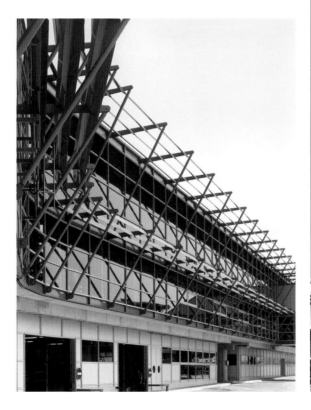

Transport

Heathrow Airport Europier and Flight Connection Centre

London, UK
1992–96

"We set out to capitalise on the excitement of flight by providing passengers with great views across the airport. Europier's ample natural light, elegance and economy of structure create surprise, delight and a generosity of space for arriving and departing passengers." Mike Davies

RRP's Terminal 5 will be the first stage in a radical transformation of London's Heathrow Airport which is likely to take several decades and see the eventual demolition of existing terminals, some of which date back to the 1950s. The Europier and Flight Connection Centre project provided an element of interim regeneration and renewal for Terminal 1, the oldest of the terminals which handles more than 22 million passengers annually.

The brief was, firstly, to provide additional stands for aircraft, allowing direct boarding without time-consuming bus transfers. Lounge facilities were to be greatly improved, with much extended retail and catering provision. Finally, facilities for the 30 percent of Terminal 1 passengers who use it to transfer to another flight were to be upgraded in line with changing standards of amenity and security. An underlying aim was the desire to counter the downbeat image of Heathrow, which was beginning to look shabby alongside competitors such as Schiphol and Paris's Charles de Gaulle. The project had to be realised with minimum disruption to the operation of the terminal and airport.

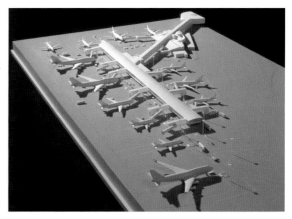

The Europier is a 280-metre-long aircraft pier, accommodating ten passenger gates designed to handle the world's largest aircraft. Structurally, it is a three-storey, independent building, designed with a high degree of modular construction to a tight budget, with a lightweight steel roof carried on 'trees' and with full-height glazing to allow panoramic views of the runway. The double-height departures area encloses a separate upper-level walkway for arriving passengers who can experience the space while being segregated from outward-bound travellers. Lightweight steel construction is used again in the Terminal 1 new departures lounge, which has seating for 1,400 and a wide range of shops, bars and cafés. The Flight Connection Centre is a distinct structure, connected by travellator to the Europier and integrated alongside the International Departure Lounge, providing a comfortable environment, with its own shops and catering facilities – a welcoming airside 'home base' for those in transit.

This highly pragmatic, relatively low-cost scheme drew on earlier RRP airport projects, including the additions at Marseilles and the unbuilt Farnborough terminal, to produce an elegant extension to one of the world's busiest airports.

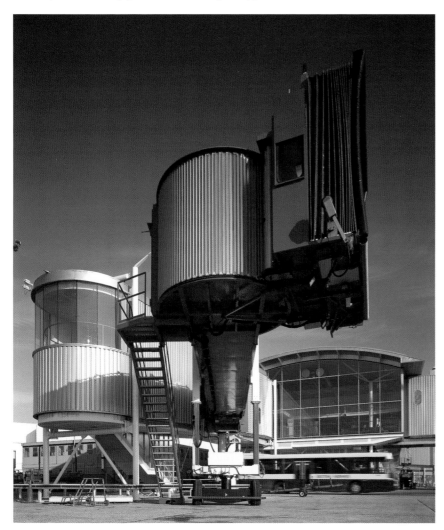

Opposite Far Left: The new pier provides additional aircraft stands that allow direct boarding without the time-consuming necessity of transferring in and out-bound passengers to their aircraft by bus. Opposite Top Right: View of cafés, lounge and retail areas at the Flight Connection Centre. Opposite Below Right: Entrance to the atrium of the Flight Connection Centre. Right: This airy, elegant pier integrates the arrivals corridor in the same volume as the main departures concourse. The structural 'trees' reduce the number of columns necessary to support the floating roofs creating a generous and uncluttered sense of space – unusual for an airport environment.

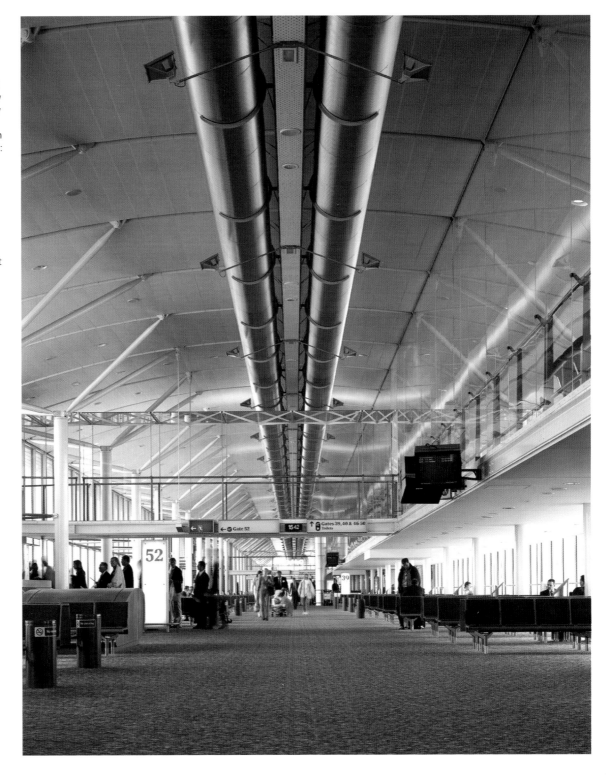

Pusan Rail Station

Below: Sketch illustrating the highly expressive roof. Opposite Top: Aerial view of the model – the corrugated folded roof provides a canopy over the platforms, booking hall and offices, as well as creating a link between two areas of the city that were previously separated by the railway lines. Opposite Below: Elevational view showing the covered platforms (left) and the five-storey booking hall (right).

The brief called for a landmark structure to replace the existing facility on the edge of the old city – a new railway station serving the TGV high-speed link between Seoul and Pusan.

The architectural response is a highly expressive steel roof structure that rises from track level, where it provides a canopy over the platforms, to enclose a five-storey booking hall and offices straddling the tracks and providing a new connection between areas of the city previously divided by the railway. The flowing form of the roof evokes the idea of movement. Inside the concourse area, the roof rises to a height of more than 20 metres, with direct connections from the concourse to the metro system, parking areas, taxis and bus station, as well as providing pedestrian routes linking

a series of high-rise office developments around the harbour.

The roof is, in structural terms, a corrugated folded plate arching in two directions and providing a high degree of economy in the use of steelwork – it is constructed of standardised components, so that much of it can be assembled off-site in pre-fabricated sections and the construction process accelerated. The form of the roof over the concourse assists the movement of air within the building. A low-velocity ventilation system is used to cool the space in preference to air-conditioning.

On the city side, the approach to the station is across a new piazza and up a monumental flight of steps. There is a strong civic and urbanistic impulse behind the scheme as well as a response to a practical transport brief.

"The station is, in essence, a bridge – the concourse bridges the tracks and the great roof bridges the whole station complex." Laurie Abbott

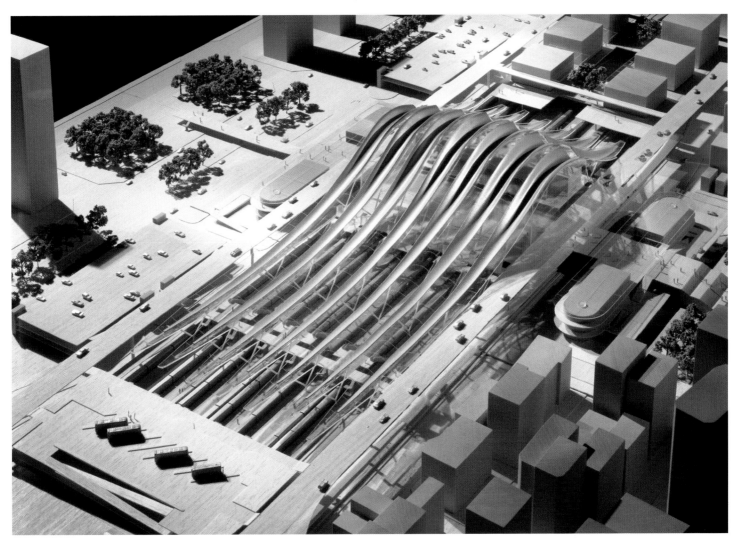

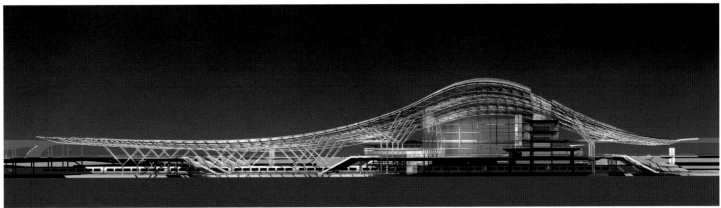

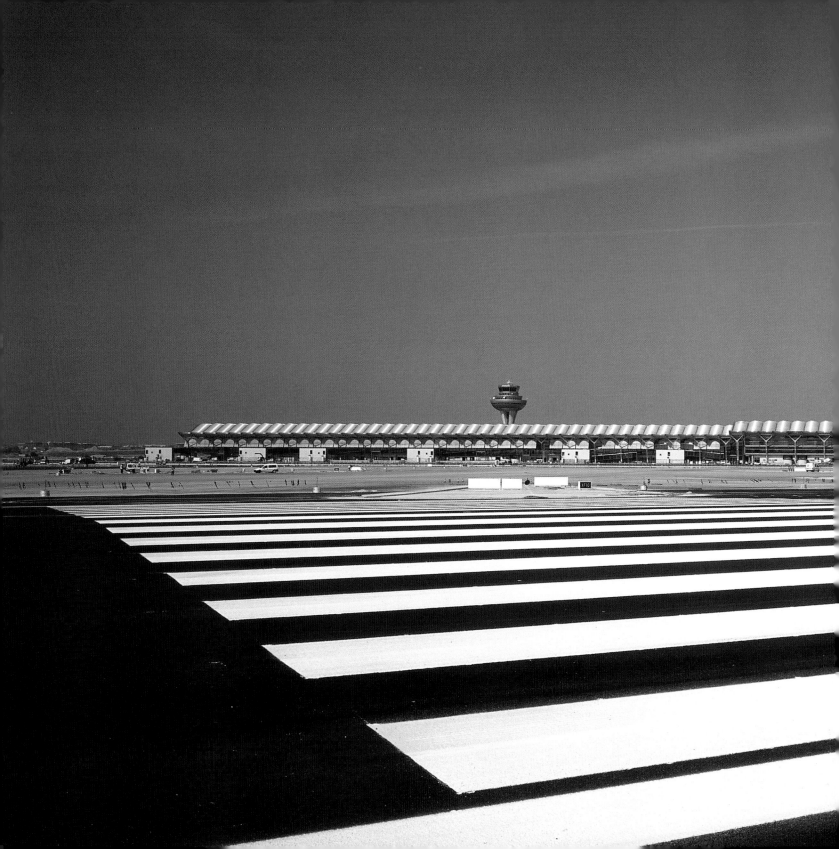

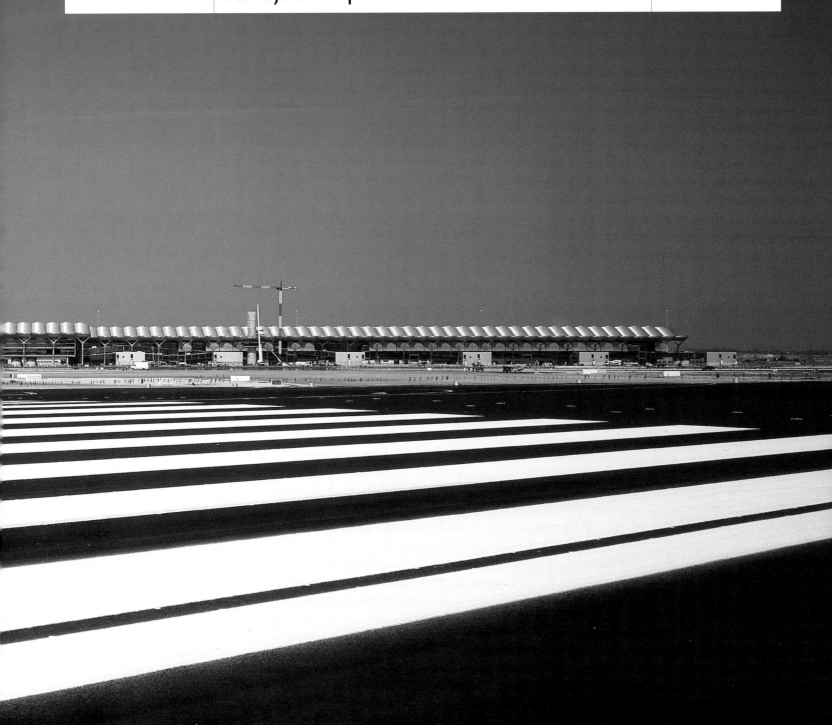

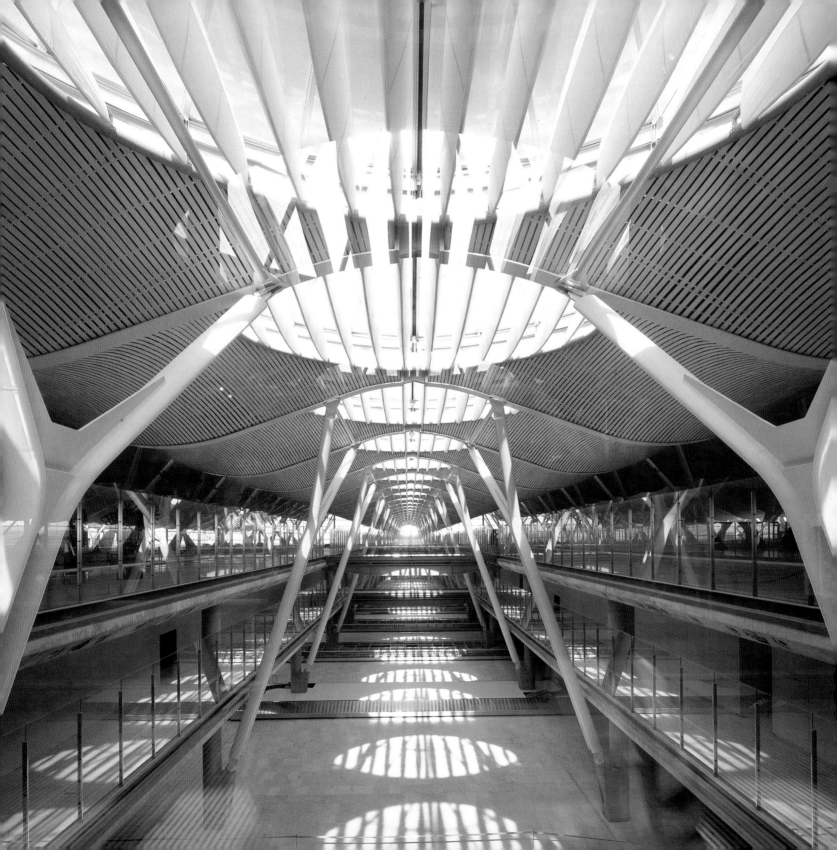

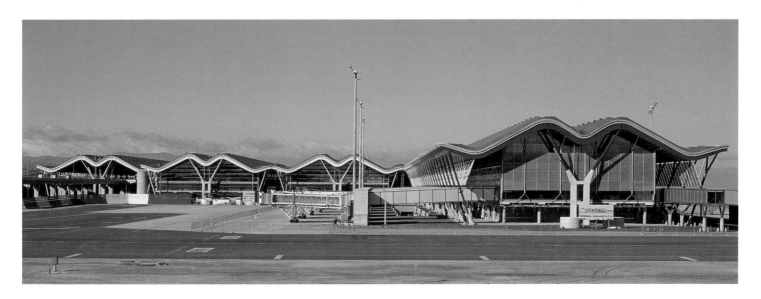

> "Our aim has been to create an airport that is fun, with lots of light, great views and a high degree of clarity." Richard Rogers

Previous Pages: View of the satellite from the east. Opposite: View of the middle canyon in the main terminal from the departures level looking down into the reclaim hall. Above: View of the south pier showing the graduated colour applied to the structural elements.

Won in competition in 1996 by a consortium of RRP with the Spanish practice Estudio Lamela and the engineering companies Initec and TPS, the Barajas project is the largest so far undertaken by the practice – more than one million square metres of buildings with a budget of around one billion Euros. The project is remarkable, however, not just in terms of scale but equally for the rapidity of its realisation (around four years from the start on site in 2000). The use of a kit of parts of standard components has been significant in this respect, suggesting a link to the Centre Pompidou and other early RRP projects.

The new terminal and satellite (a second is a long-term possibility) are designed to handle up to 35 million passengers annually, establishing Madrid as a major European hub, and are located some distance to the north-west of the existing terminal complex at Barajas. Covered car parking and a new rail station with a fast connection to central Madrid form part of the project.

Developing some of the ideas that emerged from the Terminal 5 Heathrow project (begun in 1989), the terminal at Barajas is a model of legibility, with a clear progression of spaces for departing and arriving

travellers. The building's modular design creates a repeating sequence of waves formed by vast wings of pre-fabricated steel. Supported on central 'trees', the great roof is kept free of services and punctuated by roof-lights providing carefully controlled natural light throughout the upper (departures) level of the terminal. Light-filled 'canyons' divide the series of parallel bars of space that denote the various stages of transit – from point of arrival, through check-in and passport and security controls to departure lounges and, finally, to the aircraft. The canyons channel daylight down to the lower levels of the building and are significant too as directional markers. They also form a focus for retail activities, containing potential 'sprawl' across the internal space. In addition, the daylight flooding into the building significantly reduces the need for artificial lighting – this is a key component of the environmental strategy for the building.

The sheer glazed facade is hung from the roof on a series of tensioned trusses with high-performance glass fixed on stainless steel rods. The facade is complemented with externally hung shading panels made up of steel tubes arranged to block out the

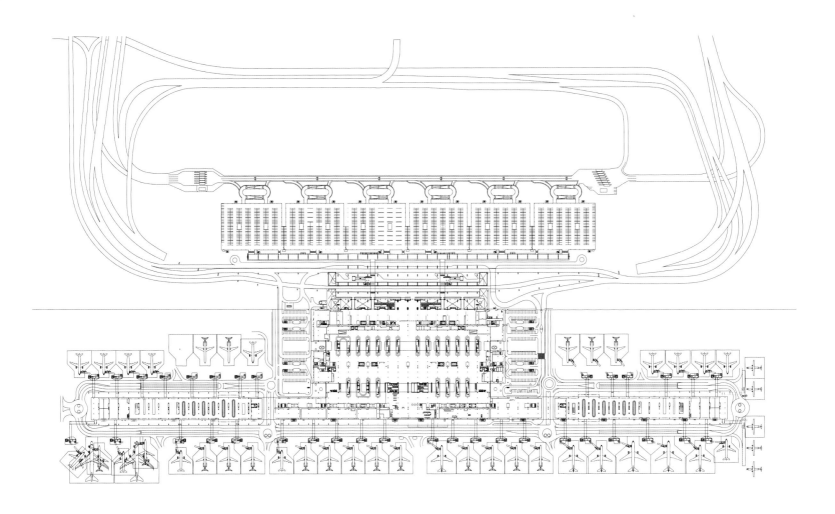

sun but allow views out across the apron. Due to the extreme heat of a typical Spanish summer, the enclosed spaces of the terminal and satellite need to be fully air-conditioned, using a low-energy displacement ventilation system. Service installations are located around the perimeter of the concrete floor slabs supplemented by high-level air supply in intensely used areas such as the check-in desks.

A simple palette of materials and a determination to avoid complex detailing reinforces the direct and forceful character of the architecture. Internally, the heavily insulated roof is clad in bamboo strips, which give it a smooth and seamless appearance. Floors are generally of natural stone. In contrast, the great 'trees'

Opposite Top: Level '0' plan of the terminal building. Opposite Below: Sketch illustrating the concept of the floating roof. Right: Aerial view from the south showing the terminal and the parking structure. Below and Bottom: Views of the steel roof structure during construction.

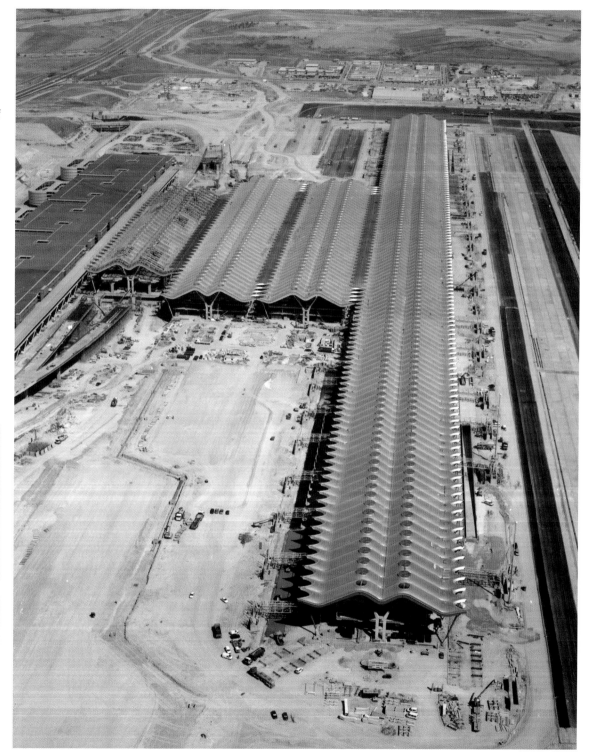

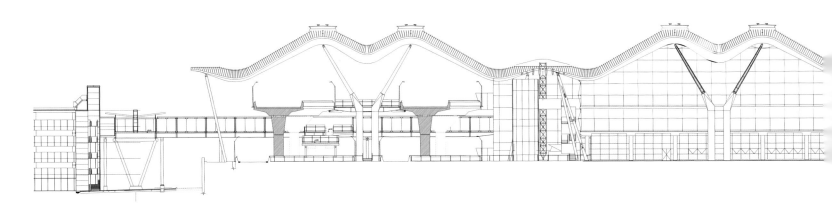

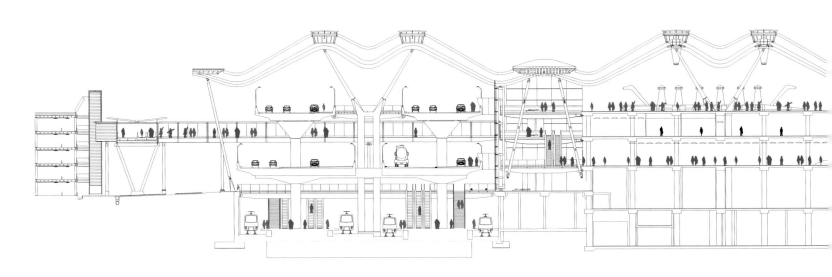

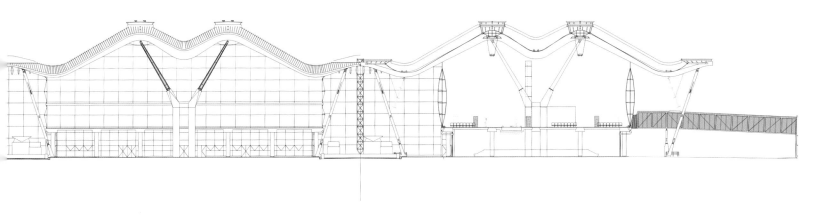

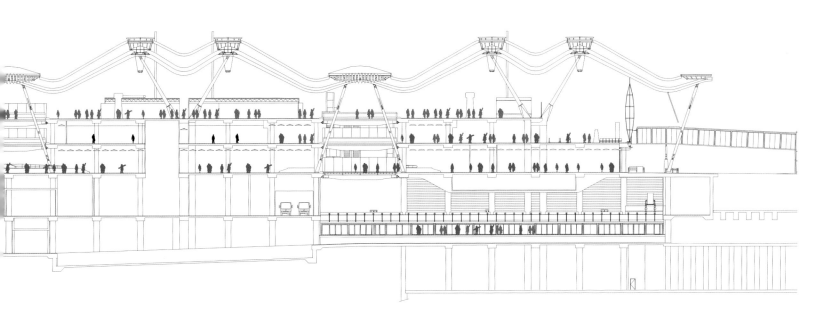

Previous Pages: The south elevation (top) showing the forecourt and pier, and a cross-section (below) through the terminal showing passenger flows – departures (red) and arrivals (blue), converging at pier level. Right: Detail view of the scalloped roof edge. Below Right: The pier is shaded by deep roof overhangs and incorporates a comprehensive steel shading system.

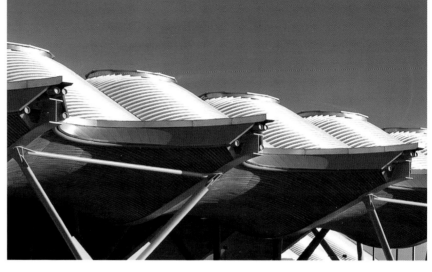

are painted to create a kilometre-long vista of graduated colour. The lower levels of the building, robustly constructed in concrete, house baggage handling, storage and plant areas and contrast strikingly with the lightweight transparency of the passenger areas above. This is a flexible shed in the best RRP tradition, but it has an element of the sublime that expresses the continuing romance of flight, even in an age of mass travel.

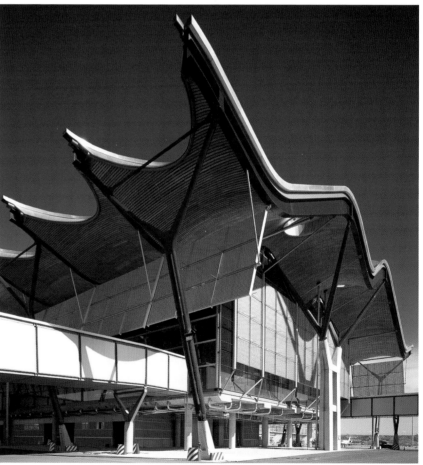

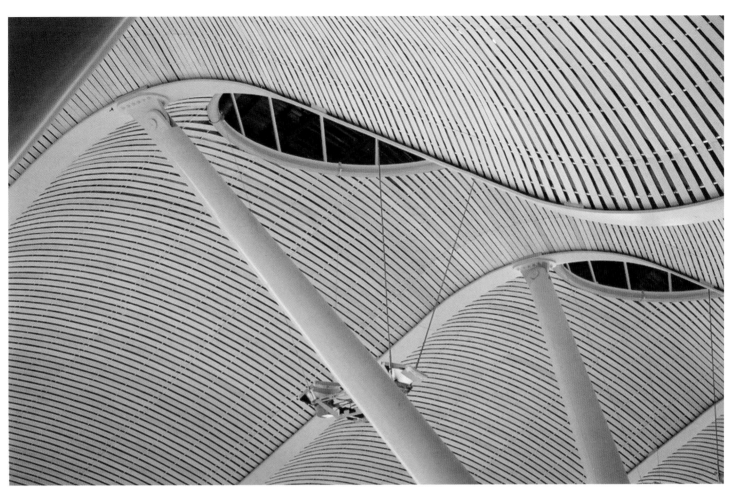

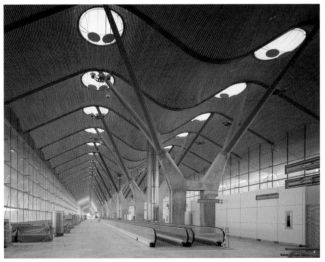

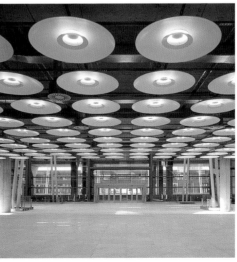

Above: Detail view of the bamboo ceiling. Far Left: View looking down the pier from the north end. Left: Bespoke light fittings, referred to by the team as 'woks', in the arrivals level.

Transbay Terminal

Opposite Top: Aerial view of the SOMA (South of Market Area) in its present condition. Opposite Below: The new terminal (shown in blue), is located in the heart of the SOMA district.

San Francisco is one American city that has held out against the malaise affecting so many large cities in the United States – the decay of central areas, the sprawl of the suburbs and dependence on the private car as a means of transport, with the consequent erosion of city life. The Bay Area Rapid Transit (BART) system, a regional rapid transit network developed from the 1970s on, serving a population of over six million in the city region, is now operating at full capacity during peak hours. Bus usage in the city has increased by 50 percent in four years as traffic congestion has driven commuters to seek alternatives to the car. Beyond the city, there is renewed interest in rail as a means of communication across the state with the prospect of a high-speed link between San Diego and Sacramento extending beyond California.

RRP's Transbay Terminal, set in an area of regeneration (the so-called SOMA – South of Market Area) close to San Francisco's waterfront, would provide a major new facility for existing public transport systems and integrate them with commuter and long-distance rail services. The building is highly functional and would be seen as a symbol of renewal in the district, at the same time providing a welcoming gateway into the city.

The new facility would utilise the existing site and reduce the land taken by the current extensive high-level road ramps off the Bay Bridge by condensing them onto two levels and shortening the loop taken back onto the bridge. The result would open up an extensive area for redevelopment with the potential to accommodate up to six million square feet of residential (up to 3,000 units) and mixed-use space – essentially enabling development of the terminal. The new development includes conference, educational and retail facilities and new public spaces – a dense, live/work neighbourhood in tune with a sustainable vision of the city.

The existing structure encloses and isolates adjacent city blocks.

A new structure opens up land for development.

A permeable Terminal creates better connections to SOMA.

New development defers to the creation of a new heart to the district.

Access via a central hall to the main building levels.

A window onto the city.

The 600,000 square foot transit terminal is capable of handling up to 25,000 bus and rail passengers per hour. In contrast to the typically grim, enclosed American bus station of urban legend, Transbay provides a naturally ventilated, daylit facility shaded by a dramatically flowing glazed roof structure incorporating solar collectors. The direct modes of transit are organised vertically, connected by a central public concourse permeated by natural light. The roof forms a window providing views across the city and to the Bay, allowing arriving passengers immediate orientation. The building is a powerful statement about the potential for great cities to develop in a responsible and sustainable fashion.

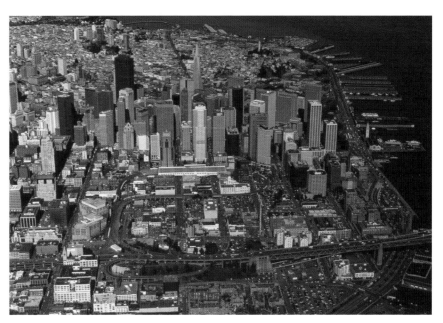

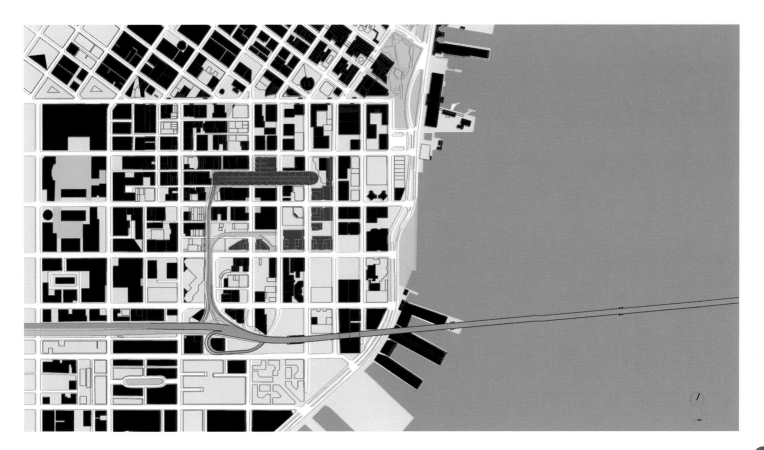

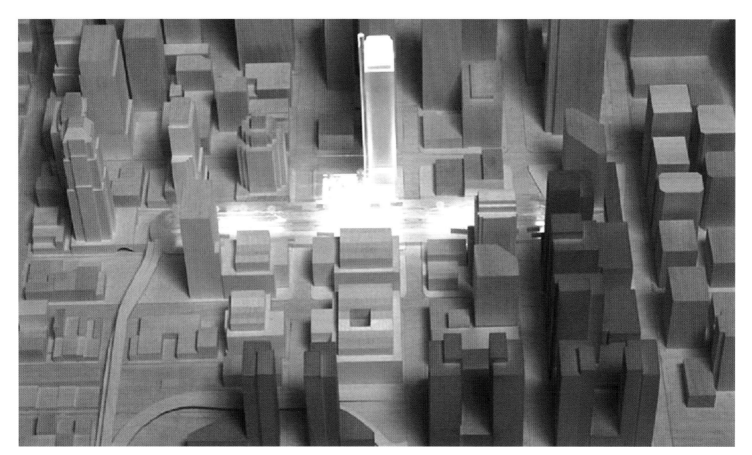

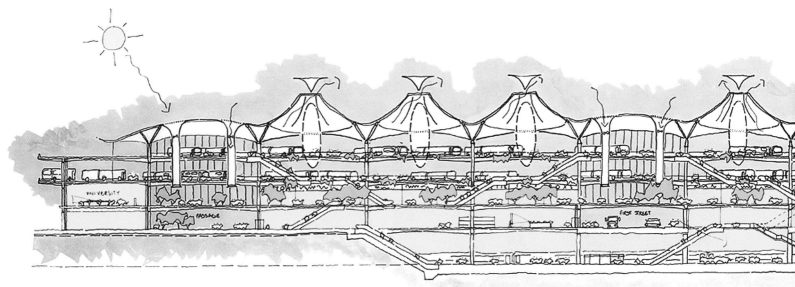

Opposite Top: Model view.
Opposite Below: Section
through the terminal. Right:
A sustainable approach has
resulted in a sunlit, naturally
ventilated and energy-efficient
building.

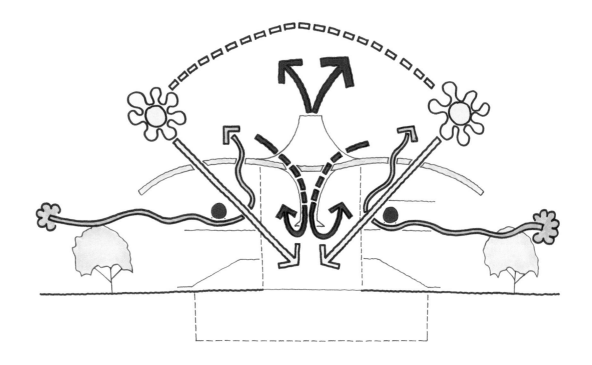

"The building features a flowing glass roof structure that provides natural lighting and ventilation and is the touchstone of a sustainable design, celebrating transit and creating a welcoming public arrival into the city." Richard Rogers

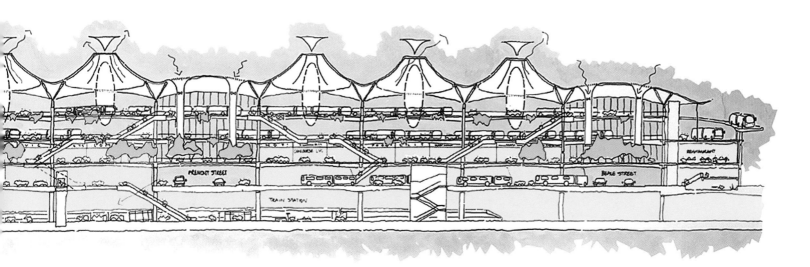

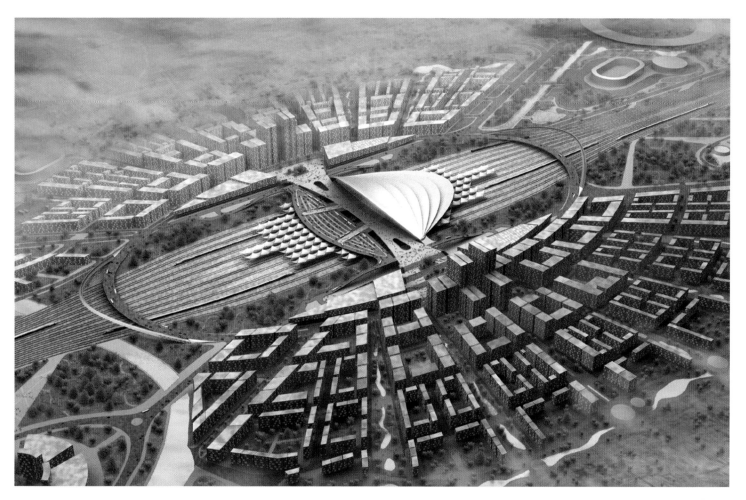

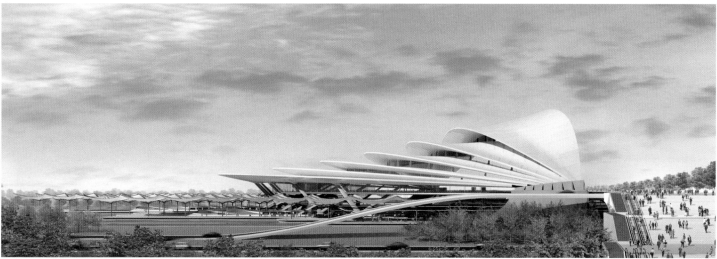

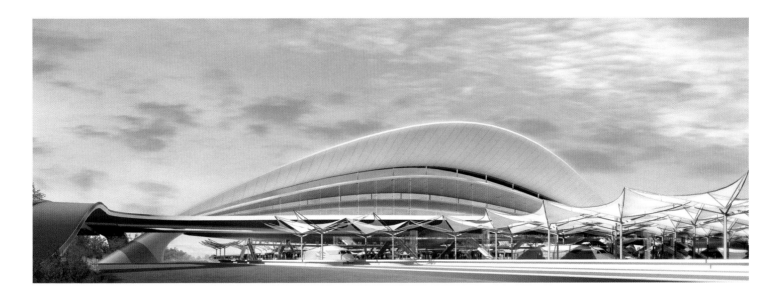

Guangzhou Railway Station

"Bold architectural forms create a dramatic people's place as the nucleus of an overall masterplan which rationalises and integrates a complex transportation interchange." Richard Paul

Opposite Top: Aerial view of the masterplan. Opposite Below: View of the approach to the station concourse. Above: The interlocking shell-like arches add drama to the process of arrival and departure.

The brief called for a rail station that would be both inspirational and spectacular in scale, whilst engaging with the surrounding masterplan and forming a catalyst for the ongoing urban expansion of the area. The principal design objective for the new building and its 266-hectare site has been to design an efficient transportation hub that successfully integrates all modes of transport.

The station has been conceived as a series of grand interlocking shell-like structures which open in a north-west orientation. Each structural shell is articulated independently. The grand arching forms add drama to the process of arrival and departure, creating a great people's place. In contrast, the platform canopies are modular in construction, providing a low-level carpet of protection at a human scale and allowing for future expansion and growth of the platform configuration, whilst also addressing the phased construction and operation of the platforms.

The scheme proposes to extend the Guangzhou-Shuhai Line to provide a direct interchange facility between the urban and regional rail systems. This would allow rail passengers to gain direct access to the existing and proposed urban rail network, which extends within and beyond the Guangzhou City Zone.

The radial nature of the masterplan ensures all movement routes originate from the forecourt of the station, thus locating the station as the nucleus of the overall masterplan. By raising the main concourse areas above the tracks, a landscape pedestrian link is created which ties both sides of the masterplan together via a major public space – the entrance and transportation interface to the station itself.

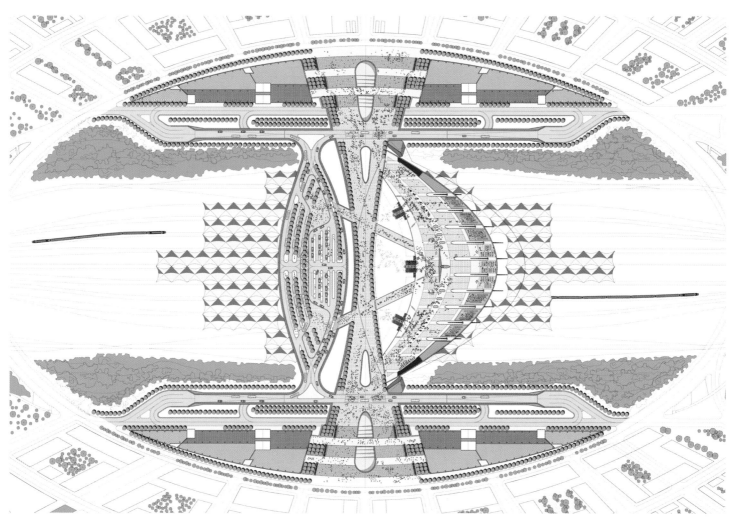

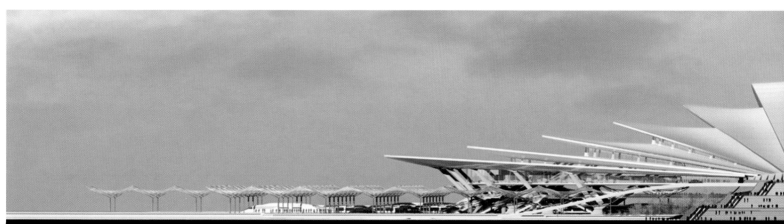

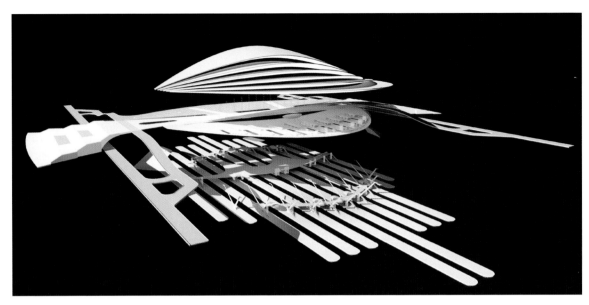

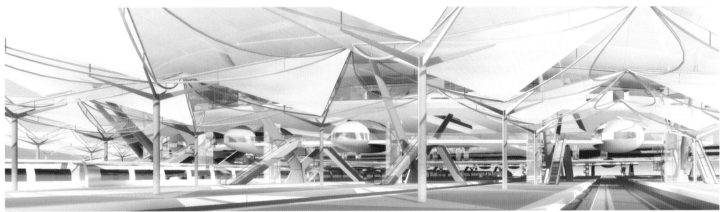

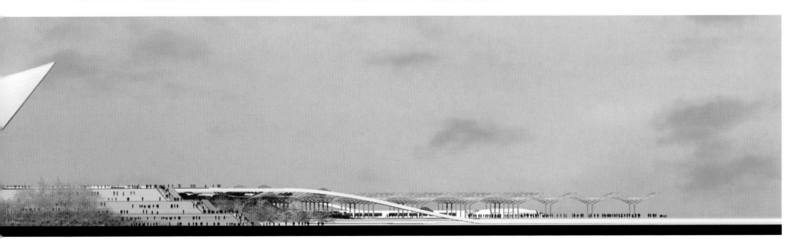

Terminal 2, Shanghai Pudong International Airport

Below: Aerial perspective of the terminal building. Opposite: Diagrammatic exploded axonometric of the terminal concourse levels. Following Pages: Masterplan.

Shanghai Pudong International Airport's Terminal 2 was conceived as a world-class airport and a lasting icon for the city that symbolises China's progress. The brief called for an iconic design, reflecting Shanghai's importance on the global stage as one of the principal trading capitals of the world and the fastest growing centre of economic development. The organic, sculptural design for the new terminal is both visually striking and highly sustainable – adaptable to future growth, it would have created one of the largest airport buildings in the world, with a capacity of 40 million passengers per annum.

State-of-the-art 21st-century terminals are expected to be operationally and commercially successful. They should simplify the complexities of modern travel by utilising integrated systems and visible way-finders, enabling large numbers of people to move effortlessly through the arrival and departure process. The design for the terminal creates a loose-fit, long-life and sustainable building offering transparency, good views and natural light, as well as generous, flexible spaces and clear way-finding.

The masterplan optimises efficiency and flexibility, responding to growth in air traffic and unknown future demands, whilst formulating an airport layout and terminal building concept that will accommodate a successful hub operation for this key international and domestic travel centre.

The scheme offers exceptional processing and service, reliable baggage handling systems, short walking distances, fast transfer times and integration of mass public transport. State-of-the-art technology will streamline systems and inform and entertain people, while excellent commercial revenue is ensured through the strategic sizing and positioning of world-class retail and leisure facilities.

The concept for the Terminal 2A design is an expandable central processor building with integral piers serving Phase 2 requirements. The two curved piers to the east and west allow swing stands to be operated easily on each pier; in addition, international stands can be easily switched to domestic and vice versa when Phase 2 becomes available.

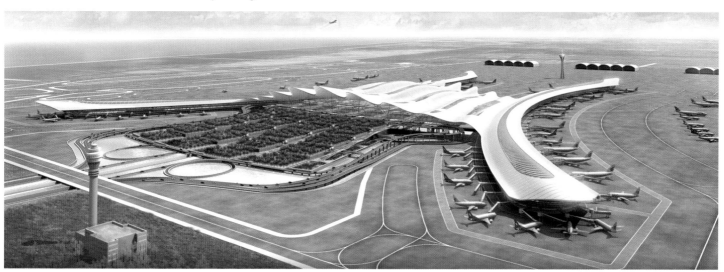

In the long term, a new terminal, known as Terminal 2B, will operate as a satellite situated opposite Terminal 1. With a capacity of 20 million passengers per annum, it will occupy a site parallel to the central axis and linked to Terminal 2A via an automated people mover. Together, Terminals 2A and 2B will provide a combined hub capacity of 60 million passengers, providing an overall airport capacity of 80 million passengers per annum.

"Both the terminal design and the overall masterplan were intended to provide technically innovative solutions, providing maximum flexibility for future growth as well as a robust, long-term strategy for existing and new infrastructure." Richard Paul

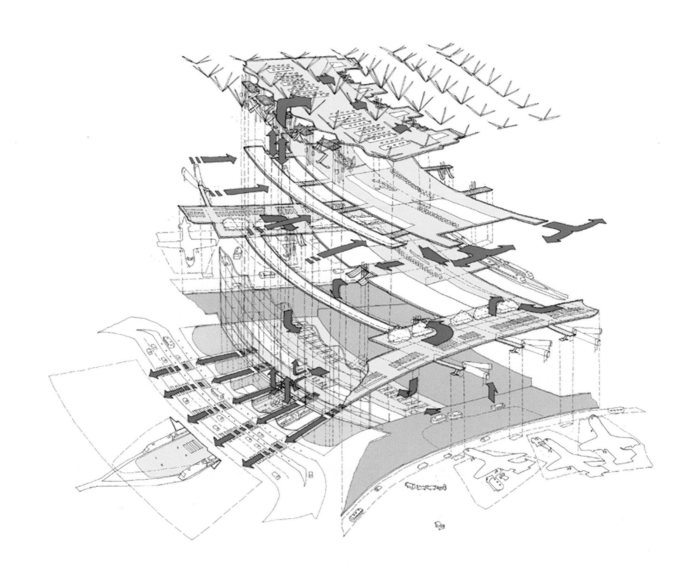

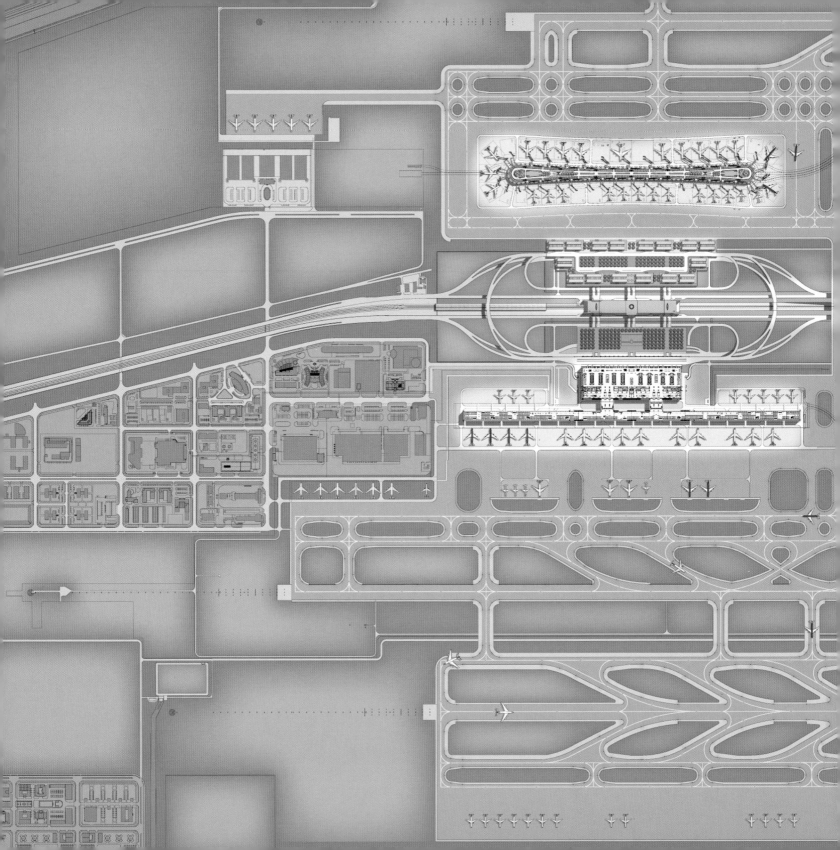

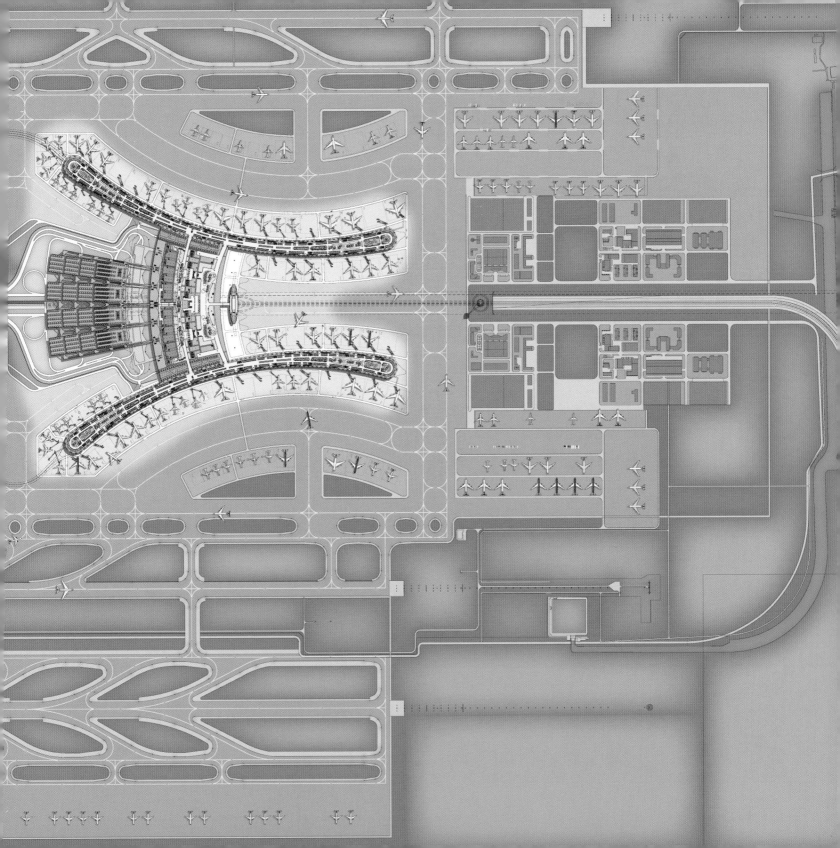

Below: Model view showing
the entrance to the terminal
under the great wave roof.
Opposite: The main terminal
building (top left) incorporates
two integral piers, while in the
long term, a new terminal,
known as 2B, will be situated
opposite the main terminal,
parallel to the central axis
(bottom left).

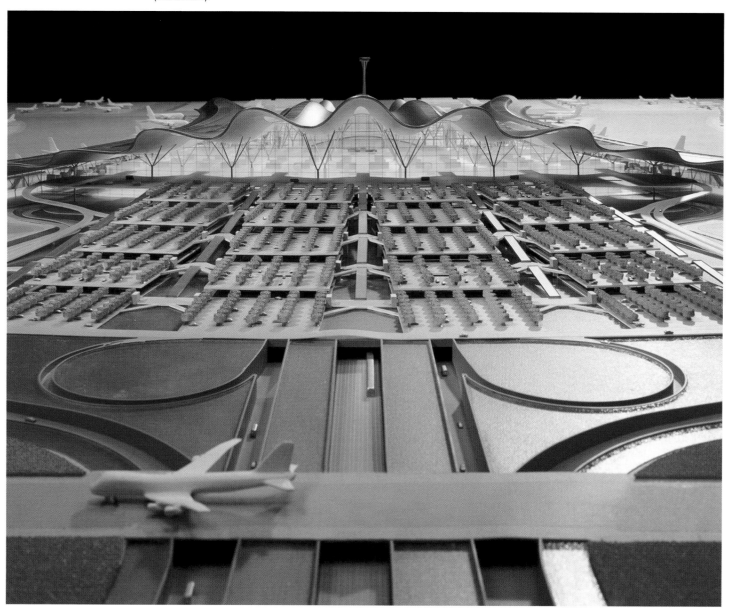

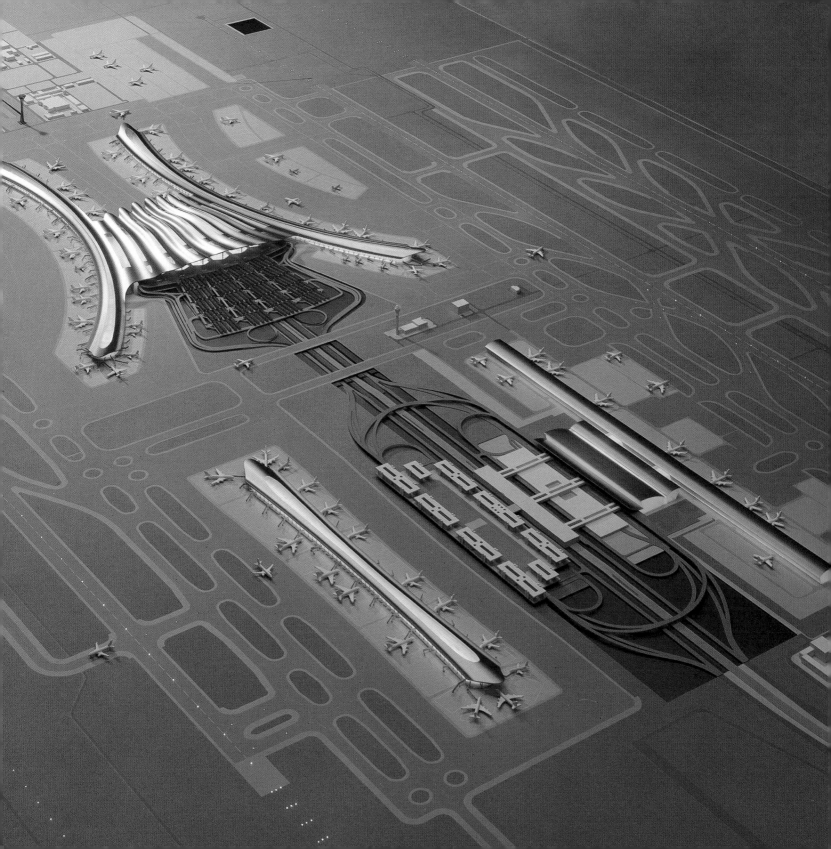

Right: View of the departure level concourse. Below: East–west section through the departures and arrivals concourse. Bottom: North–south section showing the extension of the public concourses from the main terminal processors to the linear piers. Opposite: View of the end of the pier. Following Pages: Perspective of the departures forecourt level and the main entry to the terminal.

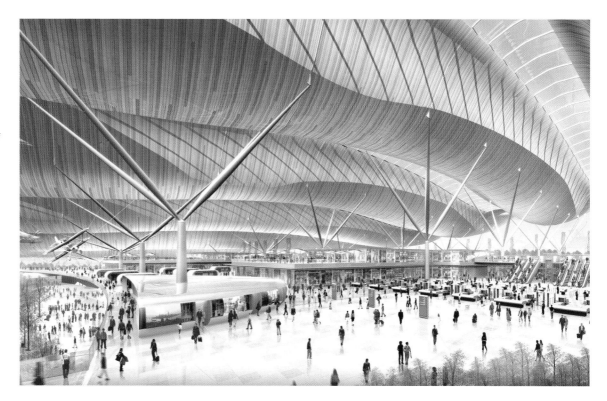

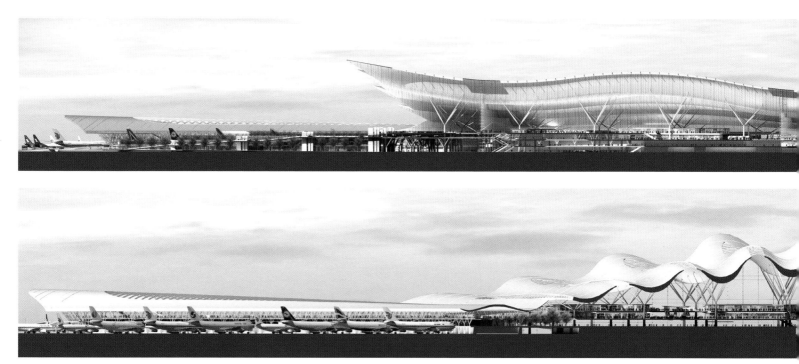

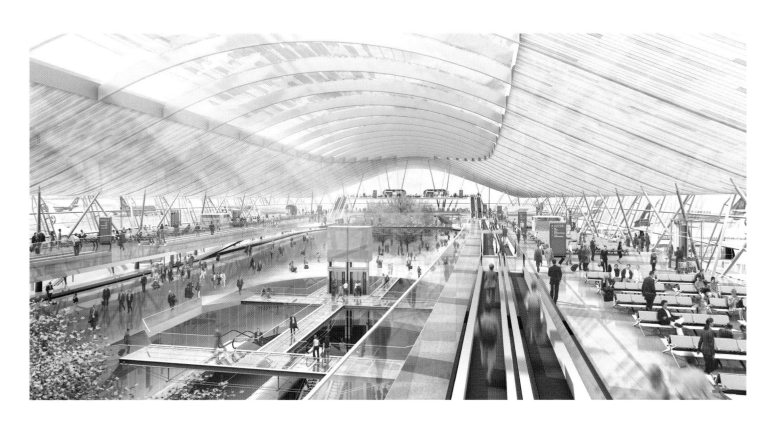

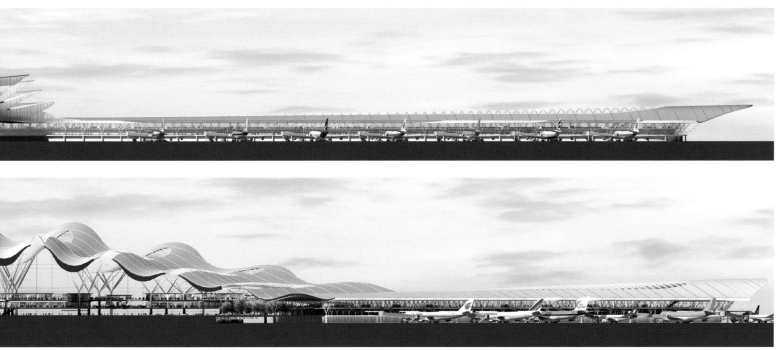

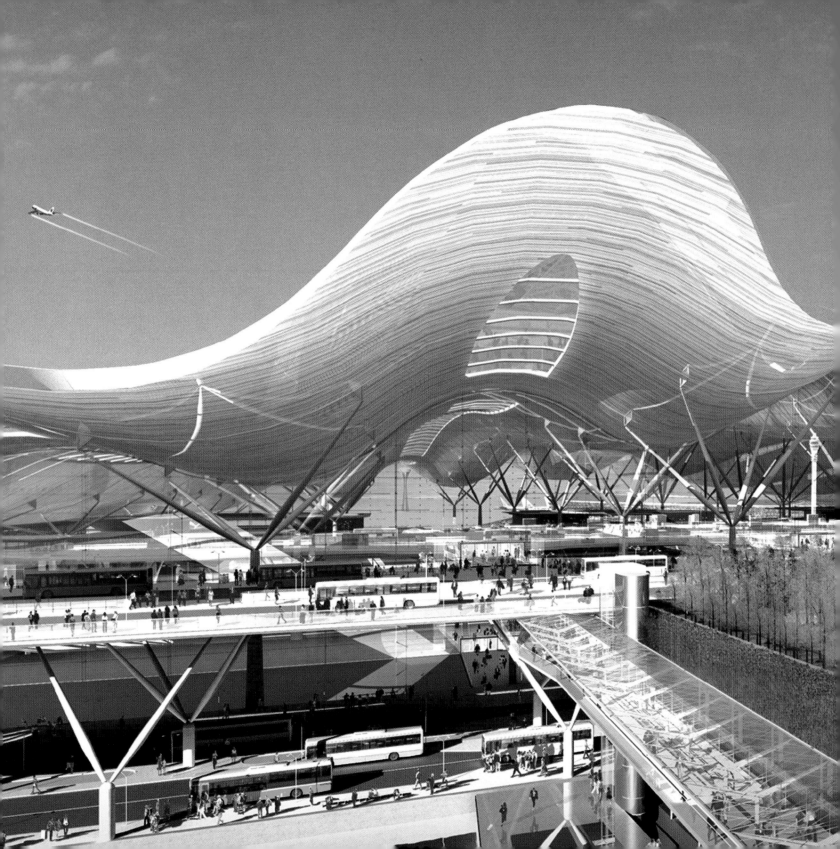

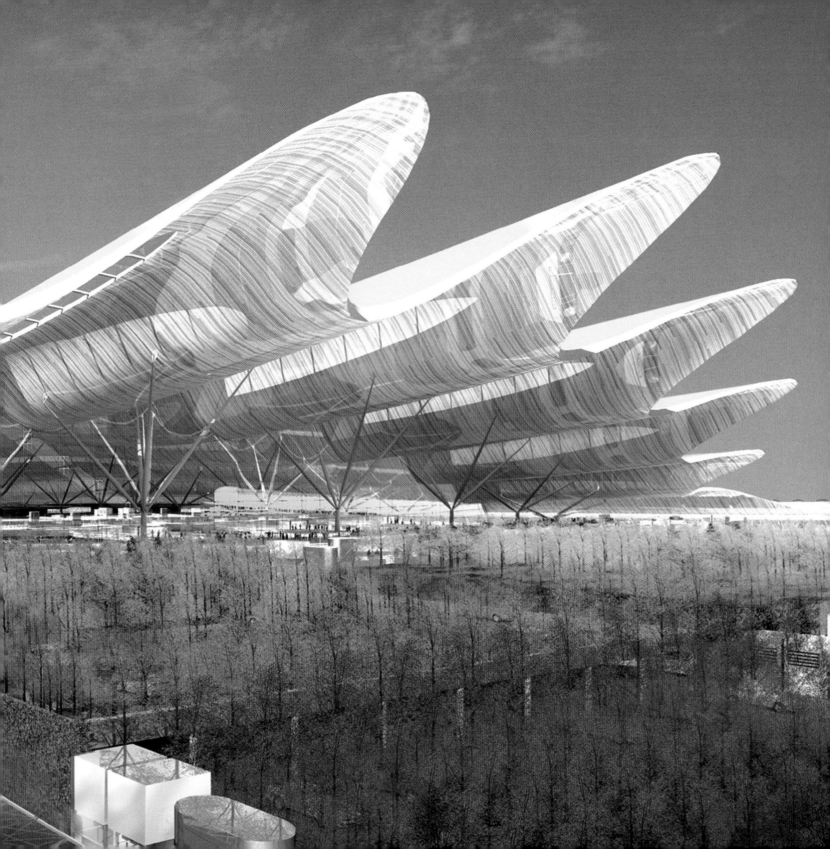

Domestic Credits

*Indicates unbuilt project

Creek Vean

Feock, Cornwall, England, UK, 1966
Client: Marcus and Rene Brumwel
Design Team: Laurie Abbott, Norman Foster, Wendy Foster, Frank Peacock, Richard Rogers, Su Rogers
Structural Engineer: Anthony Hunt Associates
Quantity Surveyor: GA Hanscomb Partnership
Main Contractor: Leonard Williams Ltd
Landscape Architect: Landscape Design Partnership
Awards: RIBA Award for Work of Outstanding Quality 1969

Zip-Up House*

Various Locations, 1968–69
Design Team: Sally Appleby, John Doggart, Marco Goldschmied, Richard Rogers, Su Rogers, John Young
Services Engineer: Max Fordham
Structural Engineer: Anthony Hunt Associates
Quantity Surveyor: GA Hanscomb Partnership
Awards: Prize winner 'House for Today' competition 1968, RIBA Research Award 1970

Rogers House

London, England, UK, 1968–69
Client: Dr and Mrs Rogers
Design Team: Pierre Botschi, John Doggart, Ingrid Morris, Richard Rogers, Su Rogers, Richard Russell, John Young
Services Engineer: H Bressloff Associates
Structural Engineer: Anthony Hunt Associates
Quantity Surveyor: GA Hanscomb Partnership
Landscape Architect: Landscape Design Partnership
Awards: Represented British Architecture at Paris Biennale 1967

Thames Reach Housing

London, England, UK, 1984–87
Client: Croudace Construction Ltd
Design Team: Peter Angrave, Paul Cook, Ian Gibson, Marco Goldschmied, Sarah Granville, Ian Hopton, Tim Inskip, Janette Mackie, Mark Roche, Richard Rogers, John Young
Services Engineer: The Sinnett Partnership
Structural Engineer: Hay Barry and Partners
Quantity Surveyor: Melvyn Newell
Main Contractor: Croudace Construction Ltd
Landscape Architect: Rendel + Branch
Area: 7,000m²
Cost: £7,244,790
Awards: RIBA Housing Design Award 1989, RIBA National Award 1989, Civic Trust Award 1989

Royal Avenue

London, England, UK, 1987
Client: Richard and Ruth Rogers
Design Team: Laurie Abbott, Tim Boyd, Marco Goldschmied, Eva Jiricna, Andrew Morris, Richard Rogers, Ruth Rogers, John Young
Services Engineer: Ove Arup & Partners
Structural Engineer: Ove Arup & Partners
Quantity Surveyor: Hanscomb Partnership
Main Contractor: J and J J Stanford
Area: 570m²

Michael Elias House*

Los Angeles, California, USA, 1991
Client: Michael Elias
Co-Architect: Appleton, Mechor and Associates
Team: Laurie Abbott, Mike Davies, Stuart Forbes, Marco Goldschmied, Cynthia Poole, Richard Rogers, Atsu Sasa, Christopher Wan, John Young
Services Engineer: MB & A
Structural Engineer: Ove Arup & Partners

Industrial Housing System*

South Korea, 1992
Client: Hanseem Corporation
Design Team: Laurie Abbott, Mike Davies, Stuart Forbes, Marco Goldschmied, John Lowe, Jackie Moore, Richard Paul, Richard Rogers, Andrew Wright, John Young
Services Engineer: Ove Arup & Partners
Structural Engineer: Ove Arup & Partners

Daimler Chrysler Residential Complex

Berlin, Germany, 1993–99
Client: Daimler Chrysler debis Immobilienmanagement
Design Team: Laurie Abbott, Yasmin Al-Ani-Spence, Michael Barth, Elliot Boyd, Sabine Coldrey, Hal Currey, Mike Davies, Barbara Faigle, Rowena Fuller, Marco Goldschmied, Lennart Grut, James Leathem, Nick Malby, Tina Manis, Richard Paul, Robert Peebles, Kim Quazi, Richard Rogers, Neil Southard, Martin White, John Young
Services Engineer: Rp + k Sozietät (joint venture with J Roger Preston & Partners) / Schmidt-Reuter und Partner
Structural Engineer: Ove Arup & Partners / Weiske & Partner GmbH / Knebel & Schumacher
Quantity Surveyor: Davis Langdon & Everest / Drees & Sommer AG
Project Manager: Daimler Chrysler
Main Contractor: Müller Altvatter + C Barasel AG GmbH
Facade Consultant: Institut für Fassadentechnik IFFT
Acoustic Consultant: Müller BBM GmbH
Retail Consultant: ECE Projektmanagement GmbH
Office Consultant: Mm Warburg Schlüter & Co
Lift Consultnt: Hundt & Partner
Fire Protection: debis Risk Consult GmbH / Hosser Hass & Partner
Landscape Architect : Kruger & Mohler
Area: 16,300m²
Cost: £18,878,556 (DM 55,000,000)
Awards: RIBA Award for Buildings in Europe 2000

Montevetro

London, England, UK, 1994–2000
Client: Taylor Woodrow Capital Developments
Co-Architect: Hurley, Robertson and Associates
Design Team: Louise Barnett, Elliot Boyd, Maurice Brennan, Andy Bryce, Maxine Campbell, Cathie Curran, Mark Darbon, Mike Davies, Mike Fairbrass, Rowena Fuller, Marco Goldschmied, Philip Gumuchdjian, Amarjit Kalsi, Roo Lam Lau, Stig Larsen, Annette Main, Catherine Martin, Tamiko Onozawa, Richard Rogers, Alison Sampson, Graham Stirk, Daniel Wright, John Young
Services Engineer: DSSR
Structural Engineer: Waterman Partnership
Quantity Surveyor: WT Partnership
Surveyor: Seaman Smith
Main Contractor: Taylor Woodrow Construction
Planning Supervisor: Taywood Engineering Ltd
Planning Consultant: Montagu Evans
Specification Consultant: Schumann Smith
Fire Consultant: Warrington Fire Research Consultants
Facade Consultant: LWC Limited
Landscape Architect: Townshend Landscape Architects
Interior Designer: Norman Dawbarn
Letting Agent: Beaney Pearce
Area: 25,000m²
Cost: £38,000,000
Awards: The American Institute of Architects London/UK Chapter Excellence in Design Award Honourable Mention 2002, Civic Trust Award, Commendation 2002

Sagaponac House*

The Hamptons, New York, USA, 2001
Client: The Brown Companies Inc
Design Team: Laurie Abbott, Mike Fairbrass, Mimi Hawley, Dennis Ho, Tim Mason, Andrew Morris, Richard Rogers
Structural Engineer: Buro Happold
Construction Manager: The Brown Companies Inc
Landscape Architect: Stephen Stimson
3D Images: Melon Studio
Area: 300m²

Workplace Credits

*Indicates unbuilt project

Reliance Controls Electronics Factory

Swindon, Wiltshire, England, UK, 1967
Client: Reliance Controls Limited
Design Team: Team 4: Sally Appleby, Norman Foster, Wendy Foster, Frank Peacock, Richard Rogers, Su Rogers, Mark Sutcliffe, John Young
Services Engineer: G N Haden and Sons Ltd
Structural Engineer: Anthony Hunt Associates
Quantity Surveyor: GA Hanscomb Partnership
Main Contractor: Pope Brothers
Area: 11,000m²
Cost: £3 / 13s per sq.ft
Awards: Architectural Design Project Award 1966, Financial Times Industrial Architecture Award 1967

B + B Italia Offices

Como, Italy, 1972–73
Client: B + B Italia
Design Team: Piano + Rogers: Cuno Brullmann, Flavio Marano, Renzo Piano, Richard Rogers
Structural Engineer: Flavio Marano

PA Technology Cambridge Laboratory

Melbourn, Cambridgeshire, England, UK
Phase 1: 1975, Phase 2: 1981, Phase 3: 1983
Client: PA Management Consultants Ltd
Design Team: Phase 1: Sally Appleby, Michael Burckhardt, Peter Flack, Marco Goldschmied, Don Gray, Alphons Oberhofer, Renzo Piano, Richard Rogers, Richard Soundy, David Thom, Peter Ullathorne, Neil Winder, John Young. Phase 2: Pierre Botschi, Mike Davies, Sally Eaton, Marco Goldschmied, John McAslan, Richard Rogers, John Young. Phase 3: Pierre Botschi, Mike Davies, Marco Goldschmied, Nathalie Moore, Brendan O'Neill, Mark Roche, Richard Rogers, John Young
Services Engineer: Hancock Design Co-ordinates / David W G Bedwell and Partners / YRM Engineers / Cressy Wilder Associates
Structural Engineer: Felix J Samuely and Partners
Quantity Surveyor: Gleeds
Main Contractor: Phase 1: R G Carter (Kings Lynn) Ltd. Phases 2 + 3:

Rattee and Kett Ltd
Landscape Architect: Landscape Design Partnership
Area: 7,500m²
Awards: Financial Times Industrial Architecture Award 1976, RIBA Regional Award 1977

Lloyd's of London

London, England, UK, 1978–86
Client: Lloyd's of London
Design Team: Directors: Mike Davies, Marco Goldschmied, Richard Rogers, John Young. Project Administrator: Richard Marzec. Analysis: Laurie Abbott, Julia Barfield, Simon Colebrook, Ian Davidson, Malcolm Last, John McAslan, Michael McGarry, Tim Oakshot, Henrietta Salvesen, Kiyo Sawoaka, Richard Soundy. Substructure: Chris Wilkinson with Marcus Lee, David Marks, Peter McMunn, Jamie Troughton. Superstructure: Richard Soundy with Maureen Diffley, Colin MacKenzie, Gennaro Picardi. Main Cladding & External Works: Stephen Le Roith with Graham Fairley, Ivan Harbour, Elizabeth Post, Niki van Oosten. Service Tower Cladding: Frank Peacock with Amarjit Kalsi, Peter St John, Clare Strasser. Services: Graham Anthony with Robert Barnes, Kieran Breen, Graham Stirk, Peter Thomas, Andrew Weston. Plantrooms: Michael Elkan with Joseph Wilson. Mechanical Systems: Stig Larsen. Interiors: Eva Jiricna with Philip Gumuchdjian, Roger Huntley, Andrew Jones, Kathy Kerr, Andrew Morris, Robert Peebles, Stephen Tsang, Yasu Yada. Administration: Susan Blyth, Julianne Coleman, Janet Dunsford, Wendy Judd, Sue McMillan, Caryn Roger, Georgina Savva, Judy Taylor. Main Cladding & External Works: Stephen Le Roith with Graham Fairley, Ivan Harbour, Elizabeth Post, Niki van Oosten Service Tower Cladding: Frank Peacock with Amarjit Kalsi, Peter St John, Clare Strasser
Services Engineer: Ove Arup & Partners
Structural Engineer: Ove Arup & Partners
Quantity Surveyor: Monk Dunstone Associates
Main Contractor: Bovis Construction Ltd
Planning Consultant: Montagu Evans
Lighting Consultant: Friedrich Wagner of Lichttechnische Planung
Rights of Light Consultant: Anstey Horne & Co
Catering Consultant: GWP Associates
Acoustic Consultant: Sandy Brown Associates

Model Makers: Tetra Design Services Ltd
Graphic Design: Pentagram Design Ltd
Internal and External Systems / Audio Visual: Theatre Developments Ltd
Awards: Civic Trust Award 1987, Concrete Society Commendation 1987, Financial Times 'Architecture at Work' Award 1987, Concrete Society Commendation 1987, Eternit 8th International Prize for Architecture Special Mention 1988, PA Award for Innovation in Building, RIBA Regional Award 1988
Area: 55,000m²
Cost: £75,000,000

Fleetguard Factory

Quimper, Brittany, France
1979–81
Client: Fleetguard International Division of Cummins Engine Co / Ville de Quimper
Design Team: Ram Ahronov, Ian Davidson, Sally Eaton, Marco Goldschmied, Kunimi Hayashi, Amarjit Kalsi, Sue McMillan, Richard Rogers, Richard Soundy, John Young
Services Engineer: Ove Arup & Partners
Structural Engineer: Ove Arup & Partners
Quantity Surveyor: Northcroft Neighbour and Nicholson
Project Manager: Fleetguard International Corporation
Area: 8,750m²
Awards: Concours de Plus Beaux Ouvrages de Construction Metallique 1982, Constructa-Preis for Overall Excellence in the Field of Architecture 1986, Premier Award for Exceptional Steel Structure, France 1982

INMOS Microprocessor Factory

Newport, Gwent, Wales, UK, 1982–87
Client: INMOS Ltd
Design Team: Julia Barfield, David Bartlett, Pierre Botschi, Mike Davies, Sally Eaton, Michael Elkan, Marco Goldschmied, Kunimi Hayashi, Tim Inskip, Peter McMunn, Richard Rogers, John Young
Services Engineer: YRM Engineers
Structural Engineer: Anthony Hunt Associates
Quantity Surveyor: GA Hanscomb Partnership
Main Contractor: Laing Management Contracting Ltd
Area: 8,900m²
Awards: Constructa Preis for Overall Excellence in the Field of Architecture 1986, Eurostructpress Award 1983, Financial Times 'Architecture at Work' Award Commendation 1983, The Structural Steel Design Award 1982

PA Technology Laboratory

Princeton, New Jersey, USA, 1982–85
Client: PA Consulting Services Inc
Co-Architect: Kelbaugh and Lee Architects
Design Team: Ram Ahronov, Pierre Botschi, Mike Davies, Marco Goldschmied, John McAslan, Gennaro Picardi, Richard Rogers, John Young
Services Engineer: Ove Arup & Partners / Syska and Hennessy Inc
Structural Engineer: Ove Arup & Partners / Robert Silman Associates
Quantity Surveyor: GA Hanscomb Partnership / GA Hanscomb Associates Inc
Area: 4,000m²

Thames Wharf Studios

London, England, UK, 1984–89 (Roof Extension 1989–91)
Client: Marco Goldschmied, Richard Rogers, John Young
Co-Architect: Lifschutz Davidson Ltd (Roof Extension)
Design Team: Pierre Botschi, Mike Davies, Patrick Davies, Marco Goldschmied, Tim Inskip, Peter Jennett, James McGrath, Nathalie Moore, Gennaro Picardi, Mark Roche, Richard Rogers, Neville Smith, Graham Stirk, Karenna Wilford, John Young
Services Engineer: Rosser and Russell / Ove Arup & Partners
Structural Engineer: Anthony Hunt Associates / Ove Arup & Partners
Quantity Surveyor: GA Hanscomb Partnership
Main Contractor: Woolf Construction Ltd, Tarmac Cubitts, Woolf Construction Ltd (roof extension)
Planning Consultant: Montagu Evans
Landscape Architect: Georgie Wolton
Area: 3,065m²
Awards: RIBA Regional Awards 1994 (Roof Extension) Civic Trust Award 1987, Structural Steel Design Award Certificate of Merit 1984

Billingsgate Market

London, England, UK, 1985–88
Client: Citibank / Citicorp
Design Team: Tom Alexander, Peter Angrave, David Bartlett, Pierre Botschi, John Cannon, Philip Chalmers, Tim Colquhoun, Mike Davies, Patrick Davies, Sally Draper, Marco Goldschmied, Ian Hopton, Shahab Kasmai-Tehran, Lester Korzilius, Clodagh Latimer, Mary Le Jeune, Amanda Levete, Kevin Lewenden, Avtar Lotay, John Lowe, Ernest Lowinger, Luke Lowings, Malcolm McGowan, Janette Mackie, Richard Marzec, Arif Mehmood, Nathalie Moore, Frank Peacock, Mark Roche, Richard Rogers, Seth Stein, Peter Thomas, John Young
Services Engineer: Ove Arup & Partners
Structural Engineer: Ove Arup & Partners
Quantity Surveyor: GA Hanscomb Partnership

Main Contractor: Taylor Woodrow Management Contracting Ltd
Lighting Consultant: Lighting Design Partnership
Area: 11,200m²
Awards: RIBA Regional Award 1988, RIBA National Award 1989, Civic Trust Award 1989, BBC Design Awards Finalist 1990

K2 St Katharine Docks

London, England, UK, 1987–2005
Client: Taylor Woodrow Property Co Ltd
Design Team: Laurie Abbott, Jo-Anne Alldritt, Torsten Burkhardt, Maxine Campbell, Martin Cook, Daniel Crane, Sean Daly, Mark Darbon, Mike Davies, Mike Fairbrass, Florian Fischötter, Rowena Fuller, Marco Goldschmied, Sera Grubb, Jane Hannan, Kathryn Humphreys, Toby Jeavons, Shahab Kasmai-Tehran, Jose Llerena, Avtar Lotay, Catherine Martin, David Merllie, Andrew Morris, Beatriz Olivares, Tamiko Onozawa, Richard Rogers, Patricia Sendin, Graham Stirk, Adrian Williams, John Young
Services Engineer: Waterman Gore
Structural Engineer: Waterman Partnership
Quantity Surveyor: Davis Langdon & Everest
Main Contractor: Taylor Woodrow Construction
Project Manager: Buro 4
Planning Consultant: Montagu Evans
Planning Supervisor: Taywood Engineering Ltd
Fire Consultant: Warrington Fire Research Consultants
Acoustic Consultant: AAD
Landscape Architect: RRP
Letting Agent: Ingleby Trice Kennard / Jones Lang Wootton / Knight Frank
Area: 24,000m²
Cost: £45,000,000

Reuters Data Centre

London, England, UK, 1987–92
Client: Rosehaugh Stanhope Developments / Reuters
Design Team: Laurie Abbott, Susie Blyth, Kieran Breen, Philip Chalmers, Mike Davies, William Firebrace, Marco Goldschmied, Ivan Harbour, Tim Inskip, Amarjit Kalsi, John Lowe, Ernest Lowinger, Graham McDougall, Andrew Morris, Mark Newton, Robert Peebles, Mark Roche, Richard Rogers, Georgina Savva, Graham Stirk, Josh Wilson, John Young
Services Engineer: Jaros Baum & Bolles
Structural Engineer: Ove Arup & Partners
Quantity Surveyor: V J Mendoza
Main Contractor: Bovis Construction Ltd
Area: 27,870m²
Cost: £1,950,000
Awards: RIBA National Award 1993

Iikura Building*

Tokyo, Japan, 1987–91
Client: K-One Corporation
Co-Architect: Irie Miyake Architects
Design Team: Laurie Abbott, Maxine Campbell, Mike Davies, Florian Eames, Marco Goldschmied, Bjork Haraldsdottir, Eric Holt, Miyuki Kurihara, Stig Larsen, John Lowe, Richard Rogers, Atsushi Sasa, Yoshi Shinohara, Kyoko Tomioka, Yoshi Uchiyama, Christopher Wan, Benjamin Warner, Andrew Wright, John Young
Services Engineer: Toda Corporation
Structural Engineer: Toda Corporation / Ove Arup & Partners in association with Umezawa Design Office
Area: 2,700m²

Kabuki-Cho Tower

Tokyo, Japan, 1987–93
Client: K-One Corporation
Co-Architect: Architect 5
Design Team: Laurie Abbott, Maxine Campbell, Mike Davies, Florian Eames, Mike Elkan, Stuart Forbes, Marco Goldschmied, Hiroshi Hibio, Eric Holt, Miyuki Kurihara, Stig Larsen, John Lowe, Richard Rogers, Atsushi Sasa, Kyoko Tomioka, Yoshi Uchiyama, Christopher Wan, Benjamin Warner, John Young
Services Engineer: ES Associates
Structural Engineer: Umezawa Design Office
Main Contractor: Kawada Industries Inc.
Area: 1,757m²
Cost: £982,090,395
Awards: RIBA National Award 1993

Tidal Basin Pumping Station, Royal Victoria Docks

London, England, UK, 1987–88
Client: LDDC / Sir William Halcrow & Partners
Design Team: Brian Bell, Paul Cook, Mike Davies, William Firebrace, Marco Goldschmied, Tim Inskip, Amarjit Kalsi, Maralyn Lai, Werner Lang, Richard Rogers, John Sorcinelli, John Young
Structural Engineer: Sir William Halcrow & Partners
Services Engineer: Sir William Halcrow & Partners
Main Contractor: Nuttall
Area: 850m²
Awards: Constructa Preis 1992

Alcazar*

Marseilles, France, 1988–90
Client: Groupement Rhodanien de Construction
Design Team: Mike Davies, Marco Goldschmied, Lennart Grut, Jackie Hands, Enrique Hermosa-Lera, John McFarland, Richard Rogers, Stephen Spence, Graham Stirk, John Young
Structural Engineer: Bureau d'Etudes / Otra, Lyons
Area: 32,500m^2

Channel 4 Television Headquarters

London, England, UK, 1990–94
Client: Channel 4 Television Company
Design Team: Laurie Abbott, Yasmin Al-Ani Spence, Helen Brunskill, Oliver Collignon, Daniel Crane, Mark Darbon, Mike Davies, Jane Donnelly, Mike Fairbrass, Florian Fischötter, Marco Goldschmied, Philip Gumuchdjian, Jackie Hands, Jane Hannan, Bjork Haraldsdottir, Stig Larsen, Carmel Lewin, Stephen Light, Avtar Lotay, John Lowe, Steve Martin, Andrew Morris, Louise Palomba, Elizabeth Parr, Kim Quazi, Richard Rogers, Daniel Sibert, Stephen Spence, Kinna Stallard, Graham Stirk, Yuli Toh, Alec Vassiliades, Martin White, Adrian Williams, Megan Williams, John Young
Services Engineer: YRM Engineers
Structural Engineer: Ove Arup & Partners
Traffic Engineer: Arup Transportation
Quantity Surveyor: The Wheeler Group Consultancy
Main Contractor: Bovis Construction Ltd
Project Manager: Fuller Peiser
Fire Consultants: Warrington Fire Research Consultants
Acoustic Consultant: Sandy Brown Associates
Surveyor: McBains Building Surveyors
Space Planner: Grey Associates
Landscape Architect: Rendel & Branch
Area: 15,000m^2
Cost: £38,500,000
Awards: Royal Fine Art Commission Award 1995, RIBA National Award 1995, BBC Design Awards Finalist 1996

Zoofenster Building*

Berlin, Germany, 1991–95
Client: Brau und Brunnen, Dortmund
Design Team: Laurie Abbott, Yasmin Ali-Ani Spence, Peter Barber, Pierre Botschi, Helen Brunskill, Sabine Coldrey, Oliver Collignon, Penny Collins, Tim Colquhoun, Julian Coward, Mark Darbon, Mike Davies, Katrin Dzenus, Karin Egge, Stuart Forbes, Pascale Gibon, Peter Gibbons, Marco Goldschmied, Lennart Grut, Jackie Hands, Bjork Haraldsdottir,

John Höpfner, Oliver Kühn, Swantje Kühn, Naruhiro Kuroshima, Stephen Light, Steve Martin, Andrew Partridge, Gregoris Patsalosavvis, Richard Paul, Robert Peebles, Cynthia Poole, Richard Rogers, Atsushi Sasa, Birgit Scheppenseifen, Yoshiki Shinohara, Simon Smithson, Neil Southard, Stephen Spence, Kinna Stallard, Graham Stirk, Taka Tezuka, Alec Vassiliades, Atsu Wada, Wolfgang Wagner, Christopher Wan, Megan Williams, Andrew Wright, John Young
Services Engineer: YRM Engineers / Schmidt Reuter
Structural Engineer: Ove Arup & Partners / Pr. Nötzold
Quantity Surveyor: ECE / Hanscomb

Süddeutsche Zeitung Offices*

Munich, Germany, 1992
Client: CKV for Süddeutsche Zeitung
Design Team: Mike Davies, Marco Goldschmied, Lennart Grut, Philip Gumuchdjian, Ivan Harbour, Marcus Lee, John Lowe, Steve Martin, Richard Paul, Richard Rogers, Simon Smithson, Stephen Spence, Taka Tezuka, Wolfgang Wagener, Christopher Wan, John Young
Services Engineer: Ove Arup & Partners
Structural Engineer: Ove Arup & Partners

Inland Revenue Office*

Nottingham, England, UK, 1992
Client: Inland Revenue
Design Team: Laurie Abbott, Yasmin Al-Ani, Mark Darbon, Mike Davies, James Finestone, Stuart Forbes-Waller, Marco Goldschmied, Philip Gumuchdjian, Carmel Lewin, Avtar Lotay, John Lowe, Andrew Morris, Louise Pritchard, Kim Quazi, Richard Rogers, Stephen Spence, Andrew Tyley, Chris Wan, Andrew Wright, John Young
Services Engineer: Ove Arup & Partners / Guy Battle, Andy Sedgewick, London
Structural Engineer: Ove Arup & Partners / Alistair Lechner

Turbine Tower Research Project*

Tokyo, Japan, 1992
Client: Richard Rogers Partnership
Design Team: Laurie Abbott, Mike Davies, Marco Goldschmied, Richard Rogers, Andrew Wright, John Young
Services Engineer: Guy Battle, Chris Twin
Structural Engineer: Ove Arup & Partners / Chris MacCarthy
Aeronautics Consultant: Professor Mike Graham, Imperial College, London

Daimler Chrysler Office & Retail

Berlin, Germany, 1993–99
Client: Daimler Chrysler
Design Team: Laurie Abbott, Yasmin Al-Ani-Spence, Michael Barth, Elliot Boyd, Sabine Coldrey, Hal Currey, Mike Davies, Barbara Faigle, Rowena Fuller, Marco Goldschmied, Lennart Grut, James Leathem, Nick Malby, Tina Manis, Richard Paul, Robert Peebles, Kim Quazi, Richard Rogers, Neil Southard, Martin White, John Young
Services Engineer: RP+K Sozietät (joint venture with J Rogers Preston & Partners) / Schmidt-Reuter und Partner
Structural Engineer: Ove Arup & Partners / Weiske & Partner GmBH / Knebel & Schumacher
Quantity Surveyor: Davis Langdon & Everest / Drees & Sommer AG
Facade Engineer: Institut für Fassadentechnik IFFT
Main Contractor: Müller Altvattar + C Barasel AG GmBH
Project Manager: Daimler Chrysler
Construction Manager: Schmidt-Reuter und Partner
Fire Consultant: Debis Risk Consult GmBH, Hosser Hass & Partner
Retail Consultant: ECE Projektmanagement GmBH
Office Consultant: Mm Warburg Schlüter & Co
Landscape Architect: Kruger & Mohler
Lift Consultant: Hundt & Partner
Area: Office Area Buildings B4 & B6: 29,000m². Housing Area Building B8: 16,300m². Retail Area Buildings B4, B6 & B8: 12,500m²
Cost: £65,562,623
Awards: RIBA Award for Buildings in Europe 2000

VR Techno Plaza

Gifu, Japan, 1993–95
Client: Gifu Prefecture and VR Techno Centre
Design Team: Lindy Arkin, Elliot Boyd, Maurice Brennan, Michael Elkan, Rowena Fuller, Lennart Grut, Ivan Harbour, Hiroshi Hibio, Akihisa Kageyama, Sanekazu Kofuku, Naruhiro Kuroshima, John Lowe, Sophie Nguyen, Tamiko Onozawa, Louise Palomba, Richard Rogers, Stephen Spence, Benjamin Warner, Yoshimori Watanabe, Andrew Wright
Services Engineer: ES Associates
Structural Engineer: Umezawa Structural Engineers
Electrical Engineer: Nichiei Architects
Mechanical Engineer: ES Associates
Quantity Surveyor: Schal Bovis
Main Contractor: Dainihon and Ichikawa Construction Joint Venture
Surveyor: Schal Bovis
Landscape Architect: Lovejoys / Equipe Espace
Area: 11,462m²
Cost: £27,600,000

Amano Research Laboratories

Gifu, Japan, 1997–99
Client: Amano Enzyme Inc
Co-Architect: Kisho Kurokawa Architect & Associates
Design Team: Lennart Grut, Ivan Harbour, Hiroshi Hibio, Akihisa Kageyama, Amarjit Kalsi, Richard Rogers, Benjamin Warner, Yoshimori Watanabe
Services Engineer: Inuzuka Engineering Consultants
Structural Engineer: Umezawa Structural Engineers
Quantity Surveyor: Nurse Engineering
Main Contractor: Takenaka Corporation
Landscape Architect: Equipe Espace
Area: 6,731m²
Cost: £9,000,000

Thames Valley University

Slough, Buckinghamshire, England, UK, 1993–96
Client: Thames Valley University
Design Team: Maurice Brennan, Mark Darbon, Michael Davies, Chris Donnington, Michael Elkan, Michael Fairbrass, Marco Goldschmied, Philip Gumuchdjian, Jackie Hands, Avery Howe, Sharni Howe, Amarjit Kalsi, Carol Painter, Louise Palomba, Richard Rogers, Stephen Spence, John Young
Services Engineer: Buro Happold
Structural Engineer: Buro Happold
Quantity Surveyor: Hanscomb Ltd
Main Contractor: Laing South East
Lighting Consultant: Lighting Design Partnership
Landscape Architect: Edward Hutchison
Area: 3,500m²
Cost: £3,600,000
Awards: Civic Trust Award 1997, RIBA Architecture in Education Award 1997, RIBA Award 1997, Structural Steel Design Award 1997

88 Wood Street

London, England, UK, 1993–99
Client: Daiwa Europe Properties
Design Team: Phil Bernard, Francesco Draisci, Mike Fairbrass, Stuart Forbes, Harvinder Gabhari, Russell Gilchrist, Marco Goldschmied, Mark Hallett, Jackie Hands, Jane Hannan, Jenny Jones, Amarjit Kalsi, Roo Lam Lau, Stig Larsen, Annette Main, Beth Margolis, Sam Masters, Charles Meloy, Andrew Morris, Sophie Nguyen, Julie Parker, Andrew Partridge, Richard Rogers, Graham Stirk, Amarjit Tamber, Robert Torday, Andy Young
Services Engineer: Ove Arup & Partners
Structural Engineer: Ove Arup & Partners

Quantity Surveyor: Gardiner & Theobold
Planning Consultant: Montagu Evans
Fire Consultant: Warrington Fire Research Consultants
Lighting Consultant: Lighting Design Partnership
Main Contractor: Kajima / Laing Management Joint Venture
Construction Manager: Laing Management Limited
Project Manager: D J Williams & Associates Ltd
Fit-Out Contractor: Kajima / Hazama Joint Venture
Landscape Architect: Edward Hutchison
Area: 33,073m²
Cost: £52,000,000
Awards: The American Institute of Architects London/UK Chapter Excellence in Design Award Winner 2002, RIBA Award/Stirling shortlist 2000, Civic Trust Award 2000, Royal Fine Art Commission Trust Award 2000, Royal Academy Summer Exhibition Bovis/Lend Lease Award for Best Architectural Exhibit 2000

Lloyd's Register

London, England, UK, 1993–2000
Client: Lloyd's Register
Design Team: Ernesto Bartolini, Phil Bernard, Maxine Campbell, Marco Goldschmied, Jane Hannan, Stephen Harty, Carmel Lewin, Avtar Lotay, Stephen Light, Samantha Masters, Andrew Morris, Louise Palomba, Andrew Partridge, Richard Rogers, Graham Stirk, Guni Suri, Martin White, Adrian Williams, Andy Young
Services Engineer: Ove Arup & Partners
Structural Engineer: Anthony Hunt Associates
Quantity Surveyor: AYH Partnership
Main Contractor: Sir Robert McAlpine & Sons Ltd
Project Manager: Richard Ellis
Planning Consultant: Montagu Evans
Fire Consultant: Warrington Fire Research Consultants
Lighting Consultant: Lighting Design Partnership
Landscape Architect: Edward Hutchison
Area: 34,000m²
Cost: £70,000,000
Awards: RIBA Award/Stirling shortlist 2002, World Architecture Award for Best Commercial Building in the World 2002, Civic Trust Award 2002, Aluminium Imagination Awards Commendation 2001, Concrete Society Certificate of Excellence 'Building Category' 2000

Seoul Broadcasting Centre*

Seoul, South Korea, 1995
Client: Seoul Broadcasting System
Co-Architect: ILKUN C&C Architects Inc
Design Team: Laurie Abbott, Yasmin Al-Ani Spence, Mike Davies, James

Finestone, Pascale Gibon, Marco Goldschmied, Lennart Grut, Dennis Ho, John Lowe, Dan McCarrie, Steve Martin, Richard Paul, Richard Rogers, Alison Sampson, Neil Southard, Andrew Tyley, John Young
Services Engineer: Hilson Moran Partnership Ltd
Structural Engineer: Buro Happold / Jeon and Associates
Acoustic Consultant: Arup Acoustics
Area: 81,882m²
Cost: £80,000,000

Waterside, Paddington Basin

London, England, UK, 1999–2004
Client: PDCL (Paddington Development Corporation Ltd) / Chelsfield plc
Design Team: Maurice Brennan, Maxine Campbell, Stephen Light, David Merllie, Andrew Morris, Richard Rogers, Marita Schnepper, Patricia Sendin, Graham Stirk, Daniel Wright, Andy Young
Services Engineer: Ove Arup & Partners
Structural Engineer: Ove Arup & Partners
Civil Engineer: Halcrow Fox
Quantity Surveyor: Gardiner & Theobold
Main Contractor: Carillion plc
Project Manager: Mace
Planning Consultant: Montagu Evans
Lighting Consultant: Ove Arup & Partners
Cladding Consultant: Bickerdike Allen Partners
Lift Consultant: Ove Arup & Partners
Acoustic Consultant: Bickerdike Allen Partners
Fire Consultant: Warrington Fire Research
Landscape Architect: Gillespies
Area: 34,000m²
Cost: £56,000,000

Grand Union, Paddington 1 & 2

London, England, UK, 2001–
Client: PDCL (Paddington Development Corporation Ltd) / Chelsfield plc
Design Team: Andy Bryce, Maxine Campbell, Martin Cook, Mike Fairbrass, Angela Gates, Russell Gilchrist, Jan Güell, Mark Hallett, Stephen Light, Jose Llerena, John McElgunn, Annette Main, Tim Mason, Simon Jon Mercer, David Merllie, Andrew Morris, Richard Rogers, Patricia Sendin, Marita Schnepper, Kish Sohal, Graham Stirk, Jo Walters, Martin White, Simon Williams-Gunn, Will Wilmshurst, Andrew Yek
Services Engineer: Cundell Johnston & Partners
Structural Engineer: Pell Frischmann
Civil Engineer: Halcrow Fox
Quantity Surveyor: Davis Langdon & Everest
Project Manager: Mace
Main Contractor: Laing O'Rourke

Fire Consultant: Safe / Warrington Fire Research
Environmental Consultant: Environ
Traffic Engineer: Halcrow
Acoustic Consultant: AAD
Vertical Transportation: Lerch Bates & Associates
Cladding Consultants: Hyder
Planning Consultants: Turner & Townsend
Agents: Knight Frank
Landscape Architect: Gillespies
Area: Gross Area: 122,000m² (97,000m² above ground). Site Area: 11,400m². Net Lettable Area: 80,000m²
Cost: £218,000,000

Minami-Yamashiro Elementary School

Kyoto, Japan, 1995–2003
Client: Minami-Yamashiro Village
Design Team: Mark Darbon, Lennart Grut, Ivan Harbour, Hiroshi Hibio, Akihisa Kageyama, Sanekazu Kofuku, Naruhiro Kurosima, Tamiko Onozawa, Richard Rogers, Benjamin Warner, Yoshimori Watanabe
Services Engineer: Setsubi-Sekkei 21 / Six Squares
Structural Engineer: Umezawa Structural Engineers
Main Contractor: Asanuma Corporation
Landscape Architect: Equipe Espace
Surveyor: Dan Surveyors Office
Area: 24,384m²
Cost: £11,800,000

Broadwick House

London, England, UK, 1996–2002
Client: Derwent Valley Holdings plc
Design Team: Yasmin Al-Ani Spence, Maurice Brennan, Maxine Campbell, Mike Fairbrass, Stig Larsen, Annette Main, Andrew Morris, Tamiko Onozawa, Richard Rogers, Stephen Spence,
Martin White, John Young
Services Engineer: BDSP
Structural Engineer: Ove Arup & Partners
Quantity Surveyor: Davis Langdon & Everest
Main Contractor: John Sisk & Son
Project Manager: Buro Four Project Services
Acoustic Consultant: Arup Acoustics
Area: 32,000m²
Cost: £6,900,000
Awards: RIBA Award 2003, Estates Gazette Architecture Award 2001

Chiswick Park

London, England, UK, 1999–2004
Client: Stanhope plc
Design Team: Daniel Crane, Charles Gagnon, Pascale Gibon, Nick Hancock, Charles Meloy, Richard Paul, Tosan Popo, Richard Rogers, Neil Southard, Andrew Tyley
Services Engineer: Ove Arup & Partners
Structural Engineer: Ove Arup & Partners
Civil Engineer: O'Rourke Civil Engineering Ltd
Quantity Surveyor: Davis Langdon Everest / Mott Green & Wall
Main Contractor: Bovis Construction Ltd
Traffic Consultant: Halcrow Fox & Associates
Fire Consultant: Warrington Fire Research Consultants
Facade Consultant: Josef Gartner
Landscape Architect: W8 Landscape Architects and Urban Planners / Charles Funke Associates
Specialist Steelwork: Westbury Steel (Phase1), CMF (Phase 2)
Computer Graphics: Hayes Davidson
Letting Agents: Jones Lang La Salle & PDF Savills
Area: 150,000m²
Cost: £130,000,000
Awards: RIBA Award 2003, BALI National Landscaping Award 2002, British Construction Industry Award for Best Practice 2002, The British Council for Offices 'Best of the Best' Award 2002, Civic Trust Award 2002, Office Agent Society Development of the Year Award for Best Town Centre Suburban Office Development 2001

Robert Bosch Foundation

Stuttgart, Germany, 2000
Client: Robert Bosch Foundation
Design Team: Stuart Blower, Torsten Burkhardt, Lennart Grut, Ivan Harbour, Sanekazu Kofuku, Tom Lacey, Richard Rogers, Simon Smithson
Services Engineer: BDSP
Structural Engineer: Expedition Engineering

Canary Wharf – Riverside South

London, England, UK, 2000–
Client: Canary Wharf
Executive Architect: Adamson Associates
Design Team: Stephen Barrett, Martin Cook, Dan Crane, Mike Davies, Mike Fairbrass, Stuart Forbes, Pascale Gibon, Nick Hancock, Ivan Harbour, Charles Meloy, Andrew Morris, Beatriz Olivares, Tosan Popo, Richard Paul, Richard Rogers, Neil Southard, Andrew Tyley
Services Engineer: Hilson Moran Partnership

Structural Engineer: Yolles Partnership Ltd
Main Contractor: Canary Wharf Contractors Ltd
Lift Consultant: HH Angus and Associates
Facade Consultant: REEF Associates Ltd
Geotechnical Consultant: ARUP Geotechnics
Fire Safety Consultant: ARUP Fire
Road Engineering: Steer Davies Gleeve
Acoustic Consultant: Sandy Brown Associates
Landscape Architect: Derek Lovejoys Partnership
Area: Gross: 279,075m². Net Lettable: 165,727m². Site Area: 21,101m²

Viladecans Business Park

Barcelona, Spain, 2001–2004
Client: Ajuntament de Viladecans / Bali / Proinosa / Arlington
Co-Architect: Alonso Balaguer y Arquitectos Asociados
Design Team: (RRP / Alonso Balaguer y Arquitectos Asociados) Laurie Abbott, Luís Alonso, Lennart Grut, Amarjit Kalsi, Juan Laguna, Erick Mass, Richard Rogers, Patricia Sendin, Patricia Vasquez
Services Engineer: BDSP Partnership / J.G. y Asociados
Structural Engineer: Obiol, Moya y Asociados / Brufau & Asociados
Quantity Surveyor: G3 Tecnics
Main Contractor: Proinosa
Fire Consultant: G3
Area: Plots A, B and C Site Area 84,300m². Built Area 130,600m²

Torre Espacio 1–3*

Madrid, Spain, 2001–
Client: Inmobiliaria Espacio
Design Team: Andy Bryce, Maxine Campbell, Hilde Depuydt, Angela Gates, Russell Gilchrist, Jan Güell, Mark Hallett, Tim Mason, John McElgunn, Richard Rogers, Graham Stirk, Will Wimshurst, Andrew Yek
Services Engineer: Arup
Structural Engineer: Arup
Area: 56,250m²

122 Leadenhall Street

London, England, UK, 2002–
Client: British Land
Design Team: Andy Bryce, Maxine Campbell, Russell Gilchrist, Mark Hallett, Justin Lau, Robert Luck, John McElgunn, Charles Meloy, Andrew Morris, Jack Newton, Louise Palomba, Richard Rogers, Graham Stirk, Kenny Tsui, Will Wilmshurst, Andrew Yek
Services Engineer: Ove Arup & Partners
Structural Engineer: Ove Arup & Partners

Quantity Surveyor: Davis Langdon & Everest
Project Manager: M3 Consulting
Planning Consultant: Montagu Evans/DP9
Fire Consultant: Warrington Fire Research
Planning Consultant: DP9
Agent: DTZ
Landscape Architect: Derek Lovejoy Partnership
Area: Gross Internal Area: 84,424m². Net Lettable Internal Area: 56,333m². Site Area: 3,500m²

Mossbourne Community Academy

London, England, UK, 2002–2004
Client: Mossbourne Community Academy Ltd
Design Team: Sean Daly, Lucy Evans, James Finestone, Ivan Harbour, Jose Llerena, Steven Leung, Tracy Meller, Annie Miller, Andrew Morris, Louise Palomba, Leonardo Pelleriti, Dean Pike, Sabien Rietjens, Richard Rogers, Andrei Saltykov, Paul Thompson, Yoshi Uchiyama
Services Engineer: BDSP Partnership
Structural Engineer: Whitby Bird & Partners
Quantity Surveyor: Davis Langdon & Everest / Mott MacDonald
Main Contractor: MACE Ltd
Project Manager: Osprey Mott MacDonald
Landscape Architect: Kinnear Landscape Architect
Area: 8,312m²
Cost: £25,000,000

Protos Wineries

Peñafiel, Valladolid, Spain, 2004–06
Client: Protos Bodegas
Co-Architect: Alonso Balaguer y Arquitectos Asociados
Design Team: (RRP / Alonso Balaguer y Arquitectos Asociados) Luís Alonso, Ronald Lammerts Van Beuren, Maxine Campbell, Alex Franz, Silvia Fukuoka, Russell Gilchrist, Lennart Grut, Jan Güell, Jakob Hense, Juan Laguna, Jack Newton, Tamiko Onozawa, Olga Pajares, Gustavo Rios, Richard Rogers, Graham Stirk, Patricia Vázquez, Patricia Yanes, Andrew Yek
Services Engineer: BDSP Partnership / Grupo JG - Agroindus
Structural Engineer: Ove Arup & Partners / BOMA / Agroindus
Quantity Surveyor: Tècnics G3
Area: 19,000m²
Cost: £12,000,000

Public Buildings Credits

*Indicates unbuilt project

Aram Service Module*

Various Locations, 1971
Client: Association of Rural Aid in Medicine Inc
Design Team: Marco Goldschmied, Renzo Piano, Richard Rogers, Su Rogers, Peter Ullathorne, John Young
Services Engineer: Max Fordham
Structural Engineer: Anthony Hunt Associates
Area: 2,500m²

Centre Culturel d'Art Georges Pompidou

Paris, France, 1971–77
Client: Ministére des Affaires Culturelles / Ministére de l'Education Nationale
Design Team: Partners in Charge: Renzo Piano, Richard Rogers.
Competition: Sally Appleby, Peter Flack, Gianfranco Franchini, Marco Goldschmied, Jan Kaplicky, Su Rogers, John Young. Collaborators: Ken Allinson, William Carmen, Chris Dawson, Tony Dugdale, Alphons Oberhofer, Judith Raymond, Martin Richardson, Philippe Robert
Administration: Françoise Gouinguenet, Claudette Spielmann, Colette Valensi
Services Engineer: Ove Arup & Partners
Structural Engineer: Ove Arup & Partners
Substructure and Mechanical Services: Walter Zbinden with Hans-Peter Bysaeth, Johanna Lohse, Peter Merz, Philippe Dupont. Superstructure and Mechanical Services: Laurie Abbott with Shunji Ishida, Hiroshi Naruse, Hiroyuki Takahashi
Facade Engineer: Eric Holt with Michael Davies, Jan Sircus
Quantity Surveyor: Ove Arup & Partners
Main Contractor: Grands Travaux de Marseilles
Site Management: Bernard Plattner
Interior Design: Gianfranco Franchini
Furniture Systems: John Young with Francois Barat, Helen Diebold, Jacques Fendard, Jean Huc, Helga Schlegel
Internal and External Systems / Audio Visual: Alan Stanton with Michael Dowd, William Logan, Noriaki Okabe, Rainer Verbizh
Environment and Piazza Scenographic Spaces: Cuno Brullmann

Graphic Design: VDA Group
Cost: £58,800,000
Area: 100,000m²
Awards: International Union of Architects August Perret Prize for most outstanding international work 1975–78

IRCAM

Paris, France, 1971–77
Client: Ministére des Affaires Culturelles / Ministére de l'Education Nationale
Design Team: Mike Davies, Alphons Oberhofer, Noriaki Okabe, Renzo Piano, Bernard Plattner, Richard Rogers, Ken Rupard, Jan Sircus, Walter Zbinden
Services Engineer: Ove Arup & Partners
Structural Engineer: Ove Arup & Partners
Quantity Surveyor: Ove Arup & Partners
Main Contractor: Grands Travaux de Marseilles
Acoustic Consultant: Peutz and Associates
Scenographer: G L Francois
Cost : £4,750,000
Area: 6,000m²

Coin Street Development*

London, England, UK, 1979–83
Client: Greycoat Commercial Estates Ltd
Design Team: Laurie Abbott, Mike Davies, Jan Dunsford, Marco Goldschmied, Philip Gumuchdjian, Amarjit Kalsi, Sue McMillan, Andrew Morris, Tim Oakshott, Richard Rogers, John Sorcinelli, Peter Thomas, Chris Wilkinson, John Young
Services Engineer: Ove Arup & Partners
Structural Engineer: Ove Arup & Partners
Quantity Surveyor: Gardiner and Theobald
Traffic Consultant: W R Davidge and Partners
Area: Offices: 92,500m². Residential: 18,500m². Shopping + Restaurants: 10,500m². Leisure: 6,500m². Light Industrial Units: 2,800m²

National Gallery Extension*

London, England, UK, 1982
Client: Speyhawk plc / The Property Services Agency by direction of the Secretary of State for the Environment
Design Team: Laurie Abbott, Julia Barfield, Mike Davies, Marco Goldschmied, Philip Gumuchdjian, Di Hope, Sue McMillan, Andrew Morris, Gennaro Picardi, Richard Rogers, John Sorcinelli, Richard Soundy, Peter St John, Peter Thomas, John Young
Services Engineer: YRM Engineers
Structural Engineer: Ove Arup & Partners
Quantity Surveyor: Axtell Yates Hallett
Area: 11,900m^2

Centre Commercial St Herblain

Nantes, France, 1986–87
Client: Groupement Rhodanien de Construction, Lyon Commercial Centre
Co-Architect: Atelier Claude Bucher
Design Team: Kieran Breen, Philippa Browning, Mike Davies, Pierre Ebbo, Florian Fischötter, Marco Goldschmied, Lennart Grut, Werner Lang, Stig Larsen, Richard Rogers, Stephen Spence, John Young
Services Engineer: Ove Arup & Partners / OtH
Structural Engineer: Ove Arup & Partners / Rice Francis Ritchie, OtH Rhone-Alps
Quantity Surveyor: Thorne Wheatley Associates, Paris
Lighting Consultant: Lighting Design Partnership
Landscape Architect: David Jarvis Associates / Dan Kiley
Interior Designer: B & FL, Paris
Awards: Concours des Plus Beaux Ouvrages de Construction Metallique 1988
Area: 21,000m^2
Cost: £6,300,000

Autosalon*

Massey, France, 1987
Client: Groupement Rhodanien e Construction, Lyon, France
Design Team: Laurie Abbot, Kieran Breen, Mike Davies, Florian Fischötter, Marco Goldschmied, Lennart Grut, Stig Larsen, John McFarland, Richard Rogers, Stephen Spence, John Young
Services Engineer: OtH, Paris
Structural Engineer: Ove Arup & Partners, London / RFR, Paris / OtH Rhone-Alps, Lyon
Quantity Surveyor: Thorne Wheatley Associates
Area: 20,000m^2

Pont d'Austerlitz*

Paris, France, 1988
Client: Ville de Paris
Design Team: Laurie Abbott, Kieran Breen, Philip Chalmers, Mike Davies, Marco Goldschmied, Lennart Grut, Enrique Hermosa-Lera, Avtar Lotay, Richard Rogers, Stephen Spence, John Young
Structural Engineer: Ove Arup & Partners

The European Court of Human Rights

Strasbourg, France, 1989–95
Client: Conseil de l'Europe
Co-Architect: Atelier d'Architecture Claude Bucher
Design Team: Laurie Abbott, Peter Angrave, Eike Becker, Elliot Boyd, Mike Davies, Karin Egge, Pascale Gibon, Marco Goldschmied, Lennart Grut, Ivan Harbour, Amarjit Kalsi, Sze-King Kan, Carmel Lewin, Avtar Lotay, John Lowe, Louise Palomba, Kim Quazi, Richard Rogers, Pascale Rousseau, Yuli Toh, Sarah Tweedie, Andrew Tyley, Yoshiyuki Uchiyama, John Young
Services Engineer: Ove Arup & Partners / Omnium Technique Européen
Structural Engineer: Ove Arup & Partners / Omnium Technique Européen (OTE)
Quantity Surveyor: Thorne Wheatley Associates
Main Contractor: Campenon Bernard SGE
Lighting Consultant: Lighting Design Partnership
Acoustic Consultant: Sound Research Laboratories / Commins Ingemansson
Landscape Architect: David Jarvis Associates / Dan Kiley
Area: 300,000m^2
Cost: £35,000,000

Tokyo International Forum*

Tokyo, Japan, 1990
Client: Mitsubishi
Design Team: Laurie Abbott, Peter Angrave, Mike Davies, Fiona Galbraith, Marco Goldschmied, Jackie Hands, Shahab Kasmai-Tehran, Hiroshi Kawana, Avtar Lotay, Michael McNamara, Mark Newton, Richard Rogers, Masaaki Sekiya, Stephen Spence, Graham Stirk, Benjamin Warner, John Young
Services Engineer: Ove Arup & Partners
Structural Engineer: Ove Arup & Partners
Acoustic Consultant: Arup Acoustics

Futurum Diner*

1990
Client: Wilhelm W Gladitz
Design Team: Mike Davies, Marco Goldschmied, Philip Gumuchdjian, Richard Rogers, Stephen Spence, John Young

Christopher Columbus Center*

Baltimore, Maryland, USA, 1990
Client: Christopher Columbus Center Development Inc
Co-Architect: Grieves Associates Inc
Design Team: Laurie Abbott, Mike Davies, Max Fawcett, Marco Goldschmied, Amarjit Kalsi, Swantje Kühn, Ernest Lowinger, Andrew Morris, Richard Rogers, Stephen Spence, Graham Stirk, Yuli Toh, John Young
Services Engineer: H C Yu
Structural Engineer: Robert Silman Associates
Civil Engineer: Rummel Klepper and Kahl
Quantity Surveyor: Hanscomb Ltd
Parking Consultant: Central Parking

Tomigaya Exhibition Space*

Tokyo, Japan, 1990–92
Client: K-One Corporation
Co-Architect: Architect 5
Design Team: Laurie Abbott, Maxine Campbell, Mike Davies, Stuart Forbes, Marco Goldschmied, Miyuki Kurihara, John Lowe, Richard Rogers, Kyoko Tomioka, Benjamin Warner, Andrew Wright, John Young
Services Engineer: ES Associates / Ove Arup & Partners
Structural Engineer: Umezawa Design Office

Bordeaux Law Courts

Bordeaux, France, 1992–98
Client: Ministère de la Justice & Tribunal de Grande Instance
Design Team: Stephen Barrett, Elliot Boyd, Mike Davies, Pascale Gibon, Marco Goldschmied, Lennart Grut, Philip Gumuchdjian, Jackie Hands, Ivan Harbour, Avery Howe, Eric Jaffrès, Amarjit Kalsi, Stig Larsen, Carmel Lewin, Avtar Lotay, Annette Main, Sophie Nguyen, Tamiko Onozawa, Louise Palomba, Kim Quazi, Richard Rogers, Dan Sibert, Simon Smithson, John Young
Services Engineer: OtH Sud-Ouest / Ove Arup & Partners
Structural Engineer: Ove Arup & Partners / OtH Sud-Ouest
Quantity Surveyor: Interfaces, Ingérop
Main Contractor: Spie Citra Midi Atlantique
Site Management: OtH Sud-Ouest
Lighting Consultant: Lighting Design Partnership
Cladding Consultant: Rice Francis Ritchie
Acoustic Consultant: Sound Research Laboratories
Landscape Architect: Dan Kiley / Edward Hutchison / Branch Associates
Area: 25,000m²
Cost: £27,000,000

Saitama Arena*

Saitama, Japan, 1995
Client: Saitama Prefecture
Design Team: Richard Rogers Partnership: Laurie Abbott, Sabine Coldrey, Mike Davies, Mike Fairbrass, Marco Goldschmied, Lennart Grut, Jackie Hands, Dennis Ho, Chun Jiang, Paul Johnson, Naruhiro Kuaroshima, James Leathem, Nick Malby, Carol Painter, Richard Paul, Richard Rogers, Neil Southard, Ben Warner, John Young. Other Constituent Team Members: Ove Arup & Partners, Japan, LOBB Partnership, Wembley International, Dumais Japan, NHK Art, MHS Planners, Architects & Engineers, Nippon Steel Corporation, Overseas Bechtel, Kayaba Industry, SONY Facility Service, Komatsu Wall Industry, The SWA Group, Fujita, Samsung Engineering & Construction, Saeki. Collaborators: YAMAHA Music Foundation, STBRI, FUJITSU, Matsushita Electric Works, NHK Integrated Technology, SETIMEG, SCENE, Fuji Sound, Hochiki, Kotobuki, ATAKA Fire Safety Design Office, Virgin Mega Store, SEGA, Shimizu Sports
Services Engineer: Fujita Construction
Structural Engineer: Arup
Quantity Surveyor: Fujita Construction
Computer Graphics: Dan MacCarrie
Area: 96,000m²
Cost: £335,000,000

Millennium Experience

London, England, UK, 1996–99
Client: The New Millennium Experience Company
Design Team: Maurice Brennan, Eliot Boyd, Andrew Bryce, Maxine Campbell, Martin Cook, Joe Croser, Chris Curtis, Mike Davies, Chris Dawson, Francesco Draisci, Michael Elkan, Mike Fairbrass, James Finestone, Paul Forbes, Stuart Forbes, Harvinder Gabhari, Angela Gates, David Giera, Marco Goldschmied, Philip Gumuchdjian, Rachel Hart, Dennis Ho, Lucy Hooper, Jenny Jones, Amarjit Kalsi, Stig Larsen, Roo Lam Lau, Marcus Lee, Annette Main, Nick Malby, Catherine Martin, Steve Martin, Tim Mason, Andrew Morris, Sophie Nguyen, Andrea Parigi, Adel Pascale, Andrew Partridge, Tosan Popo, Richard Rogers, Nadine Rulliere, Alison Sampson, Katie Sohal, Neil Southard, Richard Stanton, David Thompson, Andrew Tyley, Angela van Herk, Robert Webb, Martin White, Adrian Williams, John Young, Nick Zervoglos
Services Engineer: Buro Happold Consulting Engineers
Structural Engineer: Buro Happold Consulting Engineers
Civil Engineer: WS Atkins
Quantity Surveyor: Hanscomb
Main Contractor: McAlpine / Laing
Construction Manager: McAlpine / Laing joint venture

Planning Supervisor: Ove Arup & Partners on behalf of RRP
Fire Consultant: Buro Happold / Fedra
Environmental Consultant: Battle McCarthy
Acoustic Consultant: Sandy Brown Associates
Specification Writer: Davis Langdon Everest / Schumann Smith
Landscape Architect: Desvigne & Dalnoky / Bernard Ede
Area: 100,000m^2
Awards: RIBA Award 2000, Civic Trust Award Commendation 2000,
European Structural Steel Design Award 2000, Royal Academy Summer
Exhibition 1998
Cost: £43,000,000

Ashford Designer Retail Outlet Centre

Ashford, Kent, England, UK, 1996–2000
Client: BAA McArthurGlen UK Ltd
Design Team: Laurie Abbott, Martin Cook, Sean Daly, Mark Darbon,
Mike Fairbrass, Rowena Fuller, Jane Hannan, Toby Jeavons, Tom Lacey,
Catherine Martin, Tim Mason, Andrew Morris, Richard Rogers, Neil
Southard, Andrew Tyley, Robert Webb, Martin White, Daniel Wright,
John Young
Services Engineer: John Brady Associates
Structural Engineer: Buro Happold
Civil Engineer: Buro Happold / Arup
Quantity Surveyor: Davis Langdon & Everest
Main Contractor: Galliford Northern
Planning Consultant: Montagu Evans
Lighting Consultant: Equation Lighting Design
Landscape Architect: Derek Lovejoy Partnership
Area: 19,510m^2
Cost: £21,000,000

Antwerp Law Courts

Antwerp, Belgium, 1998–2005
Client: Regie der Gebouwen
Co-Architect: PVK Architects
Design Team: David Ardill, Stuart Blower, Ed Burgess, Yoon Choi,
Martin Cook, Benjamin Darras, Hilde Depuydt, Mike Fairbrass, Rowena
Fuller, Angela Gates, Kevin Gray, Sera Grubb, Sean Han, Ivan Harbour,
Dennis Ho, Amarjit Kalsi, Steven Leung, Avtar Lotay, John Lowe, Tim
Mason, Annie Miller, Andrew Morris, Tamiko Onozawa, Sabien Rietjens,
Richard Rogers, Renee Searle, Patricia Sendin, Simon Smithson, Yoshi
Uchiyama, Martin White
Services Engineer: Ove Arup & Partners / Bureau Van Kerckhove
Structural Engineer: Ove Arup & Partners / Bureau Van Kerckhove

Electrical Engineer: VK Engineering

Quantity Surveyor: Bureau Van Kerckhove
Main Contractor: Interbuild / KBC / Artesia
Fire Consultant: IFSET NV
Lighting Consultant: Ove Arup & Partners
Facade Consultant: Lesos Engineering
Acoustic Consultant: Arup Acoustics
Landscape Architect: Wirtz International BV
Area: 77,000m^2
Cost: £86,000,000

National Assembly for Wales

Cardiff, Wales, UK, 1998–2005
Client: National Assembly for Wales
Design Team: David Ardill, Ed Burgess, Mike Davies, Lucy Evans,
Mike Fairbrass, Rowena Fuller, Marco Goldschmied, Ivan Harbour,
Mimi Hawley, Kazu Kofuku, Tom Lacy, James Leathem, Jose Llerena,
John Lowe, Tim Mason, Stephen McKaeg, Annie Miller, Liz Oliver,
Tamiko Onozawa, Mathis Osterhage, Inma Pedragosa, Tosan Popo,
Richard Rogers, Simon Smithson, Neil Wormsley, Daniel Wright, Yoshi
Uchiyama, John Young
Services Engineer: BDSP Partnership
Structural Engineer: Arup
Civil Engineer: Arup
Facade Engineer: Arup Facade Engineering
Quantity Surveyor: Taylor Woodrow Construction / Northcroft
Project Manager: TPS
Main Contractor: Taylor Woodrow Construction
Fire Consultant: Warrington Fire Research
Glass Consultant: John Colvin
Access Consultant: Vin Goodwin
Aerodynamics Consultant: Arup
Specification Consultant: Davis Langdon Schumann Smith
Environmental Consultant: BDSP Partnership
Acoustic Consultant: Sound Research Laboratories
Landscape Architect: Gillespies
Wind Tunnel Testing: BMT Fluid Dynamics
Set Design: Department Purple
Modelmakers: Richard Rogers Partnership Modelshop / Millennium
Modelmakers
Area: 4,000m^2
Cost: £40,997,000

Shin-Puh-Kan Shopping Centre

Kyoto, Japan, 1999–2001
Client: NTT Urban Development Co
Co-Architect: NTT Facilities, Inc
Design Team: Lennart Grut, Ivan Harbour, Akihisa Kageyama, Naruhiro Kuroshima, Richard Rogers, Benjamin Warner
Structural Engineer: NTT Facilities, Inc
Mechanical Engineer: NTT Facilities, Inc
Electrical Engineer: NTT Facilities, Inc
Main Contractor: Shimizu Corporation
Audio/Visual Consultants: P4
Lighting Design: Uchihara Creative Lighting Design
Area: 8,234 m²

Hesperia Hotel & Conference Centre

Hospitalet, Spain, 1999–2006
Client: Hespería Hotels SA
Co-Architect: Alonso Balaguer y Aquitectos Asociados
Design Team: Laurie Abbott, Luís Alonso, David Ardill, Miquel Bargallo, Olga Curell, Silvia Fukuoka, Lennart Grut, Ýr Gudmundsdottir, Dennis Ho, Martin Kehoe, Mateo Miyar, Andrew Morris, Beatriz Olivares, Andrew Partridge, Maite Payà, Gustavo Rios, Richard Rogers, Patricia Vázquez, Nuria Widman
Services Engineer: BDSP / J G y Asociados
Structural Engineer: Buro Happold / Obiol, Moya y Asociados, Brufau y Asociados
Quantity Surveyor: Atkins, Faithful & Gould / G3 Tecnics
Main Contractor: Construcciones Castro
Area: Site Area including Park: 50,000m². Hotel: 14,000m². Conference Centre: 4,500m². Sports Club: 5,900m²
Cost: £30,000,000

Rome Congress Centre Competition*

Rome, Italy, 2000
Client: Centro Congressi Italia
Design Team: Louise Barnett, Maurice Brennan, Andy Bryce, Russell Gilchrist, Mark Hallett, Carmel Lewin, Andrea Parigi, Richard Paul, Richard Rogers, Andrei Saltykov, Patricia Sendin, Kish Sohal, Graham Stirk, David Thompson, Nick Zervoglos
Services Engineer: Ove Arup & Partners
Structural Engineer: Ove Arup & Partners
Quantity Surveyor: Atkins, Faithful & Gould (Hanscomb Ltd)
Traffic Consultant: Arup Transportation
Awards: AR/MIPIM Future Project Award High Commendation 2003, Royal Academy Summer Exhibition Gold Medal AJ / Bovis Award 2001

Las Arenas

Barcelona, Spain, 2000–2008
Client: Sacresa
Co-Architect: Alonso Balaguer y Arquitectos Asociados
Design Team: Laurie Abbott, Luís Alonso, M Angels Fernández, David Ardill, Miquel Bargallo, Ronald Lammerts Van Beuren, Iñaki Díez Aguirre, Mike Fairbrass, James Finestone, Angela Gates, Lennart Grut, Jakob Hense, Dennos Ho, Martin Kehoe, James Leathem, Erick Maas, Andrew Morris, Liz Oliver, Tamiko Onozawa, Richard Rogers, Neil Wormsley
Services Engineer: JG & BDSP
Structural Engineer: Expedition Engineering & BOMA
Quantity Surveyor: TG3
Main Contractor: ACS
Facade Consultant: Expedition Engineering and BOMA
Acoustic Consultant: BDSP and Audioscan
Retail Consultant: Sociedad Centros Comerciales España (S.C.C.E)
Area: Total Area: 149,000m². Bullring: 45,000m². Eforum: 51,000m². Parking: 53,000m²
Cost: £67,160,000

Maggie's Centre London

London, UK, 2001–2006
Client: Maggie's Centre
Design Team: Ed Burgess, James Curtis, Mike Fairbrass, Ivan Harbour, Tom Lacy, Carmel Lewin, Tim Mason, Annie Miller, Liz Oliver, Richard Rogers, Martin White, William Wimshurst, Neil Wormsley
Services Engineer: Ove Arup & Partners
Structural Engineer: Ove Arup & Partners
Quantity Surveyor: Turner Townsend
Landscape Architect: Dan Pearson Studio
Fire Consultant: Warrington Fire Research
Lighting Consultant: Speirs and Major
Planning Supervisor: TPS Schal
Approved Inspectors: Butler and Young
Area: 370m²
Cost: £2,000,000

City of Justice*

Barcelona/ L'Hospitalet de Llobregat, Spain, 2002
Client: Generalitat de Catalunya, Regional Government of Catalunya
GISA Gestió d'Infrastructures SA
Co-Architect: Alonso Balaguer y Arquitectos Asociados
Design Team: Luís Alonso, Natxo Alonso, Andy Bryce, Ronald Lammerts van Bueren, Benjamin Darras, Russell Gilchrist, Jan Güell, Mark Hallett, John McElgunn, Richard Rogers, Graham Stirk, Andrew Yek
Services Engineer: Ove Arup & Partners
Structural Engineer: Ove Arup & Partners
Area: Total Gross Area: 264,500m². Gross Area Above Ground: 180,500m². Gross Area Below Ground: 84,000m²

Library of Birmingham

Birmingham, England, UK, 2002–
Client: Birmingham City Council
Design Team: Andy Bryce, Ed Burgess, Maxine Campbell, Justin Lau, Carmel Lewin, John McElgunn, Jack Newton, Richard Rogers, Graham Stirk, Andrew Yek
Services Engineer: BDSP Partnership
Structural Engineer: Ove Arup & Partners
Quantity Surveyor: Gleeds
Area: 35,000m²
Cost: £130,000,000

Sabadell Congress & Cultural Centre*

Sabadell, Spain, 2002
Client: Sabadell City Authority
Co-Architect: Alonso Balaguer y Arquitectos Asociados
Design Team: Natxo Alonso, Phaedra Corrigan, Adam Cossey, Ben Darras, Mike Fairbrass, Angela Gates, Jan Güell, Ivan Harbour, Justin Lau, Stephen McBean, Tim Mason, Jon Mercer, Jack Newtown, Richard Rogers
Services Engineer: Ove Arup & Partners
Structural Engineer: Ove Arup & Partners
Quantity Surveyor: Tècnics G3 / Grupo JG
Area: 50,000m²

Fourth Grace*

Liverpool, England, UK, 2003
Client: Liverpool Vision
Design Team: Maxine Campbell, Adam Cossey, Sean Daly, Mark Darbon, Lucy Evans, Toby Jeavons, Tracy Meller, Richard Rogers
Services Engineer: Ove Arup & Partners
Structural Engineer: Ove Arup & Partners
Quantity Surveyor: DTZ
Area: 77,938m²
Cost: £75,000,000

Glasgowbridge.com

Glasgow, Scotland, UK, 2003–
Client: Glasgow City Council
Design Team: Maurice Brennan, Benjamin Darras, Philip Dennis, Mike Fairbrass, Angela Gates, Russell Gilchrist, Jon Mercer, David Merllie, Ben Nicholls, Liz Oliver, Richard Rogers, Patricia Sendin, Graham Stirk, Will Wimshurst, Andy Young
Services Engineer: WS Atkins
Structural Engineer: WS Atkins
Hydraulic Engineer: WS Atkins
Quantity Surveyor: Faithful & Gould
Lighting Consultant: Speirs & Major Associates
Project Manager: Faithful & Gould
Landscape Architect: WS Atkins
Cost: £40,000,000

Sightseeing/Television Tower

Guangzhou, China, 2004
Client: Guangzhou Municipal Construction Commission / Guangzhou Urban Planning Bureau
Design Team: Laurie Abbott, Natxo Alonso, Benjamin Darras, Nick Hancock, Tim Mason, Jon Mercer, Richard Paul, Inma Pedregosa, Tosan Popo, Richard Rogers, Matt Venn
Area: Site Area: 84,880m². Gross Floor Area: 94,462m²
Structural Engineer: Arup
Services Engineer: Arup
Quantity Surveyor: Gleeds

Masterplanning Credits

*Indicates unbuilt project

Arno Masterplan*

Florence, Italy, 1983–84
Client: Council of the City of Florence
Co-Architect: Claudio Cantanella
Design Team: (RRP / Claudio Cantanella) Mike Davies, Marco Goldschmied, Philip Gumuchdjian, Andrew Morris, Gennaro Picardi, Richard Rogers, Alan Stanton, John Young
Hydraulic Engineer: Enrico Bougleux

Royal Albert Docks Masterplan*

London, UK, 1986
Client: Rosehaugh Stanhope Developments
Design Team: Laurie Abbott, Graham Anthony, Kieran Breen, Philip Chalmers, Tim Colquhoun, Mike Davies, Marco Goldschmied, Philip Gumuchdjian, Ivan Harbour, Shahab Kasmai-Tehran, Avtar Lotay, Ernest Lowinger, Andrew Morris, Tom Nugent, Andrew Partridge, Robert Peebles, Mark Roche, Richard Rogers, Stephen Spence, Andrew Tyley, John Young
Structural Engineer: Ove Arup & Partners
Civil and Geotechnical Engineer: Ove Arup & Partners
Quantity Surveyor: Gardiner & Theobald
Construction Consultant: Schal
Retail Consultant: Edward Erdman
Landscape Architect: Hanna Olin Limited
Area: Retail Centre: 139,400m². Business Park: 241,600m². Marina + Leisure Zone: 55,800m². Riverside Housing Zone: 50,200m². Windsor Park Housing Zone: 69,700m²

London as it could be

London, UK, 1986
Design Team: Laurie Abbott, Philip Gumuchdjian, Stephen Pimbley, Richard Rogers
Structural Engineer: Ove Arup & Partners
Exhibition Design: John Andrews, Philip Gumuchdjian

Paternoster Square Masterplan*

London, England, UK, 1987
Client: Paternoster Consortium Ltd
Design Team: Laurie Abbott, Tim Colquhoun, Mike Davies, Ruth Elias, Marco Goldschmied, Ivan Harbour, Andrew Jones, Shahab Kasmai-Tehran, John Lowe, Richard Rogers, Graham Stirk, Joseph Wilson, Tina Wilson, John Young
Collaborators: Lifschutz Davidson Design, Doris Saatchi, Jim Allan Design
Services Engineer: Ove Arup & Partners
Structural Engineer: Ove Arup & Partners
Quantity Surveyor: Davis Langdon & Everest
Model Maker: R W Models
Area: 141,000m²

Potsdamer Platz Masterplan*

Berlin, Germany, 1991
Client: Daimler Benz AG, Sony AG, Hertie, ABB, Haus Vaterland
Design Team: Laurie Abbott, Peter Barber, Oliver Collignon, Mark Darbon, Alan Davidson, Mike Davies, Pascale Gibon, Marco Goldschmied, Lennart Grut, Ivan Harbour, Amarjit Kalsi, Oliver Kühn, Swantje Kühn , Avtar Lotay, Andrew Partridge, Richard Paul, Richard Rogers, Stephen Spence, Graham Stirk, Hugh Turner, Adrian Williams, John Young
Services Engineer: Ove Arup & Partners
Structural Engineer: Ove Arup & Partners

Shanghai Masterplan*

Shanghai, China, 1992–94
Client: Shanghai Development Corporation
Design Team: Laurie Abbott, Hal Currey, Mike Davies, Marco Goldschmied, Richard Rogers, Simon Smithson, Andrew Wright, John Young
Services Engineer: Ove Arup & Partners / Battle McCarthy
Resarch Consultants: Cambridge Architectural Research

Southbank Redevelopment*

London, UK, 1994
Client: South Bank Arts Centre
Design Team: Elliot Boyd, Maxine Campbell, Elantha Evans, Mike Fairbrass, Paul Forbes, Rowena Fuller, Ivan Harbour, Amarjit Kalsi, Tina Manis, Catherine Martin, Tim Mason, Richard Rogers, Simon Smithson
Area: 40,000m²
Cost: £70,000,000

ParcBIT 1 & 2

Mallorca, Balearics, Spain, 1994–
Client: Govern Balear, Conselleria d'Economia, Hisenda i Innovació
Design Team: Laurie Abbott, David Ardill, Maurice Brennan, Andrew Bryce, Sonia Costello, Mark Darbon, Mike Fairbrass, Lennart Grut, Ivan Harbour, Dennis Ho, Paul Johnson, Richard Rogers, Jaime Sicilia, Simon Smithson, Graham Stirk, Andrew Wright
Lead Environmental Consultant: Battle McCarthy
Transport Engineer: Ove Arup & Partners
Quantity Surveyor: GA Hanscomb Partnership
Hydrological & Sewerage Surveys: Binnie Black & Veatch
Communications Consultant: Ove Arup & Partners
Environmental Consultant: Battle McCarthy
Energy for Sustainable Development: ESD Limited
Landscape Architect: Nicholas Pearson Associates
Area: 44 hectares

Piana di Castello Masterplan*

Florence, Italy, 1995
Client: Comune di Firenze
Design Team: Laurie Abbott, Ernesto Bartolini, Dennis Ho, Richard Rogers
Environmental Engineer: Battle McCarthy
Landscape Architect: Battle McCarthy
Area: Site Area: 80 hectares, Built Area: 1,400,000m²

East Manchester Strategic Masterpan*

Manchester, England, UK, 1996
Client: Manchester City Council / North West Development Agency / English Partnerships
Design Team: Marcus Lee, Andrew Morrison, Richard Rogers, Andrew Wright (Andrew Wright Associates)

Greenwich Peninsula Masterplan

London, England, UK, 1997–2000
Client: English Partnerships
Design Team: Maxine Campbell, Mike Davies, Stuart Forbes, Philip Gumuchdjian, Adele Pascale, Nadine Rulliere, Nicholas Zervoglos
Services Engineer: WS Atkins
Structural Engineer: WS Atkins
Civil Engineer: WS Atkins
Transport Engineer: JMP / WS Atkins
Quantity Surveyor: Gardiner & Theobold
Project Manager: W S Atkins
Property Consultant: Jones Lang La Salle
Landscape Architect: Desvigne & Dalnoky / WS Atkins / Bernard Ede and Nicholas Pearson Associates
Area: 120 hectares
Cost: Construction Cost: £197,500,000. Contract Value: £147,500,000
Awards: Civic Trust Award for Landscaping Works (Greenwich Peninsula Masterplan) 2002

Viareggio Masterplan

Viareggio, Italy, 1999–
Client: Comune di Viareggio
Co-Architect: Alessandro Rizzo Architetto
Design Team: (RRP / Alessandro Rizzo Architetto) Laurie Abbott, Simon Catton, Dennis Ho, Tamiko Onozawa, Richard Rogers
Structural Engineer: Adamson Associates
Quantity Surveyor: Alessandro Rizzo Architetto
Landscape Architect: Grant Associates
Area: 50 hectares

Tate Bankside

London, England, UK, 2000
Client: Tate Modern
Design Team: Mike Davies, James Finestone, Tracy Meller, Nick Zervoglos
Planning Consultant: Drivers Jonas

Singapore Masterplan*

Singapore, 2000
Client: JTC, Singapore
Design Team: Jo-Anne Alldritt, Ler Bing Huan, James Finestone, Marco Goldschmied, Lennart Grut, Dennis Ho, Marcus Lee, Nick Zervoglos, Lee Shu Zhen
Traffic Engineer: Ove Arup & Partners
Environmental Consultant: Battle McCarthy
Area: 4,000,000m²

Silvertown Dock*

London, England, UK, 2001
Client: Capital & Provident Regeneration Ltd
Developer: George Wimpey plc / Countryside Properties plc / Capital and Provident Regeneration Ltd
Design Team: Sean Daly, Mark Darbon, Tracy Meller, Andrew Morris
Services Engineer: WSP Group plc
Structural Engineer: WSP Group plc
Engineering Consultant: WSP Group plc
Infrastructure Consultant: WSP Group plc
Quantity Surveyor: Martin Associates
Environmental Consultant: Richard Hodkinson Consultancy
Project Manager: George Wimpey plc
Area: 3,250 new homes and 106,000m² of other uses (commercial, retail, leisure and community)
Cost: £700,000,000

Wembley Masterplan

London, England, UK, 2002
Client: Quintain Estates & Development plc
Design Team: Laurie Abbott, Maxine Campbell, Martin Cook, Sean Daly, Mark Darbon, Hile Depuydt, Mike Fairbrass, Stuart Forbes, Angela Gates, Carolyn Gembles, Marco Goldschmied, Maria Hadjinicolaou, Dennis Ho, Tim Mason, Andrew Morris, Richard Rogers, Martin White, Neil Wormsley, Daniel Wright, John Young,
Services Engineer: Buro Happold
Structural Engineer: Buro Happold
Civil Engineer: Buro Happold
Transport Engineer: Buro Happold
Quantity Surveyor: EC Harris
Planning Consultant: Gerald Eve / RPS
Landscape Architect: Randle Siddeley
Area: Site area: 17 hectares, Development Area 493,000m²

Convoys Wharf

London, England, UK, 2002–
Client: News International plc
Design Team: Joveria Baig, Phaedra Corrigan, Sean Daly, Mark Darbon, Lucy Evans, Mike Fairbrass, Marco Goldschmied, Maria Hadjinicolaou, Toby Jeavons, Marcus Lee, Tracy Meller, Annie Miller, Nick Zervoglos
Services Engineer: Buro Happold
Structural Engineer: Buro Happold
Civil Engineer: Buro Happold
Transport Engineer: Buro Happold
Quantity Surveyor: Faithful & Gould
Planning Consultant: Montagu Evans / DP9

Geotechnical Consultant: Buro Happold
Landscape Architect: Bell Fischer
Area: 16 hectares

Almada Masterplan

Lisbon, Portugal, 2002–
Client: Municipal de Almada
Co-Architect: Santa-Rita Arquitectos LDA
Design Team: (RRP / Santa-Rita Arquitectos LDA) Laurie Abbott, Natxo Alonso, Ben Darras, Lennart Grut, Dennis Ho, Marcus Lee, Shu Zhen Lee, Marita Schnepper, Nick Zervoglos
Services Engineer: WS Atkins
Structural Engineer: WS Atkins
Quantity Surveyor: WS Atkins
Landscape Architect: WS Atkins
Area: 100 hectares

Woolston Shipyard

Southampton, UK, 2003–
Client: SEEDA Development & Infrastructure / English Partnerships
Design Team: Maxine Campbell, Mark Darbon, Andrew Morris, Georgina Robledo, Richard Rogers, Stephen Spence, Andy Young
Planning Consultants: Drivers Jonas
Environmental Research: Campbell Reith Hill
Traffic Engineers: Alan Baxter Associates
Quantity Surveyor: Davis Langdon & Everest
Area: 12.5 hectares

Lower Lea Regeneration / Olympic Masterplan

London, UK, 2003
Client: London Development Agency
Co-architects: Renzo Piano Building Workshop
Design Team: Jo-Anne Alldritt, Maurice Brennan, Maxine Campbell, Mike Davies, Benjamin Darras, Chris Dawson, Philip Dennis, Lucy Evans, Mike Fairbrass, Nick Hancock, Ivan Harbour, Tracy Meller, Jon Mercer, Andrew Morris, Richard Rogers, Marita Schnepper, Robert Torday, Joanne Walters, Martin White, Simon Williams-Gunn, John Young, Nick Zervoglos
Development Consultants: Lendlease
Structural Engineer: WS Atkins
Civil Engineer: WS Atkins
Transport Engineer: WS Atkins
Environmental and Planning Consultants: WS Atkins
Sports Consultants: Sport Concepts
Landscape Architect: West 8
Community Consultants: Community Action Network
Area: 600 hectares

Transport Credits

Terminal 5 Heathrow Airport

London, England, UK, 1989–2008
Client: BAA
Masterplanners and Lead Architects: RRP
Co-Architects: Pascal + Watson (production); Chapman Taylor (retail); HOK (rail systems); YRM (BAA liaison)
Design Team: Jimmy Abatti, Laurie Abbott, Jo-Anne Alldritt, Dennis Austin, Louise Barnett, Stephen Barrett, Stuart Blower, Maurice Brennan, Andy Bryce, Torsten Burkhardt, Maxine Campbell, Oliver Collignon, Mark Collins, Tim Colquhoun, Phadrai Corrigan, Davide Costa, Cathie Curran, Mike Davies, Chris Dawson, Hilde Depuyt, Desirée Dupuy, Bryn Dyer, Carol Eagles, Alantha Evans, Mike Fairbrass, James Finestone, Florian Fischötter, Stuart Forbes, Angela Gates, Pascale Gibon, Marco Goldschmied, Jorge Gomendio, Sera Grubb, Lennart Grut, Jackie Hands, Ivan Harbour, Alex Haw, John Höpfner, Avery Howe, Toby Jeavons, Jenny Jones, Amarjit Kalsi, Sze-King Kan, Shahab Kasmai-Tehran, Kazu Kofuku, Ronald Lammerts van Bueren, Marcus Lee, John Lowe, Clodagh Latimer, Carmel Lewin, Avtar Lotay, Stephen MacBean, Catherine Martin, Steve Martin, Tim Mason, David Merllie, Jackie Moore, Andrew Morris, Mark Newton, Sophie Nguyen, Beatriz Olivares, Astrid Osborn, Tim O'Sullivan, Carol Painter, Louise Palomba, Andrea Parigi, Julie Parker, Andy Partridge, Robert Peebles, Cynthia Poole, Kim Quazi, Susan Rice, Matt Rees, Richard Rogers, Yann Salmon, Andrei Saltikov, Rennee Searle, Patricia Sendin, Simon Smithson, Kish Sohal, Graham Stirk, Andrew Strickland, Taka Tezuka, Will Thorne, Yuli Toh, Jochen Tombers, Fai Tsang, Andrew Tyley, Yoshiyuki Uchiyama, Katherina Walterspiel, Christopher Wan, Adrian Williams, Megan Williams, Neil Wormsley, John Young, Chris Wan, Robert White, Sarah Wong
Services Engineer: DSSR / Arup
Structural Engineer: Arup
Civil Engineer: Mott McDonald
Quantity Surveyor: Turner & Townsend / E.C. Harris
Principal Contractors: Laing O'Rourke / Mace / Balfour Beaty / AMEC
Construction Management: BAA
Area: Including plant and baggage T5A (core terminal building) 300,000m². T5B (satellite 1) 60,000m². T5C (satellite 2, phase 2) 55,000m²
Cost: £4.2 billion

Control Tower, Heathrow

London, England, UK, 1989–2005
Client: BAA / NATS
Design Team: Stephen Barrett, Mike Davies, Amarjit Kalsi, Steve Martin, Richard Rogers, Andrei Saltykov, Stephen Spence
Services Engineer: DSSR / Amec
Structural Engineer: Arup
Facade Engineer: Arup Facade/ Schmidlin
Quantity Surveyor: Turner & Townsend
Main Contractor: MACE Ltd
Construction Manager: Mace Ltd
Fire Consultant: Warrington Fire Research Consultants
Lighting Consultant: Spiers & Major Lighting
Facade Consultant: Schmidlin UK
Lift Consultant: Schindler
Acoustic Consultant: Arup Acoustics
Substructure: Mott MacDonald
Specialist Steelwork: Watsons Steel
Area: 4,050m²
Cost: £50,000,000

Marseilles International Airport

Marseille, France, 1989–92
Client: Chambre de Commerce et d'Industrie de Marseille / Aeroport Marseille Provence
Co-Architect: Atelier 9 / ETA
Design Team: (RRP / Atelier 9 / ETA) Peter Barber, Pierre Botschi, Tim Colquhoun, Mike Davies, Pascale Gibon, Marco Goldschmied, Lennart Grut, Enrique Hermosa-Lera, Oliver Kühn, Swantje Kühn, Michael McNamara, Andrew Partridge, Gregoris Patsalosavvis, Kim Quazi, Richard Rogers, John Smith, John Young
Services Engineer: OtH Mediteranée
Structural Engineer: Ove Arup & Partners
Quantity Surveyor: CEC
Construction Manager: Bovis Construction Ltd
Specification Consultant: Schumann Smith
Acoustic Consultant: Sandy Brown Associates
Conducteur d'Operation: Service Special des Bases Aériennes Sud-Est
Area: 16,000m²
Cost: £14,582,100 (FF142,500,000)

Europier, Terminal 1, Heathrow Airport

London, England, UK, 1992
Client: Heathrow Airport Limited
Design Team: Laurie Abbott, Fiona Charlesworth, Tim Colquhoun, Julian Coward, Joe Croser, Hal Currey, Alan Davidson, Mike Davies, Mike Elkan, James Finestone, Jayne Fischer, Harvinder Gabhari, Marco Goldschmied, Jackie Hands, Ivan Harbour, Stephen Harty, Jim Huffman, Amarjit Kalsi, Stig Larsen, Marcus Lee, Avtar Lotay, John Lowe, Stephen Martin, Andrew Morris, Karen Murray, Ariff Azmee Nik, Julie Parker, Liz Parr, Andrew Partridge, Gregoris, Patsalosavvis, Richard Paul, Robert Peebles, James Philipps, Kim Quazi, Paul Richards, Richard Rogers, Daniel Sibert, Takaharu Tezuka, Yui Tezuka, Atsu Wada, Harriet Watson, Martin White, Megan Williams, John Young
Services Engineer: Hulley & Kirkwood Consulting Engineers
Structural Engineer: Waterman Partnership
Construction Manager: Bovis Construction Ltd
Fire Consultant: Warrington Fire Research
Retail Consultant: BDG / McColl
Specification Consultant: Schumann Smith
Facade Consultant: Ove Arup & Partners Facade Engineering
Acoustic Consultant: Sandy Brown Associates
Area: 15,350m^2
Cost: £21,500,000
Awards: British Construction Industry Award 1996

Heathrow Terminal 1, Flight Connection Centre

London, England, UK, 1992–96
Client: BAA and Bovis
Design Team: Laurie Abbott, Fiona Charlesworth, Tim Colquhoun, Julian Coward, Joe Croser, Hal Currey, Mike Davies, Chris Dawson, Michael Elkan, Mike Fairbrass, James Finestone, Jayne Fischer, Stuart Forbes, Stephen Harty, Harvinder Gabhari, Marco Goldschmied, Lennart Grut, Bjork Haraldsdottir, Stephen Harty, John Hopfner, Avery Howe, Marcus Lee, Stephen Light, Avtar Lotay, John Lowe, Steve Martin, Jackie Moore, Andrew Morris, Arif Azmee Nik, Julie Parker, Matt Parker, Elizabeth Parr, Gregoris Patsalosavvis, Robert Peebles, James Philipps, Kim Quazi, Paul Richards, Richard Rogers, Daniel Sibert, Stephen Spence, Gurit Suri, Takaharu Tezuka, Yui Tezuka, Yuli Toh, Atsu Wada, Harriet Watson, Martin White, Megan Williams, John Young
Structural Engineer: Hutter Jennings and Titchmarsh
Services Engineer: WSP Kenchington Ford
Construction Manager: Bovis Construction Limited
Lighting Consultant: Lighting Design Partnership
Baggage Handling: GEC
Fire Consultant: Warrington Fire Research
Acoustic Consultant: Sandy Brown Associates
Retail Consultant: BDG McColl

Pusan High Speed Rail Station Competition*

Pusan, South Korea, 1996
Client: Korean Highspeed Rail Company
Design Team: Dennis Ho, Dan Macarie, Richard Paul, Richard Rogers, Stephen Spence, Andrew Tyley
Co-Architect: POSCO Co Ltd Seoul
Structural Engineer: Ove Arup & Partners
Mechanical and Electrical Engineer: Ove Arup & Partners
Environmental Consultant: Ove Arup & Partners
Area: Site Area: 316,830m^2. Floor Area: 758,000m^2. Building Area: 114,800m^2

NAT Barajas, Madrid Airport

Madrid, Spain, 1997–2005
Client: AENA
Co-Architect: Estudio Lamela
Design Team: (RRP / Estudio Lamela) José Aguilar, Emilia Alonso, David Ardill, Adolfo Arellano, Andrés Arellano, Enrique Azpilicueta, Kenta J. Bacas, Mercedes Barbero, Neus Barbosa, Louise Barnett, Stephen Barrett, Michael Barth, Susana Blanes, Stuart Blower, Mercedes Bolín, David Bottos, Ed Burgess, Torsten Burkhardt, Almudena Bustos, Javier Calvo, Ana Carbonero, Juanjo Carrancedo, Sònia Castellò, Paco Chocano, Eva Clark, Andrew Clarkson, Pablo Codesido, Sebastián Collado, Iván Cordero, Miguel Ángel Cordero, Phaedra Corrigan, Alicia Cortell, Dan Crane, Marta Cumellas, Cathie Curran, John Denehy, Hilde Depuyt, José Carlos Díez, Concha Estaban, Javier Esteban, Elantha Evans, Mike Fairbrass, Andrés Fernández, Leo Fernández, Sara Fernández, Ricardo Fuentes, Harvinder Gabhari, Iván García, Jason García, Raúl García, Rosa García, Victor García, Marta García-Haro, Courtney Goldsmith, Juan Manuel Gómez, Ignacio González, Jorge González, Pedro González, Lucy Gould, Sera Grubb, Lennart Grut, Carmen Gundín, Ivan Harbour, Javier Hernández, Jesús Hernández, Sergio Hernández, José Julián Horcajo, Amarjit Kalsi, Jorge Keipo, Kazu Kofuku, Tom Lacey, Juan Laguna, Carlos Lainer, Matthew Lake, Antonio Lamela, Carlos Lamela, Ronald Lammers van Bueren, Stig Larsen, James Leathem, Marcus Lee, Tomás Llamas, César López, Francisco López de Blas, Javier López, Isabel Lorenzo, Avtar Lotay, John Lowe, Erick Maas, Rachel McGovern, Annette Main, Élida Margitic, Carmen Márquez, Francisco Martin, Steve Martin, Andrés Martínez, Tim Mason, Natalie Mayes, David Morales, Pedro Morales, Julio Moreno, Paz Moya, Jesús Municio, Javier Muñiz, Paul Nelson, Beatriz Olivares, Caireen O'Hagan, Tamiko Onozawa, Raquel Ortega, Iván Pajares, Louise Palomba, Jorge Palomero, Richard Paul, Inma Pedregosa, Adolfo Preus, Pablo Querol, Olga Ramírez, Matt Rees, Claudia Rieradevalle, Richard Rogers, Francisco Rojo, Andrei Saltikov, Inés Salvatierra, Cristina Sánchez, Francisco Sanjuán, Laureano Sanz, Birgit Schlösser, Patricia Sendin, Ana Serrano, Simon Smithson, Hugo Soriano, Neil

Southard, Kirsti Stock, Carlos Temprano, Jochen Tombers, Andrew Tyley, Yoshi Uchiyama, Eva Utrera, Verónica van Kesteren, Joaquín Vaquero, Patricia Vázquez, Laura Vega, Susana Vega, Isabel Vergara, Luis Vidal, Laura Villa, Dan Wright, John Young, Ignacio Zamorano, Nick Zervoglos
Services Engineer: TPS / INITEC
Structural Engineer: Anthony Hunt Associates / TPS with OTEP / HCA
Facade Engineer: Arup
Fire Engineer: Warrington Fire Research Consultants
Quantity Surveyor: Hanscomb Ltd / Gabinete
Airport Consultant: Initec / TPS
Lighting Consultant: Arup / Speirs and Majors Associates
Acoustic Consultant: Sandy Brown Associates
Landscape Architect: dosAdos
Main Contractors: Terminal: ACS, NECSO, FCC, Ferrovial Agroman, SACYR; Satellite: OHL Dragados; Car-parking and road access: Dragados;
Area: Total Area: 1,120,000m². New Terminal: 470,000m². Satellite Building: 315,000m²
Cost: £448,000,000

Transbay Terminal

San Francisco, California, USA, 1998–
Client: Metropolitan Transportation Commission
Co-Architects: Simon Martin-Vegue Winkelstein Moris
Design Team: Ivan Harbour, John Lowe, Andrew Morris, Richard Rogers, Graham Stirk, Andrew Tyley
Real Estate Consultant: Jones Lang LaSalle
Services Engineer: Arup
Structural Engineers: Arup
Civil Engineer: Treadwell & Rollo
Quantity Surveyor: Oppenheim Lewis
Traffic Engineer: Arup / Fehr & Peers
Area: 310,000 m² plus ramps affecting 10 city blocks
Cost: US$ 500,000,000

Pudong International Airport

Shanghai, China, 2003
Client: Shanghai Pudong Airport Authority
Co-Architects: Adamson Associates
Design Team: Dennis Austin, Mike Davies, Ivan Harbour, Jon Mercer, Krishan Pattni, Richard Paul, Richard Rogers
Structural Engineer: Arup
Services Engineer: Arup
Airport Consultants: Arup
Quantity Surveyor: Gleeds
Retail Consultants: The Design Solution
Area: 1,100,000m²

Guangzhou Station

Guangzhou, China, 2004
Client: Guangzhou Department Planning Authority
Design Team: Jimmy Abatti, Laurie Abbott, Natxo Alonso, Dan Crane, Benjamin Darras, Nick Hancock, Dennis Ho, Shu Zhen Lee, Richard Paul, Tosan Popo, Richard Rogers, Matt Venn
Structural Engineer: Arup
Services Engineer: Arup
Cost Consultant: Gleeds
Area: Masterplan: 266 hectares, Building: 40,000m²

Index

Headings and page numbers in **bold** indicate main entries

Headings and page numbers in **bold** indicate main entries

Headings and page numbers in **bold** indicate main entries

Headings and page numbers in **bold** indicate main entries

Picture Credits

All drawings and images courtesy of Richard Rogers Partnership, unless otherwise specified. Image sources have been listed where possible.

Abbreviations: TRW: Top Row, MRW: Middle Row, BRW: Bottom Row, SRW: Second Row, THRW: Third Row, TL: Top Left, TR: Top Right, BL: Bottom Left, BR: Bottom Right, L: Left, R: Right, M: Middle, T: Top, BM: Bottom Middle, TM: Top Middle

Accent Visual: p266BR.

Aerofilms: p364.

Marijke Anné: p315.

David Ardill: p327.

Martin Argles / The Guardian: p18TL.

Otto Baitz: p13THRW2; p26TR; p100; p102T, R.

Richard Bryant / arcaid.co.uk: p10TL; p13THRW1; p15R; p18BL, BR; p28TL, TR, M, BL; p34BL; p36; p39L; p44; p47; p48B; p50; p51TL, TR; p52L, R; p68; p80; p83; p85; p86TR; p88L; p89R; p90; p91; p105L; p106; p120; p121; p122T, BL; p123; p125T, B; p157BR; p189; p190L, R; p191; p243; p254T.

Jean de Calan: p194T; p197L, R.

Domus Casali: p13THRW3; p73.

Martin Charles: p17M; p86BR; p89TL; p244; p245TL, BR.

David Churchill: p225; p226TL; p228.

CIBSE Journal: p122BR.

Cityscape: p218; p220; p223.

Peter Cook: p86L; p88BR; p254B; p255; p456L, R; p457L.

Corbis: p232.

Countrywide Photographic: p309.

Richard Davies: p22L, R; p368; p369; p370; p371; p406; p408.

Michel Denancé: p16BL.

John Donat: p21TR; p82; p89BL; p245TM, TR; p251; p253; p375.

Cuno Brullmann: p72.

Steve Earl-Davies: p8TRW3, BRW1, BRW3.

Richard Einzig / arcaid.co.uk: p10TR; p13TRW1; p14L, R; p16BR; p38; p39R; p40; p41TL, BL, BR; p46B; p236; p248; p249.

Mike Fairbrass: p351; p352; p355T, B.

Florian Fischotter: p46T.

Norman Foster / Foster and Partners: p13SRW2; p70; p71T, B.

Y. Futugawa and Associates: p156.

Amparo Garrida: p10BL; p20BL; p35; p464; p466; p467; p473T, BL.

Chris Gascoigne: p460BR.

Dennis Gilbert / VIEW: p12TL; p33M; p160; p162; p172; p174L, R; p175TL, ML, BL, R; p226TR; p227; p229L, R.

Janet Gill: p19L.

Halcrow: p13SRW3; p116; p117L.

Hayes Davidson: p25TL; p171R; p180; p183; p321; p386; p387; p427T; p449; p450; p454B.

Andrew Holmes: p78; p79.

Timothy Hursley: p53.

i Guzzini Illuminazione: p461.